DOLLS OF CANADA

A Reference Guide

Kirsten April Strahlendorf with Rose the childhood doll of
Evelyn Robson Strahlendorf

DOLLS OF CANADA

A Reference Guide

Evelyn Robson Strahlendorf

Photography by U.C. Strahlendorf

Eaton's Beauty Chapter
by Judy Tomlinson Ross

University of Toronto Press
Toronto Buffalo London

Kirsten April Strahlendorf with Rose, the childhood doll of
Evelyn Robson Strahlendorf

© Copyright 1986 Evelyn Strahlendorf and U.C. Strahlendorf

First printing 1986 by Booklore Publishers Ltd.
Second printing 1990 published by
University of Toronto Press
Toronto Buffalo London
Printed in Hong Kong

ISBN 0-8020-2747-4

Canadian Cataloguing in Publication Data

Strahlendorf, Evelyn Robson
 Dolls of Canada : a reference guide

"Eaton's Beauty doll chapter by Judy Tomlinson Ross".
Includes index.
Bibliography: p.
ISBN 0-8020-2747-4

1. Dolls — Collectors and collecting — Canada.
2. Doll industry — Canada — History — 20th century.
3. Dollmakers — Canada. I. Strahlendorf, U.C.
(Ulrich Carl) II. Tomlinson, Judy Eaton's
Beauty dolls, III. Title.
NK4894.C3S87 1986 745.592'21'0750971 C86-090241-2

ACKNOWLEDGEMENTS

A book of this scope cannot be produced by one person alone but requires the assistance, cooperation, and encouragement of collectors, doll manufacturers, and many others.

My thanks and appreciation, therefore, must go to many people. First and foremost is my husband Carl, whose tireless help in so many fields I could not have done without. He has faithfully and uncomplainingly photographed dolls for two years as well as done countless other tasks towards the production of this book.

To Judy Tomlinson Ross who willingly took on the job of further research into the Eaton Beauty dolls of which she is an ackowledged authority.

To my daughter Susan for her professional editing, my son Peter for his legal guidance, research and encouragement. To my Mother Rose Robson for constantly pitching in to relieve me of household tasks that I might be free to work on the book. To my Father-in-law Walter Strahlendorf for his help and advice. To Kathleen Hunter, Toronto lawyer, and Gina La Force of the Hamilton Public Library for the encouragement I needed to perform this task. To Betty Hutchinson for her assistance in dating dolls, and to Florence Langstaff and Mary Alice Thacker for their help and assistance.

To the doll manufacturers who took the time to inform, advise, and guide me with the benefit of their extensive knowledge. To Arthur Cone, Mannie Grossman, Earle Pullan, David Cone, Ben Samuels, L.S. Samuels, Irving Samuels and Mr. H. Zigelstein.

To Robert McGhee of the archeology section of the Canadian Museums of Canada for his help with the prehistoric Inuit dolls. To Valerie Grant of the Royal Ontario Museum for her interest and assistance. To the staff of the National Library with their research assistance. To Dan Hoffman, curator of the Bowmanville Museum. And to all the collectors who took the time to prepare their dolls for photographs and permitted us to use their homes as a photography studio.

TABLE OF CONTENTS

TABLE OF CONTENTS Cont'd

Chapter 1

INTRODUCTION

This book is for doll collectors, museums, libraries, antique dealers, doll stores, and flea market operators. It contains the dates, names, and characteristics to identify about one thousand Canadian dolls from prehistoric times to the present, with the emphasis on dolls of this century manufactured commercially and dolls made by Canadian artists. It may be considered a history of Canadian dolls. Also included are about fifty dolls sold by The T. Eaton Co. Limited labeled as Eaton's Beauties. Many of the Eaton Beauty dolls were made by European companies like J. D. Kestner, Armand Marseille, and Cuno and Otto Dressel. However, they are included because they are an integral part of Canadian doll history. Attention is devoted to the doll industry in Canada and how the manufacturing process evolved from bisque and composition dolls through the various plastics to the dolls of today. Reproduction dolls are not presented, although two are shown as working dolls. With few exceptions, every doll described in this book has been personally examined by the author.

This book is also intended for a special class of doll enthusiast whom we call the closet collector. There are tens of thousands of these doll lovers in North America who have dolls and may also collect dolls, but do not admit this pleasure to others.

Doll collecting is a very popular pursuit in Europe and in the United States. It is rapidly gaining ground in Canada. Doll collectors have had access to several small books on Canadian dolls but nothing comparable in scope and size as, for example, Johana Gast Anderton's book *Twentieth Century Dolls: From Bisque to Vinyl*, which contains dolls that were manufactured in the United States and Europe. As the number of Canadian collectors has increased, they have been buying foreign books which has given them detailed information about foreign dolls but nothing much about Canadian dolls. It is hoped that this book will satisfy the demand for accurate information about the many dolls of Canada.

Not only is a book needed by collectors but also by flea market operators, antique dealers, pickers, museums, and doll stores. There is a great deal of erroneous information circulating among dealers and collectors, so it is hoped that the three years of research that went into this work will benefit everyone.

During the last ten years, the number of doll shows in Canada has multiplied dramatically, and every show has helped to increase interest and the number of collectors. The time has come when the demand for information must be filled. It is time for collectors to write about their collections and spread the knowledge that they have gained through experience, research, and study.

Canada has been exporting dolls for half a century. Many collectors in other countries own these dolls but cannot identify them, which is not surprising because Canadians have not been able to do it either.

What is included in this book? We will try to present dolls in chronological order starting with the prehistoric dolls of the Inuit. We will also show what the Inuit are making in the twentieth century, including many examples of well-made dolls from this ancient culture. The Indian dolls will be discussed from the past to the present day as well. Twentieth century Indian dolls include traditional ones such as the feather clothed Eagle Dancer and commercial plastic dolls dressed in Indian styled costumes. We will cover dolls of the early settlers and see the variety of dolls that children have played with during a period of three hundred years. Some of these dolls came to Canada with their immigrant owners and some were imported, but we must consider them in order to have a cohesive account of dolls and their history in this country. We will look at ethnic dolls which cover a wide spectrum of cultures in such a diversified country as Canada. Many of these dolls tell a story or make us curious about the different cultures which make up our whole.

Next, Judy Tomlinson Ross, author of *Those Enchanting Eaton Beauty Dolls*, presents a chapter on the Eaton's Beauty doll which was the most popular doll in Canada for many years. Time and considerable recent investigation in all the Eaton catalogues has enabled Judy to give the reader a comprehensive and updated story. Although many of these dolls were not Canadian made, they are so much a part of our history, our culture, and our memories, that they should not be excluded.

There are not a large number of celebrity dolls in the chapter that follows the Eaton Beauty dolls. Canadians are not a people who are given to self-praise. If an outstanding citizen is commemorated by a doll, however, we are very happy to make it an instant collector's item. The celebrity doll is a field in which our artists could do more work. Imagine a collection of authentic and life-like Prime Ministers, suffragettes of the past such as Agnes McPhail, Nellie McClung, or famous women such as Pauline McGibbon, Jeanne Sauvé, and Margaret Atwood.

The next chapter is about the working doll, a class of doll that has not received attention in the past. We are not referring to mechanical dolls. The working doll is one that has a function other than as a plaything. For example, in 1984 the National War Museum held an extensive exhibit about Canadian women at war. This exhibit included dolls in uniform, work attire, and historical costumes. Another example is the doll used for advertising. We will look at the many uses that have been made of the working doll.

The next type of doll occupies a large part of this book. Starting with the twentieth century, we present the commercial dollmakers and the evolution of their dolls. During the last seventy-five years, our dollmakers have experimented with different mediums and have made a wide assortment of styles and models. They have produced character dolls, walking, talking, wiggling, singing, drinking, wetting, and bilingual dolls. Our dollmakers have kept up with the latest doll making technology, and have dressed their dolls in the latest and most fashionable styles and materials. The history of each company is given with all available information about their products, progress, and accomplishments. The dolls are presented in chronological order for each company. This has never been done for Canadian dolls. The date of manufacture for each doll is the earliest known date that a given doll has appeared on the market. Some models were made for a few years, while other perhaps more popular models were produced for several decades. Therefore, unless a doll still retains its original dress it is not always possible to determine the exact year that it was made. But, we have been fortunate in at least partially solving this problem of dating as well. This chapter should help immensely to date commercially made dolls.

When my husband and I began this project, we believed that by photographing and cataloguing a large number of dolls, which we have succeeded in doing in great measure thanks to the cooperation of many collectors, we might see patterns emerge over the years in materials, manufacturing techniques, and styles. We sometimes found dolls in mint condition, in their original costume, box, and with the tag. These dolls enabled us to fix dates within groups of unknown dolls. Although this plan worked, we still had many unidentified dolls from a given manufacturer. We approached the owners of past and present companies and happily discovered that some of the salesmen's doll catalogues were extant. Copies of most catalogues came into our possession through the generosity of their owners, which has enabled us to identify and date most Canadian commercial dolls. It was a long intricate job that has enabled us to give doll names, dates, and accurate information about the original costumes worn, so that those persons who buy undressed dolls, or inappropriately dressed dolls, may restore them to their original state. It will also make the pricing of these dolls much easier.

Lastly, we will look at the dolls that have been created by artists. We have not been able to cover every outstanding doll artist in Canada, but we have been able to sample about forty of them. Some of the dolls are truly original and are works of art. This is a new field in Canada, and the doll artists are pioneers in an exciting and evolving art form. Some of the best buys from an investment point of view would be the artist's dolls that have been made in small editions or one of a kind. Many of these will increase in value as the years go by. We have covered excellent examples of dolls that have been made by many such artists. We believe that the artists chosen are among those who have fashioned their dolls with much creativity, skill, and imagination.

With the assistance of the photographs in this book, it will be possible for collectors to correctly date, name, and dress their dolls. Hopefully, it will increase the number of ardent collectors of Canadiana. There are many possibilities for the development of unique collections. One could specialize in any of the categories covered in this book, or even concentrate on acquiring dolls made by only one company. There is room for everyone in doll collecting. Some collectors enjoy making the clothing to dress their dolls authentically. Other collectors are adept at making shoes as well; a real asset. Restoring or repairing dolls is another field of endeavor. Cataloguing one's dolls accurately is another challenge. Dolls also make a wonderful subject to photograph. Arranging dolls for photographing is another creative challenge. Some collectors catalogue their dolls by means of photographs. Groups such as doll clubs, children's groups, and senior citizens enjoy a talk with photograph slides of a doll collection. The possibilities are endless.

Few museums in Canada have large doll collections on display. The dolls they have are usually stored away in drawers or on open storage shelves. There seems to be a chronic shortage of funds to catalogue, restore, and exhibit the dolls we have seen. Perhaps doll clubs could play a role here. Many doll clubs look for worthy causes to pursue. Possibly they could donate dolls to museums and assist curators in the restoration and exhibition of dolls. The preservation and display of Canadian dolls would attract visitors and would help to preserve a part of women's culture.

Dolls are necessary to mankind, for why else would

they appear time and time again through many human cultures and over thousands of years? Watch a child playing with dolls. The child is in a world of fantasy. Many children verbalize their emotions, and we can hear a variety of commands, endearments, reprimands, and plain conversation of the child who has been transported to another world, the world of imagination. Perhaps this explains the age-old appeal of a doll. Pick one up and experience a momentary flight into the world of yesterday.

SE2
ca.1920. Courtesy of Lillian Rowan of St. Justine de Newton, Québec.

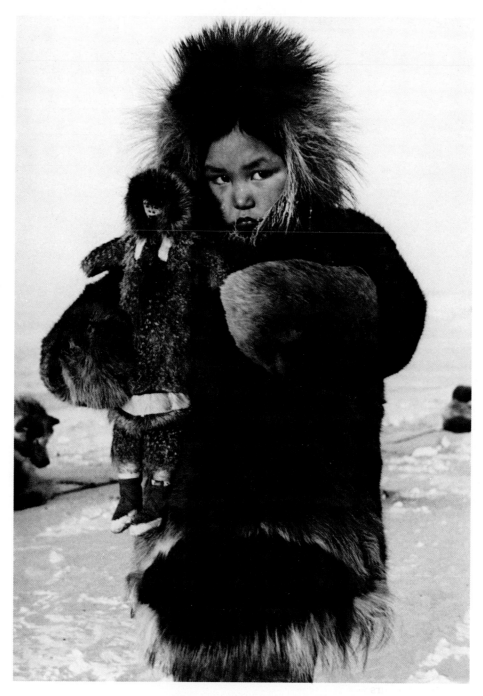

SL8

SL8
Inuit child, Coppermine River district. 1949-50. Photograph by
Richard Harrington. Public Archives Canada, neg. no.
PA-129021.

Chapter 2

INUIT DOLLS

The oldest dolls found in Canada were made by the Inuit. There were Inuit living in the Arctic for thousands of years before Christ was born. We do not know at what point in their history they began making dolls, but it is certainly an ancient tradition. What is significant is that dolls were being made in Canada long before the white man came.

The Inuit hunters used to mount a small doll on their boats before going hunting to bring them luck. Archaeologists have unearthed small doll figures made of ivory or wood in the remains of Inuit camping sites. It is easy to imagine that these small figures were also playthings of long ago. A tiny doll could be tucked into the clothing and carried from place to place as the hunters moved frequently looking for food. We are fortunate to be able to see these ancient dolls that survived, only because they were in a cold dry place and therefore did not deteriorate quickly.

The ivory head (see Fig. BO16) was carved in beautiful detail that included well formed ears and brows made with separate strokes. It may have been attached to a leather body and dressed in furs which disintegrated during the last eleven hundred years.

The wooden doll (see Fig. BO24) is just as old. It has also been made with great skill. We thought that we were seeing the first anatomically correct dolls in the nineteen-sixties, but the Inuit were making them a thousand years ago.

The whalebone doll (see Fig. BC10) is of unknown vintage, but whalebone has been an available material to the Inuit for millenia, so it could well be an ancient form of doll. The primitive bone dolls with arms and legs attached with string could also have been made for generations, although the examples shown were made in 1970. They do, however, show us dolls that could have been made exactly the same way centuries ago using

sinew or gut instead of string to attach the arms and legs.

The Inuit doll in Fig. BJ30 was acquired by the New Brunswick Museum in 1926. The clothing indicates that it is from the Labrador area. The doll shows the influence of Europeans as the head is a shoulderhead which is not typical of Inuit dolls. The Inuit dolls of today are made of modern materials such as wool, cotton, rickrack trim, and even plastic. However, aboriginal dolls of precontact times were made with readily available local materials such as bone, ivory, sealskin, caribou hide, fur, and driftwood.

The Inuit doll was a teaching device because little girls made dolls and thereby learned how to prepare leather and fur, how to sew, and how to fashion the clothing, just as they would do it in later life for the family. The doll shown in Fig. AR22 is a perfect example of a doll made by a child who was acquiring this skill. The doll is dressed as a woman wearing an amautik with a large hood to hold the baby, and a belt crossed in the front with ties around the waist to hold the baby in place. It has one arm shorter than the other, and the leather appears to have been cut by a beginner making her first doll. This historical doll tells a story.

Inuit doll clothing expresses the character of the community where the doll originated, for the different regions wore different styles. Collectors wishing to specialize in Inuit dolls could acquire dolls representing the different regions and dressed according to local styles. However, collectors should be aware that dolls made of natural furs are subject to infestations of tiny insects and thus should be kept in a cool dry place.

Another type of Inuit doll, which is of interest to collectors, are the Spence Bay packing dolls. This type of doll shows animals in human posture and wearing human clothing. Each doll represents an Arctic animal, bird, fish, or mythical creature, and packs a baby in its

hood. They combine a universal theme: mother and child, but with an Inuit feeling for the animal world and for mythology. The packing dolls reach across cultural barriers and are very appealing.

Doll making in the Arctic is now mainly for collectors in the south, and a number of doll artists names have become familiar to collectors. Jeannie Snowball

from Fort Chimo, who made the original Ookpik, has made a collection of sealskin birdlike figures. Joy Haluk of Eskimo Point makes beaded costumes, and Lizzie Tooktoo from Great Whale River makes sealskin and soapstone dolls. Inuit dolls are in demand by foreign doll collectors. Perhaps Canadian collectors have not fully appreciated the quality of Inuit dolls.

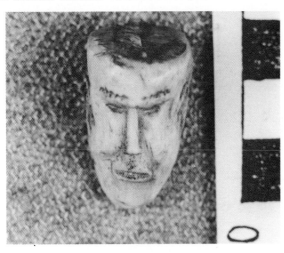

BO16

BO16
Inuit. 800 A.D. Face carving (Thule). 1.25 in. (3 cm). Ivory head, carved features. From Brooman Point, Bathurst Island. Possibly the head of a doll. It has a carved vertical tongue and groove on the back of the head which could have been the method of fastening the head to a leather body. Courtesy of National Museums of Canada, National Museum of Man, Ottawa, Ont. See also Fig. BO17.

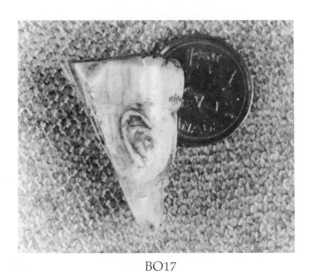

BO17

BO24
Inuit. 800 A.D. Wooden doll. 6 in. (15.5 cm). Carved wooden doll with jointed hips and shoulders; one arm missing. Carved spine and ribs. Sexed doll. From the southeast tip of Bylot Island. Courtesy of National Museums of Canada, National Museum of Man, Ottawa, Ont. See also Fig. BO26.

BO24

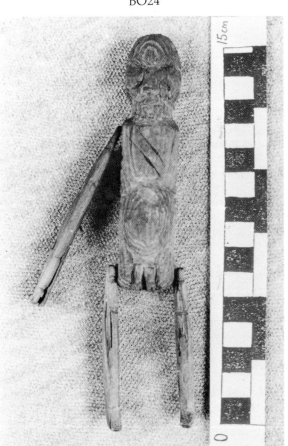

BO26

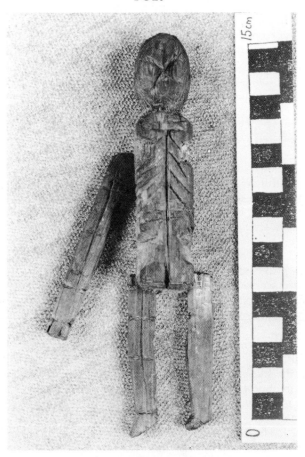

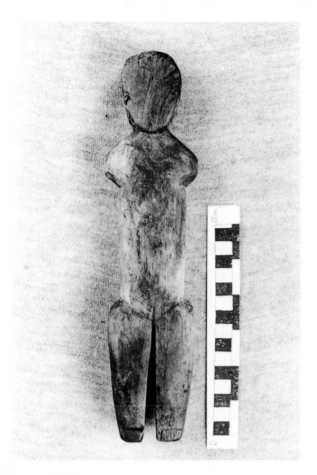

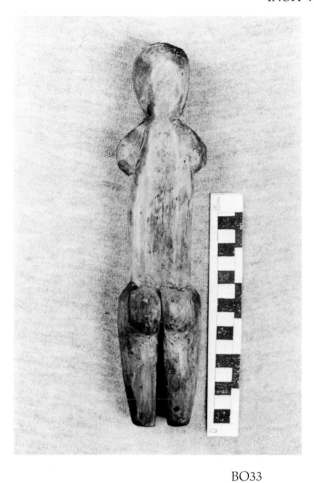

BO31

BO33

BO31
Inuit. 1200 A.D. Wooden figure. 3.5 in. (9 cm). Carved wooden figure, flat featureless face. From Brooman Point, Bathurst Island. Courtesy of National Museums of Canada, National Museum of Man, Ottawa, Ont. See also Fig. BO33.

BO27
Inuit. 1200 A.D. Wooden doll. 3.25 in. (8.5 cm). One piece armless wooden figure with headdress indicating a woman. From Strathcona Sound. Courtesy of National Museums of Canada, National Museum of Man, Ottawa, Ont. See also Fig. BO28.

BO27

BO28

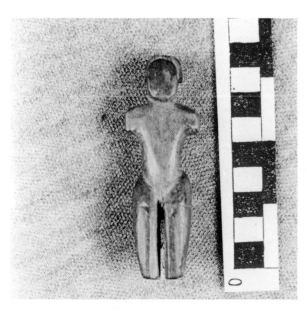

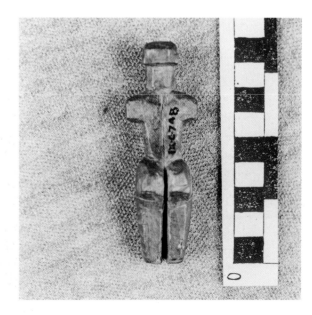
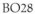

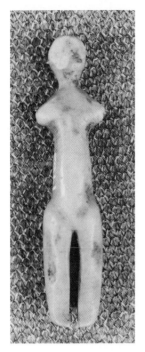

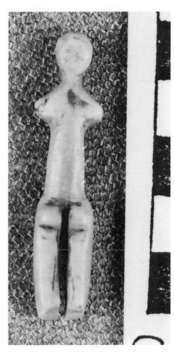

BO19 BO21

BO19
Inuit. 1200 A.D. Thule ivory doll. 1.75 in. (4.5 cm). One piece armless ivory doll. From Brooman Point, Bathurst Island. Courtesy of National Museums of Canada, National Museum of Man, Ottawa, Ont. See also Fig. BO21.

BJ30
Inuit. Date unknown. 13.75 in. (35 cm). Cloth body, wooden hand; one missing. Wooden shoulderhead; carved features. Eyes made of bone. Dark brown human hair inserted in circular indentation. Tag around the waist labelled Kunana. Leather knee-length pants with vertical stripes, knee-high boots, cotton shirt. Believed to be from Labrador. Courtesy of New Brunswick Museum, Saint John, N.B.

BC10
Inuit. Date unknown. Whalebone doll. 15.75 in. (40 cm). Carved whalebone doll with carved clothing. The whalebone has deteriorated but the outline of clothing and facial features can still be seen. Courtesy of Dartmouth Heritage Museum, Dartmouth, N.S.

BJ30 BC10

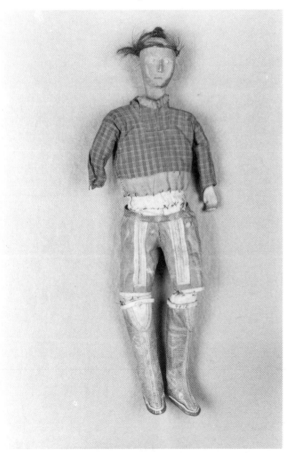
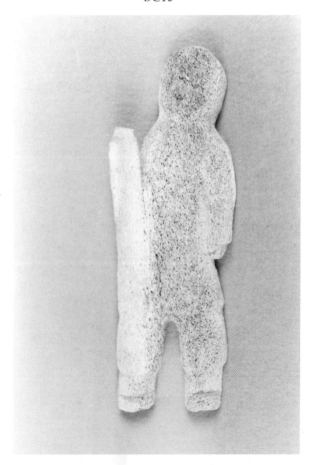

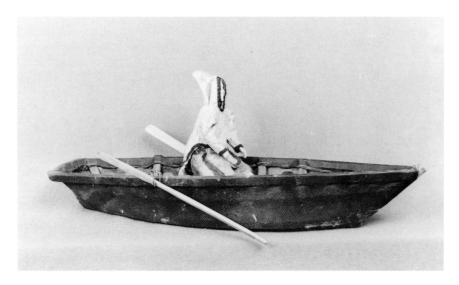

AZ25

AR22
Inuit. Date unknown. Inuit woman. 15.25 in. (39 cm). Cloth body. Wooden head with carved features and carved tatto marks on cheeks. Carved hair. Mark: on foot, 784. Original authentic fur and leather clothing. One arm is shorter than the other which probably indicates the doll was made by a child learning to sew. Large hood to accomodate a baby. From the collection of Barbara Bickell, Whitby, Ont.

AZ26
Inuit. Date unknown. WOMAN POWER. Height, sitting, 8.25 in. (21 cm). Leather body in a sitting position; carved ivory hands. Ivory carved head; eyes painted black. Mark: label, Canadian Eskimo Art ; Community 757/DNA Frsb./Frobisher Bay/E564. Authentic sealskin clothing. Umiak is 22.75 in. (58 cm) long with a wooden frame covered in sealskin and includes oars. From the collection of Mrs. D. Steele, Ottawa, Ont. See also Fig. AZ25.

AR22

AZ26

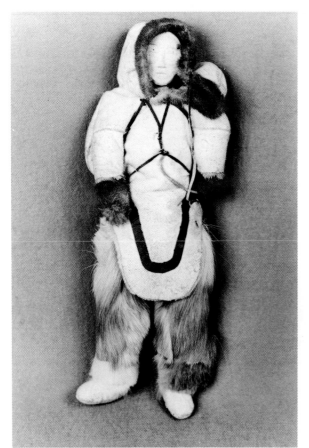

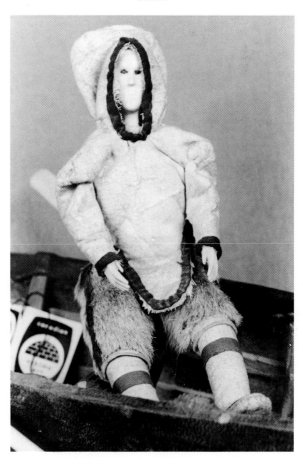

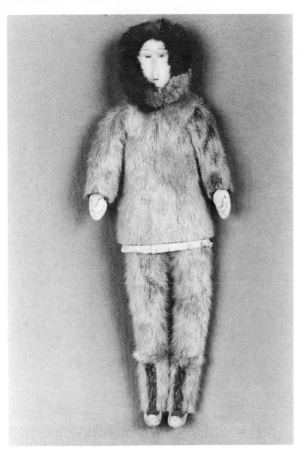

AR19

AR19
Inuit. Date unknown. Inuit man. 17 in. (43 cm). Cloth body. Wooden head with carved features. Authentic sealskin clothing; well made leather mitts and boots. From the collection of Barbara Bickell, Whitby, Ont.

BV7
Inuit. Early twentieth century. Smallest doll is a man with a carved bone face. Clothing is removable. Three larger dolls are women, two with leather faces and one with a carved wooden face and painted features ; wool hair. Sealskin clothing. Photograph courtesy of Black Creek Pioneer Village, Toronto, Ont.

BV7

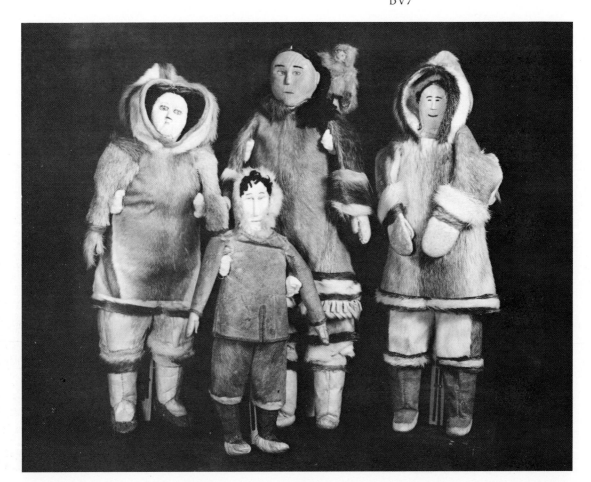

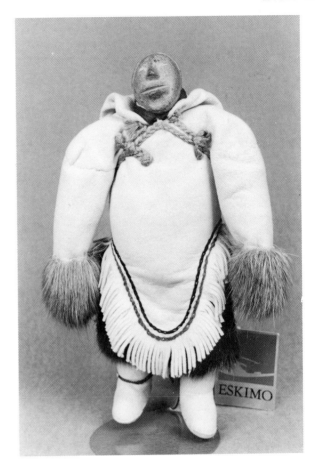

AZ32
Inuit. Date unknown. Inuit woman. 8.25 in. (21 cm). Leather body. Soapstone head; carved features and hair. Leather and sealskin clothing. Mark: label, Eskimo art, Made by an Inuit at Eskimo Point. From the collection of Mrs. D. Steele, Ottawa, Ont.

AR20
Inuit. Date unknown. Inuit man. 19.75 in. (50 cm). Cloth body. Wooden head; carved features. Unmarked. Dressed in a woollen hooded parka with fur trim, woolen pants, leather and fur mukluks. From the collection of Barbara Bickell, Whitby, Ont.

AE14
DaLacia Kasudluck. Date unknown. Inuit woman. 10 in. (25.5 cm). Cloth body. Soapstone head with carved features and hair. Mark: label, #1073, made by DaLacia Kasudluck at Dnoucdjovck. Handmade sealskin pants and parka with large hood to accomodate a baby; leather gloves and boots. From the collection of Judy Smith, Ottawa, Ont.

AZ32

AR20

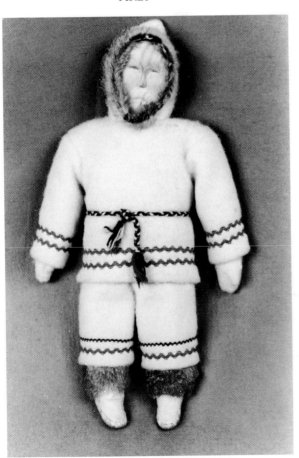

AE14

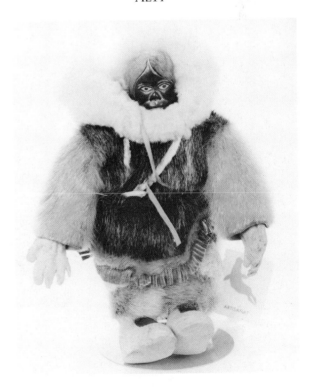

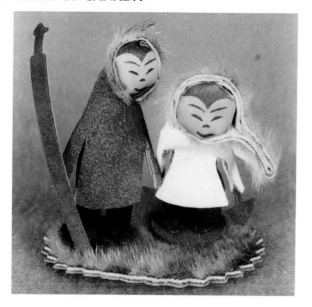

BX32

BX32
La Fédération des Coopérative du Nouveau. Date unknown. Inuguguliajuit (The Little People). 4 in. (10 cm). Leather body. Leather head with painted features. Leather and fur clothing are part of doll. Mark: on label, La Fédération des Coopérative du Nouveau, Qué. Lévis, Qué., Canada. Miniaturized Eskimos. The Inugaguliajuit inhabit the regions of the Artic. They emulate the life of the Eskimos and are said to possess magic powers and amazing strength. There are many legends about these clever dwarfs. One such tells of an Inugaguliajuit asking for the meat of a fox just killed by an Eskimo. To the Little People, the fox is as prized as the polar bear is to the Eskimo. The foolish hunter refuses and the Inugaguliajuit retaliates by asking the man to open his mouth. It remains that way forever. From the collection of Marsha Nedham, Ajax, Ont.

AZ33
Inuit. Date unknown. Inuit man. 9.75 in. (24.5 cm). Cloth body; soapstone mitts and boots. Soapstone head with carved features. Mark: label, Eskimo/made by an Inuit at Pond Inlet. Dressed in a hooded wool parka trimmed in fur; black pants. From the collection of Mrs. D. Steele, Ottawa, Ont.

AZ33

BH7
Inuit. Date unknown. Inuit man. 7 in. (17 cm). Cloth body. Plastic shoulderhead; painted eyes; moulded black painted hair. Mark: on foot, Labrador. Dressed in a sealskin hooded jacket, cotton pants, leather mukluks and mitts. Made in Labrador. From the collection of Christine Mont, Eastern Passage, N.S.

BH7

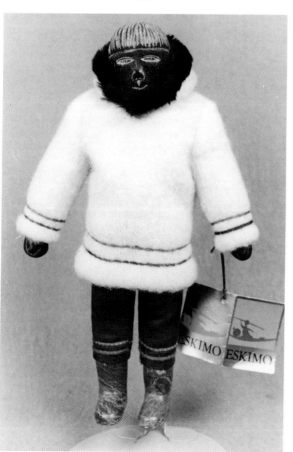

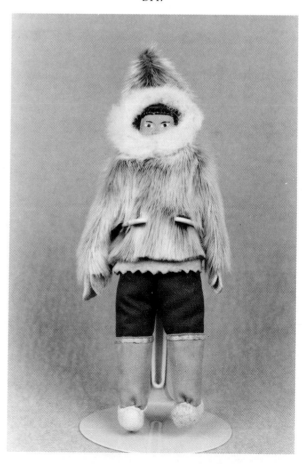

CB15
Inuit. ca.1966. Inuit man. 11 in. (28 cm). Cloth body. Bone head with carved features. Unmarked. Dressed in an embroidered white parka trimmed around hood with white fur cloth, wolverine mitts, navy blue sailcloth pants, leather mukluks. Made by an Inuit on Baffin Island. From the collection of Mary Van Horne, Chilliwack, B.C.

AB1A
Ootoovah Tigullaraq. ca.1970. Clyde River Inuit. 16 in. (40.5 cm). One piece cloth body. Cloth head with attached nose; painted features. Completely dressed in baby sealskin and leather boots. Mark: label, Eskimo Art, Handmade by Ootoovah Tigullaraq from Clyde River. From the collection of Ann Thacker, Ottawa, Ont.

BC7
Inuit. 1970. Bone play dolls. 3.50 in. (9 cm), 4.75 in. (12 cm), 5.25 in. (13.5 cm). Holes drilled in the bone, arms, and legs; attached with strong thread. Largest doll has been carved to suggest clothing. From the collection of Mrs. D. Steele, Ottawa, Ont.

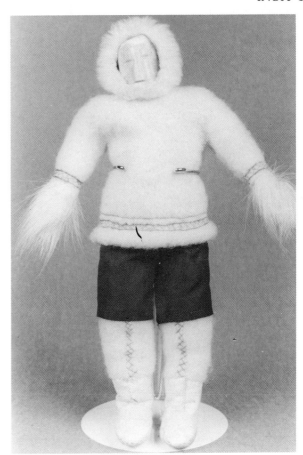

CB15

AB1A

BC7

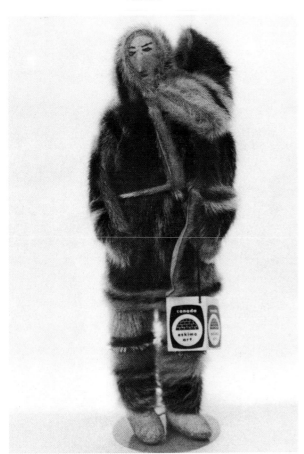

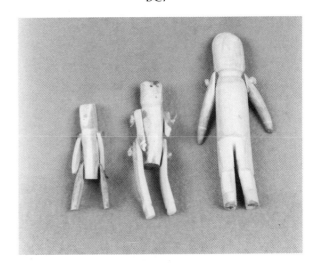

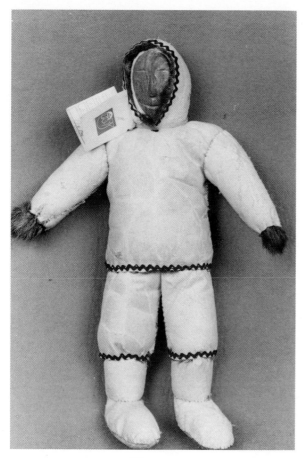

CP29

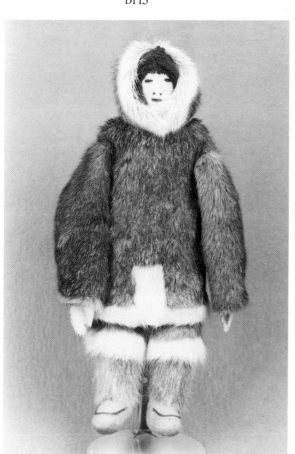

BH5

CP29
Esau Ulayok. 1976. Inuit man. 13 in. (33 cm). Cloth body; soapstone head with carved features. Clothing made of caribou turned inside out and trimmed with rickrack. Mark: label, made by Esau Ulayok from Eskimo Point. From the collection of Ruth Mesley, Barrie, Ont.

BH5
Allikie Eeshieiut A-K. ca.1976. Inuit man. 13 in. (33 cm). Cotton head with embroidered features; wool hair. Felt hands. Authentic fur and leather clothing, felt and fur boots, and leather mitts. Handmade by Allikie Eeshieiut A-K from Frobisher Bay. From the collection of Margaret Edmonds, Waverley, N.S.

AR18
Noleeant. 1977. Inuit man. 5.75 in. (15 cm). Cloth body. Leather head; no features; wool hair. Mark: label, Noleeant of Spence Bay/63Y9210. Handmade leather clothing; fur trimmed hood. From the collection of Barbara Bickell, Whitby, Ont.

AR18

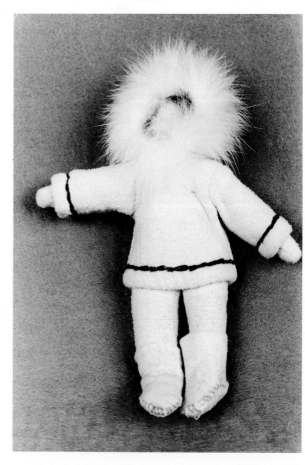

BZ13
Jimmy Jacobson. 1977. Inuit man. 12 in. (30.5 cm). Whalebone body. Stone head and carved features. Mark: label, Jimmy Jacobson from Tuktoyaktuk, N.W.T. Dressed in fox, seal, and rabbit furs. From the collection of Phyllis McOrmond, Victoria, B.C.

CE2
Emily Katiak. 1977. Inuit woman. 13 in. (33 cm). Cloth body. Canvas head embroidered features; black wool hair. Mark: label, made by Emily Katiak from Coppermine, N.W.T. Cotton print overdress, felt underskirt, trimmed with rabbit fur, dark red satin pants, navy felt mukluks with rawhide bottoms, fur mitts, fastened by a braided and tasselled holder, and hood with wolf fur trim. From the collection of Roberta LaVerne Ortwein, Olds, Alta.

BZ13

CE2

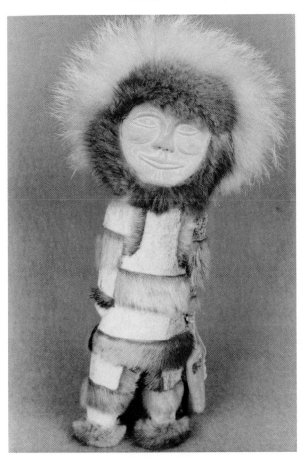

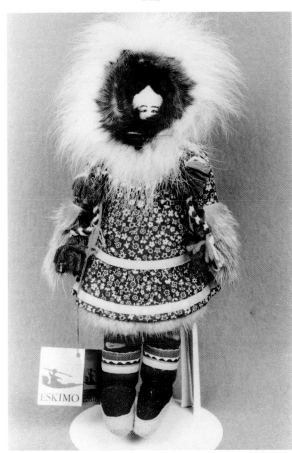

Chapter 3

INDIAN DOLLS

INDIAN DOLLS

"My People have always made dolls," was the answer given by a Canadian Indian doll artist when asked about the history of Indian doll making. Because Indian dolls were generally made of natural materials such as wood, leather, fur, and cornhusk, which are perishable in a temperate climate, they did not survive over the centuries as did the Inuit dolls of the far north. It is known, however, that at least some of the Indian tribes were making dolls long before the arrival of the Europeans.

Dolls were made from almost any available natural material. Some examples are given of dolls made from these materials by Indian tribes in various parts of Canada such as eastern Indians, plains Indians, west coast Indians, and northern Indians.

The Ojibwa Indians, who lived in the region from the Ottawa Valley westward to the Prairies, are known to have made very early dolls from willow withes and spruce roots. Later dolls were made from skin stuffed with spruce moss and dressed in leather clothing decorated in quillwork.

The Ongwe-oweh, or Iroquois, did not waste food. They believed that the Creator would not permit food to grow to be wasted. Therefore, every bit of the corn harvest was used, including the corncobs and cornhusks. The husks were used to make mats, slippers, masks, and dolls. Dolls made from corncobs and cornhusks were popular among the Six Nation Indians, a confederation of Indian tribes near Lake Ontario, for they had an abundance of these materials. The cornhusk doll, or Kania-ton-ni, as made by The People of the Longhouse, had a body which was fashioned of cornhusks. It had no face, because if a face were put on it the maker presumed upon the power of the Creator and instilled the doll with a spirit. That spirit had the power to revenge itself on a person who was responsible for the destruction of the doll. Therefore, the doll was made with no face,

and so it only carried the wishes for good of the donor.

Among the Iroquois there was a belief in a race of demons known as False Faces, who could injure the living. To propitiate these evil spirits, a secret organization was formed called the False Face Society. To join this society, a person must have had a dream to that effect, which he repeated to the proper person, and then he would give a feast. When a sick person dreamed that he saw a False Face, it meant that he would be cured through the False Face Society. Dolls made of cornhusks wore tiny grotesque masks made to represent the False Face Society (see Fig. AZ36A). These dolls are made for collectors today. Many of the cornhusk dolls are made as action figures. Their bodies are cleverly modeled to show an activity, such as dancing or lacrosse, a sport invented by the Indians (see Fig. BC3).

A spirit named Loose Feet granted wishes to little children. A cornhusk doll with a dried apple face was made to represent the spirit. The Iroquois also made a doll from buckskin and dressed it in leather decorated with porcupine quill work or, at a later date, beads. This type of doll often had human or horsehair braids.

Early Plains Indians had a simple doll made from a piece of worked leather. A soft substance such as buffalo hair, grass, or bits of leather, was placed inside the centre of the leather. The sides were then pulled together and a string was tied around the soft substance to form a head. The leather that hung down to represent the body was carefully wrapped in a tiny shawl.[1]

Later Plains Indians dolls were made of leather and had arms and legs. The leather clothing was usually fringed. Before about 1840, dolls were decorated with porcupine quill work. But after that date, European beads were readily available on the Prairies, and these were used in place of quills.

A small image of stone, wood, or cloth, symbolic of the Giver of Life, was carried by the native women and children of the west coast. Some tribes made dolls with wooden heads and leather bodies. Children on Vancouver Island had dolls of cedar bark that resembled the cornhusk dolls. Sometimes these dolls were equipped with tiny cradle boards made from cedar bark. The Pacific coast Indians used shells to decorate their dolls, but this material has been replaced by buttons. Dolls are now sometimes dressed in authentic elaborate clothing heavily decorated with white buttons sewn in patterns (see Fig. BZ12).

Little girls of the Montagnais and Naskape tribes of northern Canada were given dolls and encouraged to make clothes for them to aid them in their sewing skills. Dolls were also used in these regions as charms, amulets, and fetishes.[2]

A different type of doll was found at Big Lake between the lower Yukon River and the mouth of the Kuskokwin River. The heads had been hollowed out so that the eyes and mouth could pierce the cavity. Some of these figures were made of bone with the head separated from the body and fitted onto it by means of a wooden pin which projected from the body. In this way the head could be turned as on a swivel. Sometimes these dolls were dressed in deer skin.[3]

The tea doll is an unusual and charming doll which was made by several tribes. The cloth and leather doll was made with a cavity to hold a quantity of tea. This way, even the children carried their share of the supplies when the families moved camp. Such dolls took on the aromatic smell of the tea and were consequently attractive to hold. Tiny clay figures were also made by various tribes. Small Indian girls sometimes carried dolls in miniature cradleboards as well as other miniature items from the adult world. Some Indians were known to have made a bone image of the girl they loved, and then bore a small hole in it to represent the heart. When the young man was away on a hunting trip, he would put a small piece of wood in the tiny cavity and hoped the girl would have her heart touched and return his love.[4]

Indian dolls were indigenous to Canada, but after contact with the Europeans they began to change. It is interesting to note the china head doll beautifully dressed in Indian clothing (see Fig. BV13). As modern materials have become available, the Indians have adapted their skills to the production of fine dolls. Indian dolls have been made for collectors since before the turn of the twentieth century. The most collectible are those using natural materials. The more authentic a doll is the more prized it is. Most Canadiana collectors have several examples of work by Indian doll artists in their collections.

1. Kant, Joanita. *Old Style Plains Indian Dolls*, p.8.
2. Jeuness, D. *Indians of Canada*. National Museum of Canada, Bulletin 65.
3. Moore, Lorene. *Dolls of the North American Indians*. LORE, winter, 1963, Vol. 14, No. 1. LORE is the official Magazine of the Milwaukee Public Museum.
4. MacLean, J. *Canadian Savage Folk: The Native Tribes of Canada*. W. Briggs Co., 1896.

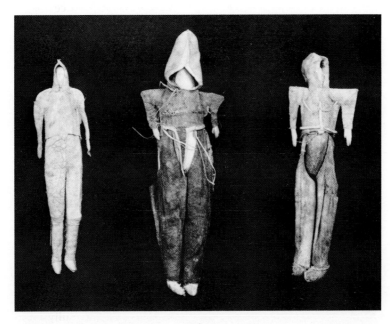

DA6

DA6
Indian. Date unknown. Primitive leather and bone dolls.
Photograph courtesy of the National Museums of Canada,
National Museum of Man.

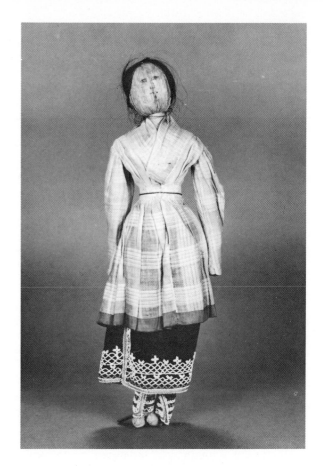

BV11
Woodland Indian. Betsy Turkana. 1840. This cornhusk doll is a particularly fine example of craftsmanship. Human hair, heavy beading on the skirt and leggings. Tuscorora parsonage, Ont. Onondaga Iroquois Indian. Photograph: cat. No. HD12702, courtesy of the Royal Ontario Museum, Toronto, Ont.

BV1
Woodland Indian. ca.1850. 11 in. (28 cm). Carved wooden woman, carved hands, jointed arms. Birchbark canoe is 28 in. (71.5 cm), authentic design, beautifully decorated with pattern in quill-work. From the Snake Island Indian Reservation at Lake Simcoe, Ont. Photograph courtesy of Black Creek Pioneer Village, Toronto, Ont.

BV11

BV1

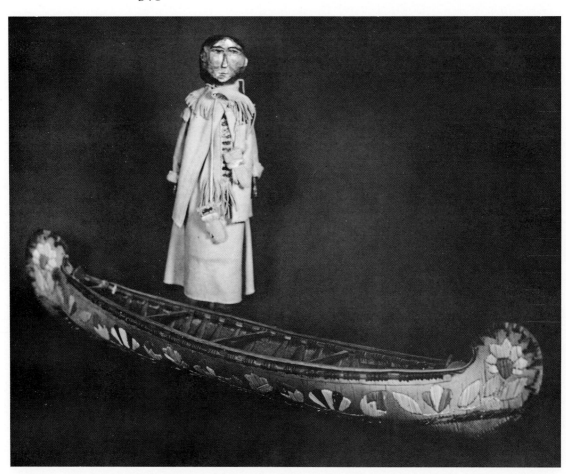

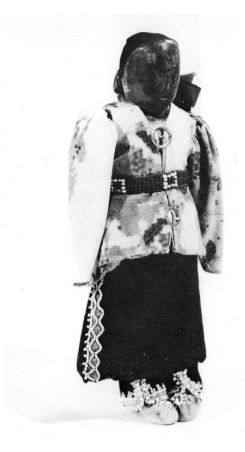

BV17

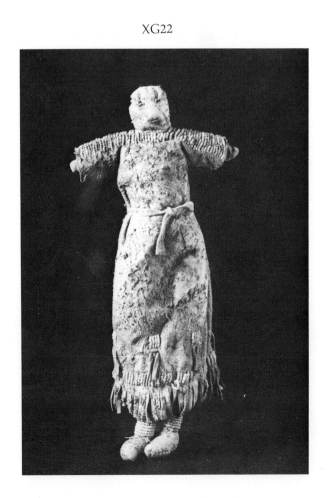

XG22

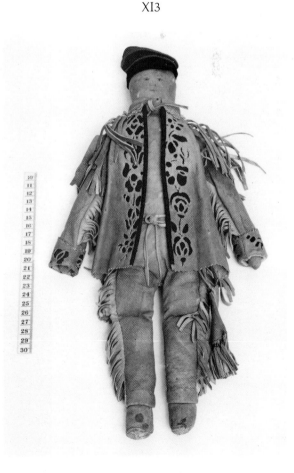

XI3

BV17
Woodland Indian. Nineteenth century. Wooden doll in traditional Iroquois Indian dress. Photograph: cat. No. HD5437, courtesy of the Royal Ontario Museum, Toronto, Ont.

XG22
Plains Indian. Date unknown. Leather body and head; eyes are beads. Unmarked. Dressed in a leather dress trimmed with beads. Photograph: cat. No. HK35, courtesy of the Royal Ontario Museum, Toronto.

XI3
Metis. ca.1898. 24 in. (61 cm). Leather body and head, features drawn on leather. Unmarked. Beautifully made fringed and embroidered leather suit. Typical of clothing worn by Meti men who worked on the Mackenzie River at the close of the nineteenth century. Doll was made as a toy for Mrs. Rusler (nee Johnson) when she lived with her family in the Hay River area. Courtesy of the Glenbow Museum, Calgary, Alberta.

BV13

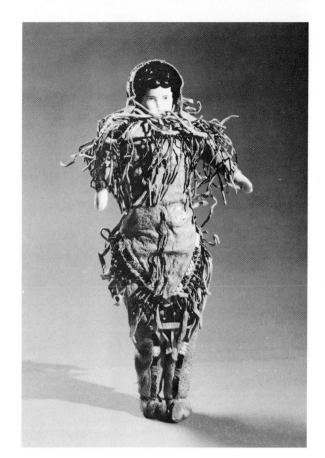

BV13
Athapaskan Indian. Date unknown. The German china head
and hands were probably bought at the Hudson's Bay store and
the body and Indian leather clothing made for it. Photograph:
cat. No. HD5394, courtesy of the Royal Ontario Museum,
Toronto, Ont.

BL2
Indian. ca.1900. Carved wooden body and head (one leg
missing). Handmade wooden toboggan, 9.50 in. (24 cm).
Leather clothing. Courtesy of the New Brunswick Museum,
Saint John, N.B.

BV12
Woodland Indian. Date unknown. Cornhusk dolls. Man dressed
in fringed leather suit; woman in cotton print dress over wool
beaded skirt and leggings, leather moccasins on both dolls.
Photograph: cat. No. 975x73.23 &.24, courtesy of the Royal
Ontario Museum, Toronto, Ont.

BL2

BV12

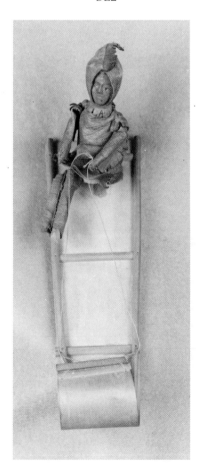

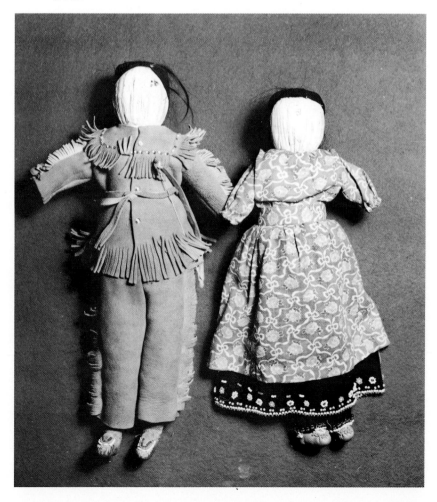

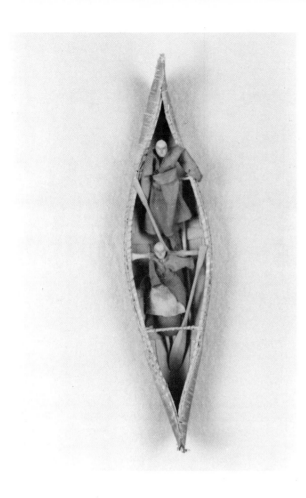

BL3

BL3
New Brunswick Indian. Date unknown. Wooden carved man and woman. Birchbark and cedar canoe, 16.5 in. (42 cm). Carved paddles and rifle. Probably made by a Micmac or Malecite Indian. Courtesy of the New Brunswick Museum, Saint John, N.B.

BZ14
Indian. 1939. PLAINS INDIAN. 19 in. (48.5 cm). Cloth body. Leather head; beaded eyes; horsehair braids; beaded mouth. Unmarked. Dressed in handmade buckskin clothing trimmed with beaded patterns, feather headdress, beaded leather shoes. Bought at Banff, Alberta. From the collection of Phyllis McOrmond, Victoria, B.C.

BM30
Six Nations Indian. 1947. 6.25 in. (16 cm). Cloth body. Cloth head; features drawn in ink; black human hair braids. Unmarked. Handmade leather clothing. Purchased from Indians at the Toronto Royal Winter Fair. From the collection of Sue Henderson, Winnipeg, Man.

BZ14

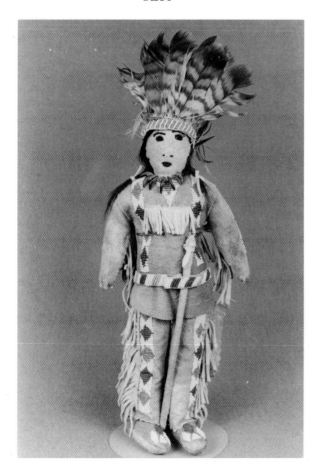

BM30

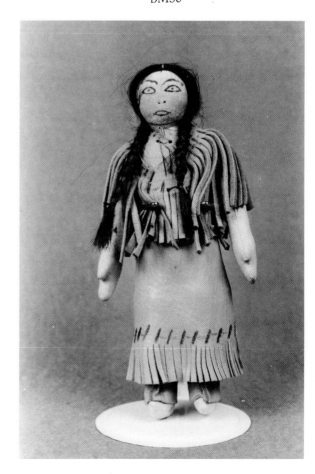

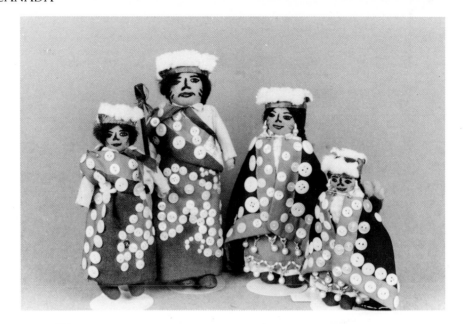

BZ12

BZ12
Katie Scow. ca.1950. INDIAN FAMILY. Father, 11 in. (28 cm); mother, 9 in. (23 cm); boy, 8 in. (20.5 cm); girl, 7 in. (17 cm). Cloth bodies and heads; embroidered features; wool hair. Mark: on mother's cape, K.C. Family of dolls made by the late Katie Scow of Alert Bay, B.C., Kwakiutl Tribe. Wife of the late Chief Scow who spoke the dedication at Martin Munro's funeral. Katie Scow died in 1979 at 80 years of age. Her dolls have been collected all over the world. She spent her last years on the Campbell River Reserve. Several members of the Scow family have been noted doll makers, Katie Scow, Joyce Willie, and Gordon Scow who makes dancing figures. From the collection of Phyllis McOrmond, Victoria, B.C.

AZ36
Owa'nyudane' and Gana'gweya'hon. 1960. BROKEN NOSE. 7 in. (17 cm). Cornhusk body. Carved wooden mask over face; long grey hair. Mark: on the bottom, Iroqrafts/Six Nation Reserve. Dressed in wool, leather with bead trim clothing. Representing a BROKEN NOSE in the Iroquois False Face Medicine Society. From the collection of Mrs. D. Steele, Ottawa, Ont.

AZ36

BC5
Six Nations Indian. 1960. EAGLE DANCER. 4 in. (10 cm). Cornhusk body. Head is that of a bird, arms are covered by the wings, eyes are beads. Unmarked. Leather clothing. From the collection of Mrs. D. Steele, Ottawa, Ont.

BC5

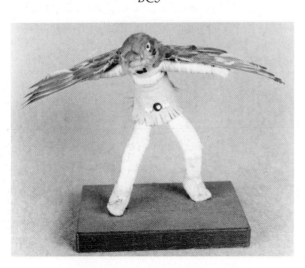

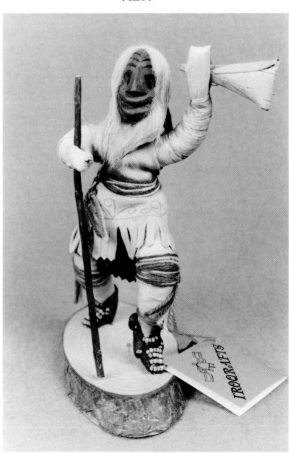

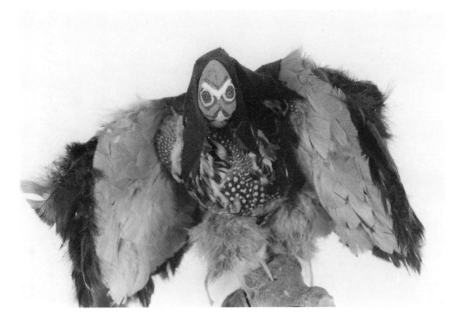

CQ14

CQ14
Peter Metatawabin. Date unknown. WEE-SA-KAY-JAC (The Owl Man). 11 in. (28 cm) high x 12 in. (30.5 cm) wide. Cloth body covered in feathers. Cloth head; painted features. Unmarked. According to Cree legend the Owl Man can turn into anything. Courtesy of the Bowmanville Museum, Bowmanville, Ont. See also Fig. CQ15.

BP11
Indian. ca.1970. 7.75 in. (10.5 cm). Brown hard plastic teen body, jointed shoulders and neck. Hard plastic head; brown sleep eyes, moulded lashes; black mohair braids; closed mouth. Unmarked. Dressed in beaded leather suit by Indians. Wears feather headdress and carries a bow. From the collection of Betty Hutchinson, Ottawa, Ont.

CQ15

BP11

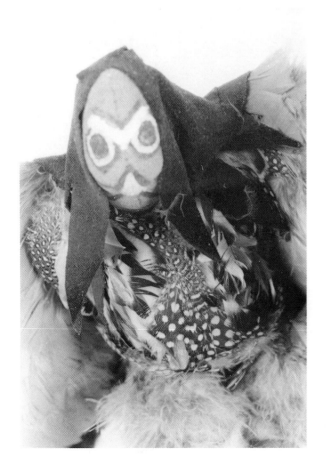

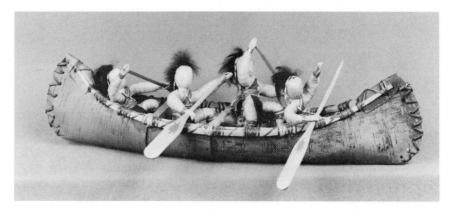

AZ27

AZ27
Six Nations Indians. 1970. IROQUOIS WARRIORS. Height, 5.5 in. (14 cm) x 22.5 in. (57 cm). Cornhusk bodies; no features; synthetic black hair. Unmarked. Dressed in wool, leather, and beads. From the collection of Mrs. D. Steele, Ottawa, Ont.

BX31
Indian. 1974. BLACKFOOT MEDICINE MAN. 10 in. (25.5 cm). Cloth body with wire armature. Leather head; beaded eyes and mouth; black braids. Unmarked. Dressed in handmade beaded leather clothing, fur headdress and carrying leather medicine bag. From the collection of Marsha Nedham, Ajax, Ont.

AZ34
Rhea Skye. 1975. HOOP DANCER. 8 in. (20.5 cm). Cornhusk body and head; no features; black wool braids. Mark: label, Rhea Skye/Mohawk Indian/Rice Lake Reserve. Dressed in leather trimmed with beads. From the collection of Mrs. D. Steele, Ottawa, Ont.

BX31

AZ34

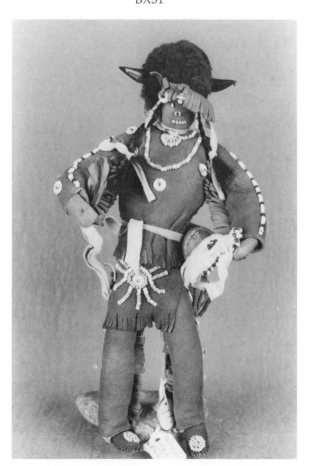

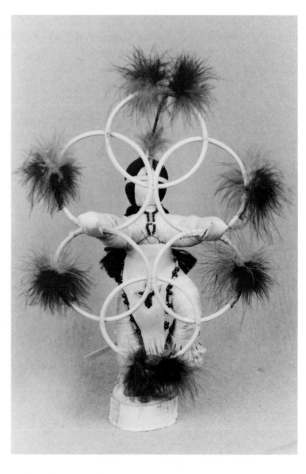

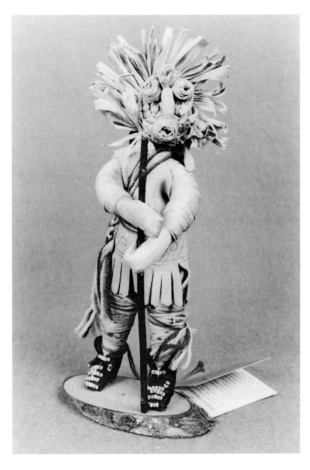

AZ36A

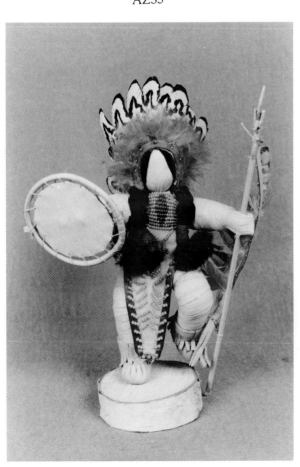

AZ35

BP14

AZ36A
Owa'nyudane and Ginada'y'asas. Date unknown. GASESA (one of the host of supernaturals dedicated to the healing of certain illnesses). 7.5 in. (18 cm). Cornhusk body. Face covered with a cornhusk mask. Mark: on bottom, Iroqrafts/Six Nation Reserve. Original label. Dressed in wool and beaded leather, carrying stick. From the collection of Mrs. D. Steele, Ottawa, Ont.

AZ35
Mohawk Indian. 1975. 9 in. (23 cm). Cornhusk body and head; no features; black wool braids. Unmarked. Dressed in beaded leather, carrying shield and spear. Made at the Rice Lake Reserve, Ontario. From the collection of Mrs. D. Steele, Ottawa, Ont.

BP14
Indian. ca.1975. 7.5 in. (19 cm). Brown hard plastic teen body, jointed shoulders and neck. Hard plastic head; brown sleep eyes, moulded lashes; black synthetic hair; closed mouth. Unmarked. Dressed by Indians in leather and fur. From the collection of Betty Hutchinson, Ottawa, Ont.

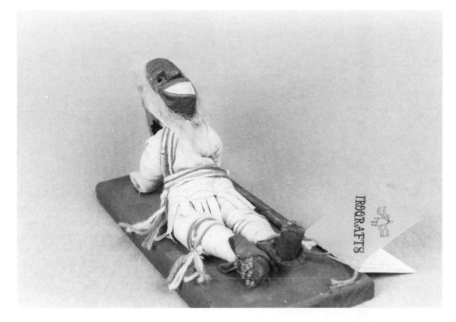

BC4

BC4
Six Nations Indian. Date unknown. Height, 4 in. (10 cm).
Cornhusk body. Carved wooden mask; long grey hair. Mark:
label. Dressed in leather and wool. From the collection of Mrs.
D. Steele, Ottawa, Ont.

BC3
Owa'ny udani' and Negi'yend'gowa. Date unknown.
LACROSSE PLAYER. 7 in. (17 cm). Cornhusk body and head;
no features on the face; black hair. Mark: on bottom,
Iroqrafts/Six Nation Reserve. Original label. Dressed in wool,
leather, and beads and carrying a lacrosse racquet. From the
collection of Mrs. D. Steele, Ottawa, Ont.

BC3

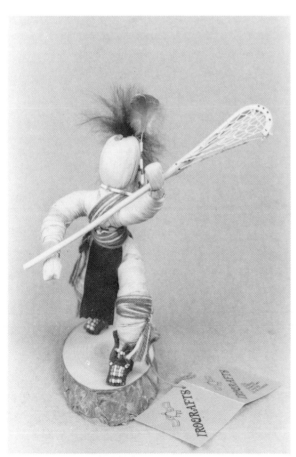

BY6
Six Nations. 1977. FALSE FACE SOCIETY DOLL. 3.25 in. (8
cm) x 5.25 in. (13 cm). Cornhusk body. Black mask face with
carved features, red painted mouth; black hair possibly dyed
moss. Unmarked. From the collection of Marsha Nedham, Ajax,
Ont.

BY6

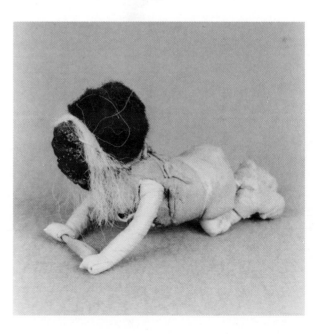

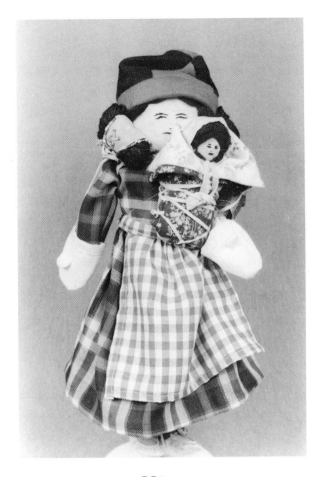

CQ8

CQ9

CQ8
Naskapi and Montagne Indians. ca.1980. LABRADOR TEA DOLL. 15 in. (38 cm). Cloth body. Leather head; embroidered features; black wool hair. Unmarked. Dressed as an Indian woman; handmade leather mocassins and woolen tuque. Made with a pouch in the body to hold tea. At one time the Indians went inland on hunting trips and everyone shared the responsibility of carrying the necessary food staples. The Indian women made dolls for the children to carry and they were filled with tea. After the tea was used, the dolls were filled with lichen or moss so the children could still play with them. The doll is very aromatic because of the tea inside. An indigenous Canadian doll. Courtesy of the Bowmanville Museum, Bowmanville, Ont. See also Fig. CQ9.

BM28
Ken and Rye Skye. 1980. Six Nations Indian. 6.50 in. (16.5 cm). Cornhusk body. Apple head; eyes look like seeds; wool hair. Unmarked. Doll is sitting on a stump which bears a label, Ken and Rye Skye/Six Nation Indian/Indians A. Handmade leather clothing, trimmed with beads. From the collection of Irene Henderson, Winnipeg, Man.

CQ9

BM28

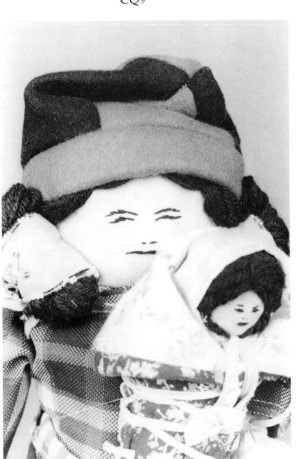

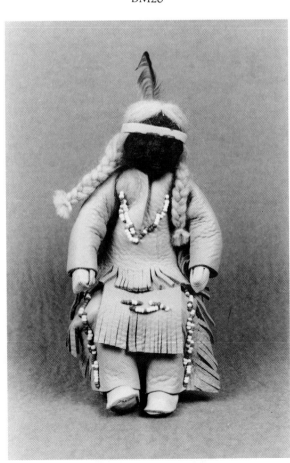

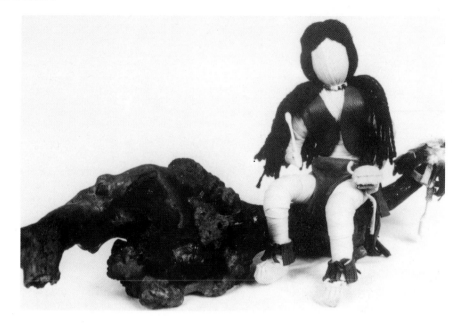

XG2

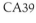

XG2
Gail General and Pam Brown. 1982. DRUMMER with feather Gus-tow-wha hat. Height, 7 in. (18 cm) ; width, 13 in. (33 cm). Cornhusk body. Cornhusk head; wool hair. Indian drummer sitting on a tree stump. Dressed in leather, leather moccasins, holding a leather drum. From the collection of Pamela Sickle, Ottawa, Ont.

CA39
Joyce Willie. 1980. SALICH BUTTON BLANKET DOLL. 18 in. (45.5 cm). Cloth body. Cloth head; embroidered features; black wool hair. Unmarked. Southern Kwagiutl button blanket and headdress. Courtesy of the Cowichan Trading Post, Victoria, B.C. See also Fig. CA40 and colour Figs. CA39 and CA40.

CA39

CA40

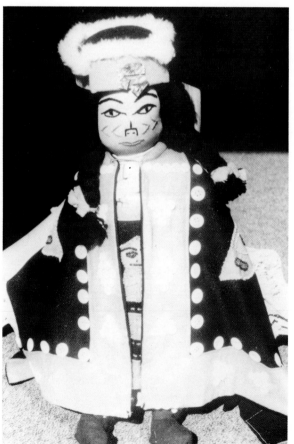

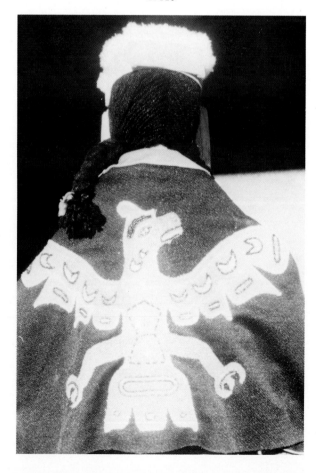

XG1

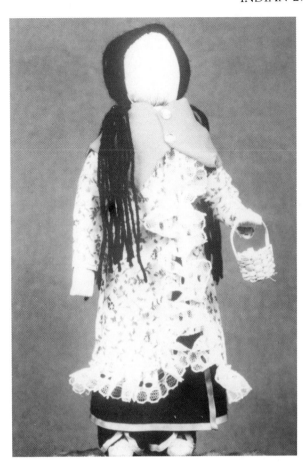

XG1
Gail General and Pam Brown. ca.1983. INDIAN BRIDE. 8.75 in. (22 cm). Cornhusk body. Cornhusk head; wool hair. Standing on a tree fungus stand. Mark: on bottom of stand, Aonwentsiyoh, (clan sign) ; Watakweniosta, (clan sign) ; year and month. Dressed in a wool underskirt, wool leggings, cotton dress trimmed in lace, red cape, leather moccasins, carrying a handmade sweetgrass basket. From the collection of Pamela Sickle, Ottawa, Ont.

CO27A
Regal. ca.1980. PLAINS INDIAN. 31 in. (79 cm). Plastic body, jointed hips, shoulders, and neck. Vinyl head; brown sleep eyes, lashes, painted lower lashes; rooted dark brown curls; closed mouth. Mark: on head, REGAL TOY LTD./MADE IN CANADA. Dressed by a Canadian Indian, Muriel Cuthbert of Wetaskiwin, Alberta. In a white buckskin dress, beaded belt, earrings and headband. Carrying a beaded leather bag. From the collection of Margaret Lister, Gallery of Dolls, Hornby, Ont.

CO27A

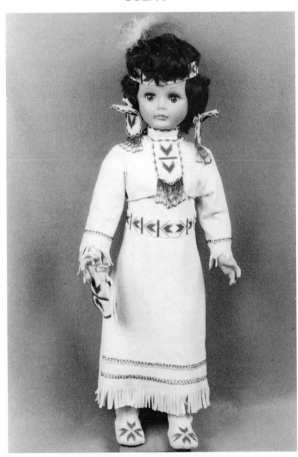

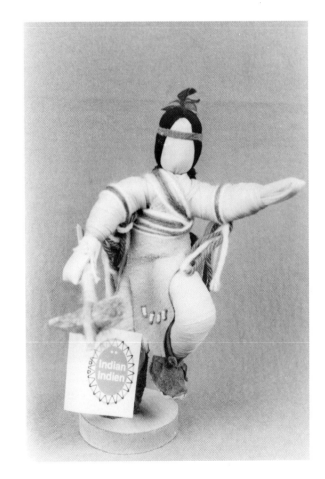

CM6
Ontario Ojibwa Indian. 1983. CORNHUSK DANCER. 8 in. (20.5 cm). Dancing figure made of cornhusk; black wool braids. Mark: label, Ontario Ojibwa/Cornhusk Dancer. Dressed in wool and leather with leather shoes, carrying axe. Author's collection.

CM6

XG3
Gail General and Pam Brown. 1983. EAGLE DANCER. 8.75 in. (22 cm). Body of cornhusks with wire in the arms and legs. Cornhusk head; wool braids. Clothing fashioned of feathers, leather, and beads to simulate a bird. The doll stands on a piece of tree fungus which makes a natural and attractive base. Mark: on the bottom of the stand, names of artists, Aonwentsiyoh; Watakweniosta; signs of the clans they belong to and the year and month. This gorgeous doll, which really must be seen to be appreciated, represents a Plains Indian dancer in the Fancy Dance who does an imitation of birds. It was made by Gail General and Pam Brown, Mohawks of St. Regis, Que., who feel that they can show their heritage and culture through their dolls. Gail was taught her doll making skills by a cousin from Six Nations and she in turn has taught Pam Brown. Doll making is a craft that has been handed down from generation to generation in their tribe. Gail began doll making in 1960 and Pam began in 1980. Both are skilled artisans who are creating unique native dolls. From the collection of Pamela Sickle, Ottawa, Ont. See also Fig. XG4 and colour Fig. XG4.

XG3

XG4

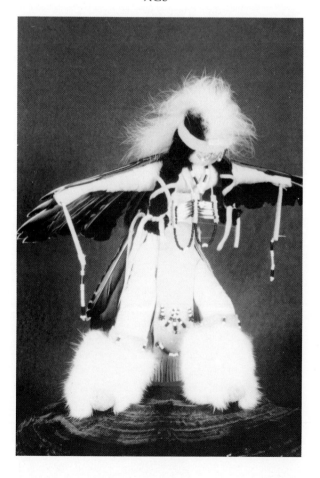

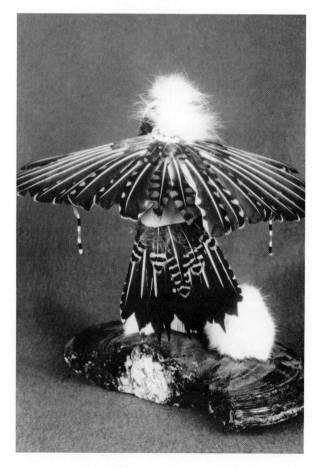

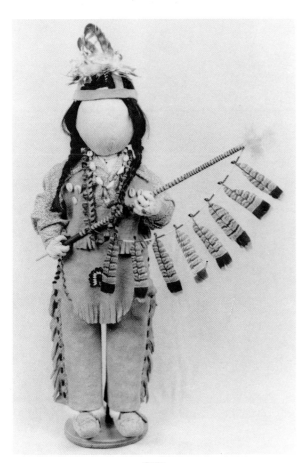

CT1

CT2

CT1
Cindy and Isabelle Skye. 1986. MOHAWK WARRIOR. 23 in. (58.5 cm). Cornhusk one-piece body, fingers individually wrapped in tiny strips of cornhusk. Cornhusk head, no features. Synthetic black hair in braids. Unmarked. Dressed in leather pants, fringed and beaded; leather apron, bead trim; leather vest, shell trimmed; cotton shirt; leather moccasins, beaded and fur trimmed; leather headdress, feathers denoting the warriors tribe; necklace of tiny shells and another of seeds; miniature beaded ring. Carrying a staff intricately beaded and trimmed in feathers which signifies the unity of the Indian peoples. Note particularly the intricate work on the hands in Fig. CT2. Author's collection.

CM7

CM7
Reliable. 1985. COWICHAN DOLL. 18 in. (45.5 cm). Brown plastic body, jointed hips, shoulders, and neck. Vinyl head; brown sleep eyes, lashes, painted lower lashes; rooted straight black hair; closed mouth. Mark: on head RELIABLE TOYS CO. LTD./c MADE IN CANADA; on body, Reliable (in script); label, Handknit Cowichan Indian sweater by S. Betts; 100% wool hand spun by G. Edwards. Wearing jeans and leather moccasins. Author's collection.

Chapter 4

SETTLERS' DOLLS

Settlers' dolls were made in Canada over a period of nearly three centuries before an indigenous commercial doll industry was established in 1911. Colonialization began in the Maritimes and Québec in the early seventeenth century and expanded to the west. Ontario was gradually populated, a process that was aided by the influx of Loyalists from the United States beginning about 1780. And, after the railway linked the entire country in 1886, settlements spread rapidly throughout the Praires and British Columbia.

During this settlement period, dolls were made at home by families for their children. Dolls were constructed of common materials used in and around the home. Generally, materials from the environment were utilized, such as wood, cornhusk, cloth, wool, and leather. Settlers made stump dolls, dolls of cornhusks, and sock dolls. They made wooden dolls, bottle dolls, and papier-mâché dolls. Such dolls became the friends and companions of children in the early days at a time when the nearest neighbour may have been miles away. Canadians have a fascinating doll history, with much variety in the dolls made for children as settlers spread from coast to coast.

In studying settlers' dolls, a rich history of the early Canadian pioneers is revealed. The ethnic background of the settlers, their socioeconomic situation in the new land, the resources available, as well as the creative ability of the settlers contributed to the wide variety of settlers' dolls that existed.

The earliest settlers adopted many handicraft techniques from the Indians, such as the art of making dolls from cornhusks. The settlers adapted this method of doll making to form a doll with a long skirt fashioned after the way European women and girls were dressed. With painted faces and little shawls over their shoulders, a fragile doll was created to be played with and discarded. Few of these have survived, but we still have the skills

to make cornhusk dolls, just as they were made by the early settlers (see Fig. BY4).

One of the simplest dolls, and perhaps the easiest to prepare, was a stump doll. Sometimes a piece of root or branch was chosen because it had some semblance of a human form. Even a small straight piece of wood could be used. A face was either painted on or perhaps it was roughly carved. The "baby" was then wrapped in a piece of cloth and a stump doll was born.

Older children needed a more sophisticated doll. What they had to play with depended largely on the skill of their parents and the amount of time that could be spared. During long cold winters, it was not uncommon for a father to carve a wooden doll for his child. Some were quite primitive, but others had smoothly articulated joints and fine featured carved faces. These could be dressed and made into very attractive dolls. Few of these dolls have survived, and so it is difficult for collectors to find examples of settlers' wooden dolls, although the occasional one does surface now and again (see Fig. AW35).

The beauty and durability of a cloth doll were dependent on the sewing ability and the artistic talents of a parent. Some cloth dolls were made with attractive embroidered faces, and others had the cloth heads painted to give them a smooth surface. Realistic features were then painted on. Wool for hair was usually added, and, finally, each doll was skillfully dressed in clothing similar to those worn by the child (see Fig. BV8).

A clothes-peg doll was made from the old fashion pegs that were carved or machined from one piece of wood. The round top was easily made into a head on which were added painted facial features. The two sides of the peg were the legs. The arms were usually made from pipe cleaners. When dressed, it made a dainty doll that was quite hardy. Making peg dolls is still a popular

home craft.

Although not a common practise, a doll head of papier-mâché, which was then painted, made quite a lovely doll when attached to a cloth body (see Fig. BV5). Two exceptionally fine examples of dolls with papier-mâché heads are those made by the carpenter who worked at Spencer Wood near Québec City for the Govenor General in the mid-nineteenth century. James Bruce, 8th Earl of Elgin and 12th Earl of Kincardine and his wife Mary Louisa had several children born in Canada between 1847 and 1854. The carpenter and his wife had children of the same age, and they played with the Govenor General's children. Consequently, the carpenter made toys for all the children, and it is believed that he was the originator of these two dolls. Undoubtedly they were dressed by his wife. These rare dolls are very important historically as few authenticated dolls of this era have survived (see Fig. BU7, BU9).

One doll that was popular with boys, as well as girls, was the dancing doll. This was sometimes called Dancing Dan or Limber Jack.[1] It was carved of wood. Usually the body and head were one piece, and the arms and legs were jointed at the knees, hips, elbows, and shoulders to make them very mobile. The doll had a hole in the back to insert a stick that was held by hand to make the doll dance to music. Another method was to insert a wire in the back, which was attached to a moveable platform. When this was tapped by hand the doll would dance with a clatter on the platform. It was quite a knack to rattle the doll in rhythm with the music. This was a fine form of entertainment in the days before television and movies, when families had to make their own fun. They were particularly popular in Québec and Acadia, and were frequently accompanied by a singer or musical instrument (see Fig. BV3).

A doll's body could also be made from an old glass bottle, much the same thing as the soap or detergent bottle used today. The head would be of stuffed cloth with painted or embroidered features. When dressed, the bottle was under the skirt and was not seen (see Fig. AT11).

Another settlers' doll was imaginatively fashioned from a wooden spoon. The bowl of the spoon became the head with a face painted on it and the handle served as the body. With wool hair and a dress added, it formed quite a presentable doll.

These were dolls made by adults for children. However, children have always made their own dolls from anything available. A child will see a hollyhock blooming and promptly pick a flower. When turned upside down, it makes a beautiful full skirt. With a bud inserted into the stem to make a head, it becomes a pretty doll to be played with for an hour and then forgotten.

Included with the settlers' dolls in this chapter are examples of dolls that were not made in Canada but were played with by Canadian children. Dolls with china heads, all bisque dolls, penny woodens, and metal heads were all imported before the twentieth century. These dolls bridge the gap between the homemade dolls of the settlers and the commercially produced Canadian dolls. Many dolls were brought by children when they immigrated from Europe to their new homes in Canada, and many more dolls were brought or sent as gifts. Moreover, as cities and towns grew and shops opened, dolls were imported and sold in the stores. Stores imported bisque headed dolls from Europe as early as 1839. Wax head dolls with kid bodies, and dolls with India rubber heads were available in stores from the mid-nineteenth century.[2]

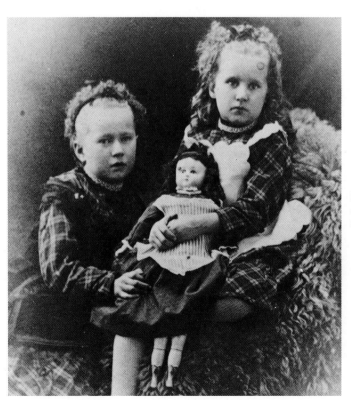

SL10
ca.1860-1885. Photograph by J.L. Jones. Public Archives Canada, neg. no. PA-125937.

As the nineteenth century progressed, European dolls increasingly found their way to the arms of Canadian children. Although these dolls were not Canadian made, it is interesting to see what was available to Canadian children. The doll in Fig. BJ21 dates from about 1880, and was given to Mrs. Lillian May in 1900 when she was a small girl in England. She brought it to Canada and has passed it on to her niece, Rebecca Douglass, of Dartmouth, N.S. Another example of an imported doll is an 1884 tiny bisque doll that was played with by Emily Main of Sackville, N.B. It is now a favourite doll in the collection of her granddaughter Geraldine Young (see Fig. AP30).

In 1884, The T. Eaton Co. Limited began producing a catalogue of goods for sale. It was distributed to almost every home, including those in outlying villages and farms across the country. Eaton's carried their first advertisement for dolls in the catalogue of 1888-89. Every year after that date the catalogue featured imported dolls for sale. It led to the demise of dolls made at home.

Eaton's also sold cloth imprinted with the form of a dressed doll on it that could be cut out, sewn up, and stuffed at home (see Fig. BL6).

Many imported metal shoulderheads were sold at the turn of the last century. Eaton's offered the Minerva heads in their catalogue. These were fitted with cloth bodies at home. Although they did not break as easily as the china heads, they did suffer damage to their paint (see Fig. CJ24). During the latter half of the nineteenth century, inexpensive imported china heads became available, and a cloth body was constructed at home to fit. Collectors can often find these today. Sometimes the body is out of proportion with the head suggesting that its creator was an amateur. China heads could also be bought with completed bodies, in either cloth or leather, or with the china arms and legs to sew on a cloth body at home. This type of doll was more suitable for an older child, for the head and limbs are extremely breakable. It is a collector's personal choice whether this type of doll is included in a Canadian collection. It should be considered as a European doll, for the head was made in Europe. However, if a doll has been owned by a Canadian family and played with, then passed down to the next generation, we can understand why many collectors regard them as Canadian (see Fig. AZ 10).

A Canadian collection, therefore, may include a wide variety of dolls. Settlers' dolls form part of the collection. These dolls were succeeded by commercial dolls imported from abroad until World War I. This war gave rise to a national manufacturing industry which, in the course of time, began making and distributing commercial dolls.

1. Jones, Iris Sanderson. *Early North American Dollmaking.* San Francisco: 101 Productions, 1976, p.77.
2. Webster, Donald Blake. *The Book of Canadian Antiques.* Toronto: McGraw-Hill Ryerson, 1974.
3. Right Honourable Earl of Elgin and Kincardine. Personal communication.

SL9
Photograph by C.W. Milne. Public Archives Canada, neg. no. PA-125141.

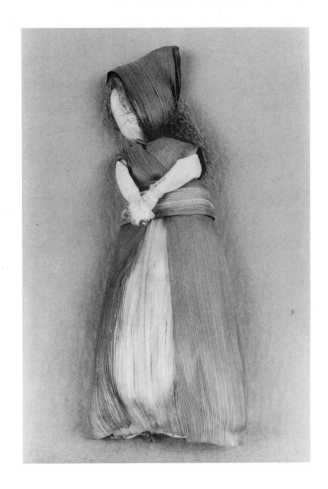

BY4

BY4
CORNHUSK DOLL. 1973. 9.75 in. (25 cm). Body of cornstalks. Head covered in cornhusk; hair of corn silk. Clothing of cornhusks. A reproduction of a popular settlers' doll. Upper Canada Village doll from the collection of Marsha Nedham, Ajax, Ont.

AW35
WOODEN DOLLS. 1898. 20.5 in. (52 cm); 16.5 in. (42 cm). Wooden carved dolls, jointed shoulders. Taller doll has jointed hips. Carved features and hair. Made by Mr. W. H. McDonald of Amherst Island, Ont. From the collection of Mrs. D. Steele, Ottawa, Ont.

BV8
CLOTH DOLL. ca.1895. Approximately 24 in. (62 cm). Head is painted to give a smooth finish and then the features expertly painted; painted two-tone hair; closed painted mouth. No mark. Original dress and bonnet in an 1895 style. Photograph courtesy of Black Creek Pioneer Village, Toronto, Ont.

AW35

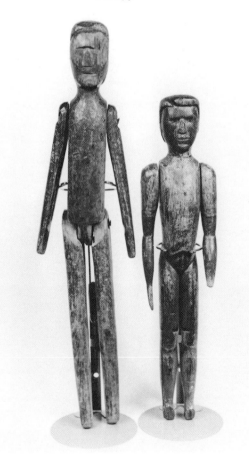

BV8

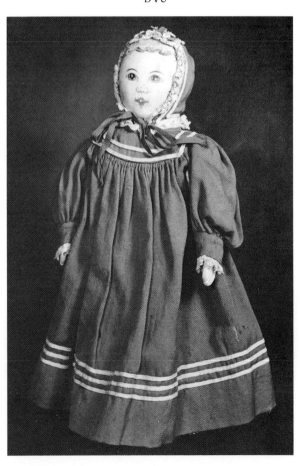

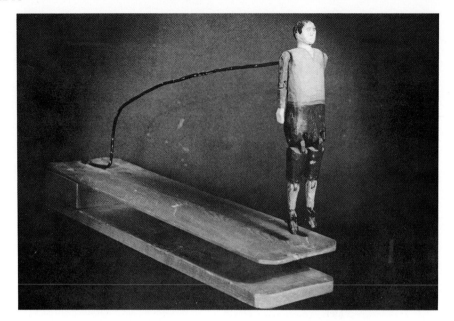

BV3

BV3
DANCING DAN. Nineteenth century. Wooden nine piece body, jointed hips, knees, shoulders, and elbows. Wire in his back attached to wooden dancing platform. Painted features and hair. No mark. Clothing painted on. Photograph courtesy of Black Creek Pioneer Village, Toronto, Ont.

BP12
DANCING DAN. Nineteenth century. 8 in. (20.5 cm). Wooden nine piece body and head, jointed hips, knees, shoulders, and elbows. Carved features. Hole in the body for a stick. From the collection of Betty Hutchinson, Ottawa, Ont.

BP9
DANCING DAN. ca.1900. 9.25 in. (23.5 cm). Wooden nine piece body and head, jointed hips, knees, shoulders, and elbows; hole in his back for a stick. Features carved. From the collection of Betty Hutchinson, Ottawa, Ont.

BP12

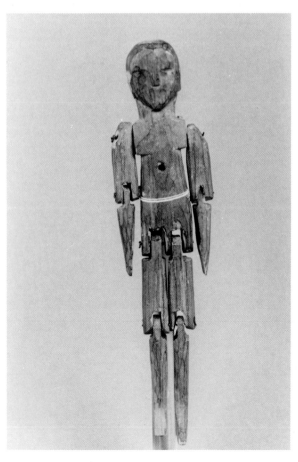

BP9

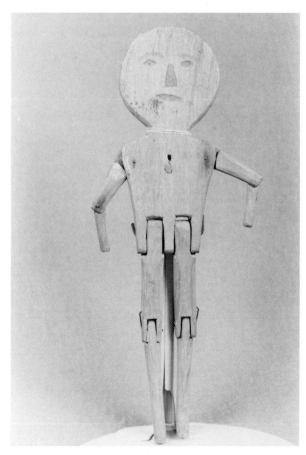

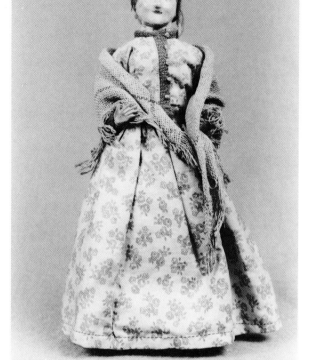

AT11

AT11
BOTTLE DOLL. ca.1890. 9.5 in. (24 cm). Cloth head attached to a bottle that is padded and covered with cloth. Head is stuffed and the face is painted to produce a smooth surface; features painted; eyes painted blue; hair painted black. Original well made dress. Handmade hat and shawl. Author's collection.

BJ21
PENNY WOODEN. ca.1880. 12.5 in. (31.5 cm). Wooden nine piece body, jointed hips, knees, shoulders, and elbows. Painted features; black painted hair; closed mouth. No mark. Childhood doll of Mrs. Lillian May who was given the doll in 1900 in England and brought it to Canada with her. A favourite doll from the collection of her neice Rebecca Douglass, Dartmouth, N.S.

AP30
BISQUE BOY. ca.1884. 4.25 in. (11 cm). All bisque five piece body, jointed hips and shoulders, arms and legs attached to the body with wire. Painted side-glancing eyes; moulded hair; closed mouth. No mark. Imported childhood doll of Emily Main of Sackville, N.B. A special doll in the collection of her granddaughter, Geraldine Young, Niagara Falls, Ont.

BJ21

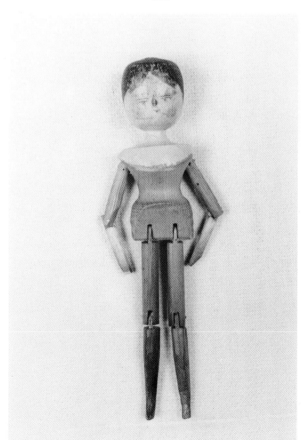

AP30

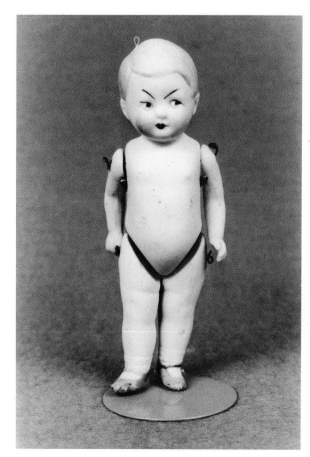

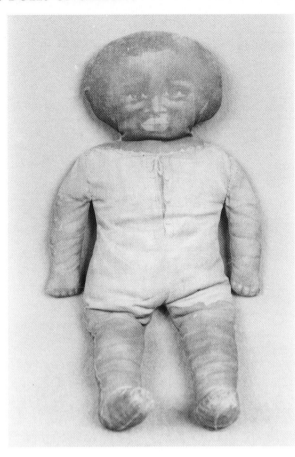

BL6

BL6
DINAH. 1904. 17.5 in. (45 cm). Black cloth body and head. Printed features and underwear. Popular doll at the turn of the century. Made by Harriet Ellis for her granddaughter. Childhood doll of Nell Walsh, Saint John, N.B.

CJ24
MINERVA. ca.1900. 13.5 in. (34 cm). Cloth body. Metal shoulderhead; eyes painted blue with fine black line over eye; deeply moulded hair painted light brown; closed mouth. Mark: on front of shoulderplate, MINERVA (over a helmet); on front of shoulderplate, GERMANY/4. Probably original dark green dress trimmed with red ribbon. From the collection of Dianne Richards, Kenosee Lake, Sask.

AZ10
CHINA SHOULDERHEAD. ca.1870. 21.5 in. (55 cm). Homemade cloth body. German china shoulderhead; painted blue eyes; moulded hair, centre part with curls, painted black. Homemade clothes. Six generations of Canadian children have played with her. She is now owned by Christine Diane Robb, Toronto, Ont. From the collection of her grandmother, Mrs. D. Steele, Ottawa, Ont.

CJ24

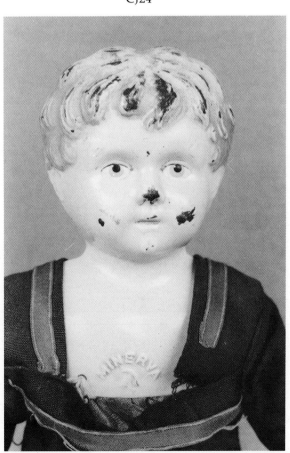

AZ10

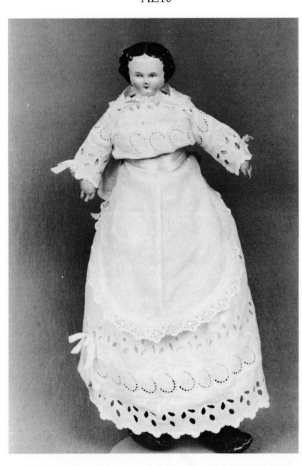

AZ24

AZ24
SOCK DOLL. Date unknown. 11.5 in. (29 cm). Black wool one piece head, body and legs; arms sewn on. Features embroidered. Hair is wool. From the collection of Mrs. D. Steele, Ottawa, Ont.

BV4
ANNIE COOLEY DOLL. ca.1840. Cloth body. china shoulderhead; painted eyes; moulded hair painted black; closed mouth. Probably original clothing with cotton dress, fur trimmed cape and fur muff. Photograph courtesy of Black Creek Pioneer Village, Toronto, Ont.

BV5
PAPIER-MÂCHÉ BOY. ca.1840. 25.5 in. (65 cm). Cloth body, composition arms; body and arms not as old as the head. Papier-mâché head; stationary glass eyes; hair painted black; open-closed mouth showing two teeth. No mark. Early but not original white cotton shirt and brown and white checked trousers. Doll belonged to Josephine Langlois daughter of John Sandfield Macdonald, the first Premier of the Province of Ontario. A beautiful example of an early Canadian doll. Photograph courtesy of Black Creek Pioneer Village, Toronto, Ont.

BV4

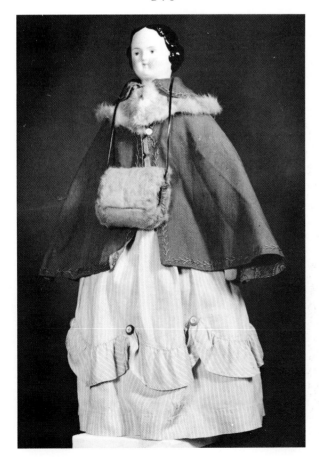

BV5

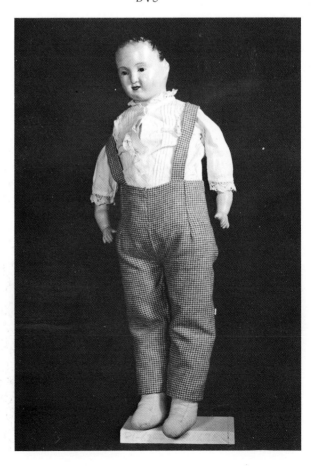

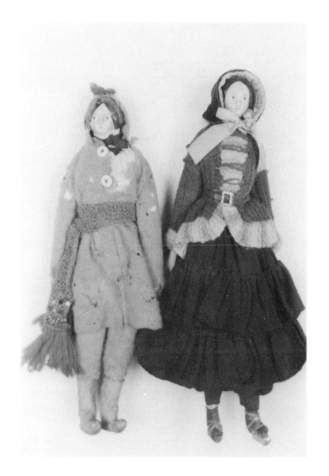

BU9

BU9
PAPIER-MÂCHÉ HEADS ca.1850. 9.5 in. (24 cm). Wire armature, wooden hands. Papier-mâché heads; painted features; moulded black hair; closed mouths. Unmarked. Dressed as Quebec habitants. The woman wears handmade ice skates with leather straps over her boots, ankle length pants with cuffs, flounced dress, knitted jacket with leather belt and a lined bonnet. The man wears a cotton shirt, wool trousers, wool coat with hood, red knitted sash trimmed with beads and handmade leather boots. Courtesy of Right Honourable Earl of Elgin and Kincardine, Dunfermline, Scotland. See also Fig. BU7.

BU7

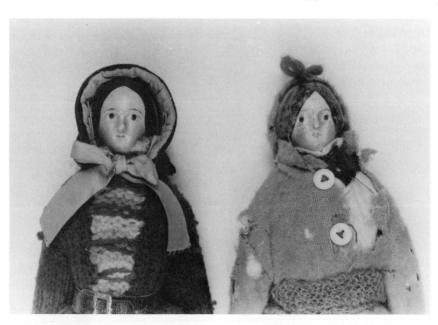

Chapter 5

ETHNIC DOLLS

OF THE CANADIAN MOSAIC

Multiculturism is fostered in Canada with such slogans as "celebrate our differences", and so most people are very much aware of their own heritage and those of others in the Canadian mosaic. Canada was initially populated with isolated settlements spread across the country. Usually an area was settled by one ethnic group, and they tended to have little contact with other groups for a long time. Consequently, many Canadians have a strong sense of belonging to one area of the country. Since each group remained somewhat isolated, they tended to maintain their ethnic identity. This has given many Canadians a strong ethnic feeling.

Canada is developing a modern culture to which the majority belongs. Most of us understand, or at least try to understand, the modern way of life, literature, movies, music, and social norms, much of which we share increasingly with other modern countries. There is, however, a national pattern made up of diverse cultures that seems to exist below the surface of modern trends.

Dolls are one way to express individual cultures. By making or collecting dolls of different cultures, we help to stimulate understanding of other cultures and preserve our own. Dolls reflect humanity and show our characteristics by their expressions, hair, style of clothing, and activities they might portray. They are small, and people are always fascinated by miniature things. They are dressed attractively, and they often tell us what people wore in other countries and many years ago. Ethnic dolls tell a story.

What is the story that the Icelandic doll tells us in Figure AB7? We can imagine the yearning of grandparents, knowing that they have grandchildren thousands of miles away who are being brought up in a different culture. To bridge that gap, to show their grandchildren where they came from, and to show them just a little of their heritage would bring solace and give the grandparents a feeling of sharing with the children so far away.

This Icelandic doll is full of mysteries. She wears a gorgeous metal belt embossed with meaningful patterns. Were the children told the meaning of these patterns? Is it a costume worn only for special occasions? What does the unusual headdress signify? Undoubtedly, all this is an attraction to the children and becomes a part of their culture.

Another story is told through the Lithuanian doll in Figure XG36. She was made in a German war camp. Her petticoat is made from a German flag. Was the woman who made the doll doing it for a child, or was she bringing back memories of her youth when she was young, happy, wore pretty clothes, and went dancing? Perhaps the doll gave her comfort and helped her keep up her courage under terrible circumstances.

The cast-iron Amish family in Figure CW35 was probably made by a man. Were they originally made as toys or as souvenirs of the area? Perhaps a father wanted his child to have a family in the proper Amish clothing as a reminder of their way of life and for play so they would not be influenced by dolls dressed in the style of another culture.

Evangeline, in Figure BP10, is a doll that is still being made today in poignant memory of the Acadian heroine from the poem Evangeline by Longfellow, who tells of the heartbreak parting and the lifelong search of two Acadian lovers for each other.

The cloth Mennonite dolls in their carefully constructed clothing, made identical to the clothing worn by Mennonite girls or women, give a glimpse of another culture. The cloth doll in Figure BR8 with jointed knees, hips, shoulders, and elbows, is unusual for it shows ingenuity and imagination by its creator.

The French Canadian wooden jointed dancing doll in Figure CS4 is a very old concept. Peasants in France made them before Canada was settled. They are an

ancient form of entertainment that is still fascinating to watch being operated to music. In fact, a well known Acadian folk singer, Edith Butler, sometimes utilizes a dancing doll as she sings. She calls him Gabriel.

The knitted Canadian dolls in Figure CB18 from World War II remind us of the sad departure of sons and husbands leaving for war duty, and of the patriotic feeling that surged in the hearts of those left behind. They made woollen soldiers, sailors, and airmen dolls, and these dolls remain with us as mementoes of a painful part of our history.

The popular concept of folk culture is that it tends to be quite primitive. Ethnic dolls could be classed as folk culture, but few could be considered primitive. Most are executed with creativity and talent, although it is true that the materials used are often primitive. Dolls are made by almost every culture, and it is fascinating to see the wide variety produced by the Canadian mosaic.

Ethnic dolls help preserve our culture. They enable us to see our heritage as something worth keeping and something very beautiful. Ethnic dolls show our rich and many faceted culture. Such dolls make worthwhile additions to a Canadian doll collection.

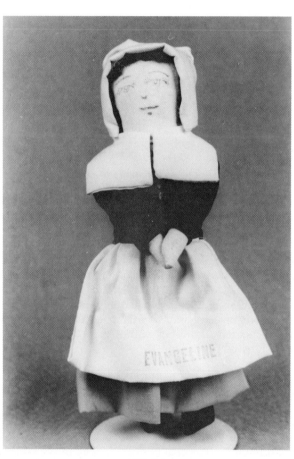

BP10

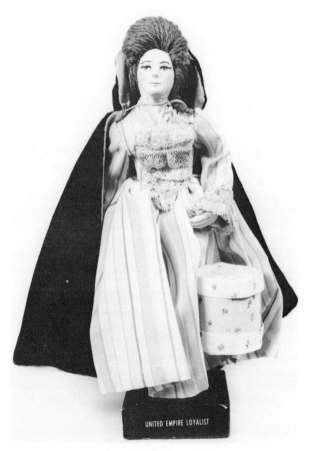

AW17

BP10
Acadian. ca.1950. EVANGELINE. 7 in. (17 cm). Cloth body and head; wool hair. Features drawn in ink. Mark: paper label on back. Dressed in an 1755 style costume. From the collection of Betty Hutchinson, Ottawa, Ont. EVANGELINE was made by Agnes Sullivan of Metghan, N.S.

AW17
American. ca.1965. UNITED EMPIRE LOYALIST. 9.5 in. (24 cm). Cloth and wire body. Clay head; painted features; wool hair. Mark: Kashi embroidered on the hem. Clothing suitable to period. Carrying a box of her possessions. Made by Kashi Carter. From the collection of Mrs. D. Steele, Ottawa, Ont.

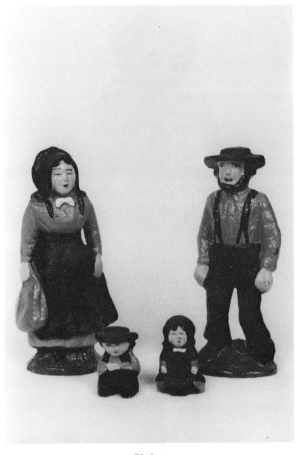

CW35

AO24

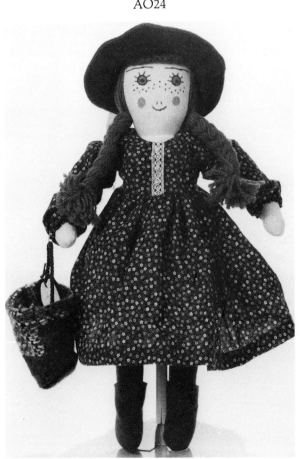

CW35
Amish from the Waterloo District of Ontario. 1985. Adults, 4.5 in. (11 cm); children kneeling, 1.5 in. (3.2 cm). Made of cast-iron and painted. Unmarked. From the collection of Roberta LaVerne Ortwein, Olds, Alta.

AO24
Anglo-Saxon. 1983. ANNE SHIRLEY. 17 in. (43 cm). Cloth body and head. Painted blue eyes, embroidered eyelashes and brows; rust wool braids and bangs; embroidered mouth. Mark: label, Lovingly made by Village Craft House, Central Bedeque, P.E.I. Original cotton print dress, white petticoat and drawers, felt boots, and carrying a bag. Author's collection.

The ANNE SHIRLEY doll is made by a group of about fifty women who also make other dolls and quilts. Usually four women make one doll. One makes and stuffs the doll; one makes the clothes; another paints the face and dresses the doll, and the fourth makes the boots and bag. ANNE SHIRLEY dolls originated with a course offered by Joan Doherty of Sherbrooke, N.S. The Village Craft House has a franchise for Prince Edward Island, and they have been making the dolls since 1972.

CB18
Canadian. ca.1940. 16 in. (40.5 cm). Knitted woollen bodies and uniforms. Embroidered features. Unmarked. Three servicemen representing the Army, the Navy, and the Air Force. Made during World War II by Emma Thorne, Squamish, B.C. From the collection of Mary Van Horne, Chilliwack, B.C.

CB18

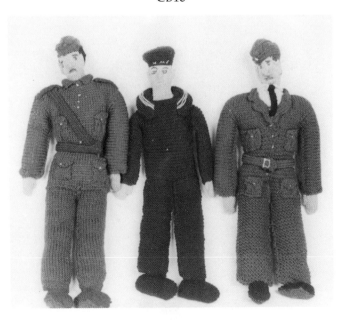

AW8
Chinese. 1967. Approximately 13 in. (33 cm). Cloth and wire body. Clay head, painted features; wool hair. Mark: Kashi embroidered on the hem. Chinese railway worker's clothing. From the Mosaic of Canada. Made by Kashi Carter. From the collection of Mrs. D. Steele, Ottawa, Ont.

AW2
English. 1967. Approximately 13 in. (33 cm). Cloth and wire body. Clay head, painted features; wool hair. Mark: Kashi embroidered on the hem. English style clothing. From the Mosaic of Canada. Made by Kashi Carter. From the collection of Mrs. D. Steele, Ottawa, Ont.

XG32
Estonian. ca.1960. 12.5 in. (32 cm). Plastic body, jointed hips, shoulders, and neck. Vinyl head, painted features; blond hair. Wool striped skirt, white blouse, embroidered beaded apron, leather belt, wool knee socks, leather shoes, embroidered, beaded headdress, chain necklace and traditional large broach. Photograph courtesy of National Museums of Canada, neg. no. 84-12571.

AW8

AW2

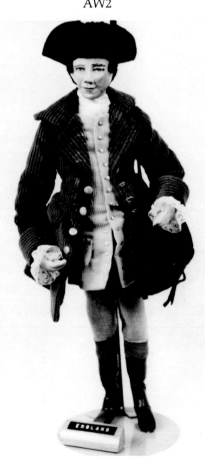

XG32

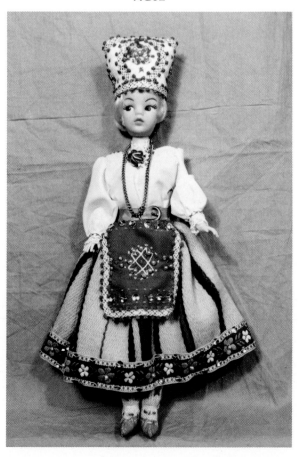

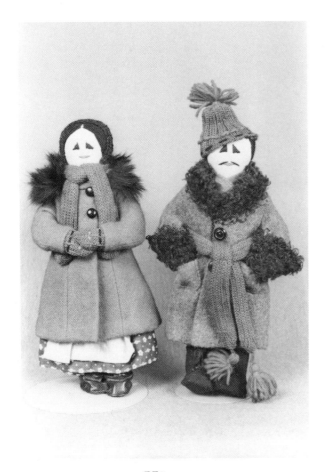

BF8

BF8
French Canadian. ca.1940. Man, ll in. (28 cm); woman, 10 in. (25.5 cm). One piece cloth body and head. Embroidered features; wool hair. Unmarked. Original clothing: man, twill pants, homespun coat with astrakan trim, knitted toque and sash; woman, cotton print dress and white apron, homespun coat with fur trim, knit hat, scarf, mitts and stockings. Made by Manoir Richelieu, Québec, and sold in Canadian craft and souvenir shops and aboard the Canada Steamship Line.[1] From the collection of Margaret Hayes, Musquodoboit Harbour, N.S.

1. Lavitt, Wendy. *Dolls*. New York: Alfred A. Knopf, 1983, p.92.

BJ36A
French. Date unknown. MARIE. 11.5 in. (29.5 cm). Cloth body, clay hands and legs. Clay head with clay earrings glued under her hat, holes for eyes; painted hair; closed mouth. Unmarked. Original French shrimp fisherwoman clothing. Cotton striped skirt, blouse, apron, wool cape, and lace headdress. Carrying a basket full of shells. Courtesy of the New Brunswick Museum, Saint John, N.B.

BJ34A
French. Date unknown. D'AULNAY CHARNISSAY. 19 in. (48.5 cm). Cloth body, papier-mâché hands. Papier-mâché head, painted features; mohair wig. Unmarked. Original clothing. Cloth suit, lace trimmed collar and cuffs, sash, French boots, felt hat with plume. Made by Mrs. W. Milner Wood, Woodman's Point, King's County, N.B. Courtesy of the New Brunswick Museum, Saint John, N.B.

BJ36A

BJ34A

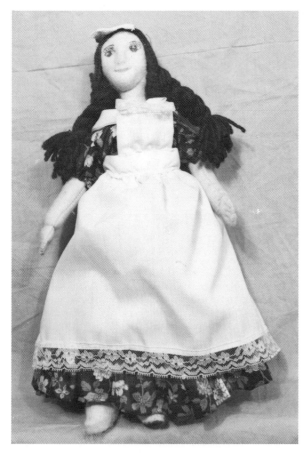

XG33

XG33
French Canadian. Date unknown. Troupe de Danse "Les Sortilèges". Man, 12 in. (30.5 cm); woman, 11.5 in. (29.5 cm). Cloth and wire bodies. Moulded felt faces, painted features; man, brown mohair wig; woman, black wool braids. Unmarked. Man: black wool pants, white shirt, velt vest, sash, white knee socks, leather shoes. Woman: print dress, white apron, white cap, slip and pantalettes. Sunday costume of the Lake Saint Jean, Québec, region. Photographs courtesy of National Museums of Canada, neg. nos. 84-12569 and 84-12562. See also Fig. XG34.

CS4
French Canadian. Date unknown. 13 in. (33 cm). Carved wooden head and body, sanded smooth; jointed knees, hips, elbows, and shoulders; carved fingers; feet are carved large wooden shoes with four nails in the bottom of each. Hole in the middle of the back for an inserted stick. Author's collection.

XG34

CS4

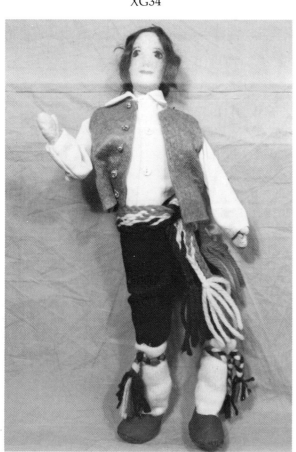

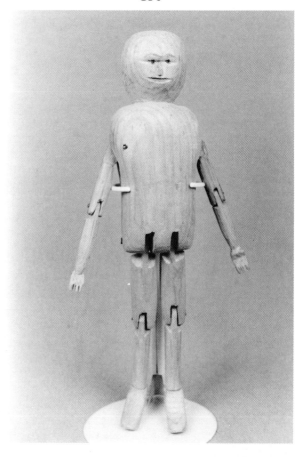

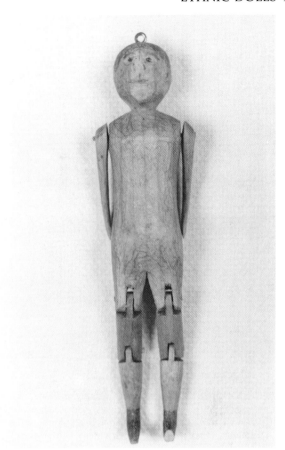

BJ19
French Canadian. Date unknown. 10 in. (25.5 cm). All wood, one piece head and body, jointed knees, hips, and shoulders. Painted features. Metal loop on top of his head. Unmarked. From the collection of Rebecca Douglass, Dartmouth, N.S.

AT20
German. 1967. Approximately 13 in. (33 cm). Cloth and wire body. Clay head, painted features; wool hair. Mark: Kashi embroidered on the hem. German farmer style clothing. From the Mosaic of Canada. Made by Kashi Carter. From the collection of Mrs. D. Steele, Ottawa, Ont.

AW15
Greek. 1967. Approximately 13 in. (33 cm). Cloth and wire body. Clay head, painted features; wool hair. Mark: Kashi embroidered on the hem. Greek style clothing. From the Mosaic of Canada. Made by Kashi Carter. From the collection of Mrs. D. Steele, Ottawa, Ont.

BJ19

AT20

AW15

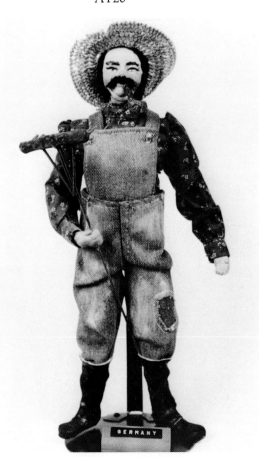

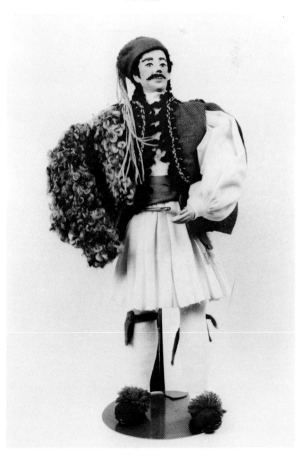

AW12
Italian. 1967. Approximately 13 in. (33 cm). Cloth and wire body. Clay head, painted features; wool hair. Mark: Kashi embroidered on the hem. Italian style clothing. From the Mosaic of Canada. Made by Kashi Carter. From the collection of Mrs. D. Steele, Ottawa, Ont.

XG29
Hutterite couple. Date unknown. Man: 16.5 in. (42 cm); Woman: 15.75 in. (40 cm). Cloth body and head. Embroidered features; wool hair. Unmarked. Man in black shirt, pants, and hat. Woman in black blouse, black and white dotted skirt, black apron, dotted kerchief, white slip, drawers, black felt shoes, and carrying cloth baby wrapped in a flannel blanket. Photographs courtesy of National Museums of Canada, neg. no. 84-12574 and 84-12575. See also Fig. XG30.

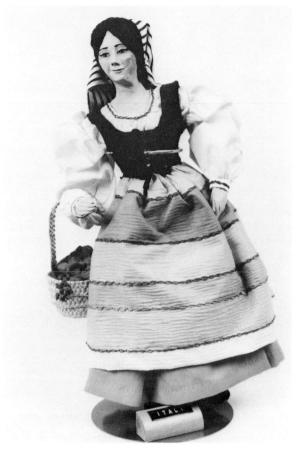

AW12

XG29

XG30

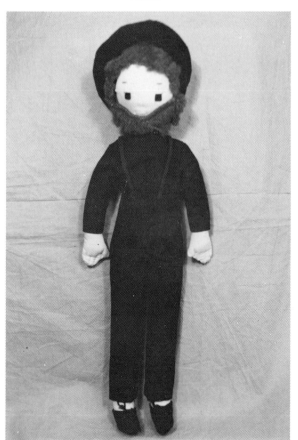

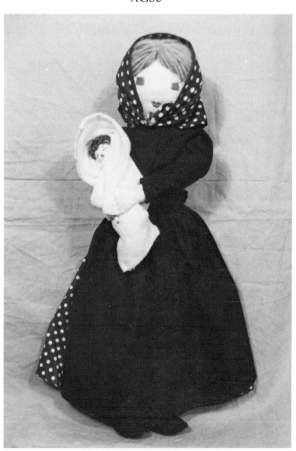

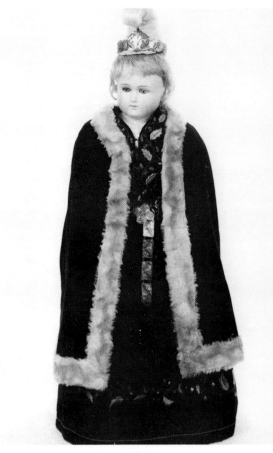

AB7

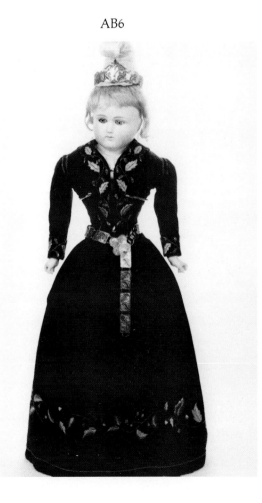

AB6

AB7
Icelandic. ca.1900. 24 in. (61 cm). Cloth body with narrow waist, unusual bisque hands. Bisque turned head on bisque shoulderplate; blue glass sleep eyes; mohair wig; closed mouth. Mark: on shoulderplate, 698 # 12. Original handmade authentic Icelandic clothing, beautifully embroidered gown, embossed metal belt, fur edged cape and elaborate headdress, authentic shoes lined with knitted insoles. Icelandic grandparents sent this doll to their Canadian grandchildren to familiarize them with their ethnic backgrownd. From the collection of Mary Alice Thacker, Kanata, Ont. See also Fig. AB6.

AW9
Japanese. 1967. Approximately 13 in. (33 cm). Cloth and wire body. Clay head, painted features; wool hair. Mark: Kashi embroidered on the hem. Japanese style clothing. From the Mosaic of Canada. Made by Kashi Carter. From the collection of Mrs. D. Steele, Ottawa, Ont.

AW9

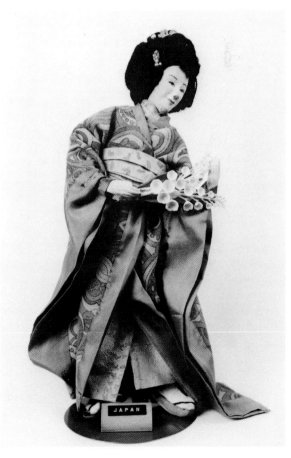

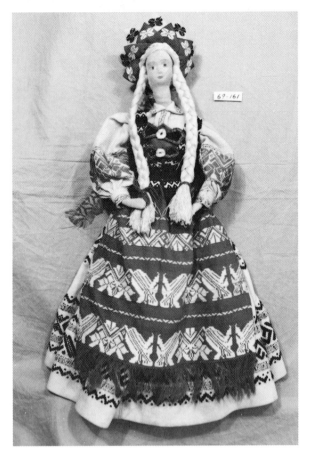

XG36

XG35

XG36
Lithuanian. ca.1942. 17.25 in. (44 cm). Cloth and wire body. Cloth head with fabric face; painted features; thread hair in braids. Mark: RASA. Woven striped skirt, striped apron, woven blouse, petticoat made from a German flag, embroidered headdress. This doll was made in a German war camp by a Lithuanian prisoner. Photograph courtesy of National Museums of Canada, neg. no. 84-12573.

XG35
Lithuanian. ca.1960. 11.5 in. (29.5 cm). Plastic Barbie body and head, jointed hips, shoulders, and neck. Vinyl head covered in stocking material and the features painted; brown wig. Woven striped skirt and apron with fringe, vest, embroidered blouse, sash, and headdress, amber necklace. Photograph courtesy of National Museums of Canada, neg. no. 84-12570.

CO6A
Mennonite. ca.1905. 12.5 in. (32 cm). Cloth body. Metal head; blue painted eyes, black line over eye, fine red line over black; brown moulded hair; closed mouth. Unmarked. Original blue print dresses and aprons, corduroy petticoats, woollen stockings. From the collection of Diane Peck, Sudbury, Ont.

CO6A

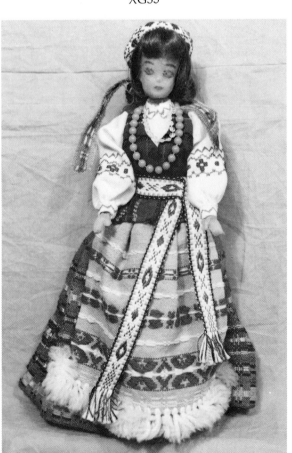

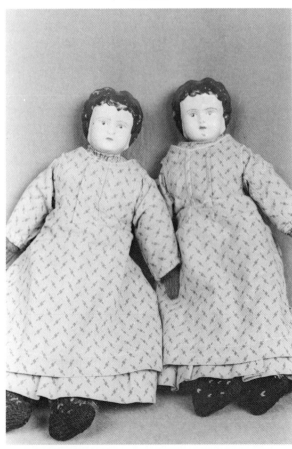

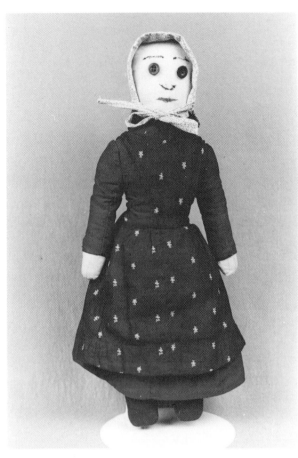

BQ26

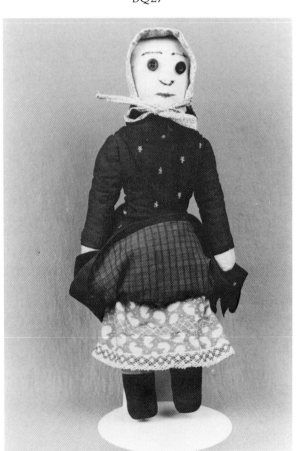

BQ27

BQ26
Mennonite woman. ca.1900. 19 in. (48.5 cm). Cloth body and head. Black button eyes, embroidered nose, mouth, and brows. Unmarked. Plain navy dress, bottom half of skirt lined with plaid for winter warmth, navy print bib apron, shoulder straps joining waistband at back, paisley print petticoat, additional material band and lace-like trim. Grey print bonnet added in 1976. From the collection of Nancy-Lou and E. Palmer Patterson, Waterloo, Ont. See also Fig. BQ27.

BR9
Mennonite child. Date unknown. 18. in. (45.5 cm). Nine piece cloth body, jointed knees, hips, shoulders, and elbows. Painted cloth head sewn on body, painted features and hair. Unmarked. Original clothing, flannelette drawers, dotted white slip, plain pink dress with tucks down the front and lace trim, blue apron with full back buttoned, woollen bonnet. From the collection of Nancy-Lou and Palmer E. Patterson, Waterloo, Ont.

BR9

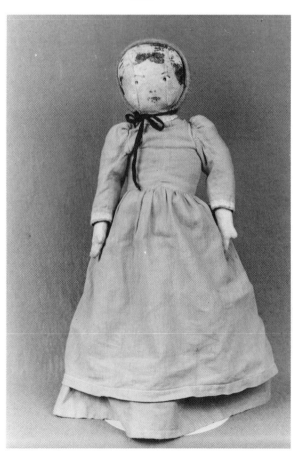

CN16
Mennonite. Date unknown. 15 in. (38 cm). One piece cloth body and head. Features and hair drawn in ink. Unmarked. Original dark dress, apron, and overapron. From the collection of Diane Peck, Sudbury, Ont.

XG27
Mennonite. Date unkown. 15 in. (38 cm). Cloth body. Cloth head painted, painted features; black wool hair. Unmarked. Navy coat and hat, purple dress, print apron, bloomers, black cotton stockings, cloth shoes. There are two identical dolls, probably made for twins. Photograph courtesy of National Museums of Canada, Neg. no. 84-12577.

BR4
Mennonite child. ca.1914. 20 in. (51 cm). Nine piece cloth body, jointed knees, hips, shoulders, and elbows. Painted cloth head sewn on; painted features and hair. Unmarked. Purple print dress with piping, matching bib apron, print slip, pink flannelette bloomers, black stockings, and knitted shoes. From the collection of Nancy-Lou and Palmer E. Patterson, Waterloo, Ont.

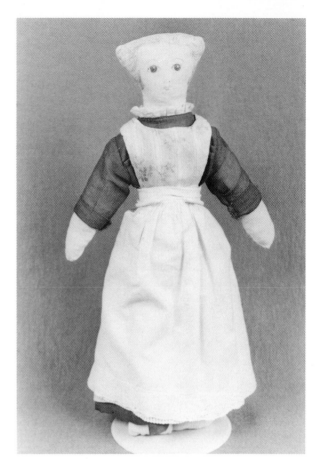

CN16

XG27

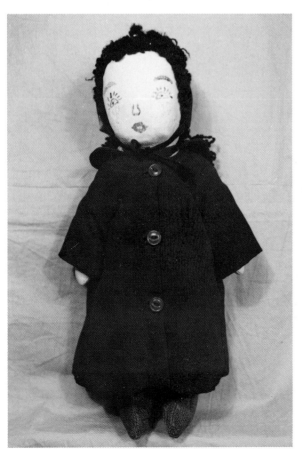

BR4

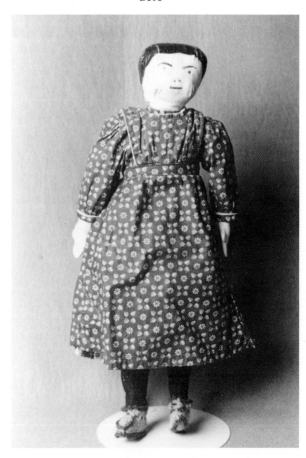

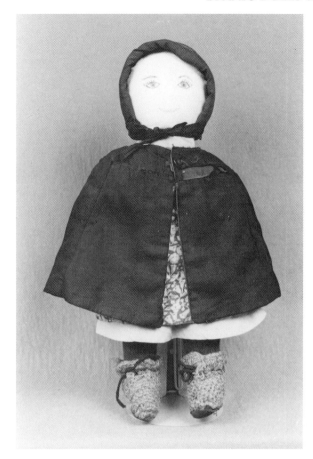

BQ28
Mennonite child. Date unknown. 16 in (40.5 cm). Cloth body and head. Painted features; wool braids. Unmarked. Original clothing, plain blue dress, print bib apron, knitted cardigan, white cotton slip and pantalettes, black stockings, knitted shoes. From the collection of Nancy-Lou and Palmer E. Paterson, Waterloo, Ont. See also Fig. BQ31A.

BR5
Mennonite child. ca.1925. 18 in. (45.5 cm). Nine piece cloth body, jointed knees, hips, elbows, and shoulders. Cloth head painted and sewn on body. Painted features and hair. Unmarked. Original clothing, striped flannelette drawers and shirt, knitted socks, one knitted shoe, green print dress with yellow piping, matching bib apron. From the collection of Nancy-Lou and Palmer E. Patterson, Waterloo, Ont. See also Figs. BR6, BR7, and BR8.

BQ28

BQ31A

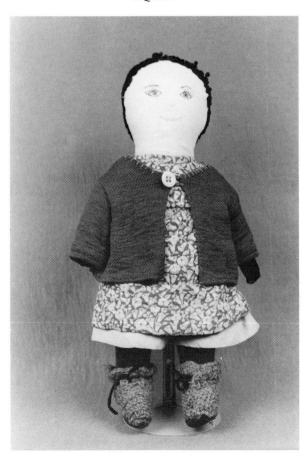

BR5

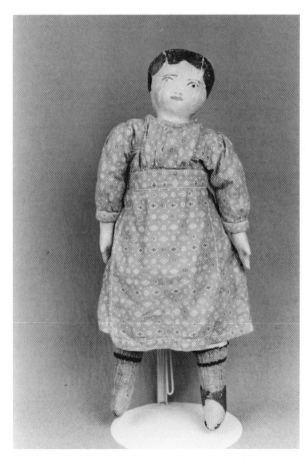

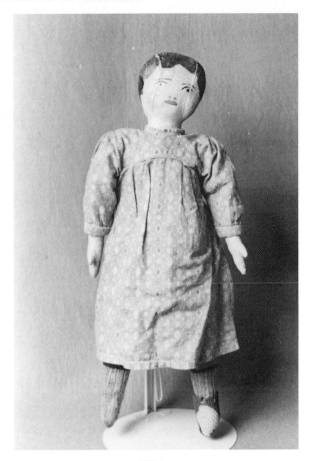

BR6

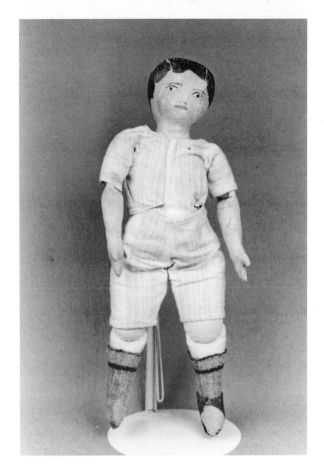

BR7

BR8

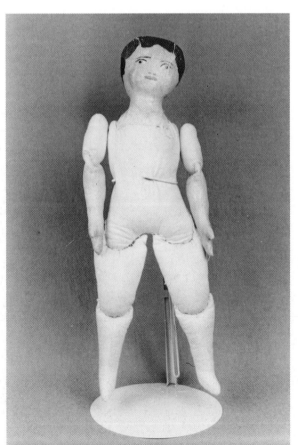

BR6, BR7, and BR8. For details see the description for Fig. BR5 on previous page.

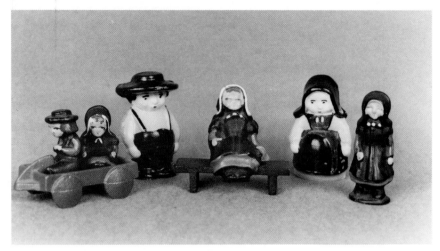

BX26

BX26
Mennonite metal dolls. ca.1980. 2 in. (5 cm). Cast-iron family, painted features and clothes. Unmarked. From the collection of Wilma MacPherson, Mount Hope, Ont.

CS3
New Brunswick Loyalist. 1984. MR. PASSA, MA QUODDY. 7 in. (17 cm). Cloth body with a wire armature. Cloth covered head; painted features; wool hair. Unmarked. Made in the Passamaquoddy Bay area of New Brunswick. Dressed in homespun and knitted clothing. Author's collection.

AW5
Scandinavian. 1967. Approximately 13 in. (33 cm). Cloth and wire body. Clay head, painted features; wool hair. Mark: Kashi embroidered on the hem. Scandinavian style clothing. From the Mosaic of Canada. Made by Kashi Carter. From the collection of Mrs. D. Steele, Ottawa, Ont.

CS3

AW5

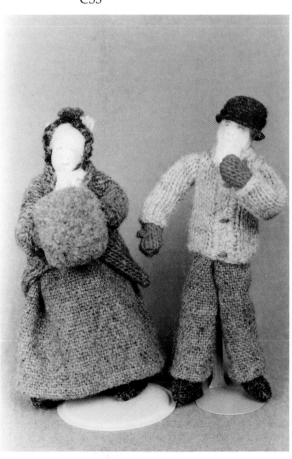

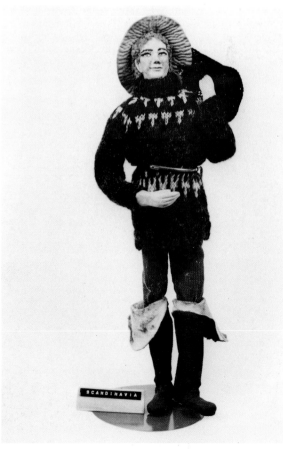

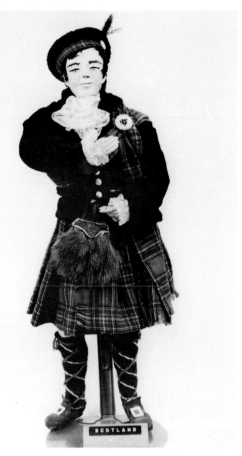

AW1

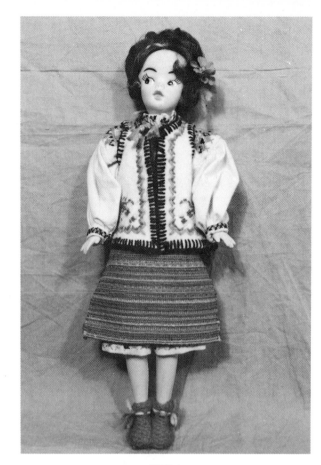

XG31

AW1
Scottish. 1967. Approximately 13 in. (33 cm). Cloth and wire body. Clay head, painted features, and wool hair. Mark: Kashi embroidered on the hem. Scottish style clothing. From the Mosaic of Canada. Made by Kashi Carter. From the collection of Mrs. D. Steele, Ottawa, Ont.

XG31
Ukrainian. ca.1960. 11.5 in. (29.5 cm). Plastic teen body, jointed hips, shoulders, and neck. Vinyl head; painted features; brown wig. Handmade embroidered felt vest, white embroidered blouse, embroidered skirt, striped overskirt, woollen boots. Photograph courtesy of National Museums of Canada, neg. no. 84-12572.

Chapter 6

EATON'S BEAUTY DOLLS

by Judy Tomlinson Ross

The history of the Eaton's Beauty dolls is a truly fascinating and never ending story. To own an Eaton's Beauty was the desire of almost every little girl in the Dominion of Canada. An Eaton's Beauty was the most popular and often the most advertised doll of the Eaton's line-up of Christmas dolls. The little girl who owned an Eaton's Beauty was the envy of the neighbourhood. Unfortunately, most of those envied little girls do not know what happened to their Eaton's Beauty. Thus, to search and find one as an adult is a pleasant walk down memory lane.

The Eaton's Beauty brought to mind a doll of "outstanding beauty" that was a very good purchase for the quality of doll offered. From the time the Eaton's Beauty first appeared in 1900, the price was kept at the $1.00 mark for the smallest size doll until 1916. When the Eaton's Beauty reappeared in 1924, the Beauty's price was raised to $1.50 and fluctuated between $1.29 and $1.99 until 1943. After that time, the price of the Beauty went from $3.98 to $450.00 (1984).

The Eaton's Beauty has been the dream of many little girls for many years. The name "Eaton's Beauty" or "Eaton Beauty", was appropriate for the dolls chosen by The T. Eaton Co. Limited. The doll was usually very pretty and the most popular type of doll that year. In the first four years that Eaton's had the doll on the market it was a leather bodied doll with a bisque shoulderhead. There is very little written about the appearance of these early Eaton's Beauties. The Eaton's Beauty moved from a papier-mâché body (1906) to a composition body (ca.1912), to a latex skin body (1954), to a vinyl skin body (1956), to a vinyl plastic body between 1960 and 1965, back to a composition one (1977), and finally to a bisque body (1983).

There were no Eaton Beauty dolls offered in the years 1917 to 1923, 1944 to 1953, 1959, 1961, 1966 to 1976, 1985, and 1986.

Some clarification needs to be made at this point about how to recognize the different types of bodies. Unless a purchaser examines the joint of a doll it is very difficult to tell if a body is made of composition or papier-mâché. A papier-mâché body is composed of many layers of paper. You can actually see the layers if a joint is carefully examined. The composition comes in two types: the first is a mixture of paper, small wood chips, and glue, etc. It has a cork look to it. The second type of "composition", which was used in the nineteen-thirties, is cardboard which had been plastered and then painted.

The lovely head on the Eaton's Beauty was bisque from 1900 to 1914. For the two year period from 1915 to 1916, the head was composition. From 1924 to 1940, the head was again bisque, only to return to composition from 1940 to 1943. The vinyl head was used from 1954 to 1965. In 1977, the head was bisque once again.

The Eaton's Beauty was sold undressed until 1908. From that time on, she was sold with a chemise, Princess slip, or was fully clothed. The chemise was a very simple dress, usually trimmed with lace. The Princess slip, an "all-in-one underwear", was introduced in 1927. It was trimmed with lace and may have been coloured or white. In 1940, extra outfits for the Beauty were offered for sale which continued until 1943. When the Eaton's Beauty doll was offered in 1954, she was dressed for the first time, and she has remained that way until 1985.

The Eaton's Beauty kept up with hair style fashions. She was offered with long curls until 1927 when a "bobbed" wig was introduced. The hair style of ringlets was put on the Beauty in the 1930s and continued until the mid-1940s. Rooted saran hair was used on the 1950s and 1960s dolls. The 1977 and later dolls had a variety of wigs chosen by the doll makers.

The Eaton's Beauty has worn a badge declaring her to be the Beauty each year from 1904 until 1964. The

Eaton's Beauty dolls made by the late Dorothy Churchill sported Eaton's Beauty badges. Unfortunately, the dolls made by April Katz (1983 and 1984) have no badge to help identify them as Eaton's Beauty dolls. Over the years, the badges were different colours and had different identifying marks on them. From 1906 until 1913, the badge was a red ribbon with a gold printed Holtz Masse symbol of the Cuno and Otto Dressel firm and the words "Eaton's Beauty". Holtz Masse means wood composition in English. In 1913 and 1914, the badges were white with no Holtz Masse symbol. The 1914 and 1915 badges were once more red and gold with the Holtz Masse symbol. The badge changed in 1915 and 1916 when the Beauty was Canadian made. That badge was white with "Made in Canada" printed where the Holtz Masse symbol had been. The red and gold badge with a Holtz Masse mark returned in 1924 and 1925 and was used intermittently as the official badge during the remainder of the 1920s and throughout the 1930s and 1940s.

The word "Eatonia" first appeared in 1924 in the catalogue advertisements of Eaton's Beauty dolls. In the summer of 1926 the words "Stands for Good Value in Good Merchandise" were added in small print below the word Eatonia. During this time, the Eaton's Beauty doll continued to carry the badge "Eaton's Beauty" on the clothing of the doll. The Eatonia doll was advertised for the first time in 1928 and carried an Eatonia badge on the clothing. This doll now replaced the Eaton's Beauty in several issues of the semiannual catalogue. In the summer of 1929, they appeared as two different dolls, each bearing their respective badges. The Eatonia doll disappeared from the fall and winter catalogue of 1932-33, never to be offered again by Eaton's.

Identifying Eaton's Beauty dolls seems to be one of the most difficult tasks there is in the wonderful world of doll collecting. Unless an Eaton's Beauty doll is purchased with her original chemise, Princess slip, or badge, there is a very great possibility of error. This latest research has brought to light a great deal of mistaken identity. In addition to Eatonia dolls, dolls originally advertised as an "Old Fashioned Beauty" have now surfaced as Eaton's Beauty dolls. The Old Fashioned Beauty is too short in height to be an Eaton's Beauty; however, she looks very much like the Beauty. The Old Fashioned Beauty was purchased fully clothed. Other dolls dressed in similar chemises to those of the Eaton's Beauty have also surfaced. These dolls were shown on the same page as the Beauty in the catalogues, but the ribbon and lace work are not the same as on the chemise of the Eaton's Beauty. These minute details have made the research slow. I must emphasize the importance of thoroughly examining any supposed Eaton's Beauty doll whose purchase you are considering.

To minimize error, only the advertisements in the Eaton's catalogues and dolls with their original chemise, Princess slip, or badges, have been used as reference sources. Some dolls that could be traced back to their original owners, who provided information as to the original dates and costuming, have been taken into consideration.

One of the problems we encountered were dolls that had been given to the original owners as Eaton's Beauty dolls but in fact have proven to be another doll advertised on the same page of the catalogue for a lower price. It seems some parents gave their daughter the lower priced doll and told them that it was an Eaton's Beauty to satisfy their daughter's desire. More problems have arisen from the fact that what Eaton's sold in their catalogues and what was offered in the stores may have been completely different. In some years, Eaton's did not offer an Eaton's Beauty in the catalogue, because they may not have had sufficient stock to supply the demand. However, at the same time, there may have been an Eaton's Beauty offered in the stores. Thus, the dating of Eaton's Beauties is very difficult.

The height of some of the dolls has caused some problems in identification as well, because ageing has caused the composition to shrink, or because the advertised height was exaggerated. An advertisement may have read "19 inches tall" but the actual doll may have been 18.5 inches tall.

Another problem that has presented itself is the badge worn by the Eaton's Beauty. The badge did not always match the doll. In 1906 and 1907, the first Holtz Masse mark of the firm Cuno and Otto Dressel appeared on the Eaton's Beauty badge. (Therefore, it is believed the dolls before this were made by other companies.) This same badge continued until 1912. Eaton's seems to have used the red and gold badge with the Holtz Masse symbol indiscriminately on the Eaton's Beauty dolls whether they were made by Cuno and Otto Dressel or not. This indicates that Eaton's had a supply of the badges on hand and pinned them to the dolls regardless of their manufacturer. Thus, some dolls made by Armand Marseille wore the Holtz Masse mark of Cuno and Otto Dressel. At other times a badge with the Holtz Masse symbol was worn on Canadian made Eaton's Beauties with the words "Eaton's Beauty Made in Canada." In some years the Eaton's Beauties made by Reliable Toy Company wore a badge that had a rose in a circle in place of the Holtz Masse symbol. It should also be noted that, according to Mr. Grossman, who had been on the production team at Reliable Toy Company, Reliable had correct badges printed and attached to the Princess slips of the dolls in their factory.

Another difference that has come to light was the appearance of a certain Eaton's Beauty in one part of the country one year and the same doll in another part of the country the next year by the T. Eaton Company Ltd. Dolls offered on the market in Toronto one year, and not sold, may have been shipped to Moncton or Winnipeg to be sold by Eaton's the next year. For example, the 1927 Vancouver catalogue illustrated the same doll as had appeared in the 1926 Toronto Eaton's catalogue. This means that a doll could be one or two years older than originally thought.

In reading the identifying marks on dolls, a common error made is in the significance of the mould number 370 or 390 on two dolls with identical faces. The 370 means the head is a shoulderhead. The 390 means it is a socket head. Any other numbers that had been used, such as 0 1/2, or 2 1/2, specify the exact size of mould.

In identifying dolls, all the marks on a head must match those already authenticated by the badge, box, or underwear, bearing in mind that manufacturers also made dolls with the same marks to be sold by many retailers in addition to Eaton's.

The problems of identification are overwhelming. Before purchasing an Eaton's Beauty doll, the prospective buyer must examine the doll to be certain that the mark on the neck, the body type, the hair style, the height of the doll, the badge, and the chemise or Princess slip match exactly the descriptions given for each Eaton's Beauty described in this chapter or in the catalogues. Authentication is the utmost goal in searching for a coveted Eaton's Beauty doll.

EATON'S BEAUTY DOLLS
STATISTICS

The following statistics on Eaton's Beauty dolls cover the years from 1900 to 1983. Information from the catalogues is given on the height, type of body, head, clothing, and the original Eaton's catalogue price for each doll. The names of manufacturers are entered if available. References are given to photographs in this book.

1900.
Christmas catalogue. EATON'S BEAUTY. Size: at least six sizes of dolls but no measurements given. Body: kid leather; arms and legs have wooden joints. Head: bisque shoulderhead, sleep eyes, curly hair. Price: from $1.00 to $10.00.

1901.
Christmas catalogue. EATON'S BEAUTY. Size: only one doll of 17 inches. Body: probably leather, jointed. Head: bisque shoulderhead, sleep eyes, curly wig. Clothing: shoes and stockings. Price: $1.00.

1901-2.
EATON'S BEAUTY. Size: at least five sizes of dolls but no descriptions given.

1903-4.
EATON'S BEAUTY. Size: at least seven sizes with no measurements given. Body: all jointed, believed to be leather. Head: pretty face, believed to be a bisque shoulderhead, curly hair. Price: $1.00 to $7.00. See Figs. CF2 and CF3.

1904.
EATON'S BEAUTY. J.D. Kestner. Size: one doll of 18 inches. Body: moveable with wooden joints. Head: bisque, curly wig. Clothing: none. Badge: light coloured with print "EATON'S BEAUTY". First appearance of a badge. The 1904 Toronto advertisement quoted seven sizes available. A 1905 advertisement stated that the 1905 doll was the same as the 1904 doll but quoted only an 18 inch size. The advertisement also stated that the manufacturer was J.D. Kestner.

1905.
EATON'S BEAUTY. J.D. Kestner. Same doll as 1904. Badge: light coloured with print "EATON'S BEAUTY". See Figs. CH22, CH23, and CI2.

1906-07.
Fall and winter catalogue, Winnipeg and Toronto.

EATON'S BEAUTY DOLLAR DOLL. By Cuno and Otto Dressel. Size: at least seven dolls starting at 18 inches. Body: ball-jointed papier-mâché. Head: bisque, sleep eyes, fine curly hair. Clothing: undressed, although a trimmed gown, shoes, and stockings were pictured. Price: $1.00 to $5.00. Badge: with the Holtz Masse symbol.

1907-08.
Catalogue information not available. See Figs. CW4 and CW5.

1908-09.
Fall and winter catalogue, Toronto. EATON'S BEAUTY. By Schoenau & Hoffmeister. Size: five sizes starting at 19.5 inches. Body: "unbreakable, finished in a natural flesh colour" (probably papier-mâché), fully jointed. Head: socket head, bisque, rosy cheeks, sleep eyes, eyebrows raised, flaxen hair in ringlets with bangs, open mouth, teeth. Clothing: frilled chemise, stocking and shoes. Price: $1.00 to $5.00. Badge: red and gold, Holtz Masse symbol outlined in gold. See Figs. BS2A and CH19.

1909-10.
Fall and winter catalogue, Toronto. EATON'S BEAUTY. By Cuno and Otto Dressel. Size: 19.5, 21, 25, and 26 inches. Body: "unbreakable", believed to be papier-mâché, fully jointed. Head: bisque socket head, rosy cheeks, sleep eyes, lashes. Clothing: frilled chemise, stockings and leather bootees. Badge: red and gold with Holtz Masse symbol. See Figs. BT17, CH20, CH21, and CH26.

1910.
Summer catalogue, Toronto. EATON'S BEAUTY. By Cuno and Otto Dressel. Size: 19.5 inches. Body: "unbreakable", believed to be papier-mâché, jointed. Head: bisque socket head, rosy cheeks, sleep eyes, lashes, large wig, long ringlets. See Figs. XH16, and XH17.

1911.
Summer catalogue, Toronto. EATON'S BEAUTY. By Cuno and Otto Dressel. Size: 19.5, 21, 22.5, and 26 inches. Body: papier-mâché, fully jointed. Head: fine bisque socket head, tinted cheeks, open mouth, teeth, moveable eyes, real hair eyelashes, large wig, thick curls, bangs; replacement head at 25 cents. Clothing: frilled chemise, stockings, leather bootees. Price: $1.00, $2.00, $3.00, and $5.00. Badge: red and gold with Holtz Masse symbol. See Fig. BH25.

1911-12.
Winter catalogue, Toronto. EATON'S BEAUTY. By Cuno and Otto Dressel. Same as 1911 summer catalogue Eaton's Beauty except the 26 inch doll was $4.50. Wigs were 25 cents for the dolls priced at one dollar. See Fig. CH31.

1912
Summer catalogue, Toronto. EATON'S BEAUTY. Same as 1911-1912 EATON'S BEAUTY.

1912-13.
Fall and winter catalogue, Toronto. EATON'S BEAUTY. By Armand Marseille. Size: 19.5, 21, 22.5, and 26 inches. Body: wire-sewn, papier-mâché, flesh coloured, enamelled, fully jointed. Head: fine bisque, dimpled chin, open mouth, ivory teeth, hair parted with a bow; replacement head at 25 cents, and replacement wig at 25 cents. Clothing: chemise with ribbon trimming, shoes and stockings. Price: $1.00, $2.00, $3.00, and $4.50. Badge: white with dark print. See Fig. BT8A.

1913-14.
Fall and winter catalogue, Toronto. EATON'S BEAUTY. By Armand Marseille. The following five dolls were available:

1. Size: 18 inches. Body: papier-mâché, fully jointed. Head: bisque. Clothing: frilled gown. Price: $2.00.

2. Size: 22 inches. Body and head: same as 18 inch doll. Price: $3.00.

3. Size: 27 inches. Body and head: same as above. Price: $4.50.

4. Size: 21 inches. Body: unbreakable (papier-mâché), fully jointed. Head: bisque. Clothing: frilled gown, Eaton's own special design Red Riding Hood doll, bright red cape and hood; small basket for arm. Price: $1.25.

5. Size: 21 inches. Body: wire-sewn, papier-mâché, will stand alone. Head: fine quality bisque replacement heads at 35 cents, replaceable wigs at 35 cents. Clothing: frilled chemise. Price: $1.00. Badges: all of the above had a badge on with no Holtz Masse mark.

1914.
Summer catalogue, Toronto. EATON'S BEAUTY. By Armand Marseille. Size: 21 inches. Body: papier-mâché, enamelled flesh colour, elastic strung, fully jointed. Head: bisque socket head, hair parted with a bow, replacement wigs at 35 cents and replacement heads at 35 cents. Clothing: white chemise, shoes and stockings. Price: $1.00. Badge: not Holtz Masse symbol; EATON'S BEAUTY.

1914-15.
Winter catalogue, Toronto. EATON'S BEAUTY. By Armand Marseille. The following three dolls were offered:

1. Size: 21 inches. Body: papier-mâché, wire-sewn, fully jointed, thickly enamelled, flesh coloured. Head: fine bisque, thick parted wig, sleep eyes; replacement heads at 35 cents and replacement wigs at 35 cents.

2. Size 25 inches. Body and head: same as 21 inch doll. Price: $3.00.

3. Size: 27 inches. Body and head: same as 21 inch doll. Price: $4.00.

1914-15.
Winter catalogue, Toronto. EATON'S BEAUTY. By Armand Marseille. The following three dolls were offered:

1. Size: 21 inches. Body: papier-mâché, wire-sewn, fully jointed, thickly enamelled, flesh coloured. Head: fine bisque, thick parted wig, sleep eyes; replacement heads 35 cents, replacement wigs 35 cents. Clothing: white chemise, shoes and stockings. Price: $1.00. Badge: Holtz Masse symbol, EATON'S BEAUTY.

2. Size: 25 inches. Body and Head: same as 21 inch doll. Price: $3.00.

3. Size: 27 inches. Body and Head: same as 21 inch doll. Price: $4.50. See Figs. BP19 and CJ19.

1915-16.
Fall and winter catalogue, Toronto. EATON'S BEAUTY. Made by Dominion Toy. World War I made it impossible for Germany to supply the Canadian market with dolls. Thus, the Canadian toy company, Dominion Toy, made the EATON'S BEAUTY in 1915-1916. Size: 20 inches. Body: new process composition, fully jointed, strung with double cord elastic. Head: composition, tinted, sleep eyes, thick curly hair, bows on both sides, closed mouth; replacement head was 35 cents. Clothing: chemise. Price: $1.00. Badge: white with dark print, Made in Canada, EATON'S BEAUTY. See Figs. CL22 and CL23.

EATON BABY DOLL. Size: 19 inches. Body: composition hands, stuffed cloth body, jointed hips and shoulders. Head: composition. Clothing: long dress, cap, knitted bootees. Price: $2.00.

1916-17.
Fall and winter catalogue, Toronto. The catalogue had the following notice: "Owing to the unusual conditions of the labour market, and the scarcity of raw materials, we are unable to supply a $1.00 EATON BEAUTY DOLL this season. We would therefore refer you to dolls 18-108 and 18-246 for the very best dolls that we can procure at their respective prices.

Doll 18-108. BABY DOLL Size: 18 inches. Body: composition hands, stuffed cloth body, jointed arms and legs. Head: composition. Clothing: completely dressed with bonnet and knitted bootees. Price: $1.00.

Doll 18-246. Dominion Toy. Size: 20 inches. Body: new process composition, flesh colour, enamelled. Head: composition, beautifully moulded and tinted, moving eyes, thick curly wig. Price: $1.75. 1917. Summer catalogue, Toronto. The only doll offered was the 18-108

BABY DOLL described in the 1916-17 catalogue.

1917-18.
Fall and winter catalogue, Toronto. Dominion Toy. There was no EATON'S BEAUTY advertised in this catalogue. The best buy was a doll called DAINTY DOROTHY. Her description was exactly the same as the 18-246 doll from 1916 and 1917. Her dress was different and her price was $1.95. The same baby doll that was offered in 1916 and 1917 was offered again, only it was named BABY BRIGHT EYES.

1918-19.
Fall and winter catalogue, Toronto. Only DAINTY DOROTHY was offered. Price: $1.95. 1919. Summer catalogue, Toronto. Dominion Toy. "A High-Grade Doll" was offered. It looked like and was described exactly as DAINTY DOROTHY was described in 1916 and 1917. Price: $2.75.

1919-20.
Fall and winter catalogue, Toronto. No EATON'S BEAUTIES were offered. The same 1916 and 1917 BABY DOLL was available for $1.00. The same jointed doll as described in the summer 1919 catalogue was advertised for $2.75.

1920.
Summer catalogue, Toronto. No EATON'S BEAUTIES were offered. The price of the 1916 and 1917 BABY DOLL was raised to $2.75.

1920-21.
Fall and winter catalogue, Toronto. EATON SPECIAL. The advertisement read: "Our Eaton Doll is renowned as a splendid value." Body: special composition, jointed. Head: well moulded composition, tinted. Clothing: chemise.

1921.
Summer catalogue, Toronto. The same jointed doll as was offered in the 1919-20 catalogue is offered again. Size: 20 inches. Body: composition, fully jointed. Head: composition, sleep eyes, curly wig. Clothing: chemise, shoes and stockings. Price: $3.50.

1921-22.
Fall and winter catalogue, Toronto. EATON SPECIAL DOLL. By S.F.B.J. Size: 20 inches. Body: special composition, fully jointed. Head: not described as to composition or bisque, moving eyes, bushy, curly wig in the nineteen-twenties style. Clothing: white chemise with ribbon and lace, shoes and stockings. Price: $2.50.

1922.
Summer catalogue, Toronto. EATON SPECIAL DOLL was the doll offered in 1921-22 fall and winter catalogue. By S.F.B.J. The clothing was the same, as was the $2.50 price tag.

1922-23.
Fall and winter catalogue, Toronto. EATON SPECIAL DOLL. By S.F.B.J. The sale of German doll heads in Canada and the United States was almost non-existent. French dolls were very popular. Size: 19.5 inches. Body: composition, fully jointed. Head: bisque, finest offered

for years, blue sleep eyes, long curling eyelashes, long curly hair (referred to as Curly-Locks). Clothing: dress with lace and ribbon rosettes, slippers and stockings. Price: $2.50. Badge: none. See Figs. CW5 and BH26.

1923.
Summer catalogue, Toronto. EATON SPECIAL DOLL. Size: 20 inches. Body: composition, fully jointed. Head: bisque, sleep eyes, curly wig. Clothing: white chemise. Price: $2.50.

1923-24.
EATON SPECIAL DOLL from France. By S.F.B.J. Size: about 20 inches. Body: composition, fully jointed. Head: bisque, big blue sleep eyes, long eyelashes, open mouth, teeth. Clothing: lace trimmed chemise, dainty stockings and slippers. Price: $1.75. Badge: none, but the advertisement shows for the first time a symbol of the diamond with an E in it. This symbol was later used on Dorothy Churchill's dolls.

1924.
Eaton's News Week, May 1924. THE EATONIA DOLL. Size: 21 inches. Body: fully jointed. Head: bisque, sleep eyes, long-lashed, dark or fair haired. Clothing: white chemise with pink or blue ribbons, white shoes and socks. Price: $1.50. See Figs. AP31 and BQ24A.

1924-25
Fall and winter catalogue, Toronto. EATON'S BEAUTY. By Armand Marseille. Size: 21 inches. Body: composition, fully jointed. Head: bisque, blue sleep eyes, lashes, thick curly wig, open mouth, teeth, dimpled chin. Clothing: dressed in chemise with socks and shoes. Price: $1.50. Ribbon: red and gold, Holtz Masse symbol, EATON'S BEAUTY. The first EATON'S BEAUTY after the war. It had the Eatonia seal of approval.

1924.
Summer catalogue, Toronto. EATONIA DOLL introduced. Size: 21 inches. Body: fully jointed composition. Head: bisque, sleep eyes, long lashes, long hair wig, dark or fair. Clothing: white frock trimmed with bows of pink or blue ribbon, white shoes and socks. Price: $1.50. Badge: white with blue print "EATON'S BEAUTY".

1924.
Fall and winter catalogue, Toronto. Famous EATON'S BEAUTY with the Eatonia symbol on the advertisement. Size: 21 inches. Body: fully jointed composition. Head: fine bisque head, thick curly wig, baby blue sleep eyes, open mouth, teeth, slight dimple in her chin. Clothing: chemise, dainty stockings and slippers. Price: $1.50. Badge: EATON'S BEAUTY with Holtz Masse mark.

1925.
Spring and summer catalogue, Moncton, N.B. EATON'S BEAUTY with the Eatonia label in the advertisement. Size: 21 inches. Body: composition, fully jointed. Head: bisque, curly wig, real eyelashes, sleep eyes. Clothing: not listed. Price: $1.50.

1925.
Summer catalogue, Toronto. EATON'S BEAUTY with

Eatonia seal of quality. By Armand Marseille. Size: 21 inches. Body: composition, fully jointed. Head: bisque, curly wig, blue eyes, eyelashes. Clothing: plain chemise. Price: $1.50. Badge: with the Holtz Masse symbol.

1925-26.
Fall and winter catalogue, Toronto. EATON'S BEAUTY. By Armand Marseille. This doll has the Eatonia label in the advertisment. Same doll as in the 1927 Vancouver catalogue. Size: 21, 24, and 27 inch dolls. Body: composition. Head: bisque, curly wig, big blue eyes, real eyelashes; replacement head at 50 cents, replacement wig at 50 cents. Clothing: white chemise, shoes and socks. Price: $1.50, $3.50, and $5.00. See Fig. BH27.

1926.
Spring and summer catalogue, Winnipeg, Man. EATON'S BEAUTY with the Eatonia label on the advertisement. Size: 20 inches. Body: composition, fully jointed, strung with strong double cord elastic. Head: bisque, long curly hair, sleep eyes, open mouth, teeth; replacement head at 50 cents, replacement wig at 50 cents. Clothing: chemise with lace and ribbon flowers. Price: $l.50. Badge: EATON'S BEAUTY; red and gold with the Holtz Masse symbol.

1926.
Summer catalogue, Toronto. EATON'S BEAUTY with the Eatonia label of quality. By Armand Marseille. Size: 21 inches. Body: composition, fully jointed. Head: bisque, sleep eyes, curly wig. Clothing: chemise. Price: $1.50.

1926-27.
Fall and winter catalogue, Toronto. EATON'S BEAUTY, an Eatonia Value. By Armand Marseille. Size: 21, 24, and 27 inches. Body: well formed composition body, fully jointed. Head: bisque, curly wig, sleep eyes, long eyelashes. Clothing: chemise. Price: $1.50, $3.50. and $5.00. Badge: outlined with a border, Holtz Masse symbol, EATON'S BEAUTY. Also offered — extra clothing, dress, panties, underskirt, and bonnet. Price: $1.50. Replacement heads, wigs, or head and wig together.

1927.
Catalogue, Vancouver B.C. EATON'S BEAUTY. By Armand Marseille. Has Eatonia label of approval in the advertisement. Size: 21 inches. Body: Composition, fully ball-jointed. Head: fine bisque, curly wig, sleep eyes. Clothing: white chemise. Price: $1.50. Badge: Holtz Masse symbol. This is the same doll as advertised in the Toronto fall and winter catalogue of 1925- 26.

1927-28.
Fall and winter catalogue, Toronto. EATON'S BEAUTY. By Cuno and Otto Dressel. This doll advertisement had the Eatonia value label. See Fig. CE34. The following four dolls were offered:

1. Size: 22 inches. Body: fully jointed composition. Head: bisque, parted lips showing teeth, sleep eyes, real eyelashes, wig, a mass of curls parted at side and tied with a ribbon. Clothing: white chemise, white socks and shoes. Price: $1.50. Badge: EATON'S Beauty with the Holtz Masse symbol.

2. Size: 22 inches. Body and Head: the same as the above doll but the wig is bobbed. Clothing: a coloured Princess slip with lace trim. Price: $1.50.

3. Size: 24 inches. Sister doll to 22 inch EATON BEAUTY. Body: composition, fully jointed, slender. Head: bisque, wavy bobbed wig. Clothing: coloured Princess slip trimmed with lace, bead necklace. Price: $3.50.

4. Size: 27 inches. The largest sister. Body and head: same as 24 inch doll; wig bobbed and dressed like a permanent wave. Clothing: Princess slip. Price: $5.00.

1927-28.
Fall and winter catalogue, Winnipeg, Man. Size: 22, 25, and 27 inch dolls. Body: composition, fully jointed. Head: bisque, no bobbed wigs. All dolls had long hair. Clothing: all three were dressed in chemises. Price: $1.50, $3.50, and $5.00. See Figs. CH32 and CH33.

1927-28
This lovely doll, while sporting possible EATON'S BEAUTY markings, is not believed to be an EATON'S BEAUTY doll. It is dressed exactly as the dolls in the advertisements for "Fully Jointed Dolls" in the 1927-28 fall and winter catalogues for Toronto and Winnipeg. The doll described could be mistaken for an EATON'S BEAUTY because she has features exactly as the EATON'S BEAUTY offered that year. See Fig. BY14.

1928.
Summer catalogue, Toronto. EATON'S BEAUTY with the Eatonia seal of good quality. Size: 21 inches. Body: composition, fully jointed. Head: bisque, curly or bobbed hair, sleep eyes. Clothing: white Princess slip. Price: $1.50.

1928-29.
Fall and winter catalogue, Toronto. EATON'S BEAUTY. By Cuno and Otto Dressel. Size: 22, 25, and 27 inch dolls. Body: fully jointed composition, double cord elastic strung. Head: bisque, sleep eyes, real eyelashes, open mouth, teeth, wig parted on side with a bow or a bobbed wig; replacement head available at 39 cents, replacement wig, curly or bobbed at 45 cents. Clothing: Princess slip, shoes and socks. Price: $1.50, $3.50, and $5.00.

1928-29.
EATONIA. Size: 21 inches. Body: fully jointed composition. Head: bisque, sleep eyes, real eyelashes, parted mouth, teeth, curly wig, parted and tied with a ribbon. Clothing: chemise with a V shaped lace trim on the front. Price: $1.00.

1929.
Summer catalogue, Toronto. EATON'S BEAUTY. Size: 22 inches. Body: fully jointed, composition. Head: bisque, sleep eyes, eyelashes, open lips, teeth, curly or bobbed wig. Clothing: Princess slip, shoes and socks. Price: $1.50.

1929.

EATONIA. The same 21 inch doll as in the 1928-29 advertisement. The price was $1.00.

1929-30.
Fall and winter catalogue, Toronto. EATON'S BEAUTY. By Cuno and Otto Dressel. Size: 22, 25, 27 inches. Body: fully jointed composition, double cord elastic. Head: bisque, real eyelashes, sleep eyes, smiling lips, curly hair parted at side and tied with a ribbon or bobbed hair. Clothing: Princess slip, lace trimmed, shoes and socks. Price: $1.50, $3.50, and $5.00. Badge: with Holtz Masse symbol.

Note: In Fig. CA18, the original box has the Holtz Masse symbol. See Figs. CA18 and CA19. EATONIA. Size: 21 inches. Body: fully jointed composition. Head: bisque, sleep eyes, real eyelashes, parted mouth, teeth, curly parted wig tied with a ribbon. Clothing: chemise, socks and shoes. Price: $1.00.

1930.
Spring and summer catalogue, Toronto. EATON'S BEAUTY. Size: 22 inches. Body: fully jointed composition. Head: bisque, sleep eyes, long lashes, open lips, teeth, thick curly ringlets. Clothing: lace trimmed Princess slip, socks and shoes. Price: $1.50. Badge: EATON'S BEAUTY with the Holtz Masse symbol. EATONIA doll. Size: 21 inches. Body and Head: same as the 1929- 30 EATONIA doll. Badge: EATONIA.

1930-31.
Fall and winter catalogue, Toronto. EATON'S BEAUTY. Size: 22, 25, and 27 inches. Body: fully jointed composition. Head: bisque, sleep eyes, rosy cheeks, open mouth with teeth, long curly hair, real eyelashes; replacement head was available at 39 cents and replacement wig at 45 cents. Clothing: Princess slip, shoes and socks. Price: $1.50, $3.50, and $5.00. Badge: EATON'S BEAUTY. Holtz Masse symbol, outlined. See Figs. BS3A.

EATONIA. Size: 21 inches. Body: fully jointed composition. Head: bisque, sleep eyes, eyelashes, open mouth with teeth, thick curls in ringlets; replacement head at 35 cents, replacement wig at 45 cents. Clothing: Chemise, socks and shoes. Price: $1.00. Badge: EATONIA badge.

1931.
Summer catalogue, Toronto. EATON'S BEAUTY. Size: 22 inches. Body: fully jointed composition. Head: bisque, sleep eyes, eyelashes, open mouth with teeth, thick curls in ringlets. Clothing: lace trimmed Princess slip, shoes and socks. Price: $1.50.

EATONIA. Size: 21 inches. Body: fully jointed composition. Head: bisque, open mouth, teeth, thick curly wig. Clothing: Princess slip, shoes and socks. Price: $1.00. Badge: Eatonia.

1931-32.
Fall and winter catalogue, Toronto. EATON'S BEAUTY. Size: 22, 25, and 27 inches. Body: fully jointed composition, strong elastic cord. Head: bisque, open mouth with teeth, long curly wig; replacement head at

45 cents, replacement wig 50 cents. Clothing: lace trimmed Princess slip, shoes and socks. Price: $1.75, $3.75, and $5.50. Badge: with the Holtz Masse symbol.

EATONIA. Size: 21 inches. Body: fully jointed composition. Head: bisque, sleep eyes, real eyelashes, parted lips, teeth, curly wig, parted, tied with a ribbon. Clothing: chemise, shoes and socks. Price: $1.15. Badge: EATONIA.

1932.
Summer catalogue, Toronto. EATONIA. Same as the 1931- 32 EATONIA doll. Price: $1.25.

1932-33.
Fall and winter catalogue, Toronto. EATON'S BEAUTY. Body: fully jointed composition. Head: bisque, sleep eyes, open mouth with teeth, long curls, real lashes; replacement head at 39 cents, replacement wig at 50 cents. Clothing: lace trimmed Princess slip, shoes and socks. Price: $1.00. Badge: EATON'S BEAUTY outlined.

1933.
Summer catalogue, Toronto. EATON'S BEAUTY. Size: 20 inches. Body: fully jointed composition. Head: bisque, sleep eyes, real lashes, long curly wig. Clothing: lace trimmed Princess slip, socks and shoes. Price: $1.00. Badge: EATON'S BEAUTY outlined.

1933-34.
Fall and winter catalogue, Toronto. EATON'S BEAUTY. Size: 19.5 inches. Body: fully jointed composition. Head: bisque, long curls, ribbon on side, sleep eyes, eyelashes, open mouth with teeth. Clothing: lace trimmed Princess slip, shoes and socks. Price: $1.00. Badge: EATON'S BEAUTY with the Holtz Masse symbol.

1934.
Spring and summer catalogue, Toronto. EATON'S BEAUTY. Size: 19.5 inches. Body: fully jointed composition. Head: bisque, sleep eyes, real eyelashes, long curls. Clothing: lace trimmed Princess slip, shoes and socks. Price $1.25. Badge: EATON'S BEAUTY outlined. See Fig. CJ17.

1934-35.
Fall and winter catalogue, Toronto. EATON'S BEAUTY. By Armand Marseille. Size: 19 inches. Body: straight limbed composition, jointed hips, shoulder and neck. Head: painted bisque, closed mouth, sleep eyes, eyelashes, curly wig. Clothing: lace trimmed Princess slip, shoes and socks. Price: $1.39. Badge: EATON'S BEAUTY.

1935-36.
Fall and winter catalogue, Toronto. EATON'S BEAUTY. By Armand Marseille. Size: 19 inches. Body: straight limbed composition. Head: painted bisque, sleep eyes, thick lashes, long curly hair, tied with a bow on the side. Clothing: lace trimmed Princess slip, socks and shoes. Price: $1.39. See Figs. BH23 and CH24.

1936-37.
Fall and winter catalogue, Winnipeg. EATON'S BEAUTY. By Armand Marseille. Size: 19 inches. Body:

straight limbed composition, jointed hips, shoulder, and neck. Head: painted bisque, sleep eyes, thick eyelashes, long curls with a bow. Clothing: Princess slip, shoes and socks. Price: $1.39. Badge: EATON'S BEAUTY with Holtz Masse symbol. See Fig. BH24.

1937-38.
Fall and winter catalogue, Toronto. EATON'S BEAUTY. By Armand Marseille. Size: 18 inches. Body: hard-to-break, straight limbed, jointed hips, shoulders, and neck. Head: painted bisque, sleep eyes, thick eyelashes, long curls tied with a bow; replacement head at 39 cents. Clothing: lace trimmed Princess slip, shoes and socks. Price: $1.00. Badge: EATON'S BEAUTY with Holtz Masse symbol. See Fig. CE32.

1938-39.
Fall and winter catalogue, Winnipeg, Man. Same doll as the 1937-38 fall and winter Toronto catalogue.

1939.
Spring and summer catalogue, Toronto. Same doll as 1937-38 was again offered.

1939-40.
Fall and winter catalogue, Toronto. EATON'S BEAUTY. By Armand Marseille. Size: 18 inches. Body: straight limbed composition, jointed hips, shoulders, and neck. Head: painted bisque, sleep eyes, thick lashes, long curled wig; replacement wig, light or dark, at 40 cents. Clothing: Princess slip, shoes and socks. Price: $1.00. Badge: white with dark print, EATON'S BEAUTY with Holtz Masse symbol.

Also offered: OLD FASHIONED BEAUTY. By Armand Marseille. Size: 16 inches. Body: straight limbed composition, jointed hips, shoulders, and neck. Head: painted bisque, real eyelashes, long blond curls. Clothing: Organdy frilled frock, bonnet, muff, slip, panties, socks and shoes. Price: $1.95. See Fig. CJ20.

World War II forced the Canadian doll manufacturers to produce enough dolls to meet the demand at home. Reliable Toy Co. produced the EATON'S BEAUTY from 1940 to 1943. It was entirely Canadian made, although the lithographed metal eyes were imported from the United States. The Canadian Government had restricted the use of tin in toys in 1942, but Reliable had enough eyes in stock for the EATON'S BEAUTIES until 1943. The ribbons were sent out to be stamped and were stitched on the Princess slips at Reliable.

1940.
Summer catalogue, Toronto. EATON'S BEAUTY. Reliable Toy. Size: 18 inches. Body: straight limbed composition, jointed hips, shoulders, and neck. Head: composition, sleep eyes, real hair eyelashes, long curls. Clothing: Princess slip, socks and shoes. Price: $1.29. Badge: White, EATON'S BEAUTY, Made in Canada.

1940-41.
Fall and winter catalogue, Toronto. EATON'S BEAUTY. Reliable Toy. Size: 18 inches. Body: straight limbed composition, jointed hips, shoulders, and neck. Head: composition, sleep eyes, thick lashes, long curly wig.

Clothing: Princess slip, shoes and socks. Price: $1.29. Badge: EATON'S BEAUTY Made in Canada. Extra clothing, 85 cents each: 1. Pleated dress with a round collar, puff sleeves, bonnet to match. 2. Bow neckline frock with full skirt, puff sleeves, ribbon streamers, bonnet to match. See Fig. CR18.

1940-41
Fall and winter catalogue, Winnipeg, Man. EATON'S BEAUTY. Reliable Toy. The same doll as advertised in the Toronto catalogue. The extra outfits were 95 cents each: 1. Ski suit with hood. 2. Old fashioned dress and bonnet. 3. Party frock, petticoat and hat. 4. Pert pleated frock and hat.

1941-42.
Fall and winter catalogue, Toronto. EATON'S BEAUTY. Reliable Toy. Size: 18 inches. Body: straight limbed composition, jointed hips, shoulders, and neck. Head: composition, sleep eyes, thick eyelashes, long curls. Clothing: Princess slip, socks and shoes. Badge: red with gold print, EATON'S BEAUTY. Made in Canada. Extra clothing on a hanger, 95 cents: l. Party frock, petticoat and hat. 2. Ski suit with hood. 3. Old fashioned dress with bonnet. 4. Nurse's outfit. See Fig. CP2.

1942.
Summer catalogue, Toronto. EATON'S BEAUTY. This doll was the same as the one shown in the 1941-42 advertisement. No extra outfits were offered.

1942-43.
Fall and winter catalogue, Toronto. EATON'S BEAUTY. Reliable Toy. Size: 18 inches. Body: straight limbed composition, jointed hips, shoulders, and neck. Head: composition, sleep eyes, thick eyelashes, long curly wig. Clothing: Princess slip, socks and shoes. Price: $1.29. Badge: red with gold print, EATON'S BEAUTY. Made in Canada. Extra clothing, 85 cents in Toronto, 95 cents in Winnipeg: 1. Party dress. 2. Ski suit. 3. Pyjamas suit. While Reliable made no EATON'S BEAUTIES after 1943, Eaton's continued to sell their stock of dolls for at least two more years. That is why people can have Eaton's Beauties bought in 1945, but these dolls were not manufactured in 1945. See Fig. BC13.

1943-53.
No EATON'S BEAUTY was offered in the catalogues. Eaton's advertised other dolls such as the LITTLE ANGEL and BABY PRECIOUS as the type of doll most popular each year.

1950-51.
1951-52.
In these years the feature value was a rubber doll complete with outfit and suitcase.

1953-54.
Fall and winter catalogue, Toronto. feature value Curly-Locks. Size: 12 inches. Body: Hard plastic, walking doll. Head: Hard plastic, sleep eyes, eyelashes, wavy hair. Clothing: lace trimmed rayon polka dot dress and attached panties, socks tied with ribbons. Price: $1.98.

1954.
Gift book, Winnipeg, Man. EATON'S BEAUTY. Size: 18 inches. Body: latex skin. Head: vinyl, rooted saran hair, sleep eyes. Clothing: striped dress and hat. Price: $5.98. Badge: EATON'S BEAUTY.

1955-56.
Christmas catalogue, Winnipeg, Man. EATON'S BEAUTY. Size: 18 inches. Body: latex skin. Head: moulded vinyl, rooted saran hair, cooing voice. Clothing: rayon taffeta dress in two-tone colour, straw hat with tie-on ribbon, panties, boots and socks. Price: $5.98. Badge: red, EATON'S BEAUTY.

1956.
Christmas catalogue, Toronto. EATON'S BEAUTY. Dee an Cee Co. Size: 17 inches. Body: Flexee-vinyl; could sit, kneel or pose; crier. Head: vinyl, sleep eyes, turning head, rooted saran hair. Clothing: rayon ninon dress, rayon taffeta half-slip, panties, knitted socks, vinyl shoes, lace-trimmed straw bonnet with flowers. Price: $5.98. Badge: red and gold, EATON'S BEAUTY.

1957.
Christmas catalogue, Toronto. EATON'S BEAUTY. Dee an Cee Co. Size: 8, 18, and 23 inches. Body and Head: same as the 1956 EATON'S BEAUTY. Clothing: matching bonnet and dress. Price: $2.98, $5.98, and $7.98. Badge: white with blue print.

1958.
Spring and summer catalogue, Toronto. EATON'S BEAUTY. Dee an Cee Co. Size: 18 inches. Body: Flexee-vinyl. Head: vinyl, sleep eyes, rooted hair. Clothing: matching dress and bonnet. Price: $5.98. Badge: white, outlined in blue, EATON'S BEAUTY.

1958.
Christmas catalogue feature value. English Walking Doll Size: 21 inches. Body: all-plastic walking doll, jointed hip, shoulders, and neck. She could walk, cry, sit down, and turn her head. Sleep eyes, curly hair. Clothing: organdy dress and bonnet, slip panties, socks and plastic shoes. Price: $7.59.

1958-59.
Fall and winter catalogue. Feature Value. Roddy Co. Size: 13 inches. Body: all-plastic walking doll, (marked RODDY on back), jointed hips, shoulders, and neck. Head: hard plastic, sleep eyes, synthetic wig. Clothing: polka dot dress, panties, socks and shoes, (shoes are marked Roddy on the soles). Price: $1.98. See Fig. BS10.

1959-60.
Same doll as the previous year was offered again.

1960.
EATON'S BEAUTY. Dee an Cee Co. Size: 18 in. Body: plastic, jointed hips, shoulders, and neck. Head: vinyl, sleep eyes, lashes, rooted saran curly hair, open mouth nurser. Dressed in flowered stiff taffeta, fitted bodice, Peter Pan collar, pinstripe nylon pinafore over-dress, velvet tie, silk panties, socks, black plastic strap shoes. See Fig. CA29.

The above information regarding costuming is from Mr. A. Cone.

1960-61.
Fall and winter catalogue, Toronto. Reliable. Feature Value: BABY TEAR DROPS. Size: 14 inches. Head and Body: vinyl, rooted saran hair, crier. Clothing: a complete layette. Price: $4.98.

1962.
Christmas catalogue, Toronto. EATON BEAUTY. Size: 22 inches. Body: plastic, jointed hips, shoulders, and neck. Head: vinyl, sleep eyes, lashes, rooted blond saran hair with bangs, open mouth, teeth. Clothing: two-tone dress, slip panties, shoes and socks. Extra clothing: 1. Cotton print dress with sash. 2. Skirt and blouse. 3. Slacks. 4. Coat and hat. Price: doll only, $4.98; doll with all the extra outfits, $7.98. White badge with red lettering, EATON BEAUTY.

1963.
Christmas catalogue, Toronto. EATON BEAUTY. Regal Toy Co. Size: 21 inches. Body: plastic, jointed hips, shoulders, and neck. Head: vinyl, sleep eyes, lashes, rooted curly saran hair, open mouth nurser. Clothing: dress of white and pink sheer material with lace trimmed pink overskirt. Extra clothing: 1. Blue flannelette crawler suit. 2. Cotton dress with a colourful printed skirt attached to a white top with a red overlay. 3. Cotton red flannel coat with white lace trim and a bonnet to match. Price: doll with pink and white dress, $4.98; doll with extra three outfits, $7.98. See Fig. CP4.

1964.
Christmas catalogue, Toronto. EATON BEAUTY. Regal Toy Co. Three EATON BEAUTIES were offered:

1. Size: 21 inches (all three dolls). Body: plastic, jointed hips, shoulders, and neck. Drink and wet doll. Head: vinyl, rooted saran hair, sleep eyes. Clothing: each doll carries its own bottle. Dotted nylon dress with puff sleeves, velveteen bodice trimmed with lace, two-tiered taffeta slip, simulated pearl bracelet and necklace. Price: $9.98. See Fig. BQ11.

2. Cotton polka dot dress and bright red coat with matching tam, collar, and sleeves, trimmed with white lace, white muff. Price: $6.98.

3. Sheer dress of white taffeta with a velveteen red bodice and puff sleeves trimmed with lace. Price: $4.98.

1965:
Christmas catalogue, Toronto. EATON BEAUTY. Reliable Toy Co. Four dolls were offered:

1. Size: 21 inches. Body: plastic, jointed hips, shoulders, and neck. Head: vinyl, sleep eyes, rooted saran hair. Clothing: sheer white taffeta dress with red velveteen bodice and puff sleeves. Price: $4.98.

2. Size: 18 inches. Body: one piece vinyl skin stuffed. Head: vinyl, sleep eyes, rooted curly saran hair. Clothing: corduroy play suit with white trim,

matching shoes and socks. Price: $5.98. Badge: heart shaped card with EATON BEAUTY on it. See Fig. BZ15.

3. Size: 14 inches. Body: one piece vinyl skin stuffed. Head: vinyl, rooted saran hair. Clothing: embroidered dress with red flowers, matching socks and shoes, panties. Price: $3.98.

4. Size: 16 inches. Body: one piece vinyl skin stuffed. Head: vinyl, rooted saran hair. Clothing: white dress trimmed with red velvet ribbon. Price: $4.98. Extra clothing: 1. Coat with hat and muff; 2. Taffeta dress; 3. Embroidered dress. Price: doll plus extra clothing, $7.98.

1966.
Christmas catalogue, Toronto. EATON BEAUTY. Reliable Toy Co. The EATON BEAUTY Family (no badges) of five dolls were offered:

1. Size: 20 inches. Body: plastic body, jointed hips, shoulders, and neck; walking doll powered by two D cell batteries. Head: vinyl, sleep eyes; rooted short straight saran hair. Clothing: blue A-line dress with white eyelet trim, panties, two pairs of shoes. Price: $13.99.

2. TWISTY PIXIE. Size: 14 inches. Body: cloth, stuffed, with wire armature so the doll can be posed in any position; vinyl hands. Head: vinyl; rooted short straight hair. Clothing: flannelette sleepers, embroidered jacket, floppy night cap. Price: $3.98.

3. Size: 16 inches. Body: vinyl. Head: vinyl, rooted poodle cut hair. Clothing: coat with ruffle around the neck and down the front, matching hat, and sportsheen dress with ribbons. Price: $3.98.

4. Size: 18 inches. Body: vinyl. Head: vinyl, hairbow. Clothing: frosty embroidered nylon dress with ribbon trim, cotton undershirt, panties, socks and shoes. Price: $4.98.

5. EATON BEAUTY BABY Size: 14 inches. Body: soft vinyl. Head: vinyl, rooted short straight hair. Clothing: embroidered nylon dress, under shirt, diaper, knitted bootees tied with baby ribbon, bracelet, locket, on a ruffled nylon pillow, complete with a birth certificate. Price: $6.98.

1977.
Christmas catalogue, Toronto. EATON BEAUTY. By Dorothy Churchill. Body: fully jointed composition. Head: bisque. Mark: 390/A4M/Dorothy Churchill/1977. Clothing: dress and hat, shoes and stockings. Badge: EATON BEAUTY.

1978.
Christmas catalogue, Toronto. EATON BEAUTY, TIMOTHY EATON. First boy EATON BEAUTY. By Dorothy Churchill. Body: fully jointed composition. Head: bisque. Mark: diamond with an E in the centre./Dorothy Churchill/1978. Made from a mould of a Steiner doll. Clothing: blue velvet suit, matching hat, white lace trimmed shirt, black shoes. Badge: white, with gold print, EATON BEAUTY. See Fig. CV12.

1980.
Christmas gift book, Toronto. EATON BEAUTY. By Dorothy Churchill. Size: 18 inches. Body: fully jointed composition. Head: bisque, blond or brunette wig. Clothing: cognac or teal blue dress, hat. Price: $300.00 Mark: diamond with an E inside/Dorothy Churchill/1980. Badge: EATON BEAUTY. See Fig. CV10.

1981.
Dorothy Churchill. Catalogue information not available. See Figs. CG35 and CG36.

1983.
Christmas gift book, Ottawa. EATON BEAUTY. By April Katz. Size: 18 inches. Body: all bisque jointed body. Head: bisque, blond wig in ringlets. Mark: on head, April Katz #/CANADA/1983. Clothing: mauve moire coat and hat, trimmed with braid and lace, dress, slip and pantalettes, shoes and stockings. Limited edition of 200. See Fig. AP5.

1984.
EATON BEAUTY again made by April Katz but we have no catalogue information for that year. However, we have photographed this doll by April Katz. See Figs. CY1 and CY3.

CF2
ARMAND MARSEILLE. ca.1900. 24 in. (62 cm). Kid leather body, upper arms and upper legs, bisque forearms, papier-mâché ball-jointed lower legs. Bisque shoulderhead; blue glass sleep eyes, lashes, painted upper and lower lashes; blond mohair wig; open mouth showing teeth. Mark: on head 370/AM 3 DEP. Clothing is old but not original. 1964 ribbon. From the collection of Gloria Kallis, Drayton Valley, Alta. This doll is the type of doll used in 1900-1903 for the Eaton's Beauty. See also CF3.

CF2

CF3

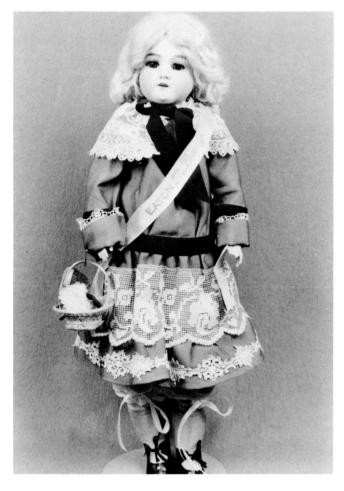

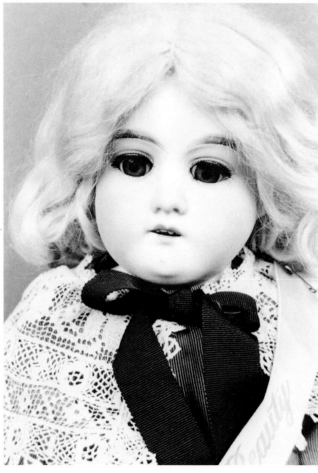

CH23

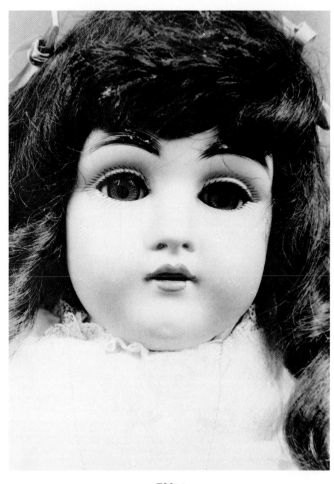

CI2
J.D. KESTNER. 1905. 26 in. (66 cm). Kid leather body, (repaired), gusset hip and knee joints, bisque replaced forearms, kid upper arms. Bisque head; replaced blue glass sleep eyes, eyelashes, painted upper and lower lashes; replaced dark brown wig; open mouth showing two teeth. Mark: on head, DEP 15413. From the collection of Muriel Clancy, Saskatoon, Sask.

The original owner of this doll received this Beauty when she was born, and thus pinpoints the date to 1905. See also CH22, CH23.

CI2

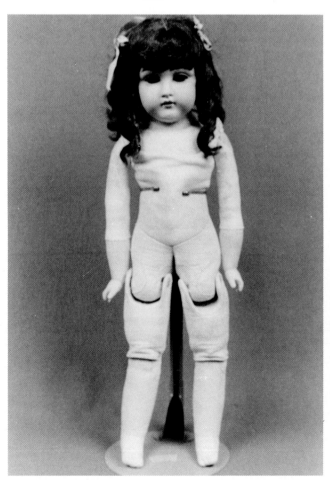

CH22

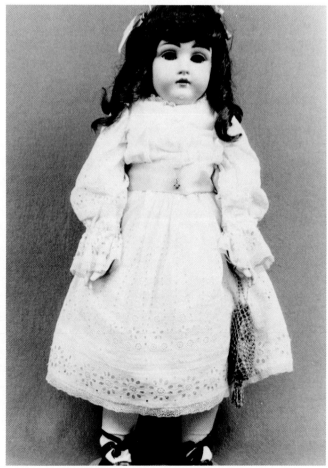

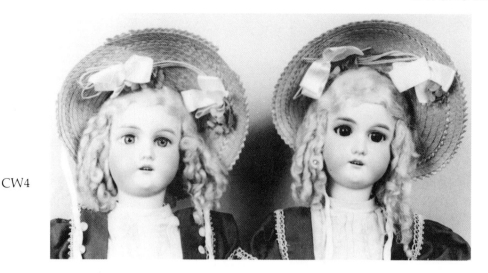

CW4

CW4
Armand Marseille. 1908. 21.5 in. (55 cm). Papier-mâché bodies, wooden stick upper arms and upper legs, composition forearms and lower legs, ball-jointed; bisque socket heads, one has fixed blue glass eyes and the other has brown glass sleep eyes, lashes, painted upper and lower lashes; blond mohair wigs in ringlets; open mouths showing four teeth. Mark: on heads, Armand Marselle/Made in Germany/390/A8M. Wearing homemade combinations with knee length legs, wine dresses trimmed with lace, knitted cotton stockings, white canvas shoes with laces, straw bonnets with wide brims, wine ribbon and flower trim. Courtesy of the Wellington County Museum, Fergus, Ont. See also Fig. CW6.

These two dolls were given to sisters in 1908. The dolls have unusual bodies in that they are quite homely in comparison with their beautiful heads. The trunk has a protruding stomach and very full bottom, and extends up to form a neck instead of having the head sit into the neck hole at the shoulder level.

BS2A
Schoenau & Hoffmeister. 1909. 18 in. (45.5 cm). Papier-mâché fully ball-jointed body with wooden forearms. Bisque head with a slight sheen; blue glass sleep eyes, lashes, painted upper and lower lashes; brown mohair wig; open mouth showing teeth. Mark: on head, S (a star with PB in the centre) H/1909/1 1/2/Germany/. White cotton and lace dress. From the collection of Wilma MacPherson, Mount Hope, Ont.

CW6

BS2A

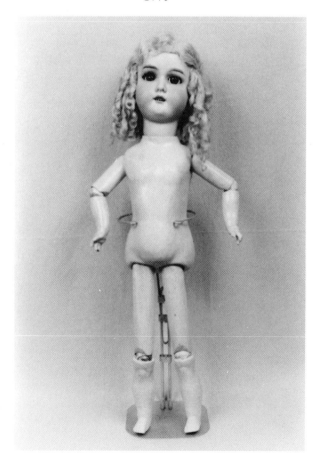

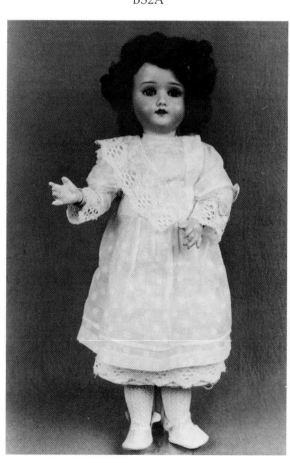

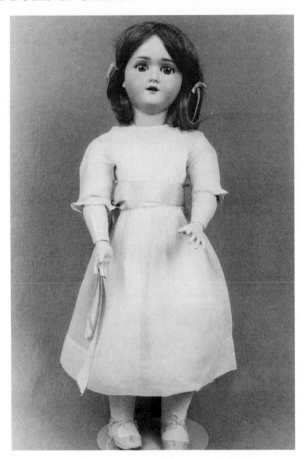

CH18

CH18
Schoenau & Hoffmeister. 1909. 21 in. (53.5 cm). Papier-mâché fully ball-jointed body. Bisque head; glass sleep eyes, lashes, painted upper and lower lashes; brown human hair wig; open mouth showing two teeth. Mark: on head S (star with PB in centre) H/1909/3 1/2/Germany. Original pink cotton slippers, replaced pink organdy dress. From the collection of Muriel Clancy, Saskatoon, Sask. See also colour Fig. CH19.

BT17
Cuno & Otto Dressel. 1909-10. 19.75 in. (50 cm). Papier-mâché fully ball-jointed body with red Holtz Masse stamp. Bisque head; blue glass sleep eyes, eyelashes, painted upper and lower lashes; brown mohair wig with curled bangs; open mouth, showing teeth. Mark: on head, C/3. From the collection of Bernice Tomlinson, Etobicoke, Ont.

BH25
Cuno and Otto Dressel. 1911. 19.5 in. (49.5 cm). Fully ball-jointed papier-mâché body. Bisque head, dimpled chin; blue glass sleep eyes, painted upper and lower lashes; blond mohair wig; open mouth showing four teeth. Mark: head, Germany/C/3. White chemise, trimmed in lace, underneath pink dress, slip and matching hat. From the collection of Rebecca Douglass, Dartmouth, N.S.

BT17

BH25

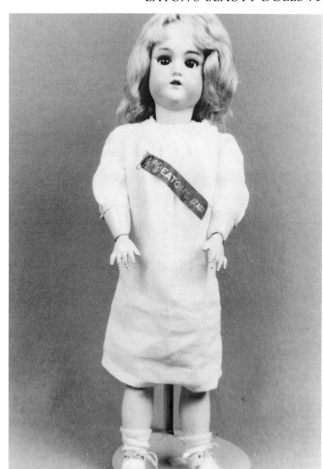

CH26

CH26
Cuno & Otto Dressel. 1909-10. 21 in. (53.5 cm). Papier-mâché fully ball-jointed body. Bisque head; brown glass sleep eyes, lashes, painted upper and lower lashes; long blond wig with bangs; open mouth showing two teeth. Mark: on head, C/4; oval hole in the back of head. Original chemise, badge, socks and shoes, and dress made for her when new. From the collection of Muriel Clancy, Saskatoon, Sask. See also CH21, and colour Fig. CH20.

CH21

CH20

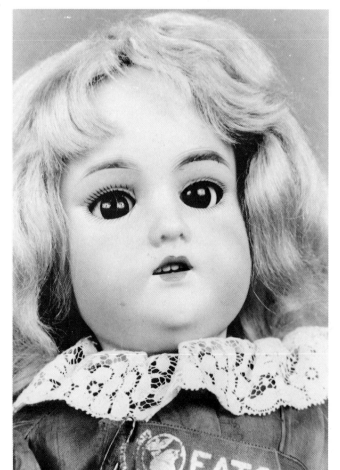

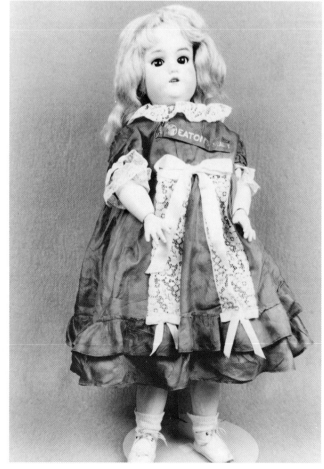

XH17

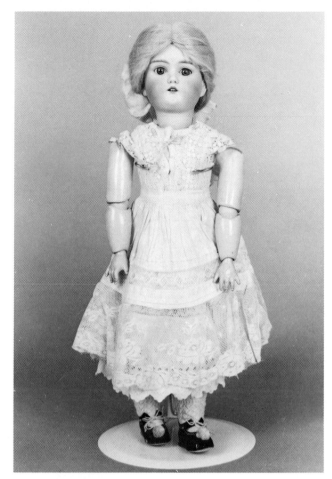

XH16

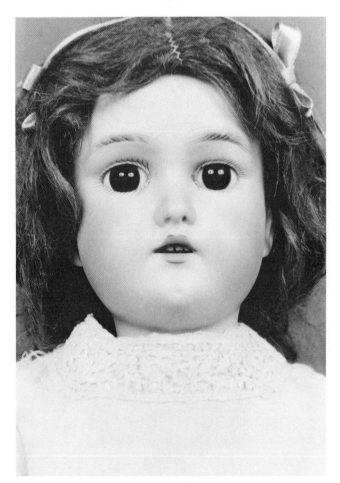

CH31

XH17
Cuno & Otto Dressel. 1910. 20 in. (51 cm). Papier-mâché fully ball-jointed body. Bisque head, dimpled chin; blue glass sleep eyes, painted upper and lower lashes; blond mohair wig; open mouth showing teeth. Mark: on head, C/3, two small holes above mark, hole above each ear; on body, red Holtz Masse mark. Original shoes, socks, undershirt, pantalettes, lace slip. Photographs courtesy of Brooks-Kennedy Studio, St. Catharines, Ont. From the collection of Cathy Dorsey, St. Catharines, Ont. See also Fig. XH16 and colour Fig. XH16.

CH31
Cuno & Otto Dressel. 1911-12. 19 in. (48.5 cm). Papier-mâché fully ball-jointed body. Bisque head; stationary brown glass eyes; light brown wig; open mouth showing four teeth. Mark: on head, Germany/C/3. Clothing original to doll, cotton lace-trimmed dress, flannelette slip and drawers. From the collection of Elaine Penn, Saskatoon, Sask.

BT8A

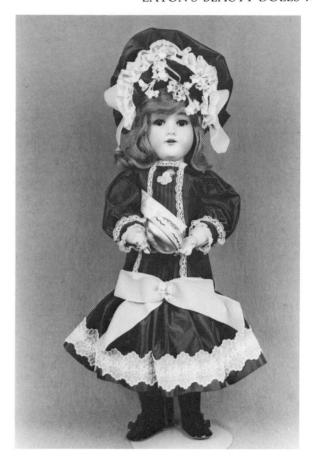

BT8A
Armand Marseille. 1912-13. 19.75 in. (50 cm). Composition fully ball-jointed body. Bisque head, dimpled chin; brown glass sleep eyes, lashes, painted upper and lower lashes; long light brown mohair wig; open mouth showing teeth. Mark: on head, Armand Marseille/Germany/390/A4M. Redressed. From the collection of Bernice Tomlinson, Etobicoke, Ont.

CJ19
Armand Marseille. 1914-15. 25 in. (63.5 cm). Composition fully ball-jointed body. Bisque head, dimpled chin; blue glass sleep eyes, lashes, painted upper and lower lashes; replaced human hair wig, original was brown mohair; open mouth, showing four teeth. Mark: Made in Germany/Armand Marseille/390/A 8 M. Wearing cotton pantalettes, petticoat, pink silk dress and pink shoes made for her when whe was new. From the collection of Beulah Caswell, Sask.

BP19
Armand Marseille. 1914. 22.5 in. (57 cm). Papier-mâché fully ball-jointed body. Bisque head; Blue glass sleep eyes, painted upper and lower lashes; light brown mohair wig; open mouth showing four teeth. Mark: on head, Armand Marseille/Made in Germany/390/A4M. Redressed. This doll was originally purchased at Eaton's in Montreal. Author's collection.

CJ19

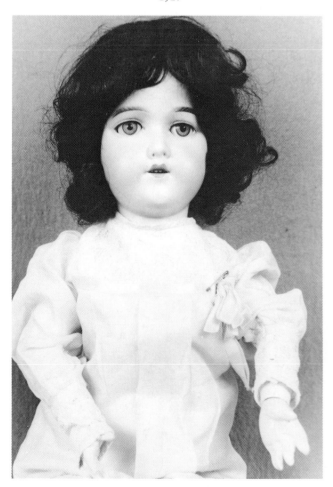

BP19

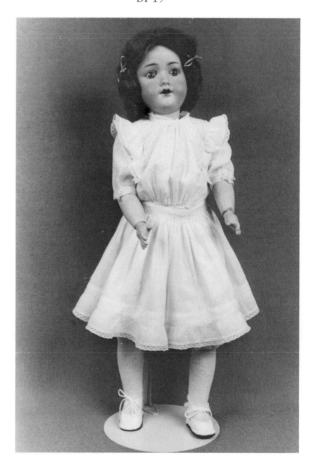

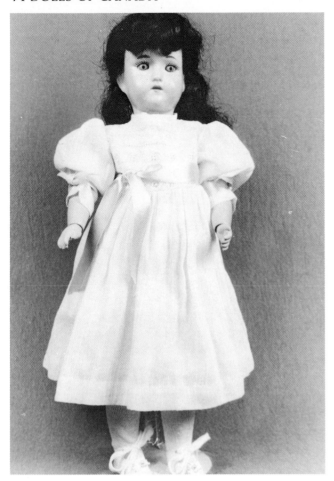

CL22

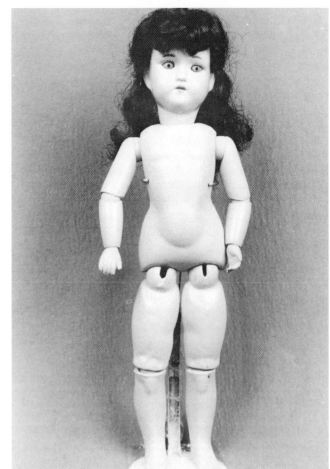

CL23

CL22
Dominion Toy. 1915 20 in. (50.5 cm). Composition hands, trunk and legs, wooden arms, fully ball-jointed. Composition head, open crown; light blue tin sleep eyes, repainted face, painted lashes, red dots in eye corners, nostril dots; replaced wig (original was mohair), closed mouth. Mark: on body, MADE IN CANADA (in an arch over) DTMC. Old white dress. From the collection of Berna Gooch, North Vancouver, B.C. See also CL23.

CW5
S.F.B.J. ca.1922. Eaton Special Doll (not an Eaton's Beauty) 20 in. (51 cm). Papier-mâché body, fully-jointed, wooden arms with French joints, composition hands, composition legs with French joints. Bisque head; all black glass sleep eyes, painted upper and lower lashes; dark brown human hair wig; open mouth showing four porcelain teeth. Mark: on head, S.F.B.J./60/PARIS. From the collection of Berna Gooch, North Vancouver, B.C.

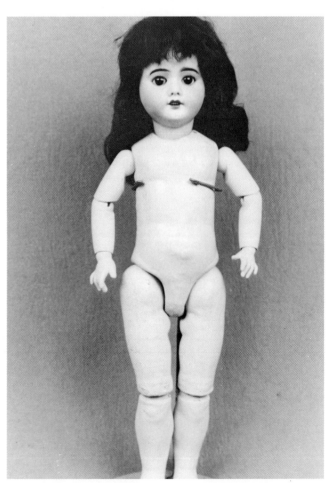

CW5

BH26

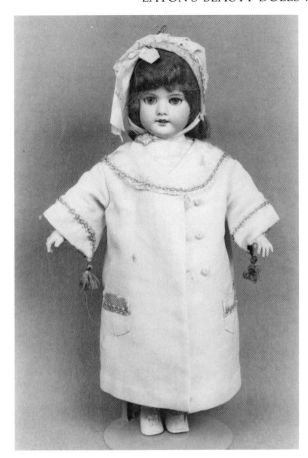

BH26
S.F.B.J. 1922-23. Eaton Special Doll (not an Eaton's Beauty). 19 in. (48.5 cm). Composition fully-jointed French body marked with the S.F.B.J. mark. Bisque head; blue glass sleep eyes, lashes; light brown human hair wig; open mouth, four moulded porcelain teeth. Mark: on head, 22/D/S.F.B.J./60/Paris/3. Wearing dress, slip, pantalettes, coat and hat trimmed in silk. From the collection of Rebecca Douglass, Dartmouth, N.S.

AP31
Armand Marseille. 1924. 21 in. (53.5 cm). Composition fully ball-jointed body. Bisque head; brown glass sleep eyes, eyelashes, painted upper and lower lashes; replaced blond wig; open mouth, showing two teeth. Mark: on head, Armand Marseille/390n/Germany/A 6 M. Dressed in a copy of the dress worn when the doll was new. Replaced ribbon. From the collection of Geraldine Young, Niagara Falls, Ont.

BQ24A
Armand Marseille. 1924. 21.25 in. (54 cm). Composition fully ball-jointed body. Bisque head; blue glass sleep eyes, lashes, painted upper and lower lashes; blond mohair wig; open mouth showing teeth. Mark: on head, Armand Marseille/Germany/390/A4M. Dressed in a silk and lace dress, slip and mauve underwear. The doll's wig was replaced in 1928 by ordering a new one from Eaton's for 50 cents. Photograph neg. no. 79-1624 courtesy of National Museums of Canada, National Museum of Man.

AP31

BQ24A

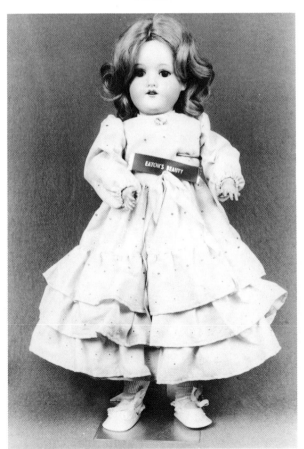

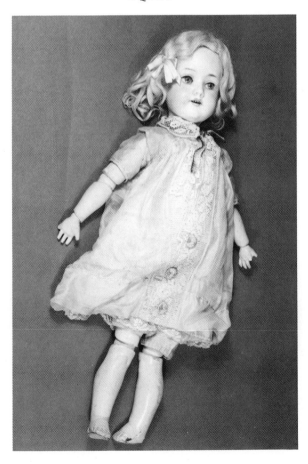

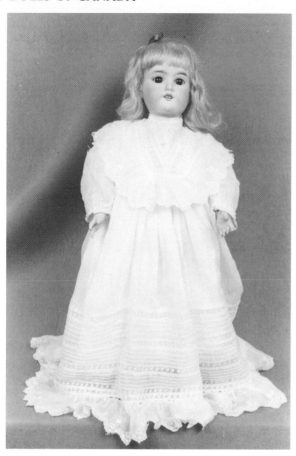

BH27

BH27
Armand Marseille. 1925. 19 in. (48.5 cm). Composition fully ball-jointed body. Bisque head; brown glass sleep eyes, painted upper and lower lashes; long blond mohair wig with bangs; open mouth showing four teeth. Mark: on head, Made in Germany/390/ A 2 1/2 M. Dressed in a white chemise with bows, slip, pantalettes and long dress. From the collection of Rebecca Douglass, Dartmouth, N.S.

CE34
Armand Marseille. 1927. 22 in. (56 cm). Composition fully ball-jointed body. Bisque head; blue glass stationary eyes (originally were sleep eyes), painted uppers and lowers; brown mohair wig ; open mouth showing four teeth. Mark: on head, Armand Marseille/Germany/390/A 4 M. Dressed in a copy of the original lace-trimmed chemise, 1964 ribbon. From the collection of Gloria Kallis, Drayton Valley, Alta.

BY14
Armand Marseille. 1927-28. Fully jointed Doll (not an Eaton's Beauty). 19.5 in. (49.5 cm). Composition fully ball-jointed body. Bisque head; blue glass sleep eyes, lashes, painted upper and lower lashes; brown mohair wig; open mouth showing four teeth. Mark: on head, ARMAND MARSEILLE/Germany/390/A 3 M. Original chemise, socks and shoes, orangy-red ribbon rosette on her chemise, matching ribbon in her hair and matching pompons on her shoes. From the collection of Catherine A. Kerr, Ottawa, Ont.

CE34

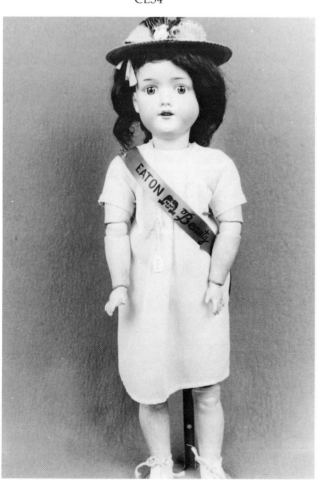

BY14

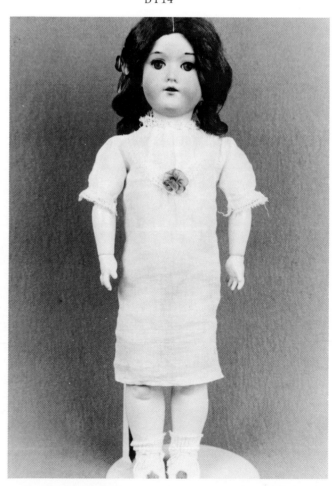

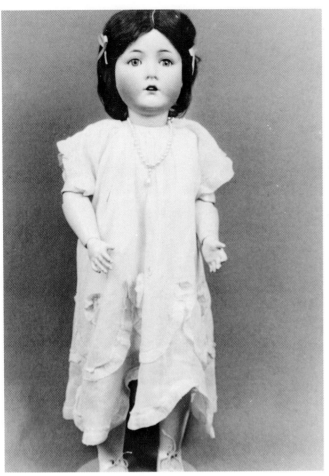

CH32

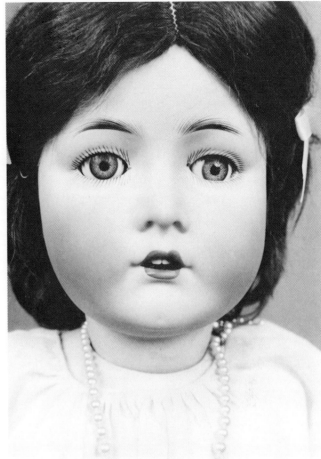

CH33

CH32
Cuno & Otto Dressel. 1927. BIG SISTER. 29 in. (74 cm).
Composition fully ball-jointed body. Bisque head, highly
coloured; blue glass sleep eyes, lashes, painted upper and lower
lashes; brown human hair wig; open mouth showing four teeth
and felt tongue. Mark: on head, CUNO & OTTO DRESSEL/
GERMANY. Dressed in an old lawn peach cotton dress, and
a Princess slip, original shoes. From the collection of Elaine
Penn, Saskatoon, Sask. This doll is taller than the catalogue
dolls and may have been purchased in Eaton's department store.
See also CH33.

BS3A
Cuno & Otto Dressel. 1930-31. 25 in. (64 cm). Composition
fully ball-jointed body. Bisque head, dimpled chin; brown glass
sleep eyes, lashes, painted upper and lower lashes; replaced
honey blond wig, original wig was mohair; open mouth showing
two teeth. Mark: on head, Cuno & Otto Dressel/Germany.
Redressed. From the collection of Wilma MacPherson, Mount
Hope, Ont.

BS3A

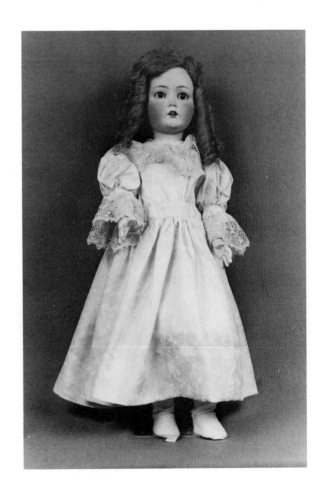

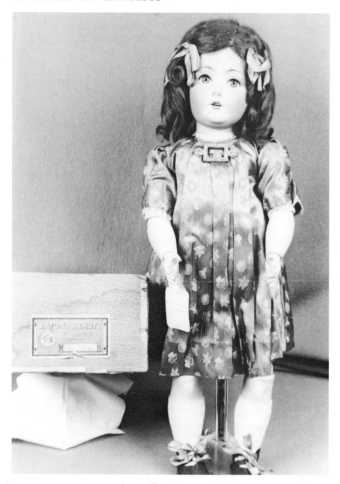

CA18

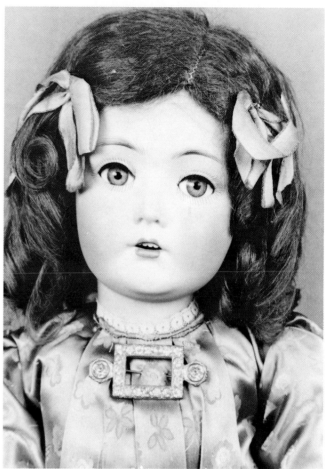

CA19

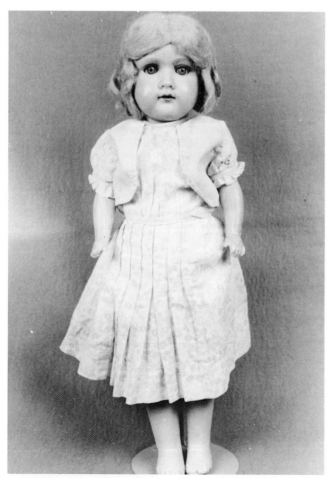

CJ17

CA18
Cuno & Otto Dressel. 1929-30. 25 in. (63.5 cm). Composition fully ball-jointed body. Bisque head; grey-blue glass sleep eyes, lashes, painted upper and lower lashes; original brown wig; open mouth showing four teeth. Mark: on head, 6/CUNO & OTTO DRESSEL/GERMANY. Redressed. Original Eaton's Beauty box. From the collection of Mrs. D.H. Morman, Victoria, B.C. See also CA19.

CJ17
Armand Marseille. 1934. 20 in. (50.5 cm). Papier-mâché, straight limbed, jointed hips, shoulders, and neck. Painted bisque head; blue glass sleep eyes, lashes, eyeshadow above eyes; blond mohair wig. Mark: on head, Armand Marseille in an arch over 390/ A 2 1/2 M. Originally wore cotton Princess slip and ribbon. Cotton dress made for her when she was new. From the collection of Beulah Caswell, Sask. The original owner dates this doll as being purchased in 1939. The description from the catalogue places her as the 1934 doll. This could well be an example of a doll that was offered for sale in one part of Canada one year then sent as surplus stock to another part of Canada at a later date.

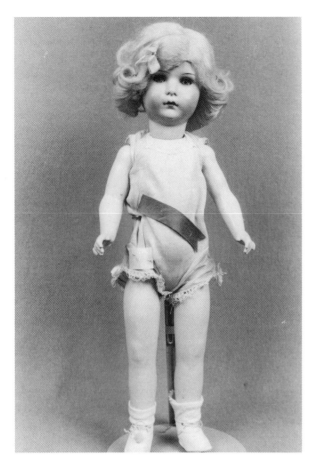

CH24

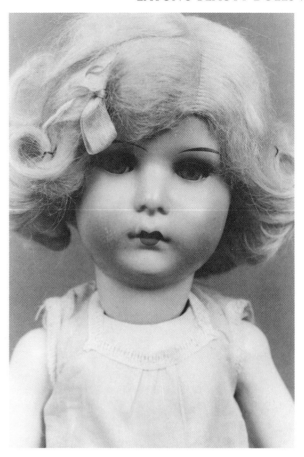

CH25

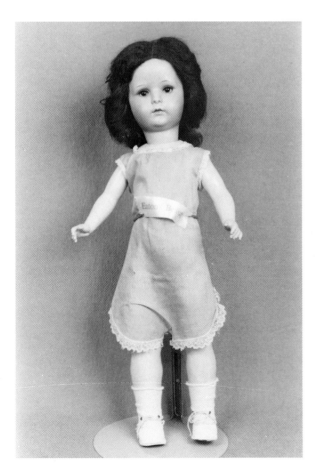

BH23

CH24
Armand Marseille. 1935-36. 20 in. (50.5 cm). Papier-mâché, straight limbed, jointed hips, shoulders, and neck. Painted bisque head; blue glass sleep eyes, lashes, eyeshadow above and below the eyes; blond mohair wig, original blue hair-ribbon; closed mouth. Mark: on head, A 449 M/Germany/0 1/2. Original blue cotton princess slip and socks and shoes. Original Eaton Beauty ribbon. From the collection of Elaine Penn, Saskatoon, Sask. See also Fig. CH25.

BH23
Armand Marseille. 1935-36. 19 in. (51 cm). Papier-mâché, straight limbed, jointed hips, shoulders, and neck. Painted bisque head; brown glass sleep eyes, lashes, eyeshadow above the eyes; brown mohair wig; closed mouth. Mark: on head, A 449 M/Germany/0 1/2. Original mauve Princess slip, replaced ribbon. From the collection of Rebecca Douglass, Dartmouth, N.S.

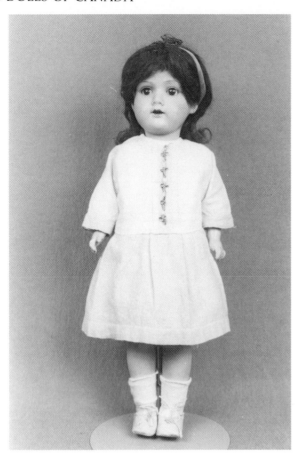

BH24

BH24
Armand Marseille. 1936-37. 19 in. (43.5 cm). Papier-mâché, straight limbed, jointed at hips, shoulder, and head. Painted bisque head; brown glass sleep eyes, lashes, painted upper lashes; brown mohair wig; open mouth showing four teeth. Mark: on head, Armand Marseille/Germany/390/A 2 1/2 M. Wearing white slip, blue slip, blue dress, shoes and socks. From the collection of Rebecca Douglass, Dartmouth, N.S.

CE32
Armand Marseille. 1937-38. 18 in. (45.5 cm). Papier-mâché, straight limbed, jointed hips, shoulders, and neck. Painted bisque head; brown glass sleep eyes, lashes; replaced wig; open mouth showing four teeth and felt tongue. Mark: on head, 390/A 2 1/2 M (rest of mark probably under wig). Original princess slip and Eaton's Beauty ribbon. From the collection of Gloria Kallis, Drayton Valley, Alta.

CJ20
Armand Marseille. 1939-40. OLD FASHIONED BEAUTY (not an Eaton's Beauty). 16 in. (40.5 cm). Composition (cardboard and plaster, painted), straight limbed, jointed hips, shoulders, and neck. Painted bisque head; brown glass sleep eyes, lashes, eyeshadow above eyes; blond mohair wig in ringlets; open mouth showing four teeth. Mark: on head, Germany/390/A 2 1/2 M. Original cotton panties, slip, organdy dress, blue satin bonnet and muff. Originally more expensive than the Eaton's Beauty. From the collection of Beulah Caswell, Sask.

CE32

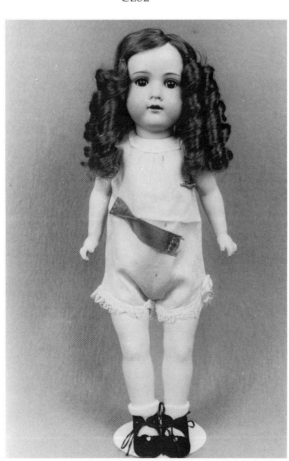

CJ20

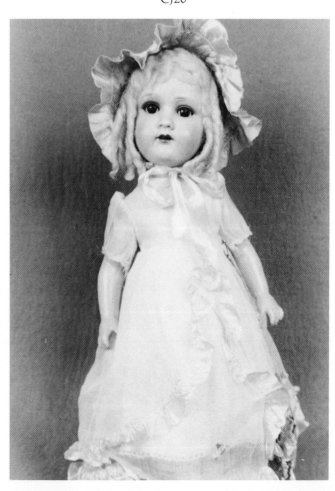

CR18

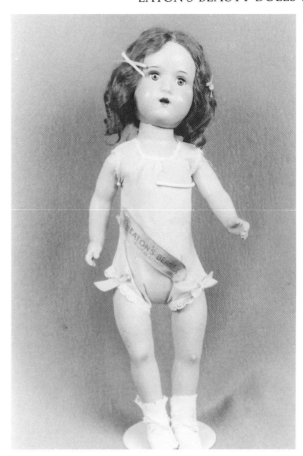

CR18
Reliable. 1940-41. 18 in. (45.5 cm). Composition, straight limbed, jointed hips, shoulders, and neck. Composition head; blue lithographed metal sleep eyes, lashes; light brown mohair wig; open mouth showing teeth. Mark: on head, RELIABLE/ MADE IN CANADA. Original yellow Princess slip, socks and shoes, original badge, replaced hair ribbons. Author's collection.

CP2
Reliable. 1941-42. 18.5 in. (47 cm). Composition straight limbed, jointed hips, shoulders, and neck. Composition head; blue lithographed metal sleep eyes, lashes; blond mohair wig; open mouth showing teeth. Mark: on head, RELIABLE/MADE IN CANADA. Original blue and white cotton nurse's uniform, socks and shoes. From the collection of Judy Tomlinson Ross, Etobicoke, Ont.

BC13
Reliable. 1942-43. 19 in. (48 cm). Composition, straight limbed, jointed hips, shoulders, and neck. Composition head; blue lithographed metal sleep eyes, lashes; light brown mohair wig; open mouth showing teeth. Mark: on head, RELIABLE/MADE IN CANADA. Original blue cotton Princess slip with EATON'S BEAUTY ribbon. Original orange organdy party dress with white trim and white socks and shoes. From the collection of Margaret Hayes, Musquodoboit Harbour, N.S.

CP2

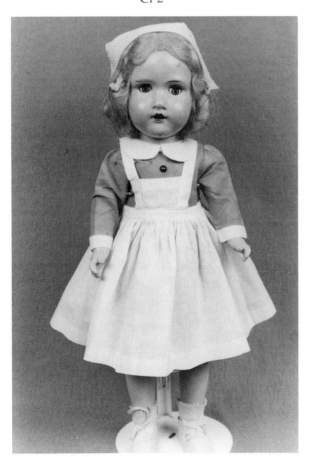

BC13

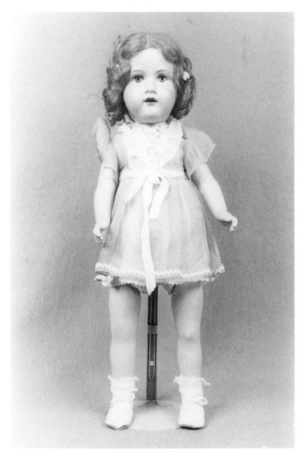

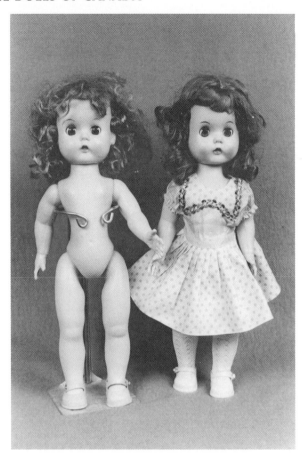

BS10

BS10
Roddy. 1958-59. Feature Value Doll (not an Eaton's Beauty). 13 in. (33 cm). Hard plastic walking doll, jointed hips, shoulders, and neck. Hard plastic head; blue sleep eyes, moulded lashes; auburn synthetic wig with bangs; closed mouth. Mark: on body, Roddy/Made in England. Original dress in dotted pink, replaced socks. This doll turns her head from side to side as she walks. From the collection of Wilma MacPherson, Mount Hope, Ont.

CA29
Dee an Cee. 1960. 18 in. (46 cm). Plastic toddler, jointed hips, shoulders, and neck. Vinyl head; brown sleep eyes, lashes, painted lower lashes; rooted brown curly hair; open mouth nurser. Mark: on head, 1960/EATON BEAUTY BY DEE & CEE, on body 2. Redressed in a white cotton dress, slip with panties attached. Originally wore a dress of flowered stiff taffeta, fitted bodice, Peter Pan collar with a pin stripe nylon pinafore over-dress, velvet tie, silk panties, socks and black plastic strap shoes. From the collection of Mrs. D.H. Morman, Victoria, B.C.

CP4
Regal. 1963. 21 in. (53.5 cm). Plastic body, jointed hips, shoulders, and neck. Vinyl head, blue sleep eyes, lashes, painted lower lashes, rooted blond saran curly hair, open mouth nurser. Mark: on head, REGAL/MADE IN CANADA. Redressed. From the collection of Judy Tomlinson Ross, Etobicoke, Ont.

CA29

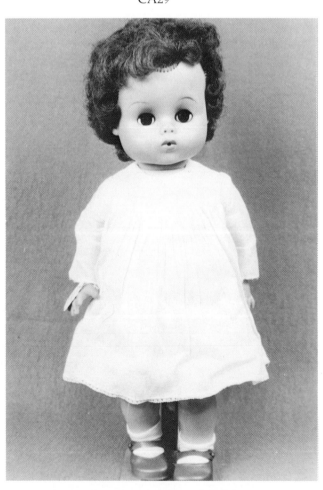

CP4

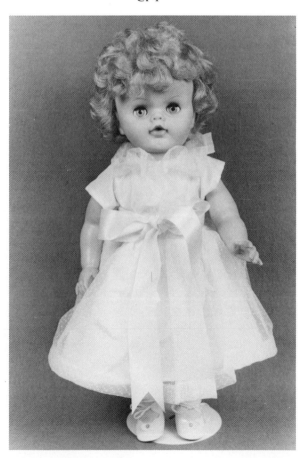

BQ11
Regal. 1964. 21 in. (53 cm). Plastic body, jointed hips, shoulders, and neck. Vinyl head; blue sleep eyes, lashes, painted lower lashes; rooted brown curls; open mouth nurser. Mark: on head, REGAL, on body, REGAL. Original red and white dress, hair ribbon, socks and bracelet. Original Eaton Beauty ribbon. Courtesy of the National Museums of Canada, National Museum of Man, Ottawa, Ont.

BZ15
Reliable. l965. 18 in. (45.5 cm). One piece Vinyl-flex stuffed body. Vinyl head; blue plastic sleep eyes, lashes, painted lower lashes; rooted brown saran hair; closed watermelon mouth. Mark: on head, RELIABLE/MADE IN CANADA. Original red corduroy playsuit, white felt shoes and original EATON Beauty heart shaped card. From the collection of K. Irene Campbell, Victoria, B.C.

CV12
Dorothy Churchill. 1978. 18 in. (45.5 cm). Fully jointed composition body. Bisque head; blue stationary eyes, lashes, painted upper and lower lashes; brown wig; open mouth showing teeth and tongue. Mark: on head, 47 of 100/E (inside a diamond) Dorothy Churchill. Original blue velvet suit, matching hat, white lace trimmed shirt, black shoes, original white ribbon with gold print. From the collection of Florence Langstaff, North Vancouver, B.C.

Note: This is the first bisque headed Eaton's Beauty doll in almost forty years. The artists who made the Eaton's Beauties between 1978 and 1984 used moulds from dolls first produced in Europe. The value of the Eaton's Beauty dolls made during this period lies in the fact that they are an authentic part of a long series of Eaton's Beauty dolls and, as such, are a valuable addition to a collection of Eaton's Beauty dolls.

BQ11

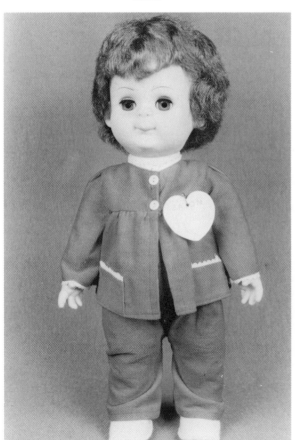

BZ15

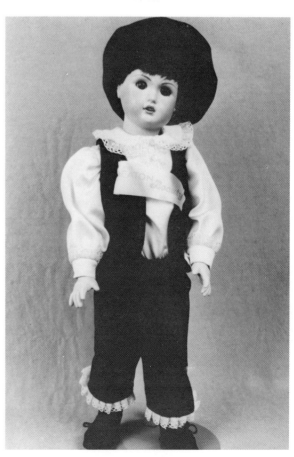

CV12

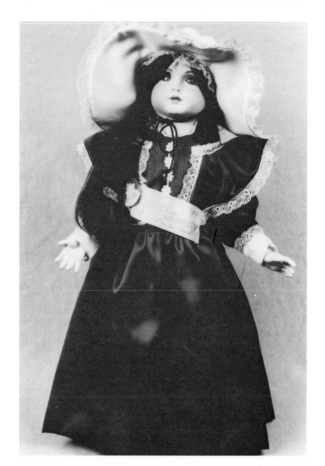

CV10
Dorothy Churchill. 1980. 20 in. (51 cm). Fully jointed composition body. Bisque head; stationary blue eyes, lashes, painted upper and lower lashes; long brown hair wig; open mouth, showing teeth and tongue. Mark: on head, Dorothy 1980/Churchill E (inside a diamond) 162. Original teal blue gown with lace trim, matching hat. Original white ribbon with gold print. From the collection of Florence Langstaff, North Vancouver, B.C.

CG35
Dorothy Churchill. 1981. 18 in. (45.5 cm). Ball-jointed composition body. Bisque head; stationary brown glass eyes, lashes and painted upper and lower lashes; human hair wig in ringlets; closed mouth. Mark: on head, Dorothy Churchill, a capital E inside a diamond, 79/1981. Original garnet red velvet coat with Eaton Beauty label inside, matching hat, mink muff. Also available with blue eyes and dressed in a blue coat. This is number 79 of a limited edition of 200. From the collection of Noreen King, Saskatoon, Sask. See also Fig. CG36.

CV10

CG35

CG36

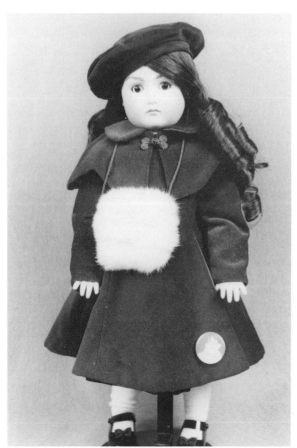

AP5

AP5
April Katz. 1983. GAIL KAREN. 17 in. (43 cm). All bisque, jointed hips, shoulders, and neck. Bisque head; stationary brown eyes, painted upper and lower lashes. Blond wig in long ringlets; closed mouth. Mark: on head, April Katz #60/Canada/1983; card bearing artist's signature. Original matching mauve moire coat, taffeta dress, slip and pantalettes, matching bonnet trimmed with a feather. Limited edition of 200. Author's collection.

CY1
April Katz. 1984. 17 in. (43 cm). All bisque body, jointed hips, shoulders, and neck. Bisque head; brown glass stationary eyes, painted upper and lower lashes; long black hair in ringlets; closed mouth. Mark: on head, 1984 Eaton Beauty/April Katz (in script) #250. Made from Steiner mould, SGDG/Paris. Original wine silk velvet coat and hat, fox fur muff, cream silk dress, lace trimmed slip and pantalettes, ice skates. Came with a pair of boots. Limited Edition of 250. Courtesy of April Katz, Toronto, Ont. See also Fig. CY3.

CY1

CY3

Chapter 7

CANADIAN CELEBRITY DOLLS

A Canadian Celebrity doll is one that is made to represent a well known Canadian. This group includes both celebrated sports figures and historical personages. It does not, however, include Canadian made dolls of celebrities from other countries, such as the Shirley Temple doll by Reliable Toy Co. Included, though, are dolls representing Canadians but manufactured outside of Canada, such as the Dionne Quintuplets and Wayne Gretsky. The important thing here is that the person to be honoured is a Canadian.

Canadian celebrity dolls is a field that has been much neglected by the dollmakers. Many collectors would enjoy collecting dolls of famous Canadians like our Prime Ministers of the past. It would be wonderful to have a doll of our first woman Governor General, Madame Sauvé. We could also have dolls of our two courageous cross-country runners, Terry Fox and Steve Fonyo. The list of Canadians who have distinguished themselves is extensive, and they deserve to be immortalized in doll form. Perhaps one day, soon, many of them will be created by Canadian doll artists to add to our meagre collection of Canadian celebrities.

BT1A
Madame Alexander. 1934. DIONNE QUINTUPLETS. 10 in. (25.5 cm). Composition bent-limb baby body, jointed hips, shoulders, and neck. Composition head; brown sleep eyes, lashes, painted lower lashes; brown moulded hair; closed mouth. Mark: on head, DIONNE/ALEXANDER; on body, MADAME ALEXANDER. Original organdy dresses in different pastel colours with their names embroidered on their bibs. From the collection of Wilma MacPherson, Mount Hope, Ont. See also Fig. BT0.

The DIONNE QUINTUPLETS were born in May 1934 at Callander, Ont. They were the first quintuplets to survive and they aroused the curiosity and fascination of millions. Madame Alexander Doll Co., in New York, was licensed to make Dionne Quintuplet dolls. Many other companies in a number of countries made sets of five dolls, but only the Madame Alexander dolls were allowed to use the family name on their dolls. Madame Alexander produced them in cloth before the moulds were available in 1934. They were manufactured in many sets for the next five years. The dolls were always dressed in five pastel colours with Yvonne wearing pink, Marie blue, Cecile green, Annette yellow, and Emilie in orchid.

BT1A

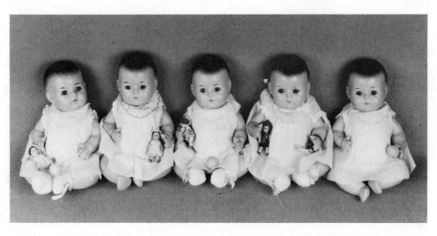

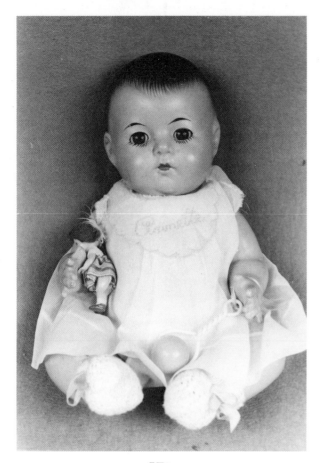

BT0

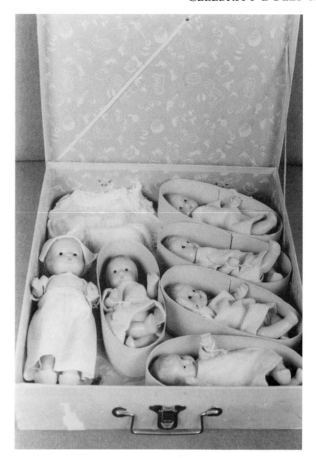

CE20

CE21
Superior. ca.1934. Quintuplets. Babies, 7 in. (17 cm); nurse, 10 in. (25.5 cm). Composition bent-limb baby bodies, jointed hips, shoulders, and neck. Nurse is straight limbed. Composition heads; babies, brown painted side-glancing eyes; nurse, black painted side-glancing eyes; light brown moulded hair; closed mouths. Mark: babies, on head, SUPERIOR; nurse, unmarked. Original clothing; babies, pink flannelette nighties, pink lace-trimmed cotton dresses, socks and towels; nurse, white cotton uniform and cap, socks and shoes. Original carrying case. From the collection of Gloria Kallis, Drayton Valley, Alta.

The Superior Mfg. company of Montréal is not known to have made dolls. It made toy housekeeping equipment. There has not been a toy company called Superior in the United States since 1922. They are, however, very good copies of Madame Alexander's 7.5 in. quints. See also Figs. CE20, CE23, CE25.

CE21

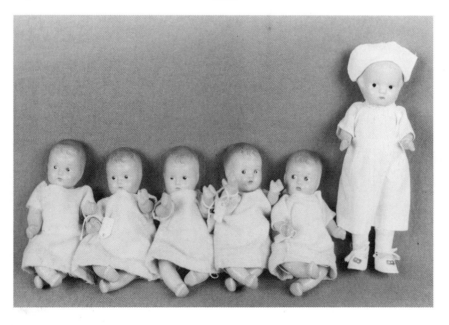

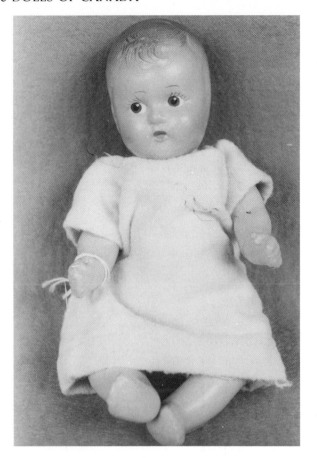

CE23

CE25

BW12

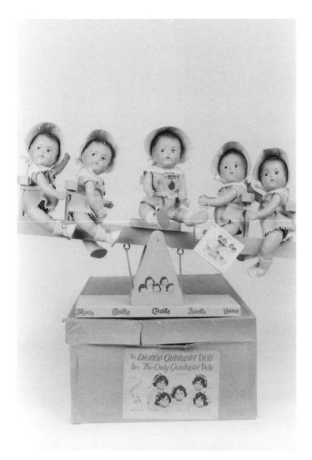

BW11

BW11
Madame Alexander. 1935. DIONNE QUINTUPLETS. 7.5 in. (18 cm). Composition bent-limb baby bodies, jointed hips, shoulders, and neck. Composition head; brown painted side-glancing eyes, painted upper lashes; brown moulded hair; closed mouth. Mark: on head, ALEXANDER; on back, ALEXANDER. Original sunsuits with matching bonnets, socks and shoes. Each doll has her original pin with her name tag. Each doll is dressed in her own pastel colour. The sunsuits are labelled genuine Dionne Quintuplets/Madame Alexander. Original teeter-totter with a seat for each doll with their names on the base. These dolls are in mint condition. They were packed away for many years and were never played with. From the collection of Mary Alice Thacker, Kanata, Ont. See also Fig. BW12 on Page 88.

BW8
Madame Alexander. 1936. DIONNE QUINTUPLETS. 16 in. (40.5 cm). Composition bodies, jointed hips, shoulders, and neck. Composition head; brown glassene eyes, lashes, painted lower lashes; brown human hair wigs; closed mouth. Mark: on body, ALEXANDER. Original cotton dresses and matching bonnets, socks and shoes. Each doll wearing her own colour dress and a metal pin with her name on it. From the collection of Mary Alice Thacker, Kanata, Ont. See Fig. BW10 and colour Fig.BW8.

BW8 BW10

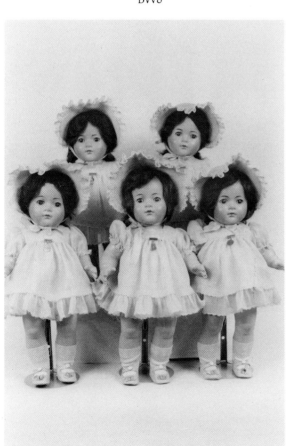

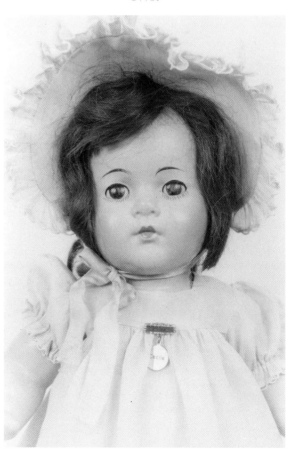

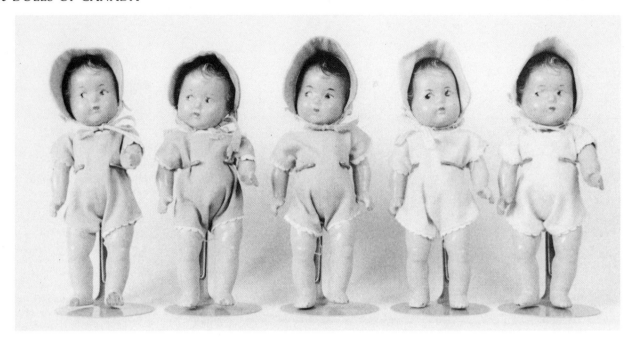

AB2

AB2
Madame Alexander. 1935. DIONNE QUINTUPLETS. 7.5 in.
(18 cm). Composition bodies, jointed hips, shoulders, and neck.
Composition head; brown painted side-glancing eyes, painted
upper lashes; brown moulded hair; closed mouth. Mark: on
head, ALEXANDER; on body, ALEXANDER. Original sunsuits
and matching bonnets in five different colours, labelled genuine
Dionne Quintuplets. From the collection of Mary Alice Thacker,
Kanata, Ont.

AM24

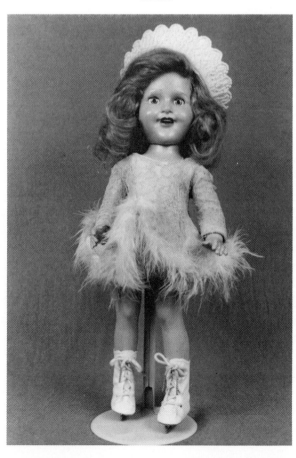

AM24
Reliable. 1948. BARBARA ANN SCOTT. 15 in. (38 cm).
Composition body, jointed hips, shoulders, and neck.
Composition head; blue sleep eyes, lashes; painted lower lashes
and brows; honey blond mohair wig; open smiling mouth
showing teeth. Mark: on head, RELIABLE/MADE IN
CANADA. Original blue lace skating costume trimmed with
maribou, pearl trimmed coronet, figure skates. Author's
collection. See also Fig. AM25.

BARBARA ANN SCOTT was born in Ottawa in 1929. She
won the Junior Figure Skating Championship of Canada in 1940;
Senior Championship of Canada in 1944-48; the North
American Championship in 1945-48; the European and the
World Championship in 1947-48. She won the Gold Medal at
St. Moritz at the Women's Olympic Champion Figure Skater
in 1948. She was awarded the Lou Marsh Memorial Trophy
for the year's outstanding sports competitor in 1945, 1947 and
1948.[1]

The BARBARA ANN SCOTT Doll was designed in the
United States by Bernard Lipfert, a well-known doll designer.
Reliable Toy Co. brought out the first doll in 1948 and made
her again each year until 1954. In 1953 the Barbara Ann doll
had a saran wig and was dressed in an embossed satin skating
costume with maribou trim and a matching poke bonnet. She
was dressed in a velveteen outfit with maribou trim and a
matching poke bonnet in 1954. Her wig was once again made
of saran. Barbara Ann Scott is Canada's most famous doll.

1. Canadian Encyclopedia

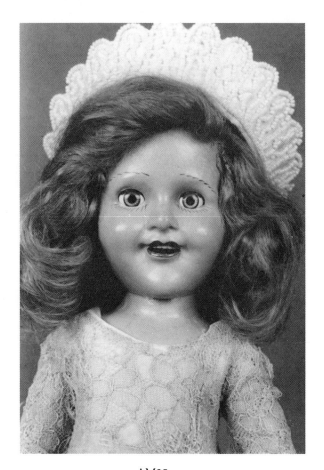

AM25

AP8

AP8
Reliable. 1949. BARBARA ANN SCOTT. 15 in. (38 cm). Composition body, jointed hips, shoulders, and neck. Composition head; blue sleep eyes, lashes, painted lower lashes, brows painted in separate strokes; blond mohair wig; open mouth, smiling and showing teeth. Mark: on head, RELIABLE/MADE IN CANADA. Original blue skating costume trimmed with maribou, matching headpiece and ice skates. From the collection of Dawn Young, Niagara Falls, Ont.

AW21

AW21
Reliable. 1950. BARBARA ANN SCOTT. 15 in. (38 cm). Composition body, jointed hips, shoulders, and neck. Composition head; blue sleep eyes, lashes, painted lower lashes and brows; honey blond saran wig; open smiling mouth showing teeth. Mark: on head, RELIABLE/MADE IN CANADA. Original tag. Original velveteen skating costume trimmed with maribou, matching hat, figure skates. Also shown in 1950 with a large brimmed velvet hat trimmed with maribou. From the collection of Mrs. D. Steele, Ottawa, Ont.

CA23

BQ1

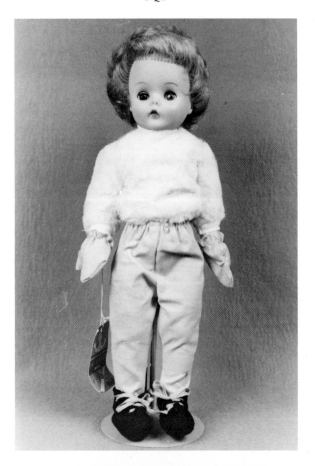

CA23
Reliable. 1951. BARBARA ANN SCOTT. 15 in. (38 cm). Composition body, jointed hips, shoulders, and neck. Composition head; blue sleep eyes, lashes, painted brows; honey blond mohair wig; open smiling mouth showing teeth. Mark: on head, RELIABLE/MADE IN CANADA. Original blue and gold skating costume with maribou trim, matching hat, figure skates. Original box. From the collection of Mrs. D.H. Morman, Victoria, B.C. See also Figs. CA24 and CG9.

CA24

CG9

Dear Little Friend:

I'm awfully proud and happy to have such a sweet doll named after me. I know the Reliable Toy Company has worked hard to make the Barbara Ann Scott Doll the kind of little friend you can play with happily for a long, long time to come. Did you know, too, that the sale of the Barbara Ann Scott Doll is helping little boys and girls who haven't as many privileges as we have?

I hope you will have lots and lots of fun with your very own Barbara Ann Scott Doll.

Love,

Barbara Ann Scott.

BQ1
Reliable. 1961. ANNE HEGGTVEIT. 16 in. (40.5 cm). Plastic body and legs, vinyl arms, jointed hips, shoulders, and neck. Vinyl head; blue sleep eyes, lashes, painted lower lashes; rooted blond saran hair; closed mouth. Mark: on body, RELIABLE/CANADA. Original tag, Canadian Olympic Ski Champion/Anne Heggtveit Doll. Made by/Reliable in Canada. Original short blue plush pullover, blue pants, mittens and black felt ski boots. White knit headband and miniature skis missing. Also available in a zippered print ski jacket, ski mitts, town and country ski slacks, ski boots, sunglasses, and miniature skis. Courtesy of National Museums of Canada, Ottawa, Ont.

ANNE HEGGTVEIT was born in Ottawa in 1939 and began skiing at the age of two. In 1954 she won the Holmenkollen Giant Slalom in Norway. In 1960 she won Canada's first Olympic gold medal for skiing in the slalom as well as the World Slalom and Alpine combined titles.[1]

1. Canadian Encyclopedia.

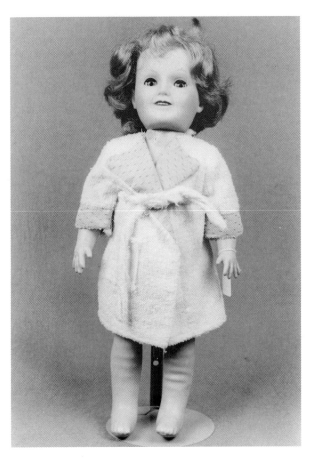

AP29A

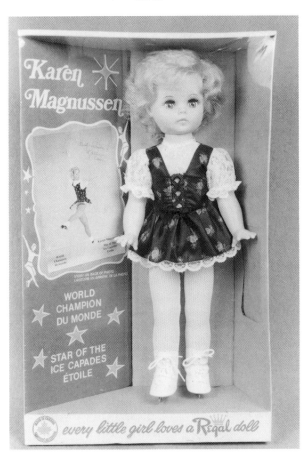

CD16

AP29A
Dee an Cee. 1954. MARILYN BELL. 16 in. (40.5 cm). One piece Skintex body. Vinyl head; blue sleep eyes, lashes, painted lower lashes; rooted blond curls; open-closed smiling mouth showing painted teeth. Mark: on head, MARILYN BELL/D&C TOY CO./1954. Original swimsuit and robe. From the collection of Geraldine Young, Niagara Falls, Ont.

The MARILYN BELL doll was designed in the United States and made by Dee an Cee Toy Co. in Toronto in 1954 to honour the swimmer who was the first person to swim across Lake Ontario. Marilyn Bell was a sixteen year old student who forced herself to keep swimming for 20 hours and 57 minutes to complete the crossing in waters of 65 degrees F.[1] There were no tall buildings such as the CN Tower by which she could maintain her orientation and, as a result, she actually swam about 40 miles, which is almost twice the width of the lake.

The swim had been arranged by the Canadian National Exhibition for the American swimmer Florence Chadwick to make the swim and land at the Exhibition grounds. She was to be paid ten thousand dollars for this feat. It was questioned in news editorials why a Canadian swimmer had not been asked. Marilyn Bell had done very well in the Atlantic City marathon, and the Toronto Star asked Marilyn to try the swim. Marilyn's answer was, "I'll swim for Canada." The American swimmer was pulled from the water suffering from sea sickness but Marilyn swam on to the finish.

Marilyn became a popular Canadian heroine in 1954. The doll was made of rubber so her young fans could make their Marilyn swim too. The doll was dressed in a swimsuit and dressing-gown and was a popular doll in her day. Because it was made of rubber, it has not always worn well and, consequently, Marilyn Bell dolls are hard to find today.

1. Toronto Star, Sept. 9, 1984.

CD16
Regal. 1974. KAREN MAGNUSSEN. 18 in. (45.5 cm). Plastic body, jointed hips, shoulders, and neck. Vinyl head; blue sleep eyes, lashes, eyeshadow; rooted blond curls; closed mouth. Mark: on head, REGAL TOY/MADE IN CANADA; on body, REGAL/CANADA/PAT. PEND.; dress tag, KAREN MAGNUSSEN, Made by REGAL TOY LTD. CANADA. Original skating dress, tights, and ice skates. Original box. KAREN was available in two different costumes. From the collection of Peggy Bryan, Burnaby, B.C.

KAREN MAGNUSSEN was born in North Vancouver in 1952. She won the Women's title in the Canadian Championships in 1968 and captured it again in 1970 after a painful bout with leg fractures. She held the title until 1973. She won the World Championship in Bratislave, Czechoslovakia in 1973, received the Velma Springstead Trophy as Canada's Outstanding Woman Athlete in 1971-73, and was awarded the Order of Canada in 1973.[1]

1. Canadian Encyclopedia.

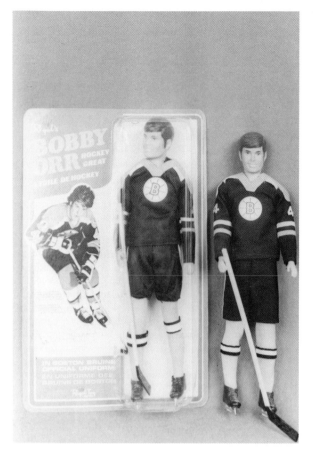

CF16

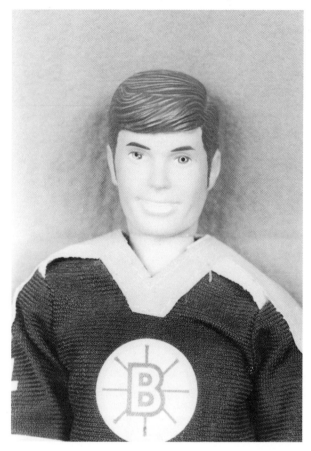

CF17

BP6

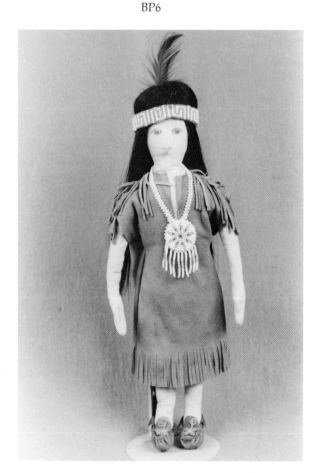

CF16
Regal. 1975. BOBBY ORR. 12 in. (30.5 cm). Plastic body, jointed hips, waist, shoulders, and neck. Vinyl head; blue painted eyes; brown moulded hair; open-closed mouth smiling, showing painted teeth. Mark: on body, MADE IN/HONG KONG. Original Boston Bruins uniform. In the original box. Also shown outside the box. Additional clothing was available. Boxed doll from the collection of Gloria Kallis, Drayton Valley, Alta. Doll beside the box and closeup picture of BOBBY ORR is from the collection of Margaret Rasmussen, Drayton Valley, Alta. See also Fig. CF17.

BOBBY ORR was born in Parry Sound, Ontario in 1948. He played hockey as a youth with the Oshawa Generals. He joined the Boston Bruins in 1967 at 18 years of age. He won the Calder Trophy. He was voted the greatest athlete in the history of Boston. He won the Hart Trophy in 1970, 1971 and 1972; the Conn Smythe Trophy in 1970 and 1972; and the James Norris Trophy for eight years, 1968- 1975.[1]

1. Canadian Encyclopedia.

BP6
Betty Hutchinson. 1979. PAULINE JOHNSON. (Tekahionwake). 17 in. (43 cm). Cloth body and head. Eyes drawn in ink; black human hair wig; closed painted mouth. Mark: on back, paper label. Leather dress and moccasins, beaded pendant and headband.

PAULINE JOHNSON, 1861-1913, daughter of a Mohawk chief and an Englishwoman, was known for her poetry celebrating her Indian heritage. From the collection of Betty Hutchinson, Ottawa, Ont.

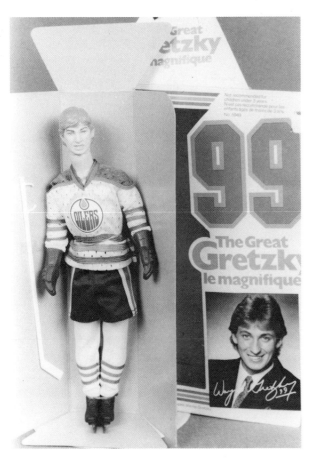

CS14A

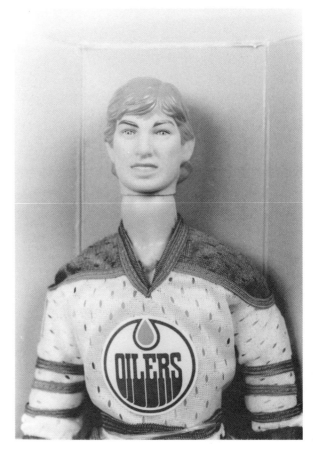

CY17

CS14A
Mattel. 1983. THE GREAT GRETSKY. 12 in. (30.5 cm). Plastic body, jointed hips, waist, shoulders, and neck. Vinyl head; painted blue eyes; blond moulded hair; open-closed mouth showing teeth. Mark: on body, MATTEL INC. 1983/TAIWAN. Original home uniform of the Edmonton Oilers; black skates, hockey stick. Available also: away from home uniform, tuxedo, and a jogging suit. Original box. Author's collection. See also Fig. CY17.

WAYNE GRETSKY, the famous Canadian hockey star, was born in Brantford, Ontario, in 1961. He played junior hockey for the Sault Ste. Marie Greyhounds, and in 1979 he joined the Edmonton Oilers. Winner of the Hart Trophy for most valuable player in the NHL every year since joining the league. He scored 50 goals in 39 games in the 81/82 season. He won the Art Ross Trophy four times. After five NHL seasons, Gretsky's 356 goals, 558 assists and 914 points placed him 21st among the all-time career point leaders and 5th among active players.[1]

1. Canadian Encyclopedia.

BP7
Betty Hutchinson. 1979. CATHERINE PARR TRAILL. 16 in. (40.5 cm). Cloth body, hands moulded by needle sculpture. Cloth head, moulded by needle scupture; embroidered features; brown human hair wig. Mark: on back, paper label. Handmade clothing, print dress, plaid shawl, bonnet. Carrying a wicker basket of plants. Wearing leather moccasins. Mrs. Traill wore moccasins made for her by an Indian woman for walking in the woods.

CATHERINE PARR TRAILL, 1802-1899, was one of the early settlers of the Peterborough region. She documented her pioneer struggles and published The Canadian Settlers Guide for immigrants. Mrs. Traill became noted as a naturalist and wrote several volumes on plant life in Upper Canada. From the collection of Betty Hutchinson, Ottawa, Ont.

BP7

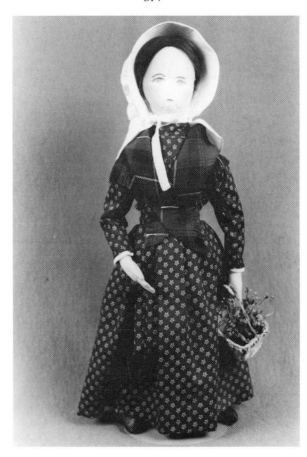

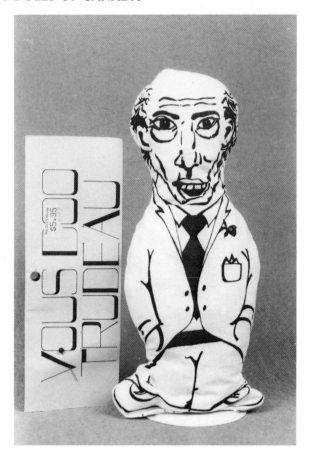

BM34

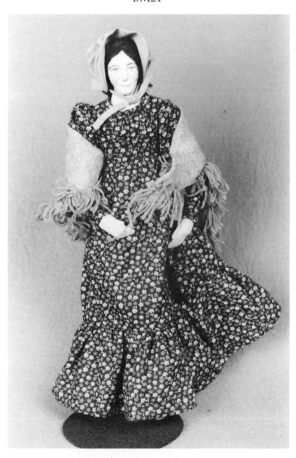

BM21

BM34
Voo Doo Doll Co. 1983. VOUS DOO TRUDEAU. 9 in. (23 cm). One piece stuffed cloth body and head. Printed features and clothing. Original label with instructions to put a spell on the doll. Includes a pin. From the collection of Irene Henderson, Winnipeg, Man.

BM22
1984. PHOEBE PARSONS. Cloth body, composition hands and feet. Painted bisque head; stationary blue eyes, painted lashes; blond mohair wig; closed mouth. Dressed in a dark print gown, white apron, cap, and armband. The doll was made in Germany but was dressed in 1984 to represent PHOEBE PARSONS in the Women at War exhibit at the Canadian War Museum. From the collection of Mrs. D. Steele, Ottawa, Ont.

PHOEBE PARSONS was one of the first four nurses to arrive from Winnipeg to nurse the wounded in the North West Rebellion in 1885. The nurses wore no specific uniform, just a plain print dress with a tea apron and Red Cross armband.

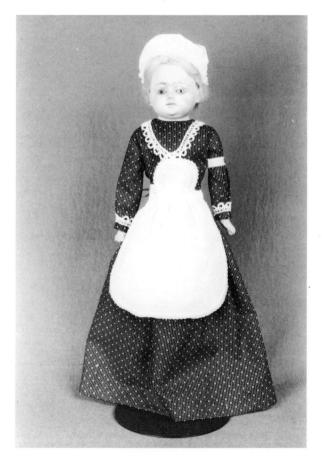

BM22

BM21
Kashi Carter. 1984. LAURA SECORD. 13 in. (33 cm). Wire and cloth body. Head and hands sculpted from Lewiscraft permaclay. Painted features; wool hair. Wearing a cotton print dress, bonnet and shawl. Created by Kashi Carter for the Women at War exhibit at the Canadian War Museum in 1984. From the collection of Mrs. D. Steele, Ottawa, Ont.

LAURA SECORD, heroine of the War of 1812, was born Laura Ingersoll in 1775. During the War of 1812 Laura walked 30 kilometers from Queenston, Ont., to Beaver Dam to warn the British officer, James FitzGibbon, that the Americans were planning to attack his outpost. Two days later, on the 24th of June 1813, the Americans were ambushed by Indians at Beaver Dam and surrendered to FitzGibbon.[1]

1. Canadian Encyclopedia

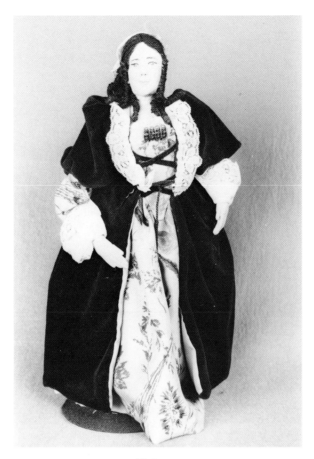

BM20

BM20
Kashi Carter. 1984. MADAME de LA TOUR. 14 in. (35.5 cm).
Wire and cloth body. Head and hands sculpted from Lewiscraft
permaclay. Painted features; wool hair. Brown velvet dress over
beige print, lace trim and lace cap. Created by Kashi Carter
for the Women at War exhibit at the Canadian War Museum
in 1984. From the collection of Mrs. D. Steele, Ottawa, Ont.

Francoise Marie de Saint-Étienne de la Tour was born in
France in 1602. Civil war raged in Acadia in 1640 when she
married Charles de Saint-Étienne de La Tour, one of the two
claimants to the colony's governorship. During her husband's
absence in 1645, she was in command of Fort La Tour at the
mouth of the St John River when it was attacked. Despite her
stout defence, her outnumbered forces were defeated and her
men were hanged by the victors.[1] She was known as the
Muskateer in Petticoats.

1. Canadian Encyclopedia.

Chapter 8

THE WORKING DOLL

Dolls are not just playthings. Since the earliest known civilizations, mankind has been using the doll figure to fill a variety of needs. Dolls were often used as fertility symbols, good luck charms, for ancestor worship, and in propitiatory ceremonies. They have been used in black magic and as voodoo dolls. Votive figures were used as religious offerings. Dolls can be used as a means to teach, persuade, frighten, comfort, educate, and demonstrate; and mankind has used the power of the doll to full effect. The working doll is as useful today as it has been throughout the ages. A working doll performs a function other than that of a plaything. But how is the working doll utilized today?

Business was quick to appreciate the value of a doll's persuasive power, and dolls have been chosen by many companies to advertise their product, or to put across a certain image. Think of the Campbell's Soup dolls. The CAMPBELL KID doll portrays a happy, healthy child with a perky, slightly mischievous, look. Surely, if your child eats Campbell's soup he or she too will be a happy rosy cheeked child; so the CAMPBELL KID doll and the soup have been popular for decades. If you feed your baby Gerber's baby food, will he be a dimpled beauty like the Gerber baby doll? The working doll gives us a happy message about a product and is very persuasive.

Churches have used dolls in their crèche scenes to represent Baby Jesus, and so the doll portrays in vivid three dimension, and with a moving message, the coming of the Christ child. In the Middle Ages, when the population could neither read or write, the Church could tell a story with small human figures that the people could understand. People still enjoy a crèche scene today.

In years gone by, information about religious orders was given to children via dolls. Many a child played with a nun doll given to her in the hope that she would be attracted to that vocation. We have no idea why the beautiful nun doll (Fig. BO1) was made. She is too well dressed to be a toy. Her habit is made of fine materials and her undergarments are sewn in precise detail. What was she used for? Perhaps she was a model for nuns making their habits. Perhaps she was a gift to a convent visitor.

Before the days of photography dolls were used by designers and dressmakers to show their wares so they could take orders for similar outfits. Roger Regor, a designer, used dolls to show the history of clothing. He made authentic clothing of many periods to show the changing fashions and the typical attire of historical figures. The mannikins in store windows are also a form of doll and are used to show the latest styles.

Organizations use dolls to encourage membership in their group. A doll dressed in the club's uniform adds glamour and makes the organization appealing, and perhaps stirs memories in those who were members when they were young (see Figs. CQ10 and CQ2).

Show business, always eager to utilize every possibility of adding glamour and fame, encourages the production of dolls representing television personalities. We have MOUSEKETEER dolls, HOWDY DOODY dolls, MARY HARTLINE, MARY MUGGINS, and many others. When radio was popularized, children became very familiar with the names of entertainers, which created a demand for personality dolls.

Patriotism makes use of dolls during wartime, when dolls are sold in the uniforms of the armed services and in nurse uniforms. Dolls are used to commemorate events such as the Queen's coronation, the birth of a Royal child, and the wedding of Prince Charles and Lady Diana.

There are also historical dolls designed to tell a story or to add realism to a story being told. Famous people

are represented by dolls in displays, libraries, and schools to encourage an interest in our history. The dolls made by Betty Hutchinson for display by the Anglican Church commemorate historical events in the Church, such as the first woman to be ordained, or Roberta E. Tilton, the founder of the Women's Auxillary of the Anglican Church.

Powerful use is made of the working doll as an exhibit. When the War Museum in Ottawa decided to have a large exhibition called Women at War, in 1984-85, to commemorate the Canadian women's role during wartime, they asked an Ottawa doll collector, Mrs. D. Steele, to put together a display of dolls. This was done using a group of dolls showing women's many roles. Five

dolls were dressed authentically as wartime nursing sisters. Civilian women were not forgotten, for Rosie the Riveter showed what thousands of women did during wartime. Volunteers were represented by the Salvation Army doughnut girl doll and by the St. Johns Ambulance nurse doll. The Women at War theme reached back into history to show dolls that represent Canadian heroines, such as Madeleine de Vercheres whose clothing was designed and made by Roger Regor (see Fig. BM25). Not to be forgotten was Jeanne Mance, Canada's first lay nurse and founder of Montréal's Hotel Dieu Hospital. The exhibit was educational and moving, and clearly demonstrated the roles that women have played in Canada's history. These dolls are working dolls.

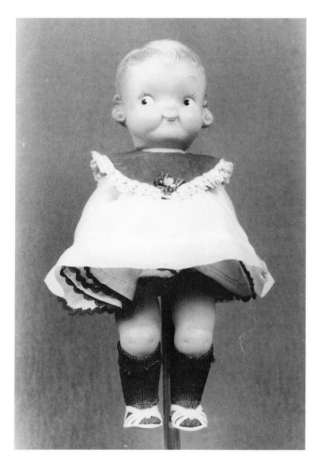

BM33

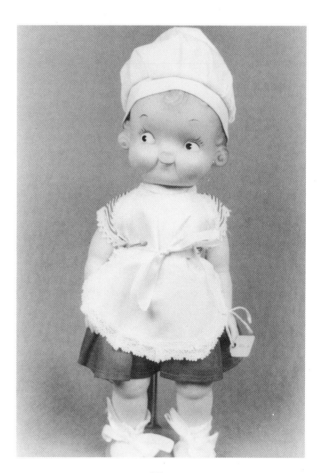

CF8

BM33
Reliable. ca.1954. CAMPBELL SOUP KID. 10 in. (25.5 cm). One piece vinyl body, jointed neck. Vinyl head; black painted side- glancing eyes, painted upper lashes; light brown moulded hair; closed watermelon mouth. Mark: on head, CAMPBELLS. Original red and white dress. Made on contract for the Campbell's Soup company: From the collection of Irene Henderson, Winnipeg, Man.

CF8
Reliable. ca.1962. CAMPBELL SOUP KID. 10 in. (25.5 cm). One piece vinyl body, jointed at neck. Vinyl head; black painted side-glancing eyes, painted upper lashes; brown moulded hair; closed watermelon mouth. Mark: on head, CAMPBELL/RELIABLE/MADE IN CANADA/10. Original red and white dress, apron, chef's hat, socks with ribbons. Did not come with shoes. From the collection of Gloria Kallis, Drayton Valley, Alta.

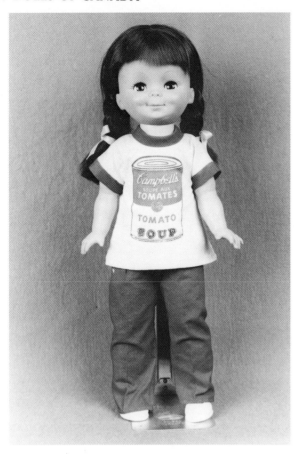

BX11

BX11
Regal. ca.1975. CAMPBELL SOUP DOLL. 18 in. (45.5 cm).
Plastic body, jointed hips, shoulders, and neck. Vinyl head;
brown sleep eyes, lashes, three painted upper lashes; rooted
black hair in braids and bangs; closed smiling mouth. Mark:
on head, REGAL TOY LTD./MADE IN CANADA/166 E.
Original red and white pant suit with Campbell's soup can on
the shirt. From the collection of Wilma MacPherson, Mount
Hope, Ont.

BN4
Viceroy. 1955. GERBER BABY. 12 in. (30.5 cm). All rubber
bent-limb baby body, jointed hips, shoulders and neck. Rubber
head with dimples; inset blue plastic eyes; detailed moulded hair;
open-mouth nurser. Mark: on body, A VICEROY/SUNRUCO
DOLL/MADE IN CANADA/Patent Pending. From the
collection of Irene Henderson, Winnipeg, Man. See also Fig.
BN6.

BN4

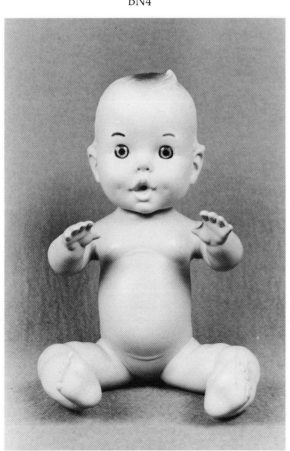

BN6

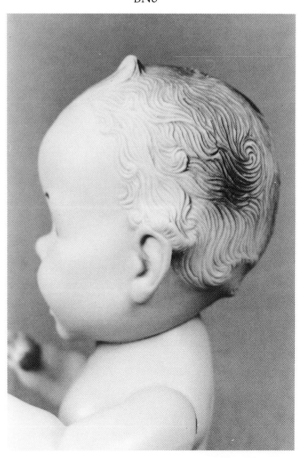

CD24

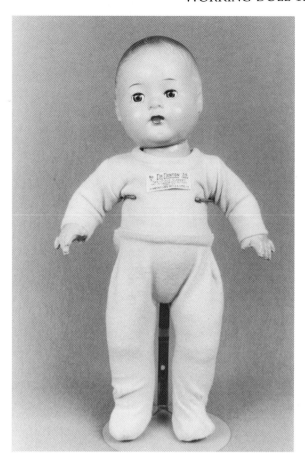

CD24
Unknown. ca.1938. DR. DENTON DOLL. 17 in. (43 cm).
Composition body, jointed hips, shoulders, and neck.
Composition head; brown sleep eyes, lashes, painted lower
lashes; brown moulded hair, closed mouth. Unmarked. Original
two piece blue sleepers with label marked, No./5/DR.
DENTON 34/INCH/TWO-PIECE SLEEPER/Pat. IN
CANADA DEC.8,1925/MADE BY/MERCURY MILLS LTD.
Probably a Reliable doll. From the collection of Peggy Bryan,
Burnaby, B.C.

BH19
Reliable. ca.1970. KATIE-CURAD. 17 in. (43 cm). Plastic teen
body, jointed hips, shoulders, and neck. Vinyl head; sleep eyes,
lashes, painted lower lashes; rooted blond curls; closed mouth.
Mark: on head, Reliable (in script); on body, Reliable (in script)
/MADE IN CANADA. Original white nurse's pant suit and cap.
From the collection of Rolande Strand, Eastern Passage, N.S.

CA16
Reliable. ca.1975. MISS WESTON. 14 in. (35.5 cm). Plastic
body and legs, vinyl arms, jointed hips, shoulders, and neck.
Vinyl head; blue sleep eyes, lashes, painted lower lashes; rooted
blond hair in ponytail and bangs; open-mouth nurser. Mark:
on head, RELIABLE/MADE IN CANADA. Original dress and
socks, original Miss Weston ribbon around waist, replaced
shoes. From the collection of Louise Rowbottom, Victoria, B.C.

BH19

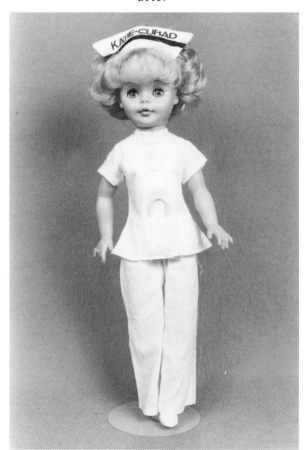

CA16

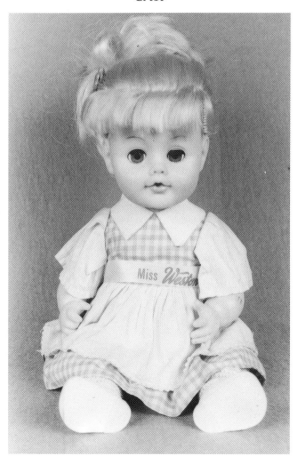

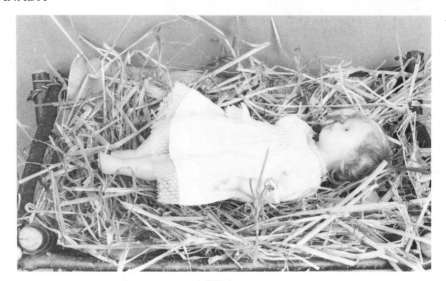

BF23

BF23
Unknown. ca.1955. CHRIST CHILD. 12.5 in. (32 cm). Cloth body, wax forearms and lower legs. Wax head; glass stationary eyes, eyelashes and eyebrows of inserted human hair; blond human hair glued on; closed mouth. Unmarked. Original clothing made by the Nuns of the Convent of the Good Shepherd. White georgette dress, lace-trimmed and honeycomb smocking at front waist; camisole, layers of lace; taffeta pantalettes trimmed with lace; muslin half-slip, divided in front. Unknown maker but probably made in Montréal for a church to use for a creche scene. From the collection of Barbara Murphy, Halifax, N.S.

BJ11
Nuns of Lac St. Jean, Québec. ca.1935. BABY JESUS. 8 in. (20.5 cm). Body and head of poured wax. Blue glass eyes; blond human hair; open-closed mouth. Unmarked. White cotton dress trimmed in lace. Lying in a manger. Used for the Christmas Christ child. From the collection of Rebecca Douglass, Dartmouth, N.S.

CH5
Reliable. ca.1955. MOUSEKETEER. 11 in. (28 cm). Vinyl body, jointed hips, shoulders, and neck. Vinyl head with mouse ears and bow moulded to the head; inset blue plastic side-glancirg eyes, painted upper lashes; brown moulded hair; open-closed smiling mouth. Mark: on head, RELIABLE. Moulded shirt and shorts, socks and shoes. Moulded Mickey Mouse Club label on shirt. From the collection of June Rennie, Saskatoon, Sask.

CH5

BJ11

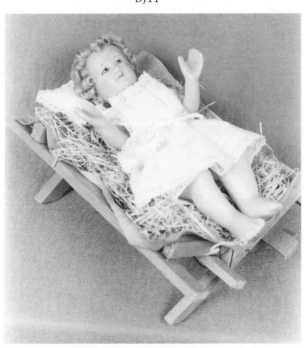

BO1

BO3A

BN9

BO1
Reliable. ca.1942. NUN. 19 in. (45.5 cm). Composition body, jointed hips, shoulders, and neck. Composition head; blue lithographed metal eyes, lashes; no hair; open mouth showing teeth. Mark: on head, RELIABLE/MADE IN CANADA. Original nun's costume, fine brown wool habit, cream linen cape, cotton wimple, leather sandals. Wearing a tiny rosary made in France. This doll is unusually well-dressed. The fabics are very good and the sewing is expertly done. Since she never had hair, she was undoubtedly bought to be dressed as a nun. She probably represents a missionary order because she is wearing sandals. From the collection of Irene Henderson, Winnipeg, Man. See also Fig. BO3A.

BN9
Reliable. 1958. YOUNG OLYMPIANS OF CANADA. 11 in. (28 cm). Hard plastic teen body, jointed shoulders and neck. Hard plastic head; blue sleep eyes, moulded lashes; blond mohair wig; closed mouth. Mark: on back, RELIABLE/PAT. 1958. Original ski suit with label on the chest, skis and poles. Original medal, YOUNG OLYMPIANS OF CANADA. JEUNES OLYMPIENS DU CANADA. From the collection of Irene Henderson, Winnipeg, Man.

CQ10

CQ2

BN19

CQ10
Unknown. Date Unknown. CANADIAN GIRL IN TRAINING.
15 in. (38 cm). Ball-jointed composition body, jointed knees,
hips, shoulders, elbows, and neck. Bisque head; blue glass eyes,
painted upper and lower lashes; blond wig; open mouth showing
teeth. Mark: 8/0. European doll dressed as a CANADIAN GIRL
IN TRAINING. Courtesy of the Bowmanville Museum,
Bowmanville, Ont.

CQ2
Ideal. ca.1975. PIONEER GIRL. 19 in. (48.5 cm). Plastic teen
body, jointed hips, shoulders, and neck. Vinyl head; blue sleep
eyes, lashes, painted upper and lower lashes; rooted black hair;
closed mouth. Redressed as a PIONEER GIRL. Courtesy of the
Bowmanville Museum, Bowmanville, Ont.

BN19
Beau Sol. 1980. CANADIAN GIRL GUIDE. 12 in. (30.5 cm).
Cloth body and head. Embroidered features; wool hair.
Unmarked. Original Girl Guide uniform. Made in the
Philippines for sale in Canada. From the collection of Irene
Henderson, Winnipeg, Man.

BV10

XH20

BV10
Ann Marie Badgley. 1984. BICENTENNIAL MISS NEW BRUNSWICK. 14 in. (35.5 cm). All bisque body, jointed hips, shoulders, and neck. Bisque head; stationary blue glass puppenaugen paperweight eyes; dark brown synthetic wig; closed mouth. Mark: on head, Bru J Ann Marie '84. Gown is in plum satin, trimmed with white cotton eyelet, covered buttons, and wearing a matching hat. Undergarments are lace-trimmed batiste, white lace stockings and black patent shoes. Photograph courtesy of the Harvey Studios Ltd., Fredericton, N.B.

Ann Marie Badgley (nee De Long) was born in Hartland, N.B. In 1980 she began working in ceramics. Although she made ceramic dolls, she was not entirely satisfied. She tried porcelain and was pleased with the results. She began taking Seeley courses with Marie Ashby of Maine, and she attained her Professional Dollmakers Certificate. She began entering her dolls in shows and won many first and second place ribbons.

When Mrs. Badgley heard about the forthcoming visit of Queen Elizabeth II to New Brunswick, she decided to make a special doll as a gift to the Queen.

The doll she made represents the Bicentennial Miss New Brunswick, Miss Brenda Durette, and will be a lasting reminder of the Queen's 1984 visit to Canada. After the presentation was made, Mrs. Badgley was told that the doll will be kept at Windsor Castle.

XH20
Norma Sayles. 1984. Bru Shandele. 24 in. (61 cm). Cloth body, porcelain arms, hands, and feet. Bisque head, June 11 Bru mold by Seeley; pre-war hazel glass eyes; blond wig styled in an upsweep, with side ringlets and long ringlets in the back and small curls around the face; closed mouth, pale pompador red outlined with dark pompador. Mark: on head, Jun 11, Norma Sayles/R.R. # 1/Mt. Pleasant, Ontario, July 5, 1984 ; on shoulderplate inscribed in gold, Presented to Her Majesty Queen Elizabeth II, in Commemoration of Ontario's Bicentenary, July 20, 1984, Council of the County of Brant. Dressed in fine embossed ecru cotton undergarments, including a bustle, pure silk taffeta dress, ivory with long train with gathered antique lace around the bottom. Fitted jacket, burgundy satin trimmed with antique lace and satin ribbon, rhinestone pin closing the jacket and her hat pin are antiques. Matching burgundy satin and lace hat with flowers and baby's breath trim. Clothing completely designed and hand made by Norma Sayles.

Brant County Council decided to give the Queen a one-of-a-kind bisque doll after seeing Mrs. Sayles collection of beautiful dolls. Knowing that the Queen had an extensive collection of dolls they felt a doll would be a very appropriate gift to commemorate Ontario's Bicentennial.

Mrs. Sayles makes reproduction dolls but does not make two alike. She enjoys making beautiful dolls which can be enjoyed by others just as they bring pleasure to her. The wooden stand with an engraved brass plaque, displaying the doll, was made by Norma's husband Ed. It was made from walnut wood obtained from a tree cut 60 years ago by Norma's father and grandfather on the family homestead in Oakland Township.

AR5A
Betty Hutchinson. 1984. SISTER JULIANA and SARAH SIMON. 15 in. (38 cm). Cloth body, bisque hands and feet. Bisque head; painted eyes; mohair wigs; closed mouths. In a red snow suit, Sister Juliana, Sisters of the CHURCH, 1929. In a cotton print dress over a parka trimmed in fur, Sarah Simon, Clergywife and Loucheux Indian, member of Anglican Church's Council on Native Affairs. Courtesy of the Anglican Church of Canada.

AR6A
Betty Hutchinson. 1984. SARAH ANN STRINGER and EVA HASELL. 15 in. (38 cm). Cloth body, bisque hands and feet. Bisque head; painted eyes; mohair wigs; closed mouths. In a long skirt knitted hat and muffler, Sarah Ann Stringer, Clergywife in Rupert's Land, 1869-1955. In a suit and floppy hat, Eva Hasell, who began the Sunday School Caravan Mission in 1920. Courtesy of the Anglican Church of Canada.

AR3
Betty Hutchinson. 1984. SISTER HANAH and MARGUERITA FOWLER. 15 in. (38 cm). Cloth body, bisque hands and feet. Bisque head; painted eyes; mohair wig; closed mouth. In a black habit, Sister Hanah, Foundress of the Sisterhood of St. John the Divine, 1884. In a short blue habit, Marguerita Fowler, OBE, Foundress of St. Faith's Bishop's Messengers, 1928. Courtesy of the Anglican Church of Canada.

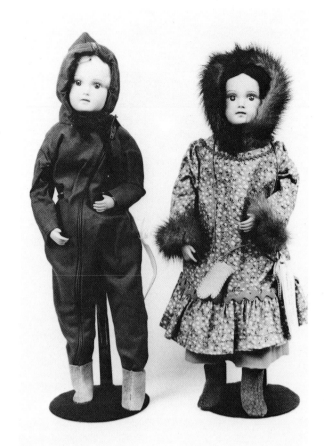

AR5A

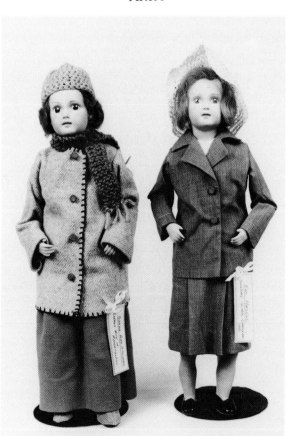

AR6A

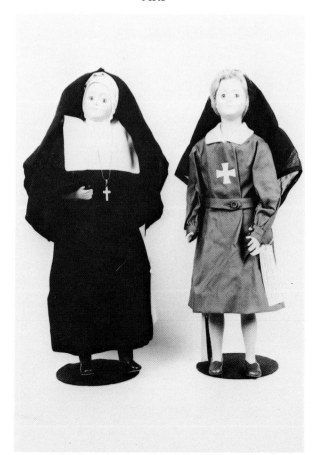

AR3

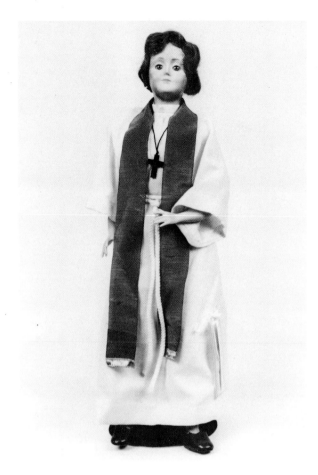

AR9A

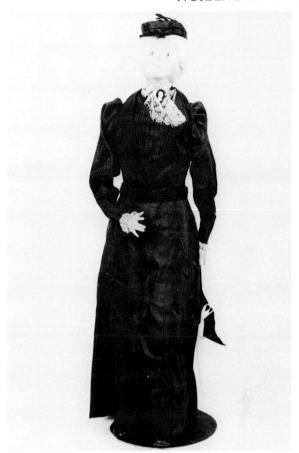

AR8A

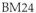
BM24

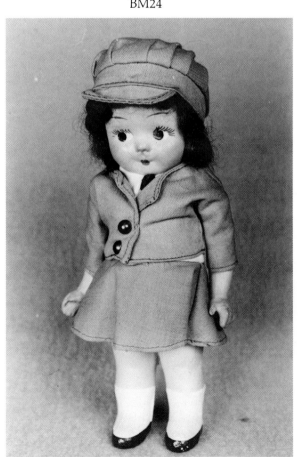

AR9A
Betty Hutchinson. 1984. CLERGYWOMAN. 15 in. (38 cm).
Cloth body, bisque hands and feet. Bisque head; painted eyes;
mohair wig; closed mouth. Dressed in a white alb with green
stole. The Anglican Church of Canada first ordained women
in 1976. Courtesy of the Anglican Church of Canada.

AR8A
Betty Hutchinson. 1984. ROBERTA E. TILTON. 15 in. (38 cm).
Cloth body, bisque hands and feet. Bisque head; painted eyes;
mohair wig; closed mouth. Dressed in a black gown in a 1885
style. Roberta E. Tilton founded the Women's Auxillary of the
Anglican Church of Canada in 1885. Courtesy of the Anglican
Church of Canada.

BM24
Reliable. ca.1943. 8 in. (20.5 cm). Composition body and head,
jointed shoulders. Painted side-glancing eyes; mohair wig, closed
mouth. Mark: on body, RELIABLE/MADE IN/CANADA.
Original army uniform, moulded painted shoes and socks. Sold
as a play doll dressed as female army personnel during World
War II. Part of the Women at War Exhibit. Courtesy of the
War Museum. From the collection of Mrs. D. Steele, Ottawa,
Ont.

BM23
Unknown. ca.1943. ST. JOHN'S AMBULANCE NURSE. 16 in.
(40.5 cm). Composition body, jointed hips, shoulders, and neck.
Composition head; sleep eyes, painted lower lashes; blond
mohair wig; closed mouth. Authentic grey dress, white apron,
white headdress, black shoes and stockings, St. John's emblem
on the bib and headdress. From the Women at War Exhibit.
Courtesy of the War Museum and St. John's Ambulance,
Ottawa, Ont. From the collection of Mrs. D. Steele, Ottawa,
Ont.

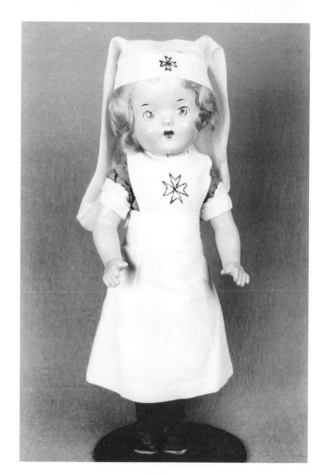

BM23

BM17

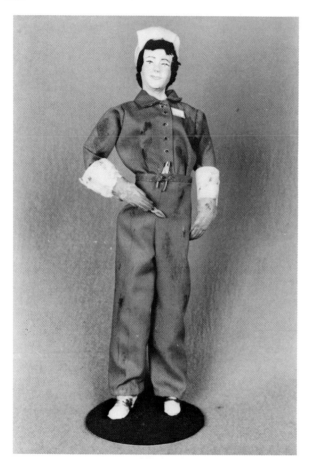

BM19

BM19
Kashi Carter. 1984. ROSIE the RIVETER. Cloth and wire body.
Permaclay head; painted features. Dressed in overalls, saddle
shoes, gloves, and head scarf. Rosie commemorates those
women who worked in munitions factories during World Wars
I and II. Part of the Women at War Exhibit. Courtesy of the
War Museum. From the collection of Mrs. D. Steele, Ottawa,
Ont.

BM17
Kashi Carter. 1984. KIT COLEMAN. 13 in. (33 cm). Cloth and
wire body. Lewiscraft permaclay head and hands. Painted
features; wool hair. Dressed in an 1898 style black skirt, striped
blouse, straw hat, and carrying a book and pencil. Kit Coleman
was a weekly columnist for the Toronto Mail and Empire
newspaper. She covered the World Columbian Exposition in
Chicago and went to England to cover Queen Victoria's
Diamond Jubilee celebration. She covered the Spanish-American
War of 1898, and was not only history's first accredited woman
war correspondent but was the first woman correspondent to
get to the firing line. She helped found the Canadian Women's
Press Club and was the first president. Courtesy of the Canadian
War Museum. From the collection of Mrs. D. Steele, Ottawa,
Ont.

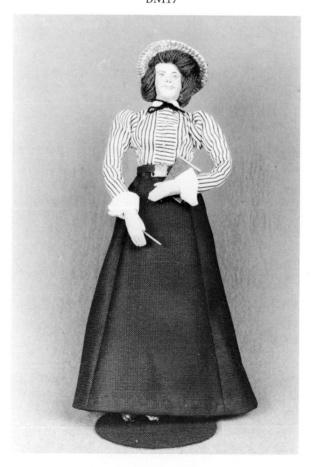

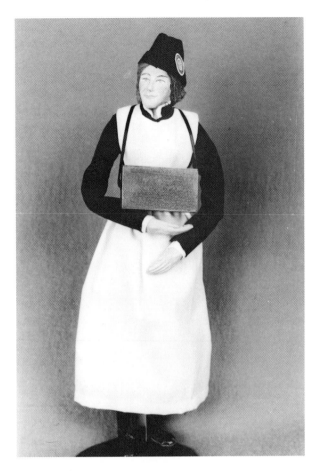

BM18

BM26

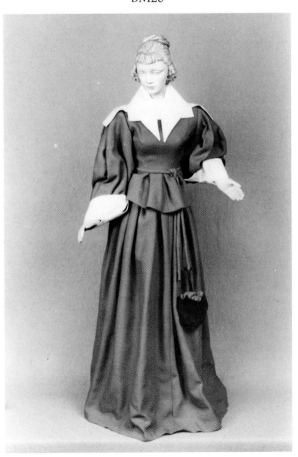

BM18
Kashi Carter. 1984. SALVATION ARMY VOLUNTEER. Cloth and wire body. Permaclay head; painted features. Dressed in authentic black dress, white apron, black hat with the Salvation Army emblem. Salvation Army Volunteers operated food huts in front line camps during World War I. They were known as Doughnut Girls. Part of the Women at War Exhibit. Courtesy of the War Museum of Canada. From the collection of Mrs. D. Steele, Ottawa, Ont.

BM26
Roger Regor. Date unknown. JEANNE MANCE. 32 in. (81 cm). Composition body; jointed shoulders. Composition head; moulded blond hair. Dressed in authentic long brown suit, cream collar and cuffs, bag hanging from belt. Gown designed by Roger Regor. It is unknown who made the figure. Jeanne Mance, 1606-1673 was the first lay nurse in the New World. She cared for colonists injured in conflicts with the Indians. Founder of Montréal's Hotel Dieu Hospital. Part of the Women at War Exhibit. Courtesy of the War Museum of Canada. From the collection of Mrs. D. Steele, Ottawa, Ont.

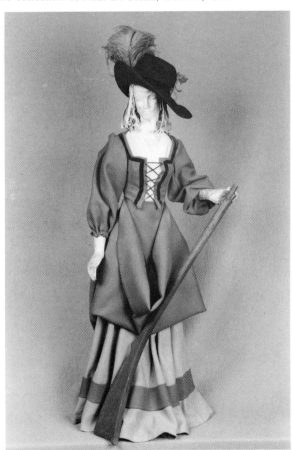

BM25

BM25
Roger Regor. Date unknown. MADELEINE de VERCHÈRES. 32 in. (81.5 cm). Papier-mâché body and head with moulded features. Authentic brown and grey long gown with overskirt, laced vest, cream blouse, felt hat with plume and carrying a wooden rifle. Clothing designed by Roger Regor. Unknown who made the figure. Marie-Madeleine Jarret de Verchères, 1678-1747 was born on her father's seigneury twenty miles below Montréal, Qué. In 1692, when her parents were absent, a band of marauding Indians appeared at the fort. Madeleine took command, and with her two young brothers, two soldiers, and an old man of eighty, defended the fort until relief came from Montréal a week later. From the Women at War Exhibit. Courtesy of the War Museum of Canada. From the collection of Mrs. D. Steele, Ottawa, Ont.

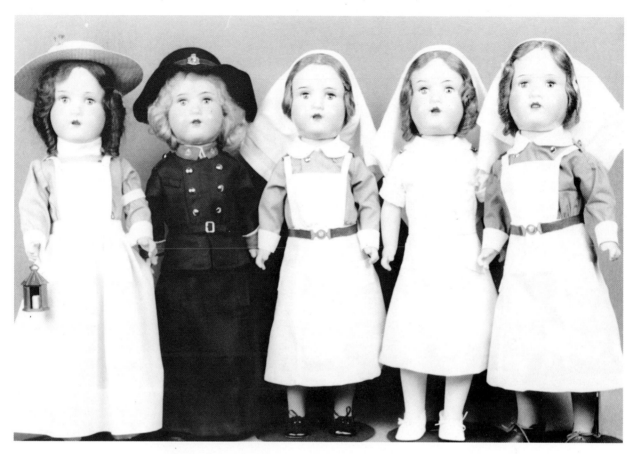

BM15

BM15
Reliable. ca.1940. Canadian Nursing Sisters. 19 in. (48.5 cm).
All composition, jointed hips, shoulders, and necks. Blue sleep
eyes, eyelashes; mohair wigs; open mouths and inset teeth.
Mark: on heads, RELIABLE/MADE IN CANADA. Dressed in
1984 in authentic uniforms to commemorate the nurses who
served with the Canadian Armed Services during wartime.
Courtesy of The Canadian War Museum. From the collection
of Mrs. D. Steele, Ottawa, Ont.
From left to right:
Canadian Army Nursing service. Nursing sister in working
uniform, South African War, 1899-1902.
Canadian Army Medical Corps. Nursing sister in dress uniform,
World War I, 1914-1918.
Royal Canadian Navy. Nursing sister in working dress, World
War II, 1939-1945.
Royal Canadian Air Force. Nursing sister in working dress,
World War II, 1939-1945.
Royal Canadian Army Medical Corps. Nursing sister in working
dress, World War II, 1939-1945. See also Figs. BM8, BM9,
BM10, BM11, and BM12 in colour.

The authentic costuming for the nursing sisters was done by
Dorothy McCleave; Betty Hutchinson made the shoes and hats;
Al Evans made the miniature brass pieces on the uniforms; and
Audrey Kellan made the tiny needlepoint badges. Mrs. D. Steele
did the research.

Chapter 9

CANADIAN PAPER DOLLS

Paper dolls are an old concept. They were first made in the mid-seventeenth century in Germany. They were used by fashionable women who were interested in the styles of the day. Some of the early paper dolls had extensive wardrobes that pictured many accessories including shoes and gloves as well as handbags and umbrellas. Late in the nineteenth century the manufacturers began making child paper dolls and, in the 1890s, advertising paper dolls appeared.

At the Canadian Toy Show in Montreal in 1961, 1966, and 1969, the Copp Clark Publishing Co. Ltd. was listed as showing paper dolls. We have not been able to find any of these in collections across Canada.

A notable Canadian paper doll product of late was the book called The P.E.T. Paperdoll Dress-up Book (see Fig. AE18) by Graham Pilsworth, published by Key Porter Books in 1982. The P.E.T. stands for Pierre Elliott Trudeau, the former Prime Minister of Canada. The illustrations in this dress-up book depict Trudeau in satirical regional costumes.

Popular paper dolls in the nineteen-eighties were those featuring Princess Diana. Some of them accurately portray the fashions the Princess has worn. Most of these paper dolls, however, were not made in Canada.

An interesting addition to a Canadian collection is the sheet of paper dolls showing one of Carmen Vair's dolls with accurate drawings of the clothing designed and made by her.

In spite of the temptation to cut out the clothing and try them on the dolls, serious paper doll collectors leave the sheets uncut. Sheets left in their original condition can be stored more easily and remain in good condition longer. They are also more valuable to the next buyer.

Canada has produced cutouts, or paper dolls, over the years, however, very few of these have reappeared on the market today. Collectors seem to be scattered evenly across the country and are not in any particular age group. Paper doll collecting is not very popular yet in Canada, although it is in Europe and the United States.

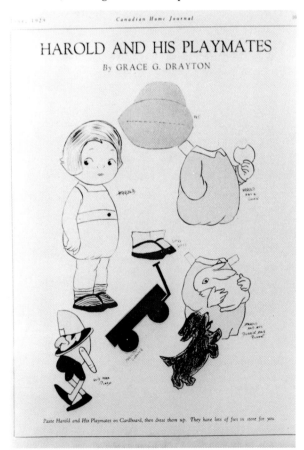

XH3

XH3
Canadian Home Journal. 1929. HAROLD AND HIS PLAYMATES. By Grace G. Drayton, from the Canadian Home Journal, June 1929. From the collection of Rebecca Douglass, Dartmouth, N.S.

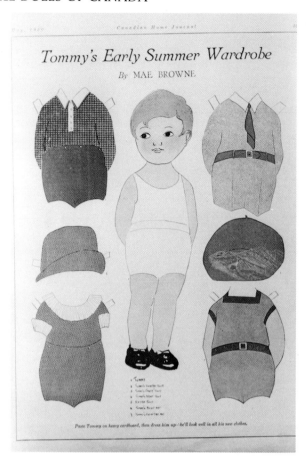

XH2

XH2
Canadian Home Journal. 1930. TOMMY'S EARLY SUMMER WARDROBE. By Mae Browne, from the Canadian Home Journal, May 1930. From the collection of Rebecca Douglass, Dartmouth, N.S.

XH5
Canadian Home Journal. 1932. MARY LOU'S COUSIN ANN. By Lydia Fraser, from the Canadian Home Journal, Jan. 1932. From the collection of Rebecca Douglass, Dartmouth, N.S.

DA5
Canadian Home Journal. 1933. MARY LOU'S COUSIN ANN. By Lydia Fraser, from the Canadian Home Journal, Nov. 1933. From the collection of Rebecca Douglass, Dartmouth, N.S.

XH5

DA5

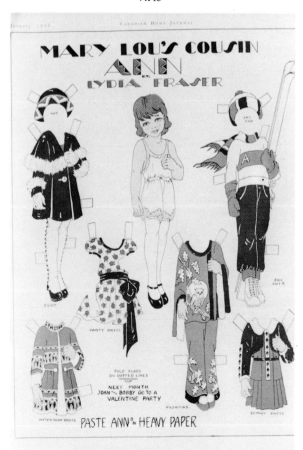

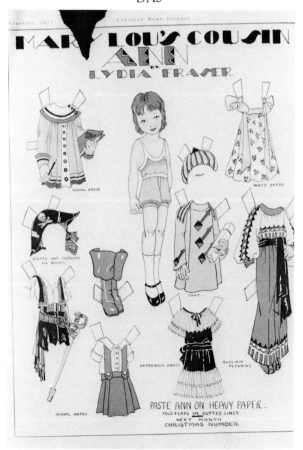

BO50

BO50
Billings Estate. ca.1980. 1835 CUTOUT DOLL. 8.5 x 14 in. (21.5 x 35.5 cm). Doll and typical clothing worn in 1835 described in English and French. Illustrated by Kay Irvine. From the collection of Irene Henderson, Winnipeg, Man. See also Fig. BO51.

CC22
Unknown. ca.1960. MISS MUFFET. 31 in. (79 cm). Cardboard doll, three dresses, and a coat. From the collection of Mrs. D.H. Morman, Victoria, B.C.

BO51

CC22

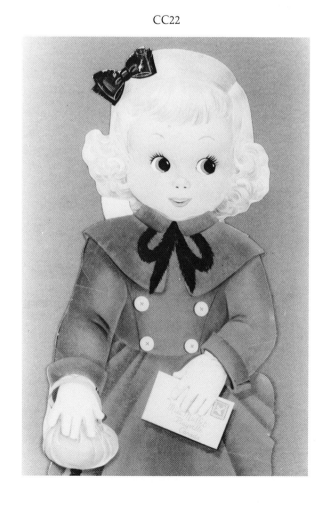

AE18

AE20

AE18
Graham Pilsworth. 1982. THE P.E.T. PAPERDOLL DRESS-UP BOOK. 9 x 12 in. (23 x 30.5 cm). Published by Key Porter Books Limited, Toronto, Ont. From the collection of Judy Smith, Ottawa, Ont. See also Figs. AE20, AE21, and AE23.

AE21

AE23

BV18

BV18
Carmen Vair. 1984. NATIVE DOLL. One sheet, 11.5 x 17.5
in. (29.5 x 44 cm). The doll illustrates the cloth dolls made by
Carmen Vair and shows the many items of clothing that her
dolls wear. Illustrated by Fran Tyrer. It would be wonderful
to see more of these. Author's collection.

Chapter 10

COMMERCIAL DOLLS OF THE TWENTIETH CENTURY

The commercial doll manufacturing industry began in Canada as the direct result of demand. At the start of the twentieth century dolls were being imported from Europe in ever increasing numbers. Nerlichs and Company, wholesalers in Toronto, put out a catalogue in 1902 that listed dozens of imported dolls for sale. They were bringing in all-bisque dolls, dolls with bisque heads and leather bodies, and dolls with bisque heads and composition bodies, as well as composition, rubber, and celluloid dolls for the market in Canada. As toy firms in the United States began expanding, dolls were imported from that source too. It was only a matter of time before a company was formed in Canada to manufacture dolls commercially.

Dominion Toy Manufacturing Company was established in Toronto, Ontario, in 1911, and began making character dolls, teddy bears, and cowboy and Indian suits. From that time on there was a proliferation of toy companies in the country. Many disappeared after a few years. The following is a list of some early Canadian commercial doll companies.

1917
Standard Toys Ltd.
Bowmanville, Ont.

Commercial Toy
Toronto, Ont.

Florentine Statuary
Toronto, Ont.

1919
Bisco Doll
Toronto, Ont.

Brophy Doll Co. Ltd.
Toronto, Ont.

1920
Reliable Toy Co.
Toronto, Ont.

Victoria Doll and
Toy Mfg. Co. Ltd.
Victoriaville, Qué.

Bruyere Toy Mfg.Co. Ltd.
Montréal, Qué.

1922
Standard Toy Mfg. Co.
Alliston, Ont.

Smith Doll and Toy Co. Ltd.
Dunnville, Ont.

1923
Canadian Toy and Novelty Co.
Montréal, Qué.

High-grade Doll Mfg. Co.
Montréal, Qué.

Standard Toy Co.
Hamilton, Ont.

1925
Lloyd-Harlan Toy Co. Ltd.
Toronto Ont.

1927
The French Art Doll Mfg. Co.
Toronto, Ont.

In 1926, Lloyd-Harlan Toy Co. Ltd. changed their name to Lloyd Toy Co. Ltd. In 1927, their advertisement proclaimed that they were manufacturers of Lloyd's

patented MAMA dolls, baby dolls, and novelty dolls.

Some of these companies were in business only a year or two, and others made dolls for ten or fifteen years. There was also an intriguing Miss. Frances Noe of Ingersoll, Ontario, listed as a toy manufacturer for a number of years. But it is unclear what kind of toys or dolls she made.

Most dolls in Canada came from Europe before World War I. Germany was able to produce dolls with bisque heads and china heads so cheaply and so well that competition was extremely difficult. Soloman Hoffman's idea of making composition with a base of wood pulp was new in 1892, when he began manufacturing the "can't-break-em" composition dolls in Germany. Composition before that date was made with a paper paste base pressed into hollow moulds. It is sometimes referred to as papier-mâché. This method of doll making was described as early as 1567 by Philibert Délorme in his Traite d'Architecture.

During and after World War I, when the supply of German dolls was cut off, at least three and possibly four companies in Canada produced bisque headed dolls for the national market. The bisque was rather coarse and thicker than European bisque. Commercial Toy was in business only a year. They manufactured a doll with a bisque head in 1917. The Bisco Doll Company produced bisque headed dolls from 1918 to 1920. And, C&W Doll Co. operated from 1919 to 1920. They made a shoulderhead doll, but it is unknown if the body was leatherette or cloth. There was also the mysterious company with a mark of CLS on the head, but no company in the twentieth century has been identified with these initials. There was no potter or pottery registered with these initials after 1900. So it remains a task for further reseach.

Character dolls were developed after 1910, as naturalness became the keynote of the twentieth century. The new wood pulp composition was the perfect medium to create character dolls. The new composition dolls received a terrific boost in popularity during World War I, when it was fashionable to buy things made in Canada. This trend to manufacture dolls in Canada continued after the war. Some of the labour supply to support this industry came from Canadian soldiers returning home. Eaton's department store catalogue used a maple leaf beside the pictures of dolls made in Canada to encourage parents to buy Canadian.

Composition dolls increased in popularity in the nineteen-twenties with the introduction of the mama voice box. This voice box was enclosed in the stuffed cloth body of each doll. The voice box would cry "mama" every time the doll was tilted or raised from a sleeping position. For the next thirty years, the mama doll was a favourite one for many little girls. It was offered in every size up to a life-sized doll. Less expensive versions had cloth legs, while the most expensive dolls had composition arms and legs plus a mohair wig. Some were very cheaply and simply dressed; others had elaborate ruffled dresses with lace and ribbon trim, and matching bonnets.

Most wigs were mohair before 1950; few dolls had human hair wigs. During the nineteen-thirties and - forties, some dolls had caracul wigs, which were made from the skin of very young Asiatic or Russian sheep. The chief difficulty with this material was the trouble the dollmakers had in attaching the wigs to the heads. The wigs had a propensity for sliding off to one side or the other

Composition dolls stand up well to time if treated with care. Dampness is the enemy of composition. Cold and heat are equally damaging, causing cracks in the surface. Unfortunately, dolls are often stored in the basement or attic and both are fatal to composition. However, many composition dolls have been cared for, and so they have survived in almost perfect condition.

Another new doll, very different from the mama doll, appeared on the market about the same time. These were known as bed dolls in Canada and as flapper dolls in the United States. They were mainly designed to appeal to young women. Both Dominion and Reliable Toy Companies are known to have produced these long, slim, elegantly dressed ladies, which were used as decor in bedrooms.

Little girl dolls that resembled the SHIRLEY TEMPLE doll sold very well in the nineteen-thirties, and these were made by several companies. Children in the late nineteen-thirties and early nineteen-forties were very much attracted to the new line of functional dolls that could drink water and wet their diapers. A composition doll that was fed regularly tended to deteriorate rather rapidly. New features, like drink-and-wet dolls, compelled manufacturers to search for better materials.

New materials did appear in the nineteen-forties. A new era in doll making was born, and Canadian firms were quick to pick up the challenge. A latex skin was developed, called Magic Skin by Reliable, while Dee an Cee's version was called Skintex. This material was stuffed with kapok and made a cuddly doll. However, its popularity did not last, for it tended to give away at stress points, such as the neck. There are few examples left in good condition. Some years later a vinyl skin was developed and made into a one-piece body. These dolls were highly advertised. They looked wonderful in their boxes. They had soft vinyl heads which had led to the invention of rooted hair. Rooted saran hair, something new in the early nineteen-fifties, was a great improvement over the unmanageable mohair wigs, which often ended up looking rather scruffy. These vinyl skin dolls were also elaborately dressed, but they tended to be unwieldy dolls that refused to sit properly because of their one-piece stuffed body construction.

Another type of doll that was popular for a short time in the early nineteen-fifties was the hard plastic doll made by the injection moulded method. The body, head, arms, and legs were made in two halves then glued together. It was durable and looked attractive. It made a fine walking doll, but it was definitely not a doll to cuddle. Because it was made for such a short time, and was a fashionably dressed well-proportioned doll, it will probably be the next doll to go up in value. Many of the

early vinyl heads on the hard plastic dolls tended to discolour, which now makes them look rather unhealthy. So, those with the hard plastic heads are the most desirable.

The soft vinyl dolls made by rotational moulding were new in the late nineteen-fifties. Whether they were jointed dolls, or dolls with cloth bodies and vinyl arms and legs, they made a satisfactory warm and cuddly doll. Soft vinyl was particularly effective on baby dolls. And, as the trend to natural looking babies came in during the nineteen-sixties, soft vinyl was the most appropriate material.

Next were blow-moulded plastic dolls. They were not as thick or hard as injection moulded plastic dolls, and the separate parts of the body were each moulded in one piece. It was not necessary to glue halves together. It was a perfect material for little girl dolls and for teenage dolls, for it was firm enough to be a walking doll but did not feel rigid and cold to the touch.

Teenage dolls came into fashion in the late nineteen-fifties and continued in popularity for the next twenty years. The accessories were a very important feature of teen dolls and so were the fashions they wore. It is interesting to note, that during a period when most teenagers were wearing jeans non-stop, teen dolls had extensive wardrobes.

After blow-moulded plastic came vinyl foam, which produces a soft skin-like texture. It makes for very realistic baby dolls. Dollmakers now have such advanced skills with plastic materials that they are able to produce vinyl with the fine smooth surface of bisque and a skin-like texture.

What we have given the reader is a chronological history of the evolution of the development of the commercial doll in Canada. Without going into too much technical detail, we can separate the four types of plastics mentioned in this book. They are of course all made of polyvinyl chloride, but it is used differently to produce materials that vary in texture, rigidity and hardness. Firstly, we use the term hard plastic for a plastic that is injection-moulded and is recognizable by its rigidity and the seam lines on each piece. Secondly, there is a one-piece vinyl doll that is made of stuffed vinyl skin and is called Vinyl-flex by Reliable and Flexee-vinyl by Dee an Cee. Thirdly, there is soft vinyl referred to simply as vinyl. It is made by rotational moulding and is recognizable because it is soft, but unstuffed, and a little thicker than the Vinyl-flex. Finally, there is the blow-moulded plastic that is not as hard as injection- moulded plastic, but not as soft and flexible as vinyl. It is referred to simply as plastic.

These materials have allowed modern dollmakers to finally achieve realistic and lifelike models. The dollmakers can now produce a doll with a perfect child's body. Not only is it well modelled, it is almost indestructible. Today's plastic material will not deteriorate with age. It is extremely durable and will not crack, melt, peel, or break easily. Plastic dolls dressed in their original clothing, especially if the clothing is typical of the fashions of the period, or dressed as a particular character, will become collector's items of the future, and in time they will increase in value.

Many collectors erroneously believe that Canadian companies may indiscriminately copy American dolls, or simply make a doll that closely resembles a popular American doll. This is not so. The Canadian dollmaker buys moulds from a mould maker who may sell the same moulds to a number of companies. In the case of dolls designed specifically for one company, such as POLLYANNA for the Walt Disney Company, the Canadian dollmaker must be licenced to make that doll and pays for the privilege.

The dolls of the nineteen-thirties and -forties were fun to collect because they had names and personalities. Little girls in those days all had different dolls, and in later life they could remember the names of their dolls. They knew if it was SHIRLEY TEMPLE or CHUCKLES. The dolls were well dressed, and their clothes could withstand repeated washing.

Little girls playing together in the mid-nineteen-eighties all have exactly the same doll. Every child wants a Cabbage Patch. At first, television was a boon to the doll industry in advertising their dolls. Television is now used to flood the marketplace with one special doll, and no one can sell anything else. This same phenomenon happened with the Barbie doll over twenty years ago. Many companies at that time were making attractive teen dolls, but every child wanted a Barbie because of the massive advertising campaign.

The dolls of the late nineteen-fifties and early nineteen- sixties were made of thicker and heavier plastics than today. They were very sturdy. They had a variety of features: they could sing, wiggle, sleep, walk, and wet, etc. As competition increased, and it was necessary to cut costs, the plastic on dolls became thinner. Many dolls in a given year had the same name, and dolls lost their character. The dolls of hard plastic from the fifties and the blow moulded dolls of the sixties, particularly the action dolls in working condition, are very collectible.

There are many interesting Canadian commercial dolls. One need only look at the character dolls of the Dominion Toy Company; dolls that may now be considered antiques. In the past, many dolls were designed in Canada, then quietly, and simply, put on the market without reference to the fact that they are totally Canadian. The two black dolls by Dee an Cee, CALYPSO JILL and BILL, are a case in point. Until Arthur Cone quietly but proudly told the author that his father, Morris Cone, had designed these two dolls, it was unknown to collectors. CLEOPATRA and LITTLE MISTER BAD BOY by Pullan are interesting dolls. Reliable's BARBARA ANN SCOTT and the EATON'S BEAUTY from 1940 to 1943 are also of interest to collectors. Another case that is not widely known is that of Palmer Cox. He was the designer of the famous American Brownies He was born in Grandby, Québec, where he later retired. Unfortunately, the doll designers have not been considered important and are not honoured as important contributers to the doll industry.

Canadian dollmakers have produced a wide variety of dolls over a period of seventy-five years. Many of those in the business have expressed their pleasure in having been part of the business of producing dolls. It has been a difficult and challenging business, but one that gave satisfaction. Canadian doll collectors appreciate the high quality of many of the dolls they produced. These dolls are worth preserving as part of our heritage and examples of our material culture.

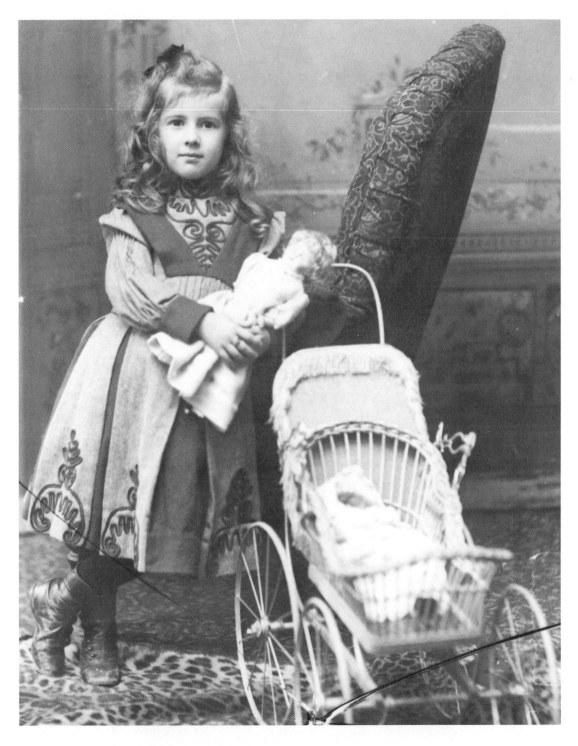

SL11
Missie Currier, 1890. Photograph by W.J. Topley, Public Archives Canada, neg. no. C-73324.

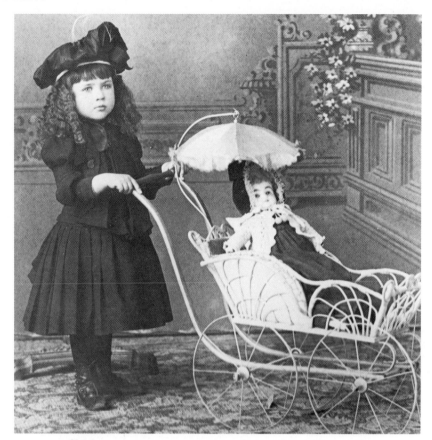

SL12
Albertine Dorion, 1892. Photograph by J.B. Dorion. Public
Archives Canada, neg. no. PA-123632.

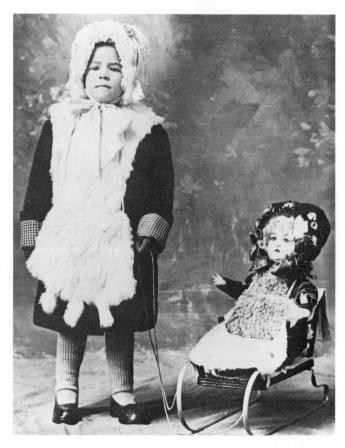

SL13
ca1913. Photograph by J.A. Lessard. Public Archives Canada,
neg. no. C-54470.

Beaver Doll and Toy Co.

Little is known about this company. There was a company in Toronto, Ontario, in 1917 known as the Beaver Toy Mfg. Co. We have found only one doll in a box marked Beaver, and the construction of the body and the style of costuming indicate that it was made about 1917. We can only assume it is the same company using a slightly different form of the name.

CX10

CX9

CX10
Beaver. ca.1917. 18 in. (45.5 cm). Excelsior stuffed body and legs, composition forearms. Composition shoulderhead; blue sleep eyes, painted upper and lower lashes; human hair wig over moulded hair; open mouth with two replaced teeth. Unmarked. Original box: Beaver Doll and Toy Co. Doll dressed in original white cotton, lace trimmed dress, slip and combinations. A rare doll. From the collection of Cathy Dorsey, St. Catharines, Ont. See also Figs. CX9 and CX11.

CX11

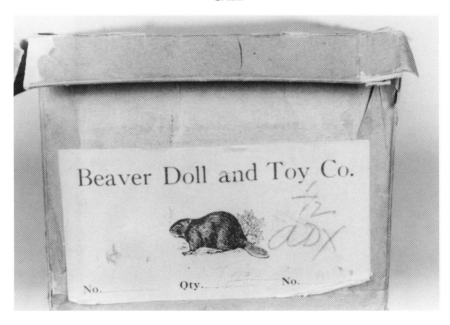

Bert Perlman Inc.
(Kehagias Dolls)

The Bert Perlman Inc. Company of Long Beach, N.Y., sells dolls under the name Kehagias. The dolls are made in Canada by the Reliable Toy Co. The doll boxes and the tags on the dolls are marked Kehagias. These dolls are sometimes referred to as the K dolls, possibly because Kehagias is a Greek word that is difficult to pronounce.

Kehagias is the name of a company which made dolls in Greece for fifty years. Mr. Perlman worked for Kehagias for many years and when the company closed its doors Mr. Perlman bought the moulds. Reliable is now using the moulds to produce dolls on contract for Mr. Perlman. Reliable distributes the dolls in Canada.

The K dolls include the "I wa-na be" dolls that come in thirteen different costumes representing different professions, are nicely dressed and have their own stands.

The babies, HEATHER and ADAM, are of a very fine vinyl, are well finished and dressed, but are difficult to find in Canada, although they are sold in the United states. There is also a series of International dolls and a series of Fairy Tale characters.

CN7

CN3A

CN7
Kehagias. 1985. ARTIST. 9.5 in. (24 cm). Plastic body, vinyl arms and legs, jointed hips, shoulders, and neck. Vinyl head; blue sleep eyes, lashes; long black rooted hair; closed mouth. Mark: on body, KEHAGIAS/MADE IN/CANADA. Wrist label KEHAGIAS/RELIABLE TOY CO. LTD. Original blue slacks and matching hat, white cotton smock, smeared with paint, white socks, black shoes and carrying an artist's palette and a paint brush. One of a series of thirteen dolls representing different professions. Author's collection.

CN3A
Kehagias. 1985. BEAUTY QUEEN. 9.5 in. (24 cm). Plastic body, vinyl arms and legs, jointed hips, shoulders, and neck. Vinyl head; blue sleep eyes, lashes; long blond rooted curly hair; closed mouth. Mark: on body, Kehagias/MADE IN/CANADA. Wrist label Kehagias/RELIABLE TOY CO./TORONTO,CANADA. Original white nylon gown trimmed with rows of lace, nylon slip and panties, white lace stockings, white shoes, red velvet cape trimmed with white. Wearing a paper label BEAUTY QUEEN and a silver crown and carrying red roses. One of the "I-wa-na be" series. From the collection of Gloria Kallis, Drayton Valley, Alta.

XH24

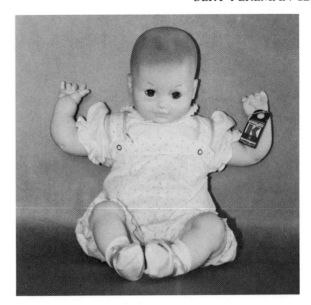

XH23

XH24
Kehagias. 1985. HEATHER. Cloth body, vinyl arms and legs. Vinyl head ; blue sleep eyes, lashes; slightly moulded light brown hair; closed mouth. Marks: the same as ADAM. Original pink cotton dress with small rosebuds, white collar with lace and pink ribbon trim, white cotton panties, white socks, pink ribbon around them. From the collection of Gloria Kallis, Drayton Valley, Alta.

XH23
Kehagias. 1985. ADAM. 21 in. (53.5 cm). Cloth body, vinyl arms and legs. Vinyl head; blue sleep eyes, lashes; slightly moulded light brown hair; closed mouth. Mark: on head, Reliable (in script)/Made in Canada ; tag on body, Made by Ont. Reg. no. 63A 3438/RELIABLE TOY CO. LTD. TORONTO, CANADA ; tag on arm, KEHAGIAS / RELIABLE TOY CO. LTD/LTEE /TORONTO, CANADA. Original white cotton blouse with pink bow, lace trim. White cotton rompers with blue and pink hearts, pink bias tape trim, white socks, pink ribbon around them. From the collection of Gloria Kallis, Drayton Valley, Alta.

CS15A

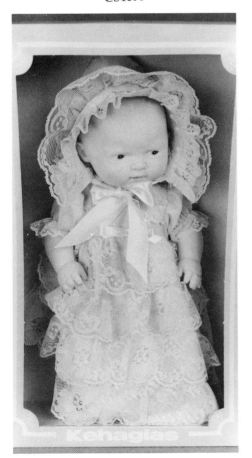

CS15A
Kehagias. 1985. 12 in. (30.5 cm). Vinyl one-piece bent-limb baby body. Vinyl head; blue painted side-glancing eyes; light brown moulded hair; open mouth nurser. Unmarked. Original box, KEHAGIAS/RELIABLE TOY CO./MADE IN CANADA. Original cream lace tiered gown and matching bonnet. Made from a fine smooth vinyl. Author's collection.

CZ9

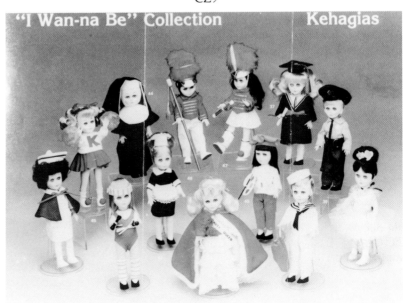

Bisco Doll Company

Jesse William Wyatt arrived in Canada in 1912. He had previously worked as a designer and mould maker for a large pottery in England which made fine dinnerware. He came from a family devoted to pottery. His father and grandfather before him worked for the same pottery, as did many of his relatives. He was a well trained potter, an ambitious man, and he hoped to have a pottery of his own some day.

After arriving in Toronto, Mr. Wyatt worked as a potter at the Davisville Pottery for several years. He met Maxim Maggi, who was a partner in the Florentine Statuary Company, which was already producing dolls in 1917. Just whose idea it was to create a Canadian bisque-headed doll is lost in the mists of time; but we do know that these two men, and a third man, Ex Charboneau, formed a partnership in January of 1918 and registered the Bisco Doll Company, which was originally listed at 221 Richmond West in Toronto, Ontario.

Bill Wyatt, as he was known, and family, moved to a house at 36 D'Arcy, in Toronto, and the Bisco Doll Co. operated from that address. His eldest son, also called Bill Wyatt, recalls that the kiln was in the backyard. The whole family helped with the production of dolls. Bill Wyatt made the bisque heads with imported clay, and a European artist called Hans was employed to paint the faces. His son also recalls that the bodies were of composition, although none of these seem to have survived. Mrs. Wyatt made the wigs, and their son Bill made porcelain teeth and fitted them into the doll's mouths. He also tied the dolls into their boxes when they were finished.

Both Bill Wyatt and Maxim Maggi were sculptors, so it is unknown exactly who sculpted the model heads. It is possible that the composition bodies were manufactured at Florentine as Mr. Maggi was a partner in that firm. There was not enough room for the bulky equipment needed to make composition at 36 D'Arcy Street so it seems likely that the work was contracted out.

The surviving Bisco baby has a beautifully modeled head and well proportioned body. The body is so good it seems well ahead of its time. The material of the head is a bisque but, although it is of a fine smooth texture, it seems to be quite thick compared to European bisque heads.

The body is also modeled with a thick bisque. The white of the clay can be seen inside the joints. The doll appears to have been spray painted with the facial features painted by hand. They are extremely well done with the lips being a soft pink delicately outlined in a darker pink.

The Bisco Doll Company ceased operations in 1920. But Bill Wyatt had new plans, for in 1919 he incorporated the C & W Dolls and Pottery Company. But that is another story.

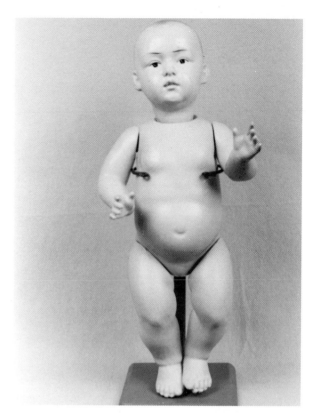

CW9

CW9
Bisco. 1918. 16.5 in. (42 cm). All painted bisque, bent-limb body, jointed hips, shoulders, and neck. Painted bisque socket head, blue painted intaglio eyes with highlights, black line over eye; nostril dots; light brown moulded hair; open-closed mouth painted soft pink with fine outline in dark pink. Mark: head and body clearly marked (see Fig. CW16A). Redressed in a blue sailor suit. See also Figs. CX3 and CW11. The Bisco Baby is a rare Canadian doll. From the collection of Mr. and Mrs. C. Milbank, Sarnia, Ont.

CX3

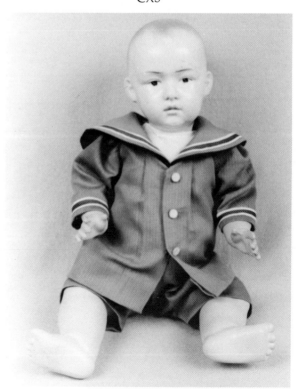

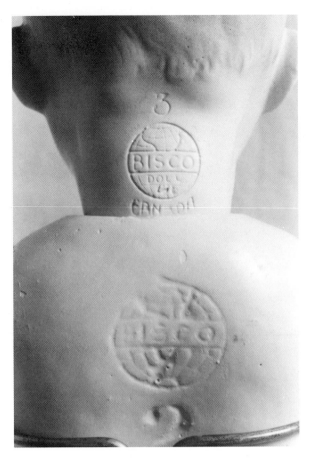

CW16A

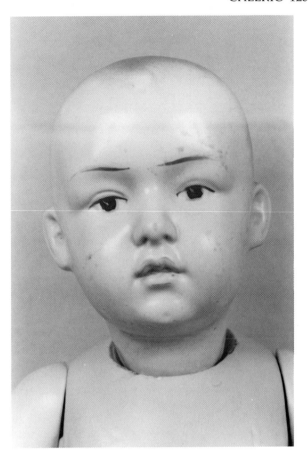

CW11

Brophy Doll Company Ltd.

BW20

Brophy Doll Co. Ltd. was listed at 472 Bathurst Street, Toronto, Ontario, in 1920. They were mostly importers but apparently made unmarked dolls for a short time. We found no dolls that could be attributed to Brophy.

Cheerio Toy Company

The Cheerio Toy Co. was established about 1939 with J. Wainberg as president, A. Lang as secretary, and S. Dubiner as treasurer. They were listed at 54 Lombard Street in Toronto, Ontario.

By 1941, Sam Dubiner was president, and they were now situated at 80 Duchess Street. In 1945, they moved to 9 Church Street and, in 1946, they were advertising toys, novelties, and plastic goods. They were mainly distributors; however, they did manufacture a few small hard plastic dolls. They continued in business until 1966. It is doubtful that they were still producing dolls in the later years, because no dolls have surfaced from this period.

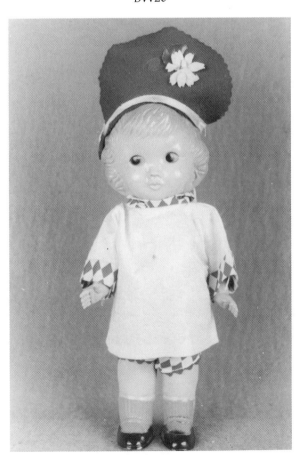

BW20
Cheerio. ca.1950. 8 in. (20.5 cm). One piece hard plastic doll. Blue painted side-glancing eyes, light brown moulded hair; closed mouth. Mark: on body, CHEERIO/MADE IN CANADA. Original white and red dress, red felt hat, moulded socks and shoes. Author's collection.

C.L.S.

We have found two dolls with bisque heads and a trademark incised on the back of the head with the initials CLS and the words Toronto, Canada. The middle initial L is larger and more prominent than the C and the S. It leads one to think that it was a company using someone's name with the L representing the last name and the C the first name. The S could stand for "and Son.'

However, despite an extensive search, no company has been located using these initials during the early part of the twentieth century. The other three companies making bisque heads were all in operation between 1917-1920. A search of potteries in operation during this period did not locate a potter with these initials either.

The bodies of the dolls are particularly interesting, for they are so well made and proportioned. They could only have been made by an experienced dollmaker. However, they are not all ball jointed like Dominion Toy bodies, but have a French knee joint and a German ball jointed elbow.

One of the dolls made by CLS has very large eyes, a feature more common among dolls of the nineteenth century. The body is very well modelled and has a slim build, something that was also common in the nineteenth century. The upper arms and legs are wooden and are beautifully shaped which is typical of French bodies before 1890.[1] This speculation led me to wonder if, indeed, the dolls could be from an earlier era.

In searching through the potteries of the nineteenth century, I found a pottery company named Cyrus Little and Son. The initials fit perfectly, however, the pottery was located in Beamsville, Ontario, about sixty miles from Toronto. Cyrus Little and Son was not known to have marked their pottery. Moreover, the pottery went out of business in 1872. Therefore, in order for this company to be involved, they would have had to be making dolls about 1870. Although it is an intriguing idea, we wonder if these two dolls are that old. It remains a question for further research.

1. Betty Hutchinson. Personal communication.

CP22
CLS. Date unknown. 19.5 in. (49.5 cm). Composition body, forearms, hands, and lower legs; wooden upper arms and upper legs. French knee joints, German ball-jointed elbows. Painted bisque head; blue glass sleep eyes; painted upper and lower lashes; brown horsehair wig; open mouth showing four teeth. Mark: on head, incised, CLS trademark with TORONTO/ CANADA (see Figs. CP25, CP23, CP28). From the collection of Ruth Mesley, Barrie, Ont.

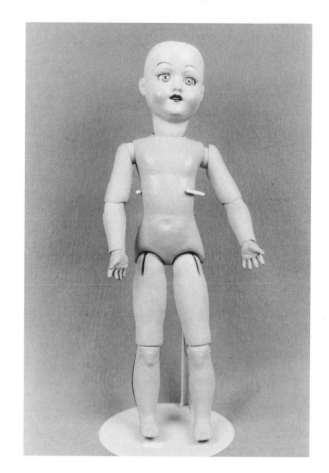

CP22

CP25

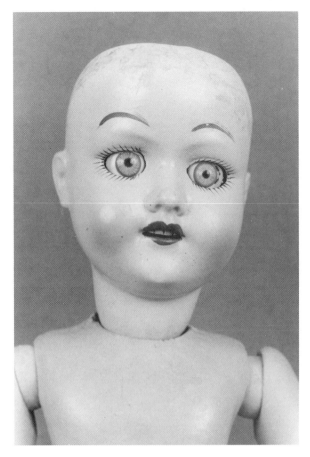

CP23

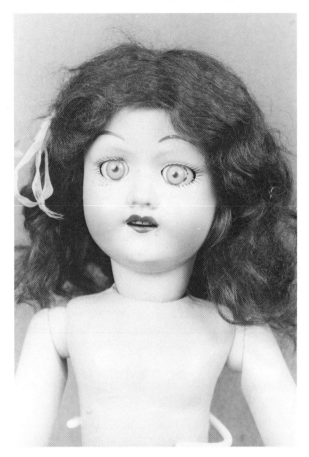

CP28

CS19

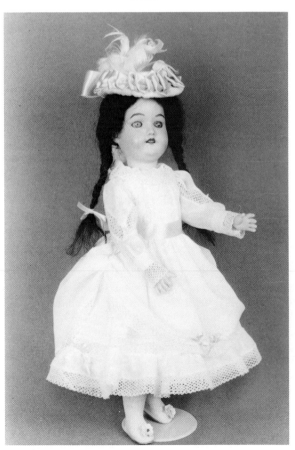

CS19
CLS. Date unknown. 19.5 in. (49.5 cm). Composition body, forearms, hands, and lower legs; wooden upper arms and upper legs. French style knee joints, German ball-jointed elbows. Painted bisque head; blue glass sleep eyes, painted upper and lower lashes; dark brown horsehair wig; open mouth showing teeth. Mark: On head, incised CLS trademark. Redressed in antique white cotton in an 1870 style by Georgee Prockiw. Lace trimmed pantalettes, petticoat, bustle, gown and overskirt tucked and lace-trimmed, blue ribbon trim, white stockings, white leather slippers, hat with ribbon and feather trim. Author's collection.

Commercial Toy Company

The Commercial Toy company existed at the same address on King Street East in Toronto, Ontario, as the Florentine Statuary Company. Commercial Toy is known to have produced painted bisque headed dolls during its short existence. Maxim Maggi, a sculptor, was involved in the Florentine Statuary company and the Bisco Doll company of 1918, which also made bisque headed dolls. It is not difficult to imagine that Commercial Toy was Mr. Maggi's first attempt at making bisque dolls, and when that failed he became a partner in the Bisco Doll company.

Very few Commercial Toy dolls are believed to have survived. We were unable to locate any examples.

C&W Dolls and Pottery Ltd.

C & W Dolls and Pottery Ltd. was incorporated in Ontario in 1919 with a capital of $50,000. It was owned by Jesse William Wyatt. He named the company after his wife, Clara, and himself, William. Bill Wyatt, as he was known, had been a partner with Maxim Maggi in the Bisco Doll Co. When that company floundered, Bill Wyatt decided to go it alone.

His wife, Clara, was an active partner who made the wigs and dressed the dolls. Mr. Wyatt used imported clay for the heads, and he hired an experienced artist to paint them. His son, also known as Bill Wyatt, remembers that they made the dolls in two sizes. The heads were clearly marked with an incised mark. The C&W company also made vases, and a few of these have survived.

Unfortunately, the company lasted only two years. Mr. Wyatt moved to Oshawa where he worked in a pottery. In 1924, he and his family left for Medicine Hat, where he became the supervisor at Medalta Pottery.

CL13
C&W Dolls. 1919. Painted bisque shoulderhead. Painted upper and lower lashes. Open mouth with two inset teeth. Badly deteriorated paint. See also Fig. CL15. From the collection of Vera Goseltine, Vancouver, B.C.

CL15

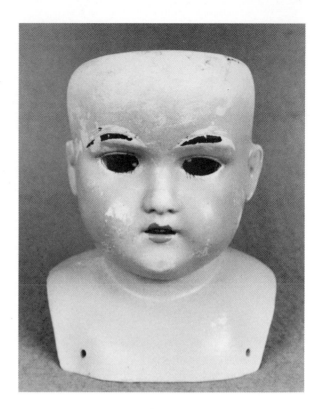

CL13

Dee an Cee Toy Company Ltd.

The forerunner of the Dee an Cee Company was Amusement Novelty Supply Company, which was founded in 1932 at 64 Adelaide Street East in Toronto, Ontario, with W.J. Broudy as president, Max Diamond as secretary, and Morris Cone as manager.[1] The founding of a new toy company during the Great Depression took courage and confidence. The founders knew that toys were important to children, and, even during a time of scarcity, parents would do their best to buy a doll that a child longed for. They had the confidence to manufacture toys during the Depression when most companies survived by supplying the Canadian public with basic essentials. Perhaps the founders understood the nature of millions of people who had so little beauty in their lives they flocked to see movies that appealed to their fantasies, such as the Shirley Temple films. During the Depression, Reliable Toy Company was the only other company in Canada of any size making dolls. Dominion Toy Ltd. was closing, and Florentine Statuary Co. was switching to other products.

In 1935, the company needed more space and, therefore, moved to 295-301 King Street East. Hot presses were installed in 1936 to begin the manufacture of composition dolls. During 1936 and 1937, when the company's name was still Amusement Novelty Supply Co., most dolls produced were probably unmarked. However, one doll has been found marked C and D, and it is believed that at least some of the dolls were so marked. During these two years, Morris Cone was president and Max Diamond was the secretary. So, it is likely that they experimented with the initials of their names before deciding to call the company Dee an Cee.

Diamond and Cone were related by marriage, and they worked well together. In 1938, the company's name was changed and incorporated as Dee an Cee. The new name stood for the partners' names, "Dee" for Diamond and "Cee" for Cone. The name of the company appeared in different ways on the dolls: D&C, Dee an Cee, Dee and Cee, or DEE & CEE.

Morris Cone's son, Arthur, joined the firm in 1939 and began learning the business from the ground up. He tried his skill at every job and learned firsthand the processes of doll production.[2]

Dee an Cee made dolls for twenty-four years and produced the quality dolls that many collectors look for. It was a progressive company, usually in the forefront of doll manufacturing with new ideas. They made everything they needed to produce dolls, although they did import some eyes from the United States. They started using French in their advertisements in the early fifties long before other companies did. This was at the instigation of Arthur Cone who was in charge of sales. Since he was making many trips to Québec, he was aware of the sales appeal of products with bilingual advertising and packaging. He was proven right, for sales in Québec promptly increased. It was also Arthur Cone's idea to advertise on television, and Dee an Cee was the first doll company to do this. Their advertisements were so successful they had trouble keeping up with the orders![3]

"Quality Above All" was the Dee an Cee motto. It had been the brain child of Arthur Cone, who had been inculcated by his father from childhood on with the importance of quality in the manufacture of dolls. It was a slogan that Morris Cone truly believed in. He would always spend a little more to buy better quality material, ribbon, or lace, because he wanted the Dee an Cee doll to be a superior product.

Dee an Cee composition dolls were made with a mixture of Norwegian pine sawdust, corn starch, rosin, and water. This mixture was put in moulds and then pressed in hot steam presses. This was the most difficult and hottest job in the factory. It produced a rough brown composition. The parts were then dipped in liquid glue to give a hard smooth surface, which could then be given a smooth coat of paint.

Dee an Cee began to experiment with new materials in the early nineteen-forties. They made Skintex from natural rubber, but it had a tendency to break away at pressure points, particularly the neck. In 1944-45, they began using Flexee-vinyl, a type of vinyl skin that resembled the rubber but which lasted longer. In 1949, Dee an Cee began making vinyl heads. The vinyl plastic was easy to mould, was consistent in its results, gave dolls flexibility, permanance, and was economical to use.

Mannie Grossman joined Dee an Cee in 1951 as production manager, and was part of the team that guided the company into the new plastics technology age. Mr. Grossman had previously worked with the Reliable Toy Company, and he was an experienced dollmaker. Because no one had ever made dolls with plastic before, the production team used a trial and error approach with the new materials to determine the best methods to use. They simply kept trying until they got the results they wanted. The first plastic dolls became sticky or developed spots before the dollmakers learned to control the materials.

There were engineering as well as chemical problems. The modern doll often has internal tubes and reservoirs, and springs or weights, so children can change their doll's diaper and dry their tears. A doll may need a walking or a talking mechanism, or be equipped with a windup key to enable it to wiggle realistically.

Max Diamond died in 1954, but the company was flourishing by this time. Morris Cone was president and his son, Arthur, became a partner. They were exporting dolls all over the world, including England, South America, the West Indies, Australia, and even Hong Kong! Dee an Cee made CHERUB the smile-n-cry doll in 1949, a sweet cuddly little doll with a cheerful face that turned into a crying face with an open mouth and eyes shut tight when the head was turned around. SNUGGLES was a mama doll that came either with a mohair wig or with moulded hair. She had a cloth body, composition head, composition arms and legs, and was dressed in an organdy dress and bonnet. SWEETUMS was available that year with a composition head and Skintex rubber arms and legs. Another doll was TOIDEE TOT made of Skintex, and she came with her own glass bottle. She drank, wetted, and could be washed.

HEIDI and WILLY-WHISTLE were new in 1954. Both were 13 inches, were made of Skintex rubber, and had vinyl heads. They were dressed in Tyrolean costumes. A 12 inch CAMPBELL KID boy and girl in all vinyl were also presented. They were old favourites, but they were made of the new plastic materials. Another popular doll was BETTY the knockabout doll with her hair moulded into a loop for a hairbow. KANDY had a moulded vinyl ponytail that was tied with a satin ribbon.

Morris Cone designed many of the Dee an Cee dolls, including the beautiful sister and brother black dolls in 1956 named MANDY and DUSTY. They had ethnic features and heavily detailed moulded hair. MANDY and DUSTY were 14 inches tall and were made with Skintex bodies. In 1960, the vinyl heads came with the harder plastic bodies in a 14 inch size, and were redressed as CALYPSO BILL and CALYPSO JILL. A year later, BILL and JILL were made two inches taller.

TINY TEARS was advertised on the Canadian Ding Dong School program on television in 1956 as a lifelike doll that could be fed, changed, and bathed. It also cried and blew bubbles. Another innovative doll that year was CINDY STRUTTER who had jointed knees. NINA, the 30 inch bride, elegantly dressed in lace and net, turned her head from side to side as she walked when held by one hand. BUTTERCUP was a baby doll dressed in a satin snowsuit trimmed with white furry plush.

In 1957 SWEET SUE, a teenage beauty, came dressed either as a bride, or in an evening gown of lace and velvet. She wore a velvet choker and earrings and had a turning

waist. Seventeen inch BABY JANE was made of Flexee-vinyl and wore a christening gown and matching bonnet of flocked nylon and lace. DOLLY TRAVELLER was packaged in her own trunk with four extra outfits to wear. The BATHINETTE DOLL was equipped with a bathinette and bubble bath, powder, sponge, soap, and a change of diaper. Another DEE an Cee feature was CINDY-PETITE, a tiny 8 inch doll with rooted saran hair. Six outfits were available for different occasions.

Morris Cone died in 1957 at the age of sixty-seven. He had spent forty-five years as a Canadian dollmaker. His son, Arthur, a quiet unassuming man, became the president of Dee an Cee. He had eighteen years experience in the business. He had learned every phase of production, and had spent a number of years as sales manager. He also had several years training in the research and design of doll clothing. He frequently travelled to New York and Chicago to see the latest styles, to bring samples home, and to improve on them for the Canadian market. At this time, Mr. Grossman, who had been buying Dee an Cee stock over the years, became a partner.

In 1958 TONI was advertised on television. She was 10.5 inches tall, had a swivel waist and long rooted saran hair. She had twelve different outfits, one for every occasion. The LOVABLE FAMILY was new and included a well-dressed mother, her 12 inch daughter, and an 8.5 inch baby. CINDY, a pretty teenage nurse, was dressed in a striped dress, white apron, and navy blue cape with a white cap. She carried a tiny baby in a brushed rayon bunting suit. PENNY was a cute doll, 12 inches high, with a Buster-Brown hairdo. An innovative idea in 1958 was PUPPET BABY, a tiny baby with vinyl head and hands, dressed in a nightie, and tucked into a quilted polished cotton carrier pillow. The pillow had an opening in the back through which a child's hand could animate the doll. It had a zippered pouch for a child's nightwear, and so it served a useful purpose as well as being a delightful bedtime companion.

Dee an Cee offered TINY TEARS in many packages in 1959. She came with a white plastic cradle, a car bed, or different layettes, and in different sizes. KELLY in PIGTAILS was introduced in 1959. She was 25 inches tall with a freckled face and pigtails, and wore a pretty cotton dress with a white ninon apron and a straw hat. She also came in 19 and 17 inch sizes in different hair styles and costumes, and was known simply as KELLY. CINDY nurse was back, this time pushing her baby in a tiny carriage. There were also three dolls in Scottish costumes, a 20 inch boy named SANDY, a teenage girl named BONNIE, and BONNIE the 20 inch toddler. A boy doll named BOBBY came in two sizes, 21 inches and 30 inches. He wore a tartan sports jacket, long pants, and a cap.

Dee an Cee was licensed in 1968 to make and sell POLLYANNA of movie fame. She was 32 inches tall and was authentically dressed in a red and white checked dress trimmed with eyelet, plus matching pantalettes, a straw hat, and black shoes with gaiters of felt. Dee an Cee also had the rights from Madame Alexander in the United States to make MARYBEL the GET-WELL doll, 16 inches tall with rooted saran hair. Wearing a satin playsuit and dark glasses, she came in a carrying case complete with removable casts for a leg and arm, a pair of crutches, band-aids, bandages, and spots to give her measles. She had terrific play value for a child who planned to be a nurse or doctor, for one who had been sick, suffered a broken limb, or was recovering from a childhood disease. GIGI was a quite different doll, with a pert little face and long straight hair. She came dressed for play, a party, ballet, or for ice skating. Brown-eyed GINA was another outstanding doll, noted for her gorgeous red curly saran hair and simulated teeth. She wore a yellow polished cotton dress with matching shawl. A substantial part of the production line for 1960 included six black dolls, CALYPSO JILL and CALYPSO BILL, LULUBELLE a 15 inch toddler, and three baby dolls. However, the most popular one of the year was the well made doll of superior quality, CHATTY CATHY, 20 inches tall, with a cute freckled face. She charmed children and adults alike by her ability to speak sentences clearly when the string was pulled from between her shoulders. Dee & Cee was licensed to make her in Canada by the American firm Mattel. CHATTY CATHY was just as much in demand the following year, and so was MARYBEL the get-well doll. A new feature was the MOON BABY, the doll with the peek-a-boo eyes that followed you everywhere. She also said "Mama" to make her even more realistic. The WHIMSIES arrived with their impish snub-nosed faces, some with open eyes and some with closed. They were 21 inches tall, and, with their silly looking costumes, they were likely to appeal to older children. Versatile WILLY, a boy doll, came dressed as a Mountie, a graduate, a hockey player, a sailor, in formal attire, and in short pants. POLLYANNA was reintroduced in 1961 in a 19 inch size. GINA was back too with hair in different colours and styles and dressed in various costumes, including a beatnik outfit. Another clever costume for Gina was an authentic Trans Canada Airlines stewardess uniform just at a time when many little girls dreamed of being a stewardess. A variety of well dressed walking dolls in 36 and 30 inch sizes were also popular.

During the 1961 Canadian Toy Fair in Montréal, Dee & Cee received many favourable comments from the press for the quality and variety of their dolls. They attracted attention because many of their dolls were new to the Canadian market and were fashionably and tastefully dressed. Dee & Cee did so well in selling CHATTY CATHY that Mattel bought the company. A new line was designed for 1962 but less than half of it was produced. At the time the company was sold, Arthur Cone had a contract to stay on as president for two years, which he fulfilled. Mannie Grossman stayed on for a year and a half, but Mattel soon stopped production in Canada and began importing dolls from other countries. This was the end of a long line of DEE & CEE dolls that had begun in 1938. For the Cone family, the long line of dolls went back to 1911 when Arthur Cone's father and grandfather established the doll industry in Canada.

The Dee an Cee dolls are very collectable today, particularly the composition dolls. To find one in mint condition with its original clothing is a find indeed, for the Dee and Cee clothing tends to be of a superior quality that adds to the value of the doll.

1. Toronto Directory, 1932.
2. Arthur Cone. Personal communication.
3. Ibid.

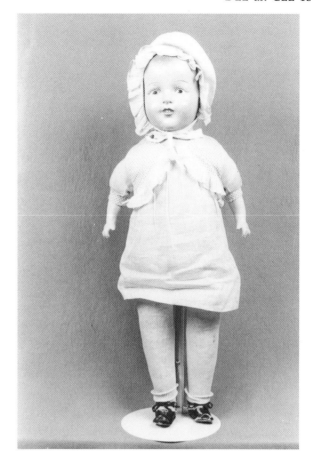

BF36
Dee an Cee. ca.1938. 27.5 in. (71 cm). Excelsior stuffed cloth body, legs, and upper arms, composition forearms. Composition shoulderhead; painted blue eyes, long painted upper lashes; moulded hair, painted brown; open-closed mouth showing two painted teeth. Mark: on shoulderplate, Dee an Cee/Made in Canada. Original blue combination undergarment, blue dress and bonnet, socks and shoes. A fine example of an early D&C doll. From the collection of Donna Gardiner, Dartmouth, N.S.

BN15
Dee an Cee. ca.1938. BETTY. 15 in. (38 cm). Cloth body, upper arms and legs, composition forearms. Composition shoulderhead; blue painted eyes; moulded hair, painted reddish blond; closed mouth. Original name tag on her dress. Original dress and bonnet. From the collection of Irene Henderson, Winnipeg, Man.

CE8
Dee an Cee. ca.1938. 24 in. (61 cm). Cloth body, composition arms and legs. Composition shoulderhead, repainted; blue sleep eyes, lashes; moulded hair, light brown; closed mouth. Mark: on shoulderplate, A/Dee & Cee Toy. Original pink cotton dress with blue bolero, replaced bootees. From the collection of Roberta LaVerne Ortwein, Olds, Alta.

BF36

BN15 CE8

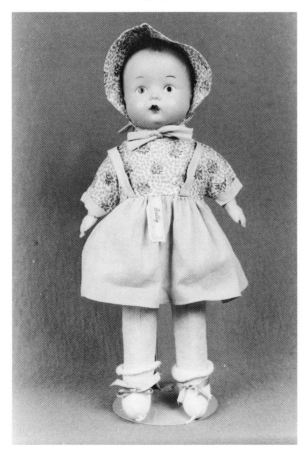

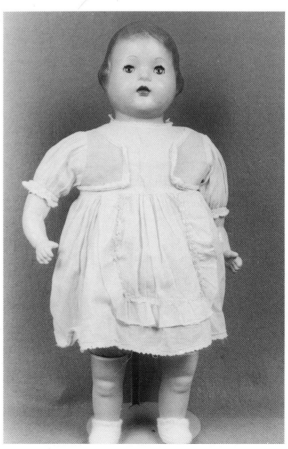

CW25
Dee an Cee. ca.1939. 17 in. (43 cm). Cloth body, composition forearms and bent-limb legs. Composition shoulderhead; blue tin sleep eyes, painted upper lashes; moulded hair; closed mouth. Mark: on shoulderplate, DEE & CEE Toy Co./MADE IN CANADA. Redressed. From the collection of Sylvia Higgins of the Remember When Museum at Laidlaw, B.C.

CN23
Dee an Cee. ca.1939. SNUGGLES. 23 in. (58.5 cm). Cloth body, composition forearms and straight legs. Composition shoulderhead; blue metal sleep eyes, lashes, painted lower lashes; reddish brown moulded hair, closed mouth. Mark: label on the dress, Snuggles/DEE an CEE TOY/MADE IN CANADA. Original white and pink organdy dress and matching bonnet, blue rickrack trim. From the collection of Dianne Peck, Sudbury, Ont.

AM19
Dee an Cee. ca.1939. KNOCKABOUT DOLL. 15 in. (38 cm). Cloth body and legs, composition forearms. Composition shoulderhead; painted brown side-glancing eyes; moulded short brown hair; closed mouth. Mark: on shoulderplate, DEE AN CEE/MADE IN/CANADA. (The N in AN and IN are backward). An inexpensive and sturdy style of doll, it was made until 1949 in various versions. Author's collection.

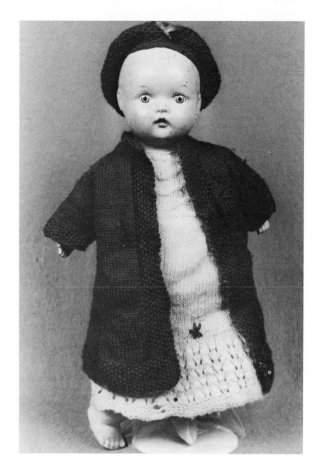

CW25

CN23

AM19

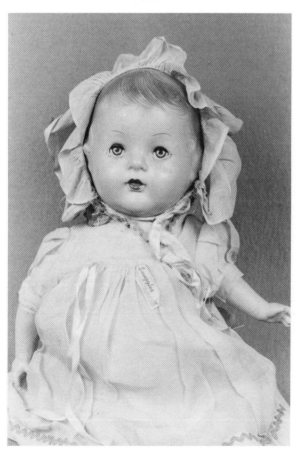

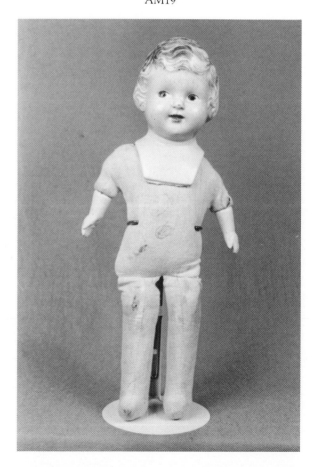

CC14
Dee an Cee. ca.1940. 11.5 in. (29.5 cm). Dark brown composition bent-limb baby, head and trunk one piece, jointed hips and shoulders. Painted side-glancing black eyes, moulded black hair plus wool top-knots, closed mouth. Mark: on back, DEE AN CEE/CANADA. Redressed. From the collection of Mrs. D.H. Morman, Victoria, B.C.

CT16
Dee an Cee. ca.1940. 24 in. (61 cm). Excelsior stuffed cloth body and legs, composition arms. Composition shoulderhead; blue painted eyes; reddish blond moulded hair; closed mouth. Original pale pink organdy dress and matching bonnet. From the collection of Glenda Shields, London, Ont.

BJ4
Dee an Cee. ca.1940. SNUGGLES. 22 in. (56 cm). Cloth body, composition forearms and straight legs. Composition shoulderhead; blue tin sleep eyes, lashes, painted lower lashes; blond mohair wig; closed mouth. Original white dress bearing the SNUGGLES name. From the collection of Rebecca Douglass, Dartmouth, N.S.

CC14

CT16

BJ4

CB36
Dee an Cee. ca.1941. 24 in. (61 cm). Cloth body, with crier, composition arms and straight legs. Composition shoulderhead; blue sleep eyes, black lashes, dark eye shadow; replaced brown wig, moulded hair underneath; closed mouth. Mark: on shoulderplate, DEE & CEE TOY. From the collection of Peggy Bryan, Burnaby, B.C.

DA1
Dee an Cee. ca.1941. DRINKING BABY. 12 in. (30.5 cm). Composition bent-limb body, jointed hips, shoulders, and neck. Composition head; brown painted eyes, black line over eye; moulded brown hair; metal mouth nurser. Mark: on body, DEE AN CEE/CANADA. From the collection of Mr. and Mrs. C. Milbank, Sarnia, Ont.

BJ3
Dee an Cee. ca.1942. SNUGGLES. 22 in. (56 cm). Cloth body, composition forearms and straight legs. Composition shoulderhead; blue tin sleep eyes, lashes, painted lower lashes; moulded black hair; open mouth showing two inset teeth and red tongue. Original cotton dress with a sewn in name tag, Snuggles/Dee & Cee Toy/Made in Canada. Matching bonnet and original shoes. From the collection of Rebecca Douglass, Dartmouth, N.S.

CB36

DA1

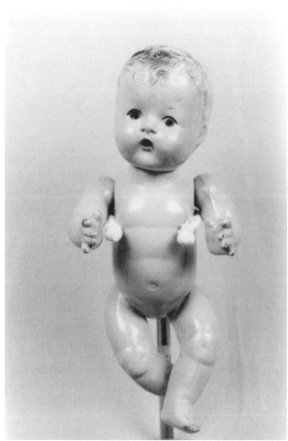

BJ3

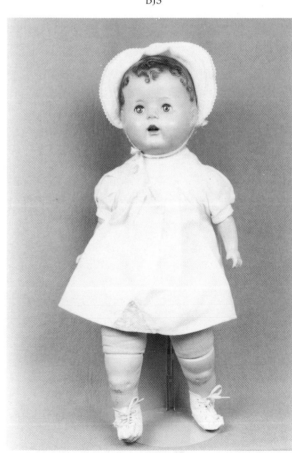

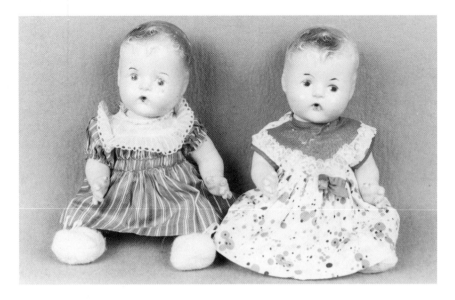

BJ12

BJ12
Dee an Cee. 1943. DRINKING BABY. 13 in. (33 cm.). All composition bent-limb baby, jointed hips, shoulders and neck; rubber tube through the body for feeding. Composition head. Painted brown eyes. Moulded brown hair. Open mouth nurser. Mark: on body, Dee an Cee/Canada. Redressed. Originally sold with a glass bottle with a rubber nipple and wearing a flannel diaper. From the collection of Rebecca Douglass, Dartmouth, N.S.

BJ10
Dee an Cee. 1944. CRYING BABY. 21 in. (53.5 cm.). Cloth body, with crier, composition forearms and straight legs. Composition head; blue painted eyes, long painted upper lashes; brown moulded hair; open-closed mouth showing two painted teeth. Unmarked. Original dotted cotton lace-trimmed dress and matching bonnet, socks and shoes. Shown in Eaton's catalogue, 1944-45. From the collection of Rebecca Douglass, Dartmouth, N.S.

CI15
Dee an Cee. ca.1944. LITTLE DARLING. 24 in. (61 cm). Cloth body, composition forearms and straight legs. Composition head; blue tin sleep eyes, lashes, painted lower lashes; moulded brown hair; open mouth showing two teeth. Mark: on shoulderplate, DEE CEE TOY/MADE IN CANADA. Original pink cotton dress with matching bonnet and bloomers. From the collection of Ruth MacAra, Caron, Sask.

BJ10

CI15

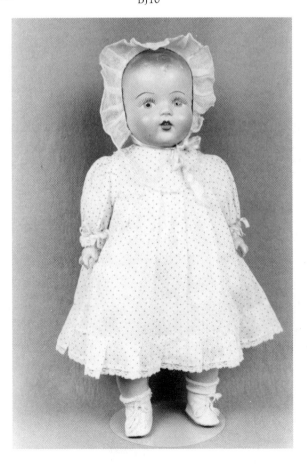

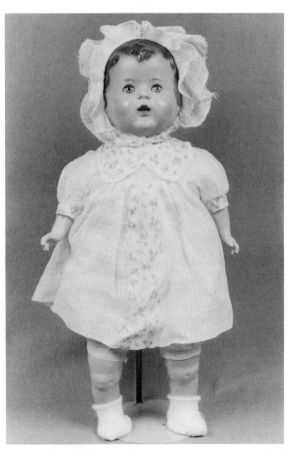

BF31
Dee an Cee. ca.1945. LITTLE DARLING. 24 in. (61 cm). Cloth body, composition forearms and straight legs. Composition head; blue sleep eyes, lashes, painted lower lashes; moulded brown hair; open mouth showing two teeth. Mark: on shoulderplate, DEE & CEE TOY CO./MADE IN CANADA. Original pink cotton dress and matching bonnet. Original tag with her name. From the collection of June C. MacDonald, Halifax, N.S.

BC18
Dee an Cee. ca.1945. BETTY. 23 in. (58 cm). Excelsior stuffed cloth body, legs, and upper arms; composition forearms. Composition shoulderhead; painted brown eyes; moulded strawberry blond hair. Mark: none. Original navy dress with label sewn on, Betty/Dee an Cee Toy/Made in Canada. From the collection of Margaret Hayes, Musquodoboit Harbour, N.S.

CE31
Dee an Cee. ca.1946. 14 in. (35.5 cm). Composition body, jointed hips, shoulders, and neck. Composition head; blue sleep eyes, lashes, painted lower lashes; blond mohair wig; closed rosebud mouth. Mark: on back, DEE AN CEE/CANADA. Redressed. From the collection of Gloria Kallis, Drayton Valley, Alta.

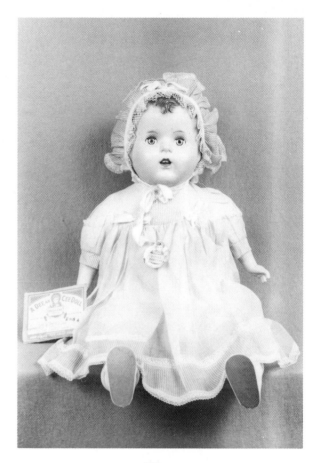

BF31

BC18

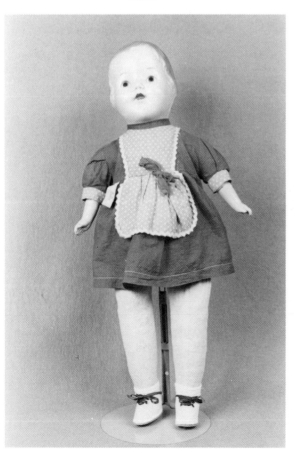

CE31

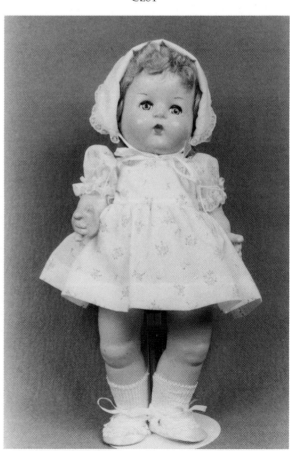

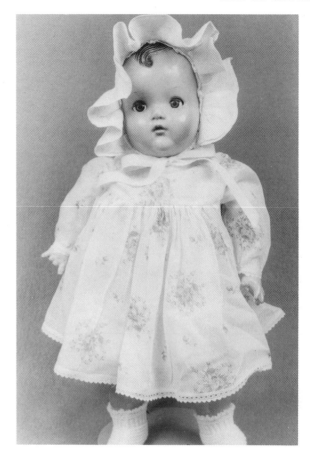

CI4
Dee an Cee. ca.1947. SNUGGLES. 18 in. (45.5 cm). Cloth body, composition hands and straight legs. Composition head; brown sleep eyes, lashes painted lower lashes; moulded brown hair; closed mouth. Mark: on head, DEE & CEE DOLL. Original printed cotton dress and matching bonnet. Also came with a mohair wig. From the collection of Ruth MacAra, Caron, Sask.

BC19
Dee an Cee. 1948. SWEETUMS. 14 in. (35.5 cm). Cloth body with crier, Skintex arms and legs. Composition shoulderhead. Eyes painted blue. Moulded hair, painted strawberry blond. Closed mouth. No mark but original label pinned to dress: SWEETUMS/A Dee an CEE Doll. Original combination underwear, pink organdy dress and matching bonnet. Some hats had a fringe of hair sewn into the brim. From the collection of Margaret Hayes, Musquodoboit Harbour, N.S. See Fig. BC20.

CI4

BC19

BC20

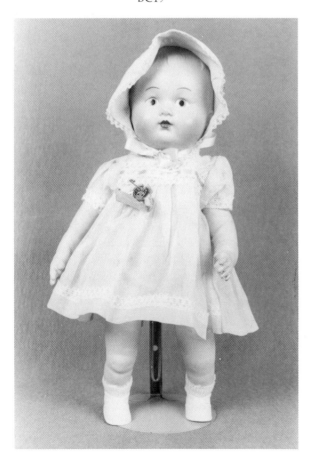

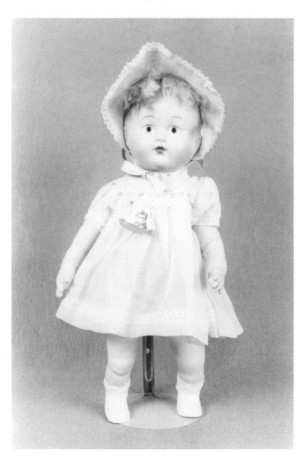

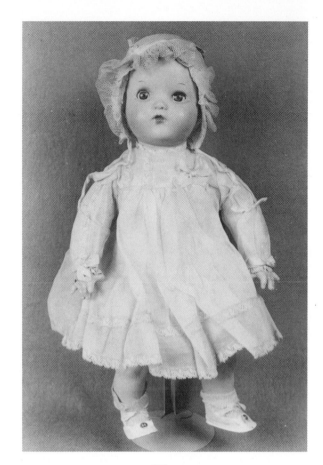

CK2
Dee and Cee. ca.1948. SNUGGLES. 18 in. (45.5 cm). Cloth body, composition hands and straight legs. Composition head; blue glasseine iris set in tin sleep eyes, lashes, painted lower lashes; moulded hair, painted dark brown; closed mouth. Mark: on head, DEE AN CEE DOLL. Original lace trimmed organdy dress and matching bonnet, socks and shoes. From the collection of Ruth Condello, Winnipeg, Man.

CC11
Dee an Cee. 1948. CHERUB SMILE-N-CRY DOLL. 13.5 in. (34.5 cm). Cloth body, legs and upper arms, composition forearms. Composition two-face head, one face smiling and one crying; painted blue side-glancing eyes; bald head; closed mouth on one face open-closed mouth on the other. Mark: none. Original label, Cherub/Smile-n-Cry Doll/A Dee an Cee Product/ Made in Canada. Original red an white checked dress and bonnet. From the collection of Mrs. D.H. Morman, Victoria, B.C. See Fig. CC12.

CK2

CC11

CC12

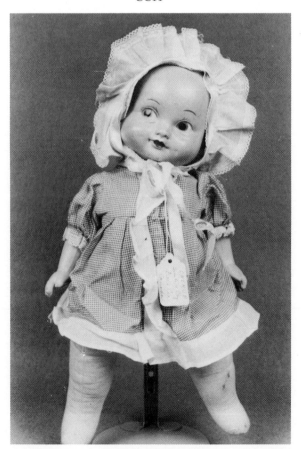

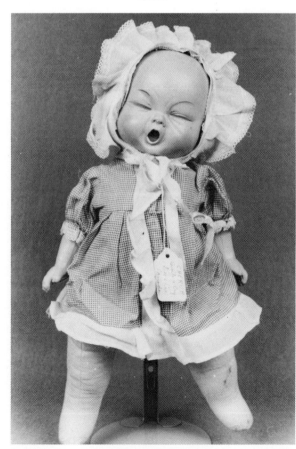

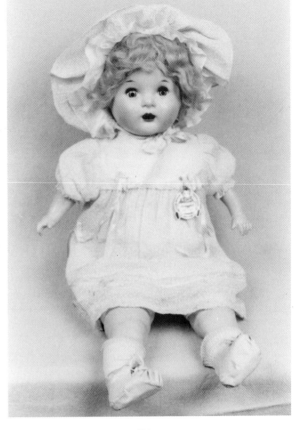

CX18
Dee an Cee. ca.1949. SNUGGLES. 22 in. (56 cm). Cloth body, composition forearms and straight legs. Composition shoulderhead; blue tin sleep eyes, lashes, eyeshadow, painted lower lashes; blond mohair wig; open mouth showing two teeth and tongue. Unmarked: original label, SNUGGLES/A/Dee an Cee/Doll. Original pink and white dress, trimmed with ribbons and lace and matching frilled bonnet, socks and shoes. From the collection of Cathy Dorsey, St. Catharines, Ont.

CE29
Dee an Cee. 1949. BETTY. 18 in. (45.5 cm). Excelsior stuffed cloth body, legs and upper arms, composition forearms. Composition shoulderhead; blue painted eyes; moulded reddish-brown hair; closed mouth. Mark: on shoulderplate, A/DEE & CEE TOY. Original cotton dress and hairbow, replaced shoes. BETTY was made until l954. From the collection of Gloria Kallis, Drayton Valley, Alta.

CB21
Dee an Cee. ca.1950. 26 in. (66 cm). One piece Skintex body, swivel neck. Vinyl head; blue sleep eyes, lashes; light brown moulded hair; open-closed mouth, moulded tongue. Mark: on head, DEE & CEE. Redressed. From the collection of Mary Van Horne, Chilliwack, B.C.

CX18

CE29

CB21

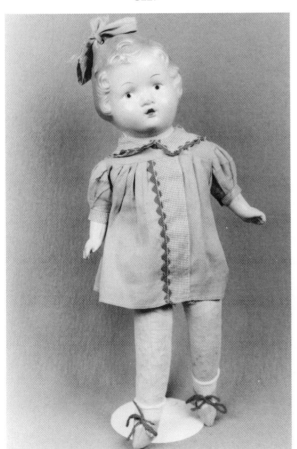

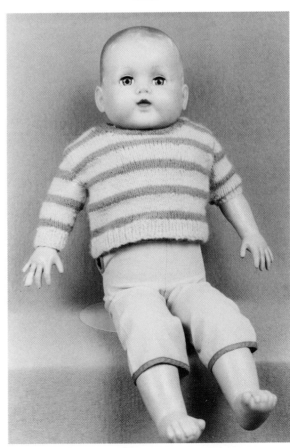

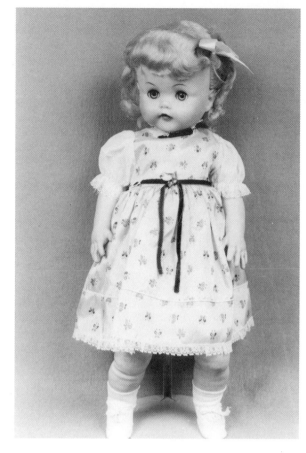

CF12
Dee an Cee. ca.1952. CAROL. 25 in. (63.5 cm). One piece Skintex body. Vinyl head; blue sleep eyes, lashes, painted lower lashes; rooted blond saran hair with bangs; closed mouth. Mark: on head, DC. Original mauve print taffeta with lace trim and black velvet ribbons, shoes and socks. From the collection of Gloria Kallis, Drayton Valley, Alta.

CB32
Dee an Cee. ca.1954. HONEY BEA. 15 in. (38 cm). One piece Flexee-vinyl body, dimpled knees. Vinyl head; brown sleep eyes, lashes, painted lower lashes; rooted saran ponytail and bangs; closed mouth. Mark: on head, DEE & CEE. Original red and white checked dress, roller-skates and socks. From the collection of Andra Tucker of the White Elephant Museum at Sardis, B.C.

CG23
Dee an Cee. 1954. HEIDI. 13 in. (33 cm). One piece stuffed Skintex body. Vinyl head; inset plastic eyes; moulded hair in braids, painted yellow with red barretts; open-closed mouth, painted teeth. Mark: on head, Dee Cee. Redressed. Originally wore a gabardine dress with white organdy apron and a silk scarf and coloured shoes. From the collection of June Rennie, Saskatoon, Sask.

CF12

CB32

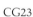
CG23

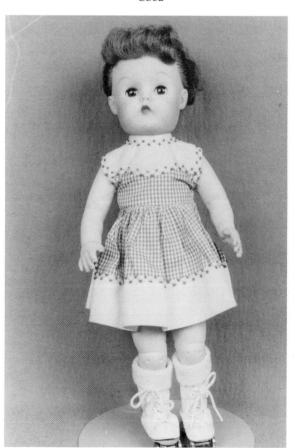

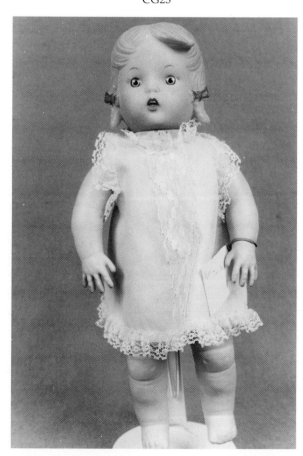

CI10
Dee an Cee. 1955. BRIDE DOLL. 17 in. (43.5 cm). One piece
Flexee-vinyl body. Vinyl head; blue sleep eyes, lashes, painted
lower lashes; rooted blond saran hair; closed mouth. Mark:
none. Original Dee an Cee wrist tag and original Dee an Cee
box. Original brocade bridal gown with net underskirt and lace
trimmed veil. From the collection of Ruth MacAra, Caron, Sask.

BU3
Dee an Cee. ca.1955. KOWEEKA BABY. 10.5 in. (26.5 cm).
Stuffed cloth body in a sitting position. Vinyl face from the
KOWEEKA mould; painted black eyes; black synthetic hair;
open- closed smiling mouth, showing teeth. Unmarked. Body
is made of artificial fur to simulate a fur snow suit. Hands and
feet are longer fur to simulate mitts and boots. Made exclusively
for the Hudson's Bay Company. Author's collection.

CF31
Dee an Cee. 1956. MANDY. 14 in. (35.5 cm). One piece stuffed
Skintex brown body. Vinyl head; black painted eyes, ethnic
features; heavily detailed moulded hair in braids at the back
and painted black; open-closed mouth, painted teeth. Mark:
on head, DEE & CEE. All original. Mandy had a brother named
DUSTY in 1956 who wore long pants with shoulder straps and
a knitted striped sweater. Designed by Morris Cone. From the
collection of Gloria Kallis, Drayton Valley, Alta.

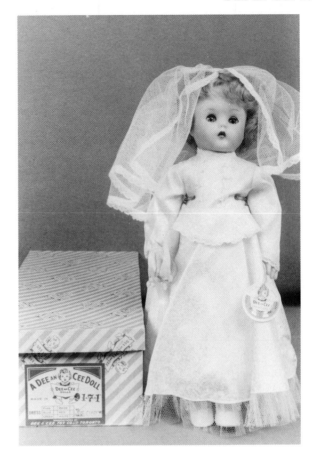

CI10

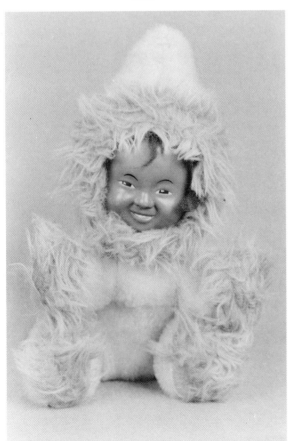

BU3

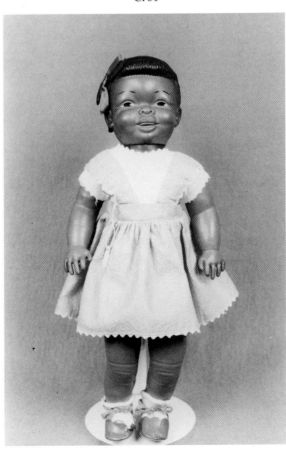

CF31

BF30

BC15

Dee an Cee. 1957. CAROL. 25 in. (63.5 cm). One piece stuffed Flexee-vinyl body. Vinyl head; blue sleep eyes, lashes, painted lower lashes; rooted honey blond saran hair; closed mouth. Mark: on head, DC. Original dress, hat, panties in pink and white check. From the collection of Margaret Hayes, Musquodoboit Harbour, N.S.

CJ3

Dee an Cee. 1958. TINY TEARS. 13 in. (33 cm). Vinyl bent-limb baby body, jointed hips, shoulders, and neck. Vinyl head; blue sleep eyes, lashes, painted lower lashes; rooted blond saran curls; open mouth nurser. Mark: none. Original blue cotton sunsuit with her name on it. Originally came with a layette, plus soap, towel, sponge, feeding bottle, pacifier, bubble pipe, package of kleenex, and instruction book. A doll with a lot of play value. From the collection of Marilyn Cox, Regina, Sask.

BF30

Dee an Cee. 1958. TINY TEARS. 13 in. (33 cm). Vinyl bent-limb baby, jointed hips, shoulders, and neck; with crier. Vinyl head. Brown sleep eyes, eyelashes. Rooted brown curls. She was also sold with moulded hair. Open mouth nurser. No mark. Original clothing, accessories and carrying case with brochure from Dee an Cee Toy. TINY TEARS was also available with moulded hair. From the collection of June C. MacDonald, Halifax, N.S.

CJ3

BC15

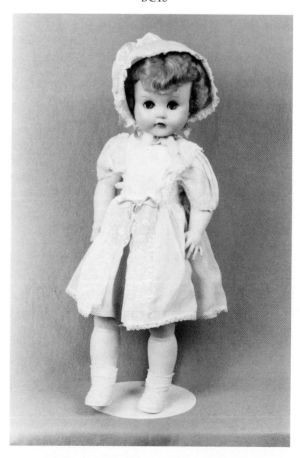

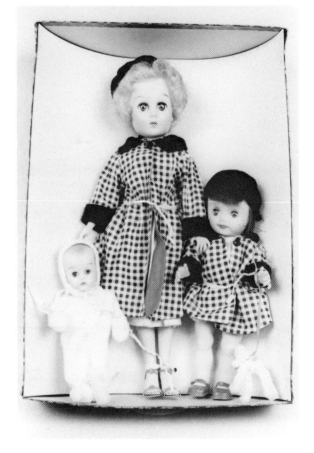

CX19
Dee an Cee. 1959. OUR LOVABLE FAMILY, CINDY, PENNY and BABY SISTER. CINDY has a plastic body with jointed hips, waist, shoulders, and neck. Vinyl head, sleep eyes, lashes and painted lower lashes; rooted blond hair; closed mouth. PENNY has a vinyl body, jointed hips, shoulders, and neck. Vinyl head; sleep eyes, lashes; rooted Buster Brown hair; closed mouth. BABY SISTER has a one piece vinyl body. CINDY is wearing all original black check coat, brushed rayon tam which matches the coat collar and cuffs, white taffeta dress with black silk braid trim, nylons, and high heels. PENNY wears a similar outfit, and BABY SISTER wears a white brushed rayon snowsuit. Includes dog on a leash. Original box. From the collection of Cathy Dorsey, St. Catharines, Ont.

AE10
Dee an Cee. 1959. DREAM BABY. 16 in. (40.5 cm). Plastic body, jointed hips, shoulders, and neck. Vinyl head; blue sleep eyes, lashes, painted lower lashes; rooted short curly brown hair; closed mouth. Mark: on head, DEE CEE; on body, dee an cee. This is a basic doll and had different names and different outfits. Also came in 14, 18, 21 inch sizes. From the collection of Judy Smith, Ottawa, Ont.

CF30
Dee an Cee. 1958. CINDY IN HER SUNDAY BEST. 17 in. (43.5 cm). Plastic body, jointed hips, waist, shoulders, and neck. Vinyl head; blue sleep eyes, lashes, painted lower lashes; rooted honey blond saran curls; closed mouth. Mark: on head, D & C; on body, DEE AN CEE. Original polished cotton dress trimmed with velveteen ribbon and matching straw hat. From the collection of Gloria Kallis, Drayton Valley, Alta.

CX19

AE10

CF30

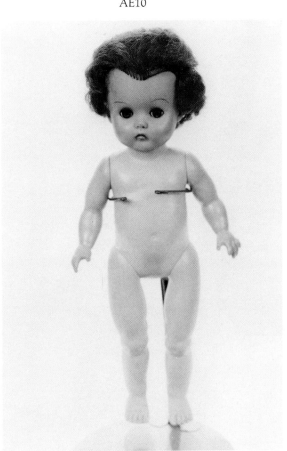

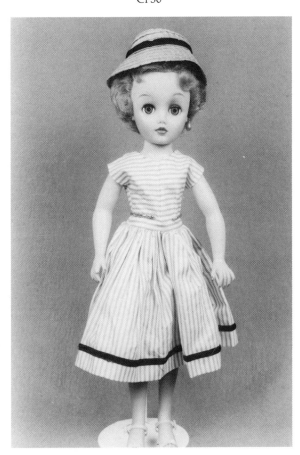

BY16
Dee an Cee. ca.1958. 22 in. (56 cm). Hard plastic body, jointed hips, shoulders, and neck. Hard plastic head; blue sleep eyes, lashes, painted lower lashes; moulded hair, painted light brown; open mouth showing two inset teeth and tongue. Mark: on body, D&C. Original pink eyelet dress and matching bonnet. Author's collection.

CR10
Dee an Cee. 1959. KELLY IN PIGTAILS. 16 in. (40.5 cm). Plastic body, jointed hips, shoulders, and neck. Vinyl head; blue sleep eyes, lashes, painted lower lashes; rooted blond saran hair in pigtails with bangs; closed mouth. Mark: on head, 3 ; on body, D&C. Original red and white checked dress with white apron. Replaced straw hat. Author's collection.

BX5
Dee an Cee. 1959. BABY SUE. 24 in. (61 cm). Plastic baby body, jointed hips, shoulders, and neck. Vinyl head; brown sleep eyes, lashes, painted lower lashes; rooted auburn short curls; open mouth nurser. Mark: on body, DEE AN CEE. Redressed. Originally wore a three piece cotton sunsuit in pink or blue composed of a sunsuit, bolero jacket, and skirt with white sandals. She also came in 13, 15, 18 and 20 inch sizes. From the collection of Wilma MacPherson, Mount Hope, Ont.

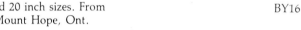

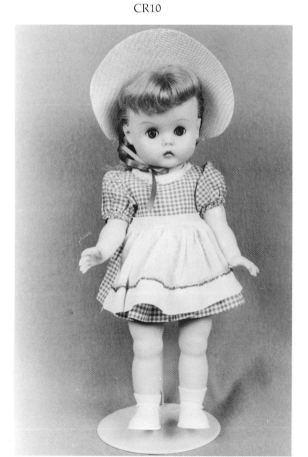

BY16

CR10

BX5

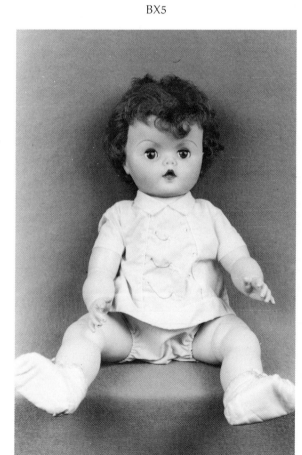

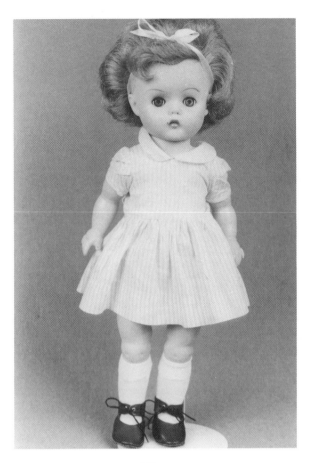

CB14

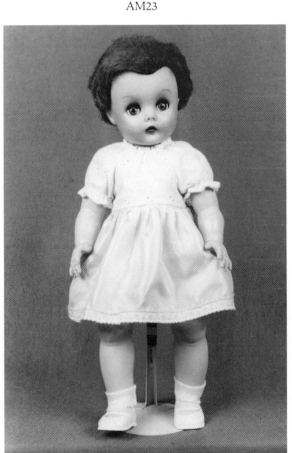

AM23

CB14
Dee an Cee. 1959. KELLY. 15 in. (38 cm). Plastic body, jointed hips, shoulders, and neck. Vinyl head; blue sleep eyes, lashes, painted lower lashes; rooted blond saran curls; closed mouth. Mark: on head, Made in Canada/Dee an Cee. Original pink and white striped dress and matching panties, replaced socks and shoes. From the collection of Mary Van Horne, Chilliwack, B.C.

AM23
Dee an Cee. 1959. DREAM BABY. 18 in. (46 cm). Plastic body, jointed hips, shoulders, and neck. Vinyl head; blue sleep eyes, lashes, painted lower lashes; rooted curly brown hair; closed mouth. Mark: on head, Dee an Cee. Redressed. Well made of a heavy plastic, probably one of the early blow moulded plastics when a thicker plastic made a very sturdy doll. Author's collection.

CF29
Dee an Cee. 1959. BONNIE. 19 in. (48.5 cm). One piece stuffed Flexee-vinyl. Vinyl head; blue sleep eyes, lashes; rooted blond saran hair; closed mouth. Mark: on head, Dee an Cee. Original Scottish outfit. From the collection of Gloria Kallis, Drayton Valley, Alta.

CF29

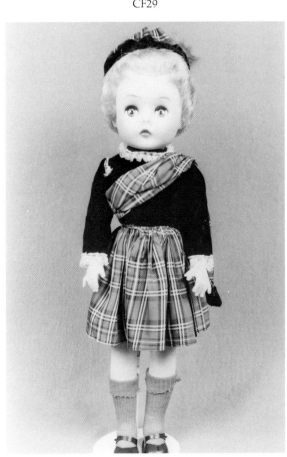

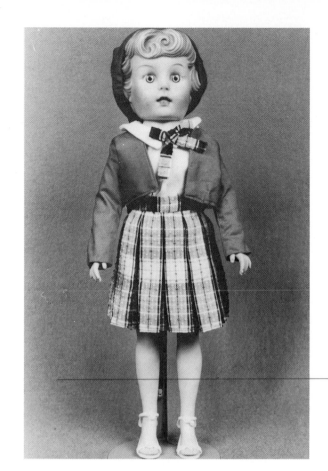

CW31
Dee an Cee. l959. BONNIE. 17 in. (43 cm). One piece stuffed vinyl body. Vinyl head; inset blue eyes; deeply moulded hair; closed mouth. Mark: on head, DEE & CEE. Possibly original clothing, although BONNIE usually wore a Scottish costume. From the collection of Sylvia Higgins of the Remember When Museum at Laidlaw, B.C.

BS12
Dee an Cee. 1959. HONEY BEA. 18 in. (45.5 cm). Plastic body, jointed hips, shoulders, and neck. Vinyl head; brown sleep eyes, lashes, painted lower lashes; rooted, saran, brown ponytail and bangs; closed mouth. Mark: on head, Dee an Cee. Original pink nylon lace-trimmed dress, socks and buttoned shoes. Original box. A very pretty doll in mint condition. From the collection of Wilma MacPherson, Mount Hope, Ont. See also Fig. BS14.

CW31

BS12

BS14

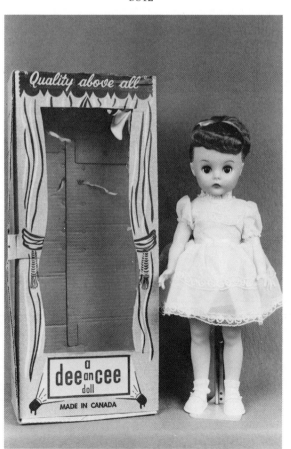

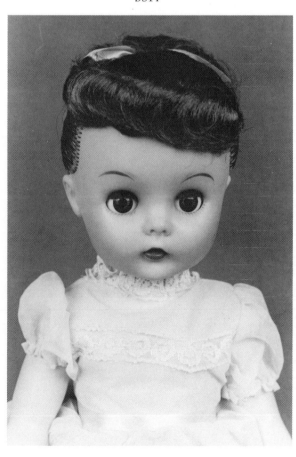

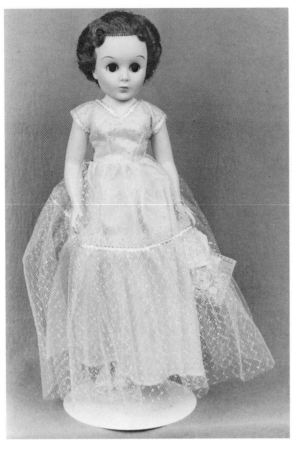

BQ15

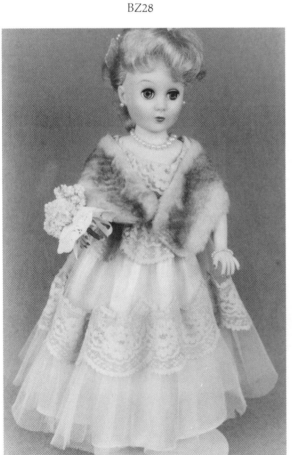

BZ28

BQ15
Dee an Cee. 1959. NANETTE BRIDESMAID. 19 in. (48.5 cm). Hard plastic teen body, jointed hips, waist, shoulders, and neck. Vinyl head; brown sleep eyes, lashes, painted lower lashes; rooted brown saran curls; closed mouth. Mark: none, but wearing wrist tag, D&C Toy Co. Quality Above All. Original yellow net gown with silver trim. A bride doll named NINA was also sold. Courtesy of the National Museums of Canada, National Museum of Man, Ottawa, Ont.

BZ28
Dee an Cee. 1959. SWEET SUE FORMAL. l8 in. (45.5 cm). Plastic body, jointed waist, hips, shoulders, and neck. Vinyl head; blue sleep eyes, lashes, painted lower lashes; rooted saran hair in a pony tail with bangs; closed mouth. Mark: on head, DEE CEE. Elegantly dressed in her original gown with tiers of lace on net over satin with simulated blue mink stole and pearl earrings, necklace and bracelet. SWEET SUE also came in 20 and 25 in. sizes. From the collection of Phyllis McOrmond, Victoria, B.C.

CT14
Dee an Cee. 1959. MARGO. 24 in. (61 cm). One-piece Flexee-vinyl body. Vinyl head; blue sleep eyes, lashes, painted lower lashes; rooted blond curls; closed mouth. Redressed. Originally wore a knee-length flower flocked nylon dress with lace trim, contrasting ribbon sash to match the ties on her poke bonnet, white socks and button vinyl shoes. From the collection of Glenda Shields, London, Ont.

CT14

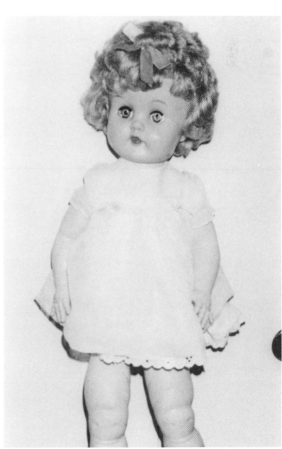

BX16
Dee an Cee. 1959. CINDY BRIDE. 17 in. (43.5 cm). Plastic body, jointed hips, waist, shoulders, and neck, wearing nail polish. Vinyl head; pierced ears and pearl earrings; blue sleep eyes, lashes, painted lower lashes; rooted short blond saran hair; closed mouth. Mark: on head, D&C; on body, Dee an Cee. Original bridal gown in net with silver threads over white taffeta; lillies-of-the-valley sprays on each side of her headdress and veil, carrying a matching bouquet; originally wearing a solataire ring. From the collection of Wilma MacPherson, Mount Hope, Ont.

CR21
Dee an Cee. 1960. CALYPSO JILL. 14 in. (35.5 cm). Plastic body, jointed hips, shoulders, and neck. Vinyl head; moulded eyes painted black; black moulded hair in pigtails and bangs; mouth open-closed. Mark: on head, DEECEE. Replaced patchwork pattern dress by Georgee Prockiw, Nepean, Ont. A close copy of the original. Originally wore a dress of patchwork pattern cotton with white pique collar trimmed with red rickrack; red hair ribbons; red shoes. Author's collection.

CD8
Dee an Cee. 1960. DRINK 'N WET BABY. 19 in. (47 cm). Plastic baby body, jointed hips, shoulders, and neck. Vinyl head; blue sleep eyes, lashes, painted lower lashes; moulded light brown hair; open mouth nurser. Mark: on head, DEE CEE. Original underwear and plastic bag. From the collection of Lola Fast, Burnaby, B.C.

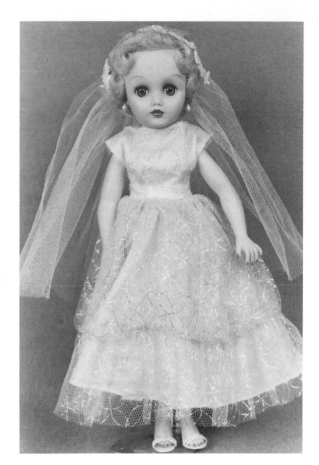

BX16

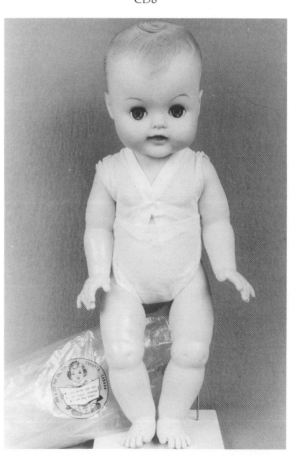

CD8

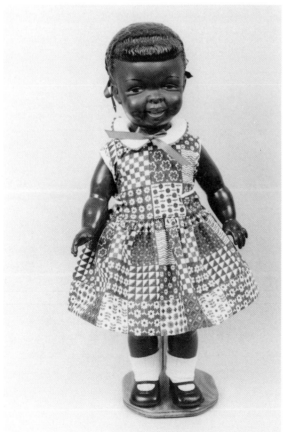

CR21

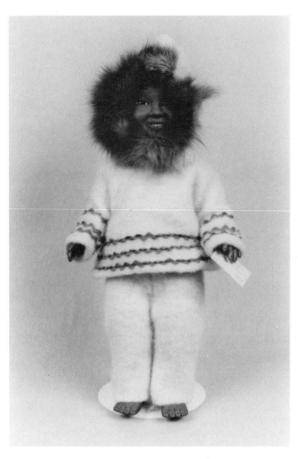

CX14

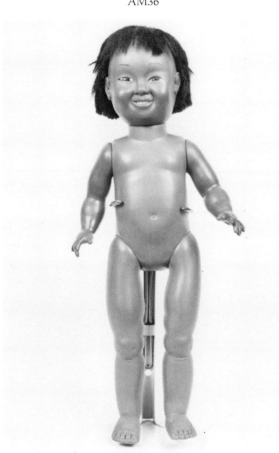

AM36

CX14
Dee an Cee. ca.1960. KOWEEKA. 15 in. (38 cm). Brown plastic body, jointed hips, shoulders, and neck. Vinyl head; painted black eyes; rooted straight black hair; open-closed mouth, smiling and showing painted teeth. Mark: on head, KOWEEKA © /HUDSONS BAY CO.; on body, Made in Canada/dee and cee. Original parka trimmed with rickrack, fur trimmed hood, boots missing but were originally made of the same material as the parka. Zipper down the back of the jacket for easy dressing. Hudsons Bay Co. owned the copyright on this head and licensed Dee an Cee to make it. From the collection of Cathy Dorsey, St. Catharines, Ont. See also Fig. AM36.

CG19
Dee an Cee. 1960. DRINK 'N WET BABY. 19 in. (47 cm). Plastic baby body, jointed hips, shoulders, and neck. Vinyl head; blue sleep eyes, lashes, painted lower lashes; brown rooted saran curly hair; open mouth nurser. Mark: on head, Dee Cee. Redressed in old yellow nylon dress and 58 year old crocheted bonnet. She originally wore a sunsuit. From the collection of June Rennie, Saskatoon, Sask.

CG19

CS22A

CS22A
Dee an Cee. 1960. POLLYANNA. 31 in. (79 cm). Plastic teen-aged girl, jointed hips, shoulders, and neck. Vinyl head; blue sleep eyes, lashes, distinctive black lashes painted at outside of upper eyelids; rooted blond saran hair with bangs; open-closed mouth, smiling and showing painted teeth. Mark: on head WALT DISNEY/Prod./Mfr. BY Dee An Cee/NF; on body, Dee an Cee. A beautifully modelled body and face, POLLYANNA moulds were obtained in the United States. Dee an Cee was licensed to produce the doll in Canada. She represents POLLYANNA from the 1960 Walt Disney movie of the same name. Replaced clothing a close copy of the original by Georgee Prockiw. Author's collection. See also Figs. CS23A and BU37.

CS23A

BU37

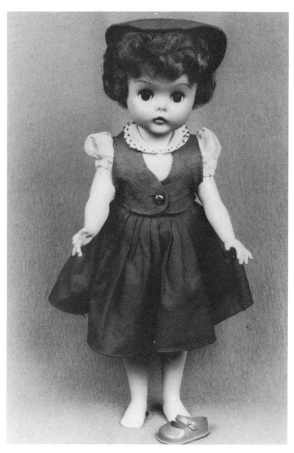

CW7

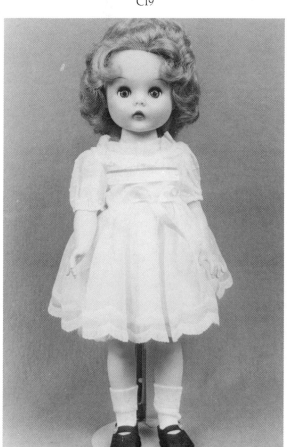

CI9

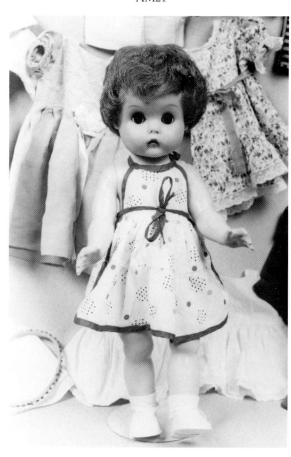

AM21

CW7
Dee an Cee. 1960. KELLY GOING TO SCHOOL. 19 in. (47 cm). Plastic body, jointed hips, shoulders, and neck. Vinyl head; brown sleep eyes, lashes, painted lower lashes; rooted curly saran brown hair; closed mouth. Mark: on head, Dee An Cee; on body, D&C. Original navy pleated skirt, white blouse attached, red felt vest and matching hat, one red shoe. From the collection of Joyce Cummings, North Vancouver, B.C.

CI9
Dee an Cee. 1960. KELLY. 18 in. (45.5 cm). Plastic body, jointed hips, shoulders, and neck. Vinyl head; blue sleep eyes, lashes and painted lower lashes; rooted blond saran hair; closed mouth. Mark: on head, DEE AN CEE. Original embroidered pink nylon dress, socks and shoes. From the collection of Ruth MacAra, Caron, Sask.

AM21
Dee an Cee. 1960. KELLY. 16 in. (40.5 cm). Plastic body, jointed hips, shoulders, and neck. Vinyl head; brown sleep eyes, lashes, painted lower lashes; rooted short curly brown saran hair; closed mouth. Mark: on head, D&C/3; on body, 165-5/D&C. Original red-trimmed sunsuit. Originally wore white toeless sandals. Childhood doll of Susan Strahlendorf. KELLY, like some of the nineteenth century dolls, has an extensive wardrobe, all beautifully tailored by Susan's grandmother, Charlotte Strahlendorf. Author's collection.

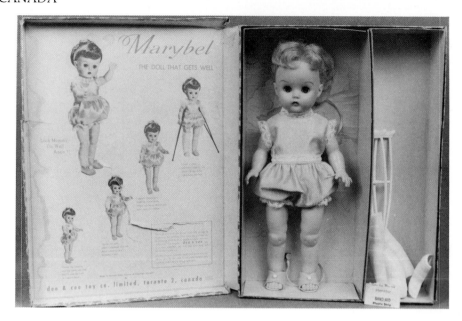

CG4

CG4
Dee an Cee. 1960. MARYBEL THE DOLL THAT GETS WELL.
15 in .(38 cm). Plastic body and legs, vinyl arms. Vinyl head;
blue sleep eyes, lashes; rooted blond saran hair; closed mouth.
Mark: on head, DEE CEE; on body, D&C. Original box,
crutches, arm and leg casts. Replaced clothing a copy of the
original satin playsuit which came with matching slippers and
sunglasses. MARYBEL can catch measles and chicken-pox very
easily, and lose her spots just as quickly. From the collection
of Gloria Kallis, Drayton Valley, Alta.

CX1
Dee an Cee. ca.1961. DREAM BABY. 14 in. (35.5 cm). Cloth
body, vinyl bent-limb arms and legs. Vinyl head; blue sleep
eyes, lashes; rooted blond straight hair; open-closed mouth.
Mark: on head, DEE AN CEE/ © 1961. From the collection of
Mr. Mrs. C. Milbank, Sarnia, Ont.

CB5
Dee an Cee. 1960. PATTY KAY. 30 in. (76.5 cm). Plastic body,
jointed hips, shoulders, and neck. Vinyl head with dimpled
cheeks and chin; brown sleep eyes, lashes, painted lower lashes,
repainted brows; rooted brown curly hair; open-closed mouth
with four moulded teeth, two up and two down. Mark: on head,
DEE CEE. PATTY KAY is wearing a cream pantsuit with a but-
terfly design hand painted by Bea Gott of Chilliwack. Originally
she wore either a nylon party dress or a broadcloth dress with
detachable apron. From the collection of Mary Van Horne,
Chilliwack, B.C.

CB5

CX1

C129
Dee an Cee. 1960. GIGI. 20.5 in. (52 cm.). Plastic body, jointed hips, shoulders, and neck. Vinyl head; green sleep eyes, lashes; long red-gold saran hair with bangs; smiling closed mouth. Mark: on body, D & C. Originally wore her hair long and straight with bangs and was dressed either in an ice skating dress, a party dress, a play dress, or a ballet costume. From the collection of Elva Boyce, Regina, Sask.

CW22
Dee an Cee. 1960. WILLY. 16 in. (40.5 cm.). Plastic body, jointed hips, shoulders, and neck. Vinyl head; blue sleep eyes, lashes, painted lower lashes; well defined moulded hair, painted black; closed mouth. Mark: on body, Dee an Cee. Original black wool suit and white shirt. From the collection of Sylvia Higgins of the Remember When Doll Museum at Laidlaw, B.C.

CJ4
Dee an Cee. 1961. DRINK 'N WET BABY. 20 in. (50.5 cm.). Brown plastic body, jointed hips, shoulders, and neck. Vinyl head; brown sleep eyes, lashes, painted lower lashes; rooted short curly hair; open mouth nurser. Mark: on body, 20-638. Originally wore a red and white polka dot sunsuit and came with a bottle. From the collection of Marilyn Cox, Regina, Sask.

C129

CW22

CJ4

CD19

CS9

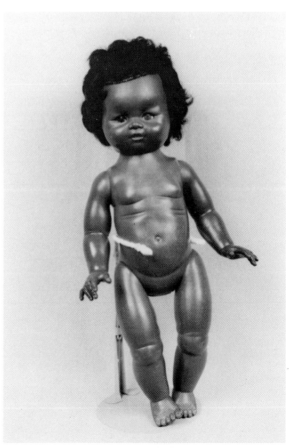

CW22A

CD19
Dee an Cee. 1961. CALYPSO BILL. 16 in. (40.5 cm). Brown plastic body, jointed hips, shoulders, and neck. Vinyl head; painted black eyes; moulded black curly hair; open-closed mouth showing six painted teeth. Mark: DEE CEE. Mint in box. All original. An outstanding doll designed by Morris Cone. BILL and JILL are truly Canadian dolls because they were designed by a Canadian and made by a Canadian company. They represent one of the ethnic groups in Canada. From the collection of Peggy Bryan, Burnaby, B.C.

CS9
Dee an Cee. 1961. CALYPSO JILL. 16 in. (40.5 cm). Brown plastic body, jointed hips, shoulders, and neck. Vinyl head; painted black eyes; well defined moulded hair with bangs and pigtails in black; open-closed mouth, smiling and showing painted teeth. Mark: on body, dee an cee. Replaced clothing a close replica of the original by Georgee Prockiw. CALYPSO JILL and BILL were designed by Morris Cone. The same head was used in 1956 with a Skintex body. Author's collection.

CW22A
Dee an Cee. 1961. LULUBELLE. 20 in. (51 cm). Brown plastic body, jointed hips, shoulders, and neck. Vinyl head; golden brown sleep eyes, lashes; rooted black curly hair; open mouth nurser. Mark: on head, DEE AN CEE ; on body, dee an cee. From the collection of Mr. Mrs. C. Milbank, Sarnia, Ont.

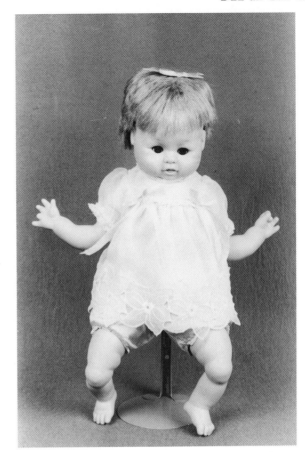

BN32
Dee an Cee. 1961. DREAM BABY. 17 in. (43 cm). Cloth body, vinyl bent-limb arms and legs. Vinyl head; chubby face, blue sleep eyes, lashes, rooted straight blond hair over moulded hair; open-closed mouth. Mark: on head, DEE AN CEE. Original embroidered nylon dress and matching panties. From the collection of Irene Henderson, Winnipeg, Man.

CW10
Dee an Cee. 1961. DREAM BABY. 18 in. (45.5 cm). Cloth body, vinyl bent-limb arms and legs. Vinyl head; painted blue eyes; rooted straight saran hair; closed mouth. Mark: on head, DEE CEE. Originally wore flannelette baby doll pyjamas and was wrapped in a blanket and tied with a ribbon. Several different babies were called DREAM BABY in 1961. From the collection of Berna Gooch, North Vancouver, B.C.

BX6
Dee an Cee. 1961. DREAM BABY. 19 in. (47 cm). Vinyl bent-limb baby body, jointed hips, shoulders, and neck. Vinyl head; blue sleep eyes, lashes and painted lower lashes; reddish brown moulded hair; open mouth nurser. Mark: on head, DEE CEE/1961; on body, DC. Originally came in shirt, diaper and blanket tied with a ribbon and including a bottle. From the collection of Wilma MacPherson, Mount Hope, Ont.

BN32

BX6

CW10

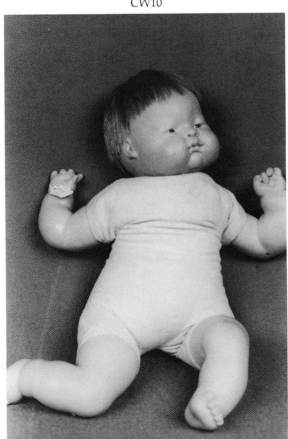

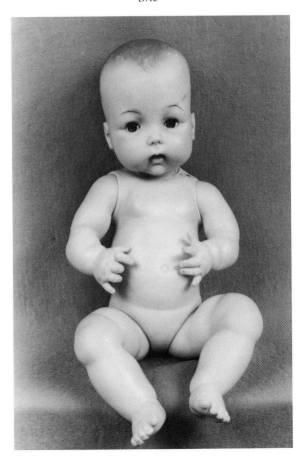

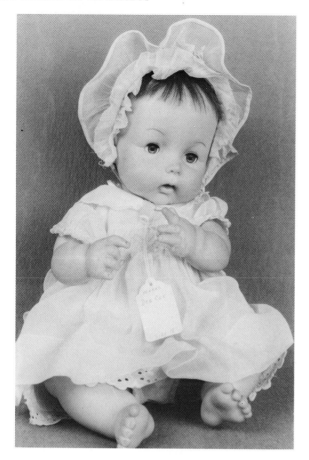

CA36

CT23

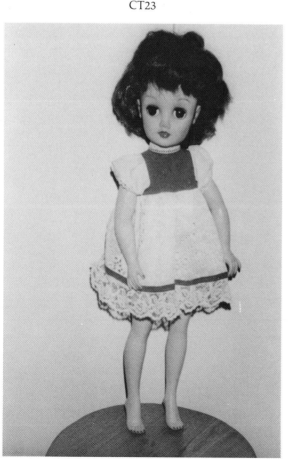

CA36
Dee an Cee. 1961. DREAM BABY. 18 in. (45.5 cm). Vinyl bent-limb baby body, jointed hips, shoulders, and head. Vinyl head; blue sleep eyes, lashes, painted lower lashes; rooted brown straight hair over moulded hair; open mouth nurser. Mark: on head, DEE CEE; on body, DEE CEE. Redressed in white organdy similar to the original dress and bonnet. DREAM BABY also sucks her thumb. From the collection of Mrs. D.H. Morman, Victoria, B.C.

CT23
Dee an Cee. 1961. CINDY. 17 in. (43 cm). Plastic teen body, jointed hips, waist, shoulders, and neck. Vinyl head; brown sleep eyes, lashes, painted lower lashes; rooted brown hair; closed mouth. Redressed. High Fashion Teenaged Doll. CINDY came in three different outfits: 1. a chromespun strapless evening gown trimmed with gold braid, black net cocktail hat and stole, lace trimmed panties, nylons and high heels; 2. a two piece jumper suit of red gabardine with matching piping, matching hat, nylons and high heels; 3. a dress of beige playcord and leopard lined coat with leopard cuffs and hat, nylons and high heels. From the collection of Glenda Shields, London, Ont.

CD3
Dee an Cee. 1961. MOON BABY. 18 in. (45.5 cm). Plastic body vinyl bent-limb arms and legs, jointed hips, shoulders, and neck. Vinyl head; large blue sleep eyes, long dark lashes; rooted blond saran hair; open mouth nurser. Mark: on head, DEE CEE. Original sunsuit, bonnet and bottle. Original label: MOON BABY/The doll with the/PEEK-A-BOO EYES/They follow you wherever you go./T.M. Reg'd. 1960/Made in Canada/dee & cee toy co. ltd. From the collection of Peggy Bryan, Burnaby, B.C.

CD3

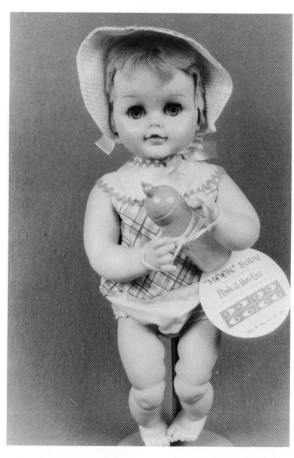

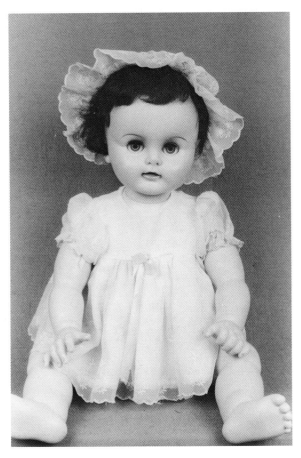

BZ21

BZ21
Dee an Cee. 1961. MOON BABY. 28 in. (71.5 cm). Plastic bent-limb baby body, jointed hips, shoulders, and neck, with a crier in the body. Vinyl head; blue sleep eyes, lashes, painted lower lashes; rooted saran black hair in a baby feather cut; open mouth nurser. Mark: on head, Dee Cee. Original embroidered nylon dress and matching hat; originally wore knitted bootees. An innovative doll with eyes that follow you, called the doll with the peek-a-boo eyes, beautifully dressed. She also came in 22 and 18 inch sizes. From the collection of Phyllis McOrmond, Victoria, B.C.

BQ6
Dee an Cee. 1961. WILLY THE SAILOR. 16 in. (40.5 cm). Plastic body, jointed hips, shoulders, and neck. Vinyl head; blue sleep eyes, lashes, painted lower lashes; moulded hair, painted black; closed mouth. Original label, Dee and Cee/Quality above all. Original sailor suit. Courtesy of the National Museums of Canada, National Museum of Man, Ottawa, Ont.

BN29
Dee an Cee. 1961. WILLY. 16 in. (40.5 cm). Plastic body, jointed hips, shoulders, and neck. Vinyl head; blue sleep eyes, lashes, painted lower lashes; moulded hair, painted black; closed mouth. Mark: on body, deeancee. Original clothing, replaced shoes and socks. From the collection of Irene Henderson, Winnipeg, Man.

BQ6

BN29

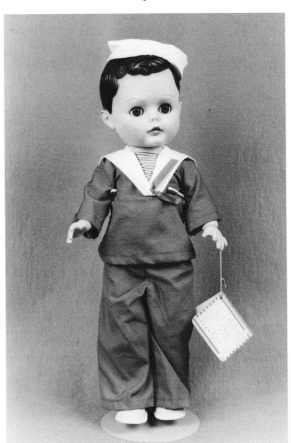

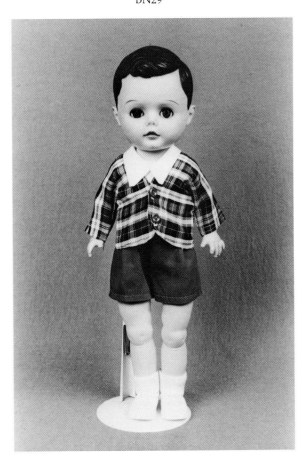

BQ21
Dee an Cee. 1961. WILLY THE MOUNTIE. 16 in. (40.5 cm). Plastic body, jointed hips, shoulders, and neck. Vinyl head; blue sleep eyes, lashes, painted lower lashes; moulded black hair; closed mouth. Original Dee an Cee label. Original clothing, hat missing. Courtesy of the National Museums of Canada, National Museum of Man, Ottawa, Ont.

CF32
Dee an Cee. 1961. MARYBEL THE GET WELL DOLL. 15 in. (38 cm). plastic body and legs, vinyl arms. Vinyl head; blue sleep eyes, lashes, painted lower lashes; rooted brown saran hair; open mouth nurser. Mark: on head, DEE CEE; on body, D&C. Original cotton playsuit (a different style than 1960), wearing her arm and leg cast. From the collection of Margaret Rasmussen, Drayton Valley, Alta.

BS32
Dee an Cee. 1961. KELLY. 22 in. (56 cm). Plastic body, jointed hips, shoulders, and neck. Vinyl head. Brown sleep eyes, eyelashes; painted lower lashes. Rooted dark brown short curls. Open-closed mouth. Mark: on head, D&C. Original checked dress with black frill. Original label: Hold my left hand up and I will walk with you. A beautifully made doll in mint condition. From the collection of Wilma MacPherson, Mount Hope, Ont.

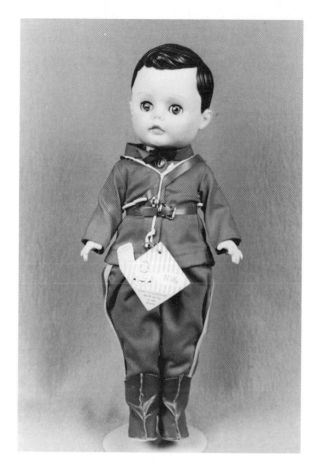

BQ21

CF32

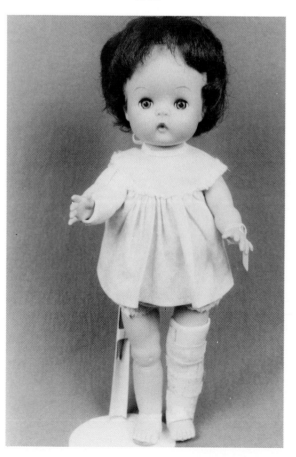

BS32

BU5

CD25

CB17

BU5
Dee an Cee. 1961. CHATTY CATHY. 20 in. (50 cm). Hard plastic body, jointed hips, shoulders, and neck; holes in the front for speaker and pullring in the back to operate talking device. Vinyl head; blue sleep eyes, lashes, freckles; rooted blond saran hair with bangs; open-closed mouth showing two teeth. Mark: on body, CHATTY CATHY/c1960 CHATTY BABY/c1961/BY MATTEL INC./U.S. PAT. 3,017,187/Other U.S. &/FOREIGN PATS. PEND./PAT. IN CANADA 1962. Redressed. Also available with different coloured hair. Dee an Cee was licensed by Mattel to make CHATTY CATHY. Author's collection.

CD25
Dee an Cee. ca.1962. DREAM BABY. 18 in. (45.5 cm). Cloth body, vinyl bent-limb arms and legs; Vinyl head; blue sleep eyes, lashes; light-brown slightly moulded hair; open-closed mouth. Mark: on head, DEE AN CEE/MADE IN CANADA. From the collection of Peggy Bryan, Burnaby, B.C.

CB17
Dee an Cee. ca.1962. DREAM BABY. 18 in. (45.5 cm). Pink cloth body, vinyl bent-limb arms and legs, swivel neck. Vinyl head; blue sleep eyes, lashes; rooted blond straight hair; open-closed mouth, moulded tongue. Mark: on head, DEE AN CEE/MADE IN CANADA. Redressed. From the collection of Mary Van Horne, Chilliwack, B.C.

CX16

CX16
Dee an Cee. 1962. TINY CHATTY BABY. 15 in. (38 cm). Plastic body, jointed hips, shoulders, and neck, pullring at shoulder. Vinyl head; blue sleep eyes, lashes; rooted straight brown hair; open-closed mouth showing two moulded teeth. Original dress and panties with her name on the bib. Original label. Original box with Dee an Cee in small print at the bottom. From the collection of Cathy Dorsey, St. Catharines, Ont.

CP5
Dee an Cee. ca.1962. 19 in. (47 cm). Plastic bent-limb baby body, jointed hips, shoulders, and neck. Blue sleep eyes, lashes; light brown moulded hair; open mouth nurser. Mark: on head, DEE AN CEE. Redressed. From the collection of Bernice Tomlinson, Etobicoke, Ont.

CD9
Dee an Cee. ca.1963. 19 in. (47 cm). Plastic body, jointed hips, shoulders, and neck. Vinyl head; blue sleep eyes, lashes; light brown slightly moulded hair; closed mouth. Mark: on head, DEE AN CEE CANADA ; on body, MADE IN CANADA dee an cee. From the collection of Peggy Bryan, Burnaby, B.C.

CP5

CD9

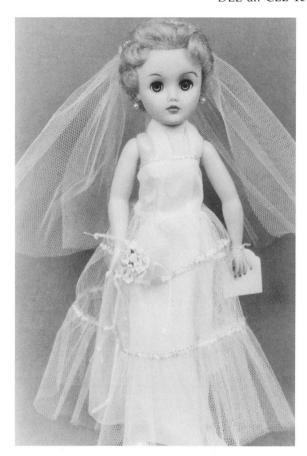

CF21
Dee an Cee. ca.1962. CINDY BRIDE. 17 in. (43 cm). Plastic teen body, jointed hips, shoulders, and neck. Vinyl head, holes for earrings; brown sleep eyes, lashes, painted lower lashes; rooted blond saran hair; closed mouth. Mark: D & C. Original white net gown, trimmed in silver, white net veil. From the collection of Margaret Rasmussen, Drayton Valley, Alta.

CF25
Dee an Cee. ca.1962. 17 in. (43 cm). Plastic teen body, jointed hips, shoulders, and neck. Vinyl head; blue sleep eyes, lashes; rooted blond saran hair; closed mouth. Mark: D & C. Original green gown with net overskirt. From the collection of Margaret Rasmussen, Drayton Valley, Alta.

BU17
Dee an Cee. ca.1963. KOOKIE. 25 in. (64 cm). Black cloth body, legs and upper arms, pink cloth forearms. Vinyl head; brown sleep eyes, lashes, eyeshadow and extra heavy upper lashes, painted lower lashes; rooted long black hair; open-closed mouth. Mark: on head, DEE CEE. Original burlap dress. A trendy doll to appeal to older children. From the collection of Dominique Lévesque and Steven Miles, Ottawa, Ont.

CF21

CF25

BU17

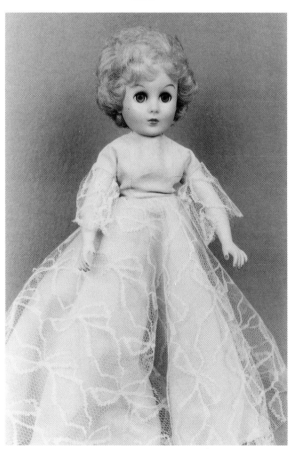

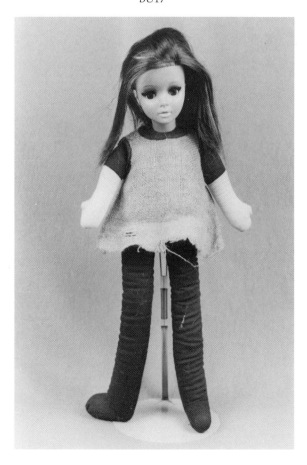

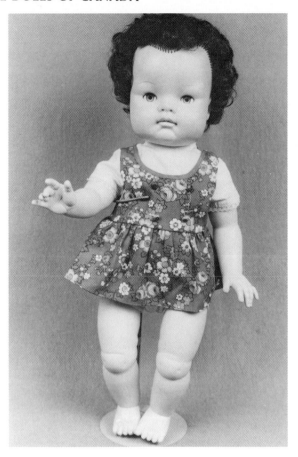

CL26

CL26
Dee an Cee. ca.1963. 20 in. (51 cm). Plastic body, jointed hips, shoulders, and neck. Vinyl head; blue sleep eyes, lashes; rooted brown saran curly hair; closed mouth. Mark: on head, DEE CEE/CANADA/20; on body, MADE IN CANADA/dee an cee. Original print dress. From the collection of Joyce Cummings, North Vancouver, B.C.

BX13
Dee an Cee. ca.1963. 17 in. (43 cm). Plastic teen body, jointed hips, waist, shoulders, and neck. Vinyl head; blue sleep eyes, lashes, tiny painted lower lashes, three long upper lashes at outside edges of eyes; rooted brown saran hair with blond streak at the front; closed mouth. Mark: on head, DEE & CEE; on body, Dee An Cee. Original grey lace dress and high heels. From the collection of Wilma MacPherson, Mount Hope, Ont.

CF7
Dee an Cee. ca.1963. BABY PATTABURP. 17 in. (43 cm). Cloth body, vinyl arms and legs. Vinyl head; blue sleep eyes, lashes; rooted straight blond hair; open-closed mouth. Mark: on head, DEE AN CEE; label on body, MATTEL. Redressed. From the collection of Gloria Kallis, Drayton Valley, Alta.

BX13

CF7

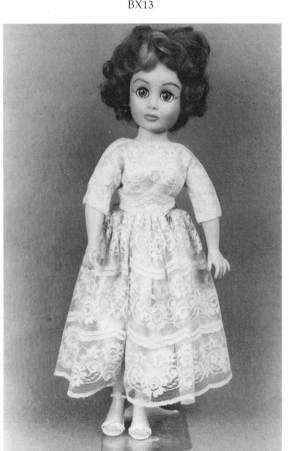

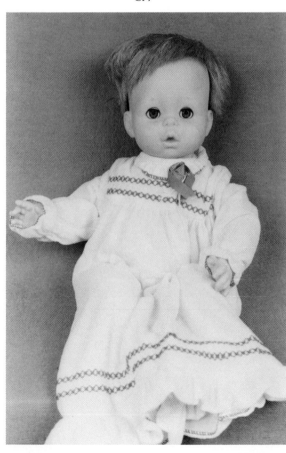

CJ11
Dee an Cee. ca.1963. 12 in. (30 cm). Brown plastic body and legs, vinyl arms, upturned hands. Brown vinyl head; inset brown plastic eyes, moulded lashes, painted lower lashes; rooted light brown hair; open-closed mouth. Mark: on head, DEE CEE/MADE IN CANADA. Original orange dress, white trim. From the collection of Elva Boyce, Regina, Sask.

CJ10
Dee an Cee. ca.1963. 12 in. (30 cm). Plastic body, jointed hips, shoulders, and neck. Vinyl head; fixed blue plastic eyes, moulded lashes; rooted brown curls; open-closed mouth. Mark: on head, DEE CEE/MADE IN /CANADA. Original red and white checked dress. From the collection of Elva Boyce, Regina, Sask.

BU31
Dee an Cee. ca.1963. ll.5 in. (29 cm). Brown plastic body, vinyl arms, upturned hands, jointed hips, shoulders, and neck. Vinyl head; fixed brown eyes, plastic lashes, painted lower lashes; rooted straight black hair; open-closed mouth. Mark: on head, DEE CEE/MADE IN CANADA; on body, dee & cee/ Made in Canada. Original wool snow suit with hood trimmed in synthetic fur. Author's collection.

CJ11

CJ10

BU31

BX10

AN5

BX10
Dee an Cee. 1964. 15 in. (38 cm). Plastic body, jointed hips, shoulders, and neck. Vinyl head; blue side-glancing sleep eyes, lashes; rooted long blond hair; closed pouty mouth. Mark: on head, DEE & CEE/MADE IN CANADA/1964. Original striped dress. This doll is not a true Dee an Cee doll for it was made after Mattel acquired the company. It has, however, the Dee an Cee mark. From the collection of Wilma MacPherson, Mount Hope, Ont.

AN5
Dee an Cee. 1964. 15 in. (38 cm). Plastic body and legs, vinyl arms, jointed hips, shoulders, and neck. Vinyl head; blue side-glancing sleep eyes, lashes; rooted platinum blond saran hair; closed pouty mouth. Mark: on head, DEE & CEE/MADE IN CANADA/ copyright 1964. Original green and white dress and bolero, socks and shoes. Author's collection.

Dominion Toy Manufacturing Company Limited

Canadians had been importing European dolls for many years and had begun buying them from the United States during the early years of this century. In 1911 Aaron Cone[1] founded the doll industry in Canada by establishing the Dominion Toy Manufacturing Company Limited at 157-165 Queen Street East in Toronto, Ontario. A man of vision, Mr. Cone knew that there was no domestic toy industry in Canada and that here was a potential market. He became Canada's first successful doll manufacturer.

A talented designer, an inventor, and a gifted musician, Aaron Cone had previously founded Ideal Novelty Company in New York City, in 1902, with his partner Morris Michtom. Mr. Cone designed many character dolls for Ideal Novelty Company, such as

Naughty Marietta, Russian Boy, and Captain Jinks. His wife, Sarah Cone, was also a doll designer who created many dolls for Ideal. Aaron Cone loved children and seemed to know what children enjoyed. His grandson Arthur Cone still has the small wooden violin that his grandfather painstakingly made for him when he was a child. But Aaron Cone did not want to create dolls with pretty faces; he believed dolls should look like real children with character-type faces. His aim, when he began the Dominion Toy Company, was to make realistic dolls that children could love. His son Morris joined him in Toronto in 1911 as manager of the new company to achieve this goal.

Not long after production began, Aaron Cone returned to New York City leaving his son behind to manage the fledgling company. Morris Cone worked hard to make it a successful business in Canada and, because he was a gifted designer like his father and mother, the company gradually grew.

By 1915, Aaron Cone took on three partners to help finance the Dominion Toy Manufacturing Company and to enlarge its capacity to turn out well-made toys, stuffed animals, teddy bears, and cowboy and Indian suits. Max Cohen became president, and Barnet Bernstein and Harry Solway became more or less silent partners.[2]

The new company won a contract with The T. Eaton Co. Limited to supply the 1915 all-composition Eaton's Beauty doll. World War I had started and Eaton's had been unable to get their usual supply of bisque head dolls from Europe, so Eaton's sold large numbers of this doll. It was quite a plum for the first Canadian doll company. Aaron Cone became president of Dominion Toy in 1916 and moved to Toronto. The company grew rapidly. As little as possible was imported, for the company made as many parts as it could in an effort to be self-sufficient.

There was a tremendous market in North America for dolls and toys after World War I broke out, because toys had been traditionally imported from Europe, and this source was now cut off. Dominion strove to produce quality dolls to fill that need. By 1915 the Dominion dolls had wigs and sleep eyes. The company was making an excellent fully ball-jointed composition body at this time, but we have not found a Dominion body with an imported bisque head. Dominion heads were always composition. Mr. Barnet Bernstein, a Dominion Toy Co. executive, took out a Canadian patent in 1918 for a method of constructing the mechanism for sleep eyes. We have found such a Dominion doll head with the patent sticker attached (see Fig. CL20 for a view of the mechanism inside of that head).

The dolls made by Dominion are notable for their very fine smooth hard composition which has stood the test of time. The composition, if properly cared for, will remain well preserved, often with only a little paint flaking to show its age. These dolls were made with Aaron Cone's recipe for a composition dough; a mixture of rosin, glue, wheat flour, and Japanese wax. This recipe was also used by Ideal Novelty Company in the United States during the early years of the twentieth century.

Dominion used the "cold process" method of making composition dolls. The presses and moulds were not heated. The composition had the texture of dough, which was kept hot, then was kneaded into flat pieces determined by the desired size of the head. One piece of composition dough was inserted at the bottom of the cavity of the brass mould, then a collapsable core (invented by Aaron Cone) was inserted, and the mould was placed under the hand press.

After the pressing operation, the head came out of the mould when the collapsable core was removed. The heads were placed on trays where they hardened for twelve to fifteen hours.[3] The two sides of the hardened heads were then glued together and buffed around the seams. They were then ready for colouring.

Paint on composition dolls had a tendency to peel and crack at first, but this problem was overcome by a method of using a lacquer discovered by the Zapon Company of Stamford, Conn.[4] This enamel, a cellulose

product, made it possible for the head to be washable as well as serviceable. We have found some dolls with badly deteriorated bodies but with intact heads, which probably indicates that this product was used only on the heads.

Many early Dominion dolls had composition heads and hands, but the bodies and legs were cloth and stuffed with excelsior. The very early dolls had ugly bodies. The trunk was a shapeless sausage, and the arms and legs were attached by means of a long wire pushed into one arm, through the torso, and out the other arm, with a metal disc on each end. This is one of a number of ways to identify an early Dominion doll.

CL20
View of the mechanism inside a Dominion doll head. Courtesy of Vera Goseltine, Vancouver, B.C.

The earliest dolls were not marked on the body but carried a label on their clothes. Another clue to these dolls is the composition hand and forearm that is pushed onto the cloth arm like a gauntlet, and glued into place. We have discovered only two dolls of another brand with this type of arm, and they were both made by Florentine (see Figs. AM26 and CN10). It is possible that Florentine borrowed this technique from Dominion when Florentine began manufacturing dolls in 1917. However, later Florentine dolls have the usual arm, that is, the cloth is fastened over the composition lower forearm. Dominion also used the latter method of arm construction on some of their later dolls (see Fig. BY12).

In spite of the unattractive bodies, these Dominion dolls had surprisingly fine faces. They were character dolls; they had expression. The faces were not necessarily

beautiful but they were appealing. Aaron Cone sketched the faces and had an Italian sculptor by the name of Corolla sculpt the heads. When the results met with Aaron Cone's approval, a mould was made of each head (see Fig. BW34).

Dominion also made an inexpensive doll for many years, sometimes called a knockabout doll. It had composition shoulderhead and forearms. The body and legs were cloth, stuffed with excelsior (see Fig. BH32). The manufacture of these less expensive Dominion dolls went on for so long that it is difficult now to pinpoint the date of each one, unless it has the original clothes. However, it is possible to trace the long-term improvement in quality and sophistication of Dominion dolls by comparing the bodies.

There was lull in the doll industry after the war. In 1921, Dr. Lloyd, a dentist in Orillia, Ontario, invented the mama voice.[5] It was a small sound box inserted in the stuffed cloth body of a doll. Dominion made a mama doll which contained this voice box that "cried" when the doll was tilted. This mama doll was dressed in gingham rompers and sold extremely well for the next few years. It helped Dominion become the largest doll manufacturer in Canada at that time.

In 1923 Aaron Cone obtained a Canadian patent for sleeping eyes that were made with wooden balls covered with a celluloid front. He took out a patent for these eyes in the United States in 1924.

Aaron Cone went back to New York City in 1926, leaving his son Morris to manage Dominion Toy. Aaron Cone died in 1931. He will be remembered for establishing the doll industry in Canada. He had also established a dynasty of Canadian dollmakers. Morris Cone, and eventually Aaron's grandson, Arthur Cone, followed the family tradition as dollmakers. It is interesting to note that Arthur's children, although they did not become dollmakers, are both working with children in their professional capacities.[6]

Dominion dolls are very interesting for they show how Canadian dolls progressed from their primitive beginnings to the fashionable dolls of 1930. An innovative Company, Dominion was making dolls with an elementary walking device about 1918. The first dolls, with unwieldy bodies but appealing faces, were followed by babies with painted expressive faces with big eyes, but with rather short legs and spoon shaped hands. Dominion, however, was soon producing a fine fully ball-jointed composition body. Their baby bodies improved in proportion over the years. As time progressed Dominion manufactured a popular mama doll with composition head, arms, and legs. It wore a mohair wig. This doll was very competitive with imported dolls from the United States. The company also produced beautiful bed dolls which were the rage in the nineteen-twenties. Then in the late twenties, Dominion made PANSY, a Canadian version of the American doll Patsy.

In 1931, Dominion Toy Manufacturing Company ran into financial trouble. The Reliable Toy Company in Canada had begun producing dolls in 1929 with the "hot process" method.[7] They could make dolls more quickly than Dominion could with the cold process method. In 1932, after twenty-one years of manufacturing dolls, Dominion Toy went out of business, and Reliable bought their assets. Morris Cone, however, was a born dollmaker who knew the business thoroughly, and was very familiar with the Canadian market. He formed a partnership with Max Diamond and W.J. Broudy to found Amusement Novelty Supply Company, the forerunner of the Dee an Cee Company. Years later, Arthur Cone joined Dee an Cee in Toronto and eventually became the president.

At the time of this writing, Dominion's doors have been closed over fifty years, yet, in travelling across Canada, we have found many Dominion dolls that have survived and are highly prized by collectors.

1. Aaron Cone was known as Aaron Cohn in the United States.
2. David Cohn. Brooklyn New York. Personal communication.
3. Morris Cone, *Dolls*. (Unpublished).
4. Ibid.
5. Ibid.
6. Arthur Cone. Interview.
7. Ben Samuels. Personal communication.

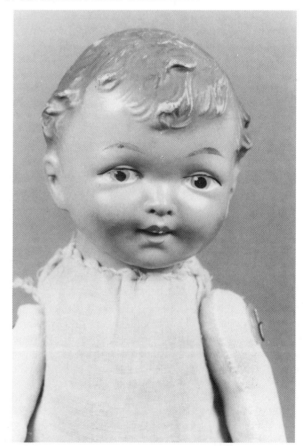

BW34

BW34
Dominion. ca.1911. 19 in. (49 cm). Excelsior stuffed cloth body, legs and upper arms; composition forearms. Composition head; painted blue eyes with highlights and a fine black line over the eye; deeply moulded hair, painted light brown; open-closed mouth showing two moulded teeth. No mark. Although this doll is unmarked, the style of body and the construction of the arms clearly marks it as an early Dominion. The character type face indicates that it was probably designed by Aaron Cone. Author's collection.

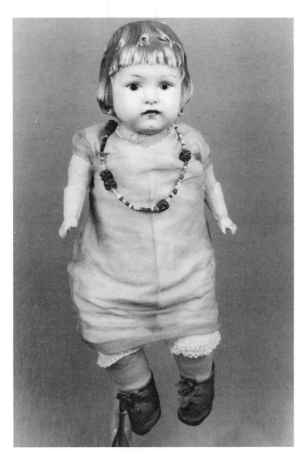

BX34

BX34
Dominion. ca.1911. 16.5 in. (42 cm). Excelsior stuffed cloth body, legs and upper arms; composition gauntlet hands. Composition shoulderhead with small round shoulderplate; eyes painted blue with a fine black line over each eye; deeply moulded hair, painted brown; closed mouth. No mark. Old clothing; probably made for her when she was new. A fine doll with a slightly sad expression. The composition is in very good condition. It is typical of the very early Dominion dolls. From the collection of Marsha Nedham, Ajax, Ont.

CN19
Dominion. ca.1911. 9 in. (23 cm). Excelsior stuffed cloth body, legs and arms, jointed hips and shoulders with metal discs; one arm is longer than the other. Blue side-glancing painted eyes, black line over eye; light brown moulded hair with moulded headband; closed mouth. Mark: Original label with the Dominion shield marked, DOMINION/BRAND/DOLLS & TOYS/MADE IN CANADA. Original white cotton dress and panties, sewn on black shoes. This is the smallest Dominion doll found so far. From the collection of Diane Peck, Sudbury, Ont.

CB24
Dominion. ca.1912. 29 in. (73.5 cm). Excelsior stuffed cloth body and legs, composition gauntlet hands, jointed hips and shoulders with metal discs. Composition flange head; blue intaglio eyes, fine black line over eye; deeply moulded light brown hair; closed smiling mouth. No mark but typical of the charming character faces designed by Aaron Cone. From the collection of Andra Tucker of the White Elephant Museum, Sardis, B.C.

CN19

CB24

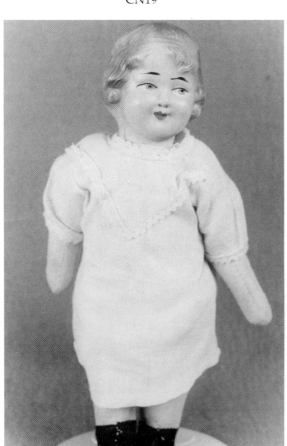

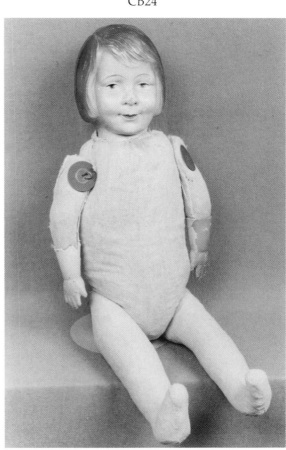

CB20

Dominion. ca.1912. 19 in. (49 cm). Excelsior stuffed body, arms and legs. Composition head; eyes painted blue; deeply moulded hair with short ringlets, painted brown; closed pouty mouth. No mark. DAISY, the childhood doll of Eva Carmell of Chilliwack, B.C., is undoubtedly a Dominion doll. Although the composition hands have come off and it has been completely repainted, the structure of the body is identical to the Dominion method of construction. The face is a character type, and the hair is deeply moulded in curls as was popular with Dominion in the early years. From the collection of Mary Van Horne, Chilliwack, B.C.

CI8

Dominion. ca.1913. l7 in. (44.5 cm). Excelsior stuffed cloth body, legs and upper arms; composition gauntlet hands. Composition head; painted blue side-glancing eyes; moulded hair with moulded hole for a ribbon, painted brown; closed mouth. No mark. Old clothing; probably made for the doll when she was new. This doll has been completely repainted but it can still be identified as an early Dominion doll. From the collection of Ruth MacAra, Caron, Sask.

AP9

Dominion. ca.1915. TIPPERARY TOMMY. 14 in. (36 cm). Cloth body with composition hands and boots. Composition head; painted blue eyes with a fine black line over each eye; moulded hair, painted light brown; closed mouth, painted red. Original uniform and hat. Original label: TIPPERARY TOMMY/MADE IN CANADA. A fine example of an early Canadian doll. The face is well defined and painted. Undoubtedly sold during the World War I. In remarkably good condition. From the collection of Dawn Young, Niagara Falls, Ont.

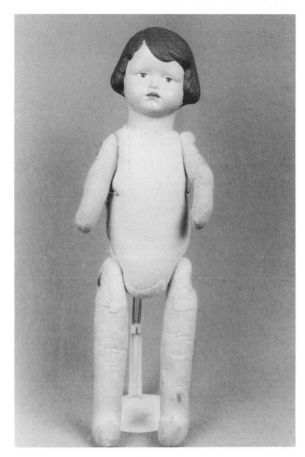

CB20

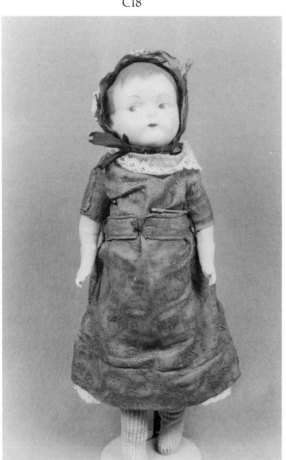

CI8

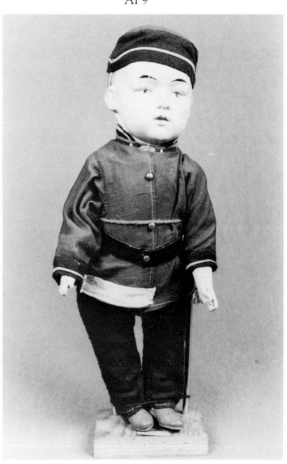

AP9

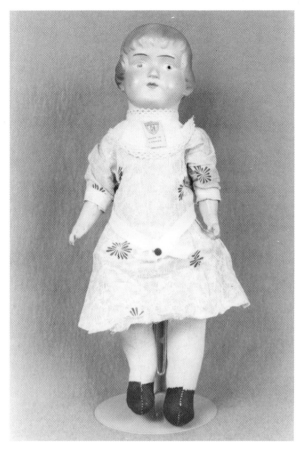

BF5

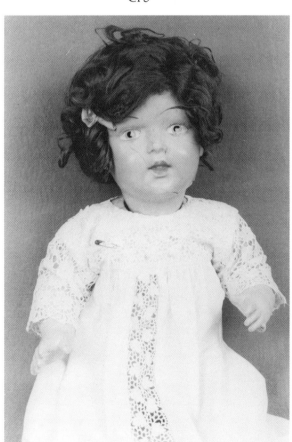

CF5

CD7

BF5
Dominion. ca.1915. 13.75 in. (35 cm). Excelsior stuffed cloth body, legs and forearms; composition lower arms; feet are stitched on black fabric; arms and legs attached to the body with a heavy wire through the body and a metal disc on the outside of each arm and leg. Composition shoulder head; painted eyes; moulded hair, painted strawberry blond; closed mouth, painted an orange-red. Label sewn on dress: DOMINION/BRAND/Dolls and Toys/Made in Canada. Original floral cotton print dress. It is in mint condition for it was kept in a glass case for 65 years. Never played with; a rare example of an early Dominion Toy Co. doll. This doll is a very important one in Dominion's history. It is labelled with the original tag and not marked on the body. This tells us that early Dominion dolls were unmarked and that they were made with this method of construction. It helps us to authenticate other dolls with the identical construction because Dominion's method was quite distinctive. A valuable addition to a Canadian collection. A similar doll was shown in the 1917 Eaton's catalogue. From the collection of Margaret Hayes, Musquodoboit Harbour, N.S. See also colour Fig. BF5.

CF5
Dominion. ca.1916. 23 in. (58.5 cm). All composition bent-limb baby. Composition head; painted blue eyes, fine black line over the eye, and painted lashes; original brown mohair wig; open-closed mouth with two painted teeth. Mark: A shield on the body with D.T.M.C. in it. Redressed in a white cotton and lace gown.

The same baby as CD7 but with a wig. From the collection of Gloria Kallis, Drayton Valley, Alberta.

CD7
Dominion. ca.1916. 25 in. (63.5 cm). All composition bent-limb baby. Composition head; painted blue eyes with a fine black line over each eye, and painted lashes; moulded hair, painted light brown; open-closed mouth showing two painted teeth. Mark: A shield on the body with DOMINION DOLL CO. in it. The body has deteriorated probably because of the type of glue used under the paint, but the head is still beautiful. From the collection of Vera Goseltine, Vancouver, B.C.

CA5

CA8

CA9

CA5
Dominion. ca.1918. DOLLY WALKER. 28 in. (71.5 cm).
Cardboard body with composition forearms, wooden upper
arms and wooden legs, jointed with hinges. Composition
shoulderhead; painted blue eyes; fine black line over eye; nostril
dots; moulded hair, painted light brown plus a human hair wig
which is not attached to the head. Closed mouth. Mark:
D.T.M.C./MADE IN CANADA. Original white cotton dress
and matching hat. DOLLY WALKER was designed in 1917 by
Harry Coleman, a ventriloquist, and produced by Wood Toy
Co. in the USA. Dominion's DOLLY WALKER has the same
body as the American doll although the head is different.
Dominion may have bought the rights to manufacture the body
and put their own head on it. It is a fine example of Dominion's
innovative dolls and an outstanding doll in Canada's history.
From the collection of Marilyn Kilby, Victoria, B.C. See also
Figs. CA8 and CA9.

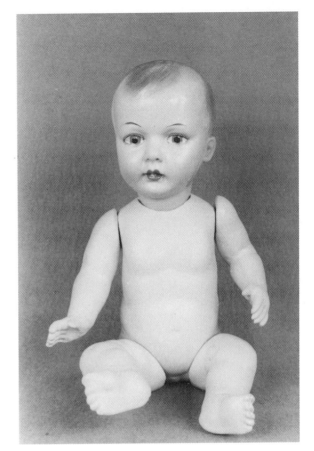

CL6
Dominion. ca.1917. 14 in. (35.5 cm). All composition bent-limb baby. Composition head; painted intaglio violet eyes with a fine black line over each eye, and painted lashes; moulded light brown hair; closed mouth. Mark: A shield on the body with D.T.M.C./MADE IN CANADA in it. Body has been repainted but the head is untouched. A beautiful baby showing the high quality of Dominion's work. From the collection of Jean M. Herriot, Vancouver, B.C.

BH32
Dominion. ca.1919. 14 in. (35.5 cm). Cloth body, legs and forearms; composition lower arms. Composition shoulder head; painted blue eyes; painted long upper lashes; moulded hair painted light brown; closed mouth painted red. Mark: D.T.Co. on shoulderplate. Replaced white cotton dress with blue and white pinafore. This is the popular knockabout doll that was made for many years. From the collection of Rebecca J. Douglass, Dartmouth, N.S.

CT13
Dominion. ca.1920. Excelsior stuffed cloth body and legs, composition gauntlet forearm. Composition shoulderhead, repainted; painted blue eyes; moulded blond hair; closed mouth. Mark: on shoulderplate, DTMC. Redressed in a knitted suit. From the collection of Glenda Shields, London, Ont.

CL6

BH32

CT13

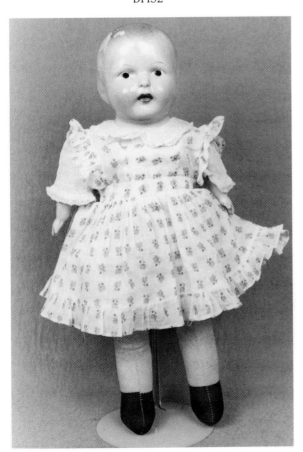

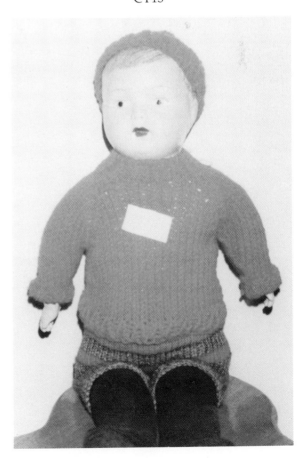

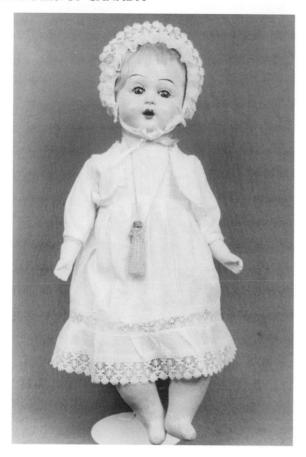

CL27

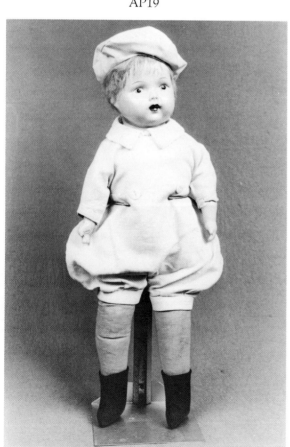

AP19

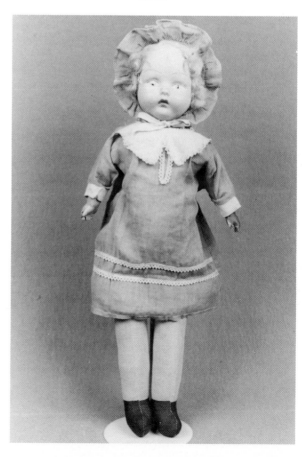

CN27

CL27
Dominion. ca.1920. 19 in. (48.5 cm). Excelsior stuffed cloth body and upper arms; bent-limb legs; composition gauntlet hands. Restored composition head with open crown and wooden pate; grey tin sleep eyes, painted lashes; original blond mohair wig; open mouth. Mark: MADE IN CANADA/ D.T.M.C. on the body. Original white cotton and lace dress and matching bonnet. Originally had pink shoes and white cotton stockings. Came with a glass bottle with a star on it encased in net. A similar doll was shown in Eaton's 1920-21 catalogue. From the collection of Berna Gooch, North Vancouver, B.C.

AP19
Dominion. ca.1920. 19.5 in. (49.5 cm). Cloth body, legs and forearms; composition lower arms. Composition shoulder head; painted blue eyes, painted long upper lashes; original blond wig; closed mouth painted red. Mark: D.T.C. on shoulderplate. Original rompers; replaced hat and shoes. Rompers with a band leg indicate the doll was made between 1915 and 1920. From the collection of Geraldine Young, Niagara Falls, Ontario.

CN27
Dominion. ca.1922. ALICE. 20 in. (51 cm). Excelsior stuffed cloth body and legs, composition gauntlet hands. Composition shoulderhead; blue painted eyes, long painted upper lashes; blond mohair wig over moulded hair; closed mouth. Mark: on head, D.T.C. Original blue cotton dress and bonnet, sewn on black shoes. ALICE is in almost new condition because her tiny owner died and ALICE was stored in a wooden box with a glass lid for many years. From the collection of Diane Peck, Sudbury, Ont.

CA31

Dominion. ca.1923. 20.5 in. (52 cm). Fully ball-jointed composition body with wooden arms. Composition head; light green celluloid sleep eyes; painted upper and lower lashes with red dots in the corners; replaced wig made from the hair of the original owner; open-closed mouth with four painted teeth. Mark: on the body, MADE IN CANADA/D.T.M.C. From the collection of Mrs. D.H. Morman, Victoria, B.C.

CC8

Dominion. ca.1924. 19 in. (48.5 cm). Fully ball-jointed composition body with wooden arms and composition legs. Composition head; grey-blue celluloid sleep eyes, painted upper and lower lashes; original brown mohair wig; open mouth with teeth missing. Mark: on the body; a shield with D.T.M.C.MADE IN CANADA in it. Clothing: replaced white cotton dress and bonnet. From the collection of Mrs. D.H. Morman, Victoria, B.C.

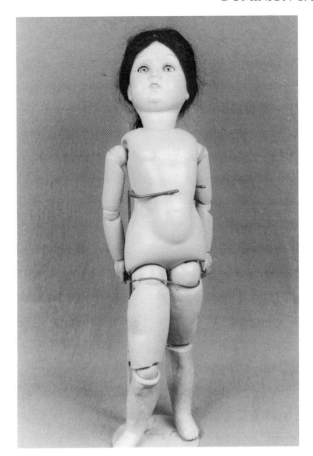

CA31

CC8

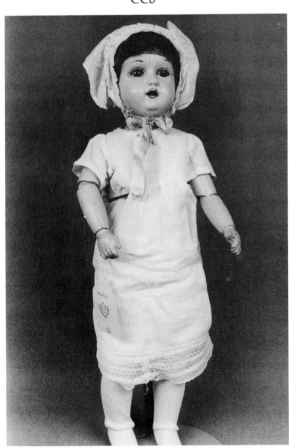

CT22

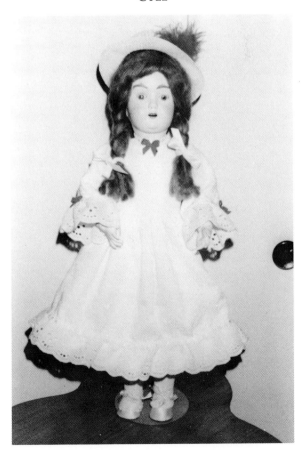

CT22

Dominion. ca.1924. approx. 18 in. (45.5 cm). All composition fully-jointed body. Composition head, open crown; wooden eyes with celluloid cover on the front; replaced wig; open mouth showing teeth. Mark: unknown. Redressed in white eyelet. An example of a doll with the type of eye invented by Aaron Cone in 1923. Photograph courtesy of Glenda Shields. From the collection of Glenda Shields, London, Ont.

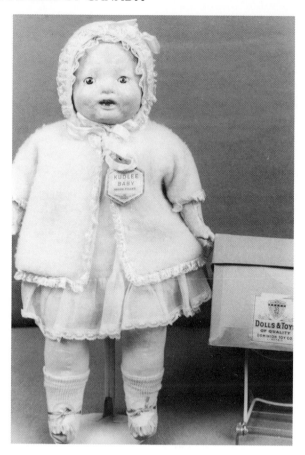

CN28

CN28
Dominion. ca.1924. KUDLEE BABY. 18 in. (45.5 cm). Kapok stuffed cloth body and legs, composition gauntlet hands. Composition shoulderhead; celluloid sleep eyes; moulded hair; open-closed mouth, tongue painted darker than the lips. Mark: on shoulderplate, DTMCo. ; original label, KUDLEE/BABY/Kapok filled/MADE IN CANADA/BY/DOMINION TOY CO. LTD./TORONTO. Original white organdy dress with pink trim, wool jacket and bonnet trimmed in lace, original shoes and socks. Original box with the Dominion label. A very well dressed doll. From the collection of Diane Peck, Sudbury, Ont.

CF4
Dominion. ca.1924. 21 in. (53.5 cm). Excelsior stuffed body, legs and upper arms, composition forearms, crier in the body. Composition shoulderhead; painted blue eyes with fine black line over each eye, painted upper lashes; blond mohair wig; closed mouth. Mark: D.T.C. on shoulderplate. Redressed. Typical of the early dolls made with a voice box in the body. From the collection of Gloria Kallis, Drayton Valley, Alta.

CD32
Dominion. ca.1925. 11 in. (28 cm). Composition bent-limb baby; jointed hips, shoulders, and neck. Composition head; celluloid blue sleep eyes, with painted lashes; blond mohair baby wig; mouth open; originally had teeth. Mark: on body; shield with DOMINION DOLL inside. From the collection of Vera Goseltine, Vancouver, B.C.

CF4

CD32

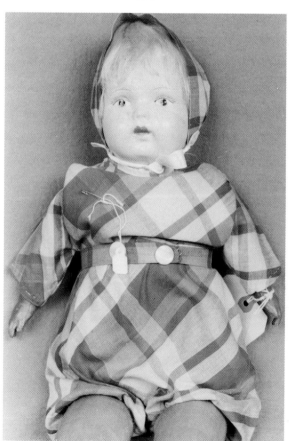

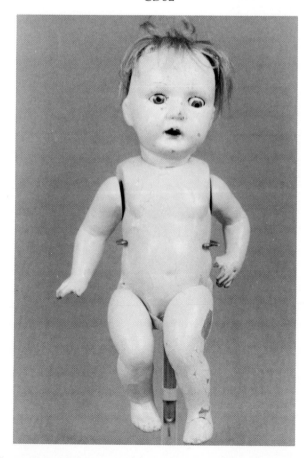

CD33
Dominion. ca.1926. 14 in. (35.5 cm). All composition bent-limb baby. Composition open crown head; blue celluloid sleep eyes with painted lashes; blond mohair wig; open-closed mouth showing two painted teeth. Mark: MADE IN CANADA/ D.T.M.C. on the body. A beautiful Dominion baby. From the collection of Jean M. Herriot, Vancouver, B.C.

CC5
Dominion. ca.1926. 27 in. (69 cm). Cloth body; very long and slender. Composition head; brown painted side-glancing eyes with highlights; a fine black line around the eye with painted upper and lower lashes; grey eye shadow and a fine black line above the eye; brows are a series of separate strokes; closed mouth and nostril dots; black synthetic wig. Mark: D.T.C. Redressed. An exceedingly fine bed doll with a very expressive face. From the collection of Mrs. D.H. Morman, Victoria, B.C.

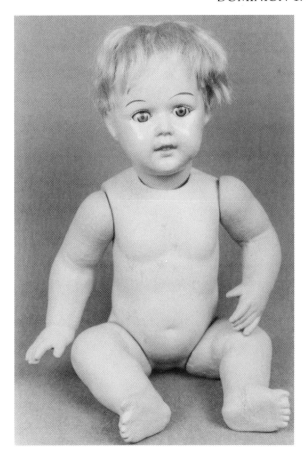

CD33

CQ12

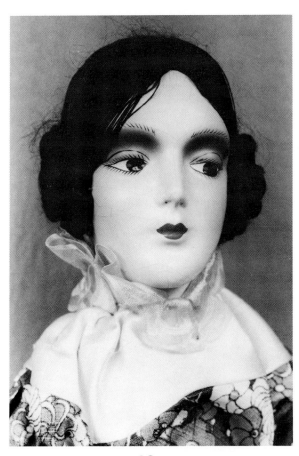

CC5

CQ12
Dominion. ca.1926. 26 in. (66 cm). Long slender cloth body. Composition head; black painted eye with black eyeliner; light brown synthetic hair; closed mouth. Mark: on head, D.T.C. Redressed. Courtesy of the Bowmanville Museum, Bowmanville, Ont.

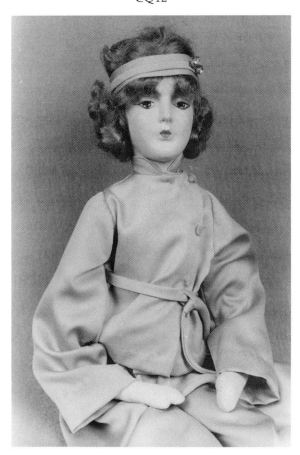

BZ7

CM8

BZ7
Dominion. ca.1926. 20 in. (51 cm). Excelsior stuffed cloth body, legs and upper arms; composition forearms. Composition shoulderhead; painted blue eyes; painted upper lashes; blond mohair wig; open mouth with two teeth. Mark: D.T. Co. on shoulderplate. Old dress and slip but probably not original. From the collection of Ruth Derrick, Victoria, B.C.

CL25
Dominion. ca.1926. 23 in. (58.5 cm). Excelsior stuffed cloth body, legs, and upper arms; composition three-quarter arms. The cloth on the legs is pink. Composition shoulderhead; blue celluloid sleep eyes; lashes; painted upper and lower lashes; blond mohair wig; open mouth showing two inset teeth and tongue. Mark: D.T.M.C. on shoulderplate. Dominion is still using the cloth arm glued into the composition, but the arm is longer. From the collection of Berna Gooch, North Vancouver, B.C.

CL25

CM8
Dominion ca.1927. 20 in. (51 cm). Excelsior stuffed cloth body, legs and upper arms; composition forearms. Composition shoulderhead; blue tin sleep eyes, lashes, painted lower lashes; original mohair wig; open mouth showing replaced teeth and tongue. Mark: none. Dress and bonnet old but not original; replaced shoes and stockings. Although this doll is unmarked she has the type of arm which identifies her as a Dominion doll. Author's collection.

CC6

Dominion. ca.1927. 27 in. (69 cm). Cloth body; very long and slender. Composition head; painted black eyes with highlights; grey eyeshadow and a black line outlining the eye; brown mohair wig; closed mouth. Mark: D.T.C. on head. Redressed. From the collection of Mrs. D.H. Morman, Victoria, B.C.

CM9

Dominion ca.1928. PANSY. 14.5 in. (37 cm). Excelsior stuffed cloth body, composition arms and legs that are attached to the body with a heavy wire going through the limb and the body and through the other limb. The outside of one arm and one leg have a nailhead showing and the wire doubled back into the composition on the other limb. Composition shoulderhead; painted blue side- glancing eyes; painted upper lashes; fine black line over the eye; moulded reddish gold hair; closed mouth. Mark: none. Original box with the Dominion Toy label. Original mauve organdy dress and bonnet, black shoes and white socks. PATSY came out in the United States in 1927. This doll is a look-alike that Dominion called PANSY. Author's collection.

BT24

Dominion. ca.1928. 27.5 in. (70 cm). Cloth body, upper arms and upper legs; composition forearms and long straight lower legs; crier in the body. Composition shoulder head; blue sleep celluloid eyes, painted upper and lower lashes; blond mohair wig with bang; open mouth showing teeth and tongue. Mark: D.T.C. on shoulderplate. Original muslin combination. This doll has the arm construction of Dominion's later years. Eaton's catalogue advertised dolls with the long straight legs as walking dolls during the twenties. From the collection of Bernice Tomlinson, Etobicoke, Ont.

CC6

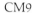
CM9

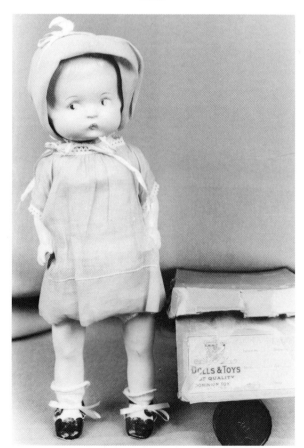

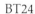
BT24

BY12

BY12
Dominion. ca.1929. 17 in. (43 cm). Cloth body, upper arms
and upper legs, composition bent-limb arms and straight legs.
Composition shoulderhead with dimpled cheeks; blue celluloid
sleep eyes; lashes; painted upper lashes; moulded hair painted
blond; open mouth showing two inset teeth and tongue. Mark:
D.T.M.C. on shoulderplate. Old cotton slip. Note the change
in arm construction from the earlier method. From the collection
of Catherine Kerr, Ottawa, Ont.

DA4 Mr. Earle Pullan.

Earle Pullan Company

In 1945, Earle Pullan established a company bearing
his name at 76 Wellington Street West in Toronto,
Ontario, and began manufacturing games and plush
animals. Two years later he bought gas fired steel moulds
from a New York company and began producing
composition dolls. He hired a plant manager, a Mr.
Harris from New York, to help set up the complicated
business of making new composition models.[1]

The Pullan Company produced a wide variety of
innovative dolls for the next nineteen years. We will trace
the development of the Pullan dolls chronologically
showing the gradual transition from composition to the
modern vinyl doll. The company manufactured many
exciting and diverse character dolls such as LITTLE
LULU, BABY TWINKLE, CLEOPATRA, THE BEATNIK
DOLL, etc. The Pullan dolls vary greatly in their
construction, for the company experimented with many
materials and combinations in search of the perfect doll
making medium. The Pullan dolls were very well-dressed
with great attention to detail. It is fair to say that Earle
Pullan created some of the most desirable dolls from the
point of view of the Canadian collector. What the
company had to offer will be presented in detail.

Most Pullan dolls covered in this chapter were from private collections. The remainder were taken from the Pullan salesmen's catalogues. The catalogues revealed nothing about Pullan's mark. Sometimes different dolls had the same name. In nearly every case the published height was slightly more than the doll actually measured. We also found Pullan dolls that did not appear in these catalogues, for Pullan was known to produce dolls for special sales and orders. Moreover, the clothing on some collector's dolls did not match the catalogue illustrations in every detail. This may have been caused by long production runs where substitutions became necessary. In such a situation the date of a doll could not be accurately determined, hence the need to use the term "circa" when indicating the year of origin of some dolls. For the majority of Pullan dolls, however, the year of manufacture was simple to determine from the beginning of production in 1947.

All of the 1947 models were made of composition. There was a 20 inch baby dressed in a long gown with a matching bonnet, that came with a birth certificate, a novel idea then and still a successful marketing device over thirty years later, as can be seen by the adoption certificates of the popular Cabbage Patch dolls. Another 1947 doll was a beautiful bride wearing a white silk crepe bridal gown with a headdress and veil over her mohair wig. Using the same mould, Pullan produced a toddler doll with a wig and sleep eyes wearing an organdy dress, the same doll in a cotton print dress, a doll with moulded hair and sleep eyes, and another with moulded hair and painted eyes. A cloth doll, BETTY ANN, with a mask face, was available for tiny tots.

PU36 Stuffing machine.

PL7 Miss Pullan holding Lana Lee.

PULLAN
for 1962
presents a complete range of outstanding new dolls and plush toys that cannot be equalled for quality, eye appeal and value!

PU38 Cutting room.

PU39 Dipping

PU30 Finishing.

The Pullan Company manufactured a large line of composition dolls in 1948. MISS PULLAN, a beautiful 20 inch toddler with a mohair wig and sleep eyes, was fashionably dressed in a tailored wool coat and hat. A black baby doll named PIXIE with painted side-glancing eyes was introduced. Undoubtedly the reason that black dolls are more expensive to collect is because relatively few were manufactured. A doll that is hard to find today is BABY TWINKLE. She can be readily identified by her knee-length blond hair. Some dolls had stuffed cloth bodies with composition heads and limbs, and two of these were dressed as little boys in romper suits. During the first two years of production most of the Pullan dolls were made entirely of composition.

In 1949, BABY BEAUTY appeared as a 22 inch doll with a composition head, cloth body, and stuffed natural rubber arms and legs. This was the first Pullan transition doll. A novel character was a cloth version of LITTLE LULU of comic strip fame. Although she was all cloth, she had a swivel type head; a very unusual feature. An all-rubber baby was also produced in 1949 with a composition head; definitely a collector's item today. However, these dolls will never be very valuable because of the tendency of rubber to deteriorate in time, although they are of great interest as transition dolls.

Two elaborately dressed composition brides came out in 1950 accompanied by a bridesmaid in an organdy gown. An 18 inch SKATING QUEEN on roller skates illustrates the popularity of roller-skating on indoor rinks in the late nineteen-forties and early nineteen-fifties. So far, the company had produced composition dolls, composition and cloth dolls, some dolls with all rubber bodies and composition heads, and others made of rubber, cloth, and composition. Rival companies, such as Reliable and Dee and Cee, were already manufacturing dolls using a stuffed soft vinyl skin or hard plastic for the bodies. The Earle Pullan Co. met the challenge with new machinery. The doll business was now in a state of transition; and for a few years, hard plastic, composition and vinyl dolls were all being marketed. The era of composition dolls was coming to an end. Saran wigs were new in 1951 and, although they were not yet rooted, they could be washed and combed. Pullan produced a composition doll in 17 and 13 inch sizes with the new saran hair. The PULLAN WALKING DOLL made her debut walking and turning her head from side to side if held by one hand. Pullan introduced the first vinyl heads on two versions of JUST BORN BABY. One model had an all-rubber body and the other had rubber arms and legs and a cloth body. An all-composition LITTLE LULU was also new. A special feature in 1951 was a pair of 28 inch GIANT DOLLS. (Large dolls were something new at that time because they had not been made for a number of years.) These dolls had hard plastic heads and all-rubber bodies stuffed with foam rubber. The eyes and eyelashes were also made of plastic so that the dolls could be bathed. This was quite a change after years of dolls with metal eyes that would rust. The GIANT DOLL cried when any part of it's body was squeezed. They are good examples of transition dolls made during the period when rubber and plastic materials were becoming more popular. Unfortunately, the rubber deteriorated, and the only ones we have seen have bodies that are in very poor condition.

In 1952, Pullan presented LITTLE RED RIDING HOOD, ALICE IN WONDERLAND, and CINDERELLA, all in composition. A new concept was a doll named TWISTY who had rubber limbs and a wire armature inside her body. This allowed the doll to sit alone, kneel, cross legs, hold a toy, and assume any position.

Rooted saran hair was a new development at Pullan in 1953. This innovation required the installation of more specialized equipment to secure the hair to the head. Rooted hair was a marvellous invention for little girls who enjoy washing and combing their dolls' hair. To commemorate the coronation of Queen Elizabeth II, the Pullan Company created a beautifully dressed doll wearing coronation robes and gown. However, this doll was all-composition and wore the old style of mohair wig.

Pullan was licensed to manufacture the Walt Disney characters DONALD DUCK, PLUTO, MINNIE MOUSE, and MICKEY MOUSE in 1953. Mr. Pullan asked Emanuel Hahn, the Canadian sculptor who created the Sir Adam Beck monument in Toronto, to sculpt the heads so that moulds could be made. MICKEY MOUSE was a popular item with a plush body and vinyl head.

The last Pullan doll with a composition head was made in 1954. BABY LOVIE was her name, and she had a cloth body with rubber arms and legs, and a composition head with a mohair wig. She marked the end of the composition era.

A new 17 inch baby with a hard plastic head was introduced in 1955 called ROCK ME BABY. She came with a cradle which could be rocked causing the baby's eyes to slowly close. She was advertised as being "almost alive." SWEET SUE had a one-piece body moulded entirely of a stuffed vinyl skin. She had a vinyl head with rooted saran hair. There were many dolls with different hair styles moulded in vinyl because it was easy to mould into braids, bangs, or a pulled-back style. A baby which held a teddy bear showed Mr. Pullan's imaginative flair and salesmanship.

BABY TEARS cried real tears in 1956 as dolls became more and more lifelike, adding to their drinking and wetting capability. BABY TEARS was made of all-vinyl; it had jointed arms and legs and came with its own layette. Another interesting development was the doll with the pastel coloured hair. Her clothing matched her hair!

When the Trans-Canada highway was under construction in 1956 Pullan produced the TRANS-CANADA DOLL, which came with a travelling case printed with the names of Canadian cities on the sides. Four gorgeous bride dolls attracted attention the same year. And then there was CINDY, a black toddler with a rubber body and a vinyl head covered in tightly curled black hair, who came in 15 and 20 inch sizes. Mr. Pullan's little daughter was shown in the advertisements playing with her father's products. Perhaps Pullan dolls were popular because his dolls had been tested at home by his two young daughters. What better way to judge a doll's

appeal than to see the reaction of small children when shown a new doll.

A new trend in 1957 was the hard plastic teenage doll. The 20 inch BIG SISTER FASHION BEAUTY had a turning waist and was beautifully dressed in fashionable clothes. Pullan also made MINDY, a black doll with ethnic features, which is a very collectible doll today.

CURLY DIMPLES was a charming doll in 1958. She was 19 inches and was made of plastic with a vinyl head and rooted curly hair. She resembled the earlier Shirley Temple dolls and had eyes that glanced from side to side. Another new doll was a 17 inch nurse that carried a tiny baby wrapped in a blanket.

MOTHER AND FAMILY was a distinctive 1958 ensemble that allowed children great scope in their play, for the set included a mother doll with a little girl, a smaller boy doll, and a baby, all extremely well dressed. MOTHER wore a highly styled tailored linen coat, a straw hat, bright print dress, panties, nylons, and high heel shoes. Her 12 inch DAUGHTER wore a similar dress and coat with a bonnet. LITTLE BROTHER was 10 inches high with a freckled face. He wore a white shirt and matching jacket with pants. BABY, at 8 inches, was dressed in a brushed rayon snowsuit and carried a plastic rattle. The attention to detail is remarkable. It was a clever idea to market this ensemble in the middle of the baby boom, when so many parents had three or four children.

The Pullan Company was expanding, for the crest of the baby boom provided a large market of small children, all wanting toys to play with. Pullan moved to much larger premises at 469 King Street West, where the company had enough space for the extensive machinery needed to produce the plastic and vinyl dolls. Pullan also had an office in Montreal to handle the sales in that area.

By 1959 the teen dolls were becoming popular with older girls, and the vinyl toddlers with jointed arms and legs were the favourites of smaller children. LITTLE LULU (the Kleenex advertising character, which was based on the comic strip LULU) was produced again in 1959, but this time she was made of vinyl.

Pullan introduced WENDY ANN the 35 inch plastic doll in 1960. She came in many versions with hair of different colours and in various styles and was dressed in an assortment of well-made pretty outfits. The 21 inch BEATNIK DOLL was new and so was BLESSED EVENT, which was a mother doll with her baby, complete with a bassinette.

There were many new and innovative Pullan dolls in 1961: BABY TALKS, which had a six reed voice mechanism to allow it to chuckle, coo and laugh; DOLLY POPS, which could raise a lollipop to her mouth; SUNNY FACE, which changed the expression on her face when her tummy was pressed; and BOBBY the popular boy doll dressed in different outfits.

In 1962, Pullan made 36 inch walking dolls, 32 inch chubby two year olds, and CLEOPATRA, which was a

doll with an unusual grownup face. SLUMBALINA was a doll that wiggled realistically when the knob on her back was turned. A modern day "bonnet head," a doll named PATSY, with a moulded vinyl bonnet on her head, was reminiscent of the china head dolls of yesteryear, which were sometimes moulded with a hat on their heads.

KISSY MISSY puckered her lips when her left arm was raised, and in the same year, 1963, a 30 inch walking boy doll named BIG BOBBY was produced. MARJIE, a 12 inch doll with rooted saran hair was introduced with twenty-four different sets of clothing and accessories. MARJIE became a Pullan family project when Earle Pullan's young daughter was seen dressed like MARJIE at the Toronto Trade Show, where equipment used in the manufacture of the dolls costumes was shown each year.[2] MARJIE was popular in England and was sold in Harrods, a large and prestigious department store in London, England, under the banner "Canada's Favourite Doll." MARJIE was also sold in Ireland and Germany. This was due to Earle Pullan's efforts to increase Canada's exports. He was one of six toymakers who were sent by the Canadian government on a trade mission to Nuremberg, Germany. It proved to be a very successful mission because sales of Canadian toys in Europe increased.

A new doll in 1964 was PEACHES, a cute 12 inch toddler with upturned hands and an open-closed mouth, which came dressed in different outfits, as did TWINKLE the souvenir doll. Pullan introduced MARJIE'S European cousin MARLANE. She had sixteen sets of costumes and accessories to add to her play value. MARJIE and MARLANE were advertised on television and at first were very competitive with the imported Barbie dolls.

MARJIE with "growing hair" was new in 1965. Toddler dolls ROSSELLA, ANNETTA, and CARLETTA with a definite European look, were also Pullan features. Walking dolls were still popular and came in 36, 30, and 24 inch sizes, and were dressed in many different outfits from trench coats to party dresses. ROSANNE, the 18 inch doll who pushed a tiny wicker pram with her baby in it, carried an umbrella that matched her dress. There was also BOXER, a Canadian champion doll that sported a permanent black eye! Pullan did not introduce new characters or models in 1966. Instead, a number of toddler and walking dolls were reintroduced wearing different clothes. BABY BEAUTY appeared again in black and in white. The twins, VIC and VICKI, which had been popular for several years, were again carried by Pullan.

It was during this time that Canadian toymakers began having difficulties in the market place. Doll making at the best of times is a volatile business and one which demands a great deal from the people involved in it. The manufacturer must have imaginative flair, know what children will enjoy, and be able to forecast just what will sell in the next season. Doll manufacturing is largely a once-a-year trade, with most of the sales coming in the few months before Christmas. This means that there are many slow months during the remainder of the year. The business demands a large cash outlay to produce dolls

during the summer months and then to hold the dolls in inventory until autumn. The doll maker must continually come up with new and innovative dolls to catch the eye of the Christmas shopper, otherwise a large inventory of "unfashionable" dolls will persist into the slow months of the following year.

The Pullan Company was in business from 1945 to 1967. But in its last year of operation the leftover inventory of 1966 dolls was sold. To the doll collector, there is no such thing as a true 1967 Pullan doll. During its relatively short life, the company manufactured a substantial part of Canada's production of dolls. The Pullan Company also made a valuable contribution to Canada's exports.

It is an unfortunate fact in Canada that if large foreign companies move into an industry there is little that Canadians can do to resist. The Canadian population is not large enough to support a powerful industry in the toy-making field. When foreign companies have the resources to mount extensive advertising campaigns, they create a demand for their products and flood the Canadian market. This is what happened in the case of the Pullan MARJIE doll. Although it was a well made and imaginative product, it could not support an advertising budget large enough to compete with the extensive and persuasive advertising campaign surrounding the American Barbie doll. Every little Canadian girl was convinced that she had to have a Barbie doll.

Earle Pullan enjoyed his work as a dollmaker and was regarded as one of Canada's leading toymakers. He had also been Vice President of the Canadian Toy Manufacturers Association, an organization which promotes high standards in the industry.

The Earle Pullan Company closed its doors in 1967 and Mr. Pullan went on to a successful commercial real estate business in Toronto. Today, the Pullan dolls are familiar to all Canadian collectors and are much sought after as valuable additions to a Canadian collection.

1. Mr. E. Pullan. Personal communication.
2. Frank and Helen Lyon. Personnal communication.

PU13
Pullan. 1947. BIRTH CERTIFICATE DOLL. 20 in. (51 cm.). All composition baby, jointed hips, shoulders, and neck. Composition head; blue sleep eyes, lashes, painted upper lashes; blond wig; closed mouth. Original silk rayon gown, matching bonnet trimmed with pastel coloured ribbons. This doll was available with either blond or brown hair. Courtesy of Mr. E. Pullan, Toronto, Ont.

BH16
Pullan. 1947. 19 in. (49 cm). All composition, jointed hips, shoulders, and neck. Composition head; blue sleep eyes, lashes, painted lower lashes; original light brown mohair wig with bangs; closed painted rosebud mouth. Mark: on head, PULLAN; on body, PULLAN. Original pink, blue, and white cotton dress and matching bonnet. Original shoes and socks. When this doll was new, she came with a birth certificate and was one of the very first Earle Pullan dolls, and in fact appeared on the cover of the 1947 catalogue. She was also made without the wig in a less expensive version. Composition Pullans are hard to find for they were only made for seven years. From the collection of Rebecca Douglass, Dartmouth, N.S.

Most Beautiful Composition Dolls In The World

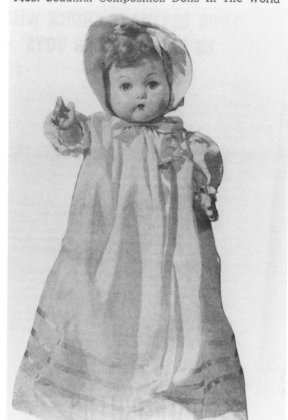

PU13

BH16

BM35
Pullan. 1948. BABY JASPER. 10 in. (25 cm). All composition
dark brown bent-limb baby, jointed hips, shoulders, and neck.
Composition head; eyes painted black, side glancing; moulded
hair painted black; closed mouth painted red. Mark: on body:
A PULLAN DOLL. Redressed. JASPER was originally dressed
in a two- tone sunsuit. He was the only brown Pullan doll in
1948. From the collection of Irene Henderson, Winnipeg, Man.

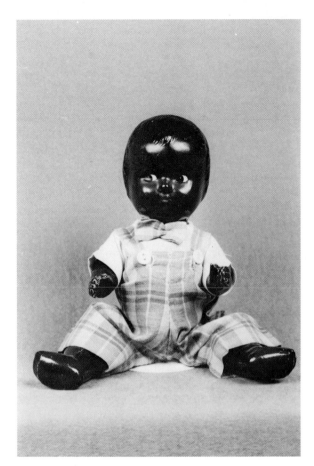

BM35

PU12

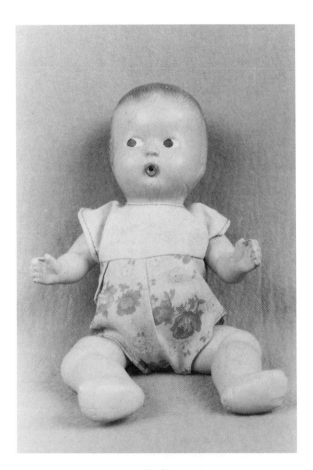

BW28

BW28
Pullan. 1948. DINKY DRINKY. 10 in. (25 cm) All
composition baby, jointed hips and shoulders. Composition one
piece head and body; eyes painted black, side glancing; moulded
hair painted reddish brown; metal ring in mouth painted red.
Mark: on body, PULLAN DOLL. Original cotton sunsuit. This
doll has a rubber tube through the body so it can be fed. From
the collection of Bruce Young, Toronto, Ont.

PU12
Pullan. 1948. BABY TWINKLE. 14.5 in. (37 cm). All
composition, jointed hips, shoulders, and neck. Composition
head; sleep eyes, lashes, painted upper lashes; knee-length blond
wig; closed mouth. Original bathrobe and diaper. Courtesy of
Mr. E. Pullan, Toronto, Ont.

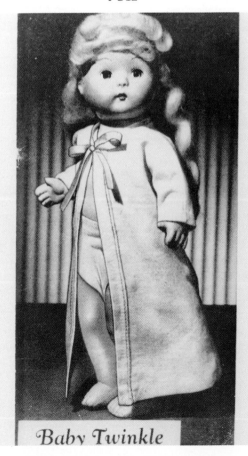

Baby Twinkle

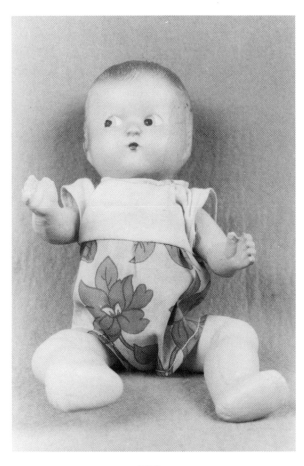

BW27

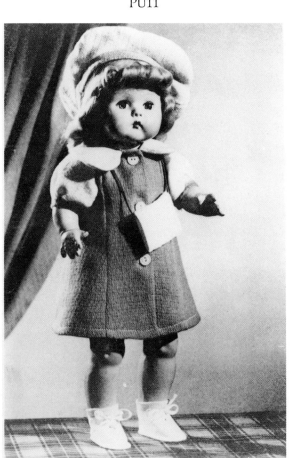

PU11

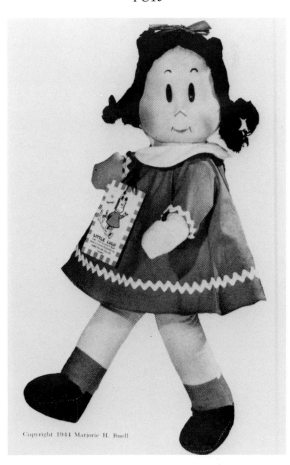

PU10

BW27
Pullan. 1948. BABY PULLAN. 10 in. (25 cm). All composition baby, jointed hips and shoulders. Composition one piece head and body; painted blue eyes, side-glancing; moulded hair painted reddish brown; closed mouth painted red. Mark: on body, PULLAN DOLL. Original cotton sunsuit. From the collection of Bruce Young, Toronto, Ont.

PU11
Pullan. 1948. MISS PULLAN. 20 in. (51 cm). All composition, jointed hips, shoulders, and neck. Composition head; sleep eyes, lashes; mohair wig; closed mouth. Original tailored woolen coat and hat which came in different colours. Romper dress, shoes and socks. Courtesy of Mr. E. Pullan, Toronto, Ont.

PU10
Pullan. 1949. LITTLE LULU. 14 in. (35.5 cm). Cloth body. Swivel type cloth head; black painted eyes ; black wig with red hairbow; watermelon mouth. Wearing a red cotton dress, slip, sewn on socks and shoes. Courtesy of Earle Pullan, Toronto, Ont.

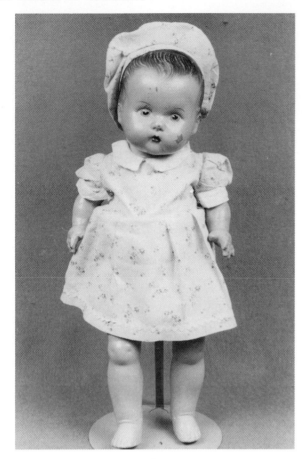

CG12

CA35

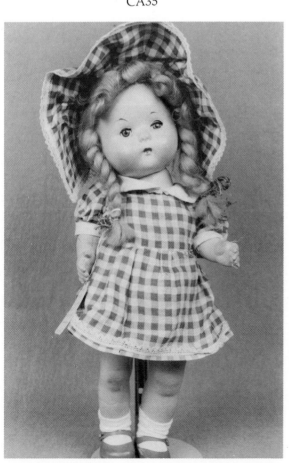

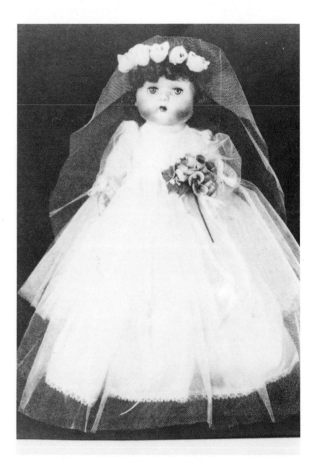

PL31

CG12
Pullan. 1949. BETTY. 20 in. (50.5 cm). All-composition toddler, jointed hips, shoulders, and neck. Composition head; blue painted eyes, painted upper lashes; moulded hair painted light brown; closed mouth. Mark: on head, PULLAN. Original blue printed cotton dress, attached panties and a matching tam. BETTY usually wore a bonnet but this one has a tam. From the collection of Margaret Wist, Saskatoon, Sask.

PL31
Pullan. 1950. WEDDING DOLL. 20 in. (51 cm). All composition, jointed hips, shoulders, and neck. Composition head; sleep eyes, lashes, painted lower lashes; brown wig; closed mouth. Original satin gown, trimmed with lace. Veil is double layers of white net. She is wearing a flowered headdress and carrying a bouquet. Courtesy of Mr. E. Pullan, Toronto, Ont.

CA35
Pullan. 1949. SHIRLEY. 14 in. (35.5 cm). All-composition toddler, jointed hips, shoulders, and neck. Composition head; brown sleep eyes, lashes, lowers painted reddish brown; original blond wig in braids; closed rosebud mouth. Mark: on head, PULLAN DOLL ; on body, PULLAN DOLL. Original blue and white cotton dress and bonnet, blue shoes and white socks. From the collection of Mrs D.H. Morman, Victoria, B.C.

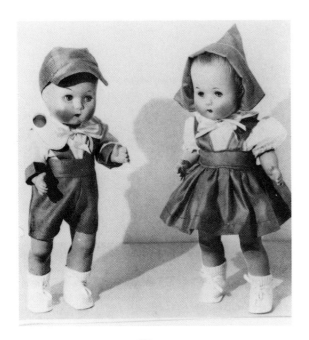

PL32

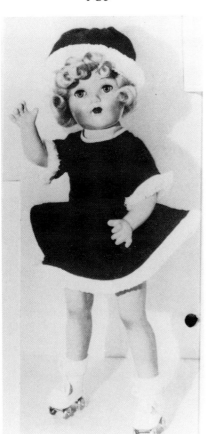

PU5

PL32
Pullan. 1950. JACK and JILL. 14 in. (35.5 cm). All composition, jointed hips, shoulders, and neck. Composition head; sleep eyes, lashes, painted lower lashes; moulded light brown hair; closed mouth. Original matching tailored two-piece outfits with matching hats. Courtesy of Mr. E. Pullan, Toronto, Ont.

PU5
Pullan. 1950. SKATING QUEEN. 18 in. (45.5 cm). All composition, jointed hips, shoulders, and neck. Composition head; sleep eyes, lashes, painted lower lashes; blond wig; closed mouth. Original flannelette skating costume with white fringe trim. Came with shoes and socks, as well as roller-skates that really turn. Courtesy of Mr. E. Pullan, Toronto, Ont.

PU7
Pullan. 1951. LOIS. 17 in. (43 cm). All composition, jointed hips, shoulders, and neck. Composition head; sleep eyes, lashes, painted lower lashes; blond saran wig; closed mouth. Satin party frock trimmed with lace and ribbon. LOIS was the first Pullan doll with saran hair that could be combed, brushed, washed, waved, and curled. A 13 in. doll with saran hair was called CATHY. Courtesy of Mr. E. Pullan, Toronto, Ont.

PU7

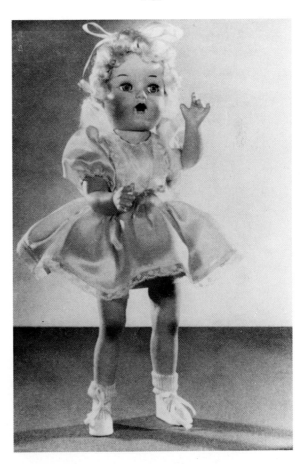

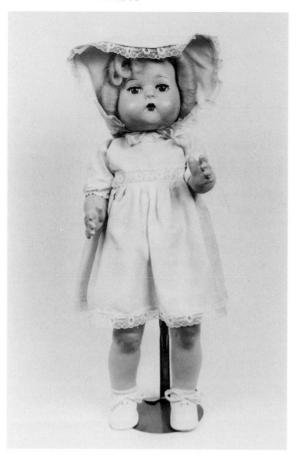

AZ4

AZ4
Pullan. 1951. WALKING DOLL. 20 in. (50.5 cm). All composition child, jointed hips, shoulders, and neck. Composition head; brown sleep eyes, lashes; blond mohair wig; closed mouth painted red. Mark: on body, PULLAN. Original blue angel skin dress and bonnet, matching petticoat and panties, trimmed with lace. Original socks and shoes. A walking doll that walks when led by the hand. She operates on a simple principle with the mechanism hidden inside the body. She also turns her head as she walks. Childhood doll of Dorothy Dawn Steele Robb. From the collection of Mrs. D. Steele, Ottawa, Ont.

PU8
Pullan. 1951. ALICE IN WONDERLAND. 17 in. (43 cm). All composition, jointed hips, shoulders, and neck. Composition head; sleep eyes, lashes, painted lower lashes; long blond hair; open mouth showing teeth. Original blue organdy dress over lace-trimmed pantalettes. White lace-trimmed organdy apron, black satin hair ribbon. Courtesy of Mr. E. Pullan, Toronto, Ont.

PU6
Pullan. 1951. SWEETIE. Came in 17 and 21 in. (43, 53.5 cm) sizes. Cloth body, crier, stuffed rubber arms and legs. Composition head; sleep eyes, lashes; curled wig; closed mouth. Dressed in sheer organdy dress and bonnet, trimmed with lace and ribbons, lace-trimmed petticoat, rubber panties, socks and shoes. Courtesy of Earle Pullan, Toronto, Ont.

PU8

PU6

AW28

PU4

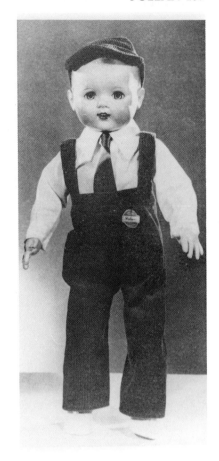

PU3

PU2

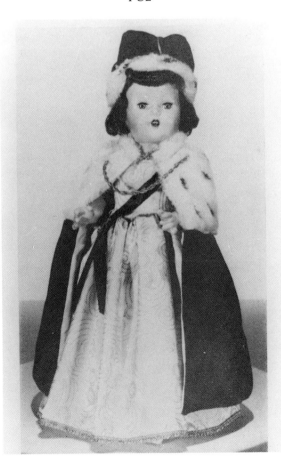

AW28
Pullan 1951. LITTLE LULU. 14 in. (35.5 cm). All composition, jointed hips, shoulders, and neck. Composition head; oval eyes painted all black; moulded hair painted black, red ribbon stapled on head; watermelon mouth painted red. Mark: on head, PULLAN DOLL. Original red cotton dress trimmed with white rickrack. Original socks and shoes. LITTLE LULU was designed by 'Marge" and was featured in comic strips and in the Kleenex advertisements. Pullan made a cloth version in 1949 followed by the composition model in 1951. In 1959 she was made in vinyl. From the collection of Mrs. D. Steele, Ottawa, Ont.

PU4
Pullan. 1952. GIANT SQUEEZE ME DOLLS. 28 in. (71.5 cm). One piece rubber latex stuffed with foam rubber. Hard plastic head; sleep eyes, lashes, painted lowers; moulded hair; open mouth, inset plastic teeth. Girl wore a corduroy skirt and matching hat and an angelskin blouse. Boy wore corduroy pants and cap, cotton shirt with bright red tie. Squeeze the body or limbs and the doll will cry. Courtesy of Mr. E. Pullan, Toronto, Ont. See also Fig. PU3.

PU2
Pullan. 1953. CORONATION DOLL. All composition, jointed hips, shoulders, and neck. Composition head; sleep eyes, lashes; brown wig; open mouth showing teeth. Dressed in an elaborate gown with ribbon sash and cape trimmed in artificial ermine. Matching hat. Courtesy of Mr. E. Pullan, Toronto, Ont.

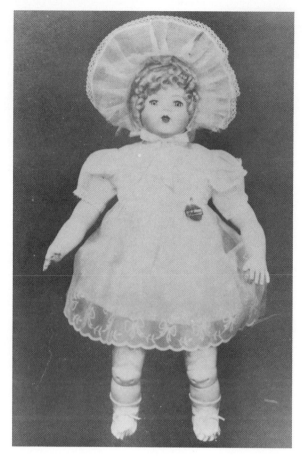

PU1

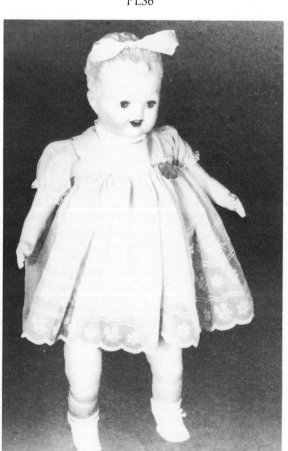

PL36

PU1
Pullan. 1953. BABY LOVIE. 25 in (63.5 cm). Cloth body, crier, stuffed rubber arms and legs. Composition head; sleep eyes, lashes; curled mohair wig; closed mouth. Wearing a dress and bonnet of contrasting organdy and ninon, trimmed with lace, net and ribbons. Skirt has wide scalloped edge of flocked ninon, petticoat, rubber pants, shoes and socks. Courtesy of Earle Pullan, Toronto, Ont.

PL36
Pullan. 1954. LUCILLE. Came in 17, 19, and 23 in. (43, 48.5, 58.5 cm) sizes. Cloth body with crier, stuffed rubber arms and legs. Vinyl head; sleep eyes, lashes; deeply moulded blond hair; open-closed mouth. Wearing a ninon dress with wide flocked scalloped edge, matching hairbow, petticoat, rubber pants, socks and shoes. Courtesy of Earle Pullan, Toronto, Ont.

CW8
Pullan. 1954. BILLY. 20 in. (51 cm). One piece latex rubber body. Vinyl head with dimples; hazel sleep eyes with lashes and painted lower lashes; deeply moulded hair with a curl in the front, light brown; open-closed mouth. Mark: on head; PULLAN. Redressed. Originally wore kriskay overalls and checked flannel shirt. From the collection of Berna Gooch, North Vancouver, B.C.

CW8

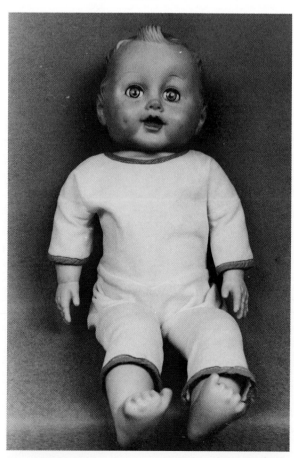

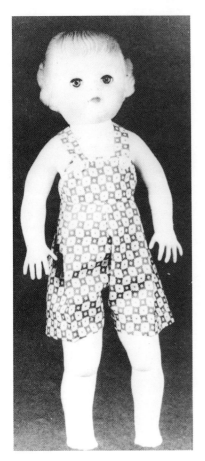

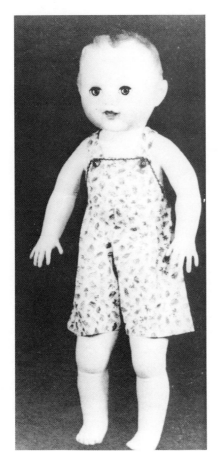

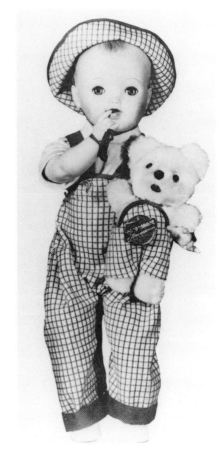

PL37

PU0

PL35

PL34

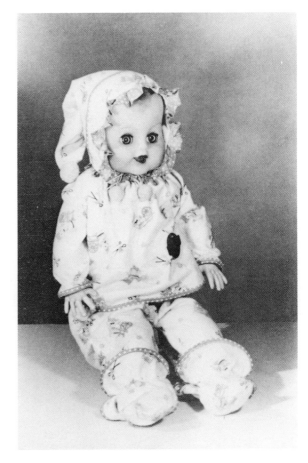

PL37
Pullan. 1954. SUNSHINE TWIN. 25 in. (63.5 cm). One-piece stuffed rubber, with cryer. Vinyl head; sleep eyes, lashes; deeply moulded light brown hair; closed mouth. Wearing a cotton print sunsuit. Courtesy of Earle Pullan, Toronto, Ont.

PU0
Pullan. 1954. SUNSHINE TWIN. 25 in. (63.5 cm). One-piece stuffed rubber body, squeeze voice. Vinyl head; sleep eyes, lashes; deeply moulded light brown hair; open-closed mouth. Wearing a cotton print sunsuit. Courtesy of Earle Pullan, Toronto, Ont.

PL35
Pullan. 1955. OVERALLS BABY. Latex body and legs, squeeze voice, vinyl arms. Vinyl head; sleep eyes, lashes; moulded light brown hair; open-closed mouth. Dressed in overalls with matching hat, knitted jersey shirt; carries a small plush bear dressed in matching overalls. Courtesy of Earle Pullan, Toronto, Ont.

PL34
Pullan. 1955. BEDTIME BUNTING. Came in 20 and 22 in. (51, 56 cm) sizes. Latex body with squeeze voice. Vinyl head; sleep eyes, lashes; moulded light brown hair; open-closed mouth. Dressed in pyjamas of printed flannelette with bootees and matching nightcap trimmed with a pompon. Courtesy of Earle Pullan, Toronto, Ont.

PL28
Pullan. 1956. CANDY. 17 in. (43 cm). One-piece vinyl skin body with wire armature inside to enable the doll to assume any position. Vinyl head; sleep eyes, lashes, painted lower lashes; brown rooted saran hair; mouth open-closed. Original striped sleepers with zippered front and a matching hat. Courtesy of Mr. E. Pullan, Toronto, Ont.

BN25
Pullan. 1956. 15 in. (38 cm). One piece vinyl body, jointed neck. Vinyl head; blue sleep eyes, lashes, painted lower lashes; very detailed moulded hair painted brown; open-closed mouth. Mark: on head, PULLAN. Redressed. From the collection of Irene Henderson, Winnipeg, Man.

PL30
Pullan. 1957. MINDY. 15 in. (38 cm). One piece doll with brown vinyl skin with flexiwire armature. Brown vinyl head; painted eyes; black heavily detailed moulded hair in braids; open-closed mouth. Original white ninon dress trimmed with red rickrack and a rosette. Courtesy of Mr. E. Pullan, Toronto, Ont.

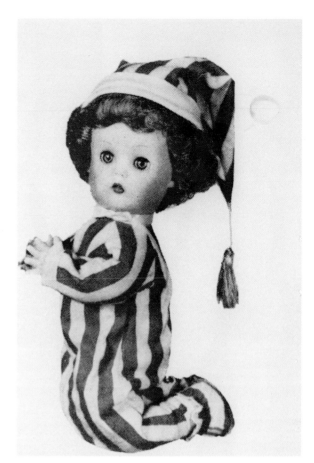

PL28

BN25

PL30

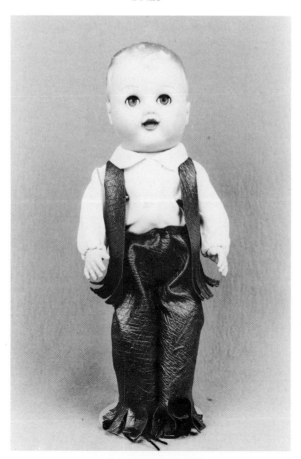

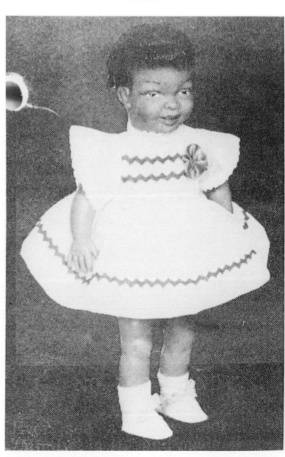

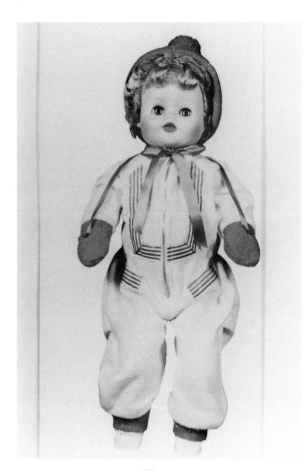

PL24

PL27

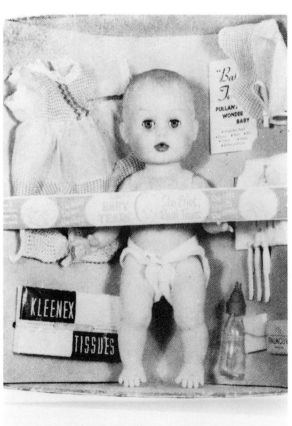

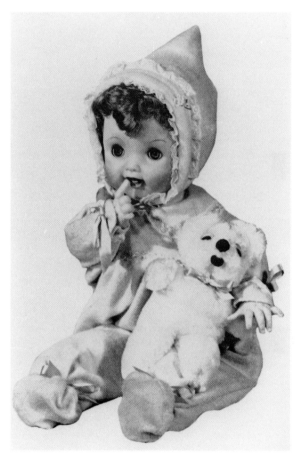

PL25

PL24
Pullan. 1957. SKISUIT DOLL. Came in 17 and 24 inch sizes. (43, 61 cm). One-piece vinyl body with flexiwire, squeeze voice. Vinyl head; sleep eyes, lashes; rooted curly saran hair; open-closed mouth. Dressed in a zippered white fleece skisuit with red braid trim, white bonnet with red pompon, red mitts. Courtesy of Earle Pullan, Toronto, Ont.

PL25
Pullan. 1957. BABY BUNTING. 22 in. (56 cm). Vinyl body with flexiwire, squeeze voice. Vinyl head; sleep eyes, lashes; rooted curly saran hair; open-closed mouth. Wearing fleece suit and matching lace and ribbon trimmed bonnet. Carries a plush bear. Courtesy of Earle Pullan, Toronto, Ont.

PL27
Pullan. 1957. BABY TEARS. 14 and 16 in. (35.5, 40.5 cm). Plastic body, jointed hips, shoulders, and neck. Vinyl head; sleep eyes, lashes; moulded hair (also available with rooted hair); open mouth nurser. Wearing a diaper; comes with a layette. BABY TEARS cries real tears, drinks, and wets. Courtesy of Earle Pullan, Toronto, Ont.

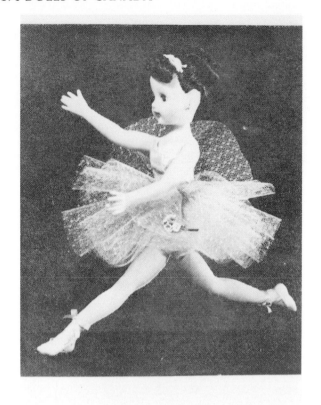

PL29

CH9

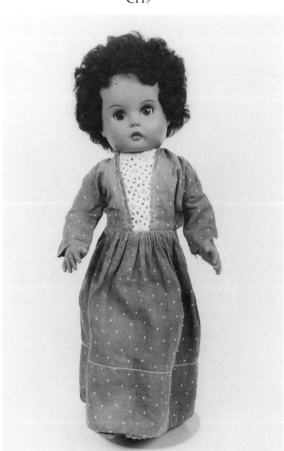

CT21

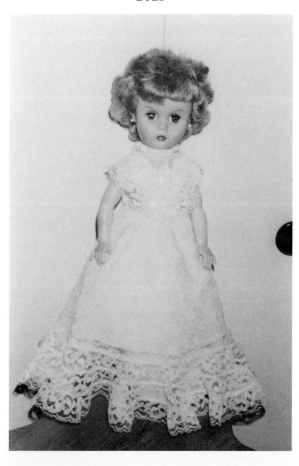

PL29
Pullan. 1957. BALLERINA. 17 in. (43 cm). Vinyl body with wire in the legs to allow the doll to assume any position. Vinyl head; sleep eyes, lashes; rooted saran hair in chignon style; closed mouth. Dressed in a sheer silver net skirt and sparkling bodice, authentic ballet stockings and shoes. Includes earrings. Courtesy of Earle Pullan, Toronto, Ont.

CH9
Pullan. 1957. CINDY. 14 in. (35.5 cm). One piece doll with brown vinyl skin, jointed neck. Vinyl head; brown sleep eyes, lashes, painted lower lashes; very curly rooted black hair; closed mouth. Mark: on head, PULLAN 2; on body, A; on foot, V-15-2. Redressed. Cindy was originally dressed in a dress of white kriskay and brightly coloured taffeta, white shoes and socks. From the collection of June Rennie, Saskatoon, Sask.

CT21
Pullan. 1958. BRIDE. 17 in. (43 cm). Plastic teen body, jointed hips, shoulders, and neck. Vinyl head, earrings; blue sleep eyes, lashes; rooted Saran blond hair; closed mouth. Mark: Pullan. Redressed. Originally wore ankle length embossed satin wedding gown, trimmed in lace. Her waist-length veil was also trimmed in lace. She carried a bouquet of lilies of the valley. Photograph courtesy of Glenda Shields. From the collection of Glenda Shields, London, Ont.

CO20

CO21

CG20

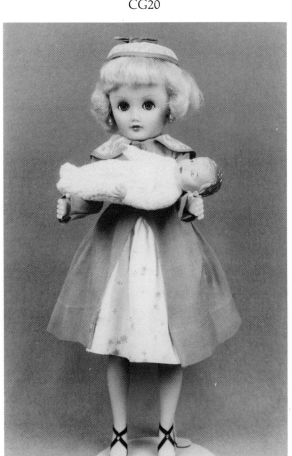

CO20
Pullan. 1957. BABS. 15 in. (38 cm). One piece vinyl body. Vinyl head; fixed brown eyes; deeply moulded hair in a ponytail; closed mouth. Mark: on head, PULLAN. Redressed. Originally wore a cotton dress with ruffled skirt. From the collection of M. Lister, Gallery of Dolls, Hornby, Ont. See also Fig. CO21.

CG20
Pullan. 1958. MOTHER and FAMILY. 20 in. (50.5 cm). Plastic teen doll, jointed at hips, shoulders, neck, and knees. Vinyl head, pierced ears, earrings; blue sleep eyes, lashes, painted lowers; rooted blond saran hair in a short style; closed mouth. Baby is 8 inches with painted eyes. Mark: on head, PULLAN. Original salmon pink coat with matching hat, white printed cotton dress, white cotton half slip and nylon stockings, black high heeled shoes. MOTHER originally came with a little girl and a little boy as well as the baby. From the collection of Margaret Wist, Saskatoon, Sask.

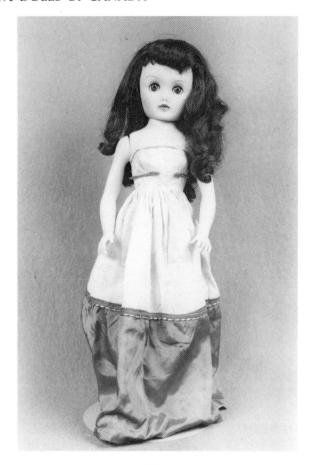

BF33

CG17

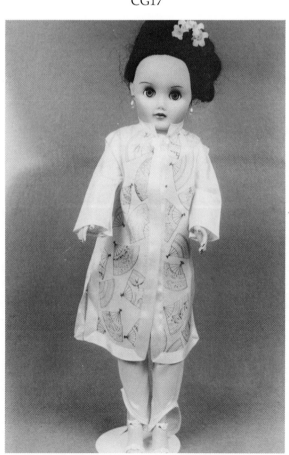

PL26

BF33
Pullan. 1958. RAGS to RICHES DOLL. 21 in. (50.5 cm). Plastic teen body and legs, vinyl arms, jointed shoulders and neck. Vinyl head; blue sleep eyes, lashes; rooted reddish-brown long saran hair with bangs and originally worn in a ponytail; closed mouth painted red. Mark: on neck, PULLAN ; on back, A ; sole of left foot 16 ; sole of right foot VH3-21. Original gown. By three very simple steps a child could convert this doll from her peasant cotton dress by reversing it to a taffeta evening gown with jewelry accessories and high heel shoes. From the collection of June C. MacDonald, Halifax, N.S.

CG17
Pullan. 1958. ORIENTAL PRINCESS. 20 in. (50.5 cm). Plastic teen doll, jointed at waist, elbows, knees, hips, shoulders, and ankles. Vinyl head with pierced ears, earrings; blue sleep eyes, lashes, painted lower lashes; rooted long black saran hair worn up in a roll; closed mouth. Mark: on head, PULLAN. Original white synthetic long sleeved body suit with matching long pants. Over top is a long sleeveless vest with an oriental fan print, bound in white grosgrain. White high-heeled shoes. ORIENTAL PRINCESS was a Christmas special and not a line usually carried by Pullan. From the collection of Margaret Wist, Saskatoon, Sask.

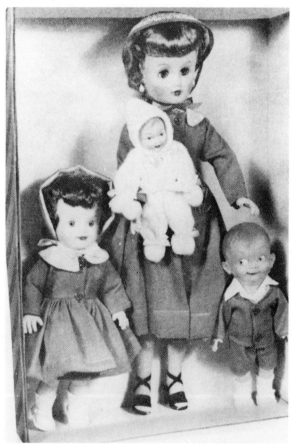

PL26

PL26
Pullan. 1958. MOTHER and FAMILY. Mother, 21 in. (53.5 cm), daughter, 12 in. (30.5 cm), son, 10 in. (25.5 cm), baby, 8 in. (20.5 cm). Mother: vinyl body, jointed shoulders and neck. Vinyl head; sleep eyes, lashes; rooted saran curls; closed mouth. Daughter: vinyl body; vinyl head; glassine eyes; rooted hair; closed mouth. Son: vinyl body and head with freckles; painted side-glancing eyes; moulded hair; closed smiling mouth. Baby: vinyl body and head; painted eyes; moulded hair. Clothing: mother, stylish linen coat and straw hat, print dress, panties, nylons, and high heels; daughter, similiar coat and dress to mother, matching bonnet; son, short pants, jacket and white shirt; baby, brushed rayon snowsuit, carrying a plastic rattle. Courtesy of Earle Pullan, Toronto, Ont.

BH14

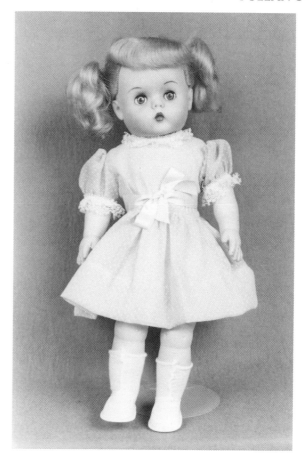

BH14

Pullan. 1958. DREAM DOLL. 16 in. (40.5 cm). One piece body, soft vinyl skin stuffed with foam, jointed neck. Vinyl head; blue sleep eyes, lashes, painted lower lashes; rooted blond saran hair; closed mouth painted red. Mark: on head, PULLAN. Replaced clothing similar to the original costume. This type of body was developed to cut costs. The body was in one piece and the legs sometimes had wire inside so the knees could be bent. From the collection of Donna Gardiner, Dartmouth, N.S.

PL2

Pullan. 1959. BABY PRINCESS. 23 in. (57 cm). Plastic baby body, jointed hips, shoulders, and neck. Vinyl head. Sleep eyes, lashes. Rooted blond saran curls with long forehead curl. Open mouth nurser. Original striped nylon dress with a coloured lace yoke, taffeta slip and panties. BABY PRINCESS also came in 10, 14, 17 and 20 inch sizes. Includes bottle. Courtesy of Mr. E. Pullan, Toronto, Ont.

BJ23

Pullan. 1959. 12.5 in. (32 cm). Plastic body, jointed hips, shoulder, and neck. Vinyl head; blue inset eyes; rooted reddish-blond straight hair; closed mouth painted red. Mark: on head, PULLAN. Original dotted pink cotton dress and bonnet. This doll came out in 1959 called BUTCH, wearing pyjamas and bathrobe. It was produced in an 18 inch version dressed in a christening dress in 1961. From the collection of Nora Moore, Fairvale, New Brunswick.

BJ23

PL2

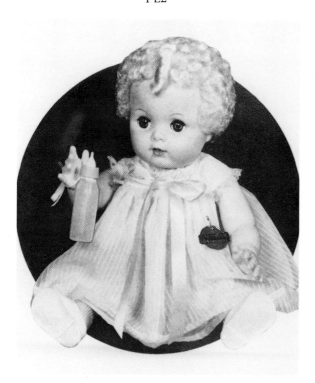

BX8

BX8
Pullan. 1959. BRIDE. 15 in. (37 cm). Plastic body, jointed hips, shoulders, and neck. Vinyl head; blue sleep eyes, lashes, painted lower lashes; rooted brown curled hair; closed mouth. Mark: on head, PULLAN ; wearing original label. Original box. Original white satin gown with silver net overlay and lace trimming, matching net veil streaked with silver, carrying flowers. From the collection of Wilma MacPherson, Mount Hope, Ont.

BZ23
Pullan. 1959. ANNETTE. 15 in. (38 cm). Plastic body, jointed hips, shoulders, and head. Vinyl head; blue sleep eyes, lashes, three painted upper lashes; rooted short blond hair with bangs; closed mouth. Mark: on head, PULLAN. Original black and white striped denim coat and cap trimmed with red. Red cotton dress. From the collection of Phyllis McOrmond, Victoria, B.C.

PL6
Pullan.1960. BEATNIK DOLL. 21 in. (53.5 cm). Plastic, jointed hips, shoulders, and neck. Vinyl head. Sleep eyes. Rooted long straight black saran hair. Mouth closed, smiling. Original striped denim shirt and slacks. Courtesy of Mr. E. Pullan, Toronto, Ont.

BZ23

PL6

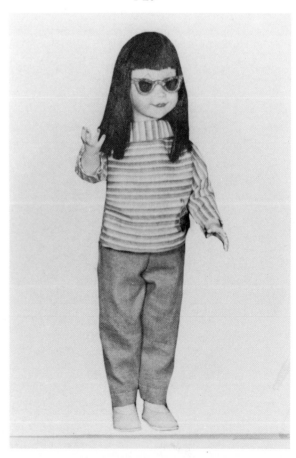

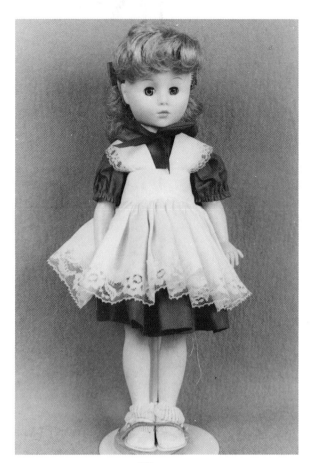

CP20

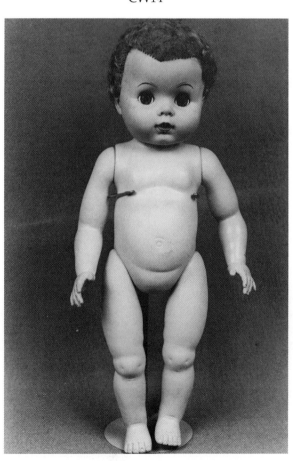

CW14

CP20
Pullan. ca.1960. MISS LUCKY GREEN. 15 in. (38 cm). Plastic body, jointed hips, shoulders, and neck. Vinyl head; blue sleep eyes, lashes, painted lower lashes; rooted honey blond saran hair in ponytail and bangs; closed mouth. Mark: on head, PULLAN. Original green cotton dress with white apron. MISS LUCKY GREEN was available at Loblaws supermarket for two books of coupons. There was also a large size available for five books. Pullan supplied these dolls on a special contract with Loblaws and did not carry this doll for sale in the stores. From the collection of Ina Ritchie, Aurora, Ont.

PL4

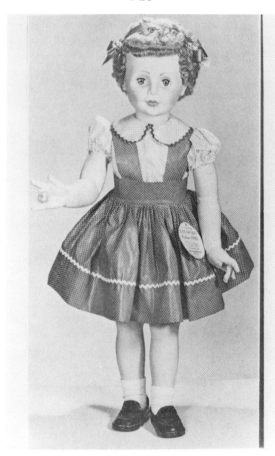

PL4
Pullan. 1960. WENDY ANN. 35 in. (89 cm). Plastic body, jointed hips, shoulders, and neck. Vinyl head; sleep eyes, lashes ; rooted curly saran hair; closed mouth. Dressed in a polished cotton pinafore and blouse, black plastic loafers, and white socks. Courtesy of Earle Pullan, Toronto, Ont.

CW14
Pullan. 1961. JILL. 20 in. (51 cm). Plastic toddler, jointed hips, shoulders, and neck; vinyl head; blue plastic sleep eyes, lashes, painted lower lashes; rooted light brown curls; open mouth nurser. Mark: on head, PULLAN ; on body, PULLAN. Originally wore a flocked taffeta dress trimmed with velvet ribbon and lace with white shoes. She also came in 16 inches. The same doll was made with longer hair and called SWEET SUE. She came in 20 and 25 inch sizes. From the collection of Joyce Cummings, North Vancouver, B.C.

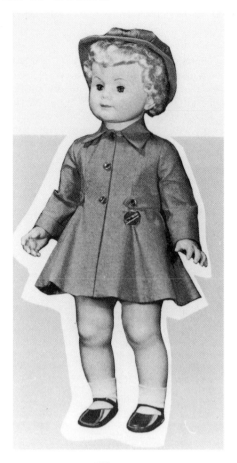

PL15

PL16

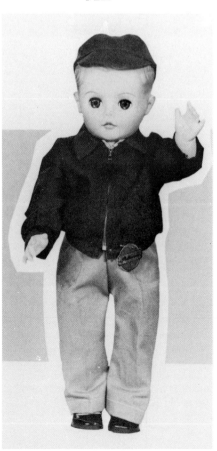

PL15
Pullan. 1961. LOIS. 32 in. (81 cm). Plastic body, jointed hips, shoulders, and neck. Vinyl head; sleep eyes, lashes, rooted curly saran hair; closed mouth. Dressed in a lined and tailored cordette coat and matching hat, print dress, socks and shoes. Courtesy of Earle Pullan, Toronto, Ont.

PL16
Pullan. 1961. BOBBY. 20 in. (51 cm). Plastic body, jointed hips, shoulders, and neck. Vinyl head ; sleep eyes, lashes; moulded light brown hair; closed mouth. Dressed in a zippered denim jacket, matching cap and denim pants. Courtesy of Earle Pullan, Toronto, Ont.

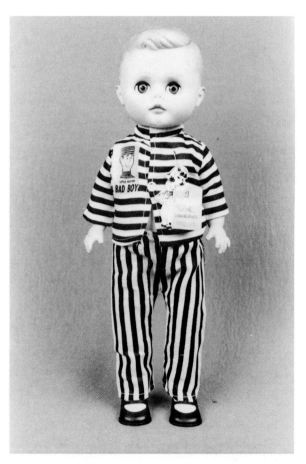

BN26

BN26
Pullan. 1961. LITTLE MISTER BAD BOY 16 in. (40.5 cm). Plastic body, vinyl arms, jointed hips, shoulders, and neck. Hard vinyl head; blue sleep eyes, lashes, painted lower lashes; well defined moulded hair painted brown; closed mouth painted red. Mark: on head, PULLAN. Original BAD BOY suit with hat missing. Original label: A PULLAN DOLL/CANADA'S FINEST/Earle Pullan Company Ltd. Toronto. BAD BOY was made for Mel Lassman for a promotional campaign for the Bad Boy furniture store in Toronto. From the collection of Irene Henderson, Winnipeg, Man.

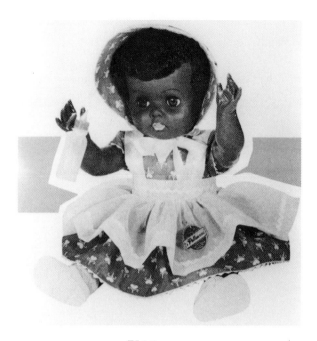

PL17

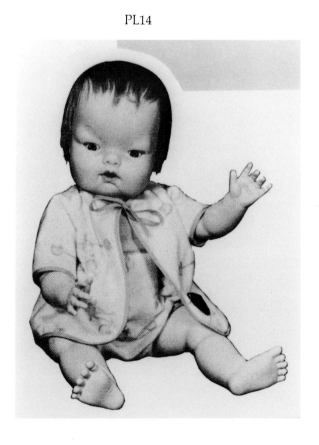

PL14

PL17
Pullan. 1961. CINDY. 20 in. (50.5 cm). Brown plastic, jointed hips, shoulders, and neck. Brown vinyl head; brown sleep eyes, lashes; rooted black saran curly hair; open mouth nurser. Original print dress and bonnet with white ninon apron. Cindy also came in a 14 inch size. Courtesy of Mr. E. Pullan, Toronto, Ont.

PL14
Pullan. 1961. BABY TALKS. 20 in. (51 cm). Vinyl body, jointed hips, shoulders, and neck. Vinyl head; inset plastic eyes; rooted saran hair; open mouth. Original flanelette jacket and panties. BABY TALKS has a special 6 reed voice mechanism that allows her to chuckle, goo, giggle, laugh, and gurgle simply by squeezing her tummy and moving her gently to and fro. Courtesy of Mr. E. Pullan, Toronto, Ont.

BZ19
Pullan. ca.1961. LITTLE MISTER BAD BOY. 30 in. (76.5 cm). Plastic body, jointed hips, shoulders, and head. Hard vinyl head; blue sleep eyes, lashes; moulded light brown hair; closed mouth. Mark: on head, PULLAN. Original striped suit; hat missing. From the collection of Phyllis McOrmond, Victoria, B.C.

BZ19

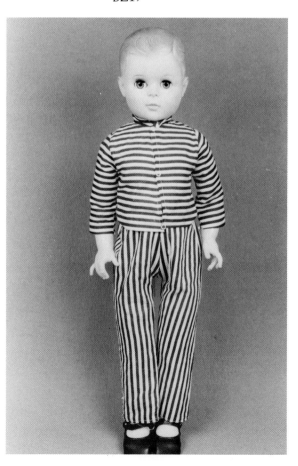

PL8
Pullan. 1962. CLEOPATRA. 22 in. (56 cm). Plastic, jointed hips, shoulders, and neck. Vinyl head; painted eyes with eye shadow and eyeliner; rooted extra long black saran hair; closed mouth. Original sheer nylon gown trimmed with gold braid, gold sandals, and headband. Courtesy of Mr. E. Pullan, Toronto, Ont.

BN30
Pullan. 1961. BOBBY. l5 in. (38 cm) Plastic boy, jointed hips, shoulders, and neck. Hard vinyl head; blue sleep eyes, lashes, painted lower lashes; well defined moulded hair painted light brown; closed mouth. Mark: on head, PULLAN; on body, PULLAN. Original pants and shirt, replaced socks and shoes. BOBBY was originally sold with a miniature car included. From the collection of Irene Henderson, Winnipeg, Man.

BQ20
Pullan. 1961. DOLLY POP. 15.5 in. (40 cm) Plastic toddler, jointed hips, shoulders, and neck; spring in the right hand to bring a lollipop to her mouth. Vinyl head; blue sleep eyes, lashes, painted lower lashes; rooted straight blond hair over moulded hair; open mouth nurser. Mark: on head, PULLAN. Original yellow and white rompers. Original label. DOLLY POP moves her real lollipop up to her mouth every time a child pushes her right arm down. She originally came in a box that made into a highchair. This doll was made under licence with U-Needa Doll Company in the United States. Courtesy of National Museums of Canada, and the National Museum of Man, Ottawa, Ont.

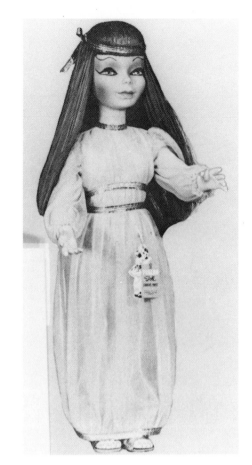

PL8

BN30

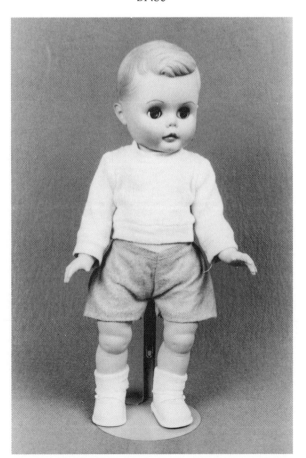

BQ20

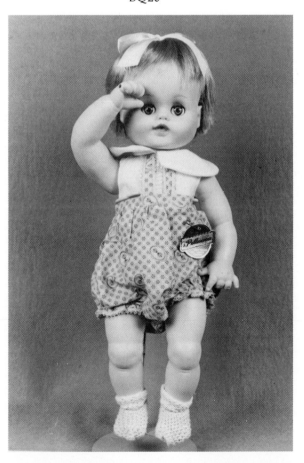

BN16
Pullan. 1962. ANGEL FACE. 14 in. (37 cm). Plastic toddler, jointed hips, shoulders, and neck. Vinyl head; blue sleep eyes, lashes; rooted brown curls with bangs; open mouth nurser. Mark: on head, PULLAN. Original ninon party dress. Replaced socks and shoes. Originally came with a lace trimmed hat and a nursing bottle. ANGEL FACE drinks and wets and has the typical well defined finger and hand detail of the blow moulded body. From the collection of Irene Henderson, Winnipeg, Man.

AM34
Pullan. 1962. VALERIE. 23 in. (58 cm). Plastic body, jointed hips, shoulders, and neck. Vinyl head; blue sleep eyes, lashes, painted lower lashes; rooted short blond hair; closed mouth. Mark: on head, PULLAN/MADE IN CANADA. Original pink and white playsuit, replaced socks and shoes. Valerie was also made in a 20 inch size. Author's collection.

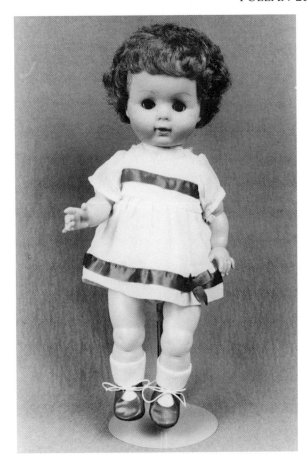

BN16

CZ10

AM34

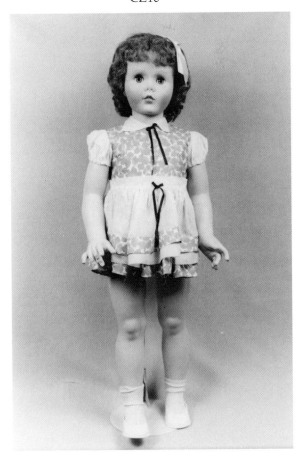

CZ10
Pullan. 1962. WENDY ANN. 36 in. (91.5 cm). Plastic body, jointed hips, shoulders and neck. Vinyl head; blue sleep eyes, lashes, painted lower lashes; honey blond saran curly hair with bangs; closed mouth. Mark: unmarked. Original box. Original blue and white cotton print flounced dress, hairbow, socks and shoes. Author's collection.

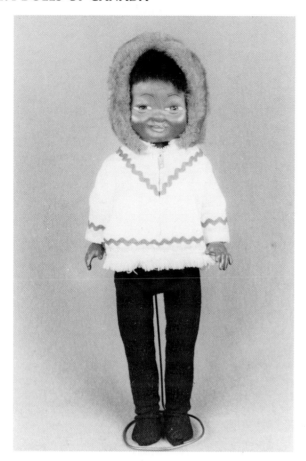

BZ32

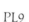

BZ32
Pullan. 1962. ESKIMO. l6 in. (40.5 cm). Plastic body and legs, vinyl arms, jointed hips, shoulders, and neck. Vinyl head; inset brown plastic eyes; rooted short straight black hair; closed mouth. Mark: on head, PULLAN. Original fur trimmed white cotton parka with red and yellow rick-rack, and zipper closing. Originally wore matching pants and felt boots. From the collection of Louise Rowbottom, Victoria, B.C.

PL9
Pullan.1957. MINDY. 15 in. (38 cm). One piece brown vinyl skin with flexiwire armature. Brown vinyl head. Painted eyes. Black, heavily detailed moulded hair in braids. Open-closed mouth. Original white ninon dress trimmed with red rickrack and a rosette. Courtesy of Mr. E. Pullan, Toronto, Ont.

PL11
Pullan. 1963. WENDY ANN. 36 in. (91.5 cm). Plastic body, jointed hips, shoulders, and neck. Vinyl head; sleep eyes, lashes; rooted long blond straight hair; closed mouth. Wearing a cotton A line dress, socks and shoes. Courtesy of Earle Pullan, Toronto, Ont.

PL9

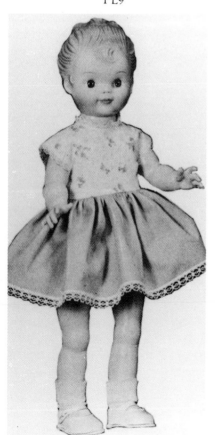

PL11

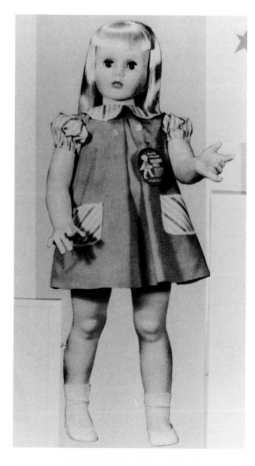

AE9
Pullan. 1963. BOBBY. 18 in. (45.5 cm). Heavy plastic body, jointed hips, shoulders, and neck. Hard vinyl head with well defined ears; large blue sleep eyes, lashes, painted lower lashes; very detailed moulded light brown hair; closed mouth. Mark: on head, PULLAN/18-5S2. BOBBY came in various outfits, as a Mountie, in short pants, and in overalls. From the collection of Judy Smith, Ottawa, Ont.

BF4
Pullan. ca.1963. POOR PITIFUL PEARL. 16 in. (40.5 cm). Plastic body and legs, vinyl arms, jointed hips, shoulders, and neck. Vinyl head with freckles; brown sleep eyes, lashes and painted upper lashes; rooted long blond hair; watermelon mouth. Mark: on head, PULLAN. Original one piece outfit. Pearl was not a popular doll in her day. Her face has become discoloured. From the collection of Margaret Hayes, Musquodoboit Harbour, N.S.

CI6
Pullan. 1963. LANA LEE. 16 in. (40.5 cm). Plastic body, jointed hips, shoulders, and neck. Vinyl head; blue sleep eyes, lashes, painted lashes at outside upper edge of eye; rooted blond hair; watermelon mouth. Mark: on head, PULLAN/MADE IN CANADA. Original pink cotton dress with lace trim. The dress originally had a bow over the lace ruffle in the skirt, and her hair was worn pulled back in two pony tails tied with bows. From the collection of Ruth MacAra, Caron, Sask.

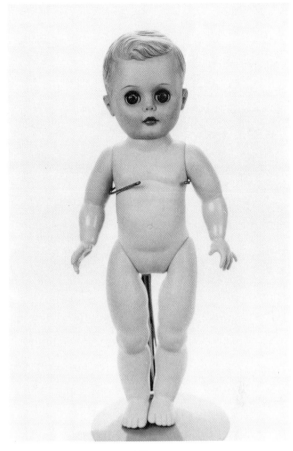

AE9

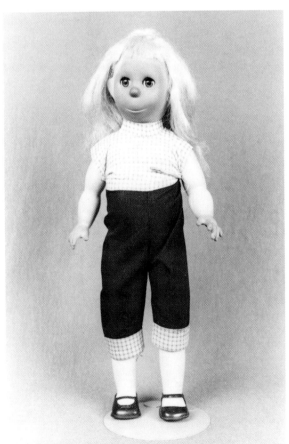

BF4

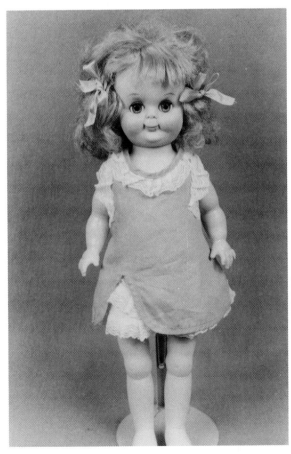

CI6

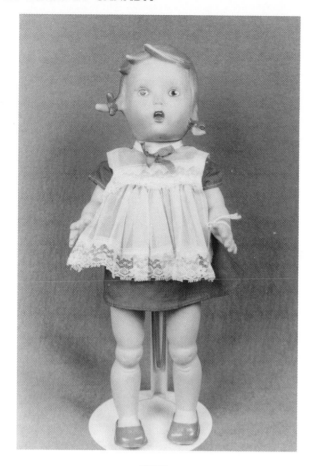

CF22

PL10

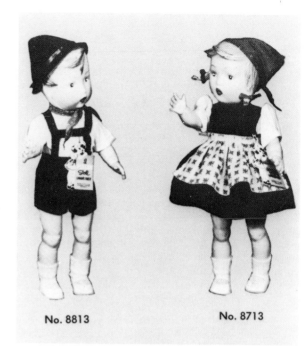

No. 8813 No. 8713

PL13

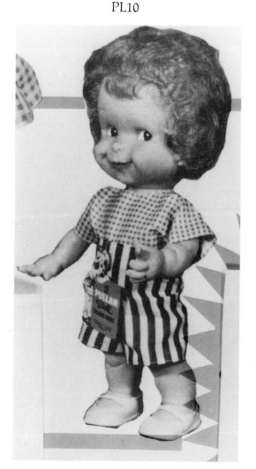

PL13
Pullan. 1963. FRITZ and FREDA. 13 in. (33 cm). Plastic bodies, jointed hips, shoulders, and neck. Vinyl head; painted eyes; deeply moulded painted hair; closed mouth. Dressed in matching cotton peasant styled clothing. Courtesy of Earle Pullan, Toronto, Ont.

CF22
Pullan. 1963. FREDA. 13 in. (38 cm). Plastic body and legs, vinyl arms. Vinyl head; brown painted eyes; hair moulded into bangs with ribbons, painted light brown; mouth: open-closed showing two painted teeth. Mark: on head, PULLAN. Original red dress and white apron. FREDA was not shown in the catalogues in this dress. She wore a sold colour dress with a print apron from the waist and a matching kerchief and white shoes and socks. There was also a little boy named FRITZ. From the collection of Gloria Kallis, Drayton Valley, Alta. See also Fig. PL13.

PL10
Pullan. 1963. LOUIE. 12 in. (30.5 cm). Plastic jointed hips, shoulders, and neck. Vinyl head; painted side-glancing eyes; rooted red saran curls; closed watermelon mouth. Original cotton print shirt and pants. A matching little girl called LISA was also produced. LOUIE and LISA also came with black hair. Courtesy of Mr. E. Pullan, Toronto, Ont.

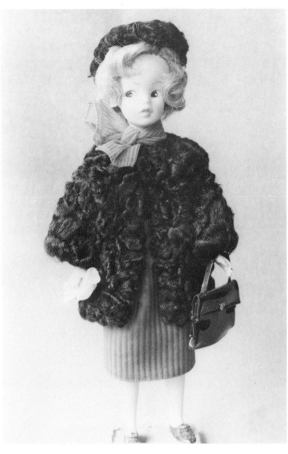

CM4

PL12

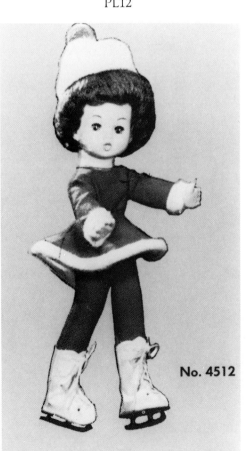

No. 4512

CM4
Pullan. 1963. MARJIE. 12 in. (30 cm). Plastic teen body and legs, vinyl arms, jointed hips, shoulders, and neck. Vinyl head; blue painted side-glancing eyes with highlights; rooted blond saran hair; closed mouth painted pink. Mark: on head, MARJIE. Redressed in skirt and blouse, fur jacket and hat, carrying purse and mitts. Author's collection.

PL12
Pullan. 1964. PEACHES. 12 in. (30.5 cm). Plastic body and legs, vinyl arms, jointed hips, shoulders and neck. Vinyl head, glassine fixed eyes, moulded lashes; rooted brown hair; open-closed mouth. Dressed in a skating costume with matching hat and ice skates. Courtesy of Earle Pullan, Toronto, Ont.

BN14
Pullan. 1964. VIC and VICKI. 10 in. (23 cm). Plastic toddlers, vinyl arms, jointed hips, shoulders, and neck. Vinyl head; painted side-glancing blue eyes, painted lashes. Boy has rooted strawberry blond hair, girl has rooted blond hair. Open-closed mouth. Mark: on head, PULLAN, MADE IN CANADA. Original diapers, label and box. Many outfits were available for VIC and VICKI and they also came sitting in a cardboard high chair. They are drink and wet dolls and were very popular. From the collection of Irene Henderson, Winnipeg, Man.

BN14

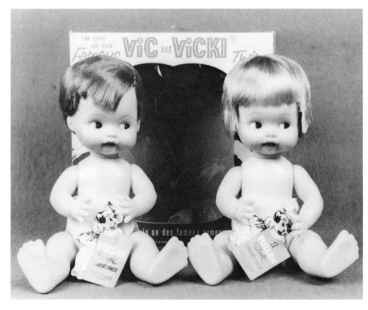

CF27
Pullan. 1964. MARLANE. 12 in. (30 cm). Plastic teen body and legs, vinyl arms, jointed hips, shoulders, and neck. Vinyl head; painted side-glancing eyes, painted upper lashes; rooted straight red saran hair; closed mouth. Mark: on head, PULLAN. Original red dress, stand and box. MARLANE had 16 sets of costumes depicting the national dress of European countries. From the collection of Gloria Kallis, Drayton Valley, Alta.

PL23
Pullan. 1965. BOXER. 12 in. (30.5 cm). Plastic, jointed hips, shoulders, and neck. Vinyl head; painted side-glancing eyes with one permanently black eye; rooted light brown hair; closed watermelon mouth. Original trunks and boxing gloves. Courtesy of Mr. E. Pullan, Toronto, Ont.

PL21
Pullan. 1965. PRETTY PENNY. 30 in. (76.5 cm). Plastic, jointed hips, shoulders, and neck. Vinyl head; sleep eyes, lashes, eyeshadow; rooted long straight saran hair with bangs; open-closed mouth. Original simulated leopard fur coat and matching hat, blouse, slacks, shoes and socks. PRETTY PENNY was a walking doll that came in a variety of hair styles and in different outfits. Courtesy of Mr. E. Pullan, Toronto, Ont.

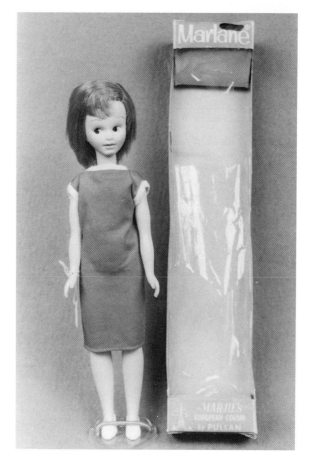

CF27

PL21

PL23

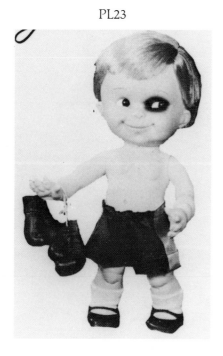

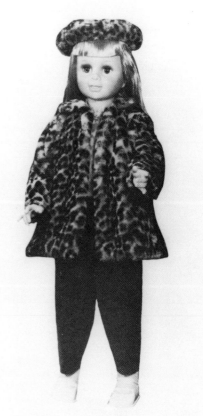

No. 3044 — PRETTY PENNY — 30" walk-ing doll with long straight Patsy Saran

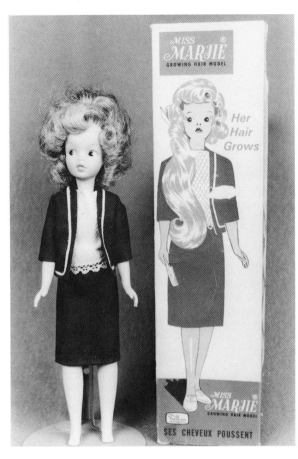

BN33

BN33
Pullan. 1965. MISS MARJIE. 12 in. (30 cm). Plastic body, vinyl arms, jointed hips, shoulders, and neck. Vinyl head; painted side-glancing eyes; rooted blond curly hair with a 'growing" section on top; closed mouth. Mark: on head, Margie. Original clothes and original box, includes brush and comb. MARJIE had different outfits available for every type of activity. A bed and a carrying case were also sold to go with MARJIE. From the collection of Irene Henderson, Winnipeg, Man.

CH12
Pullan. 1965. PEACHES INDIAN GIRL. 12 in. (30 cm). Brown plastic body and legs, vinyl arms with upturned hands, jointed hips, shoulders, and neck. Vinyl head; brown sleep eyes, plastic lashes; incised brows; rooted straight black saran hair; open-closed mouth. Mark: on head, PULLAN/MADE IN CANADA; on body, PULLAN. Original yellow satin dress trimmed with white fringe, red rickrack. PEACHES INDIAN GIRL originally had a headband with rickrack and a single feather at the back. She wore white shoes and socks. From the collection of June Rennie, Saskatoon, Sask.

XH26
Pullan. 1966. PROSPECTOR. 14 in. (35.5 cm). Cloth body formed by clothing, vinyl arms, vinyl boots. Cloth head with vinyl face; black painted eyes; grey fake fur hair, beard is rooted into face; smiling watermelon mouth. Mark: tag on body, EARLE PULLAN CO. LTD./TORONTO, CANADA. Original green and brown plaid shirt, green corduroy pants, black felt hat. Removable gold felt vest, belt and black neckscarf. Original box. Not in Pullan's catalogue. Probably a special order only available in the West. From the collection of Gloria Kallis, Drayton Valley, Alta.

CH12

XH26

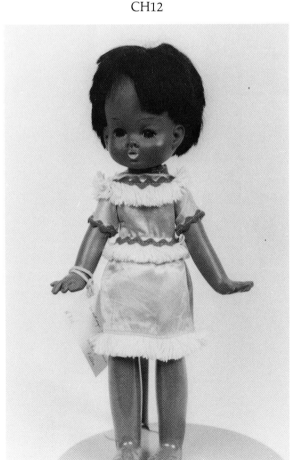

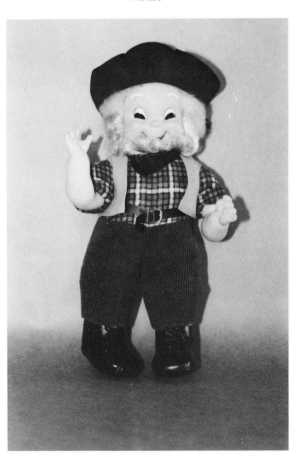

PL20
Pullan. 1966. TWINKLE ESKIMO. 10 in. (25.5 cm). Vinyl body, jointed hips, shoulders, and neck. Vinyl head; painted black side-glancing eyes; rooted straight black hair; closed mouth. Dressed in fur trimmed red flannel parka with blue flannel leggings. Courtesy of Earle Pullan, Toronto, Ont.

PL18
Pullan. 1966. SUZANNE. 17 in. (43 cm). Plastic body with vinyl arms, jointed hips, shoulders, and neck. Vinyl head; sleep eyes, lashes; rooted red Saran hair; closed mouth. Wearing a crisp red white and blue dress. Courtesy of Earle Pullan, Toronto, Ont.

CO17
Pullan. 1966. SUZANNE. 16 in. (40.5 cm). Plastic body, jointed hips, shoulders, and neck. Vinyl head; blue sleep eyes, lashes, painted lower lashes; rooted platinum blond long straight saran hair; closed mouth. Mark: on head, PULLAN. SUZANNE came dressed in different outfits and with different hairdos. With this hair she was usually dressed in a white turtle neck shirt, plaid skirt, and red corduroy jacket. From the collection of M. Lister, Gallery of Dolls, Hornby, Ont.

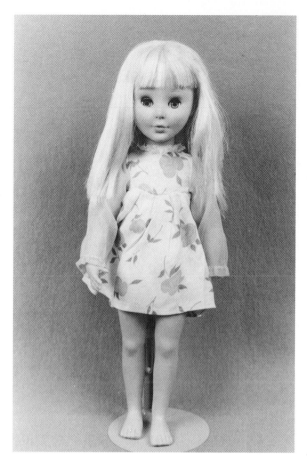

CO17

PL18

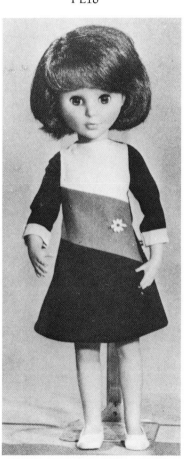

PL20

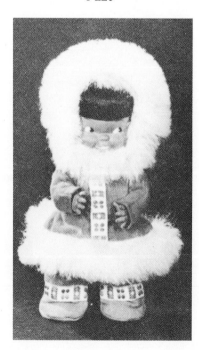

The Florentine Statuary Company

Maxim Maggi was a sculptor who loved to create dolls. His story weaves in and out of several Canadian doll making companies during the first quarter of the twentieth century. The Florentine Statuary Company is one of them.

Mr. Maggi was a partner with Mr. W.H. Davis who was also a sculptor in the Florentine Statuary Company at 277-281 King St. East in Toronto, Ontario, in 1917. However, at the same time the Commercial Toy Company was listed at 279 King St. East. Obviously both enterprises were in operation at the same address. Commercial Toy was making bisque heads, and Florentine was producing composition heads. Florentine was probably making the composition bodies for both organizations.

Commercial Toy was in business only one year. A few bisque-headed dolls have survived and are easily identifed as they are clearly marked with the company name. Perhaps the commercial or financial arrangement with two companies under the same roof was not viable. Florentine Statuary did survive and flourish and became a notable doll manufacturer in the nineteen-twenties. They used the cold process method in the manufacture of composition and produced a wide variety of dolls, including an extremely well-preserved dark skinned doll which was unusual at that time (see fig. CN9).

Florentine made dolls from 1917 to about 1932 when they switched their product line to lamps and shades. They did, however, provide some attractive dolls to Canadian doll collections. Mr. Maggi continued his efforts to make bisque-headed dolls, and his story carries on with the Bisco Doll Company.

CD27
Florentine. ca.1917. 12.5 in. (31.5 cm). Cloth body and legs, composition forearms. Composition shoulderhead; painted eyes; moulded hair with moulded hair bow; closed mouth. Mark: on shoulderplate, FLORENTINE/TORONTO. From the collection of Vera Goseltine, Vancouver, B.C.

AM26
Florentine. ca.1918. 12.5 in. (31 cm) Cloth body, legs and upper arms, wooden forearms and hands, painted pink. Composition shoulderhead; painted blue eyes with a fine black line over the eyes, painted brows; moulded Buster Brown hair, painted brown; closed mouth painted red, nostril dots. Mark: on shoulderplate, FLORENTINE/TORONTO. Original thin cotton suit, sewn on black shoes. The composition on this doll has remained in good condition although the paint is flaky in spots. Author's collection.

CD27

AM26

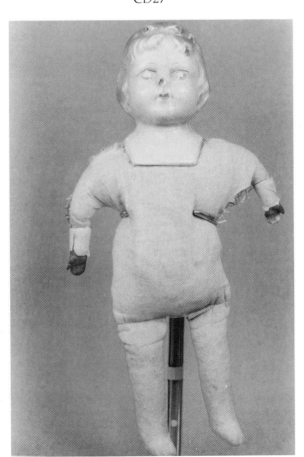

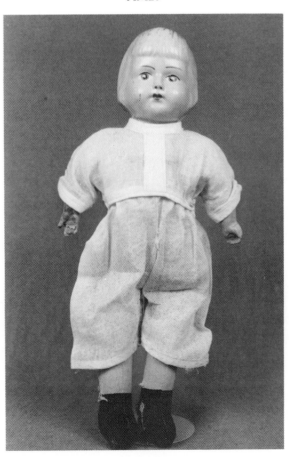

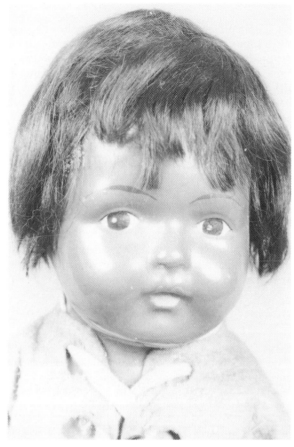

CN9

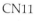

CN9
Florentine. ca.1918. Indian. 17 in. (43 cm). Excelsior stuffed cloth body and legs, composition gauntlet hand. Brown composition shoulderhead; black painted eyes with highlights, black line over eye; black human hair wig; closed mouth. Mark: on shoulderplate, FLORENTINE/TORONTO. Original red and beige felt suit and moccasins. An outstanding Florentine doll. Has the early method of arm construction which Florentine later changed. From the collection of Diane Peck, Sudbury, Ont. See also Figs. CN11, CN10, CN12.

CN11

CN12

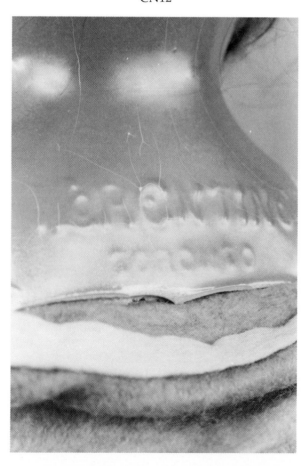

CN10

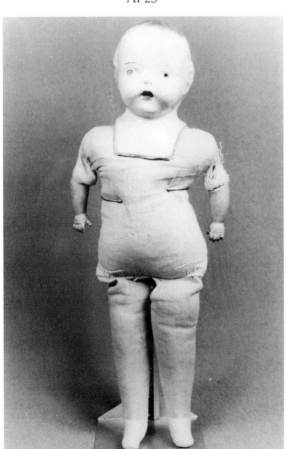

AP23

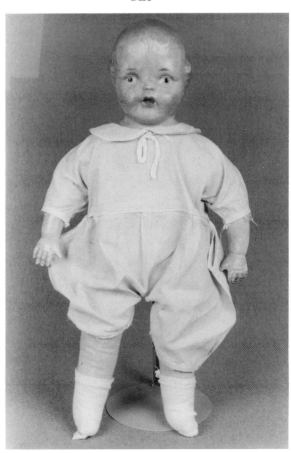

BZ8

CN10
For a description of this doll see Fig. CN9 on page 212.

AP23
Florentine. ca.1920. 21.5 in. (55 cm) Cloth body, legs and upper arms, composition forearms. Composition shoulderhead; painted blue eyes, painted upper lashes and brows; moulded hair, painted light brown; closed mouth, painted red, nostril dots. Mark: on shoulderplate, FLORENTINE/TORONTO. From the collection of Dawn Young, Niagara Falls, Ontario.

BZ8
Florentine. ca.1920. 22 in. (56 cm). Cloth body and legs, composition forearms. Composition shoulderhead; blue painted eyes, black line over eye, upper painted lashes; blond moulded hair; closed mouth. Original cotton rompers. This doll is unmarked but it appears to be the same doll as in Fig. AP23, although the painting differs slightly. From the collection of Jil Ashmore, Victoria, B.C.

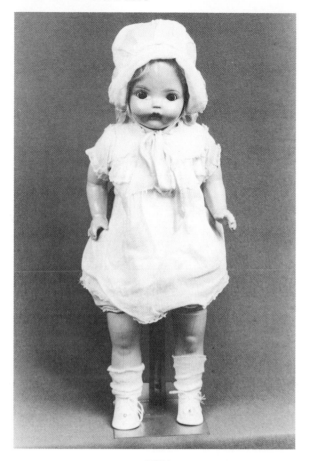

AP21

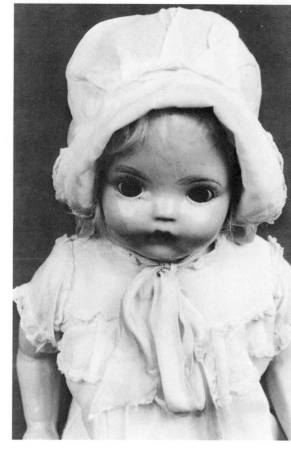

AP22

CR16

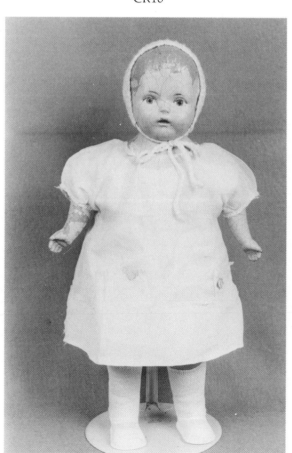

AP21
Florentine. ca.1925. 24 in. (60 cm). Cloth body with composition arms and legs. Composition shoulderhead; blue sleep eyes, painted lashes and brows; original blond wig; open mouth, showing teeth and tongue. Mark: on shoulderplate, FLORENTINE/TORONTO. All original clothing. From the collection of Geraldine Young, Niagara Falls, Ontario. A valuable doll, beautifully painted eyelashes and brows showing the quality of workmanship of the better Florentine dolls. See also Fig. AP22.

CR16
Florentine. ca.1927. 18 in. (45.5 cm). Cloth body and legs, composition forearm. Composition shoulderhead; blue painted eyes (retouched), black painted upper lashes; moulded hair; open- closed mouth. Mark: on shoulderplate, FLORENTINE/TORONTO. Original cotton dress, replaced sock, shoes and bonnet. Author's collection.

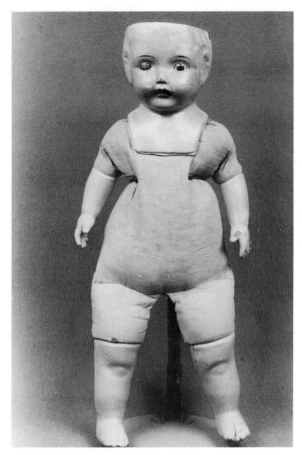

CW18

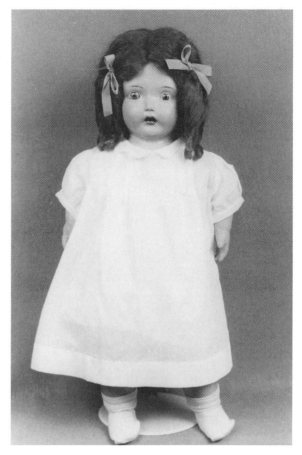

CR34

CZ2
Freeman. ca.1945. DIDY-WET. All composition bent-limb baby, jointed hips, shoulders and neck. Composition head; painted eyes; moulded hair; open-mouth nurser. Original diaper. Original box. From the collection of Mary Miller, Kelowna, B.C.

CW18
Florentine. ca.1928. 24 in. (61 cm). Cloth body, composition forearms and legs. Composition open crown shoulderhead; blue celluloid eyes (one missing), painted upper and lower lashes; open-closed mouth. Mark: on shoulderplate, FLORENTINE/ TORONTO. From the collection of Berna Gooch, North Vancouver, B.C. See Fig. CR34 after the doll has been restored.

Freeman Toy Company

The Freeman Toy company was established in 1943 at 39 Wellington East in Toronto, Ontario. A year later the fledgling company moved to 41 Colborne Street. The owners were three brothers, Sam, and twins Larry and Morley Freedman. Sam was the president and Larry and Morley held executive positions.

The moulds needed to make composition dolls were imported from the United States. The clothing was designed in Canada by Larry. The Freedman brothers were familiar with the toy business, for their father had manufactured stuffed animals and plush dolls.

The Freeman Toy company produced mama dolls with distinctive eye painting. The area over the eye was shaded darker to resemble eye shadow. Most dolls were unmarked but wore a silver tag identifying them as Freeman Dolls. The company closed its doors in 1952.

CZ2

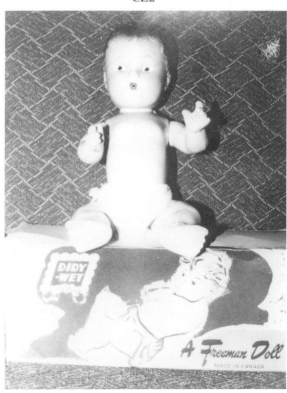

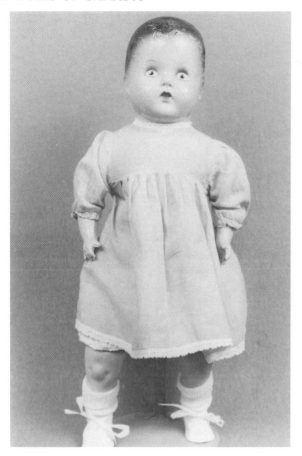

CL31

CL31
Freeman. ca.1944. 20 in. (51 cm). Cloth body, composition forearms and straight legs. Composition head; blue painted eyes, painted lower lashes, upper eyeshadow; black moulded hair; closed mouth. Unmarked. Original pink cotton dress; replaced socks and shoes. From the collection of Berna Gooch, North Vancouver, B.C.

CT20
Freeman. ca.1946. 25 in. (63.5 cm). Cloth body, composition arms and legs. Composition head; painted blue eyes, eyeshadow, painted lower lashes; moulded brown hair; closed mouth. Mark: unmarked. Original tag, A genuine Freeman Doll/Made in Canada. All original clothing, pink and blue cotton dress with matching bonnet. From the collection of Glenda Shields, London, Ont.

CA27
Freeman. ca.1946. 19 in. (48.5 cm). Cloth body, composition forearms and straight legs. Composition head; blue painted eyes, painted lower lashes, upper eyeshadow; brown moulded hair; closed mouth. Unmarked. Original white cotton dress and bonnet trimmed with rickrack; shoes and socks. From the collection of Mrs. D.H. Morman, Victoria, B.C.

CT20

CA27

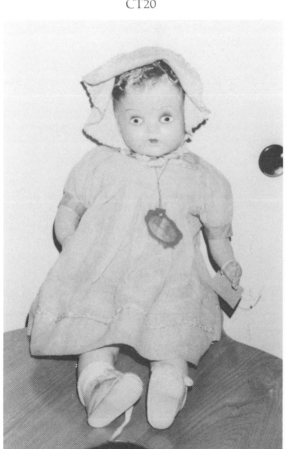

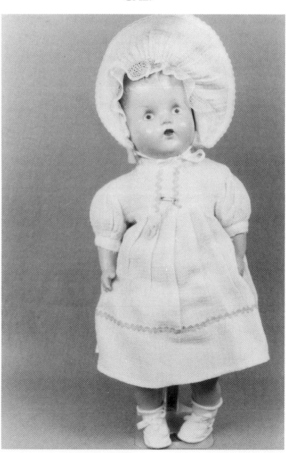

CA33
Freeman. ca.1947. 24 in. (61 cm). Cloth body, composition forearms, straight legs. Composition head; blue painted eyes, painted lower lashes, upper eyeshadow; brown moulded hair; closed mouth. Unmarked. Original tag, A/GENUINE/Freeman Doll (in script)/MADE IN CANADA. Original white and blue cotton dress and bonnet with rickrack trim, socks and shoes. From the collection of Mrs. D.H. Morman, Victoria, B.C.

AP11
Freeman. ca.1948. 16 in. (41 cm). Composition body, jointed hips, shoulders, and neck. Composition head; blue sleep eyes, lashes, painted lower lashes; brown mohair wig in braids with curly bangs; closed mouth. Mark: on body, FREEMAN TOY/TORONTO, CANADA. Original cotton dress, socks and shoes. From the collection of Dawn Young, Niagara Falls, Ont.

CT6
Freeman. ca.1948. 22 in. (56 cm). Cloth body, composition arms and legs. Composition flange head; painted blue eyes, eyeshadow, painted lower lashes; moulded dark brown hair; closed mouth. Unmarked. Original label, A Genuine/Freeman Doll/Made in Canada. Original blue dotted white cotton dress with a blue yoke, matching bonnet, replaced socks and shoes. Author's collection.

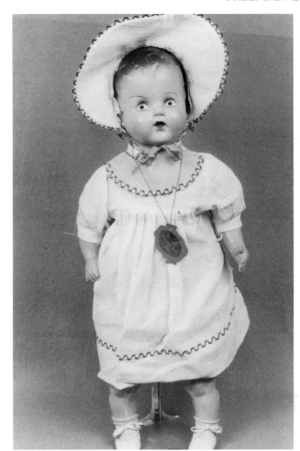

CA33

AP11

CT6

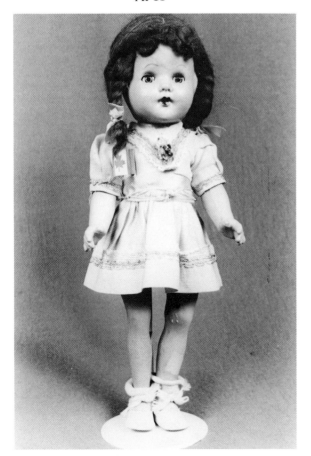

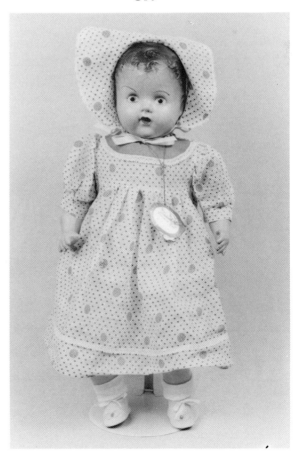

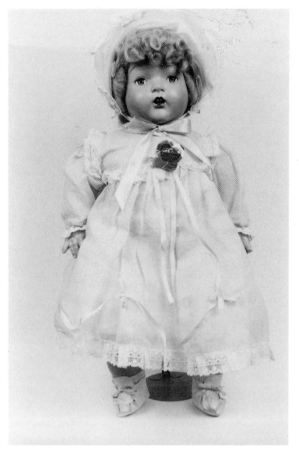

AZ5

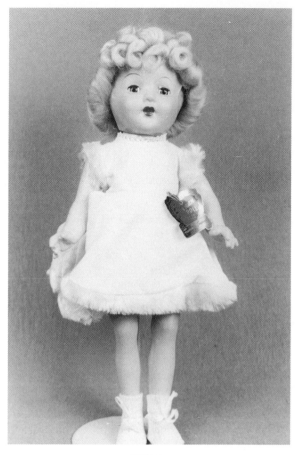

CN34

AZ5
Freeman. ca.1950. 24 in. (62 cm). Cloth body, composition hands and legs. Composition head; blue sleep eyes, lashes, painted lower lashes; blond mohair wig with curly bangs; open mouth showing two teeth and tongue. Mark: Original tag, A FREEMAN/DOLL/MADE IN CANADA/FREEMAN TOY COMPANY/TORONTO. Original pink organdy dress and matching bonnet, socks and shoes. Author's collection.

CN34
Freeman. ca.1951. 17 in. (43 cm). Composition body, jointed hips, shoulders, and neck. Composition head; blue sleep eyes, lashes, painted lower lashes; blond mohair wig; closed mouth. Mark: on head, FREEMAN TOY/TORONTO. Original label, A FREEMAN DOLL/MADE IN/CANADA/FREEMAN TOY COMPANY/TORONTO. Original pink dress, socks and shoes. Also came with brown hair and a cherry pink dress. From the collection of Dianne Peck, Sudbury, Ont.

Giltoy Company

We located only one doll with a label marked Giltoy. She is is all original and has the original box, which has Montréal on the label. The doll, however, is marked W.O.L. No record can be found of a company with those initials, and no listing of the Giltoy Company address can be found.

Two of these dolls were found in the storeroom of an old drugstore that closed its doors. Luckily, a doll collector, Mary Miller of Kelowna, B.C. heard of the dolls in mint condition, still in their boxes which were about to be thrown out. Included in this find were the two Giltoy dolls, Freeman dolls, Reliable Wetums dolls and Magic Skin dolls. All of these dolls, other than the Giltoys, were known to have been made between 1945 and 1950. Therefore we can deduce that the Giltoy company was in business in Montréal about 1945 although no trace of the company can be found in the records.

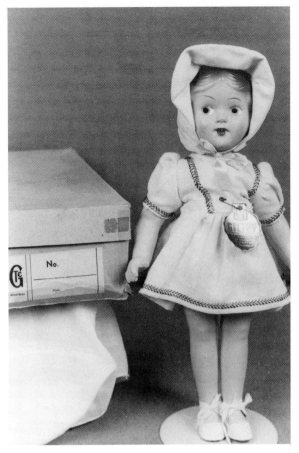

CN24

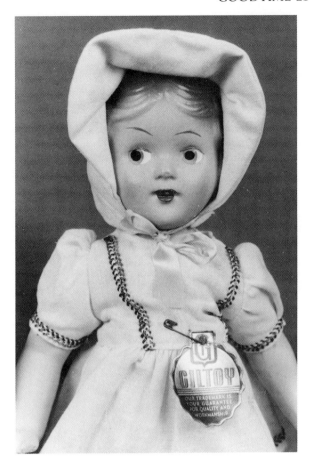

CN25

CN24
Giltoy. ca.1945. 14 in. (35.5 cm). Composition body, jointed hips, shoulders, and neck. Composition head; blue painted side-glancing eyes; brown moulded hair; closed mouth. Mark: on body, W.O.L. Original label, GILTOY/Our trademark is/your guarantee/for quality and/workmanship. Original white cotton dress with blue and white trim and matching bonnet; white shoes. From the collection of Diane Peck, Sudbury, Ont. See also Fig. CN25.

Goodtime Toys

Goodtime Toys was founded in 1970 at 48 Abell Street in Toronto, Ontario. They did not buy Star Doll Manufacturing Company, although they did buy some of the assets, particularly the moulds.[1]

Some of the Goodtime Toy dolls are marked the same as dolls made by Star Doll. This makes it difficult to distinguish between dolls made by the two companies. To make it even more difficult to identify your doll, Mighty Star used the same moulds used by Star doll and Goodtime Toys. Unless the doll comes with its original box stating who made it, it is almost impossible to identify its maker. The business was sold to Mighty Star Company Limited in 1977.

1. Harry Zigelstein. Personal communication.

BX15

BX15
Goodtime Toys. ca.1975. FASHION DOLL. 20 in. (51 cm). Plastic teen body, jointed hips, shoulders, and neck. Vinyl head; blue sleep eyes, lashes, eyeshadow; rooted platinum long hair on the side and short on top; closed mouth. Mark: on head, 14R. Original lace trimmed print gown. Original box. From the collection of Wilma MacPherson, Mount Hope, Ont.

Indien Art et Eskimo de la Maurice Inc.

Indien Art et Eskimo has been manufacturing dolls since 1979 in St. Tite (Laviolette), Québec. The models are created by Québec artists and are moulded from an unbreakable latex mixture. The dolls are then painted and dressed by the French Canadians of the town of St.Tite. Although they are imaginatively dressed they are not in authentic dress nor made by Indians. They can not be considered authentic Indian dolls, but are attractive nevertheless, and are quite popular with tourists.

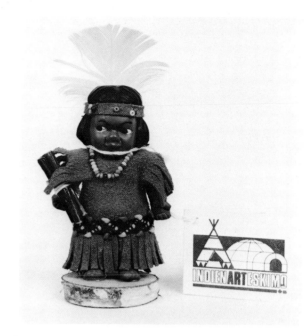

AP4

AP4
Indien Art et Eskimo. 1983. INDIAN CHILD. 4 in. (10 cm). Brown one piece moulded body. Black painted side-glancing eyes, black moulded hair, closed mouth. Mark: label, Indien Art Eskimo. Leather dress, headdress with feather, beads, carrying firewood. Author's collection.

AO22
Indien Art et Eskimo. 1982. OTTER BELT. 12 in. (30.5 cm). Brown moulded one piece body made of an unbreakable latex mixture. Painted designs on face and arms. Black painted eyes, wool braids, closed mouth. Mark: on label, Indien Art Eskimo/OTTER BELT. Dressed in leather loincloth and fur pelt over shoulder, beads, headdress and feather, leather moccasins, carrying fur shield and knife. Author's collection.

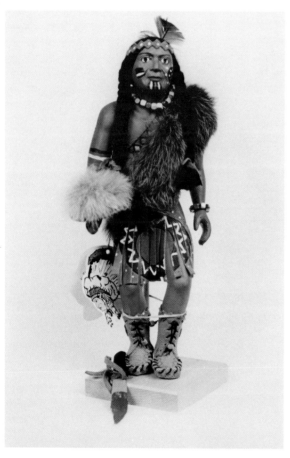

AO22

Mighty Star Company Limited

Mighty Star Company Ltd. of Toronto, Ontario, bought Goodtime Toys in 1977 and formed their Mighty Star Doll Division. They have produced a variety of attractively dressed dolls, sometimes using moulds acquired from Goodtime Toys, which makes it difficult to identify their dolls once they are out of the box. Occasionally a doll turns up marked Star Doll but in a Mighty Star box. The moulds in this case were passed on to each succeeding company.

Mighty Star stopped making dolls in Canada in 1983,[1] and began importing plush dolls and the vinyl and cloth LIV an LUV dolls which were dressed in Toronto. They are still in business in 1986.

1. Ben Samuels. Personal communication.

CG25

CG6

AO8

CG25
Mighty Star. ca.1978. 23 in. (58.5 cm). Plastic body, jointed hips, shoulders, and neck. Vinyl head; blue sleep eyes, lashes; rooted blond hair with side braids; closed mouth. Mark: on head, DOLL/c1965 CANADA. From the collection of June Rennie, Saskatoon, Sask. This doll is marked DOLL with a scratched out mark in front of it. The mould is exactly the same as the Star Doll in Fig. AN26 which has complete markings. She has the hairstyle of the late seventies and the long dress which was popular at that time. She is undoubtedly a Mighty Star Doll.

CG6
Mighty Star. 1980. 19 in. (48.5 cm). Plastic teen body and legs, jointed hips, shoulders, and neck. Vinyl head; blue sleep eyes, lashes; rooted long blond hair with bangs; closed mouth. Mark: on head, 14R. Original slacks set. Original box. From the collection of Gloria Kallis, Drayton Valley, Alta.

AO8
Mighty Star. 1981. 20 in. (51 cm). Plastic teen body, jointed hips, shoulders, and neck. Vinyl head; brown sleep eyes, lashes, painted lower lashes; rooted long brown curls with bangs; closed mouth. Mark: on box, 8474, Another Mighty Star Doll; Goodtime Toys Inc. Original gown and hat. From the collection of Connie McCleave, Ottawa, Ont.

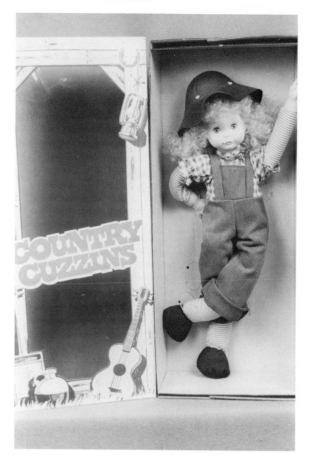

CG7

CG7
Mighty Star. 1981. COUNTRY CUZZINS. 24 in. (61 cm). Cloth body, arms and legs, vinyl hands. Vinyl head; blue sleep eyes, lashes; rooted long curly blond hair; closed mouth. Mark: on head, 4/MIGHTY STAR/CANADA. Original overalls, shirt and hat. Original box. From the collection of Gloria Kallis, Drayton Valley, Alta.

AO7
Mighty Star. 1981. 20 in. (51 cm). Plastic teen body, jointed hips, shoulders, and neck. Vinyl head; blue sleep eyes, lashes, painted lower lashes; rooted blond with bangs; closed mouth. Mark: on head, 14R; on box, 8686, Another Mighty Star Doll and Goodtime Toys Inc. Original ruffled gown and simulated fur hat. From the collection of Karen McCleave, Ottawa, Ont.

AP3
Mighty Star. 1982. 18 in. (45.5 cm). Plastic body, jointed hips, shoulders, and neck. Vinyl head; blue sleep eyes, lashes, blue eyeshadow; rooted brown curls with bangs; closed mouth. Mark: on head, 5. Original print dress and bolero, plastic boots. Original box with both Mighty Star and Goodtime Toys Inc. on it. Author's collection.

AO7

AP3

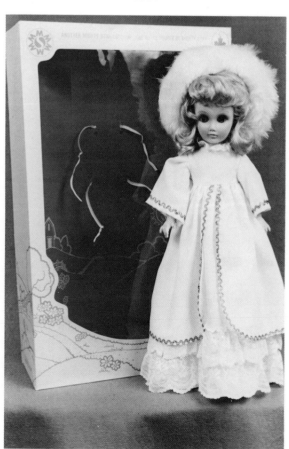

AA18

AA18
Mighty Star. 1983. CANADA GIRL. 12 in. (30.5 cm). Plastic body, jointed hips, shoulders, and neck. Vinyl head; blue sleep eyes, lashes; rooted blond short curls; open-closed mouth. Mark: on head, STAR DOLL. Original red and white dress with Canada on the front, shoes and socks. Original box. From the collection of Andria Morris, Fullerton, Ca. U.S.A. One of the Dolls of All Nations series.

XH27

XH27
Mighty Star. 1982. BABY CRISSIE. 18 in. (45.5 cm). Cloth body with crier, vinyl arms and legs. Vinyl head ; blue sleep eyes, lashes; slightly moulded light brown hair; open-closed mouth. Mark: on head, STAR/09094/Plated Moulds Inc./c1961.; on body, Made by Ont. Reg. No. 71B7816/MIGHTY STAR LTD.-DOLL DIVISION ; on original box, Made by/Fabrique par /MIGHTY STAR LTD./LTEE. /DOLL DIVISION/DIVISION POUPEE /48 Abell Street /Toronto, Canada M6J 3H2. Wearing original white knit sweater, pink quilted overalls, white socks. From the collection of Gloria Kallis, Drayton Valley, Alta. This doll was made from an old Star mould in 1982 although it was purchased in 1985.

CG5
Mighty Star. 1982. BABY WETSY. 16 in. (40.5 cm). Plastic body and legs, vinyl arms, jointed hips, shoulders, and neck. Vinyl head; blue sleep eyes, lashes; rooted brown curls; open mouth nurser. Unmarked. Original knit suit and hat. Original box. From the collection of Gloria Kallis, Drayton Valley, Alta. Although this doll was purchased in 1984, it was made in 1982.

CG5

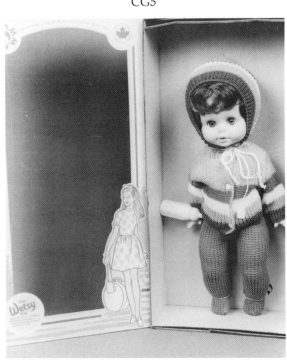

Noma Toys Ltd

Noma Toys Ltd. of Owen Sound, Ontario, was a short-lived branch of the Noma Lites Canada Ltd. Company. Dolls were made from 1945 to 1948 after which the company reverted to producing Christmas tree and decorative items.

Noma Toys was licensed by Cameo in the United States to make both the KEWPIE doll and SCOOTLES. KEWPIE dolls came out in 1945 and were sold in two different models. One was 13 inches in height and had moveable arms, legs, and head. The other was 11 inches in height and had moveable arms. Both dolls were dressed in cotton sunsuits. They were unmarked but wore identifying tags. In 1947 a PICKANINY KEWPIE was also available wearing panties.

In 1947 and 1948, SCOOTLES was sold in a 13 inch size dressed in a cotton sunsuit, socks and shoes. Unless the doll still has its box, it is difficult to identify it as a Canadian doll.

BF25
Noma. 1945. KEWPIE DOLL. 13 in. (33 cm). Composition body, jointed hips, shoulders, and neck. Composition head; black painted side-glancing eyes; distinctive kewpie-style moulded hair; closed watermelon mouth. Unmarked doll, original tag on wrist, Kewpie Doll by Rose O'Neal. Original box, Made in Canada, 1348. From the collection of Margaret Archibald, Halifax, N.S.

CD15
Noma. 1947. SCOOTLES. 13 in. (33 cm). Composition body, jointed hips, shoulders, and neck. Composition head dimpled cheeks and chin, nostril dots; blue painted eyes, painted upper lashes; reddish moulded curls; closed watermelon mouth. Mark: doll unmarked, original label, Scootles/a Cameo doll. Original box. Original cotton print sunsuit, socks and shoes. SCOOTLES won a blue ribbon in 1982 at the Second Canadian National Doll Convention in Toronto. From the collection of Florence Langstaff, North Vancouver, B.C.

BF25

CD15

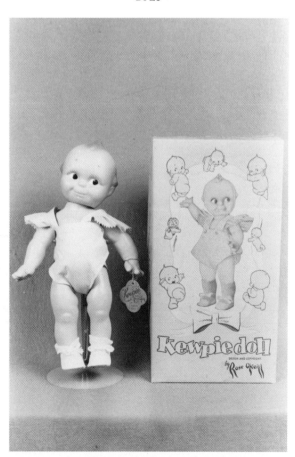

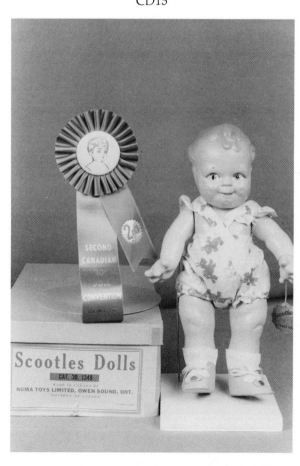

Oil Patch Kids

Oil Patch Kids is based in Edmonton, Alberta. This company, as far as is known, has produced only the Oil Patch Kid dolls in both boys and girls.

CR12
Oil Patch Kids. 1985. OIL PATCH KID. 10 in. (25.5 cm). Cloth body. Vinyl head with freckles ; blue stencilled eyes; rooted black wool hair; closed watermelon mouth. Mark: no mark on doll; original Well licence. Original yellow coveralls and gold plastic hat. Comes with plastic oil barrel and black velvet Oil Patch Pet with eyes and feet. Girl dolls are also available. Author's collection.

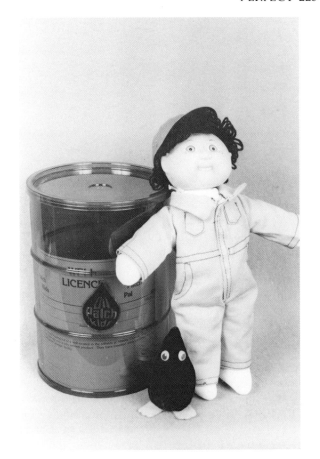

CR12

AP32

Perfect Doll Company

The Perfect Doll company was established in 1948 at 3192-96 Dundas West in Toronto, Ontario. It was founded by partners who had worked for Reliable Toy Company and decided to go into business for themselves. They were in operation for one year and went bankrupt because they did not have enough capital.

AP32
Perfect. 1948. 12 in. (30.5 cm). Composition bent-limb baby body. Composition head; blue painted eyes with fine black line and highlights; brown moulded hair; closed mouth. Mark: on head, PERFECT/MADE IN CANADA. Original cotton dress and matching tam. From the collection of Dawn Young, Niagara Falls, Ont.

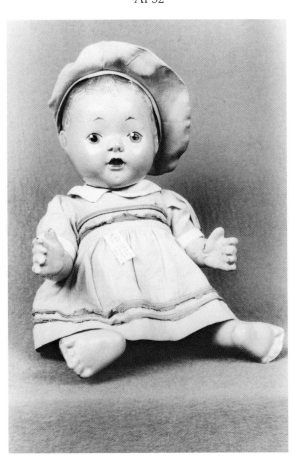

Regal Toy Company

The Regal Toy Company was established in 1959 at 35 Jutland Road, Toronto, by Frank Samuels. It was a family business with his three sons, Irving, Lawrence, and Harvey, and his brother Ben Samuels. At one time Jack Schaffter had shares in the company, but in 1972 he sold out to the Samuels family.[1]

Regal began when the transition period of the doll industry had settled calmly into the plastics age, for this company did not go through the Magic Skin or Vinyl Flex era. They installed equipment to produce blow moulded plastic dolls and soft vinyl dolls made by rotational moulding.

Regal produced a wide variety of dolls for the next seventeen years, employing essentially the same two types of plastics with which they began. Notable amongst the Regal dolls is a distinct Canadian flavour. Perhaps the fact that Ben Samuels was Canadian born, unlike his elder brothers who were born in England, influenced the company's line of dolls. Year after year Regal produced dolls of national character, showing pioneer dolls, dolls with clothes adorned with maple leaves, dolls dressed in the Maple Leaf tartan, as well as Indian, Inuit, and ethnic dolls. Regal also produced several Canadian celebrity dolls.

In 1961, they made PRIMA BALLERINA, a doll with jointed ankles, knees, waist, shoulders, and neck, suitably dressed in a complete ballet costume. From the company's inception they produced a line of black dolls and babies, including the 22 inch LIZA in a pretty frock. The LITTLE PRINCESS walking doll came in 30 and 36 inch sizes and was dressed in a variety of styles including a ninon polka dot dress and a sailor type dress in cotton.

A notable doll in 1962 was CANDY who walked and talked. She had an open-closed smiling mouth that gave her a delightful expectant look. RONNIE, a 30 inch boy was a surprise because few boy dolls were made, especially in large sizes.

KIMMIE, the perennial charmer, was new in 1963. There seems to have been four basic versions of KIMMIE. One KIMMIE, which was usually 12 inches tall, had eyes that were three dimensional. The black pupil was moulded so that it resembled an inset eye (see Fig. CH11). This model had a wider smile, and the body was slightly different from the other versions, particularly the hands. The second type was also made in 1963. It was 10 inches tall, and the eye was painted. The pupil and iris were a side-glancing half circle, and there were no breaks in the edge of the half circle (see Fig. AO37). The third type, which came out in 1964, was BABY KIMMIE with bent-limb arms and legs, and only 9 inches in height (see Fig. CW20). The fourth type was produced in 1965 and came either with the 10 or 12 inch body. Its eyes were painted and side-glancing, but the pupil and iris had a slash or

Mr. Frank Samuels and wife with their three sons Irving, Harvey, and Lawrence.

a pie-shaped piece out, which gave the doll highlights in its eyes (see Fig. CS6). This was the most common KIMMIE.

TEENY TINY TEARS was widely advertised on television in 1965. She cried tears, blew bubbles, and wetted. MUSICAL WIGGLES was an innovative doll that had a music box inside which played when the doll wiggled.

Regal prepared for Canada's one-hundreth birthday by creating a line of dolls dressed in the authentic Maple Leaf tartan, a registered industrial design. It is a tartan that captures the colours of the maple leaves changing from green, to gold, to red and brown. CANDY wore a Maple Leaf tartan outfit with matching tam and came in a variety of sizes. These dolls make excellent collector's items.

Regal created a minor sensation at the 1968 Canadian Toy Fair in Montreal with their BABY BROTHER and BABY SISTER dolls. They were designed to resemble a four month old baby complete with physiological differences. They were attractive and in good taste. Mr. Frank Samuels felt that they were a natural development towards a more realistic doll. Children seemed to agree with Mr. Samuels, and were happy to accept the new dolls. The Toronto Telegram at the time quoted Dr. Reva Gerstein, a Toronto mental health specialist, as saying that the dolls were a step forward from sexless dolls which have no basis in the child's world of experience.

A new souvenir doll in a 4 inch size was new in 1969. It was called ITSY BITSY and was dressed as an Inuit, an Indian, a bride, a nurse, or a little girl.

DOLLS FROM MANY LANDS came in the costumes of twelve countries in 1970. WENDY WALKER, a 36 inch doll with a very pretty face, was introduced the same year. She was a popular doll and was made in different sizes over the years, with various hair styles and costumes.

A very special doll was MIMI who walked, talked, and sang. Her talking mechanism was battery operated, and she came with three interchangeable records, either in English or French. In English she sang London Bridge, Baa Baa Black Sheep, Round the Mulburry Bush, and Twinkle, Twinkle Little Star. In French she sang Frère Jacques, Alouette, and Au Clair de la Lune.

VICKI wore a smart pant set in 1973, with the shirt and lower pant legs in white with small red maple leaves. MICHELLE was also new in her high fashion outfits and generous head of nylon hair. MICHELLE was a slim doll with bendable knees for posing. She wore dramatic avant-garde clothing and sometimes wore sunglasses for a glamorous appearance.

Frank Samuels died in September 1973. He had been a quiet, reserved man and a man of integrity. He had been manufacturing toys and dolls for fifty-three years and had made an impressive number of Canadian dolls. He had also served three terms as president of the Canadian Toy Manufacturer's Association. His brother, Ben Samuels, took over as president of the company and led Regal to produce some notable Canadian dolls. Regal sold the BOBBY ORR doll under their banner, although he was not made in Canada. A line of Canadiana dolls was presented in 1976 that included PENNY PENTATHALON, Canada's Olympic Hostess doll.

Regal was sold to General Mills in the United States in 1976 and continued to make dolls in Canada for a few years without changing the name Regal Toy Company.[2]

LUV and KISSES appeared in 1977 wearing a pink dress with white dots and matching panties. She kissed when her leg was squeezed. There was also a pair of MOUSEKETEER dolls in a 9 inch size. The Yesterday and Tomorrow line, in 1978, consisted of eighteen dolls with eleven of them wearing gowns with lavish lace trimming. Several had elaborate hair styles, and one wore a gay nineties gown and matching veiled hat. In 1979, another Canadian sports heroine was commemorated with the KAREN MAGNUSSEN doll. KAREN wore a black print polished cotton skating costume with white lace sleeves and trim, and white lace tights. She was also available in a lace skating costume. Another new line of sixteen dolls that year was called the Regal Collection and had dolls dressed in Victorian style velvets and laces. A beautiful baby in a long lace gown with matching bonnet was also included in the Regal Collection.

The company was sold again in 1983, this time to Peter Tervey, and in 1984 it went bankrupt ending a long and diligent history of producing distinctly Canadian dolls.[3]

1. Canadian Toy Manufacturer's Association. *Tidbits.* Vol. 4, No. 3, Summer 1972.
2. Ben Samuels. Personal communication.
3. Ibid.

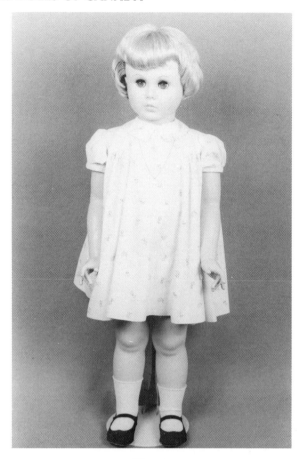

CS25A

CS25A
Regal. 1961. LITTLE PRINCESS WALKER. 36 in. (91.5 cm).
Plastic body, jointed hips, shoulders, and neck. Vinyl head; blue
sleep eyes, lashes, painted lower lashes; rooted blond saran hair;
closed mouth. Unmarked. Redressed; original socks and shoes.
Originally wore a printed cotton dress with fitted bodice and
rickrack trim. Author's collection.

CD17
Regal. 1962. WALKING PLAY PAL. 23 in. (58.5 cm). Plastic
body, jointed hips, shoulders, and neck. Vinyl head; blue sleep
eyes, lashes, painted lower lashes; rooted light brown curls over
moulded hair; open mouth nurser. Mark: on head REGAL
TOY/CANADA; on body, Regal (in script)/CANADA.
Redressed. Originally came in several different dresses or in lace
trimmed panties, plus shoes and socks, to be dressed at home.
From the collection of Florence Langstaff, Vancouver, B.C.

CG8
Regal. 1962. GAIL. 13 in. (33 cm). Plastic body, jointed hips,
shoulders, and neck. Vinyl head; blue plastic sleep eyes, lashes;
rooted dark brown saran curly hair; closed mouth. Mark: on
head, a crown over REGAL TOY/MADE IN CANADA; on
body, REGAL/CANADA. Original lace trimmed dress, socks
and shoes, and matching hair ribbon. Original box and label.
From the collection of Gloria Kallis, Drayton Valley, Alta.

CD17

CG8

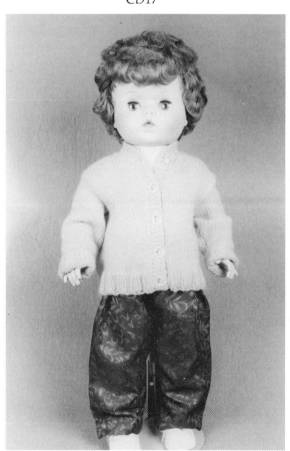

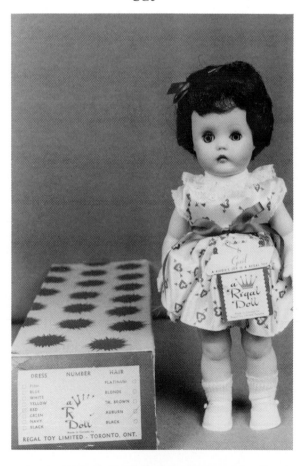

CG29
Regal. 1962. TEAR DROPS. 12 in. (30.5 cm). Plastic body, jointed hips, shoulders, and neck. Vinyl head; blue sleep eyes, lashes, painted lower lashes; rooted saran curls; open mouth nurser. Mark: on head, REGAL TOY/MADE IN CANADA; on body, REGAL/CANADA. Replaced diaper. Originally came in a diaper, print dress and bonnet, packed in a box with a layette including dress, diaper, bonnet, sponge, pacifier, bottle, powder puffs, face cloth and pins. In 1961 she also came in a 14 in. size and in a suitcase. From the collection of June Rennie, Saskatoon, Sask.

AP27
Regal. 1962. BOUDOIR DOLL. 15 in. (38 cm). Plastic body and legs, vinyl arms, jointed hips, shoulders, and neck. Vinyl head; blue sleep eyes, lashes, painted lower lashes; rooted long grey hair with bangs; closed mouth. Mark: on head, a crown over REGAL TOY/MADE IN CANADA. Original lace trimmed gown, matching hair ribbon. Hair came in various pastel colours. From the collection of Geraldine Young, Niagara Falls, Ont.

CI11
Regal. 1962. PENNY. 17 in. (43 cm). Plastic body, jointed hips, shoulders, and neck. Vinyl head; blue sleep eyes, lashes, painted lower lashes; rooted blond curly saran hair; closed mouth. Mark: on head, REGAL TOY. Original blue cotton print dress, socks and shoes. Original box. From the collection of Ruth MacAra, Caron, Sask.

CG29

AP27

CI11

CE7

CE7
Regal. ca.1963. BABY DEAR. 20 in. (51 cm). Plastic bent-limb baby body, jointed hips, shoulders, and neck. Vinyl head; blue sleep eyes, lashes; rooted dark brown hair; open mouth nurser. Mark: on head, a crown over REGAL TOY/MADE IN CANADA; same on body. BABY DEAR wore a snowsuit in 1963. From the collection of Roberta LaVerne Ortwein, Olds, Alta.

CJ13
Regal. ca.1963. 21 in. (53.5 cm). Plastic body, jointed hips, shoulders, and neck. Vinyl head; brown sleep eyes, lashes; rooted brown curls; open-closed mouth. Mark: on body, REGAL/CANADA. Redressed in white nylon and lace. From the collection of Elva Boyce, Regina, Sask.

CS7
Regal. 1963. GAIL. 16 in. (40.5 cm). Plastic body, jointed hips, shoulders, and neck. Vinyl head; blue sleep eyes, lashes, painted lower lashes; rooted blond hair with bangs; closed mouth. Mark: on head, REGAL TOY/MADE IN CANADA. Replaced dress, socks and shoes, similar to the original style. Author's collection.

CJ13

CS7

CO1A

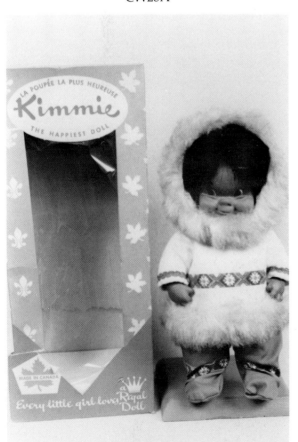

CW23A

CO1A
Regal. 1963. BABY DEAR. 20 in. (51 cm). Plastic body, vinyl bent-limb arms and legs, jointed hips, shoulders, and neck. Vinyl head; blue sleep eyes, lashes, painted lower lashes; rooted brown curls; open-closed mouth. Mark: one head, REGAL TOY/MADE IN CANADA. Replaced clothing similar to the original clothing. From the collection of Diane Peck, Sudbury, Ont.

CW23A
Regal. 1964. KIMMIE ESKIMO. 10 in. (25.5 cm). Brown plastic body, jointed hips, shoulders, and neck. Vinyl head; painted black side-glancing eyes, painted upper lashes; rooted straight black hair; closed watermelon mouth. Mark: on head, REGAL/MADE IN CANADA. Original parka and hood trimmed with simulated fur. Original box. KIMMIE the pigeon-toed toddler was one of Regal's most popular models. He or she was made as a black, white, or Inuit doll in a great variety of costumes and was produced for many years. From the collection of Mr. Mrs. C. Milbank, Sarnia, Ont.

CW20

CW20
Regal. 1964. BABY KIMMIE. 9 in. (23 cm). Vinyl bent-limb baby body, jointed hips, shoulders, and neck. Vinyl head; black painted side-glancing eyes, three painted upper lashes; rooted black straight hair; closed mouth. Mark: on head, REGAL TOY/MADE IN CANADA; on body, REGAL TOY/MADE IN CANADA/9-G. BABY KIMMIE came either dressed as an Indian or an Inuit. From the collection of Joyce Cummings, North Vancouver, B.C.

BM1
Regal. 1964. CANDY. 24 in. (61 cm). Plastic body, jointed hips, shoulders, and neck. Vinyl head; brown sleep eyes, lashes, painted lower lashes; rooted long blond nylon hair with bangs; closed mouth. Mark: on head, REGAL TOY/MADE IN CANADA. Original maple leaf tartan dress with white collar and lace jabot and sleeve frills, matching beret, red socks and black shoes. Original box. One of Regals finest dolls. From the collection of Marie Owen-Fekete, Meductic, N.B. See also colour Fig. BM1.

CH11
Regal. 1965. KIMMIE. 12 in. (30.5 cm). Brown plastic body and legs, vinyl arms, jointed hips, shoulders, and neck. Brown vinyl head; moulded black three-dimensional side-glancing eyes; rooted black hair; closed watermelon mouth. Mark: on head, REGAL/MADE IN CANADA. Original fur and leather outfit. This doll may have been dressed as an Inuit by a group who bought the doll from Regal. This work is done by some of the Indian bands. It is more expensively dressed than a commercial doll. From the collection of June Rennie, Saskatoon, Sask.

CH7
Regal. ca.1966. SNUGGLES. 18 in. (45.5 cm). Moulded foam plastic on a wire frame, vinyl forearms. Vinyl swivel head; dark brown sleep eyes, three outer lashes; rooted dark brown hair; closed watermelon mouth. Mark: on head, REGAL TOY/MADE IN CANADA. Yellow knit two piece sleepers with Trixie Dixy stamped on the feet. SNUGGLES may be wearing replaced sleepers from Trixie, a Regal doll in the 70's. Originally wore sleepers with a Peter Pan collar and a peaked nightcap. From the collection of June Rennie, Saskatoon, Sask.

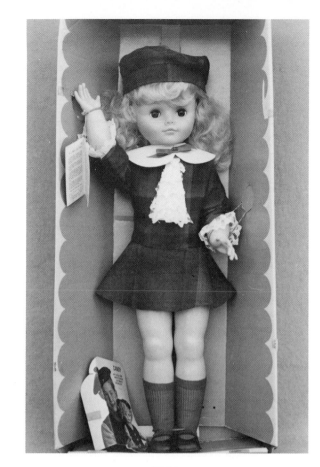

BM1

CH11

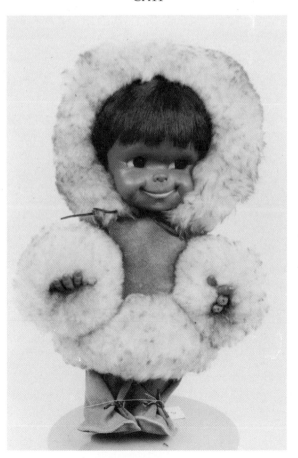

CH7

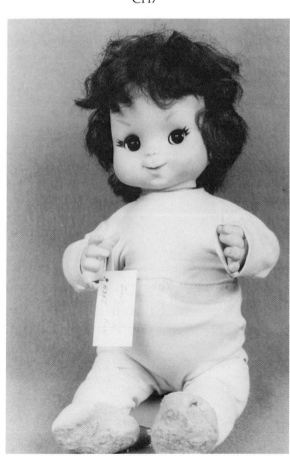

BZ30

BZ30
Regal. 1967. TRESSY. 12 in. (30.5 cm). Plastic teen body and legs, vinyl arms, jointed hips, shoulders, and neck. Vinyl head; blue painted side-glancing eyes; rooted brown saran hair with hair "growing" out of the top of her head with a key supplied to wind it back in; closed mouth. Mark: on head, REGAL. Original pink cotton dress with black trim. Original box. From the collection of Louise Rowbottom, Victoria, B.C.

CI7
Regal. 1967. CANDY WALKER. 25 in. (63.5 cm). Plastic body, jointed hips, shoulders, and neck. Vinyl head; blue sleep eyes, lashes, painted lower lashes; rooted blond nylon hair; closed mouth. Mark: REGAL TOY/MADE IN CANADA. Original maple leaf tartan dress and tam with maple leaf pin. From the collection of Ruth MacAra, Caron, Sask.

CJ27
Regal. ca.1968. INDIAN PRINCESS. 13 in. (33 cm). Brown plastic body, jointed hips, shoulders, and neck. Vinyl head; brown plastic sleep eyes, lashes, four upper lashes; rooted black long straight hair; closed mouth. Mark: on head, c REGAL TOY/MADE IN CANADA. Sealskin coat trimmed with coyote fur, matching hat, and boots. Probably not dressed by Regal. From the collection of Dianne Richards, Kenosee Lake, Sask.

CI7

CJ27

CG3

AN35

CG3
Regal. ca.1968. 23 in. (58.5 cm). Cloth body, vinyl arms and legs. Vinyl head; blue sleep eyes, lashes and three painted outer lashes; rooted blond hair; closed smiling mouth. Mark: on head, REGAL TOY LTD./MADE IN CANADA/19c68. Original nylon and lace dress. Not shown in the catalogue but appears to be the same head as BONNIE the rag doll. A very unusual doll. From the collection of Gloria Kallis, Drayton Valley, Alta.

AN35
Regal. 1969. DRINK and WET BABY DEAR. 18 in. (45.5 cm). Plastic body and legs, vinyl arms, jointed hips, shoulders, and neck. Vinyl head; blue sleep eyes, lashes, three upper lashes; rooted brown curly hair; open mouth nurser. Mark: on body, REGAL/CANADA. Original dress and panties. From the collection of Dorothy McCleave, Ottawa, Ont.

CS6

CS6
Regal. ca.1970. KIMMIE. 10 in. (25.5 cm). Plastic body, jointed hips, shoulders, and neck. Vinyl head with freckles; blue stencilled side-glancing eyes, painted upper lashes; rooted short blond curly hair; closed watermelon mouth. Mark: on head, REGAL/MADE IN CANADA. Original cotton print dress, replaced shoes. Author's collection.

AN31

CF20

BN10

AN31
Regal. ca.1970. VICKI WALKER. 18 in. (45.5 cm). Plastic body, jointed hips, shoulders, and neck. Vinyl head; blue sleep eyes, originally had lashes, three painted upper lashes on the outside of the eye; rooted long black hair; closed mouth. Mark: on head, REGAL/MADE IN/CANADA; on body, REGAL/CANADA. In 1970 VICKI came in A line dresses and pantyhose. From the collection of Dorothy McCleave, Ottawa, Ont.

BN10
Regal. 1970. BABY BROTHER and BABY SISTER. 17 in. (43 cm). Plastic bent-limb baby bodies, anatomically correct, jointed hips, shoulders, and neck. Vinyl head; blue plastic sleep eyes, lashes, three painted upper lashes; rooted nylon hair; open-closed mouth. Mark: on head, REGAL TOY CO. LTD./MADE IN CANADA. Originally came in short shirt tops and panties with a washcloth, hairbrush, and baby powder. Also came in pyjamas. Available in 16 in. in 1969 and 1968. From the collection of Sue Henderson, Winnipeg, Man.

CF20
Regal. 1970. SNUGGLES. 20 in. (51 cm). Cloth body, vinyl three-quarter arms and legs. Vinyl head; blue stencilled eyes and upper lashes; blond rooted hair; open-closed mouth. Mark: on head, REGAL TOY/MADE IN CANADA. Original dress and panties. Originally wore a lace trimmed bonnet. From the collection of Gloria Kallis, Drayton Valley, Alta.

BL7

BF26

BL7
Regal. ca.1970. WENDY WALKER. 24 in. (61 cm). Plastic body, jointed hips, shoulders, and neck. Vinyl head; brown sleep eyes, lashes; rooted blond nylon hair; closed mouth. Mark: on head, REGAL TOY LTD./MADE IN CANADA/249T. Redressed. From the collection of Nell Walsh, Saint John, N.B.

BF26
Regal. 1971. ESKIMO TODDLER. 18 in. (45.5 cm). Plastic body, jointed hips, shoulders, and neck. Vinyl head; brown sleep eyes, lashes, painted upper lashes at outside of eyes; rooted black nylon hair; closed mouth. Original plastic and simulated fur suit. Originally wore a hood trimmed with simulated fur. Made for many years dressed in different outfits as an Inuit and an Indian for the tourist trade. From the collection of Margaret Archibald, Halifax, N.S.

BN7
Regal. 1971. BABY BROTHER and BABY SISTER. 12 in. (30.5 cm). Plastic bent-limb baby bodies, anatomically correct, jointed hips, shoulders, and neck. Vinyl heads; blue plastic sleep eyes, lashes, three painted lashes on upper outside of eyes; rooted blond saran hair; open-closed mouth. Mark: on head, REGAL TOY LTD./MADE IN CANADA/129G. Originally wore print top and panties. From the collection of Irene Henderson, Winnipeg, Man.

BN7

CG31
Regal. 1973. BABY SOFTINA. 14 in. (35.5 cm). One piece vinyl body. Vinyl head; blue stencilled eyes and upper lashes; rooted auburn nylon hair; open-closed mouth. Mark: on head, 21/140 SPE/REGAL; on body, 1423 REGAL/12. Originally wore a similar dress, socks, and matching hair ribbon. From the collection of June Rennie, Saskatoon, Sask.

BZ9
Regal. 1973. BONNIE RAG DOLL. 20 in. (51 cm). Cloth body and legs, vinyl hands. Vinyl head with freckles; blue sleep eyes, three painted upper lashes; rooted nylon hair; closed watermelon mouth. Mark: REGAL TOY Co./MADE IN CANADA/30 c (in a circle) O8. Original red cotton dress and panties, red sewn on shoes. In 1973 BONNIE had a brother RONNIE. From the collection of Jill Ashmore, Victoria, B.C.

CS24A
Regal. 1973. WENDY WALKER. 30 in. (76.5 cm). Plastic body, jointed hips, shoulders, and neck. Vinyl head; blue sleep eyes, lashes, painted lower lashes; rooted blond hair; closed mouth. Mark: on head, REGAL TOY LTD./MADE IN CANADA; on body, REGAL/CANADA. Original dress. Author's collection.

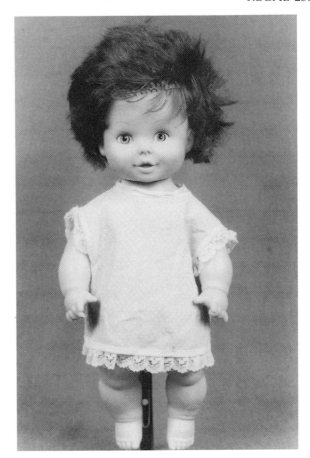

CG31

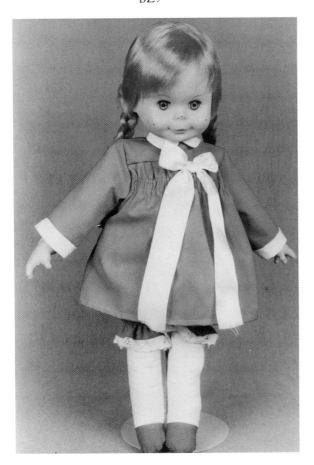

BZ9

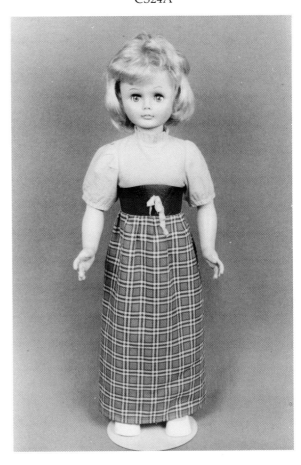

CS24A

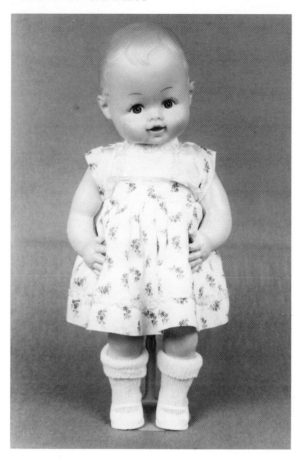

AM17

AN34

CS12

AM17
Regal. 1973. DRINK and WET BABY. 14 in. (35.5 cm). Plastic body, jointed hips, shoulders, and neck. Vinyl head; stencilled blue eyes, upper lashes; reddish brown moulded hair; open mouth nurser. Mark: on head, REGAL TOY/MADE IN CANADA/141 B.P.E. Redressed. Originally wore a diaper. Available for a number of years wearing different outfits. Author's collection.

AN34
Regal. 1973. LIZA. 18 in. (45.5 cm). Brown plastic teen body, jointed hips, shoulders, and neck. Brown vinyl head; brown sleep eyes, lashes, three outer painted lashes; rooted black nylon hair; closed mouth. Mark: on head, REGAL TOY/MADE IN CANADA; on back, REGAL/CANADA. Redressed as a bride by Dorothy McCleave, from her collection, Ottawa, Ont.

CS12
Regal. 1974. RENEE TODDLER. 18 in. (45.5 cm). Plastic body, jointed hips, shoulders, and neck. Vinyl head; blue plastic sleep eyes, lashes, painted lower lashes; rooted auburn nylon hair; closed mouth. Mark: on head, REGAL/MADE IN CANADA. Original lace and taffeta gown, lace veil. The same doll in the same gown was called VICKI in 1973. Author's collection.

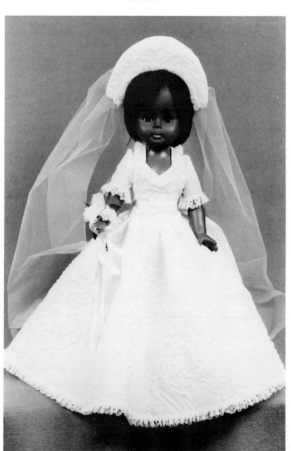

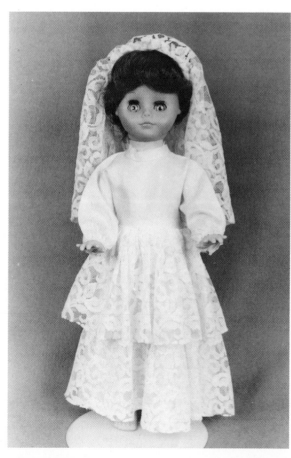

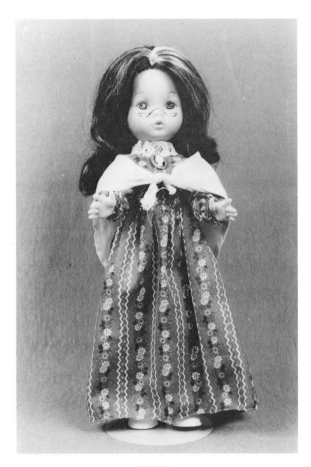

BM36

AM28

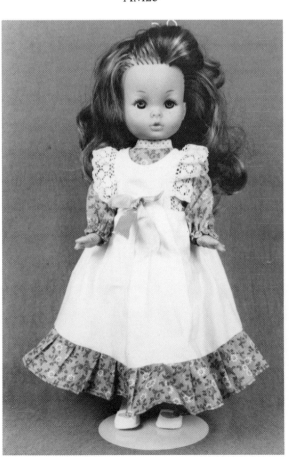

BM36
Regal. ca.1974. BUTTONS. 15 in. (38 cm). Plastic body, jointed hips, shoulders, and neck. Vinyl head with glasses painted on her face; stencilled blue eyes and upper lashes; rooted streaked black and white nylon hair; open-closed mouth. Mark: on head, 11/REGAL TOY LTD./MADE IN CANADA/151 P TE. Original print gown with a cameo broach and a white shawl. From the collection of Irene Henderson, Winnipeg, Man.

AM28
Regal. ca.1975. BUTTONS. 15 in. (38 cm). Plastic body jointed hips, shoulders, and neck. Vinyl head; blue stencilled eyes and upper lashes; rooted nylon streaked auburn hair; open-closed mouth. Mark: on head, REGAL TOY LTD./MADE IN CANADA/1817 TPE; on body, REGAL/CANADA. Original white and blue cotton print gown. Author's collection.

AN10

AN10
Regal. 1975. HUG-A-BYE BABY. 10 in. (25.5 cm). One piece vinyl body. Vinyl head; stencilled blue eyes, upper lashes; reddish brown moulded hair; open closed mouth. Mark: on head, REGAL TOY LTD./MADE IN CANADA/10 B 3 P5. Originally came either in panties or a diaper, and a blanket tied with a ribbon. From the collection of Dorothy McCleave, Ottawa, Ont.

AN15
Regal. 1975. HUG-A-BYE BABY. 14 in. (35.5 cm). One piece vinyl body. Vinyl head; stencilled blue eyes, upper lashes; reddish brown moulded hair; open-closed mouth. Mark: on head, REGAL TOY/MADE IN CANADA/141 B P.E. Originally wore a diaper. From the collection of Dorothy McCleave, Ottawa, Ont.

AO5
Regal. ca.1975. WENDY WALKER. 24 in. (61 cm). Plastic body, jointed hips, shoulders, and neck. Vinyl head; blue sleep eyes, lashes, painted lower lashes; rooted long blond nylon hair; closed mouth. Mark: on head, REGAL TOY LTD./MADE IN CANADA/249T; on body, REGAL/CANADA/Pat. Pend. Original dress. It is difficult to tell the exact year that WENDY was made because she was manufactured for fourteen years and often the clothing did not match the catalogues exactly. She came in 24, 30 and 36 inch sizes. From the collection of Karen McCleave, Ottawa, Ont.

AO25
Regal. ca.1975. INDIAN GIRL. 18 in. (45.5 cm). Brown plastic body, jointed hips, shoulders, and neck. Vinyl head; brown sleep eyes, lashes, three painted upper lashes; rooted black hair; closed mouth. Mark: on head, REGAL TOY/MADE IN CANADA. Original leatherette fringed dress trimmed with beads, original embroidered braid headband with feather, and moccasins. Author's collection.

AN15

AO5

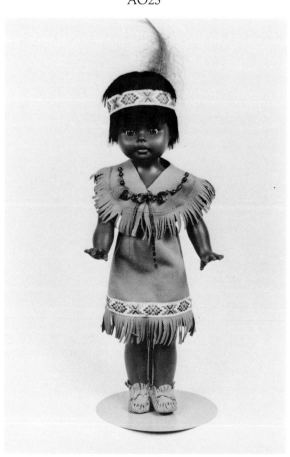

AO25

BP3

CS14

BF13

BP3
Regal. 1975. HIGHLAND LASS. 16 in. (40.5 cm). Plastic body and legs, vinyl arms, jointed hips, shoulders, and neck. Vinyl head; blue stencilled eyes, painted upper lashes; rooted long blond hair; open-closed mouth. Mark: on head, REGAL TOY LTD./MADE IN CANADA/151 TPE. Original Scottish outfit. From the collection of Betty Hutchinson, Ottawa, Ont.

CS14
Regal. 1975. HUG-A-BYE. 16.5 in. (42 cm). Body and head are one-piece vinyl. Blue painted side-glancing eyes, three painted upper lashes; light brown moulded hair; watermelon mouth. Mark: on body, 163/REGAL/MADE IN CANADA. Replaced sunsuit by Gloria Kallis is a replica of the original. In 1974 the same doll came in brown vinyl. Author's collection.

BF13
Regal. 1975. WENDY WALKER. 24 in. (61 cm). Plastic body, jointed hips, shoulders, and neck. Vinyl head; plastic sleep eyes, lashes, painted lower lashes; rooted blond curls with bangs; closed mouth. Mark: on head, 249T. Original striped gown and matching bonnet. From the collection of Marina Withers, Musquodobit Harbour, N.S.

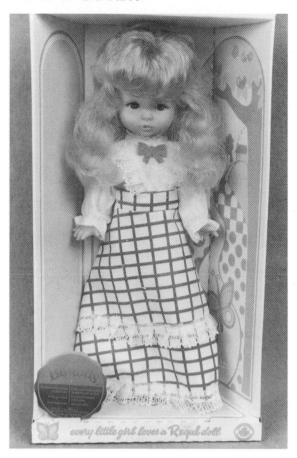

BX14

AN17

AZ18

BX14
Regal. 1975. BUTTONS. 15 in. (38 cm). Plastic body, jointed hips, shoulders, and neck. Vinyl head; blue stencilled eyes, painted upper lashes, upper eyeshadow; rooted long blond hair with bangs; closed mouth. Mark: REGAL. Original red and white skirt, white blouse. Original box. From the collection of Wilma MacPherson, Mount Hope, Ont.

AN17
Regal. 1976. LUV & KISSES. 16 in. (40.5 cm). One piece vinyl body. Vinyl head; blue sleep eyes, eyelashes, painted brows; rooted blond curls; open mouth. Makes a kissing sound when the leg is pressed. Mark: REGAL/MADE IN CANADA/166K; on body, 1616/REGAL TOY/MADE IN CANADA. Original matching dress and panties. Originally wore white socks. From the collection of Connie McCleave, Ottawa, Ont.

AZ18
Regal. 1976. OFFICIAL CANADIAN OLYMPIC HOSTESS. 15 in. (38 cm). Plastic body and legs, vinyl arms, jointed hips, shoulders, and neck. Vinyl head; stencilled blue eyes and upper lashes; rooted blond hair with bangs; closed mouth. Mark: on head, REGAL TOY LTD./MADE IN CANADA/151 T PE. Sometimes called PENNY PENTATHALON. She also came in a 30 inch size. Original dress, authentic Olympic Hostess uniform and original Olympic button. From the collection of Mrs. D. Steele, Ottawa, Ont.

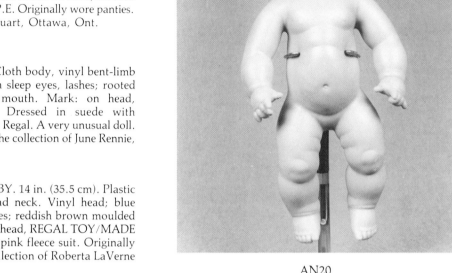

AN20
Regal. 1976. HUG-A-BYE BABY. 14 in. (35.5 cm). One piece vinyl body. Vinyl head; blue stencilled eyes and upper lashes; rooted black curls; open-closed mouth. Mark: on head, REGAL TOY/MADE IN CANADA/141 B P.E. Originally wore panties. From the collection of Lorraine Stuart, Ottawa, Ont.

CH10
Regal. ca.1976. 18 in. (45.5 cm). Cloth body, vinyl bent-limb arms and legs. Vinyl head; brown sleep eyes, lashes; rooted black hair; closed watermelon mouth. Mark: on head, REGAL/MADE IN CANADA. Dressed in suede with beadwork. Probably not dressed by Regal. A very unusual doll. Not shown in the catalogue. From the collection of June Rennie, Saskatoon, Sask.

CE10
Regal. 1976. DRINK and WET BABY. 14 in. (35.5 cm). Plastic body, jointed hips, shoulders, and neck. Vinyl head; blue stencilled eyes, painted upper lashes; reddish brown moulded hair; open mouth nurser. Mark: on head, REGAL TOY/MADE IN CANADA/141B P.E. Original pink fleece suit. Originally had matching bonnet. From the collection of Roberta LaVerne Ortwein, Olds, Alta.

AN20

CH10

CE10

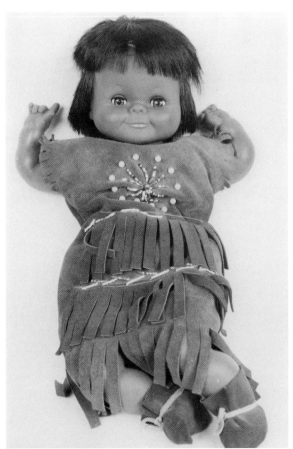

BX20
Regal. ca.1976. 15 in. (38 cm). Cotton print body, cloth head. Blue painted side-glancing eyes, painted upper lashes; yellow wool hair; painted smiling mouth. Mark: label on side, REGAL TOY LIMITED. Music box inside plays Brahms Lullaby. Not listed in the catalogue. From the collection of Wilma MacPherson, Mount Hope, Ont.

CE11
Regal. 1976. POPPI. 17 in. (43 cm). Pink cotton body, vinyl hands, black cotton sewn on shoes. Vinyl head; stencilled blue side-glancing eyes and upper lashes; rooted blond hair; closed pouting mouth. Mark: on head, REGAL TOY/CANADA. Originally came dressed as a boy or a girl. The girl wore a dress and bonnet and the boy wore overalls. From the collection of Roberta LaVerne Ortwein, Olds, Alta.

CG22
Regal. 1977. RENEE BOUDOIR 18 in. (45.5 cm). Plastic body, jointed hips, shoulders, and neck. Vinyl head; blue plastic sleep eyes, lashes, painted upper lashes on outside of eye; rooted long blond hair; closed mouth. Mark: on head, REGAL TOY/MADE IN CANADA ; on body, REGAL/CANADA/Pat. Pend. Original long pink nylon gown with white lace and ribbon trim, nylon slip, white shoes and socks. Originally had a lacy hat. One of a series of boudoir dolls. From the collection of June Rennie, Saskatoon, Sask.

BX20

CE11

CG22

CD2

CE15

CD2
Regal. 1977. SUCK-A-THUMB. 16 in. (40.5 cm). Cloth body and legs, vinyl hands. Vinyl head with freckles; black painted eyes with highlights, painted upper and lower lashes; rooted auburn hair; open-closed mouth, shaped to hold her thumb. Mark: on head, 30TS6/REGAL/CANADA. Original white apron dress, trimmed in red ribbon and lace. From the collection of Peggy Bryan, Burnaby, B.C.

CE15
Regal. 1978. BABY DRINK and WET. 21 in. (53.5 cm). Plastic body and legs, vinyl arms. Vinyl head; blue plastic sleep eyes, lashes, painted lower lashes; reddish blond moulded hair; open mouth nurser. Mark: on body, Regal (in script)/CANADA; on hip, REGAL/CANADA. Original panties. Original label on plastic bag. Includes bottle. From the collection of Roberta LaVerne Ortwein, Olds, Alta.

AO2
Regal. 1979. WENDY WALKER. 32 in. (81.5 cm). Plastic body; jointed hips, shoulders, and neck. Vinyl head; blue plastic sleep eyes, lashes, painted lower lashes; rooted nylon long auburn hair; closed mouth. Mark: on head, 3280/20 eye/c REGAL TOY LTD./MADE IN CANADA; on body, REGAL/CANADA/Pat. Pend. WENDY was not made in a 32 inch size until 1979. She has a beautifully moulded body with very detailed hands and a lovely face. She is one of Regals prettiest dolls. WENDY came in many different outfits. From the collection of Dorothy McCleave, Ottawa, Ont.

AO2

BN24
Regal. 1979. LAFFY CATHY. 17 in. (43 cm). Plastic bent-limb body with on-off switch for battery operated laughing mechanism; jointed hips, shoulders, and neck. Vinyl head; blue sleep eyes, lashes, three painted upper lashes on the outside of eyes; rooted straight auburn hair; open-closed mouth. Mark: on head, REGAL TOY CO. LTD./MADE IN CANADA. Original clothing. Came with a magic wand. When the wand is waved in front of CATHY she laughs and laughs. From the collection of Irene Henderson, Winnipeg, Man.

CI31
Regal. 1979. COLOURFUL CANDY. 20 in. (51 cm). Plastic teen body, jointed hips, shoulders, and neck. Vinyl head; blue stencilled eyes with black line over eye, painted upper lashes; rooted blond curls; open-closed mouth. Mark: on head, 5/REGAL TOY LTD./MADE IN CANADA/151 TPE. Original yellow pants and silver top. Comes with two skirts, curlers, brush, bows, barrettes, flowers and hair colours to match the skirts; in the original box. From the collection of Elva Boyce, Regina, Sask.

CI18
Regal. 1979. La Collection Regal. 20 in. (51 cm). Plastic teen body and legs, vinyl arms, jointed hips, shoulders, and neck. Vinyl head; blue sleep eyes, lashes, blue eyeshadow; rooted blond curls; open-closed mouth. Mark: on head, REGAL TOY/CANADA/207 T. Original lace, velvet gown, and matching bonnet. From the collection of Ruth MacAra, Caron, Sask.

BN24

CI31

CI18

CI19
Regal. 1979. La Collection Regal. 20 in. (51 cm). Plastic teen body, jointed hips, shoulders, and neck. Vinyl head; blue sleep eyes, lashes, blue eyeshadow; rooted blond curly hair; open-closed mouth. Mark: REGAL TOY/CANADA/207F. Original red velvet and white lace gown with matching hat. From the collection of Ruth MacAra, Caron, Sask.

BS36
Regal. 1979. WENDY WALKER. 24 in. (61 cm). Plastic body, jointed hips, shoulders, and neck. Vinyl head; blue sleep eyes, lashes, eyeshadow; rooted blond hair; closed mouth. Mark: on head, REGAL TOY CO./MADE IN CANADA/219T. Original plaid gown with white shawl. From the collection of Wilma McPherson, Mount Hope, Ont.

CI17
Regal. ca.1980. La Collection Regal. 20 in. (51 cm). Plastic teen body and legs, vinyl arms, jointed hips, shoulders, and neck. Vinyl head; blue sleep eyes, lashes, blue eyeshadow; rooted blond hair; open-closed mouth. Original green velvet cape and simulated white fur trim and muff. Original box. From the collection of Ruth MacAra, Caron, Sask.

CI19

BS36

CI17

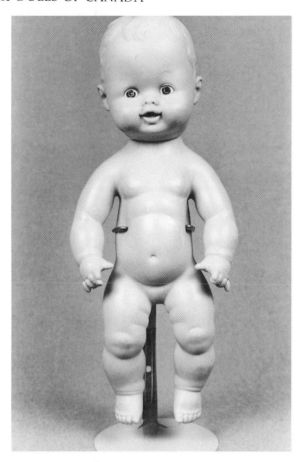

AN16

AN16
Regal. ca.1980. HUG-A-BYE BABY. 14 in. (35.5 cm). One piece vinyl toddler. Vinyl head; stencilled blue eyes, tiny upper lashes; moulded hair; open-closed mouth. Mark: on head, REGAL TOY/MADE IN CANADA/141 B P.E.; on body, 142S/REGAL/CANADA. Originally wore a diaper. From the collection of Rhonda Pickering, Ottawa, Ont.

CI16
Regal. 1980. RUFFLES and BOWS. La Collection Regal series. 18 in. (45.5 cm). Cloth body, vinyl arms and legs. Vinyl head; blue plastic sleep eyes, lashes; rooted straight blond hair; closed mouth. Mark: on head, REGAL TOY/M '1' C/200 M8. Original white eyelet dress with pink velvet yoke, matching bonnet and bloomers. Original box. From the collection of Ruth MacAra, Caron, Sask.

AO33
Regal. 1981. ESKIMO. 19 in. (48.5 cm). Brown plastic body, jointed hips, shoulders, and neck. Brown vinyl head; stencilled brown eyes, painted upper lashes; rooted straight black hair; closed mouth. Mark: on head 3604/174 PE/REGAL/MADE IN CANADA; on body, REGAL/CANADA/Pat. pend. Original blue pants, coat and hood trimmed in white simulated fur. Author's collection.

CI16

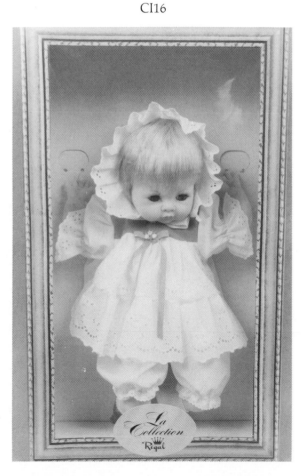

AO33

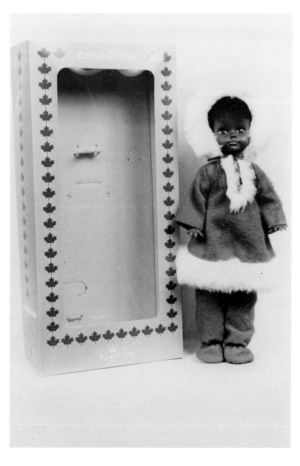

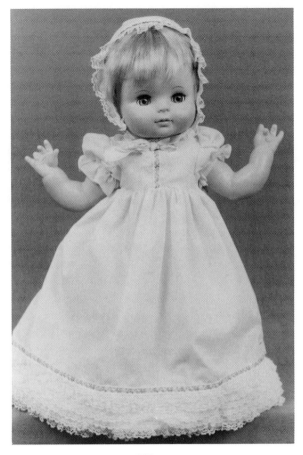

BU35

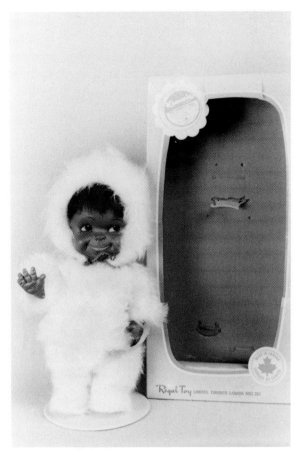

CY10

BU35
Regal. 1981. La Collection Regal. PRETTY BABY. 18.5 in. (47 cm). Cloth body, bent-limb vinyl arms and legs. Vinyl head; blue sleep eyes, lashes; rooted straight blond hair over moulded hair; closed mouth. Mark, on head, G/200 BE/REGAL/CANADA. Original dotted pink cotton gown and matching lace trimmed bonnet. From the collection of Kirsten April Strahlendorf, Ottawa, Ont.

CY10
Regal. ca.1981. KIMMIE. 12 in. (30.5 cm). Brown plastic body, vinyl arms and legs, jointed hips, shoulders and neck. Vinyl head; 3 dimensional black side-glancing eyes; rooted straight black hair; watermelon mouth. Mark: on body, Regal (in script)/CANADA. Original 3 piece simulated fur snowsuit. Original box. Author's collection.

Reliable Toy Company Limited

In 1920 a new toy company was founded in Canada by Frank Samuels, Alex Rutko, and Egnato Dash. They called it the Canadian Statuary and Novelty Company and they began operations in a 500 square foot room at 591 Queen Street West in Toronto.[1] They made plush toys and small novelties.

In 1922 the partnership was dissolved. However, Frank Samuels continued operations at the same location by establishing the Reliable Toy Co. with the able assistance of his younger brother Alex Samuels.[2] Frank was twenty-two at the time and Alex was nineteen, but for two very young men they had very big plans. In 1924, when Alex was twenty-one, he became a partner and vice-president while Frank carried on as president.

These two ambitious young men began importing bisque heads from Germany and composition parts from the United States. They used the bisque heads on composition baby bodies or on cloth bodied dolls. They were able to sell some of their dolls to Eaton's who advertised them in their catalogues. The Samuels brothers also assembled mama dolls from imported composition heads, arms, and legs, with the newly invented voice-box. Once on the market, these mama dolls were an instant success.

According to advertising and literature put out by the Reliable Toy Company, they began making original mama dolls with their own composition in 1922. They certainly were advertising the CUDDLES and CHUBBY

Mr. Alex Samuels.

dolls with caracul hair in 1924. However, it is unclear whether these dolls were simply assembled by Reliable or whether the composition was made by the company. Considering the size of the work space at that time, it seems unlikely that they were manufacturing composition themselves. Moreover, we have not found an authenticated 1924 doll with "Made in Canada" incised on the composition.

A younger brother, Ben Samuels, began working at Reliable during his summer vacations from school. He remembers the stacks of bisque heads and composition parts waiting to be assembled during the twenties. Such memories tell us the real history long after the main events took place.[3]

The company grew, and by 1927 they had moved to larger quarters at 99 1/2 King Street West in Toronto, where they had 3,000 square feet of space. They soon outgrew this location as well. So, in 1928, they moved to 1 Phoebe Street which gave them 13,000 square feet. Reliable was now able to install thirty hot presses, thus becoming the first Canadian company to use the much faster and more efficient hot process method of making composition dolls.[4] This move was to make them the leading Canadian manufacturer of dolls by the early thirties. In 1933, Reliable bought the assets of Dominion Toy, its former competitor, and so had most of the market to itself.

Alex Samuels and Mr. Kallus of Ideal were friends. Ideal Toy Corporation of the U.S.A. licensed Reliable, in 1934, to make the SHIRLEY TEMPLE doll in Canada for the Canadian market. This led to a furthur exchange of product research information over the years. A few SHIRLEY TEMPLE heads were imported from Ideal and

put on Reliable bodies before Reliable's head moulds were available in Canada. Because of this, SHIRLEY TEMPLE dolls can occasionally be found with the Ideal marking on the head but wearing the original clothing marked Reliable. We have also found SHIRLEY TEMPLE dolls with no markings on the head or body at all, only the original label from Reliable on the dress.

Chatelaine magazine gave away 16 inch SHIRLEY TEMPLE dolls in the nineteen-thirties in return for six one year subscriptions to their magazine. Many a little girl who longed for the doll with the golden curls earned her own by canvassing relatives and neighbours for new subscriptions.

Another event in 1934 was the making of two CUDDLES mama dolls for Princess Elizabeth and her sister Princess Margaret. This caused much excitement, for the company strove to produce two absolutely perfect dolls for the little princesses.[5]

Emmanuel Grossman began his long career as a dollmaker in 1934 when he joined Reliable as a boy out of school. He became fascinated by the production of dolls and began taking night school courses in machine and tool design, marketing, and psychology.[6] This paid off, for Mr. Grossman became part of the production team and eventually the president of the company.

Reliable was still growing rapidly. In 1935, they moved to 258 Carlaw Ave. They now had 72,000 square feet of space and had become the largest toy factory in the British Empire. Within this large factory there was a complete knitting mill to manufacture clothing for the dolls and an experienced hairdresser to manage the hairdressing department. There was a section for making voice boxes and squeakers, one section for making shoes, and another for making eyes of different kinds. Reliable was a self- sufficient company that manufactured all the doll parts and all the clothing to dress the dolls completely.[7]

The Canadian market was not big enough for the expanding company, consequently, Reliable began exporting their dolls all over the world. Frank Samuels was in charge of sales. He toured the world interviewing buyers. He gave a great deal of credit for his success to the cooperation and assistance of various Canadian Trade Commissioners who arranged to have him meet business people.[8] The export dolls were tailor-made for the countries they were sent to, each one dressed according to the fashions of its destination.

Alex Samuels, meanwhile, was in charge of production. It was his job to keep the factory turning out the company's entire line of unbreakable and lovable dolls in a very competitive market. This production in 1936 amounted to over one and a half million dolls of three hundred varieties.[9] It was truly a remarkable feat.

During the nineteen-thirties, the mama dolls were most popular. They came in all sizes with moulded hair or with wigs. The SHIRLEY TEMPLE dolls sold well too, and so did a variety of little girl dolls made in the SHIRLEY TEMPLE fashion. Knockabout dolls sold

steadily, as did LADDIE, the doll in the Scottish outfit. BABY MARILYN was introduced in 1936 and proved to be a popular doll for many years.

When World War II began, it was necessary to curtail their exports to some countries such as England and Australia; but Reliable was busier than ever. They enlarged their plant, and in 1941 they installed the first plastic injection moulding machines to turn out plastic items for the Canadian Armed Forces. Alex Samuels ordered the left over scraps of plastic to be gathered up, and these were used in the production of the first plastic toys. Metal was in scarce supply, for it was needed for the war effort. But many items, such as eyes, that were formerly made of metal, could be fashioned from the new plastic materials.

Because of Reliable's experience with plastics technology during the war, they were able to apply it to the production of toys after the war. Alex Samuels was quick to see the advantages of using plastics. He was always keen on producing safe toys for children, for plastic could be moulded without the sharp edges of metal. It was also easy to colour and economical to use. The first hard plastic dolls were the miniatures made in the mid- forties.

A new development after the war was Magic Skin, which was made of natural rubber. It was made into a thin skin and was stuffed to give a soft lifelike doll. Magic Skin was used at first for the arms and legs on a cloth body with a composition head. By 1950, SNOOZIE and several other dolls were produced with a Magic Skin body and a vinyl head.

In 1949, the BARBARA ANN SCOTT doll was designed by Bernard Lipfert, the well-known American doll designer and was produced by Reliable in composition.[10] She has become one of Canada's most famous dolls. Another well known doll in the forties was MAGGIE MUGGINS. She was named after the star of the Canadian Broadcasting Corporation's Maggie Muggins show.

As the fifties approached, Reliable began the production of injection moulded dolls. These were made of hard plastic with two halves glued together and with the seams buffed. The hard plastics were most popular for walking dolls, but proved to be too hard for baby dolls.

In 1948, Reliable made PLASSIKINS, an all hard plastic baby who was 14 inches tall and wore a checked cotton sunsuit and bonnet. PLASSIKINS seems to be the only large baby made entirely of hard plastic by Reliable and is a collector's item today. Vinyl-flex was also new in 1950. It was a vinyl skin similar to Magic Skin but it was stronger and wore better. It was used as a one piece vinyl skin body that was stuffed with kapok.

Saran hair was used at Reliable at first as a wig and by 1953 as rooted hair. The BARBARA ANN SCOTT doll was one of the first with a saran wig in 1950, although she wore a mohair wig again in 1951 and saran once more in 1953.

once more in 1953.

A feature of 1951 was SPARKLE PLENTY of comic strip fame who had a hard plastic head, latex body, arms, and legs. She wore a very long blond wig and carried a tiny guitar.

In that same year the 30 inch GIBSON GIRL with a composition head and arms, and long cloth legs, made a beautiful bed doll dressed in satins, silks, and lace, and wearing a large hat.

In the early fifties, the premises of Reliable were broken into and burglarized one weekend. When Monday morning arrived it was discovered that most of the brass moulds for making composition dolls had been stolen.[11] At the time brass was expensive and the moulds were probably melted down for the metal. This event precluded the possibility of Reliable making reissues of some of their classic dolls, such as the EATON'S BEAUTY doll of the forties. This ended the composition era for Reliable. The last few composition dolls were made in 1955. One of these was the perennial favourite, PEGGY, who was made with side glancing eyes for her last appearance after being in production about twenty-five years.

Reliable was licenced to make the puppet HOWDY DOODY in 1953 from the television show of the same name. Another doll modelled afer a television star was MARY HARTLINE, a 16 inch plastic doll with a saran wig. Other famous characters were BETSY MCCALL, JOAN PALOOKA, and Dick Tracey's baby, BONNIE BRAIDS.

During the fifties, the cloth bodied doll with soft vinyl arms and legs was popular, and so was the one piece Vinyl-flex stuffed bodied doll. The arms and legs had thicker vinyl than the Vinyl- flex dolls and they were not stuffed. They made a warm and realistic doll. Both of these had vinyl heads.

MAGGIE MUGGINS was made with a latex body in 1956 as was DAVEY CROCKETT. Of interest to collectors of advertising dolls was the pair of black twins made all of vinyl and dressed in polka dots, who came with a tiny box of Quakers Wheat Flakes, and a small bottle of Crown Brand Syrup in 1957. Reliable had contracts to make soft vinyl advertising dolls for many different companies, although they were seldom marked with Reliable's name.

In the late fifties, blow-moulded plastic dolls came in. This made it possible to manufacture dolls with very detailed hands and feet. It was harder than the soft vinyl heads but not as hard or heavy as the injection moulded plastic dolls. It was very suitable for toddler dolls, which were made with the vinyl heads and rooted hair. Blow moulded plastic was easy to colour, quick to manufacture, and could be handled without breaking. It made an excellent jointed doll.

The "most beautiful doll in the world," said the advertising for the REVLON DOLL in 1957. She was beautifully dressed and wore a "diamond" ring. She

ushered in the new era of teen dolls that were popular in the sixties. MISS CANADA, with her extensive wardrobe, was another of the new fashion dolls. She came in 10.5 and 18 inch sizes, and in later years in 20 and 25 inch sizes.

Ridigsol dolls appeared in 1958. Ridigsol was a stiff vinyl which produced a body that was slightly flexible. Only the head moved, which made them difficult to dress, and explains their lack of popularity.

In 1959, the Samuels brothers parted ways. Alex Samuels became the president of Reliable, while Frank Samuels established Regal Toy Co., with the assistance of his three sons and his brother Ben.

The nineteen-sixties were noted for the big life-size walker dolls. The first big Reliable dolls were PATTY SUE and MARY ANNE accompanied by 30 inch LITTLE SISTER.

Reliable gave us the ANNE HEGGTVEIT doll in 1961 to celebrate the victories of Canada's Olympic Gold Medallist in the skiing competitions. Another doll of interest to collectors was LOUISA, the multi-jointed doll who could be placed in a multitude of poses. PEBBLES FLINTSTONE was an unusual doll in 1963 because of her distinctive top knot hairstyle. This was also the year of KISSY, the 22 inch charmer who gave a realistic sounding kiss when her arms were pressed together.

Black dolls came into style in the sixties. Reliable began making them in larger sizes and dressing them in pretty clothes. It must have been frustrating for many years for the parents of black children who wanted to buy their child a big beautiful doll, because for decades the only black dolls available were small baby dolls.

After an absence of fifteen years, Mannie Grossman was brought back to Reliable in early 1966 as executive vice president by Alex Samuels whose health was failing. Mr. Samuels had always had a great deal of faith in Mr. Grossman's abilities, and he felt that the company could be helped by Mr. Grossman's expertise. Alex Samuels died later in the year. He had spent forty-six years of his life as a dollmaker. He was imaginative, innovative and had an understanding of the needs of children.

With Mr. Grossman as president and Mr. Samuel's two sons, Larry and Herbert in key executive positions, the company was able to increase exports by twenty-five per cent. Mr. Grossman stayed with Reliable until 1972 when Larry S. Samuels took over as president, and his brother Herbert became executive vice president. Larry Samuels was well qualified for the job, having obtained an engineering degree from the University of Toronto and a Masters degree from Harvard Business School.

With the huge competitive toy companies in the United States advertising their wares in Canada, it was necessary for Reliable to become a very flexible company. Reliable achieved this flexibility by developing into a uniquely self-contained toy plant, which often created its own dolls and toys, made its own tools, and tested the products in its own safety laboratory. Reliable had

increased in size and now covered 215,000 square feet of space.[12]

But Reliable was defeated in the end by a doll! When the enormous campaign to launch the Cabbage Patch doll took off in the early nineteen-eighties, no little girl wanted any other doll. The Cabbage Patch was a phenomenon comparable to the Barbie Doll craze twenty-five years earlier, which had also caused casualties in the Canadian doll industry. Before the Reliable Toy Company was taken over by Viceroy Rubber and Plastic Ltd. in 1985, it had operated longer and had produced more dolls than any other firm in Canada. The new president is now (1986) Mr. Ronald Bruhm, and the general manager is Mr. L.S. Samuels.

1. Ben Samuels. Personal communication.
2. Irving Samuels. Personal communication.
3. Ben Samuels. Personal communication.
4. Ibid.
5. Mannie (Emmanuel) Grossman. Personal communication.
6. Ibid. 7. *Saturday Night the Canadian Weekly:* March 29, 1941, p.5.
8. Ibid.
9. Ibid.
10. L.S. Samuels. Personal communication.
11. Ibid. 12. Ibid.
12. Ibid.

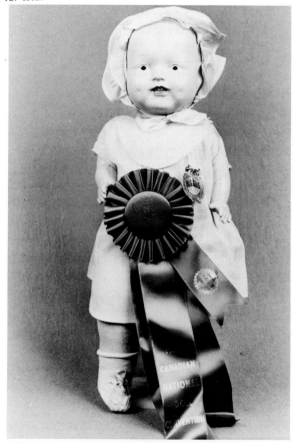

AP15

AP15
Reliable. 1929. BABY BUBBLES. 18 in. (45.5 cm). Cloth body and legs, composition arms. Composition head; painted blue eyes, upper lashes and brows; moulded hair, painted blond, open-closed mouth showing two painted teeth. Mark: Unmarked. Original label with name and company. All original clothing. BABY BUBBLES won first prize at the First Canadian National Doll Convention in Toronto in 1981. From the collection of Dawn Young, Niagara Falls, Ont.

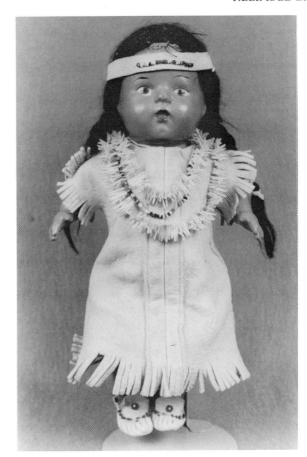

BY13
Reliable. ca.1929. HIAWATHA. 12 in. (30 cm). All composition, one-piece head and body, jointed hips and shoulders. Painted brown eyes, black line over eye; black mohair wig in braids; open-closed mouth. Mark: on head, RELIABLE/MADE IN CANADA. Original leather dress, headband and moccasins with bead trim. HIAWATHA was made for many years. This one is unusually well dressed. From the collection of Catherine A. Kerr, Ottawa, Ont.

BW29
Reliable. ca.1930. PATSY TYPE. 12 in. (30 cm). All composition, one piece head and body, jointed hips and shoulders. Repainted. Blue eyes, black line over eye, moulded hair, closed mouth. Mark: on head, RELIABLE/MADE IN/CANADA. Repainted shoes and socks. From the collection of Bruce Young, Toronto, Ont.

CC2
Reliable. ca.1930. 26 in. (66 cm). Excelsior stuffed cloth body, legs, and upper arms, composition 3/4 arms. Composition shoulderhead; painted blue eyes with black line over eye, painted upper lashes; moulded brown hair; closed mouth. Mark: on shoulderplate, RELIABLE DOLL/MADE IN CANADA. Redressed. From the collection of Mrs. D.H. Morman, Victoria, B.C.

BY13

BW29

CC2

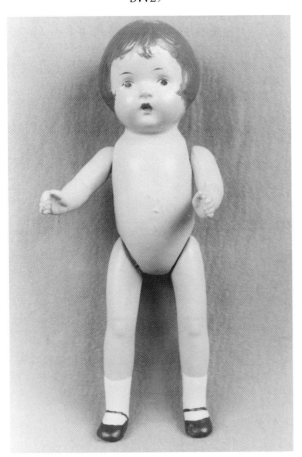

CP3
Reliable. ca.1931. 17 in. (43 cm). Cloth body, composition arms and straight legs. Repainted composition shoulderhead; blue metal eyes, lashes and painted lower lashes; moulded hair; open mouth showing two teeth. Mark: on shoulderplate, A/RELIABLE/DOLL/MADE IN CANADA. Redressed in a white cotton gown and bonnet. From the collection of Thera Overing, Etobicoke, Ont.

CB34A
Reliable. ca.1932. 22 in. (56 cm). Cloth body, composition arms and straight legs. Composition head; green tin eyes, lashes, painted lower lashes; moulded brown hair; open mouth, two inset teeth. Mark: on head, A RELIABLE DOLL/MADE IN CANADA. Redressed. From the collection of Sadie Gaston, Vancouver, B.C.

BX2
Reliable. ca.1932. 25 in. (63.5 cm). Cloth body, compositon arms and straight legs. Composition head; blue glasseine sleep eyes, lashes, painted lower lashes; brown mohair wig; closed mouth. Mark: on head, RELIABLE/MADE IN CANADA. Redressed. From the collection of Wilma MacPherson, Mount Hope, Ont.

CP3

CB34A

BX2

AO10

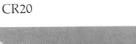

CR20

CH29

AO10
Reliable. ca.1933. BABY FONDA. 25 in. (63.5 cm). Cloth body, composition arms and straight legs. Composition head; blue tin sleep eyes, lashes, painted lower lashes; brown moulded hair; open mouth showing two teeth and tongue. Mark: on head, A RELIABLE/DOLL/MADE IN CANADA. Redressed. From the collection of Dorothy McCleave, Ottawa, Ont.

CR20
Reliable. ca.1933. 20 in. (51 cm). Cloth body, composition arms and straight legs. Composition head; blue tin sleep eyes, lashes, painted lower lashes; brown moulded hair; closed mouth. Mark: on head, A RELIABLE/DOLL MADE IN CANADA. Old but not original cotton print dress and bonnet; replaced socks and shoes. Author's collection.

CH29
Reliable. ca.1933. 18 in. (45.5 cm). Cloth body, composition arms and straight legs. Composition shoulderhead; blue sleep eyes, lashes; brown moulded hair; closed mouth. Mark: on shoulderplate, RELIABLE/MADE IN CANADA. Redressed. Courtesy of Penn's Antiques, Saskatoon, Sask.

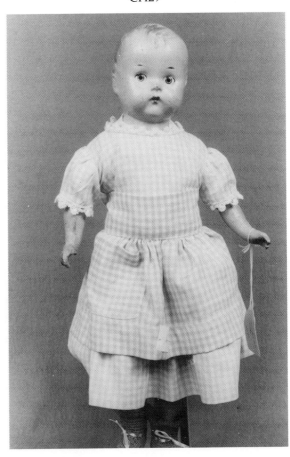

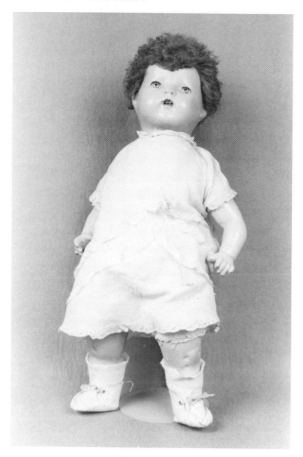

BJ7

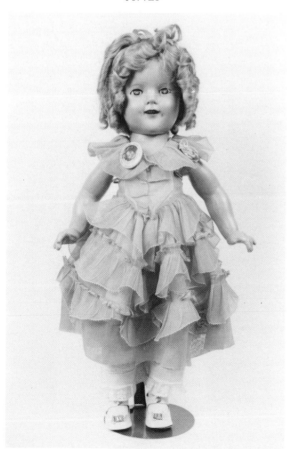

AW23

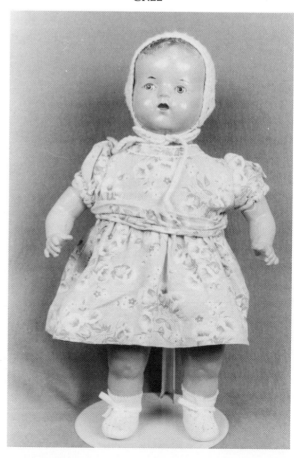

CR22

BJ7
Reliable. 1933. TOUSLEHEAD. 17 in. (43 cm). Cloth body, composition arms and straight legs. Composition head; blue tin sleep eyes, lashes, brown caracul wig; open mouth showing two teeth and tongue. Mark: on head, A RELIABLE DOLL/MADE IN CANADA. Original yellow cotton dress, slip and panties, socks and shoes. From the collection of Rebecca Douglas, Dartmouth, N.S.

AW23
Reliable. 1934. SHIRLEY TEMPLE. 18 in. (45.5 cm). Composition body, jointed hips, shoulders, and neck. Composition head with dimples; green sleep eyes, lashes, painted lower lashes; blond mohair wig; open mouth showing teeth. Mark: on head, SHIRLEY TEMPLE/Cop. IDEAL/N.& T. Co.; on dress, A GENUINE/SHIRLEY TEMPLE/DOLL DRESS/RELIABLE TOY CO. LTD., along the side, MADE IN CANADA. Original pale orange dress, pantalettes, socks and shoes; original Reliable button. This doll had a head made in the United States before Reliable had the mould to make it in Canada. It would have been one of the earliest SHIRLEY dolls sold in Canada. From the collection of Mrs. D. Steele, Ottawa, Ont.

CR22
Reliable. ca.1934. 16 in. (40.5 cm). Cloth body with crier; composition arms and straight legs. Composition head; blue tin sleep eyes, lashes, painted lower lashes; brown moulded hair, closed mouth. Mark: on head, RELIABLE DOLL/MADE IN CANADA. Old but not original cotton print dress and bonnet; replaced socks and shoes. Author's collection.

BY9
Reliable. ca.1935. HAIRBOW PEGGY. 18 in. (45.5 cm). Excelsior stuffed cloth body and legs, composition forearms. Composition shoulderhead; blue painted eyes, black line over eye; well-defined moulded hair with a hole for a hair ribbon; closed mouth. Mark: on shoulderplate, A/RELIABLE/DOLL/MADE IN CANADA. Original cotton print dress and socks. PEGGY first appeared in 1932 and sold well until 1953. In later years she was simply called PEGGY. From the collection of Margaret Ironmunger, Ottawa, Ont.

CW27
Reliable. ca.1935. 18 in. (45.5 cm). Cloth body, composition bent arms and straight legs. Composition shoulderhead; blue sleep eyes, lashes, painted lower lashes; moulded hair, originally had a wig; closed mouth. Mark: on shoulderplate, A/RELIABLE/DOLL/MADE IN CANADA. Old but not original green and white dress. From the collection of Sylvia Higgins, Remember When Museum, Laidlaw, B.C.

AP20
Reliable. ca.1935. 18 in. (45.5 cm). Excelsior stuffed cloth body, upper arms, and legs, composition 3/4 arms. Composition shoulderhead; blue painted side-glancing eyes, black line over eye; brown moulded hair; closed mouth. Mark: on shoulderplate, A/RELIABLE/DOLL/MADE IN CANADA. From the collection of Geraldine Young, Niagara Falls, Ont.

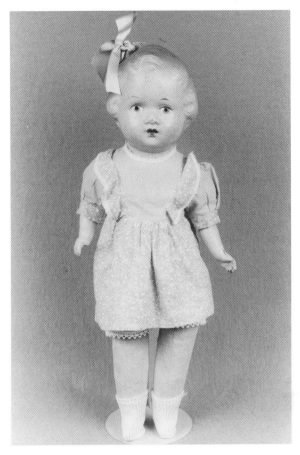

BY9

CW27

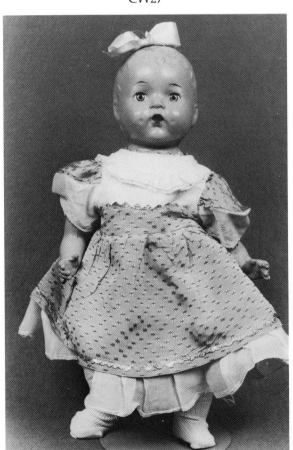

AP20

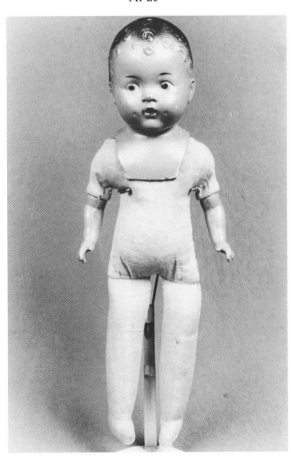

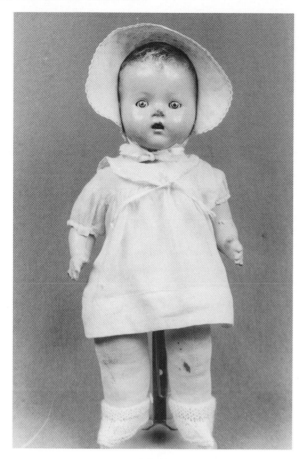

CG11

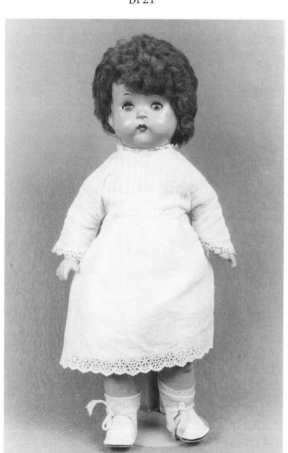

BF21

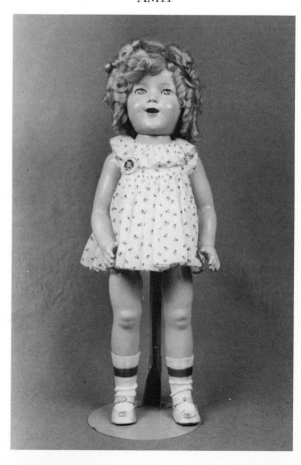

AM11

CG11
Reliable. ca.1935. BABY BUNTING. 14 in. (35.5 cm). Cloth body and bent legs softly stuffed, composition arms. Composition head; blue sleep eyes; brown moulded hair; open mouth with two teeth. Mark: RELIABLE DOLL/MADE IN CANADA. Original yellow cotton dress, chemise and bonnet; replaced booties. BABY BUNTING was still available in 1948. From the collection of Betty Wensley, Saskatoon, Ont.

BF21
Reliable. ca.1935. CHUBBY. 17 in. (43 cm). Cloth body, composition arms and straight legs. Composition head; blue tin sleep eyes, lashes, painted lower lashes; brown caracul wig; closed mouth. Mark: on head, RELIABLE/MADE IN CANADA. White cotton dress, slip, socks and shoes. From the collection of Anne Fitzsimmons, Dartmouth, N.S.

AM11
Reliable. ca.1936. SHIRLEY TEMPLE. 25 in. (63.5 cm). Composition body, jointed hips, shoulders, and neck. Composition head with dimples; green glasseine sleep eyes, lashes, painted lower lashes; blond mohair wig; open mouth showing teeth and tongue. Mark: no mark on the head or body. Original label on the dress, A GENUINE/SHIRLEY TEMPLE/DOLL DRESS/RELIABLE TOY CO. LTD.; along one side: MADE IN CANADA. Original red and white dress, white cotton slip and panties, red and white socks, white shoes; wearing original button. From the collection of Diana McGuire, Ottawa, Ont.

CA22
Reliable. ca.1936. SHIRLEY TEMPLE. 15.5 in. (39cm). All composition, jointed hips, shoulders, and neck. Composition head; green sleep eyes, lashes; blond mohair wig in original set; open mouth showing six teeth. Mark: on head, SHIRLEY TEMPLE, on body SHIRLEY TEMPLE 14. All original clothing, red and white pleated dress, socks and shoes. Original box and button. From the collection of Mrs. D.H. Morman, Victoria, B.C. See colour Fig. CA22.

CD20
Reliable. ca.1936. SHIRLEY TEMPLE LOOK ALIKE. 15 in. (38 cm). Composition body, jointed hips, shoulders, and head. Composition head with dimples; green sleep eyes, lashes, painted lower lashes; blond mohair wig; closed mouth. Mark: on head, RELIABLE/MADE IN CANADA. Replaced dress. An unusual SHIRLEY LOOK ALIKE with a closed mouth. From the collection of Sadie Gaston, Vancouver, B.C.

BN2
Reliable. ca.1936. 14 in. (35.5 cm). Cloth body and legs, composition forearms. Composition shoulderhead; blue painted eyes, black line over eye, painted upper lashes; moulded brown hair; closed mouth. Mark: on shoulderplate, A RELIABLE DOLL/MADE IN CANADA. Original cotton print dress. From the collection of Irene Henderson, Winnipeg, Man.

BZ6
Reliable. ca.1936. 17 in. (43 cm). Cloth body, composition arms and straight legs. Composition head; blue sleep eyes, lashes; brown moulded hair; open mouth showing two teeth. Mark: on head, RELIABLE/MADE IN CANADA. Original pink voile dress and matching bonnet, socks and shoes. From the colllection of Ruth Derrick, Victoria, B.C.

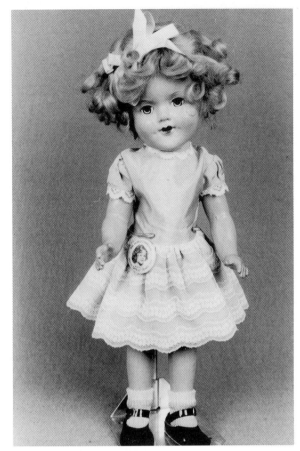

CD20

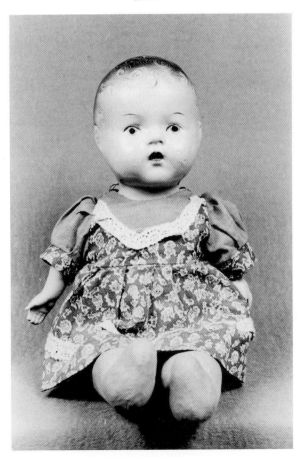

BN2

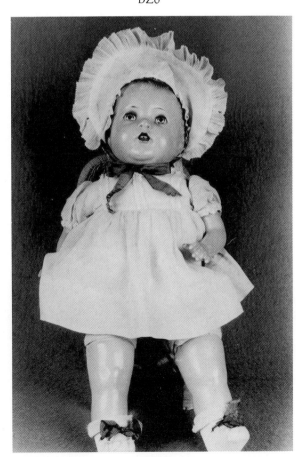

BZ6

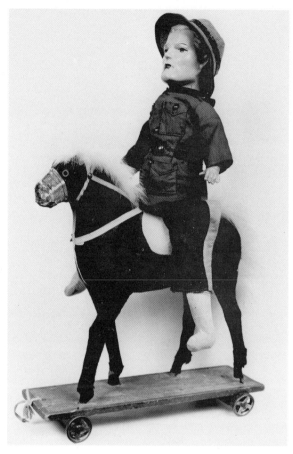

AO29

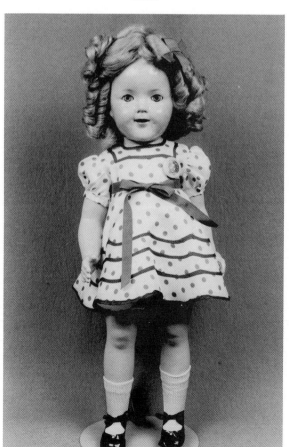

CL35

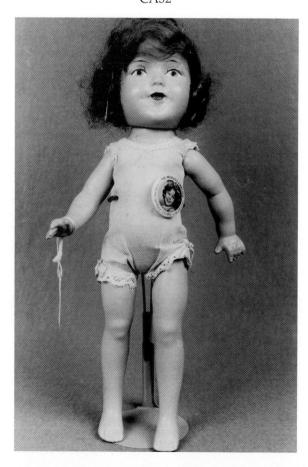

CA32

AO29

Reliable. 1936. MOUNTIE AND HORSE. 17 in. (43 cm). Excelsior stuffed cloth body and legs; composition arms. Composition head; brown painted eyes; brown moulded hair; closed mouth. Mark: on head, RELIABLE/MADE IN CANADA. Original Mountie uniform and hat, felt boots are missing. The doll was also sold separately until 1953. The base of the horse has a note written on it, "Cadeau de ton oncle Johnny à Noël 1936 âgés de 6 ans". Author's collection.

CL35

Reliable. ca.1937. SHIRLEY TEMPLE. 25 in. (63.5 cm). Composition body, jointed hips, shoulders, and neck. Composition head with dimples; blue tin sleep eyes, lashes, painted lower lashes; replaced blond wig; open mouth showing six teeth and tongue. Mark: on head, A/RELIABLE/DOLL/MADE IN CANADA. Original button. Replaced white dress with red dots: copy of the dress SHIRLEY wore in the movie Stand Up and Cheer. From the collection of Berna Gooch, North Vancouver, B.C.

CA32

Reliable. ca.1937. SHIRLEY TEMPLE LOOK ALIKE. 13 in. (33 cm). Composition body, jointed hips, shoulders, and neck. Composition head with dimples; blue painted eyes with highlights, black painted upper lashes; light brown mohair wig; closed mouth. Mark: on head, RELIABLE/MADE IN CANADA; on body, SHIRLEY TEMPLE. Original pink teddy, button not original. SHIRLEY, with painted eyes and a closed mouth is very unusual. From the collection of Mrs D.H. Morman, Victoria, B.C.

BF22
Reliable. ca.1938. SHIRLEY TEMPLE. 19 in. (48.5 cm).
Composition body, jointed hips, shoulders, and neck.
Composition head; hazel glasseine sleep eyes; lashes; blond
mohair wig; open mouth showing teeth. Mark: on head, 16
SHIRLEY TEMPLE; original label on dress, A GENUINE
SHIRLEY TEMPLE DOLL DRESS. RELIABLE TOY CO. LTD.
MADE IN CANADA. Original blue dress, white slip and
attached panties. From the collection of Anne Fitzsimmons,
Dartmouth, N.S.

CQ7
Reliable. ca.1938. 20 in. (51 cm). Cloth body, composition arms
and straight legs. Composition shoulderhead; blue metal sleep
eyes; lashes, painted lower lashes; blond mohair wig; open
mouth showing teeth. Mark: on head, RELIABLE/MADE IN
CANADA. Probably the original dress in white and red.
Courtesy of the Bowmanville Museum, Bowmanville, Ont.

BT4A
Reliable. ca.1938. BABY MARILYN. 14 in. (35.5 cm). All
composition, jointed hips, shoulders, and neck. Composition
head; brown sleep eyes,, lashes, painted lower lashes; brown
moulded hair; closed mouth. Mark: no mark on doll, original
label GENUINE/Baby Marilyn/Dolls/RELIABLE TOY CO.
LTD./MADE IN CANADA. Original green and white cotton
dress and bonnet, socks and shoes. A lovely baby from the
collection of Wilma MacPherson, Mount Hope, Ont.

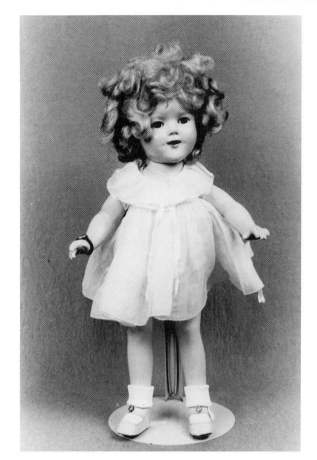

BF22

CQ7

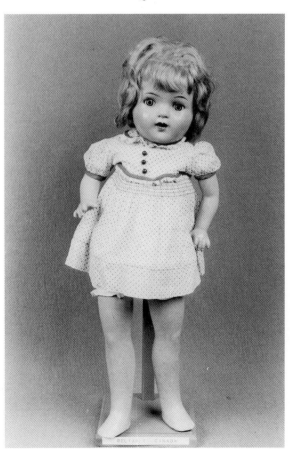

BT4A

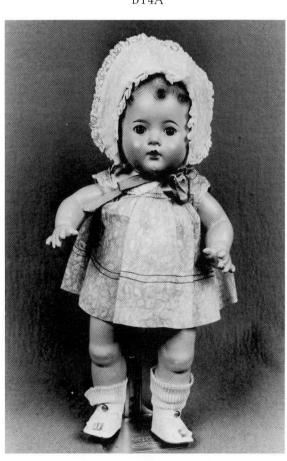

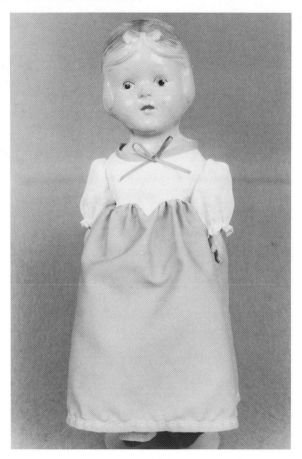

BZ17

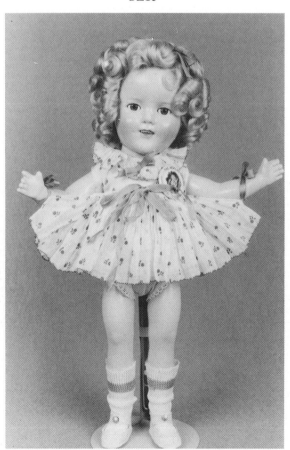

BZ18

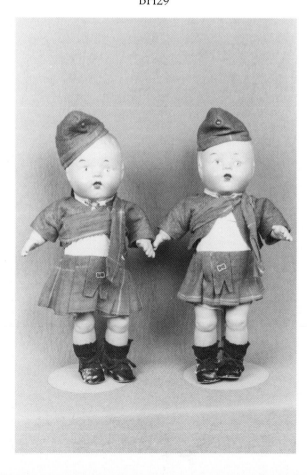

BH29

BZ17
Reliable. ca.1938. SNOW WHITE. 15 in. (38 cm). Cloth body and legs, composition forearms. Composition shoulderhead; blue painted eyes, black line over eye; brown moulded hair with hair bow moulded in; closed mouth. Mark: on shoulderplate, A RELIABLE DOLL/MADE IN CANADA. Replaced dress. From the collection of Phyllis McOrmond, Victoria, B.C.

BZ18
Reliable. ca.1939. SHIRLEY TEMPLE. 16 in. (40.5 cm). Composition body, jointed hips, shoulders, and neck. Composition head with dimples; green sleep eyes, lashes, painted lower lashes; blond mohair wig; open mouth showing six teeth. Mark: on head, SHIRLEY TEMPLE; on arms, 14; on body, SHIRLEY TEMPLE 14; on dress, A GENUINE/SHIRLEY TEMPLE/DOLL DRESS/RELIABLE TOY CO. LTD. ; on side of label, MADE IN CANADA. Original SHIRLEY TEMPLE RELIABLE button. Original red and white organdy dress, cotton chemise and attached slip, shoes and socks. From the collection of K. Irene Campbell, Victoria, B.C.

BH29
Reliable. ca.1939. LADDIE. 12 in. (30 cm). All composition, jointed hips and shoulders. Composition head; blue painted eyes, black line over eye; light brown moulded hair; closed mouth. Mark: on back, RELIABLE/MADE IN/CANADA. Original red and blue tartan, red felt jacket, matching hat, black socks and shoes. LADDIE was made for over 10 years wearing slightly different costumes. From the collection of Rebecca Douglass, Dartmouth, N.S.

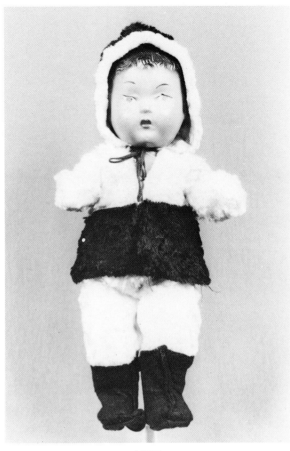

AT12

AT12
Reliable. ca.1939. ESKIMO. 14 in. (35.5 cm). All composition, jointed hips, shoulders, and neck. Composition head; black, almond shaped painted eyes, black line over eyes; black moulded hair; closed mouth. Mark: on head, 1/RELIABLE/MADE IN CANADA. Original synthetic fur snow suit with hood and felt boots. Author's collection.

BZ24
Reliable. ca.1939. BABY MARILYN. 15 in. (38 cm). All composition body, jointed hips, shoulders, and neck. Composition head; blue tin sleep eyes, lashes, painted lower lashes; blond mohair curly wig; open mouth showing two teeth. Mark: on head, RELIABLE/MADE IN CANADA. Original blue and white dotted swiss dress and hat, cotton chemise, shoes and socks. From the collection of K. Irene Campbell, Victoria, B.C.

CW17
Reliable. ca.1939. WETTUMS. 17 in. (43 cm). All composition, jointed hips, shoulders, and neck. Composition head; blue painted eyes; brown moulded hair; open mouth nurser. Mark: on head, RELIABLE TOY/MADE IN CANADA. Originally dressed in a diaper and undershirt. From the collection of Joyce Cummings, North Vancouver, B.C.

BZ24

CW17

CD13
Reliable. ca.1939. PIGTAILS. 18.5 in. (47 cm). Composition body, jointed hips, shoulders, and neck. Composition head; blue sleep eyes, lashes, painted lower lashes, grey eyeshadow over eyelids; honey blond mohair wig in original braids with curled bangs; open mouth showing four teeth. Mark: on head, RELIABLE/MADE IN CANADA. Original white taffeta dress with red dots, attached panties, pinafore and matching bonnet of white cotton with tiny red flowers and dark blue dots; socks and red shoes; original red hair ribbons. PIGTAILS was popular in the early nineteen-fifties but this doll is different and was probably made in the late thirties. There was also a PIGTAILS in 1942 but it was also a different doll. From the collection of Florence Langstaff, North Vancouver, B.C.

BW21
Reliable. ca.1939. BABYKINS. 12 in. (30 cm). All composition, jointed hips and shoulders. Composition head; blue painted eyes, black line over eye, painted upper lashes; brown moulded hair; closed mouth. Mark: on head, RELIABLE/MADE IN CANADA. Original gold label, MADE IN CANADA/BABYKINS/A RELIABLE DOLL/A BRITISH EMPIRE PRODUCT. Original box, shirt, and diaper. Author's collection.

BJ5
Reliable. ca.1940. SCOTTISH LASSIE. 15 in. (38 cm). All composition, jointed hips, shoulders, and neck. Composition head; blue sleep eyes, lashes, painted lower lashes; brown wig; closed mouth. Mark: on head, RELIABLE/MADE IN CANADA. Original Scottish outfit. Originally wore black socks and a beret. From the collection of Rebecca Douglass, Dartmouth, N.S.

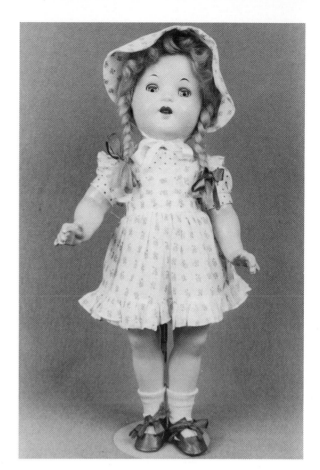

CD13

BW21

BJ5

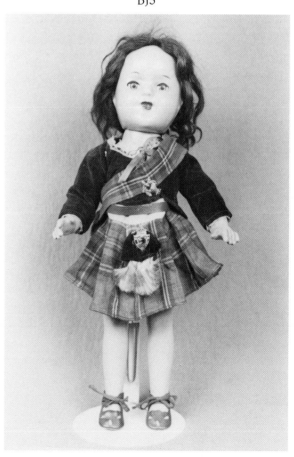

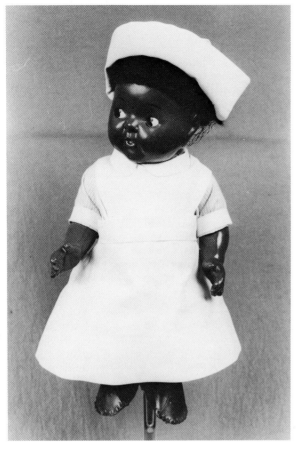

BN17

SL15
Reliable. 1940. DOPEY. 12 in. (30.5 cm). Cloth body, legs, and arms. Composition head; painted side-glancing eyes. Mark: made under license from Walt Disney. Doeskin coat and hat, cotton pants. Originally had leather belt. Also came in 20 inch size. This larger size had movable jaw and composition hands. Photograph courtesy of Glenda Shields, London, Ont. From the collection of Ethel McLean, London, Ont. See colour Fig. SL15.

BN17
Reliable. ca.1940. 14 in. (35.5 cm). Brown composition, jointed hips, shoulders, and neck. Composition head; black painted side-glancing eyes; black braided wool wig over moulded hair; open-closed mouth. Mark: on head, RELIABLE/MADE IN CANADA. Beautifully dressed as a nurse. This doll appears to be the same doll in Reliable's 1940 catalogue, however, she does not appear in a nurse's uniform. She may represent the yearning of a small black girl for a nurse doll whose mother meticulously produced a uniform to fit the only black doll available at that time. Black nurse dolls were not made until the sixties when the industry realized there was a need for them. From the collection of Irene Henderson, Winnipeg, Man.

CN31
Reliable. 1940. CHUCKLES. 20 in. (51 cm). All composition jointed hips, shoulders, and neck. Composition head; blue tin sleep eyes, lashes, painted lower lashes; brown moulded hair; open mouth showing two teeth and tongue. Mark: on head, RELIABLE/MADE IN CANADA. Original label, MADE IN CANADA/CHUCKLES/RELIABLE TOY CO. Original pink organdy dress and matching bonnet, socks, and shoes. CHUCKLES came in three sizes, from 14 to 20 inches. From the collection of Diane Peck, Sudbury, Ont.

CN31

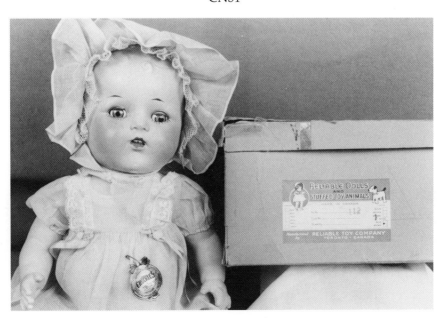

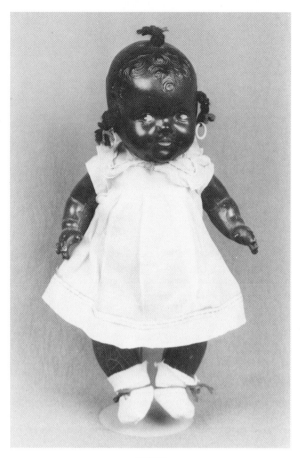

BH12

BZ2

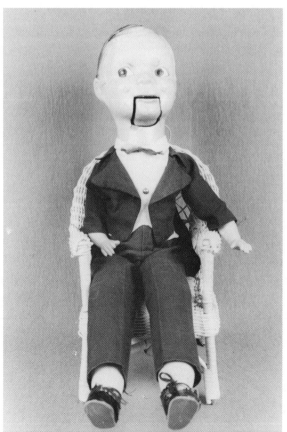

BH13

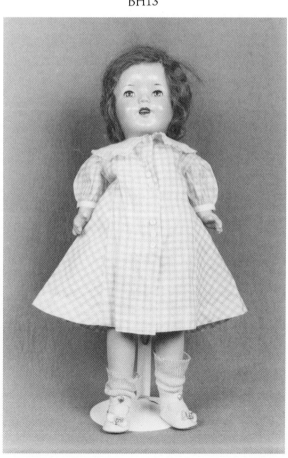

BH12
Reliable. 1940. TOPSY. 17 in. (43 cm). All composition, dark brown, jointed hips, shoulders, and neck. Composition head; black painted side-glancing eyes, painted upper lashes; black moulded hair with three inset wool braids; open-closed mouth with two painted teeth. Mark: on head, RELIABLE/Made in Canada. Original white muslin dress trimmed with red ribbon, original socks with red ribbon ties. Originally wore a matching bonnet. TOPSY was made from the middle nineteen-thirties till 1948 when she appeared without the braids. From the collection of Donna Gardiner, Dartmouth, N.S.

BZ2
Reliable. 1940. KENNY-TOK. 24 in. (61 cm). Sawdust filled cloth body, composition forearms. Composition head with moveable jaw that opens when the string at the back is pulled; painted brown side-glancing eyes; moulded hair painted black; five painted teeth. Mark: on head, MFG. BY/RELIABLE TOY CO/CANADA. Original black tuxedo, white shirt with silver buttons, oilcloth shoes. From the collection of Ruth Derrick, Victoria, B.C.

BH13
Reliable. 1940. SALLY ANN. 18 in. (45.5 cm). Cloth body, composition arms and straight legs. Composition head; blue tin sleep eyes, lashes; brown mohair wig; open mouth showing teeth. Mark: on head, A RELIABLE DOLL/Made in Canada. Original underclothes, shoes, and socks. Originally wore a variety of outfits including, in 1940, a plaid dress and matching hat. SALLY ANN also came in a 20 inch size. From the collection of Donna Gardiner, Dartmouth, N.S.

CL36
Reliable. 1940. GLORIA. 18 in. (45.5 cm). Cloth body, composition 3/4 arms and straight legs. Composition shoulderhead; dark blue tin eyes, painted upper lashes; brown mohair wig parted on one side; open mouth showing teeth. Mark: on shoulderplate, A/RELIABLE/DOLL/MADE IN CANADA. Originally wore a cotton print dress and bonnet. From the collection of Joyce Cummings, North Vancouver, B.C.

CM11
Reliable. 1940. JOAN. 20 in. (51 cm). All composition body, jointed hips, shoulders, and neck. Composition head; blue glasseine sleep eyes, lashes, painted lower lashes; blond mohair curly wig; open mouth showing two teeth and tongue. Mark: on head, RELIABLE/MADE IN CANADA. All original lace trimmed organdy dress, matching bonnet, shoes and socks. From the collection of Christine Soroka, Ottawa, Ont.

CG14
Reliable. 1940. BABYKINS. 12 in. (30 cm). All composition, jointed hips, shoulders, and neck. Composition head; blue sleep eyes, lashes, painted lower lashes; brown moulded hair; open mouth showing two teeth and tongue. Mark: no mark on doll but wearing the original tag, MADE IN CANADA/Babykins/A Reliable/Doll/Made by Reliable Toy Co. Originally wore an undershirt and diaper. From the collection of Mrs. June Rennie, Saskatoon, Sask.

CL36

CM11 CG14

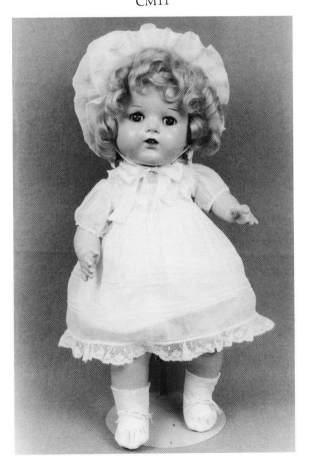

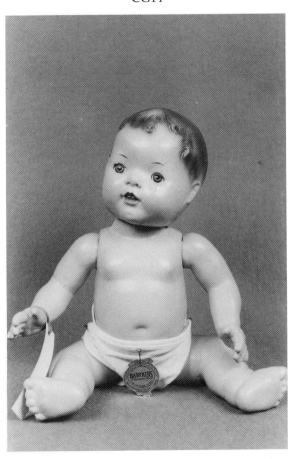

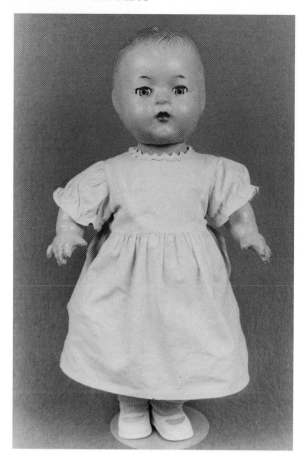

BY10

BY10
Reliable. ca.1940. 16 in. (40.5 cm). All composition, jointed hips, shoulders, and neck. Composition head; blue sleep eyes, lashes, painted lower lashes; light brown moulded hair; closed mouth. Mark: on head, RELIABLE/MADE IN CANADA. Redressed. From the collection of Margaret Ironmunger, Ottawa, Ont.

CD18
Reliable. 1940. WETUMS. 11 in. (28 cm). All composition, jointed hips and shoulders. Blue painted eyes, black line over eye; light brown moulded hair; open mouth nurser. Mark: on head, RELIABLE/MADE IN/CANADA. Original tag, MADE IN CANADA/RELIABLE/A Reliable Doll (in script)/A BRITISH EMPIRE PRODUCT/RELIABLE TOY CO. LIMITED. Original undershirt and diaper with pink binding, glass nursing bottle with, A Reliable Doll, MADE IN CANADA, inscribed on the side. From the collection of Peggy Bryan, Burnaby, B.C.

CC13
Reliable. 1940. CUDDLEKINS. 19 in. (47 cm). All composition, jointed hips, shoulders, and neck. Composition head; blue metal sleep eyes, lashes, painted lower lashes; light brown moulded curls, originally had a wig; open mouth showing two teeth. Mark: on head, RELIABLE/MADE IN CANADA. Original small print cotton dress and matching large brim bonnet, socks and shoes. From the collection of Mrs D.H. Morman, Victoria, B.C.

CD18

CC13

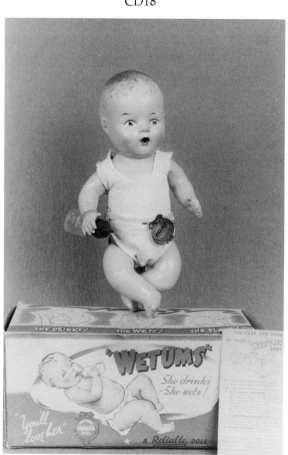

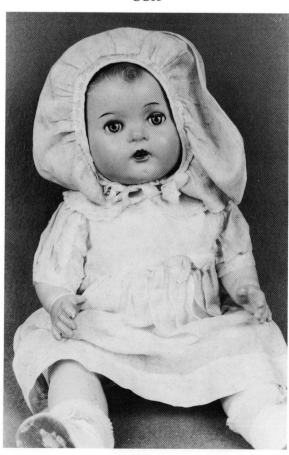

CT3
Reliable. 1941. NURSE. 24 in. (61 cm). Excelsior stuffed cloth body and legs, composition forearms. Composition shoulderhead; blue painted eyes, painted upper lashes; moulded light brown curls; closed mouth. Mark: on shoulderplate, RELIABLE DOLL/MADE IN/CANADA. Original blue cotton dress, navy cape trimmed in red, replaced shoes and socks. Her white cotton apron and head scarf are missing. Author's collection.

BJ8
Reliable. ca.1941. OLD FASHIONED GIRL. 15.5 in. (39 cm). All composition, jointed hips, shoulders, and neck. Composition head; blue tin sleep eyes, lashes, painted lower lashes; blond mohair wig; open mouth showing four teeth. Mark: on head, RELIABLE/MADE IN CANADA. Original long cotton gown trimmed with ribbons, white pinafore, pantalettes, matching bonnet, shoes and socks. From the collection of Rebecca Douglass, Dartmouth, N.S.

AM31
Reliable. 1941. BABYKINS. 20 in. (51 cm). All composition, jointed hips, shoulders, and neck. Composition head; blue glasseine eyes, lashes, painted lower lashes; brown moulded hair; open mouth showing two teeth. Mark: on head, RELIABLE/MADE IN CANADA. Originally wore an undershirt and diaper. Author's collection.

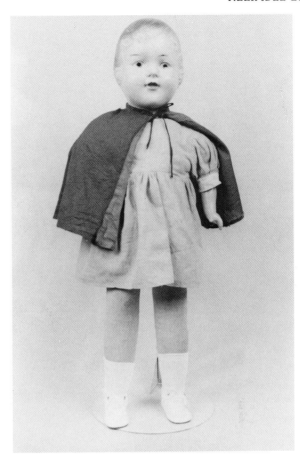

CT3

BJ8

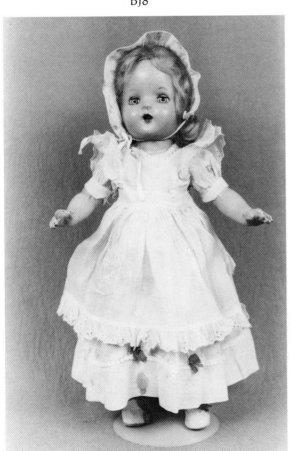

AM31

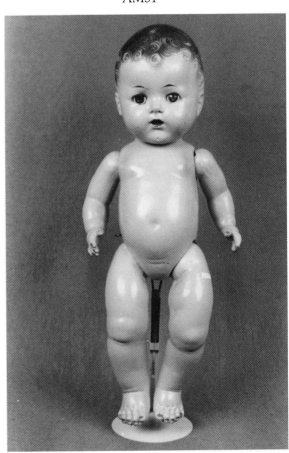

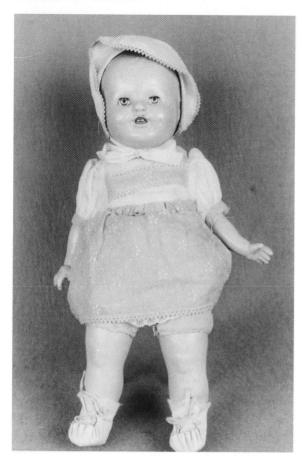

BZ33

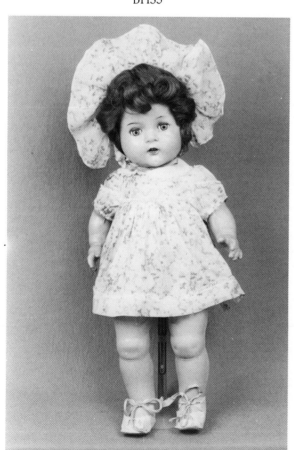

BH35

BZ33
Reliable. 1941. CUDDLEKINS. 15 in. (38 cm). Cloth body, composition arms and straight legs. Composition shoulderhead, dimples; blue tin sleep eyes, lashes, painted lower lashes; brown moulded hair; open mouth showing two teeth. Mark: on shoulderplate, RELIABLE/DOLL/MADE IN CANADA. Original pink and white dress and bonnet, slip and combinations, socks and shoes. This doll was shown in a display at the B.C. Provincial Museum. From the collection of Louise Rowbottom, Victoria, B.C.

BH35
Reliable. ca.1941. All composition, jointed at hips, shoulders, and neck. Composition head; blue tin sleep eyes, lashes, painted lower lashes; brown mohair wig, moulded hair underneath; open mouth showing two teeth and tongue. Mark: on head, RELIABLE/MADE IN CANADA. Original cotton print dress and matching bonnet. From the collection of Rebecca Douglass, Dartmouth. N.S.

CI30
Reliable. ca.1942. ARMY DOLL. 13 in. (33 cm). Excelsior stuffed body and legs, composition forearms. Composition shoulderhead; blue painted eyes, fine black line over eye; light brown moulded hair; closed mouth. Mark: on shoulderplate, RELIABLE DOLL/MADE IN CANADA. Original khaki uniform and cap with a maple leaf and Canada printed on. Black fabric boots are part of the leg. From the collection of Elva Boyce, Regina, Sask.

CI30

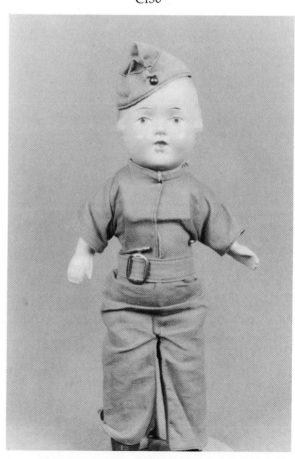

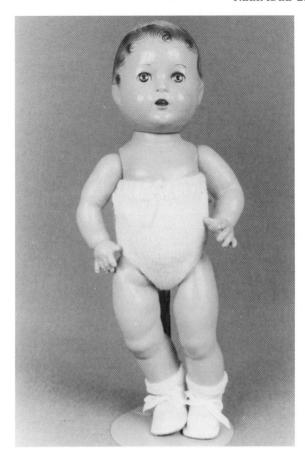

CL2
Reliable. ca.1942. 14 in. (35.5 cm). All composition, jointed hips, shoulders, and neck. Composition head; blue tin sleep eyes, lashes; brown moulded hair, originally wore a wig; open mouth, showing two teeth. Mark: RELIABLE/MADE IN CANADA. From the collection of Peggy Bryan, Burnaby, B.C.

CY5
Reliable. ca.1942. 19 in. (48.5 cm). Composition body, jointed hips, shoulders, and neck. Composition head; blue tin sleep eyes, lashes, painted lower lashes; brown mohair wig with bangs; open mouth showing teeth and tongue. Mark: on head, RELIABLE/MADE IN CANADA. Original white combinations, cotton print dress, velveteen coat and bonnet, socks and shoes. Author's collection.

CC3
Reliable. ca.1942. 21.5 in. (55 cm). Excelsior stuffed cloth body, legs and upper arms, composition 3/4 arms. Composition shoulderhead; blue painted eyes, black line over eye; brown moulded hair; closed mouth. Mark: on shoulderplate, A RELIABLE DOLL/MADE IN CANADA. Redressed. Originally wore a nurse's uniform and appeared in Eaton's catalogue for 1942-43. From the collection of Mrs D.H. Morman, Victoria, B.C.

CL2

CY5

CC3

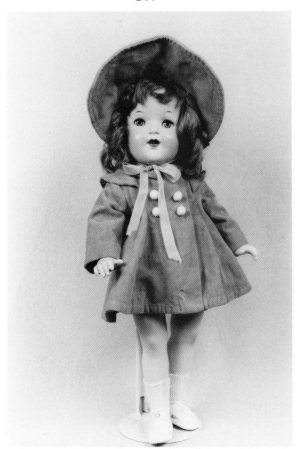

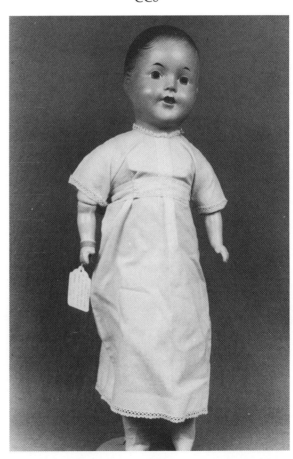

BW19
Reliable. ca.1942. STANDING DOLL, NURSE. 8 in. (20.5 cm).
All composition, jointed shoulders. Black painted side-glancing
eyes, painted upper lashes; blond mohair wig; closed mouth.
Mark: on back, RELIABLE/MADE IN CANADA. Original blue
cotton nurse's uniform with white apron and head scarf with
a white cross on it, painted shoes and socks. Author's collection.

CI34
Reliable. ca.1942. NURSE. 18 in. (45.5 cm). Excelsior stuffed
cloth body, composition arms and straight legs. Composition
shoulderhead; blue painted eyes, black line over eye, painted
upper lashes; blond mohair wig; closed mouth. Mark: on
shoulderplate, RELIABLE DOLL/MADE IN CANADA.
Original blue cotton dress, white apron with a red felt cross
on it, white headdress, shoes and socks. From the collection
of Elva Boyce, Regina, Sask.

BW17
Reliable. ca.1943. STANDING DOLL, AIR FORCE GIRL. 8
in. (20.5 cm). All composition, jointed shoulders. Black painted
side- glancing eyes, painted upper lashes; blond mohair wig;
closed mouth. Mark: on back, RELIABLE/MADE IN
CANADA. Original blue cotton suit, matching hat, white
blouse, painted, moulded socks and shoes. From the collection
of Irene Henderson, Winnipeg, Man.

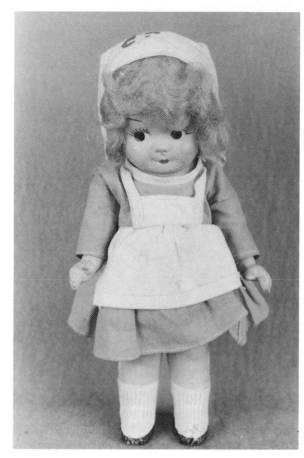

BW19

CI34

BW17

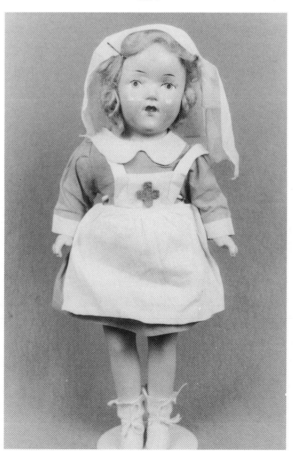

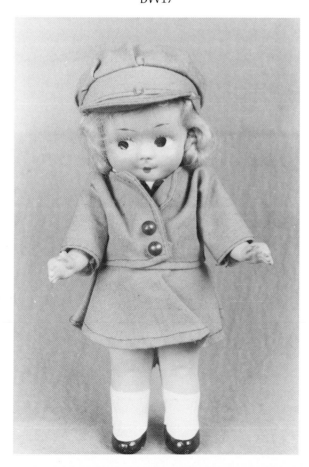

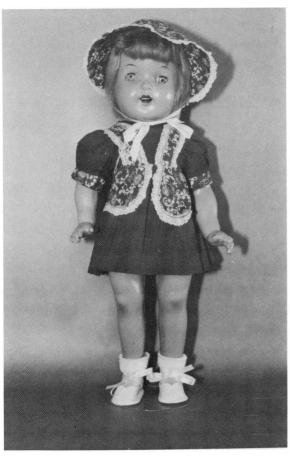

XH25

XH25
Reliable. ca.1943. 18 in. (45.5 cm). All composition body, jointed hips, shoulders, and neck. Composition head; blue tin sleep eyes, lashes; blond mohair wig; open mouth with teeth and felt tongue. Mark: on head, RELIABLE/MADE IN CANADA. Original red cotton dress with attached panties, matching red cotton print bonnet with lace trim. From the collection of Gloria Kallis, Drayton Valley, Alta.

CA2
Reliable. ca.1943. AIR FORCE DOLL. 18 in. (43 cm). Cloth body and legs, composition arms. Composition head; painted brown eyes, black line over eye; brown moulded hair; closed mouth. Mark: on head, RELIABLE/MADE IN/CANADA. Original light blue Air Force uniform and cap. From the collection of Louise Rowbottom, Victoria, B.C.

BN35
Reliable. 1943. BABY PRECIOUS. 19 in. (48.5cm). Cloth body, composition arms and straight legs. Composition head; blue tin sleep eyes, lashes, painted lower lashes; light brown mohair wig over moulded hair; closed mouth. Mark: on head, A RELIABLE DOLL. Original dress and bonnet, replaced socks, shoes and ribbons. From the collection of Irene Henderson, Winnipeg, Man.

CA2

BN35

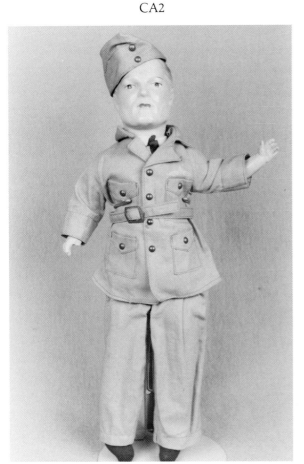

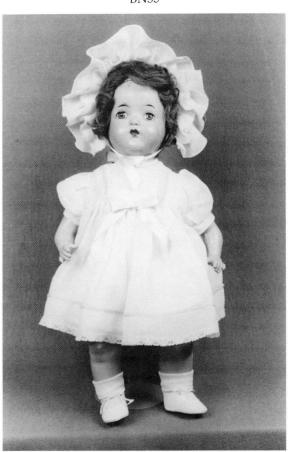

CW28
Reliable. ca.1944. NURSE DOLL. 24 in. (61 cm). Excelsior stuffed cloth body and legs, composition arms. Composition shoulderhead; blue painted eyes, white highlights, fine black line over eye, painted upper lashes; brown moulded hair; closed mouth. Mark: A RELIABLE DOLL/MADE IN CANADA. Original blue cotton uniform, white apron with white cross on the front. From the collection of Sylvia Higgins of the Remember When Museum at Laidlaw, B.C..

CN18
Reliable. ca.1944. STANDING DOLL, INDIAN GIRL. 8 in. (20.5 cm). All composition, jointed shoulders. Black painted side- glancing eyes, painted upper lashes; black synthetic wig in braids; closed mouth. Mark: on body, RELIABLE/MADE IN/CANADA. Original felt skirt and headband, moulded painted shoes and socks. From the collection of Diane Peck, Sudbury, Ont.

BP8
Reliable. ca.1945. STANDING DOLL. 8 in. (20.5 cm). All composition, jointed shoulders. Black painted side-glancing eyes, painted upper lashes; blond mohair wig; closed mouth. Mark: on back, RELIABLE/MADE IN/CANADA. Original red and white striped dress, moulded painted shoes and socks. From the collection of Betty Hutchinson, Ottawa, Ont.

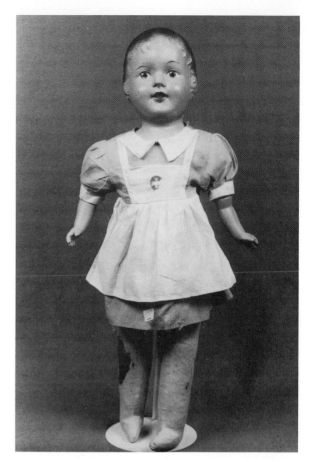

CW28

CN18

BP8

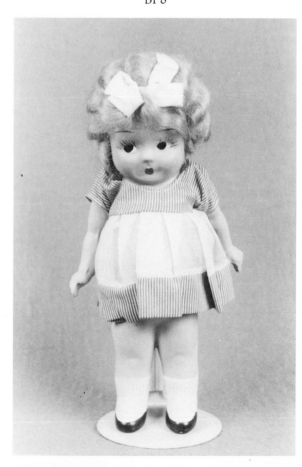

CL8

CJ35

BF27

CL8
Reliable. ca.1945. MINIATURE DOLL. 11 in. (28 cm). All hard plastic, jointed shoulders and neck. Hard plastic head; blue plastic side-glancing sleep eyes, painted upper lashes; blond mohair wig; closed mouth. Mark: on body, RELIABLE/MADE IN CANADA. MINIATURE DOLLS were produced for a number of years in 11 and 8 inch sizes. They were dressed in a variety of costumes including a bride, southern belle, nun, Scottish girl etc. From the collection of Peggy Bryan, Burnaby, B.C.

CJ35
Reliable. ca.1945. BABY PRECIOUS. 17 in. (43 cm). Cloth body, composition arms and straight legs. Composition head; blue sleep eyes, lashes, painted lower lashes; light brown mohair wig; closed mouth. Mark: RELIABLE/DOLL/MADE IN CANADA. Original organdy dress, socks and shoes. From the collection of Ruth Condello, Winnipeg, Man.

BF27
Reliable. ca.1946. 14 in. (35.5 cm). All composition bent limb baby, jointed hips, shoulders, neck, and wrists. Composition head; glasseine sleep eyes, lashes, painted lower lashes; painted hair; closed mouth. Mark: RELIABLE/MADE IN CANADA. Redressed. From the collection of Margaret Archibald, Halifax, N.S.

CB7
Reliable. ca.1947. BABY LOVUMS. 24 in. (61 cm). Cloth body with crier, composition hands and bent limb legs. Composition head; blue sleep eyes, lashes, painted lower lashes, black eye shadow over eye; light brown moulded hair; closed mouth. Mark: on head, RELIABLE. Original white organdy lace trimmed dress with matching bonnet, cotton petticoat, socks and shoes. From the collection of Mary Van Horne, Chilliwack, B.C.

BZ22
Reliable. ca.1947. BABY LOVUMS. 26 in. (66 cm). Cloth body with crier, composition bent-limb arms and legs. Composition head; blue sleep eyes, lashes, painted lower lashes; brown mohair wig; closed mouth. Mark: on head, RELIABLE. Original organdy dress and bonnet, socks and shoes. Original tag. From the collection of Phyllis McOrmond, Victoria, B.C.

AP10
Reliable. 1947. MAGGIE MUGGINS. 15 in. (38 cm). All composition, jointed hips, shoulders, and neck. Composition head; blue sleep eyes, lashes, painted lower lashes and freckles; red mohair wig in pigtails; open mouth showing teeth. Mark: on head, RELIABLE/MADE IN CANADA. Original green cotton print dress, white pinafore, green shoes, white socks. Created to represent MAGGIE MUGGINS, a little girl from the Canadian television show of the same name. From the collection of Dawn Young, Niagara Falls, Ont.

CB7

BZ22

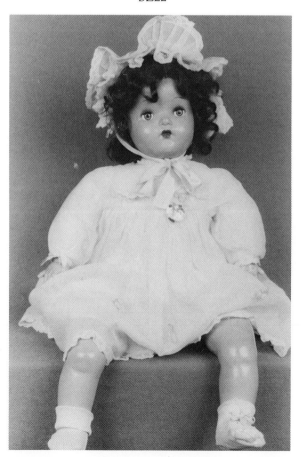

AP10

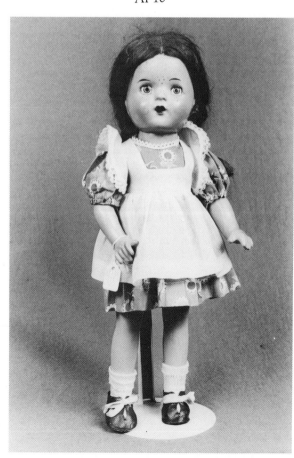

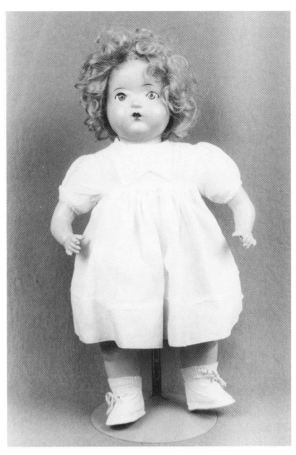

BF28

BF28
Reliable. ca.1947. BABY PRECIOUS. 20 in. (51 cm). Cloth body, composition arms and straight legs. Composition head; blue sleep eyes, lashes, painted lower lashes; blond mohair wig; closed mouth. Mark: on head, A/RELIABLE/DOLL. Original cotton dress. From the collection of Barbara Murphy, Halifax, N.S.

AO23
Reliable. ca.1947. LADDIE. 12 in. (30.5 cm). All composition, jointed hips and shoulders. Blue painted eyes, black line over eye; light brown moulded hair; closed mouth. Mark: on head, RELIABLE/MADE IN/CANADA. Original Scottish outfit with tartan kilt, velvet jacket, and forage cap, tartan muffler, sporran and metal trim, replaced socks and shoes. LADDIE was made from the mid-thirties to 1955. Some years he was called HIGHLAND LADDIE. Some years he wore a cotton jacket; other years a felt jacket. During the war there was no metal trim on his outfit. Author's collection. See colour Fig. AO23.

CX13
Reliable. 1947. BABY JEAN. 12 in. (30.5 cm). All composition, jointed hips and shoulders. One piece head and body. Painted blue eyes; moulded brown curls; closed mouth. Mark: on body, RELIABLE/MADE IN/CANADA ; label, BABY JEAN. Original cotton combinations, socks and shoes. Originally wore an organdy dress and bonnet. From the collection of Cathy Dorsey, St. Catharines, Ont.

AO23

CX13

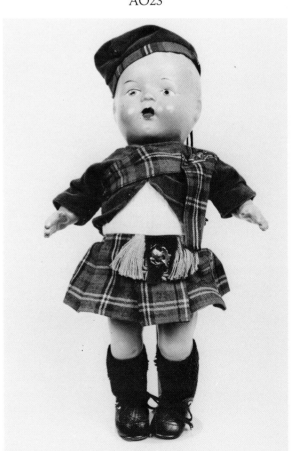

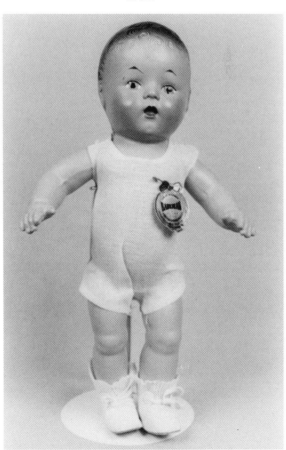

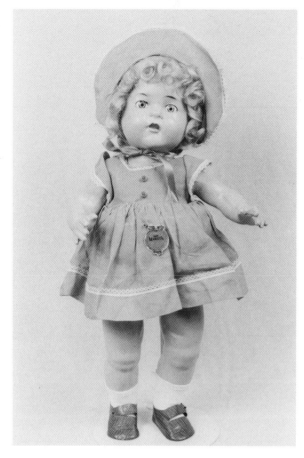

CT4
Reliable. 1947. BABY MARILYN. 20 in. (51 cm). All composition, jointed hips, shoulders, and neck. Composition head; blue plastic sleep eyes, lashes, painted lower lashes; blond mohair wig; closed mouth. Mark: on head, RELIABLE/MADE IN CANADA; original gold name label. Original blue cotton dress and matching bonnet, blue cotton teddy, replaced socks and shoes. Originally wore white shoes. Author's collection.

CF28
Reliable. ca.1948. GLORIA. 18 in. (45.5 cm). Cloth body, composition arms and straight legs. Composition shoulderhead; blue sleep eyes, lashes; blond mohair wig; closed mouth. Mark: on shoulderplate, RELIABLE/MADE/IN CANADA. Original cotton print dress and matching bonnet, socks and shoes. Original tag with her name. From the collection of Gloria Kallis, Drayton Valley, Alta.

BH6
Reliable. 1948. HIAWATHA. 12 in. (30.5 cm). All composition, jointed hips and shoulders. Brown painted eyes, black line over eye; black wig in braids; closed mouth. Mark: on back, RELIABLE/MADE IN CANADA. Original red and green cotton suit and headband with feather, moccasins. From the collection of Margaret Edmonds, Waverley, N.S.

CT4

CF28

BH6

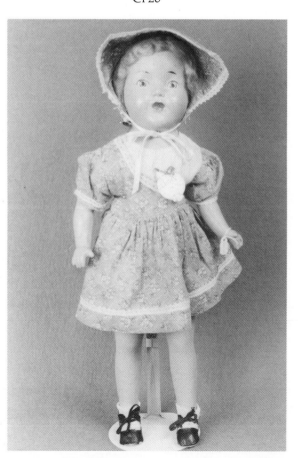

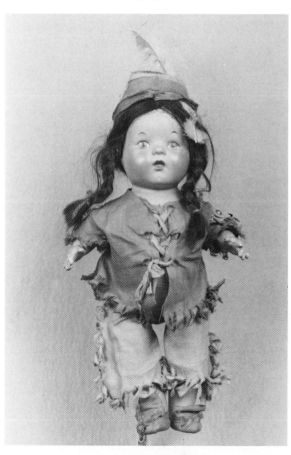

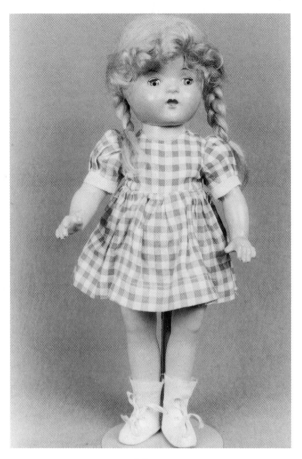

CD26

CD26
Reliable. 1948. PIGTAILS. 15 in. (38 cm). All composition, jointed hips, shoulders, and neck. Composition head; blue sleep eyes, lashes, painted lower lashes; blond mohair wig in pigtails with curled bangs; closed mouth. Mark: on head, RELIABLE/MADE IN CANADA. Original red and white checked cotton dress with attached panties, shoes, and socks. Originally wore a white organdy pinafore over her dress and ribbons on her pigtails. From the collection of Jean M. Herriot, Vancouver, B.C.

CY8
Reliable. 1948. SCOTCH LASSIE. 15 in. (38 cm). Composition body, jointed hips, shoulders, and neck. Composition head; blue tin sleep eyes, lashes, painted lower lashes; blond mohair wig with bangs; closed mouth. Mark: on head, RELIABLE/MADE IN CANADA. Original plaid skirt and scarf, velveteen jacket and matching hat with feather, socks and shoes. Also came in an 18 in. size. Author's collection.

BF32
Reliable. 1948. BABY MARILYN. 20 in. (51 cm). All composition toddler, jointed hips, shoulders, and neck. Composition head; blue sleep eyes, lashes, painted lower lashes; blond wig; closed mouth. Mark: no mark on doll. Original Reliable tag. Original red dress and tam, socks and shoes. In this picture the dress appears to be on back to front. It should be buttoned down the front with large buttons. From the collection of June MacDonald, Halifax, N.S.

CY8

BF32

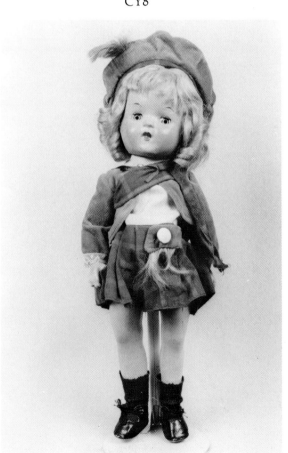

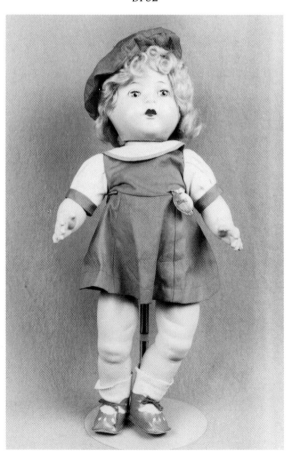

CO18

Reliable. 1948. GLORIA. 18 in. (45.5 cm). Cloth body, composition arms and straight legs. Composition shoulderhead; blue sleep eyes, lashes, painted lower lashes; blond mohair wig; closed mouth. Mark; on shoulderplate, A/RELIABLE/DOLL/MADE IN CANADA. Original cotton print dress and matching bonnet. From the collection of Margaret Lister of the Gallery of Dolls, Hornby, Ont.

CD5

Reliable. 1948. BABY PRECIOUS. 24 in. (61 cm). Cloth body, composition forearms and straight legs. Composition head; blue tin sleep eyes, lashes, painted lower lashes; replaced blond mohair wig over moulded hair; closed mouth. Mark: no mark on doll. Original tag, BABY PRECIOUS/MADE IN CANADA/A RELIABLE DOLL/MFD. BY RELIABLE TOY CO. CANADA/A BRITISH EMPIRE PRODUCT. Original blue combination under garment, white cotton dress, trimmed with bias, lace, and pink ribbon. Replaced socks. From the collection of Peggy Bryan, Burnaby, B.C.

BQ0

Reliable. 1948. TOPSY. 17 in. (43 cm). Brown composition, jointed hips, shoulders, and neck. Composition head, dimpled cheeks; black painted side-glancing eyes; open-closed mouth showing two painted teeth. Mark: on head, RELIABLE/MADE IN CANADA. Original undershirt and diaper. Courtesy of the National Museums of Canada, the National Museum of Man, Ottawa, Ont.

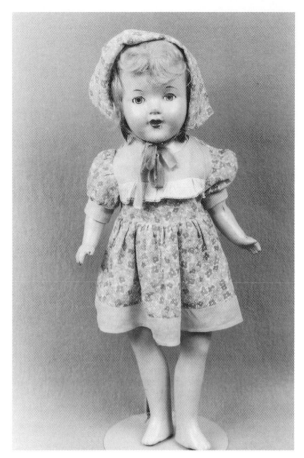

CO18

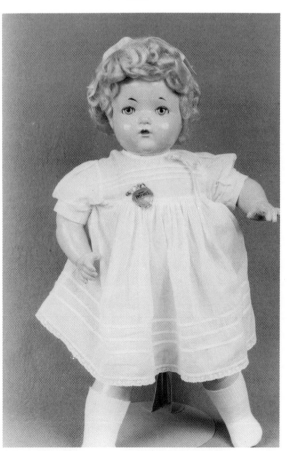

CD5

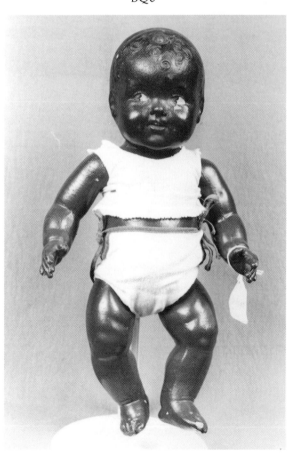

BQ0

CL3

CL5
Reliable. 1948. JOAN. 9.5 in. (24 cm). All composition bent-limb baby, jointed hips, and shoulders. Blue painted eyes, black line over eye; brown moulded hair; closed mouth. Mark: on back, RELIABLE/MADE IN CANADA. In the 9.5 in. size JOAN has no eyebrows, but she does in the 11.5 in. size. Originally dressed in a diaper. From the collection of Peggy Bryan, Burnaby, B.C.

CA34
Reliable. 1948. SALLY ANN. 22 in. (56 cm). All composition, jointed hips, shoulders, and neck. Composition head with dimpled cheeks; blue metal sleep eyes, lashes, painted lower lashes; red mohair wig; open smiling mouth showing six teeth. Mark: on head, RELIABLE/MADE IN CANADA. Original navy cotton dress and hat, shoes and socks. SALLY ANN came out in 1939. She came in 16 and 18 inch sizes also. From the collection of Mrs D.H. Morman, Victoria, B.C.

CL3
Reliable. 1948. PLASSIKINS. 14 in. (45.5 cm). Hard plastic bent-limb baby, jointed hips, shoulders, neck, and wrists. Hard plastic head; blue plastic sleep eyes, and lashes; light brown moulded hair; closed mouth. Mark: RELIABLE/MADE IN CANADA. One of the first hard plastic dolls in Canada. Originally wore a checked sunsuit with ruffles and a matching bonnet. From the collection of Peggy Bryan, Burnaby, B.C.

CA34

CL5

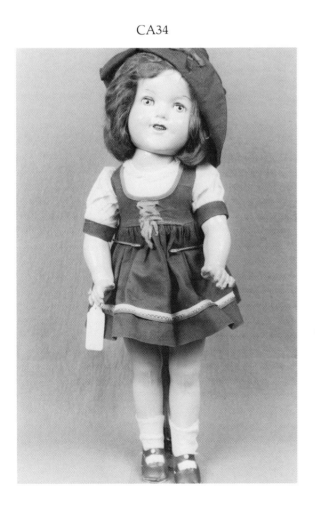

CJ36
Reliable. 1948. BABYKINS. 17 in. (43 cm). All composition, jointed hips, shoulders, and neck. Composition head with dimpled cheeks; blue tin sleep eyes, lashes, painted lower lashes; reddish brown moulded hair; open-closed mouth, two painted teeth. Mark: on head, RELIABLE/MADE IN CANADA. Original undershirt and diaper. Original label. From the collection of Ruth Condello, Winnipeg, Man.

CO24
Reliable. 1948. CUDDLES. 22 in. (56 cm). Cloth body, composition arms and straight legs. Composition head; blue metal sleep eyes, lashes, painted lower lashes; blond moulded hair; closed mouth. Mark: on head, A/RELIABLE/DOLL/MADE IN CANADA. Replaced clothing. Originally wore a lace trimmed organdy dress with matching bonnet. From the collection of Margaret Lister of The Gallery of Dolls, Hornby, Ont.

BJ6
Reliable. 1948. BABY LOVUMS. 17 in. (43 cm). Cloth body with crier, composition hands and bent-limb legs. Composition head; blue sleep eyes, lashes; brown moulded hair; closed mouth. Mark: on head, A/RELIABLE/DOLL. Original white cotton lace trimmed dress, matching bonnet, socks and shoes. From the collection of Rebecca Douglass, Dartmouth, N.S.

CJ36

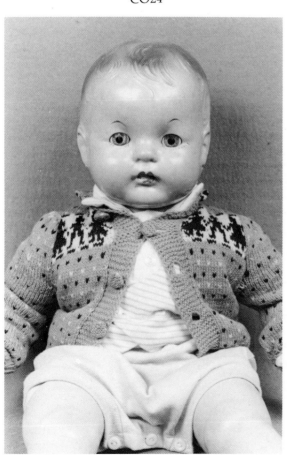

CO24

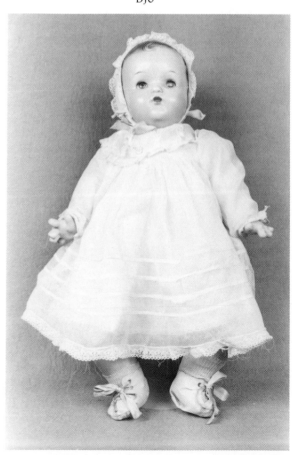

BJ6

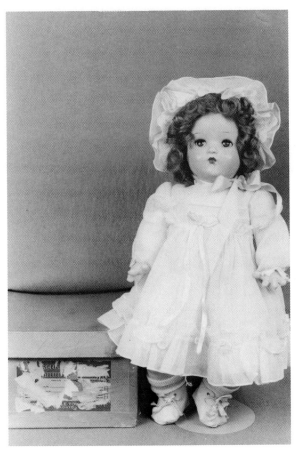

CD4

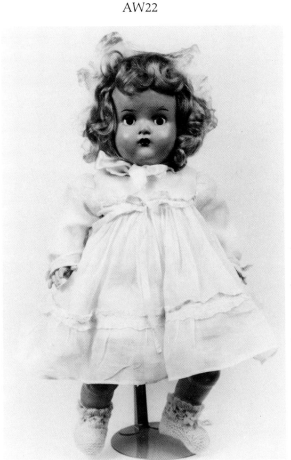

AW22

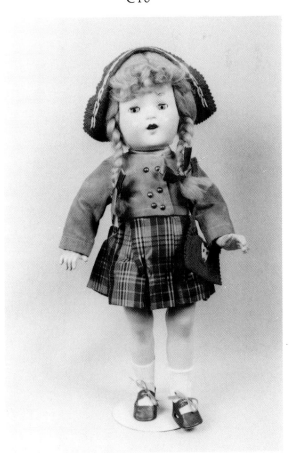

CY6

CD4
Reliable. 1942. BABY LOVUMS. 17 in. (43 cm). Cloth body, composition hands and bent-limb legs. Composition head; green sleep eyes, lashes, painted lower lashes; brown mohair curly wig; closed mouth. Mark: on head, A/RELIABLE/DOLL. Original white organdy frilled dress and matching bonnet, socks and shoes. Original box. From the collection of Lola Fast, Burnaby, B.C.

AW22
Reliable. ca.1949. RUTHIE. 17 in. (43 cm). Cloth body, bent limb, latex arms and legs, crier in the body. Composition head; brown tin sleep eyes, lashes, painted lower lashes; blond mohair wig; closed mouth. Mark: on head, RELIABLE DOLL/MADE IN CANADA. Original white cotton dress and bonnet, replaced bootees. From the collection of Mrs. D. Steele, Ottawa, Ont.

CY6
Reliable. ca.1949. PIGTAILS. 19 in. (48.5 cm). Composition body, jointed hips, shoulders, and neck. Composition head; blue tin sleep eyes, lashes, painted lowers; blond mohair wig in pigtails and bangs; open mouth showing four teeth and tongue. Mark: on head, RELIABLE/MADE IN CANADA. Original plaid taffeta skirt, attached panties, velveteen jacket, felt hat, socks and shoes, felt shoulder purse. Author's collection.

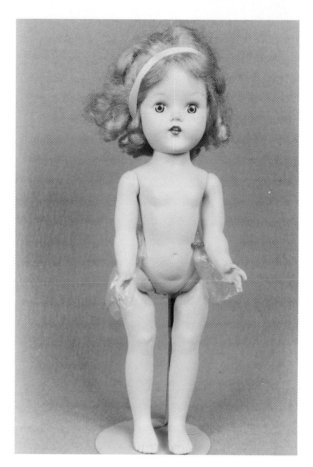

CD28

CD28
Reliable. ca.1949. SUSIE STEPPS. 15 in. (38 cm). All hard plastic walker, jointed hips, shoulders, and neck. Hard plastic head; blue sleep eyes, upper lashes missing, painted lower lashes, dark upper eye shadow; synthetic blond wig; open mouth showing four teeth and tongue. Mark: on body, Reliable (in script)/MADE IN CANADA. From the collection of Peggy Bryan, Burnaby, B.C.

BZ16
Reliable. ca.1949. BRIDE DOLL. 15 in. (30.5 cm). Composition body, jointed hips, shoulders, and neck. Composition head; blue plastic sleep eyes, lashes, painted lower lashes; blond mohair wig; open mouth. Mark: on head, RELIABLE/MADE IN CANADA. Original satin wedding gown and net veil; carrying flowers. From the collection of Phyllis McOrmond, Victoria, B.C.

BT22
Reliable. 1949. BABY LOVUMS. 24 in. (61 cm). Cloth body composition legs and hands. Composition head; blue sleep eyes, lashes, painted lower lashes, eye shadow over eye; blond mohair curly wig; closed mouth. Mark: on head Reliable/Made in Canada. Original lace-trimmed dress and bonnet; replaced shoes and socks. From the collection of Bernice Tomlinson, Etobicoke, Ont.

BZ16

BT22

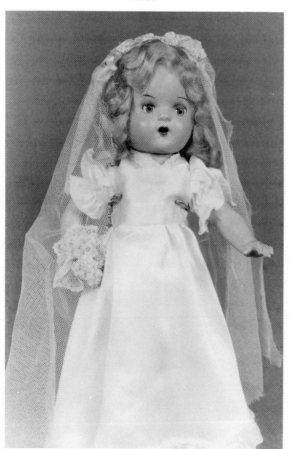

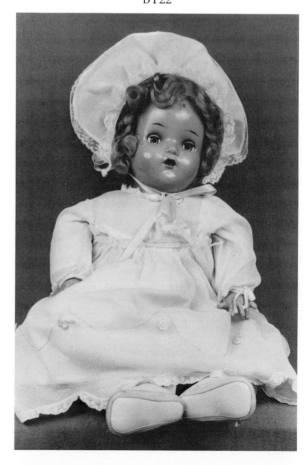

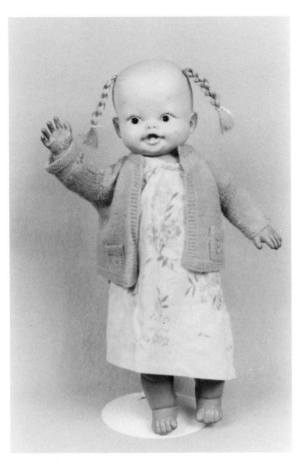

CX15

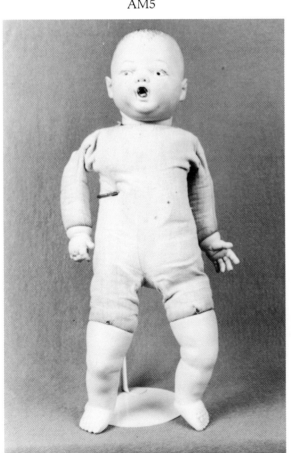

AM5

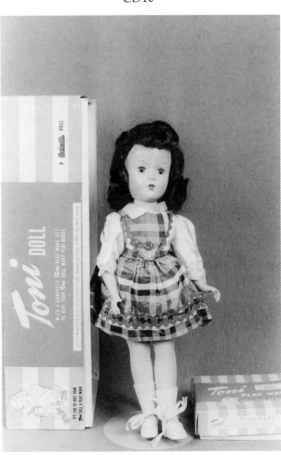

CD10

CX15
Reliable. 1950. BONNIE BRAIDS. 14 in. (35.5 cm). Magic Skin one piece body and legs, jointed shoulders. Vinyl head; painted blue eyes, painted upper lashes; moulded hair with two inset braids; open-closed mouth. Mark: on head, Reliable (in script)/13BVE. Redressed. Originally BONNIE wore a long organdy dress, petticoat panties and socks and came with her own toothbrush and tube of Ipana toothpaste. She also came in a 12 in. size. BONNIE BRAIDS was comic book hero Dick Tracy's daughter. From the collection of Cathy Dorsey, St. Catharines, Ont.

AM5
Reliable. 1950. SNOOZIE. 17 in. (43 cm). Cloth body and arms, stuffed vinyl hands and legs. Head is an early soft vinyl that feels like sponge rubber; blue painted eyes, painted upper lashes; light brown moulded hair; open-closed yawning mouth. Mark: on head RELIABLE. Also came in 12 and 14 inch sizes with latex hands and legs. The 17 and 21 inch sizes had vinyl hands and legs. Originally dressed in a diaper and nightie, wrapped in a blanket tied with a ribbon bow. From the collection of Judy Smith, Ottawa, Ont. See also Fig. AM6.

CD10
Reliable. 1950. TONI. 14 in. (35.5 cm). Hard plastic body, jointed hips, shoulders, and neck. Hard plastic head; blue sleep eyes, lashes, painted lower lashes; dark brown nylon wig (glued on head); closed mouth. Mark: none on doll. Original dress, panties, socks and shoes. Original box and wave set box. TONI was designed by the American designer B. Lipfert for Ideal. Quote from the box, 'There's enough nylon in the Toni doll's wig to make seven pairs of nylon stockings'' From the collection of Peggy Bryan, Burnaby, B.C.

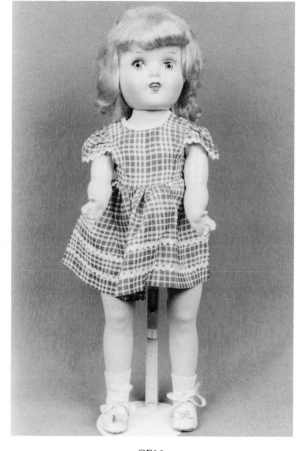

CF33

CF33
Reliable. 1950. SUSIE STEPPS. 20 in. (51 cm). Hard plastic body, jointed hips, shoulders, and neck. Hard plastic head; brown sleep eyes, lashes, painted lower lashes; light brown saran wig; open mouth showing teeth and tongue. Mark: RELIABLE. Original dress. From the collection of Goria Kallis, Drayton Valley, Alta.

CI36
Reliable. 1950. RELIABLE DOLL. 15 in. (38 cm). Cloth body, stuffed latex arms and legs. Composition head; blue plastic eyes, lashes, painted lower lashes; moulded hair, originally she wore a semi-wig; closed mouth. Mark: on head, RELIABLE/DOLL/MADE IN CANADA. Original pink organdy dress and matching bonnet, replaced bootees. From the collection of Elva Boyce, Regina, Sask.

CH8
Reliable. 1950. TOPSY. 10 in. (24 cm). All composition body, jointed hips, and shoulders. Black painted side-glancing eyes; black moulded hair; closed mouth. Mark: on back, RELIABLE/MADE IN CANADA. Originally wore a cotton print diaper. Did not come with a bottle. From the collection of Margaret Wist, Saskatoon, Sask.

CI36

CH8

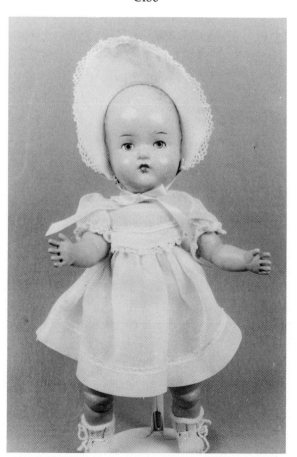

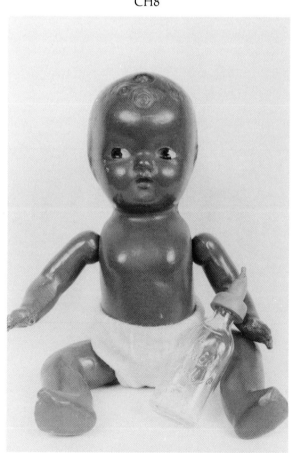

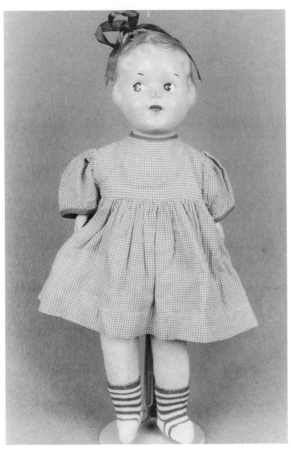

BZ29

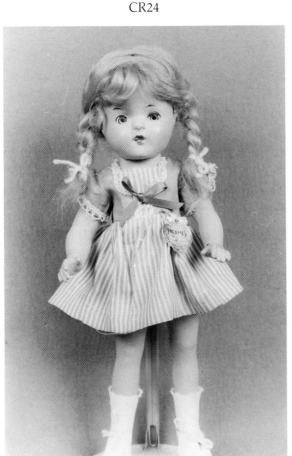

CR24

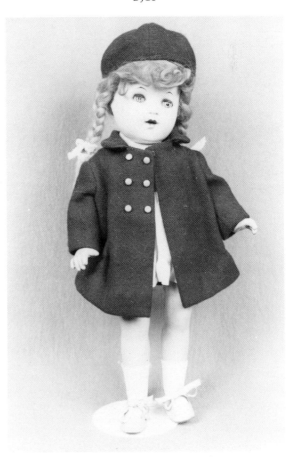

BJ13

BZ29
Reliable. 1950. PEGGY. 16.5 in. (42 cm). Cloth body and legs, composition arms. Composition shoulderhead; black painted side- glancing eyes, black line over eye; light brown moulded hair with hole for hair ribbon; closed mouth. Mark: on shoulderplate, RELIABLE DOLL/MADE IN CANADA. Replaced clothing. PEGGY, an old favourite, was made with side-glancing eyes in 1950. From the collection of Louise Rowbottom, Victoria, B.C.

CR24
Reliable. 1951. PIGTAILS. 15 in. (38 cm). All composition body, jointed hips, shoulders, and neck. Composition head; blue sleep eyes, lashes, painted lower lashes; blond mohair wig in pigtails with bangs; closed mouth. Mark: no mark on doll. Original tag on dress. Original blue striped dress and matching panties, socks, and shoes. Author's collection.

BJ13
Reliable. 1951. PIGTAILS. 18 in. (45.5 cm). Composition body, jointed hips, shoulders, and neck. Composition head; blue sleep eyes, lashes, painted lower lashes; honey blond mohair wig in pigtails with curly bangs; open mouth showing four teeth. Mark: on head, RELIABLE/MADE IN CANADA. Wearing navy wool coat and hat. Originally wore a cotton print dress. Also came in a smaller size with a closed mouth and in a larger size with a smiling mouth. From the collection of Rebecca Douglass, Dartmouth, N.S.

CO22
Reliable. 1951. PIGTAILS. 22 in. (56 cm) Composition body, jointed hips, shoulders, and neck. Composition head with dimples; blue sleep eyes, lashes, painted lower lashes; light brown mohair pigtails with curly bangs; open mouth showing teeth and tongue. Mark: on head, RELIABLE. Redressed. From the collection of Margaret Lister of the Gallery of Dolls, Hornby, Ont.

BH11
Reliable. 1951. BABY SKIN. 12 in. (30.5 cm). Stuffed latex body with coo voice. Composition head with nostril holes; blue plastic sleep eyes, lashes, painted lower lashes; light brown moulded hair; closed mouth. Mark: on head, Reliable/Made in Canada. Original diapers and undershirt. Added knit outfit. When the body is pressed baby will cry or sob with a coo voice. From the collection of Donna Gardiner, Dartmouth, N.S.

BH17
Reliable. ca.1952. DREAM BABY. 20 in. (51 cm). Cloth body, stuffed vinyl arms and legs. Vinyl head; blue sleep eyes, lashes, painted lower lashes; rooted blond saran hair; open-closed mouth. Mark: on head, RELIABLE/4CV28. Original white lace-trimmed dress. From the collection of Rolande Strand, Eastern Passage, N.S.

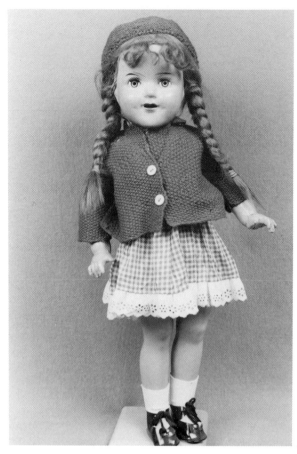

CO22

BH11

BH17

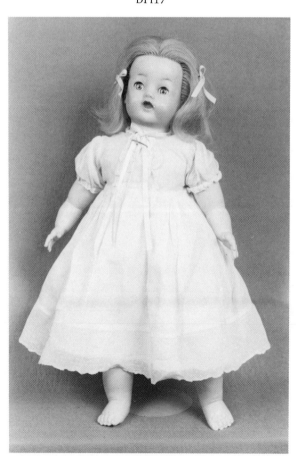

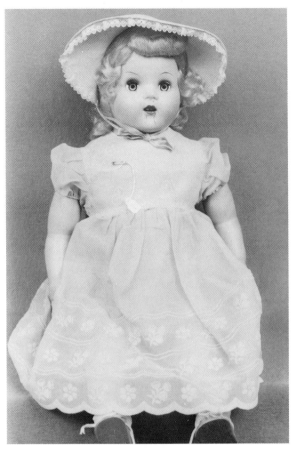

CF34

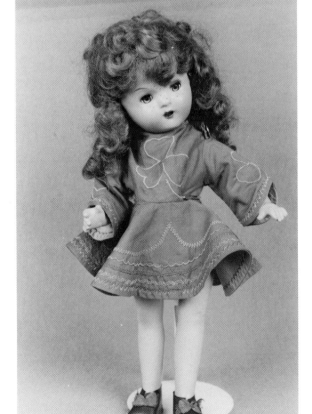

CD23

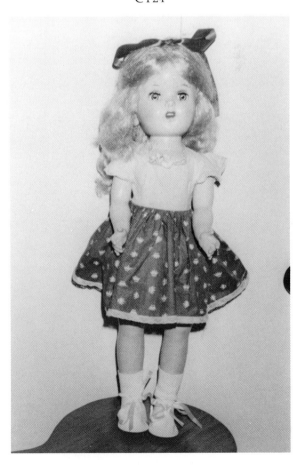

CT24

CF34
RELIABLE. ca.1952. 24 in. (61 cm). Cloth body, stuffed latex arms and legs. Composition shoulderhead; blue sleep eyes, lashes, painted lower lashes; blond saran wig; open mouth showing two teeth and tongue. Mark: on shoulderplate, A/RELIABLE/DOLL/MADE IN CANADA. Original nylon dress and matching bonnet, shoes and socks, and original box. From the collection of Gloria Kallis, Drayton Valley, Alta.

CD23
Reliable. ca.1952. 14 in. (35.5 cm). Composition body, jointed hips, shoulders, and neck. Composition head with freckles; hazel sleep eyes, lashes; auburn saran wig; open mouth showing teeth and tongue. Mark: on head, RELIABLE/MADE IN CANADA. This is a mystery doll. She has the same head and body as 1947's MAGGIE MUGGINS but her hair appears to be saran which means that she is from the early nineteen-fifties. From the collection of Vera Goseltine, Vancouver, B.C.

CT24
Reliable. 1952. SUSIE STEPPS. 19 in. (48.5 cm). Hard plastic body, jointed hips, shoulders, and neck. Hard plastic head; blue sleep eyes, lashes; Saran blond wig; open mouth showing teeth. Original dress with a green print skirt and yellow bodice. Walks and turns her head from side to side when you hold her hand. Originally SUSIE had her hair in curled bangs. Photograph courtesy of Glenda Shields. From the collection of Glenda Shields, London, Ont.

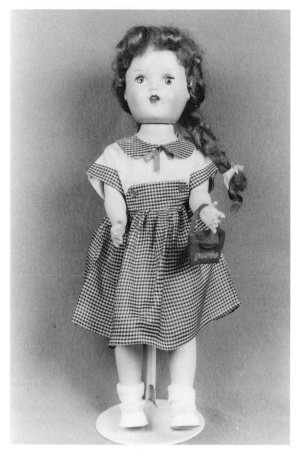

CR25

CR25
Reliable. 1952. SUSIE STEPPS. 19 in. (48.5 cm). Hard plastic body, jointed hips, shoulders, and neck. Hard plastic head; blue sleep eyes, lashes, painted lower lashes; auburn synthetic wig in braids; open mouth showing teeth and tongue. Mark: on body, Reliable (in script)/MADE IN CANADA. Original dress and purse. Author's collection.

CA30
Reliable. 1953. HER HIGHNESS CORONATION DOLL. 14 in. (35.5 cm). All composition body, jointed hips, shoulders, and neck. Composition head; blue sleep eyes, lashes, reddish brown painted lower lashes and brows; auburn wig; open mouth, smiling showing six teeth. Mark: on head, A/RELIABLE DOLL. Original white and gold gown, red velvet cape, pearl tiara, and wearing a ribbon with her name. From the collection of Mrs D.H. Morman, Victoria, B.C.

AP13
Reliable. 1953. DREAM BABY. 19 in. (45.5 cm). Cloth body, vinyl flex arms and legs. Vinyl head; blue sleep eyes, lashes, painted lower lashes; dark brown saran hair; open-closed mouth. Mark: on head, Reliable (in script)/MADE IN CANADA/V18. From the collection of Geraldine Young, Niagara Falls, Ont.

CA30

AP13

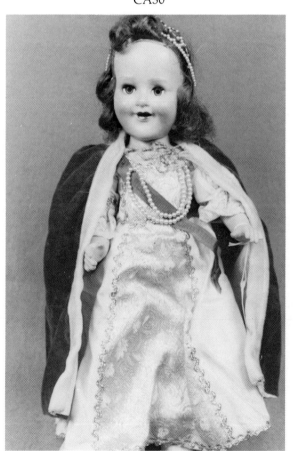

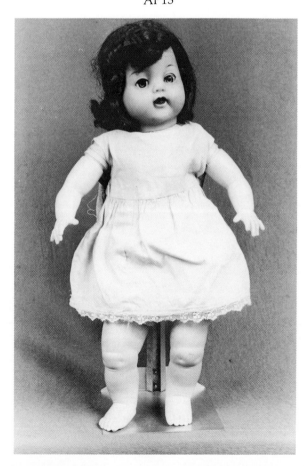

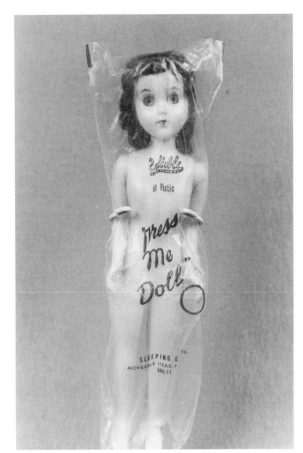

BQ5
Reliable. 1953. DRESS ME DOLL. 11 in. (28 cm). Hard plastic body, jointed shoulders and neck. Hard plastic head; sleep eyes; brown wig; closed mouth. Mark: on back, RELIABLE/pat. pend. 1953. Original plastic bag. Courtesy of the National Museums of Canada, National Museum of Man, Ottawa, Ont.

CJ5
Reliable. 1953. TICKLE TOES. 23 in. (53.5 cm). One piece stuffed latex body. Vinyl head; blue sleep eyes, lashes, painted lower lashes; rooted blond hair with bangs; open-closed mouth. Mark: on head, Reliable (in script)/MOV19. Original pink dress with print border and lace trim. Originally wore a matching bonnet. From the collection of Elva Boyce, Regina, Sask.

CI12
Reliable. 1953. PATTY. 14 in. (35.5 cm). Hard plastic body, jointed hips, shoulders, and neck. Hard plastic head ; blue sleep eyes, lashes, painted lower lashes; blond mohair wig; closed mouth. Mark: on back, Reliable (in script). Original pink print dress with matching bonnet. Original box. From the collection of Ruth MacAra, Caron, Sask.

BQ5

CJ5

CI12

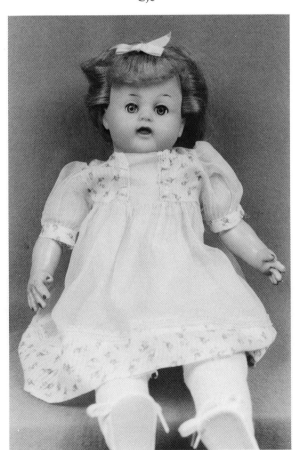

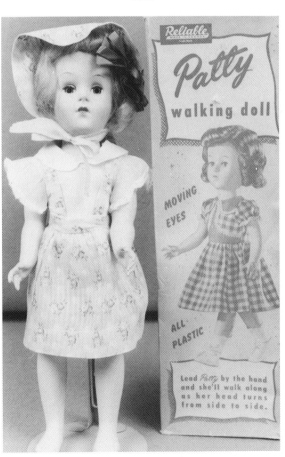

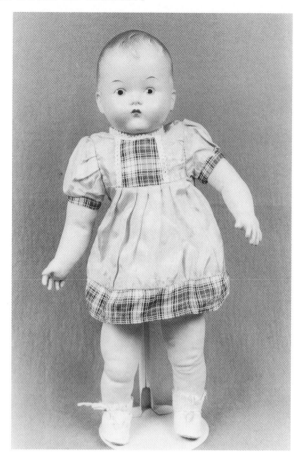

CM2

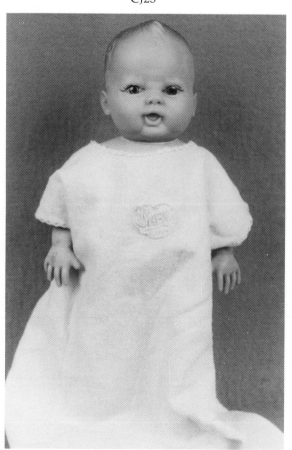

CJ23

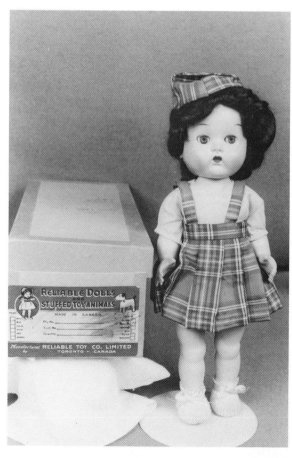

CO32

CM2
Reliable. 1953. HONEY. 16 in. (40.5 cm). Cloth body, stuffed latex arms and legs. Hard plastic head; blue painted eyes, black line over eye; brown moulded hair; closed mouth. Mark: on head, Reliable (in script). Original pink taffeta dress with plaid trim, socks and shoes. Originally wore a matching bonnet. HONEY was also made with a wig and came in four sizes. Author's collection.

CJ23
Reliable. 1953. SNOOZIE. 11 in. (28 cm). One piece magic skin (stuffed latex) body, with coo voice. Vinyl head; blue plastic inset eyes, painted upper lashes; light brown moulded hair; open-closed yawning mouth. Mark: on head, Reliable (in script)/121131. Replaced nightie. Originally wore a diaper and nightie and was wrapped in a blanket with a ribbon bow. Also came in a plastic cradle. SNOOZIE was available in four sizes. From the collection of Dianne Richards, Kenosee Lake, Sask.

CO32
Reliable. 1953. SUSIE WALKER. 13 in. (33 cm). Hard plastic body, jointed hips, shoulders, and neck. Hard plastic head; blue sleep eyes, moulded lashes, painted lower lashes; dark brown synthetic wig; closed mouth. Mark: Reliable (in script)/MADE IN CANADA. Replaced clothing. Originally wore blue organdy dress with lace trim and matching bonnet, combinations. Original box. From the collection of Margaret Lister of the Gallery of Dolls, Hornby, Ont.

SL14
Reliable. 1953. CORONATION WALKING DOLL. 16 in. (40.5 cm). Hard plastic doll with jointed hips, shoulders, and neck. Hard plastic head; sleep eyes, lashes; saran wig; closed mouth. Original white satin gown with gold trim. Originally wore a cape and tiara. Photograph courtesy of Glenda Shields, London, Ont. See colour Fig. SL14.

CG21
Reliable. 1953. SAUCY WALKER. 22 in. (56 cm). Hard plastic body with crier, jointed hips, shoulders, and neck. Hard plastic head; plastic flirty eyes, lashes, painted lower lashes; blond saran wig; open mouth showing two teeth and tongue. Mark: RELIABLE/MADE in CANADA. Original white blouse and yellow print jumper. Advertised as the doll that walks, stands, sleeps, sits, rolls her eyes, turns her head, and cries. Originally came with curlers. From the collection of June Rennie, Saskatoon, Sask.

BP16
Reliable. 1954. SOUVENIR DOLL. 10 in. (25.5 cm). Hard plastic body, jointed hips, and shoulders. Blue sleep side-glancing eyes; light brown moulded hair; open mouth. Mark: on back, Reliable (in script)/MADE IN CANADA. Dressed sometimes as a Mountie. From the collection of Betty Hutchinson, Ottawa, Ont.

BH18
Reliable. ca.1954. 19.5 in. (49.5 in). One piece Vinyl-flex body. Vinyl head; blue sleep eyes, lashes, painted lower lashes; rooted blond saran curly hair; closed mouth. Mark: on head, Reliable/1581. Original white dress and bonnet. From the collection of Rolande Strand, Eastern Passage, N.S.

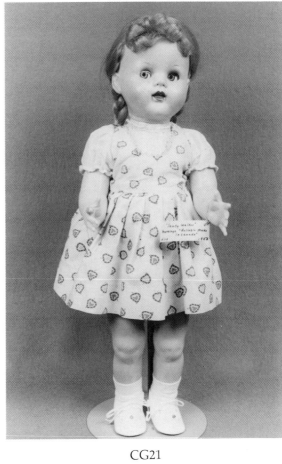

CG21

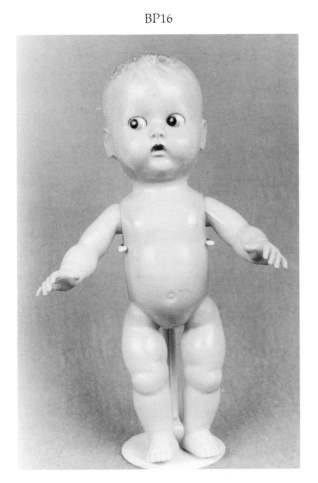

BP16

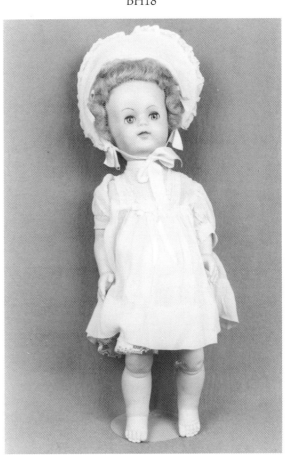

BH18

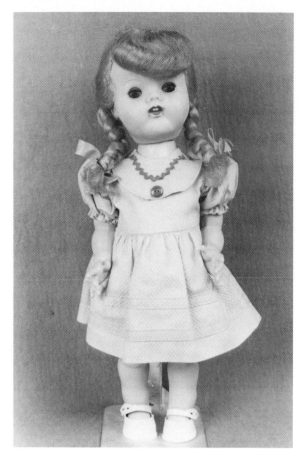

BX7

BX7
Reliable. 1954. SUSIE WALKER. 15 in. (38 cm). Hard plastic body, jointed hips, shoulders, and neck. Hard plastic head; brown sleep eyes, plastic lashes, painted lower lashes; blond wig in braids with bangs; open-closed mouth showing two moulded teeth. Mark: on back, Reliable (in script)/MADE IN CANADA. Original yellow and mauve dress, replaced shoes. From the collection of W. MacPherson, Mount Hope, Ont.

CE16
Reliable. 1955. SAUCY WALKER. 22 in. (56 cm). Plastic body, jointed hips, shoulders, and neck. Vinyl head; hazel sleep eyes, lashes, painted lower lashes; rooted blond curly hair; closed mouth. Mark: on head, 1391/Reliable (in script). Original dotted dress with black bodice and black rickrack trim, attached panties, shoes. Originally came with four curlers. From the collection of Roberta LaVerne Ortwein, Olds, Alta.

CE14
Reliable. 1955. MARGARET ANN. 20 in. (51 cm). One piece Vinyl-flex body. Vinyl head; blue sleep eyes, lashes, painted lower lashes; rooted blond saran hair; closed mouth. Mark: on head, 1481/RELIABLE (in script). Original white dress with hearts and diamond pattern in red, black bodice, matching hat, red shoes. From the collection of Roberta LaVerne Ortwein, Olds, Alta.

CE16

CE14

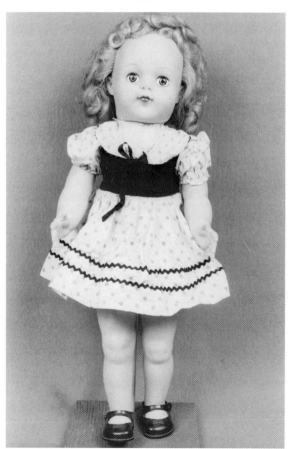

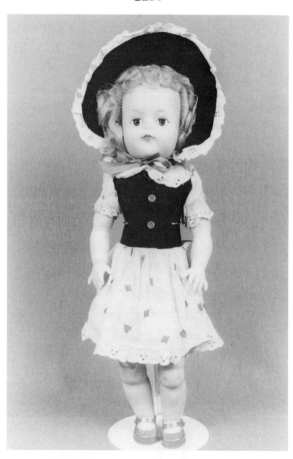

SL16
Reliable. 1955. HIAWATHA. 8 in. (20.5 cm). Hard plastic doll with jointed hips, shoulders, and neck. Hard plastic head; side-glancing black eyes; moulded hair; open mouth nurser. Mark: original Reliable label. Original clothing stapled to the doll; original felt bag. Courtesy of Peggy Bryan, Burnaby, B.C. See colour Fig. SL16.

AO4
Reliable. 1955. SUSIE STEPPS. 20 in. (51 cm). Hard plastic body, jointed hips, shoulders, and neck. Vinyl head; blue sleep eyes, lashes, painted lower lashes; rooted honey blond curls; closed mouth, mama voice. Mark: on head, 3/1568/Reliable/15; on back, Reliable (in script)/MADE IN CANADA. From the collection of Kathleen Pickering, Ottawa, Ont.

BC17
Reliable. 1956. GLAMOUR GIRL. 15 in. (38 cm). One piece Vinyl-flex body. Vinyl head; blue inset eyes, painted upper lashes; rooted blond hair; closed mouth. Mark: on back R-15X; on shoes, RELIABLE/950-O/MADE IN CANADA. Original blue and white print dress with white pinafore, socks and shoes. From the collection of Margaret Hayes, Musquodoboit Harbour, N.S.

AE8
Reliable. ca.1956. 25 in. (63.5 cm). Plastic body, jointed hips, shoulders, and neck. Vinyl head; blue sleep eyes, lashes, painted lower lashes; light brown moulded hair; open mouth nurser. Mark: on back, Reliable (in script). Childhood doll of Judy Smith, Ottawa, Ont.

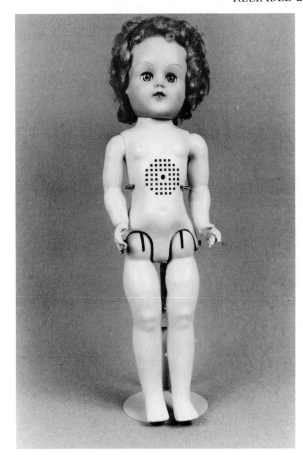

AO4

BC17

AE8

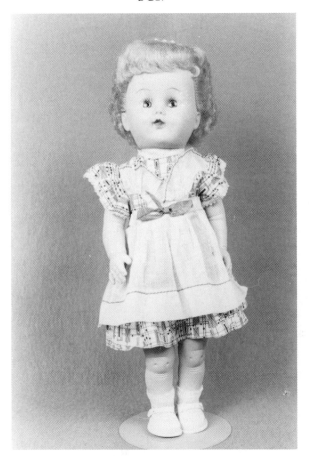

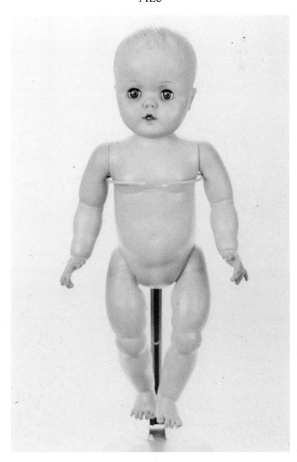

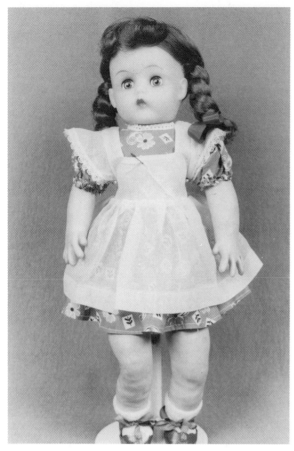

CF9

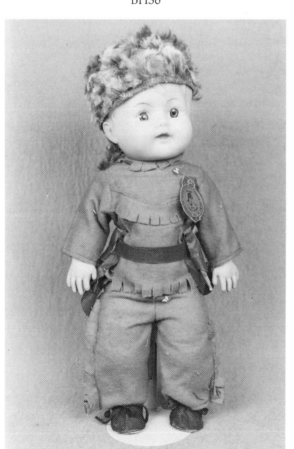

BH36

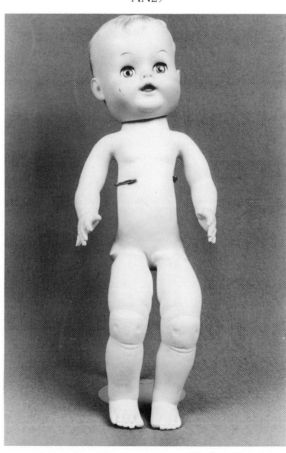

AN29

CF9
Reliable. 1956. MAGGIE MUGGINS. 16 in. (40.5 cm). One piece magic skin (stuffed latex) body. Vinyl head with freckles; blue sleep eyes, lashes, painted lower lashes; rooted red saran hair in pigtails with curly bangs; closed mouth. Mark: on head, RELIABLE. Original green print dress and white pinafore, shoes and socks. From the collection of Gloria Kallis, Drayton Valley, Alta.

BH36
Reliable. 1956. DAVY CROCKETT. 12 in. (30.5 cm). One piece magic skin (stuffed latex) body with coo voice. Vinyl head; plastic inset eyes; moulded hair; closed mouth. Mark: Original tag, MADE IN TORONTO, CANADA/by RELIABLE TOY CO. LIMITED./WALT DISNEY'S OFFICIAL DAVY CROCKETT. Original brown frontier suit complete with guns, simulated coonskin hat, simulated leather holsters, and black shoes. From the collection of Rebecca Douglass, Dartmouth, N.S.

AN29
Reliable. 1956. BABYKINS. 20 in. (51 cm). One piece Vinyl-flex body. Vinyl head; blue sleep eyes, lashes, painted lower lashes; brown moulded hair; open-closed mouth. Mark: on head, RELIABLE 1590. Originally wore a diaper. BABYKINS in this style was sold for several years. From the collection of Karen McCleave, Ottawa, Ont.

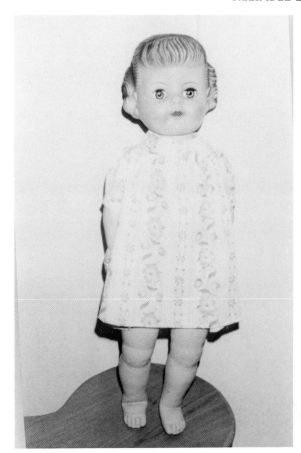

CT18
Reliable. 1957. BABY BUBBLES. 21 in. (53.5 cm). One-piece Vinyl-flex body with coo voice. Vinyl head ; blue sleep eyes, lashes; deeply moulded blond curls with bangs; closed mouth. Redressed. Originally wore a printed taffeta jumper dress trimmed with lace and an organdy blouse, knitted panties, white shoes and socks. Photograph courtesy of Glenda Shields. From the collection of Glenda Shields, London, Ont.

BP5
Reliable. 1957. SUSIE the WALKING DOLL. 9 in. (23 cm). Hard plastic body, jointed hips, shoulders, and neck. Hard plastic head; blue plastic sleep eyes, moulded lashes; blond wig; closed mouth. Mark: on back, Reliable (in script)/MADE IN CANADA. Original dress, replaced shoes. Some of the outfits available for SUSIE were nurse, bride, and lounging pyjamas. From the collection of Betty Hutchinson, Ottawa, Ont.

CF26
Reliable. 1957. BALLERINA DOLL. 20 in. (51 cm). Plastic body and legs, vinyl arms, jointed knees, hips, shoulders, and neck. Vinyl head; blue sleep eyes, lashes, painted lower lashes; rooted brown saran hair; closed mouth. Mark: on head, RELIABLE. Original red ballerina outfit, stockings, ballet slippers. From the collection of Gloria Kallis, Drayton Valley, Alta.

CT18

BP5

CF26

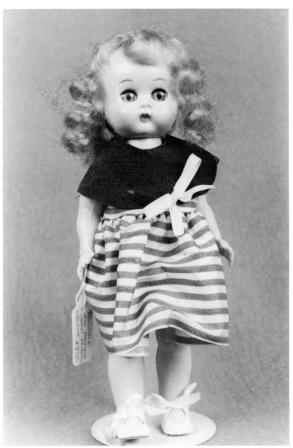

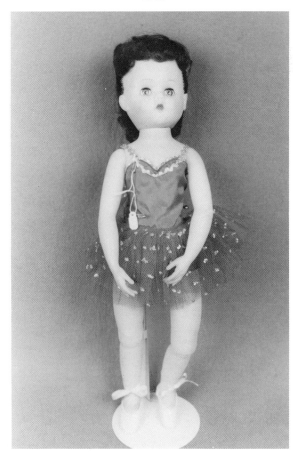

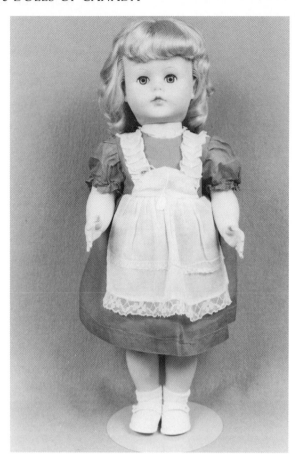

CF10

CF10
Reliable. 1957. POSIE. 23 in. (58.5 cm). Hard plastic body, jointed knees, hips, shoulders, and neck. Vinyl head; blue sleep eyes, lashes, painted lower lashes; rooted blond saran hair; closed mouth. Mark: on head and body, RELIABLE. Original pinafore dress, socks and shoes. Originally wore a straw bonnet and came with four curlers. From the collection of Gloria Kallis, Drayton, Valley, Alta.

BQ2
Reliable. 1957. TOPSY. 14 in. (35.5 cm). One piece Vinyl-flex body. Vinyl head; golden brown sleep eyes, lashes, painted lower lashes; rooted black saran curly hair; closed mouth. Original tag, TOPSY/RELIABLE/MADE IN CANADA. Original red and white dress, socks and shoes. Courtesy of the National Museums of Canada, National Museum of Man, Ottawa, Ont.

AM16
Reliable. 1957. BETSY WETSY. 14 in. (35.5 cm). Vinyl body, jointed hips, shoulders, and neck. Vinyl head; brown sleep eyes, lashes, painted lower lashes; rooted brown curly saran hair; open mouth nurser. Mark: on back, Reliable (in script)/12. Replaced socks and shoes. Originally came with a layette in a box or in a trunk. There was also a BETSY WETSY with moulded hair. Author's collection.

BQ2

AM16

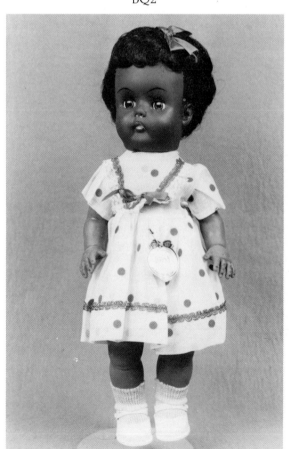

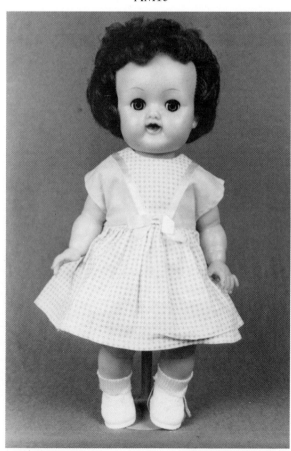

BU12
Reliable. 1957. SLEEPYHEAD. 14 in. (35.5 cm). One piece Vinyl-flex body. Vinyl head; inset plastic eyes, painted upper lashes; moulded hair; open-closed mouth. Mark: on head, Reliable (in script); on body, R-15X. Originally came in print sleepers. From the collection of Steven Miles and Dominique Lévesque, Ottawa, Ont.

BF6
Reliable. 1957. SUSIE the WALKING DOLL. 9 in. (23 cm). Hard plastic body, jointed hips, shoulders, and neck. Hard plastic head; blue sleep eyes, moulded lashes; honey blond wig; closed mouth. Mark: on back, RELIABLE. Original dress, shoes, and socks. Shoes are marked, RELIABLE N.000. From the collection of Margaret Hayes, Musquodoboit Harbour, N.S.

CO3
Reliable. 1957. SUSIE the WALKING DOLL. 9 in. (23 cm). Hard plastic body, jointed hips, shoulders, and neck. Hard plastic head; blue sleep eyes, moulded lashes; brown wig in braids; closed mouth. Mark: on back, RELIABLE. Original coat and hat. Many different outfits were available for SUSIE. From the collection of Diane Peck, Sudbury, Ont.

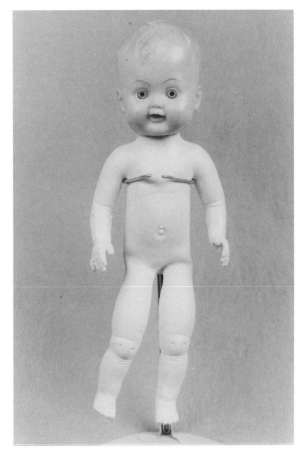

BU12

BF6

CO3

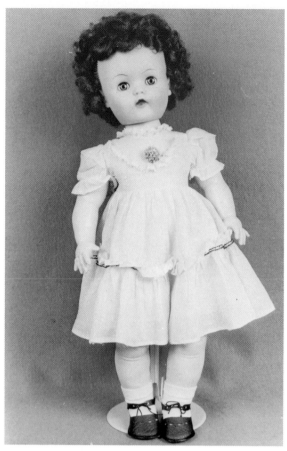

CR14

CO30

BM32

CR14
Reliable. 1957. MARY ANN. 23 in. (58.5 cm). One piece Vinyl-flex body. Vinyl head; blue sleep eyes, lashes, painted lower lashes; rooted brown curls; closed mouth. Mark: no mark on doll. Original pink dotted dress; replaced shoes and socks. Originally wore a matching straw poke bonnet and came in 14, 19, 21, 23 and 26 inch sizes. Author's collection.

CO30
Reliable. 1957. BABY TEAR DROPS. 11 in. (28 cm). Vinyl body, jointed hips, shoulders, and neck. Hard plastic head; blue sleep eyes, moulded lashes; brown moulded hair; open mouth nurser. Mark: on head, Reliable (in script)/7. Replaced clothing. Originallly came with a layette. From the collection of Margaret Lister of the Gallery of Dolls, Hornby, Ont.

BM32
Reliable. ca.1958. 7.5 in. (19.5 cm). Brown plastic baby, jointed hips and shoulders. Black side-glancing sleep eyes; moulded hair; closed mouth. Mark: on body, Reliable (in script)/MADE IN CANADA/Pat. Pend. Replaced clothing. From the collection of Irene Henderson, Winnipeg, Man.

BQ18
Reliable. 1958. MISS CANADA. 10.5 in. (26.5 cm). Hard plastic body and legs, vinyl arms, jointed hips, shoulders, and neck. Vinyl head with earrings; blue sleep eyes, moulded lashes; rooted brown hair; closed mouth. Mark: on head, P. Original box. MISS CANADA also came in 18, 20 and 25 inch sizes. She had many costumes available including nurse, bride, and evening gown with coat and hat. Courtesy of the National Museums of Canada, National Museum of Man, Ottawa, Ont.

BM31
Reliable. 1958. 8 in. (20.5 cm). Plastic body, jointed hips, shoulders, and neck. Plastic head; sleep eyes, moulded lashes; moulded hair; open mouth nurser. Mark: on body, Reliable (in script)/MADE IN CANADA/Pat. 1958. Replaced clothing. From the collection of Irene Henderson, Winnipeg, Man.

BU13
Reliable. 1958. JUDY BRIDESMAID. 17 in. (43 cm). One piece vinyl body. Vinyl head with earrings; blue sleep eyes, moulded lashes, painted lower lashes; rooted black saran curls; closed mouth. Mark: on head, RELIABLE. Original gown with net overskirt. From the collection of Steven Miles and Dominique Lévesque, Ottawa, Ont.

BQ18

BM31

BU13

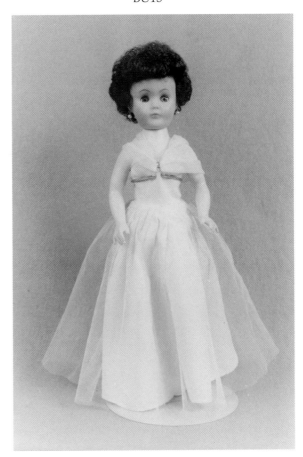

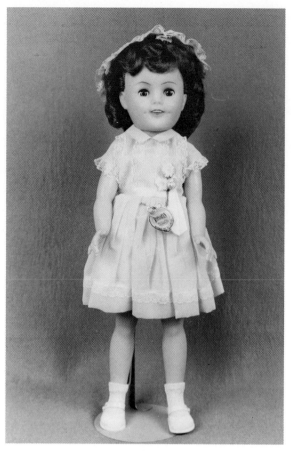

BQ19

BQ19
Reliable. 1958. ROSALYN. 18 in. (45.5 cm). Plastic body, jointed hips, shoulders, and neck. Vinyl head with dimples; brown sleep eyes, lashes, painted lower lashes; rooted brown saran hair in curls; open-closed smiling mouth showing teeth. Mark: on Head, RELIABLE. Original nylon and lace dress, matching hat, shoes and socks. Original tag. Courtesy of National Museums of Canada, National Museum of Man, Ottawa, Ont.

CT5
Reliable. 1958. BARBARA ANN. 20 in. (51 cm). Plastic teen body, jointed hips, waist, shoulders, and neck. Vinyl head; blue plastic sleep eyes, lashes, painted lower lashes; rooted black curls; closed mouth. Doll unmarked, original name tag. Original knitted striped sweater, red cotton skirt, crinoline, panties and high heels, pearl earrings. Author's collection.

BQ8
Reliable. 1958. TOPSY. 12 in. (30.5 cm). One piece vinyl body. Vinyl head with dimples; black painted side-glancing eyes, painted upper lashes; hair moulded in braids tied with ribbons; open-closed mouth. Mark: on head, RELIABLE. Original label. Original dress, moulded shoes and socks. Courtesy of the National Museums of Canada, National Museum of Man, Ottawa, Ont.

CT5

BQ8

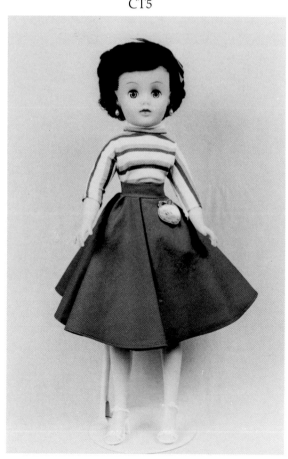

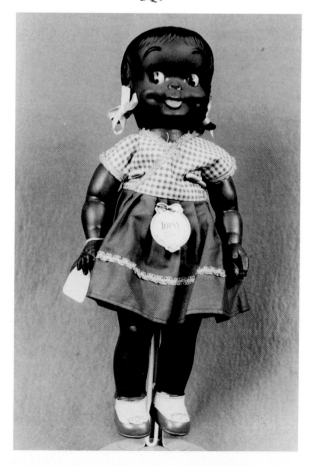

BM29
Reliable. ca.1959. PATSY. 9 in. (23 cm). Hard plastic body, jointed hips, shoulders, and neck. Hard plastic head; blue sleep eyes, moulded lashes; brown moulded hair; closed mouth. Mark: on back, Reliable (in script). Original box. Similar to PEGGY and SUSIE but without a wig. From the collection of Irene Henderson, Winnipeg, Man.

CL7
Reliable. 1959. PEGGY. 9 in. (23 cm). Hard plastic walker, jointed hips, shoulders, and neck. Hard plastic head; blue sleep eyes, moulded plastic lashes; honey blond saran wig in braids; closed mouth. Mark: on back, RELIABLE/MADE IN CANADA. Original sundress, matching hat, shoes and socks. PEGGY is the same doll as SUSIE but in 1959 she was called PEGGY. From the collection of Peggy Bryan, Burnaby, B.C.

CS8
Reliable. 1960. MISS CANADA. 18 in. (45.5 cm). Plastic teen body, jointed hips, shoulders, and neck. Vinyl head; blue sleep eyes, lashes, painted lower lashes; rooted auburn curls; closed mouth. Mark: on body, Reliable (in script)/CANADA. Replaced clothing in a close copy of the original by Georgee Prockiw. In 1960 MISS CANADA came in 10.5, 18, 20 and 25 inch sizes. Author's collection.

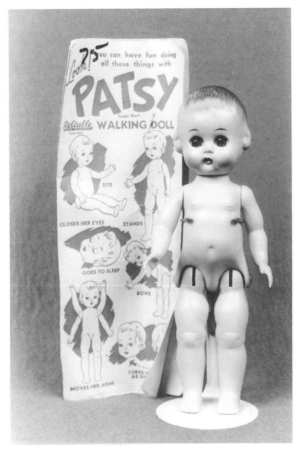

BM29

CL7

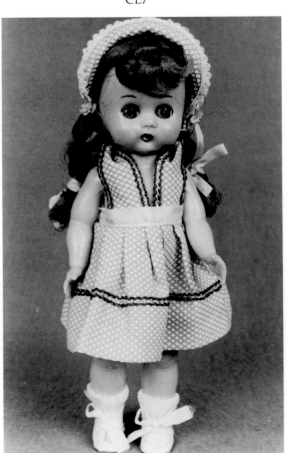

CS8

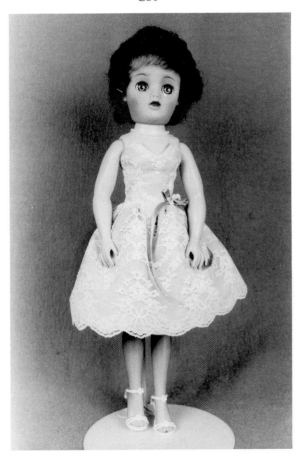

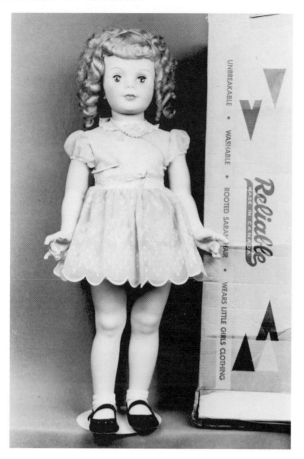

BH9

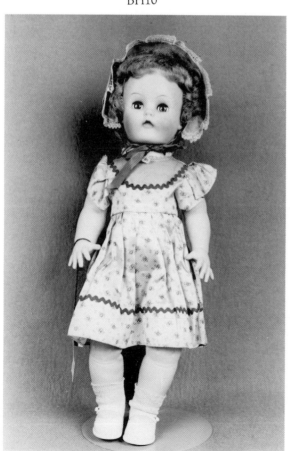

BH10

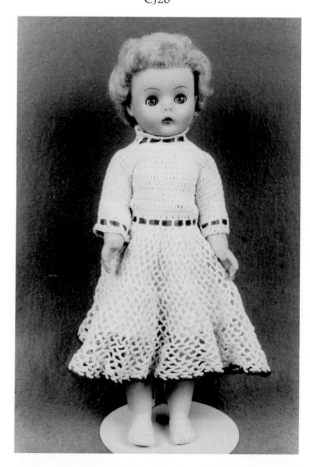

CJ26

BH9
Reliable. 1960. PATTY SUE PLAYMATE. 35 in. (89 cm). Plastic body, jointed hips, shoulders, and neck. Vinyl head; blue sleep eyes, lashes, painted lower lashes; rooted blond saran hair; closed mouth. Mark: no mark on doll. Original box, Reliable (in script)/MADE IN CANADA. Original nylon party dress, shoes and socks. PATTY SUE was also available in a jumper and blouse and in a plaid skirt and blazer in 1960. From the collection of Christine Mont, Eastern Passage, N.S.

BH10
Reliable. 1960. TICKLETOES. 18 in. (45.5 cm). One piece Vinyl-flex body. Vinyl head; blue sleep eyes, lashes, painted lower lashes; rooted blond saran hair; closed mouth. Mark: no mark on doll. Original tag, RELIABLE/MADE IN CANADA/VINYL FLEX/Has Added Play Value. Original pink floral taffeta dress with blue rickrack trim, matching bonnet, socks and shoes. From the collection of Donna Gardiner, Dartmouth, N.S.

CJ26
Reliable. 1960. BARBARA ANN. 16 in. (40.5 cm). Plastic body and legs, vinyl arms. Vinyl head; blue sleep eyes, lashes, painted lower lashes; rooted blond curly hair; open mouth nurser. Mark: Reliable (in script)/CANADA. Redressed. BARBARA ANN originally came in four different outfits including a coat and hat set. From the collection of Dianne Richards, Kenosee Lake, Sask.

BQ16
Reliable. 1960. LITTLE SISTER. 30 in. (76.5 cm). Plastic body, jointed hips, shoulders, and neck. Vinyl head; blue sleep eyes, lashes, painted lower lashes; rooted brown saran curls; closed mouth. Mark: on back, Reliable. Original print dress with organdy overskirt, socks and shoes. Courtesy of National Museums of Canada, National Museum of Man, Ottawa, Ont.

BN36
Reliable. ca.1960. GRENADIER GUARD. 16 in. (40.5 cm). Plastic body, jointed hips, shoulders, and neck. Vinyl head; blue sleep eyes, lashes, painted lower lashes; brown moulded hair; closed mouth. Mark: on back, Reliable (in script)/CANADA. Original uniform. From the collection of Irene Henderson, Winnipeg, Man.

BQ4
Reliable. ca.1960. SOUVENIR DOLL. 16 in. (40.5 cm). Plastic body and legs, vinyl arms, jointed hips, shoulders, and neck. Vinyl head; brown sleep eyes, lashes, painted lower lashes; rooted long black hair; closed mouth. Original tag, Reliable (in script) MADE IN CANADA/SOVENIR/OF CANADA. Original dress and headband. Courtesy of the National Museums of Canada, National Museum of Man, Ottawa, Ont.

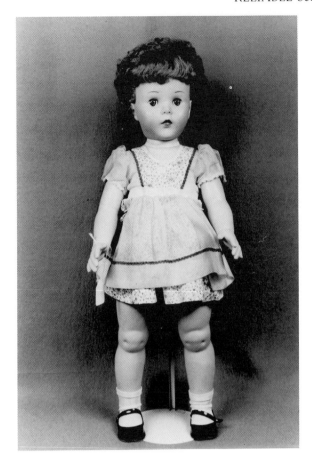

BQ16

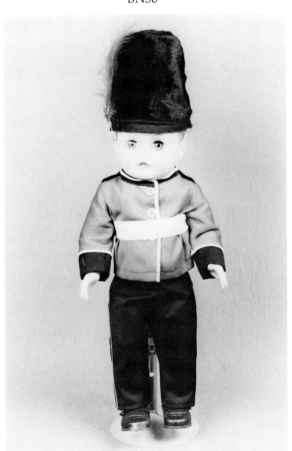

BN36

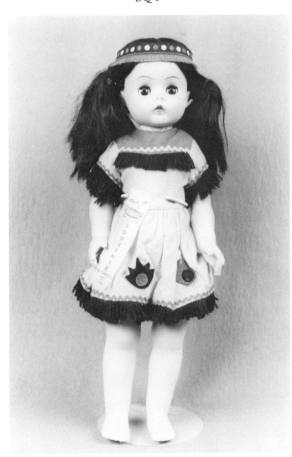

BQ4

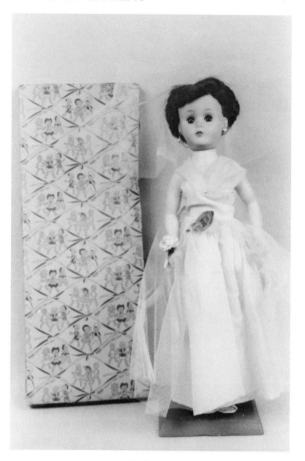

CW21A

CW21A
Reliable. 1960. BRIDE. 17 in. (43 cm). One piece Rigidsol body. Vinyl head; brown sleep eyes, lashes, painted lower lashes; rooted brown hair; closed mouth. Mark: on head, Reliable; on body, H-17. Original white taffeta gown with net overskirt and veil. Wearing earrings and carrying flowers. Original label and box. From the collection of Mr. and Mrs. C. Milbank, Sarnia, Ont.

CG30
Reliable. 1961. RELIABLE BOY. 12 in. (30.5 cm). One piece vinyl body. Vinyl head; black painted side-glancing eyes, painted upper lashes; brown moulded hair; open-closed mouth showing tongue. Mark: on head, 1/1104/RELIABLE/MADE IN CANADA. Original white cotton shirt, black bow tie, black and white shorts, moulded red shoes and white socks. From the collection of June Rennie, Saskatoon, Sask.

AT13
Reliable. 1961. WETUMS. 20 in. (51 cm). Brown plastic body and legs, vinyl arms, jointed hips, shoulders, and neck. Vinyl head; brown sleep eyes, lashes, painted lower lashes; black moulded hair; open mouth nurser. Mark: on body, Reliable (in script)/MADE IN CANADA. Originally dressed in undershirt and diaper and came with a plastic bottle. Author's collection.

CG30

AT13

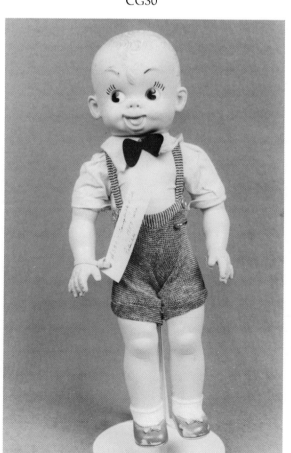

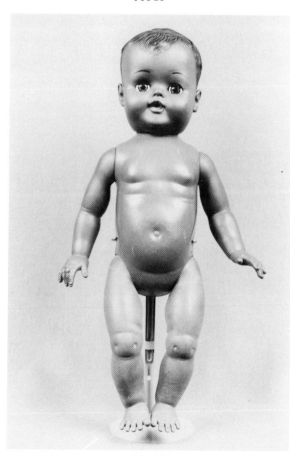

CM5
Reliable. 1961. RELIABLE GIRL. 12 in. (30.5 cm). One piece vinyl body. Vinyl head, dimples; black painted side-glancing eyes, painted upper lashes; yellow moulded hair in braids; open-closed mouth. Mark: on head, Reliable (in script). Original blue cotton dress; moulded red shoes and white socks. RELIABLE GIRL and BOY also came as black dolls in 1961. Author's collection.

CP17
Reliable. 1961. COLOURED NURSE WALKING DOLL. 30 in. (76.5 cm). Brown plastic body, jointed hips, shoulders, and neck. Vinyl head; brown sleep eyes, lashes, painted lower lashes; rooted black curls; closed mouth. Mark: on head, RELIABLE TOY/MADE IN CANADA. Redressed. Originally dressed in a white nurse's uniform with matching apron and cap. She carried a plastic infant doll wrapped in a flannelette blanket. Pinned to her uniform was an imitation pendant watch. From the collection of Ina Ritchie, Aurora, Ont.

CW12
Reliable. 1961. SAUCY WALKER. 35 in. (89 cm). Plastic body, jointed hips, shoulders, and neck. Vinyl head; blue sleep eyes, lashes, painted lower lashes; rooted auburn saran straight hair with bangs; closed mouth. Mark: on body, Reliable (in script). Replaced clothing similar to the original dress. The same doll was also called MARY ANNE in 1961. From the collection of Joyce Cummings, North Vancouver, B.C.

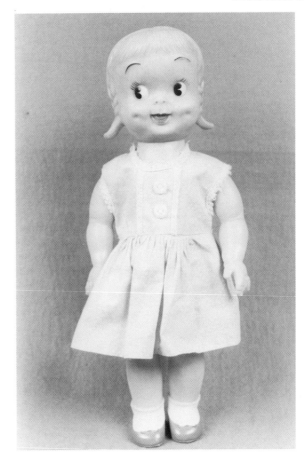

CM5

CP17

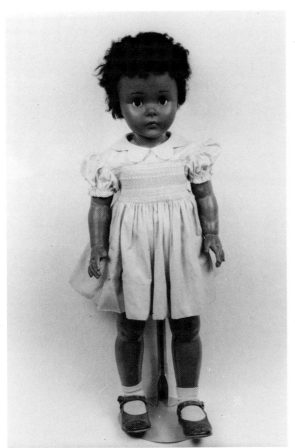

CW12

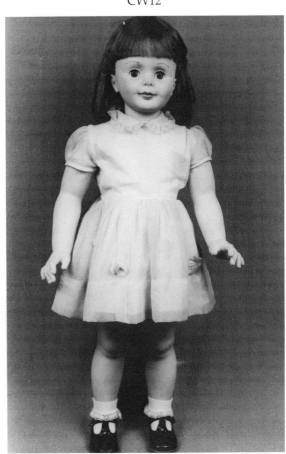

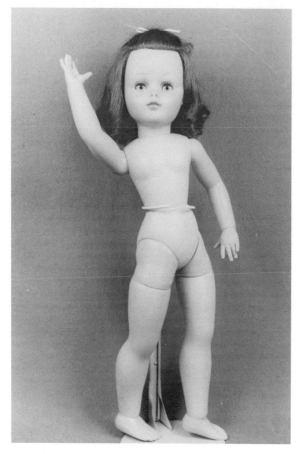

BY18

BY18
Reliable. 1961. LOUISA. 30 in. (76.5 cm). Plastic body, jointed waist, hip, shoulder, swivel-jointed upper leg, wrists and ankles. Vinyl head; blue sleep eyes, lashes, painted lower lashes; rooted red saran hair; closed mouth. Mark; no mark on doll. Original pink dress, print jumper, saddle shoes and socks. The revolutionary new doll with 1000 poses. Twelve separate and individual joints, head tilts and turns, hands rotate, feet tilt and rotate, arms swing, waist tilts and turns. Plus she has the Mona Lisa eyes that follow you. One of Reliable's finest dolls from a collector's viewpoint. Author's collection. See also Figs. CS21 and CS21A.

CS21

CS21A

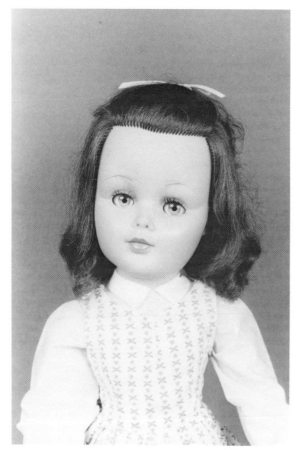

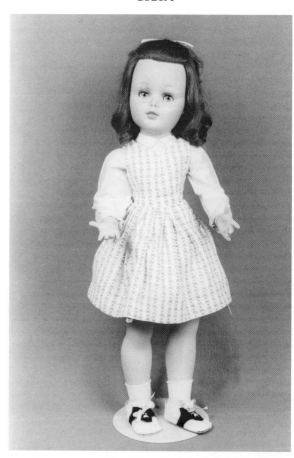

BQ13
Reliable. ca.1961. CINDY LOU. 14 in. (35.5 cm). Plastic body and legs, vinyl arms, jointed hips, shoulders, and neck. Vinyl head; blue sleep eyes, lashes, painted lower lashes; rooted brown saran hair in ponytail and bangs; closed mouth. Mark: on head, RELIABLE. Original tag, RELIABLE/CANADA'S FINEST/SINCE/1920. Original nylon dress, lace and ribbon trim. Courtesy of National Museums of Canada, National Museum of Man, Ottawa, Ont.

CY7
Reliable. ca.1961. LITTLE MISTER BAD BOY. 18 in. (45.5 cm). Plastic body, jointed hips, shoulders, and neck. Vinyl head; blue sleep eyes, lashes, painted lower lashes; moulded brown hair; closed mouth. Mark: on body. Reliable (in script). Original Bad Boy uniform and hat. Most Bad Boy dolls seem to be made by Pullan but the Bad Boy store must have had some made at Reliable as well, although this one does not have the usual Bad Boy label on the jacket. Author's collection.

CW2
Reliable. ca.1962. 19 in. (48.5 cm). Cloth body, vinyl bent-limb arms and legs, originally had a pull cord in the back of the body. Vinyl head; blue sleep eyes, lashes; rooted straight blond baby hair; open-closed mouth. Mark: on head, Reliable. This doll may be a 1962 version of TINY THUMBELINA. In 1963 she came in a 14 inch size and was dressed in a white nylon and lace dress. From the collection of Joyce Cummings, North Vancouver, B.C.

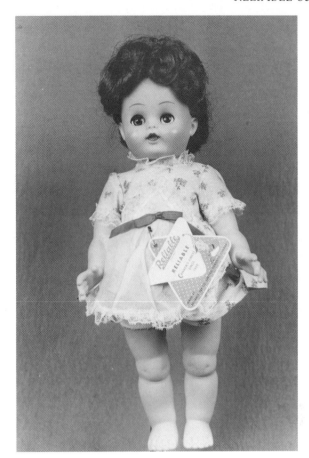

BQ13

CY7

CW2

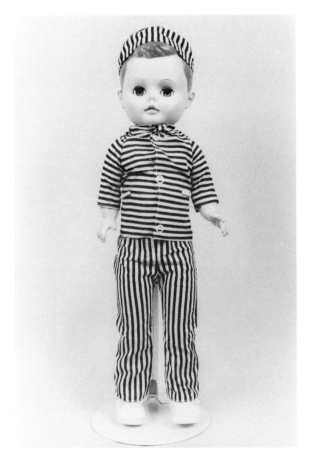

CW24

CW26

CG16

CW24
Reliable. ca.1962. 17 in. (43 cm). Plastic body, jointed hips, shoulders, and neck. Vinyl head; blue sleep eyes, lashes, painted lower lashes; rooted blond saran hair; open-closed mouth. Mark: on head, RELIABLE; on body, Reliable (in script). Original tag. Original pink and white print taffeta dress; socks and shoes. From the collection of Sylvia Higgins of the Remember When Museum, Laidlaw, B.C.

CW26
Reliable. ca.1962. 16 in. (40.5 cm). Plastic body, jointed hips, shoulders, and neck. Vinyl head; blue sleep eyes, lashes, painted lower lashes; rooted dark brown hair in twin pony tails and bangs; open-closed mouth. Mark: on head, RELIABLE; on body, Reliable (in script)/CANADA. Original yellow nylon dress, shoes and socks. From the collection of Sylvia Higgins of the Remember When Doll Museum, Laidlaw, B.C.

CG16
Reliable. ca.1962. 16 in. (40.5 cm). Plastic body, jointed hips, shoulders, and neck. Vinyl head; blue sleep eyes, lashes, painted lower lashes; black moulded hair; closed mouth. Mark: on body, Reliable (in script)/CANADA. Original cotton shirt, velvet shorts and plaid vest; black shoes. From the collection of June Rennie, Saskatoon, Sask.

CW20A
Reliable. 1963. DOCTOR TODDLER. 15.5 in. (39 cm). Plastic body, jointed hips, shoulders, and neck. Vinyl head; blue sleep eyes, lashes, painted lower lashes; black moulded hair; closed mouth. Mark: on body, Reliable (in script)/CANADA. Original white cotton medical costume with hat and mask. Includes doctor's plastic equipment. Original label and box. From the collection of Mr. and Mrs. C. Milbank, Sarnia, Ont.

BZ20
Reliable. 1963. MARY ANNE. 35 in. (89 cm). Plastic body, jointed hips, shoulders, and neck. Vinyl head; blue sleep eyes, lashes; rooted saran honey blond curls; closed mouth. Mark: on body, Reliable (in script). Original red cotton dress, white shoes. From the collection of Phyllis McOrmond, Victoria, BC.

BH30
Reliable. 1963. MARY,MARY QUITE CONTRARY. 18 in. (45.5 cm) Plastic body and legs, vinyl arms. Vinyl head; green sleep eyes, lashes, painted lower lashes; rooted blond saran hair; closed mouth. Mark: on head, RELIABLE/MADE IN/CANADA. Original orange dress with print underskirt. Originally wore flower trimmed lace hat and carried a basket of flowers. One of the Land of Make Believe series. From the collection of Crystal Anne Smith, Dartmouth, N.S.

CW20A

BZ20

BH30

XH22

CG24

BC21

XH22
Reliable. 1963. BARBARA ANNE, DRUM MAJORETTE. 15.5 in. (39 cm). Plastic body and legs, vinyl arms, jointed hips, shoulders, and neck. Vinyl head ; blue sleep eyes, lashes; rooted blond hair; closed mouth. Mark: on head, RELIABLE; on body, Reliable (in script)/CANADA. Original white and red cotton outfit, bodice has one red stripe and one blue stripe, hat has feather trim, black velveteen belt. White oilcloth boots with red trim. Originally had tassels on front of boots and carried a baton. From the collection of Gloria Kallis, Drayton, Valley, Alta.

CG24
Reliable. 1963. LITTLE MISS MUFFET. 18 in. (45.5 cm). Plastic body and legs, vinyl arms. Vinyl head; blue sleep eyes, lashes, painted lower lashes; rooted saran hair; closed mouth. Mark: on head, RELIABLE. Redressed. If that is her original cap, she is MISS MUFFET and wore a polka dotted dress and white apron with matching pantalettes. If not, her hairdo suggests she is MARY, MARY or TOMMY TUCKER, all of the Land of Make Believe series. From the collection of June Rennie, Saskatoon, Sask.

BC21
Reliable. 1963. RELIABLE GIRL. 14 in. (35.5 cm). Plastic body, jointed hips, shoulders, and neck. Vinyl head with bonnet moulded on the head; blue plastic fixed eyes, painted upper lashes; yellow moulded hair; open-closed mouth. Mark: on back, RELIABLE/CANADA. Redressed. Originally wore a tailored flannette coat with red trim and scarf. There was also a bonnet head black doll dressed the same. From the collection of Margaret Hayes, Musquodoboit Harbour, N.S.

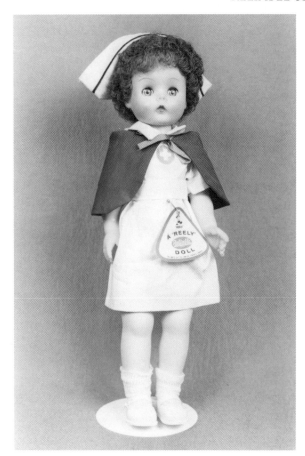

BH20
Reliable. 1963. BARBARA ANNE NURSE. 16 in. (40.5 cm). Plastic body, jointed hips, shoulders, and neck. Vinyl head; blue sleep eyes, lashes, painted lower lashes; rooted brown curls; closed mouth. Mark: on head, Reliable. Original nurse's uniform and cap, socks and shoes; original tag. BARBARA ANNE was also available dressed as a drum majorette and as a cheerleader. From the collection of Rolande Strand, Eastern Passage, N.S.

BP26
Reliable. 1963. 16 in. (40.5 cm). Brown plastic body, jointed hips, shoulders, and neck. Vinyl head; golden brown sleep eyes, lashes, painted lower lashes; rooted black curls; open mouth nurser. Mark: on head, Reliable (in script); on body, Reliable (in script)/CANADA. Redressed. Originally wore lace trimmed cotton print dress and came with a bottle. Author's collection.

CN22
Reliable. 1963. BABY CUDDLES. 20 in. (51 cm). Vinyl bent-limb body. Vinyl head; blue sleep eyes, lashes; rooted blond hair over moulded hair; open-closed mouth. Mark: on head, RELIABLE. Redressed. Originally wore matching print flannelette jacket and pants and came with a bottle. From the collection of Diane Peck, Sudbury, Ont.

BH20

BP26

CN22

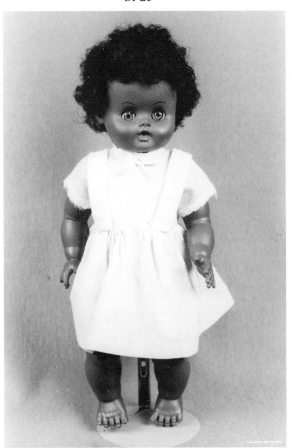

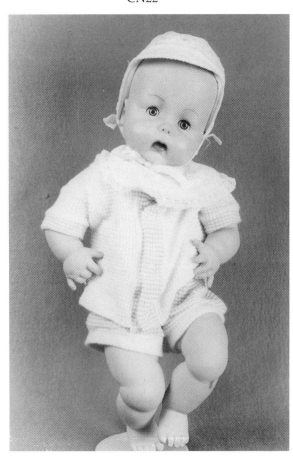

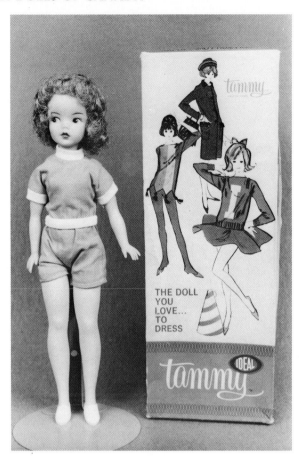

BN34

BN34
Reliable. 1964. TAMMY. 12 in. (30.5 cm). Plastic body, jointed hips, shoulders, and neck. Vinyl head; blue painted side-glancing eyes, painted upper lashes; rooted honey blond curls; closed mouth. Mark: on head, c. Ideal Toy Corp.; on back, RELIABLE/CANADA. Original shorts, top and sneakers. Original box. Many different outfits for all occasions were sold separately. TAMMY is the Canadian version of Ideal's TAMMY and was nationally televised. From the collection of Irene Henderson, Winnipeg, Man.

AO21
Reliable. 1965. RUTHIE. 18 in. (45.5 cm). Plastic body, jointed hips, shoulders, and neck. Vinyl head; blue sleep eyes, lashes, painted lower lashes; rooted honey blond hair; closed mouth. Mark: on head, Reliable (in script); on body, Reliable (in script). Original blue nylon dress and panties; replaced shoes and socks. Author's collection.

AN7
Reliable. ca.1966. 12 in. (30.5 cm). Plastic body, jointed hips, shoulders, and neck. Vinyl head; blue sleep eyes, lashes, painted lower lashes; brown moulded hair; open mouth nurser. Mark: on body, Reliable (in script)/CANADA. From the collection of Dorothy McCleave, Ottawa, Ont.

AO21

AN7

BC14
Reliable. 1966. SUSIE STEPPS. 21 in. (53.5 cm). Hard plastic body and legs, vinyl arms, jointed hips, shoulders, and neck. Body has a battery box with an on/off switch. Vinyl head; blue sleep eyes, lashes; rooted blond straight hair; closed mouth. Mark: RELIABLE/MADE IN CANADA. Original matching dress, coat and hat set with lace trimming. Replaced socks and boots. From the collection of Margaret Hayes, Musquodoboit Harbour, N.S.

CD21
Reliable. 1967. HONEY TODDLER. 14 in. (35.5 cm). Plastic body jointed hips, shoulders, and neck. Vinyl head; blue plastic sleep eyes, lashes; rooted auburn hair trimmed with black grosgrain ribbon; closed mouth. Mark: on back, Reliable (in script)/MADE IN CANADA. Original turquoise velvon dress with white lace trim and black bow, white lace tights and white shoes. Original box. From the collection of Florence Langstaff, North Vancouver, BC.

BN22
Reliable. 1967. TOPSY BABY. 1967. 16 in. (40.5 cm). Plastic body, jointed hips, shoulders, and neck. Vinyl head; brown plastic sleep eyes, lashes; rooted black straight hair; closed smiling mouth. Mark: on head, RELIABLE/MADE IN CANADA. Original striped dress; shoes and socks. From the collection of Sue Henderson, Winnipeg, Man.

BC14

CD21

BN22

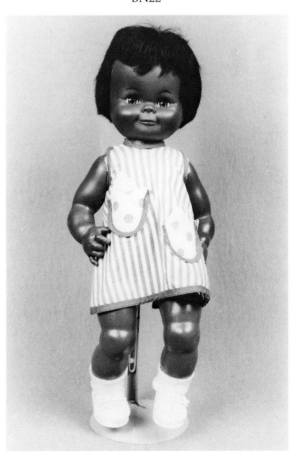

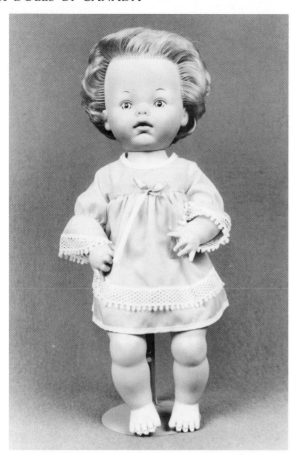

AN18

AN18
Reliable. 1968. 16 in. (40.5 cm). Plastic body, jointed hips, shoulders, and neck. Vinyl head; blue stencilled eyes; rooted blond hair; open mouth nurser. Mark: on head, RELIABLE TOY CO. LTD./19c68/MADE IN CANADA; on body, Reliable (in script)/CANADA. Original dress. From the collection of Lorraine Stuart, Ottawa, Ont.

AN24
Reliable. 1968. BABY LOVUMS. 16 in. (40.5 cm). Plastic body, jointed hips, shoulders, and neck. Vinyl head, with earrings; blue sleep eyes, lashes, painted lower lashes; rooted blond hair; open mouth nurser. Mark: on head, RELIABLE TOY CO. LTD./19c68/MADE IN CANADA. Originally dressed in a brushed lace dress and bonnet or a pastel dimity dress with brushed lace jacket and bonnet, both styles wore knitted bootees. From the collection of Karen McCleave, Ottawa, Ont.

AN11A
Reliable. ca.1969. RELIABLE BABY. 14 in. (35.5 cm). Plastic body, jointed hips, shoulders, and neck. Vinyl head; blue stencilled, side-glancing eyes; rooted honey blond curls; open mouth nurser. Mark: on head, O26914/RELIABLE TOY CO. LTD./19c69/MADE IN CANADA; on body, Reliable (in script)/CANADA. Originally came in two different A line cotton sleeveless dresses, one with lace and rickrack trim, and one with lace and ribbon trim. She wore white shoes and socks. From the collection of Dorothy McCleave, Ottawa, Ont.

AN24

AN11A

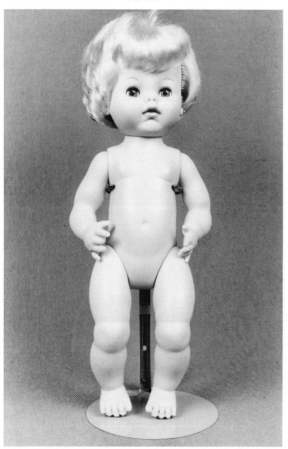

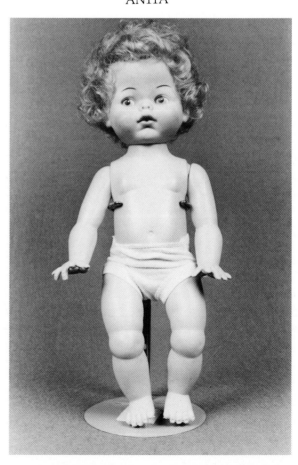

BJ24
Reliable. 1969. BABY PRECIOUS. 18 in. (46 cm). Cloth body, vinyl bent-limb arms and legs. Vinyl head; sleep eyes, lashes; rooted blond nylon curls; open-closed mouth. Mark: on head, RELIABLE/MADE. Original brushed lace dress, bonnet and bootees. Original tag. From the collection of Nora Moore, Fairvale, N.B.

BW1
Reliable. 1969. MARY ANNE WALKER. 30 in. (76.5 cm). Plastic body, jointed hips, shoulders, and neck. Vinyl head; blue sleep eyes, lashes, painted lower lashes; rooted blond hair; closed mouth. Mark: on head, Reliable (in script)/MADE IN CANADA. Replaced clothing. From the collection of Kirsten April Strahlendorf, Ottawa, Ont.

BN8
Reliable. 1969. LITTLE BROTHER. 16 in. (40.5 cm). Vinyl body, jointed hips, shoulders, and neck. Vinyl head; blue sleep eyes, lashes; rooted blond saran hair; open-closed mouth. Mark: on head, 2054/15 eye/10/RELIABLE TOY CO. LTD./c.1967/-MADE IN CANADA. There was also a LITTLE SISTER doll and they both came out in 1968 in 20 in. size. They were also available in a toter seat. From the collection of Irene Henderson, Winnipeg, Man.

BJ24

BW1

BN8

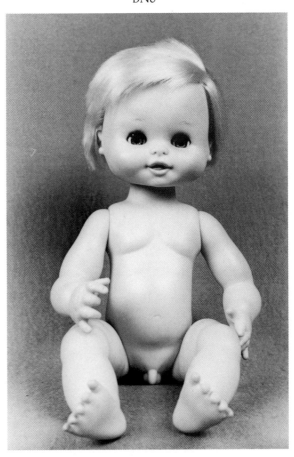

BX25

BX25
Reliable. 1969. BABY CUDDLES. 9 in. (23 cm). Plastic body, jointed hips, shoulders, and neck. Vinyl head; blue sleep eyes, lashes, three painted upper lashes; rooted blond saran curls; open mouth nurser. Mark: on head, RELIABLE TOY Co/19c69. Redressed. CUDDLES also came in 14 and 17 in. sizes. From the collection of Wilma MacPherson, Mount Hope, Ont.

CS13
Reliable. 1969. NICOLE. 16 in. (40.5 cm). Plastic body and legs, vinyl arms, jointed hips, shoulders, and neck. Vinyl head; blue sleep eyes, lashes, painted lower lashes; rooted brown straight hair; closed smiling mouth. Mark: on head, Reliable (in script); on body, Reliable (in script)/CANADA. Redressed. Author's collection.

CR11
Reliable. 1969. ROSALYN. 18 in. (45.5 cm). Plastic body, jointed hips, and shoulders. Vinyl head: blue sleep eyes, lashes, painted lower lashes; rooted blond curls with bangs; closed mouth. Mark: on head, 22/Reliable (in script); on body, Reliable (in script). Original dress, replaced socks and shoes. The same doll with the same dress was available in 1971 and was called RUTHIE the TODDLER. Author's collection.

CS13

CR11

CJ12
Reliable. ca.1970. 12 in. (30.5 cm). Plastic body, jointed hips, shoulders, and neck. Vinyl head; blue stencilled side-glancing eyes with black line over eye, four painted upper lashes; rooted blond hair; open-closed mouth. Mark: on head, RELIABLE. Original yellow dress, striped top. From the collection of Elva Boyce, Regina, Sask.

AN32
Reliable. ca.1974. CAROL WALKER. 24 in. (61 cm). Plastic body, jointed hips, shoulders, and neck. Vinyl head; blue sleep eyes, lashes, painted lower lashes; rooted blond curls; closed mouth. Mark: on body, Reliable (in script)/CANADA. Original clothing. From the collection of Dorothy McCleave, Ottawa, Ont.

CI13
Reliable. 1974. BLACK GLORIA. 16 in. (40.5 cm). Brown plastic body, jointed hips, shoulders, and neck. Vinyl head; brown stencilled eyes, black line over eye, painted upper lashes; rooted black curls; closed mouth. Mark: on head, RELIABLE TOY CO. LTD./MADE IN CANADA. Redressed. Originally wore multi-coloured long gown with long full sleeves gathered at the wrists. From the collection of Ruth MacAra, Caron, Sask.

CJ12

AN32

CI13

AN19

AN19
Reliable. 1974. GLORIA. 16 in. (40.5 cm). Plastic body, jointed hips, shoulders, and neck. Vinyl head; stencilled blue eyes, upper lashes; rooted blond curls; closed mouth. Mark: on head, RELIABLE TOY CO. LTD/MADE IN CANADA; on body, Reliable (in script)/CANADA. GLORIA came in a variety of outfits, long dresses, short dresses, and pant suits. From the collection of Dorothy McCleave, Ottawa, Ont.

CW29
Reliable. ca.1975. 18 in. (45.5 cm). Plastic body, jointed hips, shoulders, and neck. Vinyl head; blue sleep eyes, lashes, painted lower lashes; rooted blond curls; closed mouth. Mark: on body, Reliable (in script). Original gown with white apron, matching bonnet tied with yellow ribbon. From the collection of Sylvia Higgins of the Remember When Museum, Laidlaw, B.C.

AO11
Reliable. ca.1975. LORRIE WALKER. 32 in. (81.5 cm). Plastic body, jointed hips, shoulders, and neck. Vinyl head; blue sleep eyes, lashes, painted lower lashes; rooted black hair with bangs; closed mouth. Mark: on head, Reliable (in script)/MADE IN CANADA; on body, Reliable (in script)/CANADA. Original cotton print slacks and blouse. From the collection of Karen McCleave, Ottawa, Ont.

CW29

AO11

CG32
Reliable. ca.1975. BABY LOVUMS. 13 in. (33 cm). Plastic body, jointed hips, shoulders, and neck. Vinyl head; blue sleep eyes, lashes, painted lower lashes; rooted straight blond hair; open mouth nurser. Mark: RELIABLE TOY CO. LTD./10c00/MADE IN CANADA. Original lace dress and simulated fur hat. From the collection of June Rennie, Saskatoon, Sask.

CA7
Reliable. ca.1975. 16 in. (40.5 cm). Plastic body, jointed hips, shoulders, and neck. Vinyl head; black stencilled side- glancing eyes, painted upper lashes; black moulded tufts of hair; closed mouth. Mark: Reliable. Redressed. From the collection of Marilyn Kilby, Victoria, B.C.

AN22
Reliable. ca.1975. 16.5 in (42 cm). Plastic body, jointed hips, shoulders, and neck. Vinyl head; blue sleep eyes, lashes; rooted blond curls; open mouth nurser. Mark: on head, RELIABLE/MADE IN CANADA; on body, Reliable (in script)/CANADA. This doll was a special order made for the Eaton's company. From the collection of Karen McCleave, Ottawa, Ont.

CG32

CA7

AN22

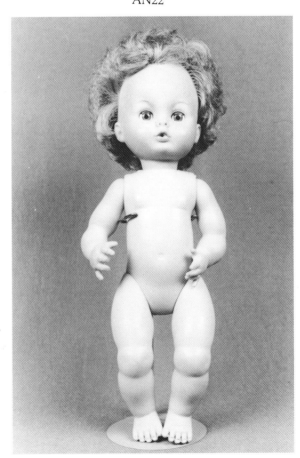

CJ28

CH2

BU30

CJ28
Reliable. ca.1976. 19 in. (48.5 cm). Plastic body, jointed hips, shoulders, and neck. Vinyl head; green sleep eyes, lashes, painted lower lashes; rooted brown curls; closed mouth. Mark: on head, RELIABLE. Original blue and white dress with red buttons and ribbons, lace trim replaced. From the collection of Dianne Richards, Kenosee Lake, Sask.

CH2
Reliable. ca.1976. CINDERELLA. 30 in. (76.5 cm). Plastic body, jointed hips, shoulders, and neck. Vinyl head; blue sleep eyes, lashes, painted lower lashes; rooted black curly hair with long hair on each side; closed mouth. Mark: on head, Reliable 9 in script)/MADE IN CANADA; on body, Reliable (in script)/CANADA; on shoe, Cinderella/no. 5. Original flocked pink gown trimmed in lace. From the collection of June Rennie, Saskatoon, Sask.

BU30
Reliable. 1978. INUIT DOLL. 12 in. (30.5 cm). Plastic body, jointed hips, shoulders, and neck. Vinyl head; black stencilled eyes, eye outlined in black; rooted straight black hair; open-closed mouth. Mark: on head, RELIABLE TOY CO. LTD./19c68/MADE IN CANADA. Original leather and fur suit, hood, and boots. Although the head was copyrighted in 1968 the doll was not bought until 1978. Moulds are used for a number of years. From the collection of Kirsten April Strahlendorf, Ottawa, Ont.

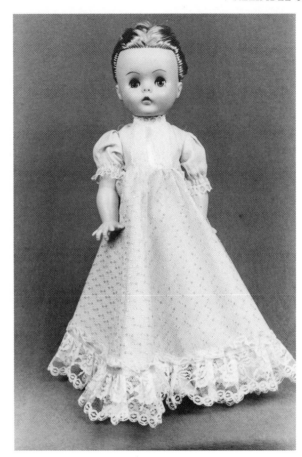

AN33
Reliable. ca.1978. 18 in. (45.5 cm). Plastic body, jointed hips, shoulders, and neck. Vinyl head; blue sleep eyes, lashes, painted lower lashes; rooted blond hair; closed mouth. Mark: on head 27/Reliable (in script); on body, Reliable (in script). Original gown with lace trim. From the collection of Karen McCleave, Ottawa, Ont.

CG27
Reliable. ca.1977. 13 in. (33 cm). Jointed hips, shoulders, and neck. Soft vinyl head; light brown moulded hair; stencilled eyes; open mouth nurser. Mark: Reliable (in script) Canada on body. Redressed. Courtesy of Mrs. June Rennie (Don), Saskatoon, Sask.

CG26
Reliable. ca.1980. 16 in. (40.5 cm). Plastic body, jointed hips, shoulders, and neck. Vinyl head; blue plastic sleep eyes, lashes, painted lower lashes; rooted blond hair; open mouth nurser. Mark: on head, Reliable (in script); on body, RELIABLE/CANADA. Redressed. From the collection of June Rennie, Saskatoon, Sask.

AN33

CG27

CG26

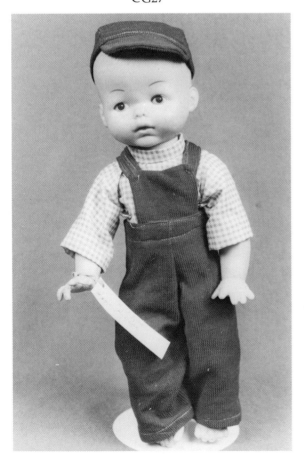

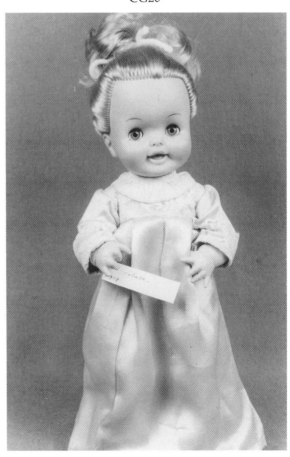

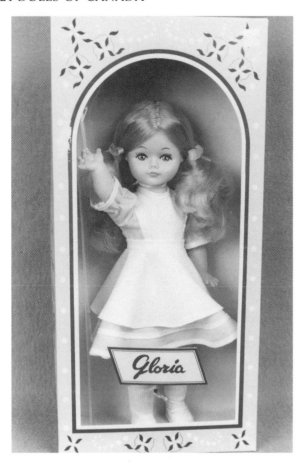

BX12

BX12
Reliable. ca.1983. GLORIA. 16 in. (40.5 cm). Plastic body, jointed hips, shoulders, and neck. Vinyl head; blue stencilled eyes, black upper lashes and upper eye liner; rooted blond hair tied at each side; closed mouth. Mark: Reliable. Original yellow and white dress, shoes and socks. Original box. From the collection of Wilma MacPherson, Mount Hope, Ont.

BU2
Reliable. 1984. CHUBBY. 21 in. (53.5 cm). Plastic body, vinyl arms and legs, jointed hips, shoulders, and neck. Vinyl head; blue plastic sleep eyes, lashes, painted lower lashes; rooted blond curls; open-closed mouth showing two moulded teeth. Mark: on head, RELIABLE/MADE IN CANADA. Original pink and white brushed nylon sleepers. Original box. From the collection of Kirsten April Strahlendorf, Ottawa, Ont.

AO18
Reliable. 1984. BALLERINA DOLL. 16 in. (40.5 cm). Plastic body, jointed hips, shoulders, and neck. Vinyl head; blue stencilled eyes with black upper lashes; rooted blond hair; closed mouth. Mark: on head, RELIABLE TOY CO. LTD./MADE IN CANADA; on back, Reliable (in script)/CANADA. Original ballet costume with white tights and ballet slippers. Author's collection.

BU2

AO18

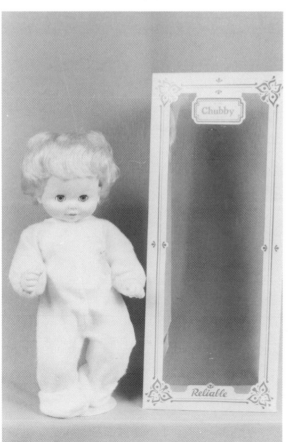

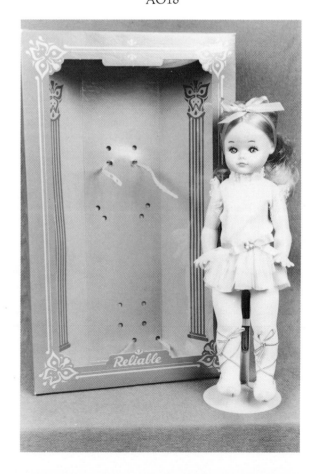

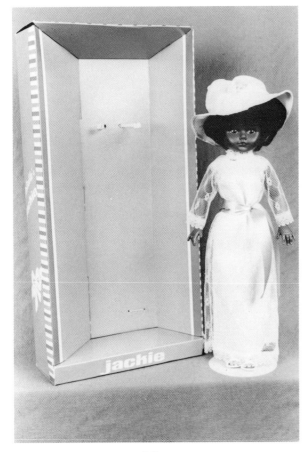

AO20

BW23

AO20
Reliable. 1984. JACKIE. 17 in. (43 cm). Plastic teen body, jointed hips, shoulders, and neck. Vinyl head; brown stencilled eyes with black upper lashes; rooted black curls; closed mouth. Mark: on head, 8/RELIABLE TOY CO LTD./MADE IN CANADA; on back, Reliable (in script)/CANADA. Original white lace gown, matching hat, high heel shoes. Author's collection.

BW23
Reliable. 1985. BRENDA. 17 in. (43 cm). Cloth body with crier, vinyl arms and legs. Vinyl head; blue plastic sleep eyes, lashes; light brown moulded hair; closed mouth. Mark: on head, RELIABLE/MADE IN CANADA. Original pink and white flannelette suit with matching bonnet. Author's collection.

BW24
Reliable. 1985. BABY LOVUMS. 15 in. (38 cm). Plastic body, vinyl arms and legs, jointed hips, shoulders, and neck. Vinyl head; blue plastic sleep eyes, lashes, painted lower lashes; rooted blond hair; open mouth nurser. Mark: on head, Reliable (in script); on body, Reliable (in script). Original pink and white fleecy snowsuit with hood. Original box. BABY LOVUMS came with her own stroller. Author's collection.

BW24

Standard Toys Ltd.

There were three companies called Standard Toys. The first one was established in 1917 and was located in Bowmanville, Ont. The second was in Alliston, Ont., in 1922, and the third was in Hamilton, Ont., in 1923.

The doll that we photographed, as shown in Fig. CN14, labelled Standard Quality Dolls inside a heart shaped trademark, was probably made in 1917 in Bowmanville. The construction of the body, the moulded boots and the style of dress, all indicate that this doll was made about that time. The doll itself is marked H.B.Co.

and was probaby made on contract for the Hudson's Bay Company to sell in their stores.

The doll was certainly made before 1920, and at that time the known manufacturers, Florentine and Dominion, did not use labels with a heart shaped trademark. Dominion's trademark was a shield, and Florentine dolls were usually clearly marked on the shoulderplate. Moreover, Florentine is not known to have made this style of body. It seems most likely that the doll was made in Bowmanville by Standard Toys Ltd.

CN14
Standard. ca.1917. 14.5 in. (36 cm). Excelsior stuffed cloth body, metal disc hip and shoulder joints. Composition head; blue painted eyes; moulded reddish-brown hair; closed mouth. Mark: on head, H.B.Co. ; label on dress, Standard Quality/Dolls/Made/in/Canada. Original blue and white cotton dress; original composition boots glued on. From the collection of Diane Peck, Sudbury, Ont. See also Fig. CN15.

CN14

CN15

Star Doll Manufacturing Company

A new doll company was formed in 1952 called Star Doll Manufacturing Co. Ltd. It was located at the same address as the defunct Freeman Toy at 41 Colbourne Street, Toronto, Ontario. Star Doll moved to 48 Abell Street a year later.

The first president of Star Doll was Joseph Fragale and the vice president was Frank Orefice. Both of these men were Americans. Mr. Fragale died in 1957 and Mr. Orefice became the president until 1960 when Harry Zigelstein, a Canadian, took over the presidency.

Star Dolls were never made of composition, for that era was almost over in 1952. All their dolls were made of blow moulded plastic or rotational moulded vinyl.

Some Star Dolls had original heads designed in Canada, and occasionally the moulds for these heads were made here as well.[1] Although we have found a number of dolls marked Star Doll, or Star, many of their dolls were unmarked.

Star Doll went out of business in 1970 as did a number of doll companies during this period. Doll making is a highly competitive business and the market is extremely fickle. A doll that is popular one year may be unsaleable the next year. Goodtime Toys founded a new company immediately after the demise of Star Doll Manufacturing Co. Ltd., and operated in the same premises. Goodtime Toys did not buy the Star Doll Company but may have bought some of the assets.

1. Harry Zigelstein. Personal communication.

XH21
Star Doll. ca.1957. 17 in. (43 cm). One piece stuffed vinyl body. Vinyl head ; green sleep eyes, lashes, painted lower lashes; rooted honey blond hair; closed mouth. Mark: on head, 14R ; on body, A. Original box marked, Star Doll Co. 7182. Original white satin and net wedding gown and hat with veil, trimmed with silver and white lace. Pearl drop earrings, white panties, white hi-heels. Carries bouquet of white flowers. From the collection of Gloria Kallis, Drayton Valley, Alta.

BQ7
Star Doll. ca.1960. 16 in. (40.5 cm). Plastic body, jointed hips, shoulders, and neck. Vinyl head; blue sleep eyes, lashes, painted lower lashes; rooted blond hair; open mouth nurser. Mark: on head, STAR. Original diaper and label. Courtesy of National Museums of Canada, National Museum of Man, Ottawa, Ont.

XH21

BQ7

BF7
Star Doll. 1961. 20.5 in. (52 cm). Cloth body, vinyl bent-limb arms and legs. Vinyl head; blue sleep eyes, lashes; rooted honey blond hair; open-closed mouth. Mark: on head, Plated Moulds Inc./c1961.; tag sewn into body, Made by/Star-Doll Mfg. Co. Ltd./Toronto Canada. Redressed. From the collection of Margaret Hayes, Musquodoboit Harbour, N.S.

AN25
Star Doll. 1962. 17 in. (43 cm). Plastic body, jointed hips, shoulders, and neck. Vinyl head; blue sleep eyes, lashes, painted lower lashes; rooted blond hair; closed mouth. Mark: on head, STAR DOLL. From the collection of Karen McCleave, Ottawa, Ont.

CO16
Star Doll. ca.1963. 18 in. (45.5 cm). Plastic body, jointed hips, shoulders, and neck. Vinyl head; blue sleep eyes, lashes, painted lower lashes; rooted light brown curls; closed mouth. Mark: on head, STAR DOLL. Original mauve skirt and print top dress. From the collection of Margaret Lister, Gallery of Dolls, Hornby, Ont.

BF7

AN25

CO16

CG18
Star Doll. ca.1963. 19 in. (48.5 cm). Plastic body, jointed hips, shoulders, and neck. Vinyl head; blue sleep eyes, lashes; rooted blond hair; closed mouth. Mark: on head, STARDOLL/MADE IN CANADA; on body, STAR DOLL. Redressed. From the collection of June Rennie, Saskatoon, Sask.

BL12
Star Doll. 1965. 24 in. (61 cm). Plastic body, jointed hips, shoulders, and neck. Vinyl head; blue sleep eyes, lashes; rooted dark brown long hair; closed mouth. Mark: on head, STAR DOLL/1965. Redressed. From the collection of Nell Walsh, Saint John, N.B.

AN26
Star Doll. 1965. 23 in. (58.5 cm). Plastic body, jointed hips, shoulders, and neck. Vinyl head; blue sleep eyes, lashes, painted lower lashes; rooted blond hair with bangs; closed mouth. Mark: on head, STAR DOLL/c1965 CANADA. Original dress. From the collection of Connie McCleave, Ottawa, Ont.

CG18

BL12

AN26

CI5
Star Doll. 1965. 24 in. (61 cm). Plastic body, jointed hips, shoulders, and neck. Vinyl head; blue sleep eyes, lashes, painted lower lashes; rooted brown hair in a pony tail; closed mouth. Mark: on head, STAR DOLL/c1965 CANADA. Original red print jumper and white blouse. From the collection of Ruth MacAra, Caron, Sask.

CG28
Star Doll. 1967. 18 in. (45.5 cm). Cloth body, vinyl bent-limb arms and legs. Vinyl head; blue sleep eyes, lashes; rooted auburn hair; closed mouth. Mark: STAR DOLL/MADE IN CANADA. Redressed. From the collection of June Rennie, Saskatoon, Sask.

AN8
Star Doll. 1968. 14 in. (35.5 cm). Plastic body, jointed hips, shoulders, and neck. Vinyl head; blue sleep eyes, lashes, painted lower lashes; rooted platinum curls; closed mouth. Mark: on head, STAR DOLL; on body, 13 G. From the collection of Dorothy McCleave, Ottawa, Ont.

CI5

CG28

AN8

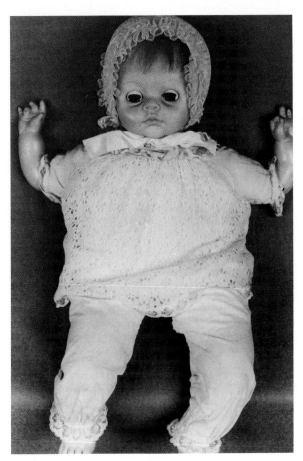

CW15

CW15
Star Doll. ca.1969. Cloth body, vinyl bent-limb arms and legs. Vinyl head; blue plastic sleep eyes, lashes, painted lower lashes; rooted straight blond hair; closed mouth. Mark: on head, STAR DOLL/MADE IN CANADA. Original white cotton lace dress, long pants, and matching bonnet. From the collection of Joyce Cummings, North Vancouver, B.C.

AE13

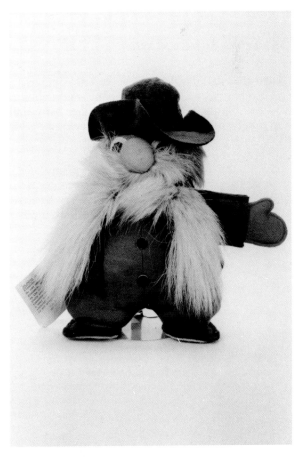

Studio Kuuskoski

Studio Kuuskoski is a small family business in Toronto, Ontario, run by Minna Kuuskoski, her mother Helena, and her brother Johannes. The family emigrated in 1973 from Finland where they had operated a troll manufacturing business.

The company produces over 100 different trolls which are made of felt and stuffed. Each troll comes with its own name and a story. Children may write to the troll of their choice and expect an answer in return.

After a slow start, business picked up in 1985 and the trolls are now sold in department stores. The Kuuskoskis feel the trolls are magic and hope someday to have the business expand to the point when they can build a troll theme park for children.

AE13
Studio Kuuskoski. 1977. GOLDNOSE. 12.5 in. (32 cm). Stuffed felt body. Felt eyes and nose; horse hair whiskers and hair. Felt hands, feet, and hat. Mark: label, GOLDNOSE by Studio Kuuskoski. From the collection of Judy Smith, Ottawa, Ont.

TE-RI Products

Te-Ri Products are located in Scarborough, Ontario, and have been in business since 1972. The company is owned by two Canadian partners, Ritva Penttila and Ted Ratcliffe. They produce a line of whimsical felt stuffed dolls to represent a variety of characters such as Royal Canadian Mounted Police, sportsmen, sailors, etc. They are handcrafted, well made dolls that come in approximately sixty styles. The Fufel Collection, as the dolls are called, are created in Canada by Finnish doll designer Eila Lamminen. They are sold all across the country and are available in many department stores.

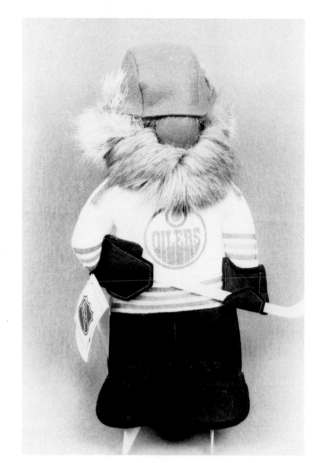

CM3
Te-Ri. 1985. HOCKEY PLAYER. With skates: 17 in. (43 cm). One-piece cloth body and head. Felt clothing is part of body, very large feet with plastic skate blades attached. Black felt eyes, red felt nose, hair and beard are reindeer fur. Mark: label, Fufel Doll collection/Te-Ri Products Ltd. ; 2nd label, Official licensed product/NHL/National Hockey League. Felt helmet, carries plastic hockey stick. Designed by Eila. Author's collection.

CM3

CQ11

Tilco International Incorp.

Tilco International Inc. is the parent company of Tilley Toy of St. Jean, Qué. The company was established in 1940 but did not begin producing rubber baby dolls till the mid-forties. They made both black and white dolls.[1]

Late in the nineteen-fifties, the company began manufacturing vinyl baby dolls which they continued to make till the late seventies. Some of the dolls were made with moulded clothing. Most were small baby dolls.

1. James Law. personal communication.

CQ11
Tilco. ca.1958. 10 in. (25.5 cm). One piece brown vinyl body. Black painted eyes, black moulded hair, open-closed mouth. Courtesy of Bowmanville Museum, Bowmanville, Ont.

BX18
Tilco. ca.1965. 6.5 in. (17 cm). One piece soft vinyl. Black painted side-glancing eyes, moulded blond hair, open-closed mouth. Mark: on back, TILLY TOY/MADE IN CANADA. Moulded nurses uniform; moulded baby in her arms. From the collection of Wilma MacPherson, Mount Hope, Ont.

BX18

Valentine Doll Company

The Valentine Doll Company of Toronto, Ontario, produced plastic dolls between 1949 and 1959 before the company was bought by the newly formed Regal Toy Company.[1]

Ann and Oscar Doster owned Valentine. Ann Doster designed most of their dolls. It is believed that they marked some of their dolls with a small v, but most were probably unmarked.

1. Ben Samuels. Personal communication.

Viceroy Manufacturing Company Limited

Viceroy Manufacturing Co. Ltd. has been in business since 1935 making a variety of rubber items. During the late nineteen-forties, Viceroy began making rubber baby dolls, and during the nineteen-fifties they made both rubber and soft vinyl dolls.

Viceroy is probably most noted for the GERBER BABY doll which they produced in the nineteen-fifties. After a lapse in doll making for some years, the company, which is now called Viceroy Rubber and Plastics Ltd., bought the Reliable Toy Company in Toronto and is back into the production of dolls. The president of the company is Ronald Bruhm.

BX24

CH6

BX24
Viceroy. ca.1950. BETTY BOWS. 11.5 in. (29.5 cm). All rubber bent-limb baby body, jointed hips, shoulders, and neck. Rubber head; sleep eyes, lashes; moulded hair with a curl on top; open-mouth nurser. Mark: A VICEROY/SUNRUCO DOLL/MADE IN CANADA/PATENT PENDING. From the collection of Wilma MacPherson, Mount Hope, Ont.

CH6
Viceroy. ca.1952. RONNY. 7 in. (17 cm). One piece rubber body and head. Blue painted side-glancing eyes; moulded hair; open-closed mouth. Mark: Ronny/c.Ruth E. Newton/VICEROY/MADE IN CANADA/3. Moulded clothing. From the collection of June Rennie, Saskatoon, Sask.

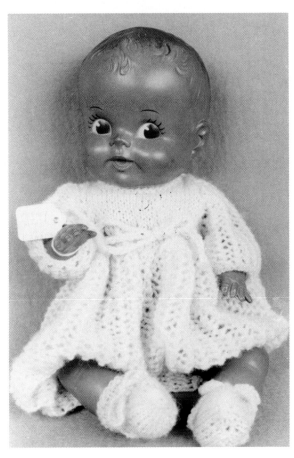

CL29

CL29
Viceroy. ca.1952. 12 in. (30.5 cm). Brown all rubber bent-limb baby body, jointed hips, shoulders, and neck. Brown rubber head; black painted side-glancing eyes, painted upper lashes; black moulded hair; open-mouth nurser. Mark: on body, A VICEROY/SUNRUCO DOLL/MADE IN CANADA/PATENT PENDING. Redressed. From the collection of Berna Gooch, North Vancouver, B.C.

CH3
Viceroy. 1953. TOD-L-TIM. 10 in. (25.5 cm). One piece rubber body and head. Inset blue eyes; black moulded hair; closed mouth. Mark: on foot, Tod-L-Tim/Sun Rubber Co./Made in Canada/by Viceroy. Moulded underwear, socks and shoes. From the collection of June Rennie, Saskatoon, Sask.

CH4
Viceroy. 1953. TOD-L-DEE. 10 in. (25.5 cm). One piece rubber body and head. Inset brown eyes; brown moulded hair; closed mouth. Mark: on foot, Tod-L-Dee/Sun Rubber Co./Made in Canada by Viceroy. Moulded underwear, socks, and shoes. From the collection of June Rennie, Saskatoon, Sask.

CH3

CH4

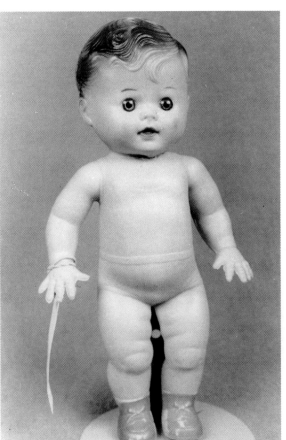

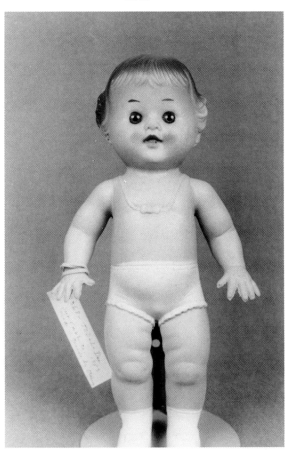

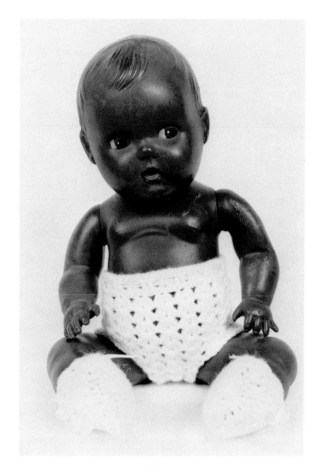

AZ3
Viceroy. ca.1954. 11 in. (28 cm). Brown all rubber bent-limb baby body, jointed hips, shoulders, and neck. Brown rubber head; brown painted side-glancing eyes; black moulded hair; open-mouth nurser. Mark: on body, A VICEROY/SUNRUCO DOLL/MADE IN CANADA/PATENT PENDING. Redressed in crocheted pants and bootees. From the collection of Mrs. D. Steele, Ottawa, Ont.

CL4
Viceroy. ca.1954. 11 in. (28 cm). All rubber bent-limb baby body, jointed hips, shoulders, and neck. Rubber head; blue painted eyes, painted upper lashes; brown moulded hair; open-closed mouth. Mark: on body, A VICEROY/SUNRUCO DOLL/MADE IN CANADA/PATENT PENDING. From the collection of Peggy Bryan, Burnaby, B.C.

BX19
Viceroy. ca.1955. 7.5 in. (18 cm). One piece vinyl body and head. Black side-glancing eyes; black moulded hair; open-closed mouth. Mark: on feet, VICEROY/MADE IN CANADA. Moulded snowsuit, hood, and boots. From the collection of Wilma MacPherson, Mount Hope, Ont.

AZ3

CL4

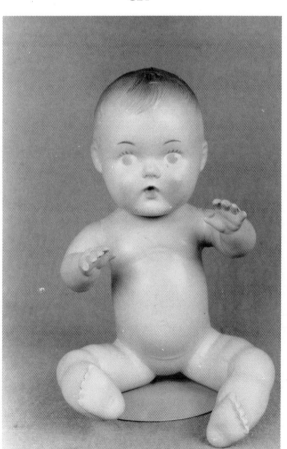

BX19

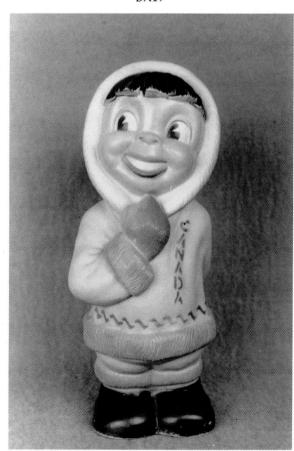

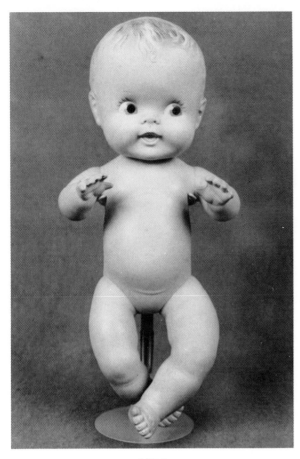

AB28

AB28
Viceroy. 1955. 12 in. (30.5 cm). All rubber bent-limb baby body, jointed hips, shoulders, and neck. Rubber head; blue painted side-glancing eyes, painted upper lashes; brown moulded hair; open mouth nurser. Mark: on body, A VICEROY/SUNRUCO DOLL/MADE IN CANADA/PATENT PENDING. Author's collection.

BX22
Viceroy. ca.1956. 11.5 in. (29.5 cm). All rubber bent-limb baby, jointed hips, shoulders, and neck. Rubber head; inset blue eyes, painted upper lashes; brown moulded hair; open-mouth nurser. Mark: on body, A VICEROY/SUNRUCO DOLL/MADE IN CANADA. From the collection of Wilma MacPherson, Mount Hope, Ont.

BX21
Viceroy. ca.1956. 12 in. (30.5 cm). All rubber bent-limb baby body, jointed hips, shoulders, and neck. Rubber head; sleep eyes, lashes, painted lower lashes; brown moulded hair; open-mouth nurser. Mark: on head, W/VICEROY/MADE IN CANADA. From the collection of Wilma MacPherson, Mount Hope, Ont.

BX22

BX21

Wis-Ton Toy Mfg. Co. Ltd.

The Wis-Ton Toy Mfg. company was established at 48 Abell Street Toronto, in 1982. It is owned by partners Mr. Sam Manganaro and Mr. Harry Hollander. Mr. Manganaro worked for Regal Toy Co. for many years gaining his expertise in the doll business.

Wis-Ton is producing every variety of doll from baby dolls to plush dolls and walking dolls. Only the eyes and hair are imported, everything else is produced in Toronto. Wis-Ton also makes their own moulds for dolls designed in Canada.

The Wis-Ton dolls have lovely colouring in their faces and the clothing is very well made. The company name on the boxes is rather inconspicuous and it is necessary to search to find the Wis-Ton dolls. It is, however, well worth the effort.

CY11

CY13
Wis-Ton. 1986. MANDY. 32 in. (81.5 cm). Plastic body, jointed hips, shoulders, and neck. Vinyl head; brown sleep eyes, lashes, painted lower lashes; rooted long streaked brown hair with bangs; closed mouth. Mark: on head, c CANADA/33W. Original red suede long dress trimmed with lace, lace sleeves and bib front (buttons down the back). Author's collection.

CY11
Wis-Ton. 1986. BABY CUDDLE-SOFT. 17 in. (43 cm). Cloth body with vinyl bent-limb arms and legs. Vinyl head; blue sleep eyes, lashes; rooted blond curls; open-closed mouth. Mark: on head, STAR DOLL/MADE IN CANADA. label on body, MADE BY WIS-TON MFG. Original pink dress and panties. Author's collection. Wis-Ton has obviously purchased some of Star Dolls moulds.

CY12
Wis-Ton. 1986. WENDY WALKER. 26 in. (66 cm). Plastic body, jointed hips, shoulders and neck. Vinyl head; brown sleep eyes, lashes, painted lower lashes, eyeshadow; rooted strawberry blond curls; closed mouth. Mark: on head, c CANADA/26W. Original lace trimmed cotton dress (open down the back for ease in dressing), panties, socks and shoes. Includes her own comb and brush. Author's collection.

CY13

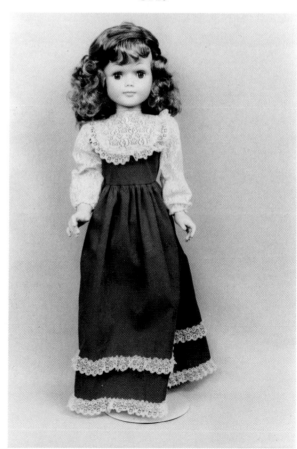

CY12

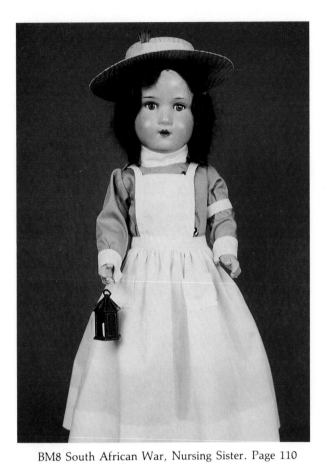

BM8 South African War, Nursing Sister. Page 110

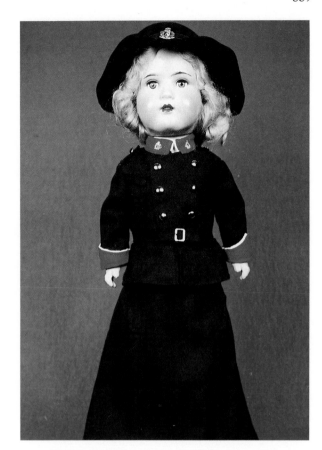

BM9 World War I, Nursing Sister. Page 110

BM10 World War II. Navy. Page 110.

BM11 World War II. Airforce. Page 110.

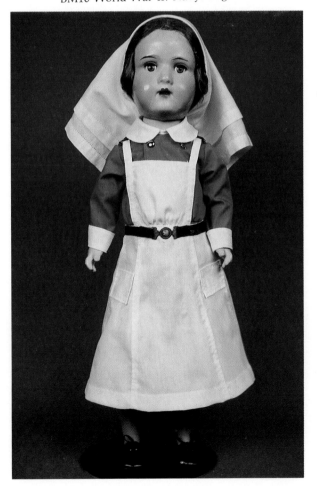

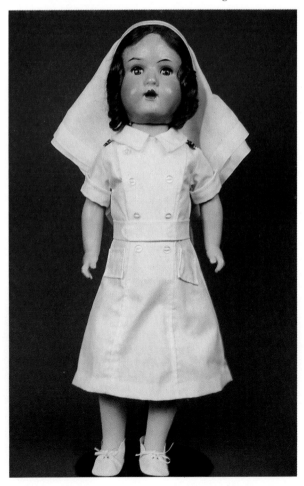

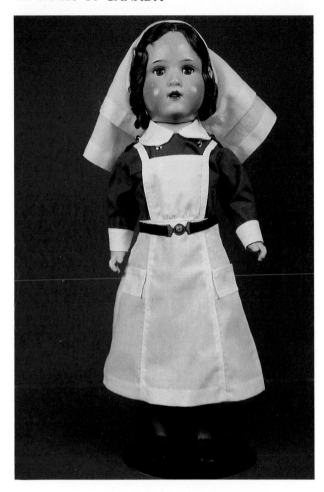

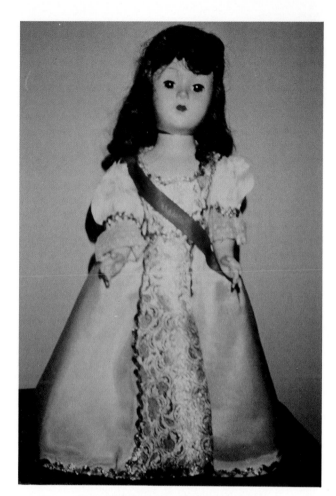

BM12 World War II. Army. Page 110.

SL14 CORONATION DOLL. Page 293

SL15 DOPEY. Page 265

SL16 HIAWATHA. Page 295.

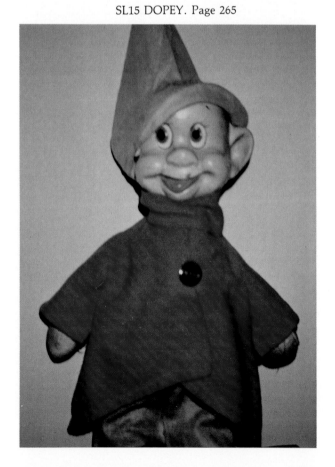

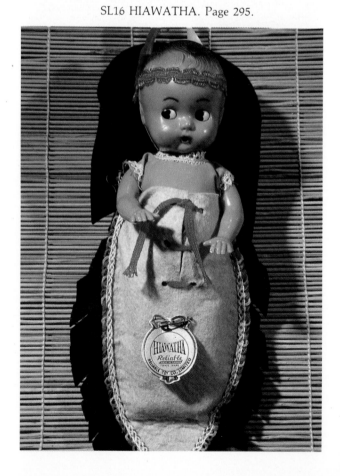

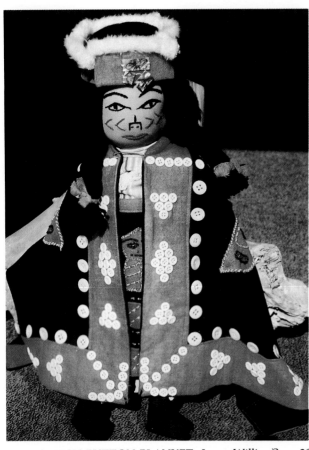

CA39 SALICH BUTTON BLANKET. Joyce Willie. Page 28

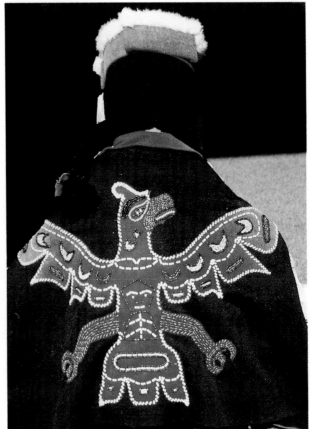

CA40 SALICH BUTTON BLANKET. (back). Page 28

XG4 EAGLE DANCER. Gail General & Pam Brown. Page 30

BF5 DOMINION. Page 169

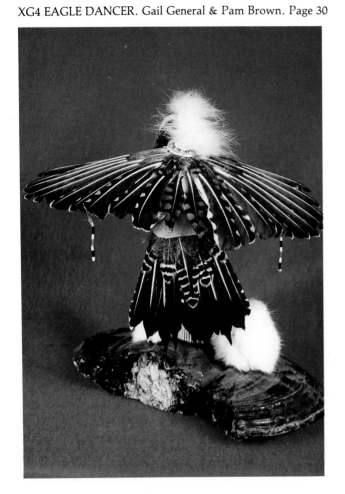

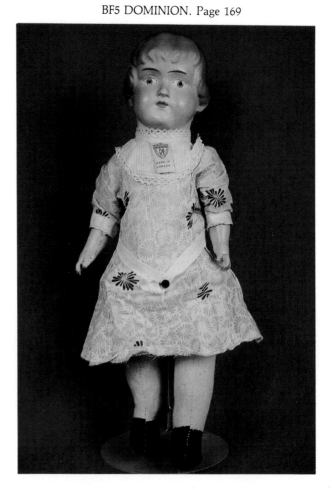

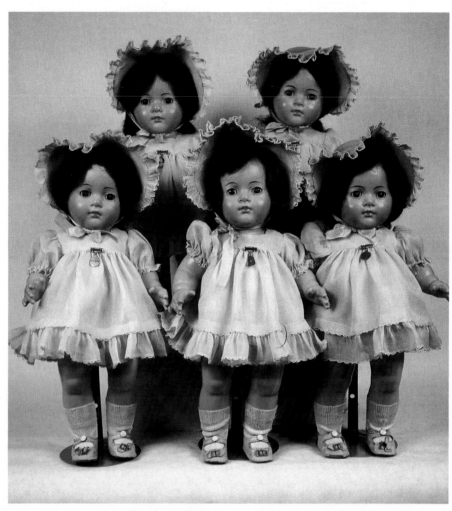

BW8 DIONNE QUINTUPLETS. Page 89

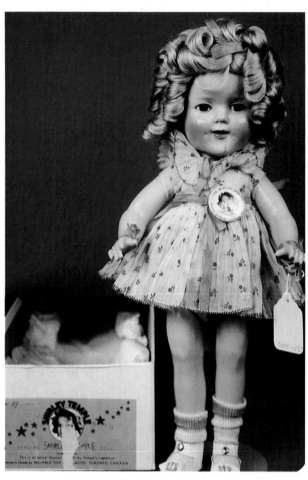

CA22 SHIRLEY TEMPLE. Page 259

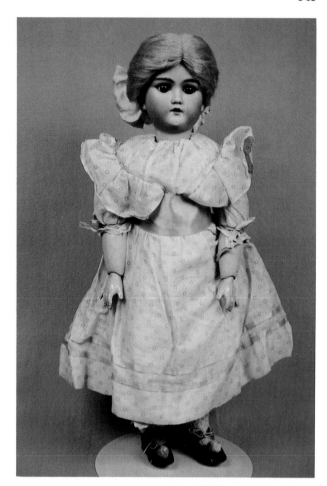

XH16 Eaton's Beauty. 1910. Page 72

CH20 Eaton's Beauty. 1909-10. Page 71

CH19 Eaton's Beauty. 1909. Page 70

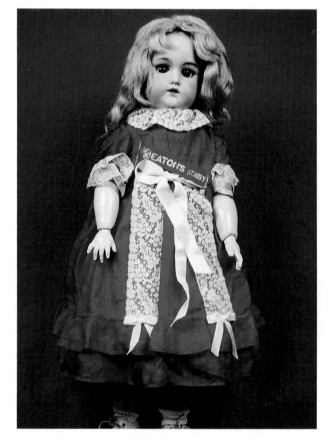

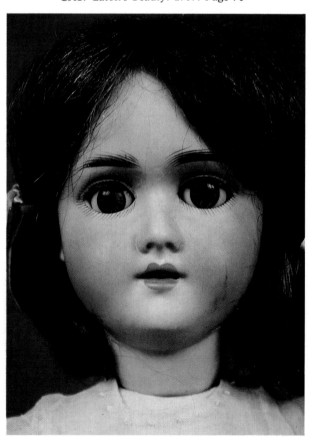

AO23 LADDIE. Page 277

BM1 CANDY. Page 232

XI2 OLD TYME COUNTRY BAND. R. Annand. Page 362

XI4 MINIATURE PEG WOODENS. F. Armstrong. Page 362

XX15 SNOWBALL. B. Bickell. Page 364

XX16 LOVENET. B. Bickell. Page 364

XX17 WOMAN WITH BIRD'S NEST. B. Bickell. Page 364

CC24. H.R.H. PRINCESS DIANA. D. Brennan. Page 364

CC26. H.R.H. PRINCESS DIANA. D. Brennan. Page 364

XX13 BLANKET OF STARS. B. Bickell. Page 364

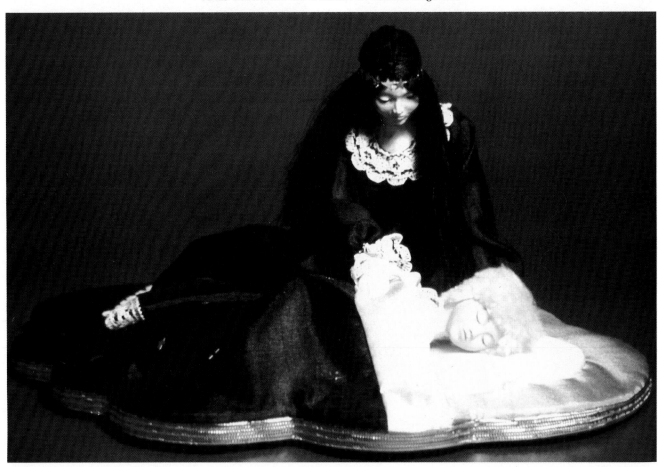

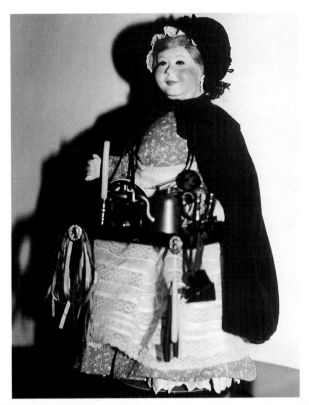

BV21 OLD ENGLISH PEDLAR LADY. G. Cassone. Page 366

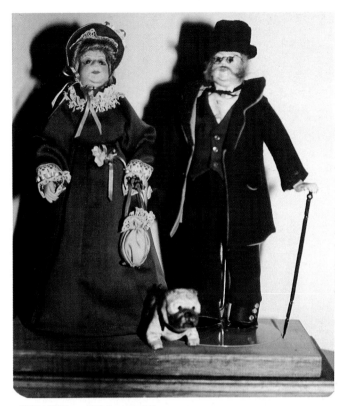

BV19 MR. & MRS. ALFRED C. BUGGS. G. Cassone. Page 366

CK9 MARILYN MONROE. R. Condello. Page 367

CK10 MARILYN MONROE. R. Condello. Page 367

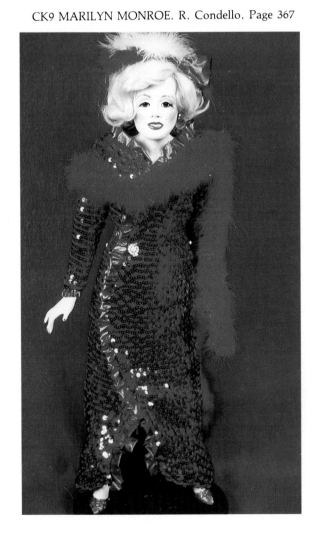

DA2 HAT SELLER. R. Dolhanyk. Page 375

BV14 BOOKSELLER. R. Dolhanyk. Page 375

XH18 MAD HATTER. J. Ferguson. Page 377

XH19 PUNCH. J. Ferguson. Page 377

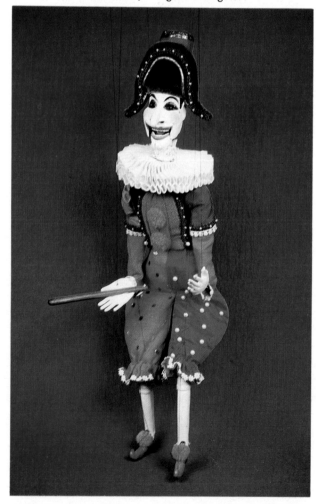

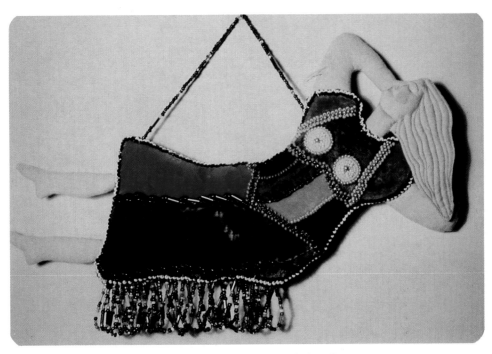

SE5 PIN CUSHION DOLL. S. Fowler. Page 377

SE4 TREE DOLL. S. Fowler. Page 377

SE6 PEDLAR DOLL. S. Fowler. Page 377

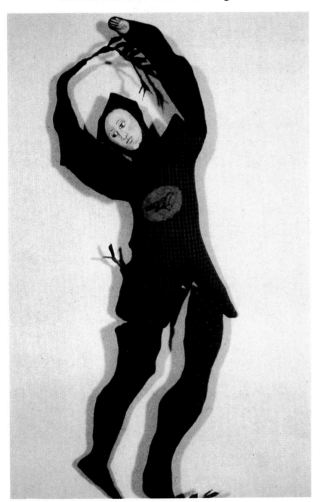

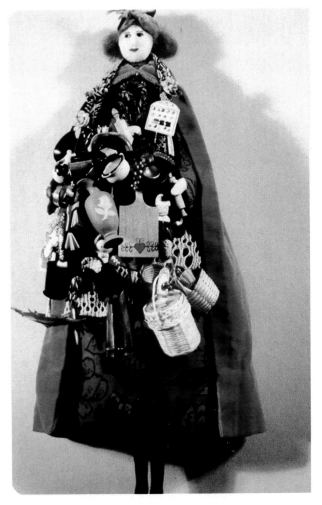

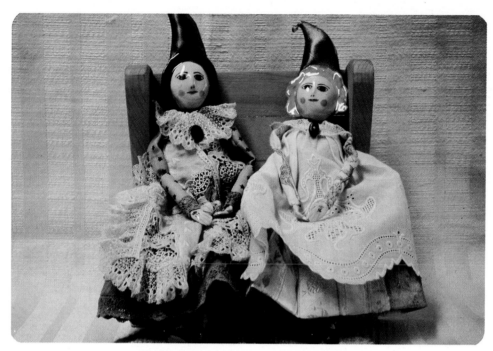

SE3 CHINA DOLLS. S. Fowler. Page 377

DA3 PRINCESS TEMLAHAM. W. Gibbs. Page. 378

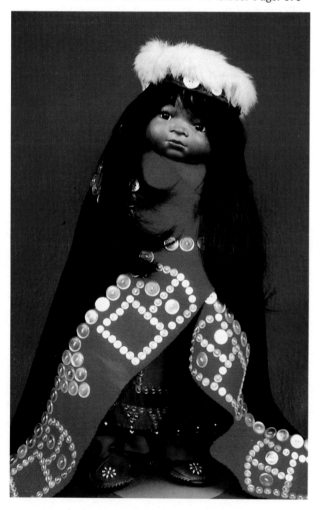

XG14 WOMAN IN BUTTON BLANKET. D. Grant. Page 379

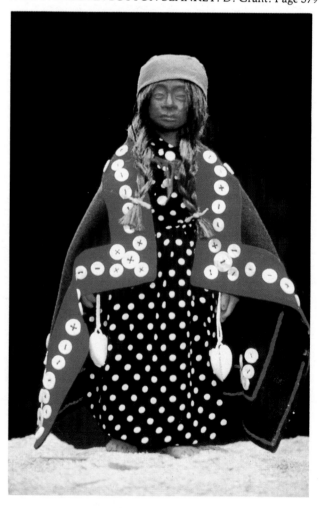

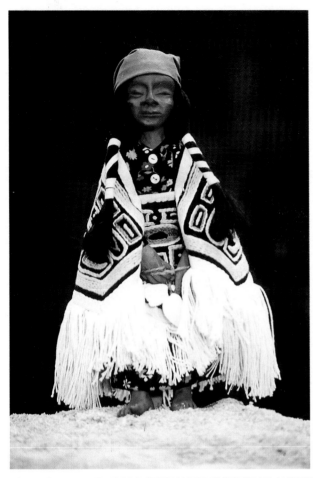

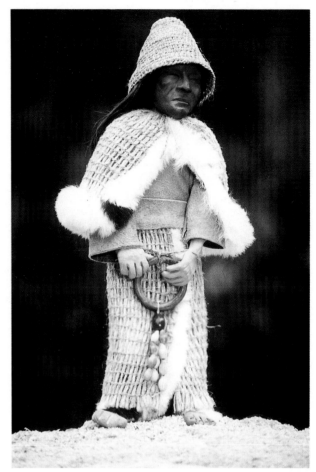

XG9 WOMAN WEARING CHILKAT DANCING BLANKET.
D. Grant. Page 379

XG11 CEDAR BARK WOVEN CLOTHING. D. Grant. Page 379

XG20 COAST SAALICH FEATHER CLOTHING.
D. Grant. Page 379

XG13 EAGLE BUTTON BLANKET. D. Grant. Page 379

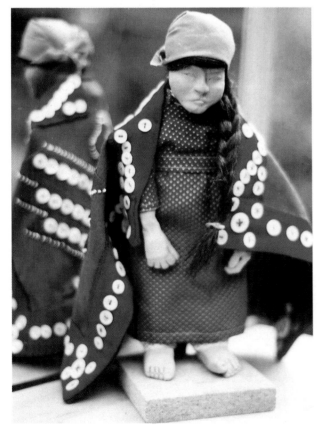

CL12A SU TSEN. M. Kilby. Page 383

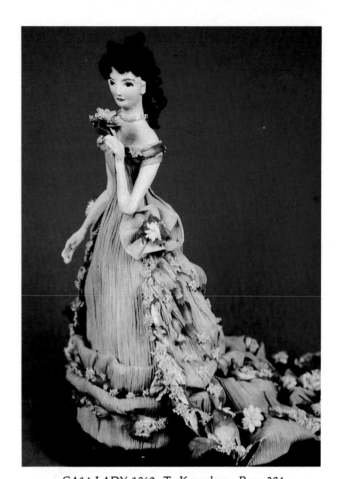

CA14 LADY 1869. T. Knowlson. Page 384

BZ26A ESKIMO WOMAN. J. Lintvelt. Page 391

CV8 TOMMITY. M. Neill-St.Clair. Page 392

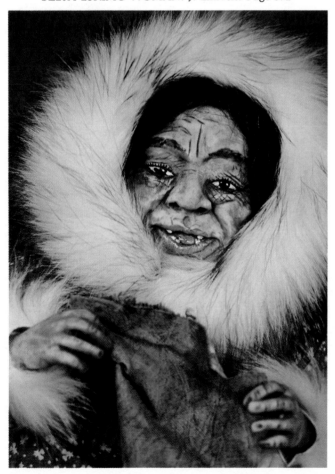

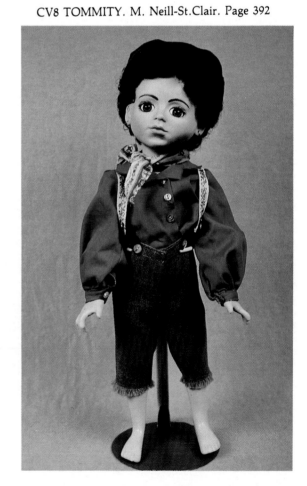

CV9 TOMMITY. M. Neill-St.Clair. Page 392

BY3 SAMUEL DE CHAMPLAIN. C. Papadopoulas. Page 393

BL12 JACQUES CARTIER. M. Prasil. Page 394

BM2 GRAND DE MAMSELLE. M. Prasil. Page 394

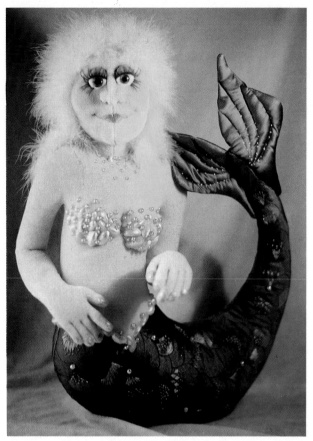

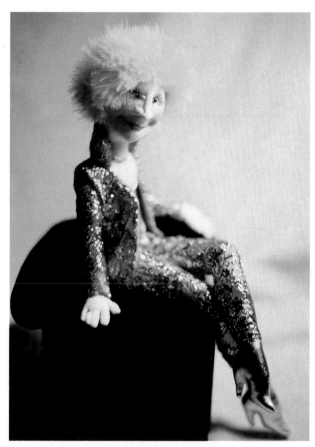

XH14 CRUISING. J. Pratt. Page 394

XH13 GLAD RAGS. J. Pratt. Page 394

XI10 CRUISING (detail). J. Pratt. Page 394

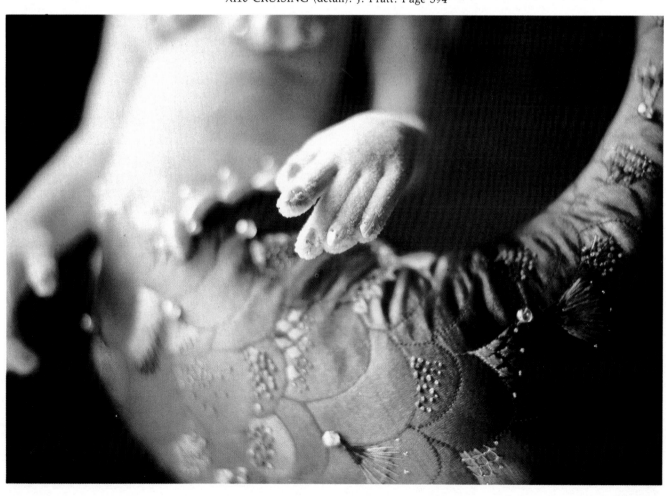

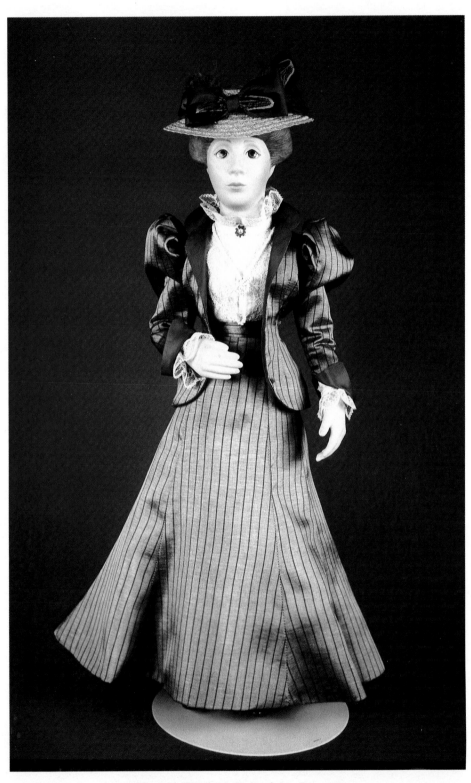

CP14 AMELIA. Y. Richardson. Page 395

CP13 CLOWN. Y. Richardson. Page 396 XH12 JUGGLING MARIONETTE CLOWN. S. Rose. Page 396-

XH8 ELF AND INSECT. S. Rose. Page 396

BV26 THE KEY. L. Schklar. Page 401

BV25 THE SECRET GARDEN. L. Schklar. Page 401

BV24 JUMPING JACK. L. Schklar. Page 401

AZ17 INDIAN BABY. C. Vair. Page 401

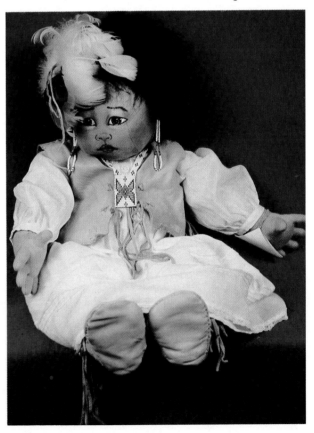

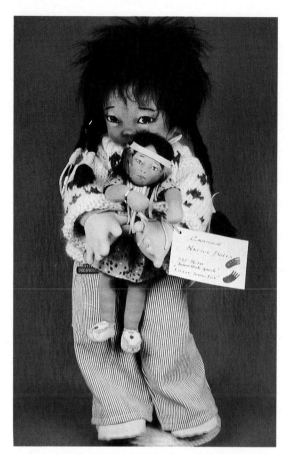

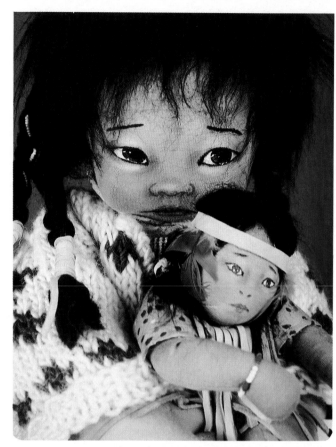

BO6A LITTLE SNOW FOX. C Vair. Page 401

BO7A LITTLE SNOW FOX. (close-up). C. Vair. Page 401

CA15 PRINCE WILLIAM. J. Venton. Page 403

CA4 SNOW WHITE. J. Venton. Page 402

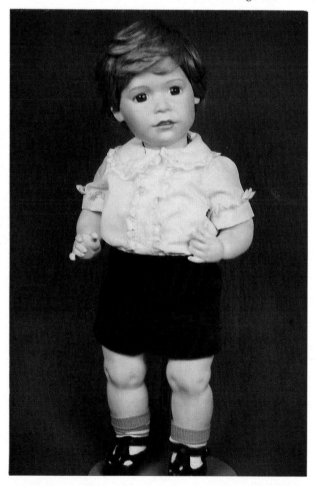

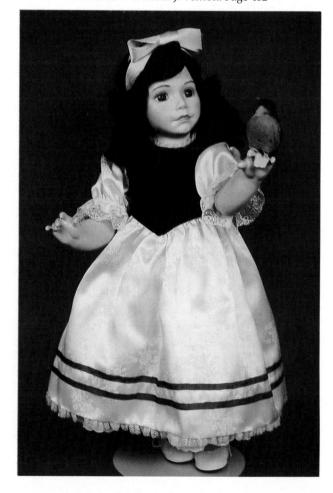

Chapter 11

ARTISTS' DOLLS OF
TODAY AND TOMORROW

It is a new idea to create a doll as a work of art in Canada.

What is art? According to Webster's dictionary it has many meanings. Perhaps the most applicable is "the conscious use of skill, taste, and creative imagination in the practical definition or production of beauty". This is a definition that aptly fits the creation of an original doll. Many of the artists are highly trained and skilled workers whose dolls are the epitome of taste and creative imagination. Another meaning is 'the expression of beauty". One cannot look at these artists' dolls and not know the meaning of "an expression of beauty".

Max von Boehn tells us in his book Dolls [1] that the doll 'can come surprisingly close to nature, but the nearer it approaches its goal, the farther it is removed from art; it can create an illusion, but the true essence of artistic enjoyment -- the raising of the soul to a higher plane -- is denied to it." Von Boehn is referring to the toy doll. The beautiful bisque nineteenth century dolls are "things of beauty" but not works of art. However, the doll form used by the artist is not a toy. It is a miniature three dimensional human being representation, but it is also a work of art. If an oil painting of a beautiful woman can "lift one to a higher plane" then so can an exquisite doll form of silk or sculptered material.

Moreover, a true artist is able to portray human emotions such as pity, sorrow, pride, envy, friendship, and passion in their work. We are able to see this quality in the work of the artists. Many doll artists do not try to copy nature. They use fantasy and the world of imagination to lift the viewer above reality.

The doll form has reached new levels in this country. It should be identified as a work of art and selected by museums and art galleries for their permanent collections. Perhaps it is time for the formation of an organization in Canada comparable to the National Institute of American Doll Artists. Such an organization could have qualified artists, possibly from recognized art schools or from museums and art galleries, to form a panel to examine the work of each artist. Those who pass with high standards would have letters after their name which could then be used on the labelling of their work. It is time that doll artists received the recognition they deserve for creating new and distinctive art forms.

What do we mean by an original doll? It is when the artist has conceived the idea of a doll, made her (his) own patterns or models, and built the entire doll herself. It is difficult to create something completely original, for, as we progress in art, we use the lessons learned by earlier students. Some artists, such as Jude Crossland, not only create a doll, they first design the materials and then weave the fabrics to make such a doll. This truly is a totally original doll.

Barbara Bickell's dolls are designed meticulously on paper first. Then she proceeds to create the doll. Her dolls are also completely original dolls. There are relatively few doll artists in Canada doing totally original work.

During the last twenty years, more young women have graduated from fine arts schools in Canada than ever before. In 1961-62 nine women graduated in fine arts, but ninety-three women graduated in 1968-69.[2] Many of these artists have chosen the miniature human form as their means of expression. More men have also graduated from fine arts programmes than ever before, but relatively few of these have chosen dolls as their favoured art form.

Although some dolls in this chapter are completely original, dolls are included that have some commercial content or reproduction parts. We are not referring to reproduction dolls but, for example, an original doll head with a commercially made body. Artists of such dolls have used their skills and imagination to create dolls that are different from all other dolls.

We have not been able to locate every original doll artist turning out innovative and exciting dolls in Canada.

However, we have tried to show a few of the varied techniques being used and to show the best artists that we could find.

The doll artists of today are using all the old mediums of doll making, plus many new materials developed in recent years. There are also dolls being made which could be considered folk art. Folk art is produced by the imaginative skill of people in general. Apple-head dolls are a good example. They are a very old medium. But if one takes this medium and creates a character doll from their own imagination, perhaps producing a group of characters engaged in some activity, that person is surely also showing originality.

There are artists making cloth dolls, which is a very old idea. The face, however, may be fashioned from a variety of materials other than cloth. The doll itself is usually made from a pattern created by the artist, and the clothing is designed so the doll will represent the image the artist has in mind. There are also dolls with cloth glued over a plastic mask. Because the mask is not original, the doll is not wholly original. However, when the painting of the face is distinctive and the body of the doll is the artist's own creation, we have a doll which can be called partly original.

With some dolls made by artists, the clothing is more important than the doll. Thersa Knowlson's cornhusk clothing is a case in point. The doll is relatively unimportant; the original part is the fantastic draping of the cornhusk material to create an illusion of fabric.

We have not included reproduction dolls because, although they are beautiful, they are intended to be close copies of antique dolls. That is their purpose, to create a copy of the original.

So many dolls are imports now that many collectors are turning to artist dolls to fill the void. Also, there are more working women today who can afford to buy art, and the doll has universal appeal for women. Although there are male collectors, the vast majority are women. Women want dolls that are both beautiful and appealing, and artist's dolls have both qualities.

1. Boehm, Max von. Dolls. New York: Dover Publications, 1973, p.24.

2. Canada Year Book, 1966 and 1970-71.

Freida Abbinet

Freida Abbinett's dolls are created totally from recycled materials. She uses nothing new but puts her imagination and creativity to work devising new methods for the use of old materials. Her dolls have character and are posed in action positions giving them a childlike realism.

Mrs. Abbinett carves the hands and feet from wood, sculpts the heads from papier-mache, and uses beads for eyes. She turns the bead back to front to expose the hole in the centre. This hole becomes the pupil that is painted black to give the eye depth. She then paints the iris around it. She also uses broken beads to make the teeth. The wigs are fashioned from recycled human wigs, and the dolls are dressed in old fabrics. The total effect is quite charming.

CB29A

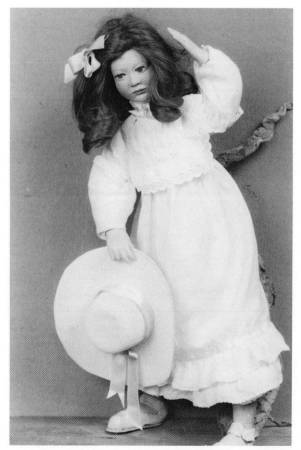

CB29A

CB29A
Freida Abbinett. FAYE. 24 in. (61 cm). Cloth body with a wire armature, wooden hands and feet. Papier-mâché head; eyes are inset painted beads; brown human hair; closed mouth. Unmarked. Original white cotton dress, socks, shoes, and straw hat. From the collection of Andra Tucker of the White Elephant Museum at Sardis, B.C.

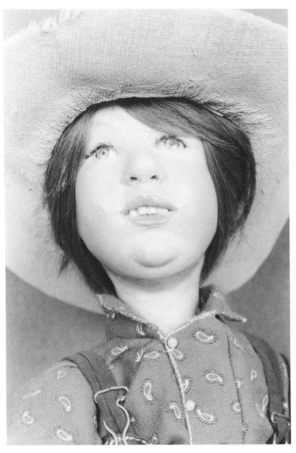

CB28

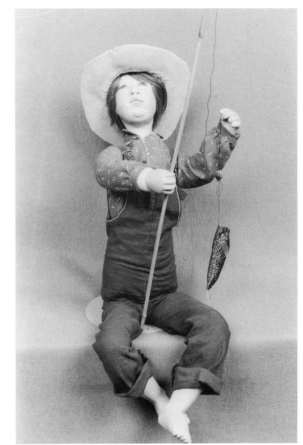

CB27

CB28
Freida Abbinett. 1981. JOEY. 24 in. (61 cm). Cloth body with
a wire armature, wooden hands and feet. Papier-mâché head;
eyes are inset painted beads; human hair wig; open-closed
mouth showing teeth made from beads. Unmarked. Original
overalls, print shirt, and straw hat. From the collection of Andra
Tucker of the White Elephant Museum at Sardis, B.C. See also
Fig. CB27.

Roberta Estelle Annand

Mrs. Annand (nee Taylor) hails from Wittenburg,
Nova Scotia, and showed her doll making talent at an
early age. When, as a child, she was given a mama doll
with long straight legs, she promptly "operated" on it and
changed its legs to bent-limb legs. She also removed the
crier and replaced it upside down so that the baby would
cry whenever she was put down. Mrs. Annand was so
fond of this doll that she has never parted with it.

After Mrs. Annand's children had grown and she
had time for hobbies, she began making apple-head dolls.
She meticulously sewed all the tiny clothes and began to
sell them in 1975. But, a few years later she changed to
soft-sculpture dolls, making mostly old ladies dressed in
their Sunday best.

She has made jointed stuffed dolls big enough to
wear a child's size five dress. One of her large dolls is
a much loved mascot to a group of children in a preschool
class. She has also made smaller jointed dolls of factory
cotton or pantihose. She particularly enjoys making the
clothes, the tiny leather shoes, and moccasins.

Roberta Annand makes more than one-of-a-kind but
no two dolls are exactly alike. She sometimes sews a tag
with her name on it to the nape of the neck or on the
clothing.

Mrs. Annand is also gifted at drawing and has
published a book of pencil sketches titled Memories.

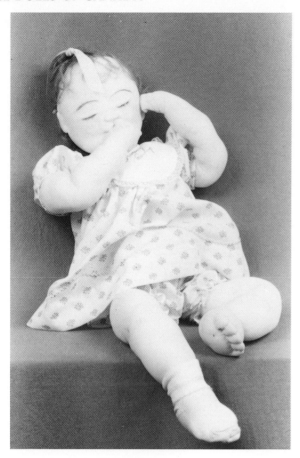

BF24

BF24
Roberta Annand. 1984. GRANDMA'S DARLING. 31 in (79 cm). Nylon body stuffed with polyester fill; jointed hips and shoulders. Nylon head, stuffed; embroidered closed eyes; red mohair tied with a hair ribbon; thumb in embroidered mouth. Her left hand is attached to her head holding a wisp of hair. Unmarked. Dressed in print dress and matching panties; bib with Grandma's Darling embroidered on it. From the collection of Margaret Archibald, Halifax, N.S.

XI2
Roberta Annand. OLD TIME COUNTRY BAND. Cloth bodies over wire armatures. Apple heads; mohair wigs. Unmarked. Clothing including the boots and moccasins and the miniature musical instruments designed and made by the artist. Photograph courtesy of Roberta Annand, Musquodoboit, N.S. See colour Fig. XI2.

Frances Armstrong

Frances Armstrong grew up in South Africa and now lives in Erin, Ontario. She received graduate degrees in British literature from the University of Natal.

This artist makes peg wooden dolls, but they are far from the ordinary peg woodens. Frances' dolls are fully articulated and incredibly tiny. She also makes miniature teddies and doll houses small enough to be in scale inside a doll house. She produces hand carved wooden soldiers only 3/8 of an inch in height and tiny "lithographed" blocks.

Frances uses only an Xacto knife, pin vise, and a miniaturists' saw to create her magic. She uses pine, basswood, and birch, but the tiniest doll is made from holly wood because it has a very tight grain and is not brittle. Each piece is coated with lacquer before she begins

in order to hold the wood fibers together. Working on miniatures of this size requires intense concentration and a large degree of patience. These miraculous dolls are the antiques of the future.

XI4
Frances Armstrong. 1983. MINIATURE PEG WOODENS. 1 in., 5/8 in., 1/4 in. All wood fully articulated limbs. Painted features and hair. Mark: largest doll only, FEA. Clothing, smallest doll only, silk. Photograph courtesy of Nutshell News, © Boynton & Associates, Inc. See colour Fig. XI4.

Alma Bednarski

Alma Bednarski began making reproduction bisque dolls in 1982. More recently, she has been doing original work. She has had no formal training but has taught herself to make original heads by studying books and learning by trial and error. She feels that her dolls are a reflection of herself and of her cultural history.

She sculpted the head of MARY JANE from clay using pictures of her grandmother as a model. She uses commercial bodies with her original heads, and has made a limited edition of twenty- five dolls. Her dolls are clearly marked on the back of the head, and the mark includes her name, year, and number of the doll.

CG33
Alma Bednarski. 1982. MARY JANE. Ball-jointed lady body. Bisque head; blue glass stationary eyes; light brown human hair wig; closed mouth. Mark: artist's symbol which includes the year and number of the doll. Original cotton batiste underwear, blouse with cream lace, silk skirt and fitted jacket, leather shoes and cream stockings. From the collection of Wendy Leedahl, Saskatoon, Sask.

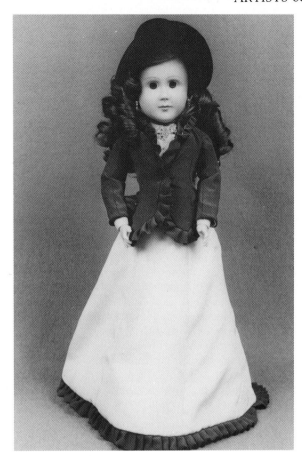

CG33

Barbara Betts

Barbara Betts was born in Fergus, Ontario, to a family that has always been busy making things. Mrs. Betts, a creative and artistic person, has been actively involved in making crafts all her life.

Barbara started making dolls about 1946 and began selling them in 1956. Although she no longer makes dolls to sell, she can look back on a successful career of making hundreds of dolls. Various organizations have sponsored tours of her dolls in the Maritimes and Ontario. A series she did of Girl Guides and Brownies is on display at national Girl Guide headquarters in Toronto.

As well as making Loyalist dolls, Mrs. Betts has made Acadian dolls, and dolls dressed in each of the Maritime tartans. She has created groups of carol singers, poker players, and bridge players, to express her sense of fun. She insists on accuracy and attention to detail, so much so that she once carefully enquired as to what are the four best poker hands, and then she patiently painted the poker players tiny cards to match.

The love and care given to her dolls makes each one a very special doll. Her dolls are easy to identify for they come with her own labels. Mrs. Betts is a member of the New Brunswick Crafts Council.

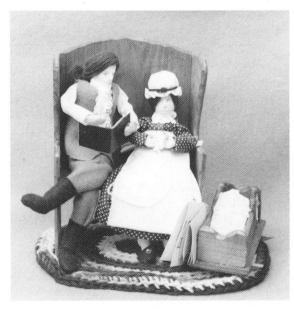

AJ25

AJ25
Barbara Betts. Date unknown. THE LOYALISTS. 9.5 in. (24 cm). Cloth bodies over a wire armature. Papier-mâché heads covered in nylon; painted features; wool hair. Mark: label, Barbara Betts dolls. Original clothing. Father holds a tiny book; mother holds her knitting while sitting on a wooden bench. Baby is in a tiny wooden cradle. Authentic crocheted rag rug. From the collection of Nora Moore, Fairvale, N.B.

Barbara Bickell

Barbara Bickell is a Whitby, Ontario, original doll artist who has focused almost exclusively on the doll as a textile art form. After graduating from Ontario's Sheridan School of Design, she went on to study sculpture, anatomy and dance. Each doll she makes is unique. The face is individually sculpted from ground marble/acrylic paste, then painted with acrylic paints. The faces are based on people the artist knows, which gives them realism. The dolls' bodies have the radiant lustre of finely woven silk. The adult dolls are about 10 inches tall, kept to a small, personal scale, and the children are proportionately smaller.

Barbara's creations vary a great deal. Some are light-hearted fantasy figures suspended in space and moved by light air currents. These ephemeral creatures express joyous, high-spirited exuberance. Others are of a contemplative evocative nature with symbolic overtones. They deal with the forces that shape emotions:love, longing, passion, serenity. The meaning ascribed to each doll depends very much on the viewer's state of mind. Some women, on seeing LOVE NET, may see a young woman held in by her love for someone, whereas a man may see her pose as seductive, the netting a provocative veil.

Barbara usually restricts her colours to a monochromatic or analogous colour scheme so that the sculptural aspects of the figure are emphasized. The colours, as well as the face and body, reflect the doll's activity and state of mind.

She has taught doll making at the Haliburton School of Fine Arts and was artist-in-residence at Artpark in Lewiston, New York. As well as demonstrating her craft at the World Craft Council's exhibition at the Ontario Science Centre, she has had her work included in the Royal Ontario Museum Doll Show, and in numerous publications and private collections. She had many one-woman shows at The Apple Doll in Toronto, where each time she created dolls with a theme, such as the series called Butterflies, Fantasy, Dreaming, and Magic. She now creates portrait dolls on commission.

Barbara's dolls are all signed and dated, usually on the foot or base. They are handled by A Show of Hands Gallery in Toronto.

XX13
Barbara Bickell. ca.1983. BLANKET OF STARS. The figure of Evening watches over the sleeping child, Morning, under a blanket of stars as they rest on a cloud. Photograph courtesy of Barbara Bickell, Whitby, Ont. See colour Fig. XX13.

XX15
Barbara Bickell. ca.1984. SNOWBALL. Although she looks sweet and innocent in her Sunday-best coat and the new hat-and-scarf set that Grandma sent her, this little girl is just waiting for the right moment to knock your hat off with the snowball she hides behind her back. She has a wicked aim. Photograph courtesy of Barbara Bickell, Whitby, Ont. See colour Fig. XX15.

XX16
Barbara Bickell. 1983. LOVE NET. 10 in. (25.3 cm). Shows a woman in a silk dressing gown enveloped in netting with knots sprinkled with tiny hearts. Courtesy of Barbara Bickell, Whitby, Ont. See colour Fig. XX16.

XX17
Barbara Bickell. ca.1983. WOMAN WITH BIRD'S NEST. Depicts a woman with responsibilities. A bird's nest with two eggs in it sits on top of her head. So as not to make the birds uncomfortable, she feels compelled to remain rooted to the spot. Holding two leaves, she tries to appear as treelike as possible. Meanwhile, a love letter (perhaps an invitation?) lies unanswered at her feet as the grass grows up around her. Photograph courtesy of Barbara Bickell, Whitby, Ont. See colour Fig. XX17.

Deborah Brennan

Deborah Brennan, a native of Vancouver Island, B.C., has been making dolls for as long as she can remember. She was strongly influenced in her childhood by a family friend from Portland, Oregon, whom she called Grandma Magnusson. She was a lady who could make a doll come to life when she took scaps of material, ribbon, and laces, and wove the magic that creates a doll. Deborah received her degree in art and English from the University of Victoria, B.C., and began teaching art in high school. She is a multi-talented young lady who also draws, paints, illustrates books, and sculpts small figurines.

Deborah Brennan thought of making a Diana doll while Prince Charles was courting Lady Diana, at which time there was a great deal of publicity and many photographs of the young woman of his choice. Deborah began the doll shortly after the Royal Engagement was announced, and it took ten months of work before the first group of dolls was ready in early 1982.

While sculpting the head, Deborah surrounded herself in her studio with photographs of Lady Diana from every angle. The Lord Snowdon portrait, which appeared in Vogue magazine, May 1981, and the Tim Graham portrait, which appeared in The Illustrated London News, April 1981, were both consulted frequently in order to capture the illusive shy quality of Lady Diana.

CC24
Deborah Brennan. 1984. H.R.H. THE PRINCESS DIANA, PRINCESS OF WALES. 24 in. (62 cm). Cloth body, upper arms and upper legs; bisque forearms, lower legs and shoulderplate. Bisque head; grey-blue eyes with highlights, mauve eye-shadow, painted lashes, fine black line over eye; blond human hair wig; closed mouth. Mark: #40/ /Diana/ Princess of Wales/ Royal Wedding/ July 29/81/ D. Brennan. Authentically gowned in a silk replica of the Princess' wedding dress. From the collection of Phyllis McCormack, Victoria, B.C. See colour Figs. CC24 and CC26.

The final mould that portrays the likeness of Lady Diana was achieved in progressive steps through a series of discarded moulds of ever increasing refinement. The features were then china painted, using at least twenty-four colours, with intermediate kiln firings. The eyes are outstanding. They deserve close scutiny to appreciate the subtle shading.

The body is cloth with reproduction porcelain shoulderplate, arms, and legs. The head is attached with a swivel and spring mechanism. The wig is human hair that is cut, dyed, frosted, and styled to portray the Princess' unique look. All of the clothing and accessories are removable, except the rhinestone earrings in her pierced ears. The dress and train are of one hundred percent ivory silk. The dress has four feet of lace-edged fullness in the skirt. The train, also lace-edged, is thirty-six inches in length. The bouquet of silk flowers is beautifully arranged by Kit Slymon, a professional florist of Victoria, B.C.

Deborah is currently working on her next doll (see Fig. CC31). This picture shows the clay model head when the work of producing an original doll is in progress.

Carol May Brown

Carol May Brown (nee Luckkovich) was born in Edmonton, Alta. Of all the dolls she had as a child, Carol May Brown's favourites were the cloth dolls made for her by her mother. Mrs. Brown began making cloth dolls when she was very young and has never stopped.

Mrs. Brown calls her dolls 'character sculptures". She produces a wild assortment of characters such as MISS McPRISS, ANASTASIA FLATOMBOSOMNOFF a snob ballerina, and SGT. McCLUSKY an RCMP officer. Her dolls vary in size from the eight inch ANASTASIA to CONSUELLA, a forty inch lady of the night. Carol Brown has a vital sense of fun, for she sees humour in everything. She spoofs her own ethnic background as well as everyone else's. When she makes dolls she is poking fun at the people in our society, but always with good taste.

She has taken numerous courses and has become an expert in many crafts. She has taught workshops and classes in batik, stitchery, crocheting, macrame, beading, primitive pottery, and porcelain.

Mrs. Brown's characters are primarily made from fabrics and yarns with the occasional use of papier-mâché and plastic. They are usually stuffed with polyester fill. She has not marked her dolls in the past, but now plans to begin marking them 'Aunty Carol".

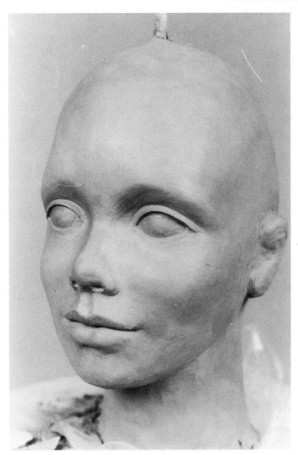

CC 31

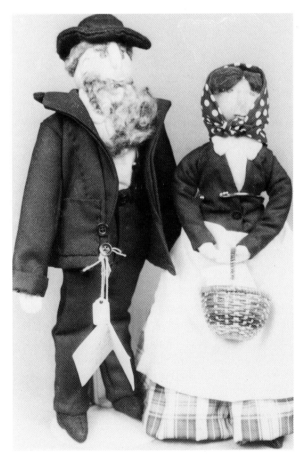

CF18

CF18
Carol Brown. 1981. HELMUT and HELGA. (Hutterite dolls). Cloth bodies. Cloth heads with needle sculptured faces, wool hair. Unmarked dolls. Original tag. From the collection of Gloria Kallis, Drayton Valley, Alta.

Kashi Carter

Kashi Carter, a native of Buffalo, N.Y., married a Canadian and moved to Canada. She was curious about the people, the country, and its history. She began to frequent museums and libraries to study the background of her adopted country. As she added to her growing knowledge of its people, she began making cloth dolls to represent historical figures. From her start in 1948, she has found a ready market for the many series of interesting dolls she has created.

Mrs. Carter modelled her doll's heads from Lewiscraft permaclay because it was a medium which enabled her to produce a better likeness to the historical figures she was presenting. She constructed the bodies of wire and cloth which she then stuffed with tissue to provide the correct shape. She always embroidered 'Kashi" on the back of the skirt or jacket so that her dolls are easy to identify. Although she sometimes made more than one-of-a-kind, no two were ever dressed alike.

Mrs. Carter does research on a theme and then produces a series of dolls based on that theme. One of her first themes was Fashions Through the Years. She made a series of these for the Lux Soap Co. She has also created sets of literary figures such as the Charles Dickens characters.

Office Overload Company wanted a series of historical Canadian women. The company asked Mrs. Carter to create them. Kashi did a great deal of research on each person to ensure that every one would be dressed authentically. She made a second set of Canadian historical figures which was used in the Toronto area schools for years to bring life and meaning to history lessons.

Eighteen of Mrs. Carter's dolls in different ethnic costumes representing the Canadian mosaic were exhibited at Expo 67 in Montréal. In 1984 Mrs. Carter's dolls, representing Canadian women who had contributed to the several war efforts during the twentieth century, were exhibited in the Canadian War Museum's Women at War Exhibit.

Kashi Carter says that she has retired from her doll making career. She has left us many beautiful dolls that show her imagination and creativity and that help to demonstrate the history of the country. Mrs. Carter's dolls are shown in the Ethnic and in the Working Doll chapters.

Gayle Cassone

Gayle Cassone of Tillsonburg, Ontario, began making dolls in 1979. She is a graduate of the Ontario College of Art where she specialized in advertising. She worked in that field and then switched to teaching art in high school. The duties of mothering four children now keep her at home, but she spends as much time as possible making dolls.

Some of her dolls have cloth bodies and others have composition bodies. The heads and hands are porcelain. The hands are carved porcelain and each hand is different. Gayle feels that doll making uses many different talents such as sculpture, painting, character development, pattern making and costume design.

Gayle's dolls are character dolls, as the personality she is portraying is clearly seen in the face of the doll. The clothing adds another dimension, being completely in tune with the character.

So far, Gayle's original dolls have not been for sale. She has prepared the moulds of each doll to allow her to make a small edition but has been too busy creating new characters to spend time making copies of the old ones.

BV19
Gayle Cassone. 1983. MR. and MRS ALFRED C. BUGGS and PET. 11.25 in. (29 cm). Bodies are unbleached cotton stuffed with polyester fiberfil; hands are carved porcelain, (each hand is different). Bisque shoulderhead; blue glass eyes. Lady has a grey wig in upswept style; man has a bald head with a grey mohair fringe, muttonchops and mustache. Both have closed mouths with a grim expression. Mark: on shoulderplate, Cassone #1 Mrs Buggs and Cassone #2 Mr. Buggs, (same mould) The dog is an old English bulldog named MAJOR. He is made out of oven fired clay and is one-of-a-kind. He has Cassone on his stomach. Mrs. Buggs is wearing a 1910 style grey blue dress and bonnet, grey purse, cream underclothes trimmed in old lace. Mr. Buggs wears a three piece suit in dark grey with wine vest and black top hat; carries a cane with a gold head. A proud and unbending couple, but Mrs. Buggs has the upper hand and controls her own small world. Photograph courtesy of Gayle Cassone, Tillsonburg, Ont. See colour Fig. BV19.

BV21
Gayle Cassone. 1984. OLD ENGLISH PEDLAR LADY. 15 in. (38 cm). Composition body, jointed hips, shoulders, and neck. Bisque socket head; blue blown glass eyes; grey mohair wig in a bun at the back; closed mouth with a gentle smile. Mark: on head, G. Cassone #1. Dressed as a pedlar, grey print dress, black cape and bonnet, white apron, mob cap, slip and bloomers with old lace trim. Carries a tray of articles to tempt her customers, wool, candlesticks, candles, shoes, buttons, ribbons, coffee pot etc. Wooden tray supported by a leather strap around her neck. She looks the picture of a gentle kind old lady. Photograph courtesy of Gayle Cassone, Tillsonburg, Ont. See colour Fig. BV21.

BV20
Gayle Cassone. 1983. SERENA the FAIRY GODMOTHER. 8.75 in. (22 cm) (without the wings). Body is made with cotton strips wound around a wire armature, hands are carved porcelain. Shoulderhead is hand carved porcelain; blue painted eyes; honey blond mohair wig; closed mouth with a slight smile. Mark: on head, G. Cassone. Clothing and wings are made from approximately 100 year old lace and white material. Dress is designed in a petal formation to represent the garden where fairies live. Her face is not young but not old. She is older than the other fairies but knowing and impish. She is slight and vapour like. Wears a crown and carries a wand. Photograph courtesy of Gayle Cassone, Tillsonburg, Ont.

BV20

Ruth Condello

Ruth Condello of Winnipeg, Manitoba, began making cloth dolls in 1963 for her two small daughters. When friends and neighbours saw the children playing with these dolls, they asked Ruth to make dolls for their children. This accidental beginning has mushroomed into the production of original dolls.

A year at the University of Manitoba in the fine arts department gave her a start. Since then, Ruth has taken courses in china painting, and has also taken sculpture classes from Helen Norman, a Winnipeg sculptor. Ruth's brother is a potter and was able to give her many tips on the handling and the firing of clay.

For a while, Ruth made reproduction dolls, but she now works only on her originally sculpted dolls. She makes a limited edition of twenty-five of each doll. Her dolls are marked with a capital C and a small capital R inside.

An unusual feature of some of her dolls is the eye which she makes from porcelain. She paints the eye, fires it, and sets it in the head. The result is a very realistic eye.

Ruth Condello makes dolls because she enjoys it, and because it makes her happy to see the smiles her dolls bring to the face of the observer.

CK9
Ruth Condello. 1985. MARILYN MONROE. 30 in. (76.5 cm). Vinyl leatherette body stuffed with cotton; porcelain forearms and lower legs. Hands beautifully modeled and finished including nail polish. Bisque head; hand painted and fired porcelain eyes, lashes, painted lower lashes; blond human hair wig; open-closed smiling mouth showing teeth. Mark: on head, Ruth Condello/1985 1. Wearing a red sequinned gown, maribou boa and matching hat. One of a limited edition of twenty-five. Courtesy of Ruth Condello, Winnipeg, Man.
See colour Figs. CK9 and CK10.

Margaret Stephenson Coole

Margaret Stephenson Coole is an Honours graduate from the Ontario College of Art, and she has a Certificate in Creative Embroidery from Sheridan College, Ontario.

Margaret began doll making in 1978 because it is a form of art that combines her love of fabrics and fibre techniques with bas relief sculpture details from the past. Her art work represents people, events, and relationships, with the emphasis on relationships. This artist's work tells a story.

As we look at each piece, a message comes through that tells us the meaning in her art. In examining Christmas Sweater, everyone may make up a story to fit their own past experiences, but it is the feeling of the piece which comes to you. The artist is able to express relationships in her detailed stitchery which portray the pride, pleasure, and excitement inherent in mother-child relationships.

Margaret has exhibited her work both in one person shows and in juried shows such as "Image, '84", Art Gallery of Hamilton, Ontario, 1984; "Quilt National '83", Athens, Ohio, American Craft Museum, New York City travelling exhibition (U.S.A.) 1983; 'Needle Expressions", Council of American Embroiderers, travelling exhibition (U.S.A.), 1982-80; "Québec/Ontario Crafts", travelling exhibition, 1979-81; and The Craft Gallery, Toronto, Ontario, 1984-83.

The artist has received recognition in many publications including *Calendar* 1985, *National Standards Council of American Embroiderers; The Quilt: New directions for an American Tradition*, Schiffer Pub. 1983; *Artisan*, Canadian Crafts Council, Winter, 1982; *Clothed with Bright Raiment*, Ontario Craft, Spring, 1981.

Her work is in the collections of the Ontario Craft Council, Canadian Living Magazine, Royal Trust Tower, Toronto, Ontario, and Mellon Bank, Pittsburgh, PA.

Margaret Stephenson Coole has received many awards and grants for her work such as the Ontario Arts Council Grant 1984; Canada Council Grant, 1983; Chatelaine Award, Ontario Crafts '82, 1982; Award of Merit, Embroiderer's Association of Canada, 1982; and the Adelaide Marriott Award for Excellance, Ontario Crafts This artist has used the doll form, executed in cloth, in an innovative new way to express the human spirit.

XI5
Margaret Stephenson Coole. 1979. MOTHER AND CHILD. 18 in. (45.5 cm). Muslin with sculpted details in cording and trapunto. Mark: M. Coole. From the collection of Helen Fitzgerald. Photographs courtesy of Margaret Stephenson Coole, Mississauga, Ont. See also Fig. XI6.

XI5

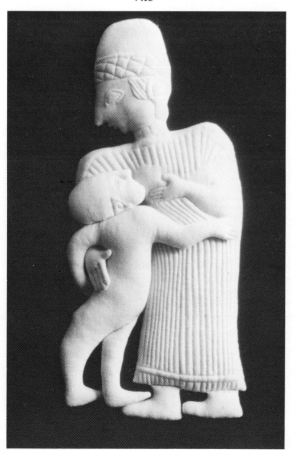

XI6

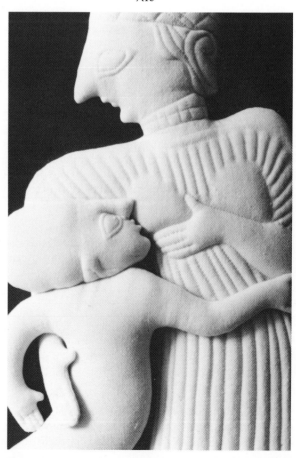

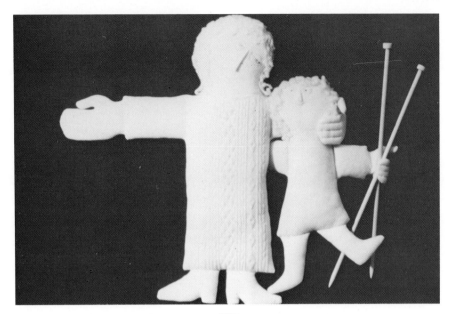

XI8

XI8
Margaret Stephenson Coole. 1981. The CHRISTMAS
SWEATER. 15 in. (38 cm). Muslin, sculpted details in cording
and trapunto; eyes embroidered with six strand floss; hair, yarn,
couched; mouth embroidered with six strand floss. Mark:
M.Coole. Photograph courtesy of Margaret Stephenson Coole,
Mississauga, Ont.

XI7

XI7
Margaret Stephenson Coole. 1982. NATIVITY. 18 in. (45.5 cm).
Muslin with sculpted details in cording and trapunto. Mark:
M. Coole. From the collection of the Reverend John Sullivan.
Photograph courtesy of Margaret Stephenson Coole,
Mississauga, Ont.

XI9

XI9
Margaret Stephenson Coole. 1984. JOY. 14 in. (35.5 cm). Muslin body; eyes and mouth embroidered with six strand floss; hair is yarn, couched. Antique lace collar. Mark: M. Coole. Photograph courtesy of Margaret Stephenson Coole, Mississauga, Ont.

Jude Crossland

Jude taught weaving and crocheting for one and a half years at the Artists Workshop in Toronto, and has taught at the Haliburton School of Art, Mohawk College, Hamilton, Ont., and the Peterborough Guild of Arts and Crafts.

Her work is in the permanent collection of the Ontario Crafts Council, the International Doll Museum in Crocovie, Poland, and the Australian Crafts Advisory Board.

She has entered her dolls in many exhibitions including the Royal Ontario Museum Doll Show "Dolls of Many Cultures Through the Ages", in 1979 , and the Québec-Ontario Crafts , an interprovincial juried show travelling throughout Ontario and Québec in 1980.

Jude won an award in Ontario Crafts '81, Ottawa, an Eastern Region Juried Show and another award at the Ontario Crafts '83 Exhibition, Craft Gallery, Toronto, Ont.

Jude uses materials such as tapestry yarn, linen, cotton, wool, leather, and lace to create different textures and forms. Her fantasy figures are finely detailed with embroidery, beads, and sequins. She is particularly noted for her "pocket people" which are an innovative combination of handwoven boxes or pouches of various shapes and sizes that have tiny detailed people peeking out when the pouches are opened. Judes work has humour and they touch the child in all of us.

Jude Crossland graduated from the Sheridan College School of Crafts and Design in 1971 as a textile major with honours. Between 1971 and 1973 Jude taught textiles at Canadore College, North Bay, Ontario.

In 1972 she won an outstanding entry award at the Canadian National Exbibition. In 1973-74 she was awarded the Travel Study Bursury by the Ontario Crafts Council. She travelled through northeastern United States and on to Great Britain studying with a wide variety of artists working in textiles, weaving and the doll field.

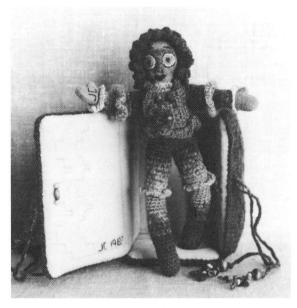

XH30

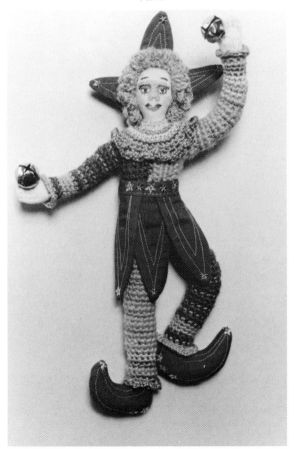

XH33

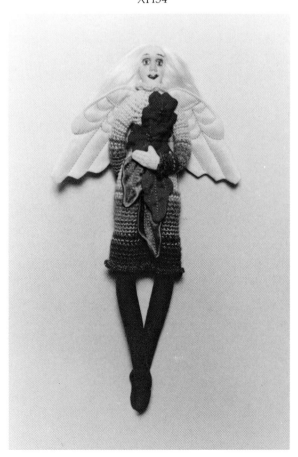

XH34

XH30
Jude Crossland. 1984. JACK-IN-THE-BOX. Doll is 7 in. (17 cm) ; box is 5 x 3.5 in. Crocheted with cotton and wool. Box is woven flat in one piece, lined, lightly stuffed, and stitched together. Mark: on doll's hand, J.C. Photograph courtesy of Jude Crossland, Wilno, Ont.

XH33
Jude Crossland. 1984. JUMPING JESTER WITH BELLS. 8 in. (20.5 cm). Crochet and stitchery using mercerized cotton, tapestry yarn, and sewing thread. Mark: JC. Photograph courtesy of Jude Crossland, Wilno, Ont.

XH34
Jude Crossland. 1984. CHRISTMAS ANGEL. 10 in. (25.5 cm). Crochet and stitchery using mercerized cotton, tapestry yarn, and silk. Mark: JC. Photograph courtesy of Jude Crossland, Wilno, Ont.

XH35
Jude Crossland. 1984. TWIN PACK. 17 in. (43. cm). Crochet and leather pouch, lined. Pouch hangs on the wall and holds twin figures. Figures made with crochet and stitchery. Mark: JC. Photograph courtesy of Jude Crossland, Wilno, Ont.

XH36
Jude Crossland. 1984. ANNIE. 20 in. (51 cm). Crocheted figure using cottons, wools, linens, leather, and lace. Mark: JC. Photograph courtesy of Jude Crossland, Wilno, Ont.

XH37
Jude Crossland. 1984. PRIMITIVE. A primitive piece in both design and materials used; woven and stuffed; hangs on the wall. Early Indian and South American influence. Mark: J.C. Photograph courtesy of Jude Crossland, Wilno, Ont.

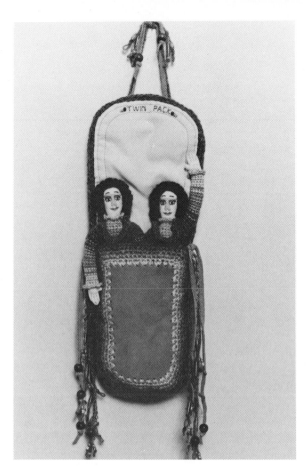

XH35

XH36

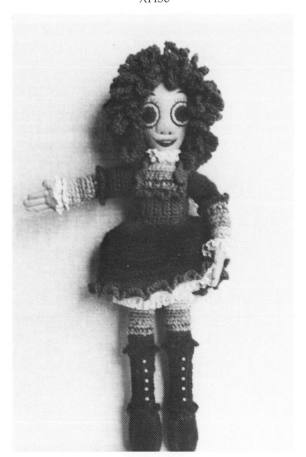

XH37

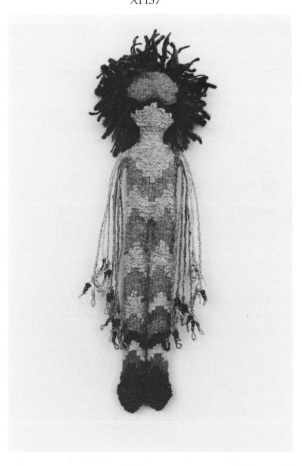

Hanna-Maria Cybanski

Hanna-Maria Cybanski comes from Poland but is now a resident of Richmond, Ont. She studied commercial art and also took private lessons in clay sculpture.

This artist makes cloth dolls which vary in height between twelve inches and six feet. Her dolls have a wire armature covered with a nylon skin and are stuffed with polyester fibre fill. The feet are made of clay to give them balance.

Hanna researches the time period that she is representing so her dolls will be dressed authentically. She has also made dolls in Canadian, English, Polish, and Ukrainian costumes.

Her dolls are marked on the bottom of a foot 'Hannacraft" and they are usually one-of-a-kind.

BU14
Hanna-Maria Cybanski. ca.1983. MAID MARION. 19 in. (48.5 cm). Nylon cloth body, wire armature with polyester fibre fill stuffing. Nylon head, features made with needle sculpture; inset eyes in prepared sockets; brown long human hair wig. Authentic period costume in turquoise, trimmed in fur. From the collection of Dominique Lévesque and Steven Miles, Ottawa, Ont.

BU18
Hanna-Maria Cybanski. 1983. DIANA ROSS. 21 in. (53.5 cm). Tan nylon body with wire armature, stuffed with polyester fibre fill, individual fingers. Nylon head with needle sculptured features; inset teddy bear eyes in prepared sockets; black theatrical crepe hair wig. Silver and white brocade evening gown with matching shoes. From the collection of Dominique Lévesque and Steven Miles, Ottawa, Ont.

BU14

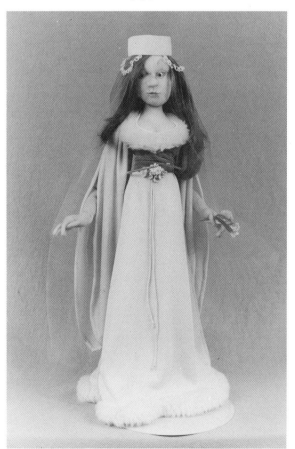

BU18

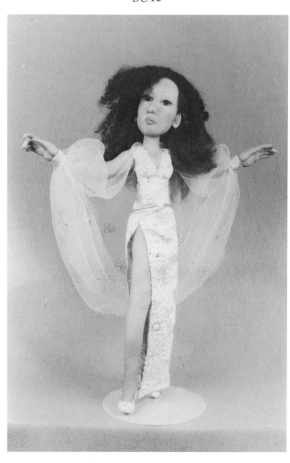

Joan Doherty

Halifax, Nova Scotia, was the birthplace of Joan Doherty. At the early age of twelve, she began making dolls. By eighteen years of age she was selling her dolls.

Joan has studied weaving and dyeing fabrics in art schools in Canada, England, and Finland. She uses her training to create cloth dolls which she feels offer her the opportunity to combine her interest of working with a wide variety of beautiful fabrics and the expression of the human personality as seen in poetry and story. The dolls have facial features that are painted as well as embroidered. She may use wool or mohair for her doll's hair, and the clothing is made almost entirely of natural fibre materials.

Joan bases most of her doll ideas on a poem or nursery rhyme, and tries to convey the spirit of it through colour, style of clothing, texture, and detail.

Joan's dolls are usually one-of-a-kind and bear a label with her name and address sewn on the back of each doll.

BV22
Joan Doherty. 1980. RAINBOW DOLL. 18 in. (45.5 cm). Cloth body stuffed with polyester. Cloth head; embroidered and painted eyes; wool hair; embroidered mouth. Mark: on back, label with the artist's name and address. Wearing drawers, petticoat, dress, pinafore, shoes and stockings. From the collection of Paula Warman, Stephenville, Newfoundland. Photograph courtesy of Joan Doherty, Halifax, N. S.

BV23
Joan Doherty. 1984. SPRING. 22 in. (56 cm). Cloth body, stuffed with polyester. Cloth head; embroidered and painted eyes; mohair wig; embroidered mouth. Mark: label on back, artist's name and address. Dressed in lace-trimmed underwear, cotton dress, skirt trimmed with handmade lace. Shoulder cape of antique lace. Straw hat trimmed with velvet flowers, silk organza bow, antique silk veil, ostrich feathers. Photograph courtesy of Joan Doherty, Halifax, N.S.

BV22

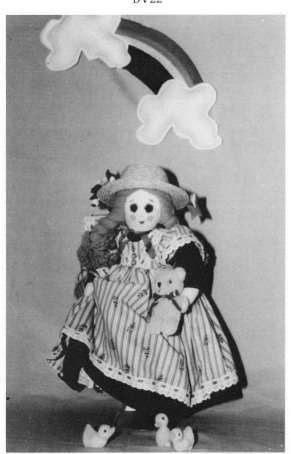

BV23

Rose Dolhanyk

Rose Dolhanyk is a dollmaker in Grimsby, Ontario. She loved to draw as a very young child but it was not long before she changed to three dimensional figures. Rose feels that making dolls fills a need to create beauty and satisfies her love of textures. Her dolls are often the centre of a booth or tiny shoppe surrounded by items for sale. She particularly enjoys using the many different materials necessary to make the small scene perfect. One of her favourite scenes is the Doll Collector, complete with tiny dolls.

The heads are sculpted from synthetic clay and are hand painted. The tiny hands are also modeled from clay. The bodies are made with a wire armature covered with a muslin skin which allows them to assume any position. Some of her more recent dolls have heads made from papier-mâché.

Although the artist makes dolls with the same theme, each doll is individually made and no two are exactly alike.

BU29

DA2
Rose Dolhanyk. 1984. HAT SELLER. 11 in. (28 cm). Padded muslin over wire armature. Head and hands are sculpted clay. Hand painted features. Carrying tiny hats. Photograph courtesy of Rose Dolhanyk, Grimsby, Ont. **See colour Fig. DA2.**

BV14
Rose Dolhanyk. 1984. BOOK SELLER. 11 in. (28 cm). Padded muslin over wire armature. Head and hands are sculpted clay. Centred in a tiny book shop, backed by book shelves. Tiny lace covered table. Photograph courtesy of Rose Dolhanyk, Grimsby, Ont. **See colour Fig. BV14.**

BU29
Rose Dolhanyk. 1984. WOOL SELLER. 11 in. (28 cm). Muslin padded wire armature. Head and hands are sculpted clay; grey mohair wig; closed mouth. Mark: label, Handmade/by/Rose Dolhanyk/Grimsby, Ont. Dressed in lace trimmed drawers and slip, cotton dress, white lawn apron, grey wool cape, matching bonnet trimmed with feather and ribbon over a white cotton dust cap. Wearing spectacles. Carrying a wicker basket full of skeins of wool and knitted goods. Author's collection.

Gail Ewonchuk

Gail Ewonchuk was born in Winnipeg, Manitoba, but now lives in Clearbrook, B.C. Her reason for making dolls is a little unusual. She enjoys costuming the dolls. She is an expert on historical fashions. She may choose a year from the past and create a costume that matches the fashions of that time. The dolls in this case are simply props to show off the beautiful clothing.

Even so, the dolls are also unusual. The bodies are cloth. The cloth heads are painted to give a hard smooth surface resembling papier-mâché, and the nose is made of wood that is glued on the face.

Gail marks her dolls with the month and year that they were made plus the word Snail. Her mark is usually on the doll's bottom but could be on the back of the head.

CB10

CB10
Gail Ewonchuk. 1984. 1875 LADY. 11.5 in. (29.5 cm). Cloth body, painted legs and shoes. Cloth head; painted eyes; black mohair wig; closed mouth. Mark: SNAIL/May 84. Dressed in 1875 promenade dress, plum skirt, purple polonaise, black and plum hat with feathers; black lace umbrella. Courtesy of Gail Ewonchuk, Clearbrook, B.C.

CB11
Gail Ewonchuk. 1982. 1806 MAN. 13.5 in. (34 cm). Cloth body with painted cloth arms and legs. Painted cloth head; wooden nose; painted brown eyes; blond mohair wig; closed mouth. Mark: May 82/SNAIL. Dressed in 1806 style with rust wool frock coat, vest, white pants, shirt, and cravat. Courtesy of Gail Ewonchuk, Clearbrook, B.C.

CB12
Gail Ewonchuk. 1982. 1806 LADY. 13 in. (33 cm). Cloth body with arms and legs painted cloth. Painted cloth head; wooden nose; painted green eyes; painted black hair plus mohair curls; closed mouth. Mark: May 82/SNAIL. Dressed in 1806 style simple gown with green velvet stole trimmed with a gold fringe. Courtesy of Gail Ewonchuk, Clearbrook, B.C.

CB11

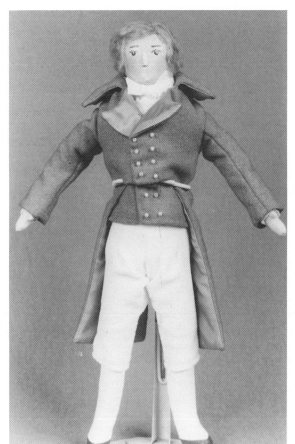

CB12

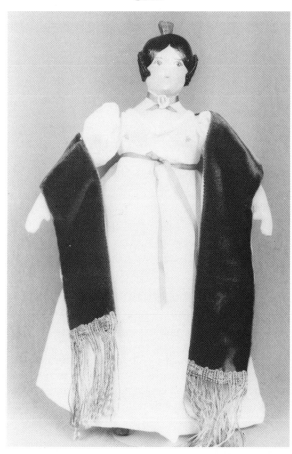

John Ferguson

John Ferguson resides on Vancouver Island but is a native of Toronto where he attended art school. He is an artist with a great deal of experience in interior design and window display in New York City. The human figure in all its representations is artistically facinating and the study and creation of marionettes with their ability to mimic the postures of the human body has wonderful possibilities for the creative artist.

John uses different methods of construction. Although most of his marionettes have carved wood heads with wooden painted bodies, some are papier-mâché and some have plastic wood features. Others have wood and cloth bodies and some have cloth heads filled with cotton and sand for weight.

His marionettes are completely original and his version of well known fantasy characters is vibrant and exciting. A marionette show with figures such as these would be delightful to see.

XH18
John Ferguson. 1971. MAD HATTER. 23 in. (58.5 cm). Carved wooden body. Carved wooden head; glass eyes; grey human hair; painted moveable mouth. Mark: JKF. Cream wool and velvet suit, papier-mâché hat. From the collection of John Ferguson, Victoria, B.C. See colour Fig. XH18.

XH19
John Ferguson. 1971. PUNCH (marionette). 30 in. (76.5 cm). Carved wooden body. Carved wooden head; lac bead eyes; painted moveable mouth. Mark: JKF. Dressed in velvet and satin. Courtesy of John Ferguson, Victoria, B.C. See colour Fig. XH19.

Shelly Fowler

Shelly Fowler graduated in Fine Arts in 1967 from the University of Toronto. She had always loved the colour and texture of fabrics and began using this medium in her art work.

Although Shelly also painted, she used soft sculpture to create figures and wall hangings which she exhibited at shows almost every year. Another facet of her work was the design and production of containers and jewellery.

Shelly's favourite materials to work with when developing a doll figure are silks and cottons which she stuffs with kapok. Sometimes she constructs the face and then uses gesso on it before painting the features. At other times she simply paints the face on the flat fabric.

Over the years the doll figure in her work has evolved and combined with other ideas becoming more abstract in her later works. Shelly Fowler no longer makes doll figures but many collectors prize examples of her art.

SE3
Shelly Fowler. CHINA DOLLS. 8 in. (20.5 cm) ; 9 in. (23 cm). Tiny china head dolls with dainty clothing lavishly trimmed with lace. Photograph courtesy of Shelly Fowler, Toronto, Ont. See colour Fig. SE3.

SE4
Shelly Fowler. ca.1975. TREE DOLL. 14 in. (35.5 cm). Cotton body stuffed with kapok. Face treated with gesso and painted. Photograph courtesy of Shelly Fowler, Toronto, Ont. See colour Fig. SE4.

SE5
Shelly Fowler. ca.1970. PIN CUSHION DOLL. 10 in. (25.5 cm). Velvet and cotton construction with beadwork detail. Made as a wallhanging. Photograph courtesy of Shelly Fowler, Toronto, Ont. See colour Fig. SE5.

SE6
Shelly Fowler. ca.1970. PEDLAR DOLL. 17 in. (43 cm). Photograph courtesy of Shelly Fowler, Toronto, Ont. See colour Fig. SE6.

Wendy Gibbs

A resident of Vancouver Island, B.C., Wendy Gibbs majored in art and studied sculpture under Maggie Head and doll artist Joyce Wolf. She began making and selling dolls in 1980.

Wendy's dolls represent the native children of Canada dressed as you would see them today, or in traditional attire. She focuses on a different tribe each year, and researches the clothing and customs of the tribe. She locates elderly Indian women who are able to reproduce miniature copies of authentic Indian styles using the old time skills, which are not practised by the young people.

Many native art forms, such as cedar bark weaving, are dying out. Wendy has been able to incorporate the ancient skills into the clothing of her dolls.

Wendy uses the same mould for all her native dolls. The head and hands are bisque, tinted to obtain the correct shade of skin tone, and the bodies are cloth. Each style of dress is made in an edition of twenty-five. The authentic native clothing makes the dolls of Wendy Gibbs uniquely Canadian.

CC34
Wendy Gibbs. 1984. PRINCESS TEMLAHAM (Kwakiutl tribe, meaning paradise). 26 in. (66 cm). Cloth body, bisque hands. Bisque head; hand blown glass eyes; black human hair wig; closed mouth. Mark: on head, Wendy Gibbs/8420. The Kwakiutl Ceremonial Dance attire is that of a Button Blanket; Dancing apron, and Headdress. Approximately 500 hand sewn buttons. The patterns are from the Hunt family and are entitled the "Sun" pattern of the 'Salmon'. Dressed by native artist Shirley Ford Hunt, daughter of Henry Hunt (son-in-law of Mungo Martin who was a famous native carver, painter, singer, and songwriter). Courtesy of Wendy Gibbs, Sidney, B.C. See colour Fig. DA3.

CC35
Wendy Gibbs. TALEETHA (small island close to the mainland). 26 in. (66 cm). Cloth body, bisque hands. Bisque head; hand blown glass eyes; human hair wig; closed mouth. Mark: on head, Wendy Gibbs. Dressed in traditional cedar bark clothing from the Nuu- Chah-Chah-Nulth band of the west coast. Cedar bark cape and skirt, Maquinna hat (a sign of greatness, worn by high-ranking whalers and Chieftains). Cedar bark warp entirely covered by wrapped twining of swamp grass, bleached and dyed in colours woven in traditional design depicting whale hunt. Carries berry basket with matching traditional design. Clothing made by Alice Paul of Hesquiat, B.C. Her work is in many museums and her weaving is featured in the book "Indian Artists at Work", by Ulli Stlzer, published in 1976/1980. Courtesy of Wendy Gibbs, Sidney, B.C.

CC34

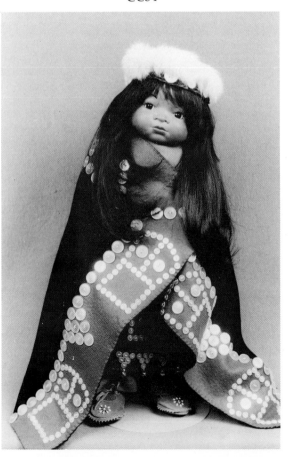

CC35

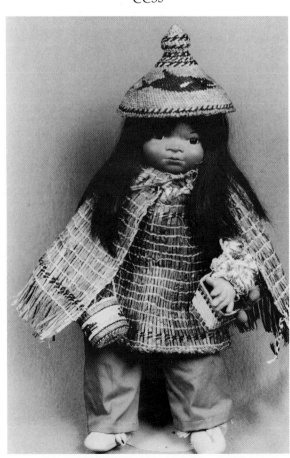

Dorita Grant

Dorita Grant, of Vancouver Island, B.C., is a professional embroiderer and crewel artist, and has taught stitchery for a number of years. She became interested in doll making after sculpting a face from clay while entertaining her grandchildren. She was surprised to find that she had a remarkable talent for sculpture.

She does not paint the clay, but leaves it in its natural brown shade which is ideally suited to the creation of native dolls. The hands and feet are also modeled from clay. She then assembles the doll with a cloth body stuffed with sawdust.

She draws on her expertise to design and sew beautiful and authentic clothing for her dolls. In order to design the clothing like those worn by the natives in earlier times, Dorita has researched the culture and customs of the native peoples of the west coast. Consequently, she is able to create perfect miniature reproductions of the famed Chilkat blankets and clothing made of woven cedar bark. Her skills in sculpting the faces, designing the clothing, and her creativity in embroidery and dressmaking are all combined to create outstanding one-of-a-kind dolls. Her dolls have been exhibited in several museums and are much in demand by collectors.

XG9
Dorita Grant. 1983. WOMAN WEARING CHILKAT DANCING BLANKET and APRON. 12 in. (30.5 cm). Cloth body filled with sawdust; clay hands and feet. Sculpted clay head. Mark: on back and foot, Dorita Grant/83-5-3. Wearing cotton dress under blanket. Photograph courtesy of Dorita Grant, East Sooke, B.C. From the collection of Bruce Logan, Sooke, B.C. See colour Fig. XG9.

Pacific northwest coast Tsimishian woman wearing a Chilkat Dancing Blanket. The ultimate in regal apparel was the Chilkat ceremonial robe. A Chief would wear a dancing blanket, an apron trimmed in puffin beaks, and a carved mask and fur. Women wove and wore dancing blankets. The right to weave and wear a blanket was usually an inherited privilege. Chilkat Dancing Blankets were a symbol of wealth and prestige.

Although the Tsimshian are credited with the Chilkat blanket, it was the Tlingit who long ago made and developed the art to its peak. They were traded and worn by any chief or noble who could afford to buy one. The Chilkat blanket was woven from the cedar bark and mountain goat wool woven by women from designs drawn by a man. The colours used: yellow, black, and a greenish blue. A blanket took about a year to weave. They were traded and often cut up and made into smaller ceremonial clothing, such as aprons or leggings.

XG13
Dorita Grant. 1984. EAGLE BUTTON BLANKET. 12 in. (30.5 cm). Cloth body filled with sawdust; clay hands and feet. Clay sculpted head; human hair. Mark: on the back and on foot, Dorita Grant/84.5. Dressed in a cotton dress and head scarf with a button blanket over the shoulders. Photograph courtesy of Dorita Grant, East Sooke, B.C. See colour Fig. XG13.

XG11
Dorita Grant. 1983. CEDAR BARK WOVEN CLOTHING. 12 in. (30.5 cm). Cloth body filled with sawdust; clay hands and feet. Sculpted clay head; human hair. Mark: on back and foot, Dorita Grant/83.S.6. Dressed in cedar bark woven clothing. Photograph courtesy of Dorita Grant, East Sooke, B.C. Doll owned by the Glenbow Museum Gift Shop, Calgary, Alta. See colour Fig. XG11.

The fibrous inner bark of the western red cedar, or the yellow cedar tree, was used for ceremonial head and neck rings as well as for robes, capes, and skirts.

The inner bark was beaten and shredded before twining the rows of bark. The twining that held the rows of bark together was often less than half and inch apart.

The roots of the cedar, or the Sitka spruce tree, were used in weaving hats that were so finely done as to be waterproof. The roots were often dyed and patterns imbricated, although patterns were also painted on by the Pacific Northwest Coastal Indians.

XG14
Dorita Grant. 1983. WOMAN in BUTTON BLANKET. 12 in. (30.5 cm). Cloth body filled with sawdust; clay hands and feet. Sculpted clay head; human hair. Mark: on back and foot, Dorita Grant/83- 13. Clothing researched, designed and stitched by the artist. Sitches: buttonhole, chain, wool appliqued on wool worsted, mother of pearl buttons, some very old, variegated red cotton perle thread. Dress and underwear of cotton fabrics. Photograph courtesy of Dorita Grant, East Sooke, B.C. Doll owned by the Glenbow Museum Gift Shop, Calgary, Alta. See colour Fig. XG14.

Button Blankets were traditionally made from blankets obtained from the early fur traders. They were generally dark green or blue but black is usually used now.

Pearl buttons, small to very large, were also used to trade. These buttons were used as money; the larger the button the more valuable it was. Family crests were appliqued in a contrasting colour or outlined in beads or buttons in the centre of the blanket. The edges of the blanket were also appliqued and trimmed with buttons.

These blankets were worn for ceremonies and festivals. The buttons were a sign of wealth. The blankets were traded at Potlack and were highly prized. Button blankets were worn by the Pacific Northwest Coast Indians.

XG20
Dorita Grant. 1983. COAST SAALICH FEATHER CLOTHING. 12 in. (30.5 cm). Cloth body filled with sawdust; clay hands and feet. Sculpted clay head; human hair. Mark: on back and foot, Dorita Grant/83.8. Clothing researched, designed, and stitched by the artist. Made of cotton, feathers, and wool. Photograph courtesy of Dorita Grant, East Sooke, B.C. See colour Fig. XG20.

Coast Saalish Feather clothing with Sxwaixive (pronounced swi swi) mask used in ceremonial dances. The Coast Saalich were neighbours of the Nootka and Kwakiutl people. The Saalich carved welcoming figures ten to twenty feet high of men with their arms raised in welcome.

The Coast Saalish women wove baskets with embricated designs, and made handsome fringed blankets from the hair of a white dog that is now extinct.

Gerrie van den Hoek

Gerrie and her husband Teur are new Canadians who immigrated from Holland. They lived at first in Ontario but moved to Nova Scotia to be near the sea. Soon after Gerrie's arrival in Canada, she took a course in doll making and found it rewarding and fun. In 1982 she began selling her original dolls, and in 1983 Gerrie won first prize at the National Doll Convention in Toronto in the composition/clay catagory.

Gerrie sculpts a doll's head, hands, and feet from self-hardening clay. After the clay has hardened, which takes about a week, she sands the pieces to prepare them for the paint. Gerrie mixes her own water base paints to get just the right colour. The eyes are particularly well painted, which gives the doll's face a lifelike expression.

After the paint dries, she varnishes all the clay pieces using a very soft brush which leaves no brush marks. Gerrie then contructs the body from cloth and stuffs it. She marks her dolls on the shoulderplate: G.v.d.Hoek, month, year, and number. The dolls' wigs are also handmade by Gerrie, as well as the clothing. These are well made and in a European style. Among the dolls Gerrie has created are a boy, a girl, a baby, and an elf. Since each one is made individually, they are unique dolls.

BF15
Gerrie van den Hoek. 1983. SARAH. 16 in. (40.5 cm). Stuffed cloth body, clay hands and feet. Shoulderhead of self-hardening clay; grey painted eyes; painted lashes and freckles; honey blond human hair wig in braids; closed mouth. Mark: on shoulderplate, G.v.d. Hoek/march '83/no. 27. Original black dress with tiny white flowers, grey striped pinafore, black socks and wooden shoes. This doll won first prize in the 1983 National Doll Convention in the composition/clay category. Author's collection.

BF17
Gerrie van den Hoek. 1983. ELMER. 14 in. (35.5 cm). Stuffed cloth body, clay hands and feet. Shoulderhead of self-hardening clay; painted eyes and lashes; grey synthetic hair and long beard; closed mouth. Mark: Gerrie's dolls/June'83/no. 29. Original green pants and hat, green and white shirt, red moulded boots. Courtesy of Gerrie van den Hoek, Great Village, N.S.

BF15

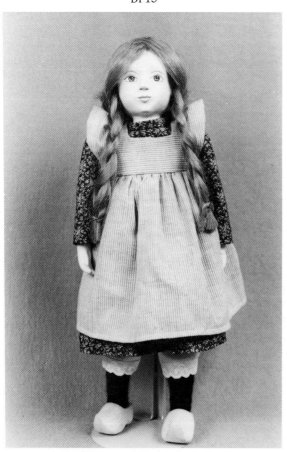

BF17

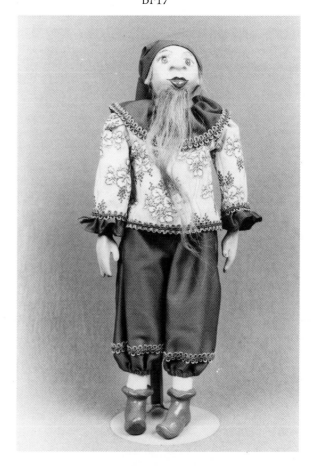

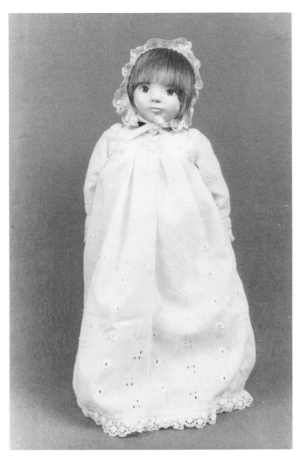

BF18

BF18
Gerrie van den Hoek. 1983. BABY CORINA. 12 in. (30 cm). Stuffed cloth body, clay hands and feet. Shoulderhead of self-hardening clay; painted eyes and lashes; human hair wig, closed mouth. Mark: on shoulderplate, G.v.d.Hoek/March '83/no. 26. Original long eyelet gown and matching bonnet. Courtesy of Gerrie van den Hoek, Great Village, N.S.

CK7

Betty Jackson

Betty Jane Jackson was born in Manitoba but now lives in British Columbia. She began sewing as a very young child, and created an extensive wardrobe for her MAGGIE MUGGINS doll.

She began designing her own patterns in 1981, and creates fabric people with personalities. Her fertile imagination devises original dolls of many kinds: babies, dancers, gnomes, clowns, toddlers, and elves. Some are one-of-a-kind, and some are made in small editions. The facial features are embroidered and each face is unique. Every doll has the label, Original/Betty Boop.

CK7
Betty Jackson. 1981. GOOSLUM. 24 in. (61 cm). Cloth body, jointed hips and shoulders. Cloth head with face a separate piece; embroidered blue eyes; blond crocheted wool hair. Dressed in a printed flannelette nightie. From the collection of Ruth Condello, Winnipeg, Man.

Marilyn Kilby

Marilyn Kilby of Victoria began making rag dolls in 1975 and then changed to reproduction bisque dolls in 1978. Marilyn's story however, goes on from there. For, after taking two courses in the manufacture of bisque dolls, she began to study books on the methods of creating original heads.

This she has taught herself to do so well that she is now able to teach others the methods she uses. Dollmaking for Marilyn is an obsession. It is something she feels she must do for she has a creative urge which cannot be denied.

Marilyn begins to sculpt a head from clay but never knows exactly what the head will look like when finished. When sculpting the head of Su Tsen, she did not intend to create a Chinese child but the face simply took form under her probing fingers.

So far, Marilyn has used reproduction bodies for her dolls. She is now making smaller heads and plans to make small versions of the characters she has created. Marilyn does not plan to make more than 100 dolls of each original head that she creates and each doll is clearly marked with her name, the date and the doll's number.

CA3
Marilyn Kilby. 1982. NATASHA. 22 in. (56 cm). Cloth body with porcelain arms and legs. Bisque head; fixed brown glass eyes, painted upper and lower lashes; synthetic black braids; open mouth with two teeth. Mark: on head, Marilyn Kilby/1983 2/83. Hand-knit woollen suit, leather moccasins. Courtesy of Marilyn Kilby, Victoria, B.C.

CA11
Marilyn Kilby. 1985. JOKER JACKSON, MINSTREL MAN. 15 in. (38 cm). Porcelain body with musical mechanism, jointed hips shoulders, and neck. Bisque socket head; fixed brown glass eyes, painted upper and lower lashes; synthetic curly black wig; open mouth showing two teeth. Mark: on head, Marilyn Kilby 1985. Dressed in a velvet suit, white ruffled shirt, hat, socks and boots. Courtesy of Marilyn Kilby, Victoria, B.C.

CA3

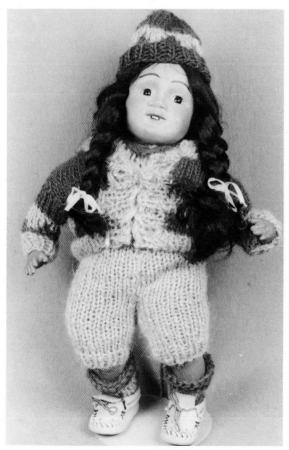

CA11

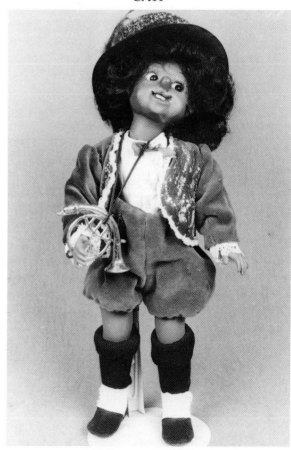

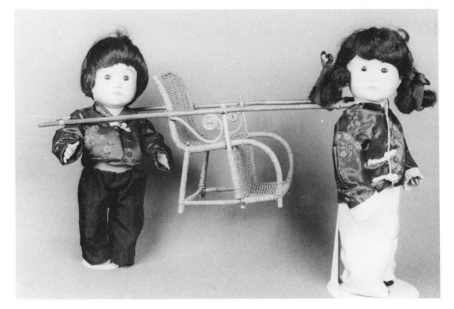

CA6

CA6
Marilyn Kilby. 1981. KIM and MIA. 16 in. (40.5 cm). KIM has a porcelain body, MIA has a composition body. Bisque heads; fixed brown glass eyes; synthetic black wigs; closed mouths. Mark: on heads, Marilyn Kilby 1981 The Twins, #13/85 on KIM and #20/85 on MIA. Dressed in oriental suits, carrying a bamboo chair. Courtesy of Marilyn Kilby, Victoria, B.C.

CL12
Marilyn Kilby. 1982. SU TSEN. 25.5 in. (64.5 cm). Composition body, fully jointed. Bisque socket head; fixed brown glass eyes; black human hair wig; closed mouth. Mark: on head, Original by Marilyn Kilby #3, Vic. B.C. Dressed in blue brocade blouse pinned with old brooch of brass and black laquer fan design. Blue-green satin wide-leg pants, black leather shoes. From the collection of Florence Langstaff, Vancouver, B.C. See also colour Fig. CL12A.

CL12

Thersa Knowlson

Thersa Knowlson was born in Yorkshire, England, and emigrated to Canada in 1923. She trained as a dressmaker and then worked for the Joseph and Milton Company in Toronto, where she learned to drape fabrics. She subsequently worked for the Robert Simpson Company in Toronto where she became familiar with the work of European dress designers. Later, she taught senior and advanced dressmaking at Central Technical School in Toronto for nineteen seasons.

Mrs. Knowlson began making dolls in 1982 for pleasure and relaxation. She made the dolls from papier-mâché and gave them elegant and sophisticated expressions. Then she created the costumes from dyed or painted cornhusks expertly draped to simulate fabric. This was so well done that one can examine the dolls closely and wonder with what the clothing is fashioned.

She has made sixty-five dolls showing the changes in fashions over a period of 200 years (from 1783 to 1983). She has not sold her dolls and has not made more than one of a kind. Each doll is marked in the nape of the neck with the tiny initials of the artist.

The dolls of Thersa Knowlson are outstanding. They are totally original, cleverly designed and executed, and are entirely different from dolls of other artists. They truly belong in a museum where they may be enjoyed by everyone.

CA12
Thersa Knowlson. 1984. GENTLEMAN 1934. 10 in. (25.5 cm). Body and head of papier-mâché; painted features; wool hair. Mark: on back of neck, T.K. Dressed in formal attire entirely of cornhusks. From the collection of John Ferguson, Victoria, B.C.

CA13
Thersa Knowlson. 1984. LADY 1933. 10 in. (25.5 cm). Body and head of papier-mâché painted features; wool hair. Mark: on back of neck, TK. Attired in a dramatic gown of 1933 made entirely of cornhusks. From the collection of John Ferguson, Victoria, B.C.

CA14
Thersa Knowlson. 1984. LADY 1869. 10 in. (25.5 cm). Body and head of papier-mâché; painted features; wool hair. Mark: on back of neck, T.K. Dressed in an elegant gown made of cornhusks and dried flowers. From the collection of John Ferguson, Victoria, B.C. See colour Fig. CA14.

CA12

CA13

Claudette Kristof

Claudette Kristof of Hull, Québec, was born in Ottawa. She remembers that she was always making clothes for her dolls as a child. She made her first doll at twelve. It was a black doll and she used persian lamb fur for hair to give it a black curly hairdo.

She began making dolls for her daughter in 1965 and these were so popular that she began to sell them in 1966. Her dolls have evolved over the years and now she makes a very sophisticated lady doll. Each one is different and she tries to put a little of her mood in each one. The hair is mohair and wool. The body is stuffed tightly with polyester batting. Every doll is signed with her name on the hem of the slip. Some dolls are dressed in a Victorian style but they all have one thing in common, they have no noses! The embroidery of the eyes is so effective, one doesn't miss the nose.

AE7
Claudette Kristof. 1980. 20.5 in. (52 cm). Cloth slim lady body. Cloth head; embroidered blue eyes, black lashes, blue eyeshadow; mohair and wool hair; embroidered closed pink mouth. Mark: on slip hem, C. Kristof. Elaborately dressed in taffeta and lace with matching hat and veil, carrying an umbrella. From the collection of Judy Smith, Ottawa, Ont.

AO28
Claudette Kristof. 1984. MALORIE. 23 in. (58.5 cm). Cloth slim lady body. Cloth head; embroidered blue eyes, eyelashes and eyeshadow; mohair and wool hair; embroidered closed mouth. Mark: on slip hem, C. Kristof. Red brocade gown with lace trim, white pinafore, matching hat. Author's collection. See also Fig. AO27.

AE7

AO28

AO27

Angelica La Haise

Angelika La Haise was born in the Black Forest area of West Germany. She now lives in Lanark County, Ontario. She has taken courses in oil and watercolour painting and in portrait drawing. She also has experience in sewing, all of which is useful in the production of dolls

Angelika made cloth dolls for her children and then turned to making dolls with cotton tricot over a plastic face mask in 1983. She paints the eyes with a gentle appealing glance that sets her dolls apart. There is a slight questioning look that seems to elicit a warm response from those who examine the dolls.

The bodies of her dolls are extremely well done and are so expertly shaped and stuffed that each body is smooth and firm. Angelika loves sewing and it shows in the imaginative finely- crafted clothing her dolls wear. The detail is well thought out and the clothes, hairstyle, and facial expression combine to make a superior doll of this type.

The La Haise dolls all bear a cloth label which is sewn on the back of the neck. The label states, Hand Made/by/Angelika La Haise. The year, the initials of the dolls name, and the number of the doll are inked on one side of the label. Each doll holds a small toy or miniature item such as a basket or a teddy bear, and this attention to detail results in a very appealing and cuddly doll.

CO9A
Angelika La Haise. 1985. MARK. 17 in. (43 cm). Cloth body, jointed hips and shoulders. Cloth head sewn to the body, plastic facial mask covered in cotton tricot; painted blue eyes, painted upper lashes; brown wig; closed mouth. Mark: on cloth label, Hand Made by Angelika La Haise/85 S #41. Wearing grey wool pants, tailored white cotton shirt, hand made blue woollen sweater, black leather shoes; carrying a teddy bear. Author's collection.

CO11A
Angelika La Haise. 1985. SUSIE. 10 in. (25.5 cm). Cloth body, jointed hips and shoulders. Head is sewn on the body and is made with a plastic facial mask covered with cotton tricot; painted blue eyes, painted upper lashes; hand sewn straight hair; closed mouth. Mark: cloth label on neck, Hand Made/by Angelika La Haise/85 P 31. Wearing cotton undies, smocked cotton nightie, smocked bonnet; sitting in a wicker buggy. From the collection of Norma Blaine, Almonte, Ont.

CO9A

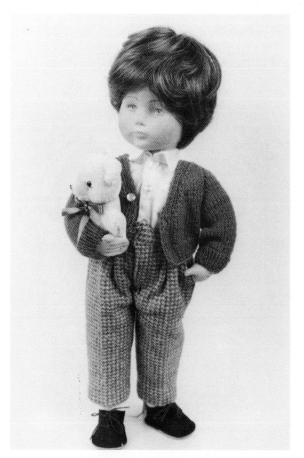

CO11A

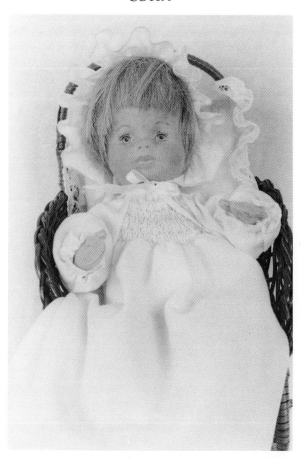

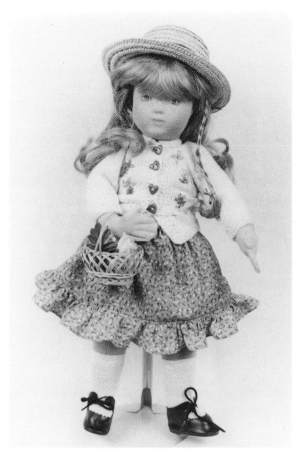

CO12A

CO12A
Angelika La Haise. 1985. ANNELIESE. 18 in. (45.5 cm). Cloth body, jointed hips, and shoulders. Cloth head sewn on body, plastic facial mask covered in cotton tricot; painted blue eyes, painted upper and lower lashes; blond wig; closed mouth. Mark: cloth label, Hand Made/by/Angelika La Haise/85 S #44. Dressed in a blue print cotton skirt, white cotton blouse, handknit cardigan, socks and leather shoes; carrying a basket with flowers and wearing a straw hat. Courtesy of Angelika La Haise, Lanark, Ont.

Barbara Lalicich

Barbara Lalicich (nee Holmes) is from Niagara Falls, Ontario. Her craft was self-taught through trial and error. She began making life-size needle sculpture people in 1980, and began selling her work in 1982. She now makes both adult and baby dolls. All her babies have needle sculptured navels. She utilizes nylon panty hose and stuffs the bodies with polyester fibre fill. The features are handstitched, and she applies make-up to the face to give a realistic colour.

Barbara applies her vivid imagination to create individual personalities in her unique adult characters. She sometimes produces a group of people, such as a bride and groom with wedding guests seated at a table, to create a hilarious scene. Each doll is signed and dated on the buttocks.

XX4
Barbara Lalicich. 1984. THINKER. 5.5 ft. Nylon body stuffed with polyester fibre fill. Nylon head; crystal eyes attached to Halex plastic to create the whites of eyes; human hair wig; features shaped by stitching and then make-up is applied for colouring. Mark: on the bottom, signed by the artist. Dressed in pants, shirt, and shoes. Photograph courtesy of Barbara Lalicich, Niagara Falls, Ont.

XX4

Susan Lindsay

Susan Lindsay, a Toronto, Ontario, artist has a Bachelor of Arts degree from the University of Western Ontario in psychology and English and a Bachelor of Education from the College of Education, University of Toronto. She has also studied Fabric Design at the Sheridan School of Design in Mississauga, Ontario.

Susan began making dolls in 1977 because she was able to use them to express ideas and feelings that she wished to share. She feels that the forms, colour, and fabric speak of her. Her dolls are made of linen and are not dressed except for strips of cloth, and they have no faces. Their form gives them expression. The medium of fabric has a sensual quality which allows her to express an intimacy in her work. The forms she creates express a personal struggle which is universal. In examining her dolls and letting the emotions they bring to the fore flow, one can feel the various vital emotions of womanhood and all it entails in personal relationships.

Susan's work has been exhibited in a one person show 'Messages, Memories and Musings", at the Cedarbrae District Library, Scarborough, Ontario, and at invitational exhibitions, including "Works on a Personal Scale", at the Burlington Cultural Centre, and Woodstock Art Gallery 1984, Ontario; "New Directions in Fibre Art", Art Gallery, Mohawk College, Hamilton, Ontario in 1981; "feminie dialogue '79", UNESCO, Paris, France, in 1979; and 'Contemporary Fibre Statements", in Toronto, Oakville, Cambridge, Grimsby, Lindsay, Burlington, Cobourg and Simcoe, Ontario.

Susan Lindsay has received the Award of Excellence, Excelsior Life Award, and the Regional Certificate of Merit from the Ontario Crafts Council. Her work is in a number of private collections.

SL1
Susan Lindsay. 1978. TILL DEATH DO US PART. 8 in. (20.5 cm). Double weave and wrapping; linen. Photograph courtesy of Susan Lindsay, Toronto, Ont.

SL2
Susan Lindsay. 1978. PRIMITIVE DOLL. 11 in. (28 cm). Double woven; linen. Photograph courtesy of Susan Lindsay, Toronto, Ont.

SL1

SL2

SL4

SL4
Susan Lindsay. 1980. MOTHERS. 8 in. (20.5 cm). Linen and coconut fiber. Photograph courtesy of Susan Lindsay, Toronto, Ont.

SL7
Susan Lindsay. 1984. FRIENDS. 13.5 in. (34 cm). Linen. Photograph courtesy of Susan Lindsay, Toronto, Ont.

SL7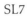

Joan Lintvelt

Joan Lintvelt was born in England but is now a resident of Vancouver Island, B.C. Joan began making dolls in 1980. She took courses in ceramics and bisque reproduction and a six month course in sculpture. Mrs. Lintvelt has a natural talent and an eye for the authentic that cannot be learned.

She is able to produce dolls from several different materials. Her dolls in bisque are lovely and are completely different from the dolls sculpted in FIMO ® clay. Her Eskimo woman is particularly impressive for, despite her missing teeth and wrinkled skin, she is touching in appearance with her cheerful and expressive face. Joan does her research into costuming well, for each doll is meticulously dressed according to character.

Like many doll artists, Joan finds the work addictive and enjoyable. Others seem to enjoy her dolls just as much.

BV28
Joan Lintvelt. 1985. AUSTRIAN GIRL. 18 in. (45.5 cm). Felt over wire armature body. Felt over porcelain head; painted eyes; fleece hair; painted mouth. Mark: card with artist's signature. Dressed in authentic Austrian national costume. Photograph courtesy of Joan Lintvelt, Sidney, B.C.

BV27
Joan Lintvelt. 1985. AUSTRIAN BOY. 18 in. (45.5 cm). Felt over wire armature body. Head is porcelain covered with felt; painted eyes; fleece hair; open-closed mouth showing teeth. Mark: card with artist's signature. Dressed in authentic Austrian national costume with hand painted lederhosen and beaver felt hat. Photograph courtesy of Joan Lintvelt, Sidney, B.C.

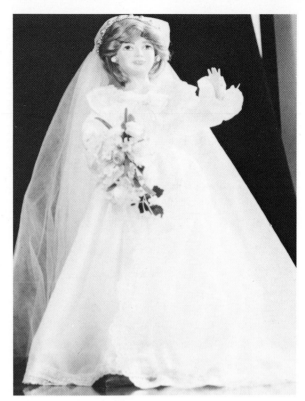

XG21

XG21
Joan Lintvelt. 1983. PRINCESS DIANA. 24 in. (61 cm). Cloth over wire armature body. Porcelain head; painted eyes; dynel wig; closed mouth. Mark: on nape of neck, artist's signature. Dressed in a gown of silk and old lace with a handmade bouquet. Photograph courtesy of Joan Lintvelt, Sidney, B.C.

BV28

BV27

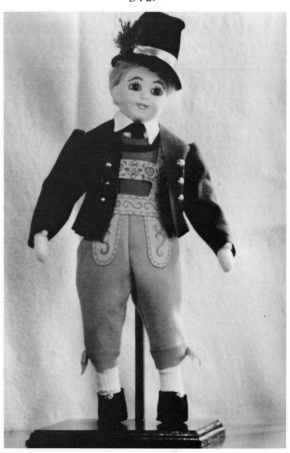

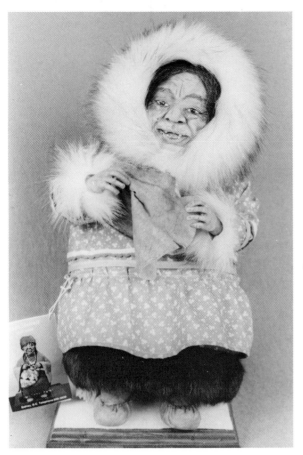

BZ26

BZ26
Joan Lintvelt. 1985. ESKIMO WOMAN. 16 in. (40.5 cm). Cloth over wire armature body; sculpted clay hands. Head sculpted from FIMO® acrylic modelling clay; painted eyes; yak hair wig; open- closed mouth with tongue and teeth. Mark: on back of neck, artist's signature. Authentically dressed in fur trimmed parka, hide mukluks. Courtesy of Joan Lintvelt, Sidney, B.C. See also colour Fig. BZ26A.

BF34
June Cherie MacDonald. 1984. MISS NOVA SCOTIA. 19 in. (48.5 cm). Cloth stuffed body. Cloth head; embroidered eyes; wool hair; embroidered mouth. Mark: label, Made with tender loving care by June Cherie. Dressed in cotton underwear, cotton print dress, white cotton pinafore, lace hose and velvet shoes. Wearing mayflowers (the N.S. provincial flower) in her hair. Courtesy of June C. MacDonald, Halifax, N.S.

June Cherie MacDonald

June MacDonald was born in Moncton, N.B. She began making cloth dolls in the 1950's and by 1965 had begun to sell them.

June makes dolls for the pleasure of seeing a little person take form under her flying fingers. Rag dolls have no personalities until they are stuffed when they suddenly assume a character of their own.

June's dolls are imaginatively dressed in quality fabrics. Her dolls are apt to sport such details as lace stockings and velvet shoes showing that they truly are "Made with tender loving care by June Cherie" as the cloth label sewn on the back or on the clothing states.

BF34

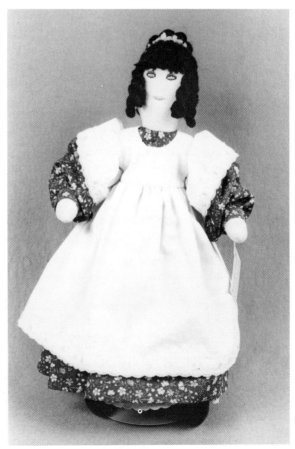

Catherine MacKay

Catherine MacKay was born on Cape Breton, N.S. She took a course in doll making in Halifax and began creating dolls for the pleasure it gives her and for the enjoyment of her grandchildren.

Her dolls are cloth, and the happy expressions on the faces are embroidered. They are unmarked. The clothing is innovative and well-made. These are happy cheerful looking dolls that are a joy to see and cuddly to hold.

BH3
Catherine MacKay. 1978. MAC. 18 in. (45.5 cm). Cloth body and head, stuffed with polyester fill. Embroidered eyes: wool hair; embroidered smiling mouth. Unmarked. Dressed in the Cape Breton Tartan kilt, black velvet jacket, lace jabot and cuffs. From the collection of Catherine MacKay, Dartmouth, N.S.

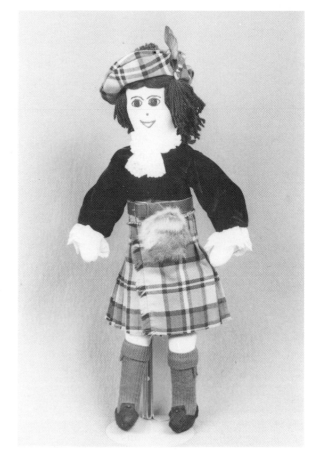

BH3

Madeleine Neill-St.Clair

Madeleine Neill-St.Clair of Nanoose Bay in British Columbia is a native of Lancashire England. She began making dolls about fifteen years ago but didn't sell her dolls until twelve years later. She took courses in porcelain work and china painting but had no training in the sculpting of original heads which she is doing so well now.

The bodies of Madeleine's dolls may vary from all porcelain to cloth bodies with a wire armature, to composition bodies which are made to the artists specifications.

The dolls are costumed all in pure silk and cotton with lavish use of antique lace and fabrics. The clothing is all designed by the artist.

All the "Maddy Dolls" as they are called, are marked on the back of the neck with Madeleine or just M on the tiny dolls. Although Madeleine makes 10 or 12 dolls from an original mould, all the dolls are painted and finished differently, therefore no two are ever identical.

Madeleine's dolls are mostly girls and come in all sizes, from the very tiny to quite large dolls. Her dolls have large eyes and expressive pixie faces. The colouring is delicate and the painting precise. The gentle expectant expression on the faces of the Maddy Dolls is very appealing.

CV8
Neill-St.Clair. 1986. TOMMITY. 16 in. (40.5 cm). Composition body with French jointed knees hips, elbows, shoulders. Bisque socket head, pierced ears; brown glass paperweight eyes, painted upper and lower lashes; black curly wig; closed mouth. Authentic gypsy clothing, grey pants, blue cotton shirt, green velvet cap, embroidered suspenders trimmed with Russian kopecs. From the collection of Florence Langstaff, North Vancouver, B.C. See colour Figs. CV8 and CV9.

Christos Papadopoulas

Christos Papadopoulas was born in Russia of a Russian mother and a Greek father. He was only three when his family moved to Greece. He was fascinated as a young child by the dolls his mother created and expertly dressed. As a young man he saw a film of an artist who made wax figures for a museum. He was so impressed that he began to experiment with doll making and soon was producing Greek historical figures. In 1960 Christos gave an exhibition of his dolls in Thessalonika. He also gave an exhibition of his miniature figures in Athens in 1967.

In 1971 Christos met Claudette, a Canadian, whom he married. In 1974 they moved to Canada and settled near Montréal, Québec. It is here that Christos practises the art of doll making. He now makes over thirty characters, many of which are Canadian figures.

He sculpts the head from a mixture of marble powder and oil polyester, and paints the features to give the doll a lifelike expression. The clothing is carefully researched so that each historical figure is authentically dressed. His wife Claudette has been very helpful with this painstaking research.

Christos loves his work and feels he puts a little of himself into each doll. His Canadian historical figures are extremely popular with tourists and collectors alike.

BY3
Christos Papadopoulas. 1976. SAMUEL de CHAMPLAIN. 13 in. (33 cm). Cloth body with wire armature. Sculpted latex head; painted features; black hair and moustache. Unmarked. Authentic period costume. From the collection of Marsha Nedham, Ajax, Ont. See colour Fig. BY3.

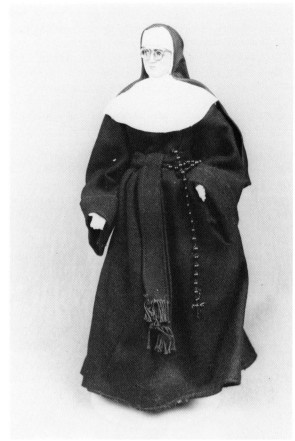

BX35

BX35
Christos Papadopoulas. 1975. URSULINE NUN from 1640. 12 in. (30.5 cm). Clay sculpted figure; wire armature. Clay sculpted head; painted features. Unmarked. Dressed in the habit of an Ursuline Nun. From the collection of Marsha Nedham, Ajax, Ont.

Michèle Prasil

Michèle Prasil is an original doll artist who has spent many years perfecting her craft. She has created series of dolls to represent different eras and different regions of Québec. Her research has covered the clothing worn by French Canadians from many walks of life over the last 300 years. Although she is a native of France and a professional teacher, she has studied the French Canadian culture in depth. She has interviewed many elderly people concerning the customs and the culture as they remember it from their youth. She has pored over books and records in libraries and museums studying the early costumes and the materials used by the habitants. She will not use any materials which were not available to the early settlers. She has, in fact, had some materials handmade by local weavers to produce the correct effect of the home made clothes of the early settlers.

Madame Prasil uses various methods of production on the heads to obtain the right effect. Some of her dolls that are entirely cloth are of the type usually called bed dolls. They have the long slender cloth body which was

popular in the nineteen- twenties. Some of the heads are also cloth. They are made of a very fine silk-like material to give the appearance of skin. When making an adult couple, Michèle will use a slightly coarser material for the man's face to portray the coarser skin of a man who shaves. Michèle also makes some heads of a material which she refers to as powdered stone. This material is sculpted to form the smooth beautiful sophisticated faces for which she is noted.

Michèle Prasil's historical figures are outstanding. Her Jacques Cartier doll stands over three feet tall. He is meticulously dressed in the fashions of his day with slashed satin, padded trunk hose and a coat heavily trimmed with beaver fur. His beard appears to "grow" on his stone face. His features are sensitively sculptured and the eyes are realistically painted.

Madame Prasil has created a series of country people of the eighteenth century from Orléans, an island near Québec City. Another series of very fashionably dressed

ladies represent 1902 chic city dwellers. Michèle will make the costumes her dolls wear exact copies of styles in the old Eaton's catalogues. She has also created a series of nineteenth century children authentically dressed using materials from vintage clothing. One of her series was of dolls in fancy costumes, dressed as if waiting for a masquerade to begin. She accomplishes this with old laces, feathers, ribbons, rich fabrics and furs which give the doll a fantasy look.

Michèle Prasil began making dolls for sale in 1976. Many of her dolls are bought by American doll collectors visiting Québec City. She is an active member of the Corporation des Artisans de Québec. She has shown her work at a number of exhibitions including as far away at Mexico City. She has appeared on many television shows. A trip to her shop on rue Champlain in Québec City is a delightful and rewarding experience. A doll of hers is totally original and is a fine addition to a Canadian collection.

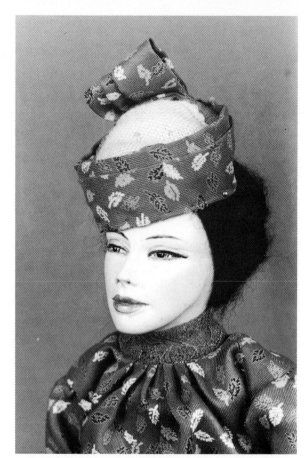

BP37

BM12
Michèle Prasil. Jacques Cartier. 43 in. (110 cm). Cloth body. Sculpted stone head; painted features; human hair wig and beard. Gorgeously attired in a wine satin tunic, padded trunk hose, doublet, brown velvet jacket lavishly trimmed with beaver, felt hat. Courtesy of Michèle Prasil, Québec, P.Q.

BM2
Michèle Prasil. 1984. GRAND de MAMSELLE 30 in (76 cm). Long slim cloth body. Sculpted stone head with painted features; brown wig; closed mouth. Label attached to the wrist. Dressed authentically from the 1901 Eatons catalogue in purple skirt, cape trimmed with fur and fur and feather hat. Courtesy of Michèle Prasil, Québec, P.Q. See colour Fig. BM2.

BP37
Michèle Prasil. 1984. 24 in. (61 cm). Long slender cloth body. Sculpted stone head; painted features; goat fleece wig; closed mouth. Wears a tag with the artist's name. Dressed in a long beige skirt, print blouse and matching pill-box hat, suede boots. Author's collection.

Joanne Pratt

Joanne Pratt was born in Brampton, Ontario. She was taught to sew by her mother and paternal grandmother. She also had a year of basic design at the Ontario College of Art in Toronto.

Joanne began making dolls in 1964 and began selling them in 1970. She makes about one hundred a year, but they are not all for sale. She enjoys experimenting and making extravagant one of a kind pieces. Many of her techniques are self-taught and are the result of experimentation.

The bodies are made with cotton knit fabrics or velour. They are stuffed with polyester fibre and are beautifully dressed in exquisite silks and brocades. The bottom of each piece is stitched with the initials JP over the year, or J.Pratt over the year. Joanne Pratt's whimsical dolls are unique and very elegant.

XH13
Joanne Pratt. 1981. GLAD RAGS. 12 in. (30.5 cm). Cotton knit body and head. Soft sculptured head; eyes are seed beads and embroidery; hair is orange maribou feathers stitched to head; mouth embroidered with silk thread. Mark: on bottom, J.Pratt/81. Photograph courtesy of Joanne Pratt, Forresters Falls, Ont. See colour Fig. XH13.

XH14
Joanne Pratt. 1982. CRUISING. 24 in. (61 cm). Body and head made from beige velour; bosom covered with mother of pearl shells; mermaid tail, overlay of organza, padded, quilted, hand embroidered and beaded with mother of pearl and opalescent beads; eyes have glass iris and pupil, eyelid of organza and false eyelashes; cream maribou feathers hand stitched to head for hair; mouth embroidered with cotton thread; silver lame fingernails. Mark: on botton J. Pratt 82. Photographs courtesy of the artist. See colour Figs. XH14 and XI10.

Yvonne Richardson

Yvonne Richardson is a Toronto artist with a Fine Arts degree from the University of Toronto. She has chosen to create original dolls simply because she says that little people appeal to her. And that is what she creates; little people with such strong character in their faces they almost speak to you.

This artist has an impressive resume that includes her experience in teaching art both in public school and in adult education classes. She has had a number of solo exhibitions of her paintings, and has entered her art in group exhibitions. Yvonne has produced television shows as well as having appeared as a guest on television to discuss sculpture.

Mrs. Richardson has designed the logo for the Seven Oaks Camera Club, of which she is an active member, and has served as Chairman of a committee which co-ordinates their tape and slide shows. She has been co-ordinator of exhibitions and seminars on sculpture. She has also exhibited her work and has won two awards for best sculpture.

Yvonne began creating dolls in 1985. They are totally original. She scuplts the hands and feet as well as the head. She makes the hands slightly bigger that usual to allow the doll to hold a small article. She uses a covered wire armature inside the cloth body to enable the doll to assume any position (see Fig. CP8).

One of Yvonne's two original dolls is called AMELIA with moulded hair and a turn of the century look; the other is AURORA with a bald pate that allows her looks to be changed dramatically by the use of different wigs and clothing. Both dolls have gorgeous hand painted eyes that few artists can match. Yvonne makes only ten of each doll, but each one is painted so creatively that no two are alike. The dolls may be bought undressed if desired. The artist, however, chooses the colours and designs her dolls clothing with a sure hand. The result is such an artistic feast to the eye that the dressed doll is difficult to resist.

CP11
Yvonne Richardson. 1985. AURORA. 17 in. (43 cm). Cloth over wire armature body, bisque lower legs and forearms. Bisque shoulderhead; two-tone brown painted eyes, brown line over the eye, painted lower lashes; brown short straight wig (recut to suit the doll); closed mouth. Mark: on shoulderplate, Aurora/Yvonne 85 6/10. Dressed in green moire knickers, lace trimmed shirt, brocade vest, shoes are moulded on the feet. Carrying tiny books. Courtesy of Yvonne Richardson, Scarborough, Ont.

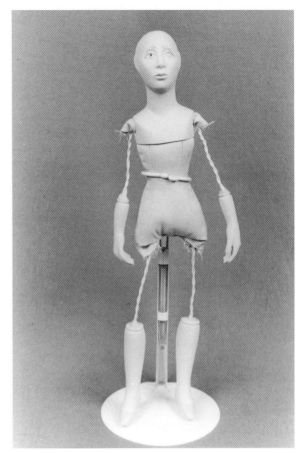

CP8

CP11

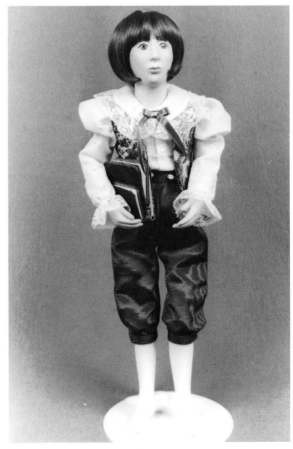

CP13

CP13
Yvonne Richardson. 1985. CLOWN. 17 in. (43 cm). Cloth over a wire armature, bisque lower legs and forearms. Bisque shoulderhead; green and turquoise painted eyes, dark line over eye, painted lower lashes; turquoise curly wig (remade); closed mouth. Mark: on shoulderplate, Aurora/cYvonne 7/10. Wearing a white silk clown suit, trimmed with turquoise ribbon and lace, matching hat. Holding a turquoise ball. Courtesy of Yvonne Richardson, Scarborough, Ont.

CP14
Yvonne Richardson. 1985. AMELIA. 17 in. (43 cm). Cloth body over wire armature, bisque lower legs and forearms. Bisque shoulderhead; medium brown painted eye with brown line over eye, painted lower lashes; light brown hair moulded in a pompadour and showing tiny tendrils; closed mouth. Mark: on shoulderplate, Amelia/cYvonne 1984 ; tiny Y on heel of both feet. Wearing a silk skirt and jacket, lace trimmed blouse, straw hat trimmed with feathers and matching ribbon, wearing a pearl necklace. Courtesy of Yvonne Richardson, Scarborough, Ont. See colour Fig. CP14.

Sheila Rose

Sheila Rose is a Toronto, Ontario, doll artist. A very creative person, she showed her talents early in drawing, painting, sewing, and makings things. She is a graduate of the fine arts course at the University of Toronto, and has taken many night school courses in life-drawing, painting, illustrating, cartooning, graphic designing, and ceramics.

All of this extensive training comes together in the creation of one-of-a-kind original dolls. The artist approaches each figure as a sculpture and the human form as an expressive mechanism.

Sheila uses many materials to achieve the effect that she is after. She has tried many different techniques as well. Sometimes she makes her own form of composition which can be moulded, carved, sanded, and painted in fine detail. Occasionally, the composition is glazed with wax to give it a soft, translucent, skin-like appearance. She has also used stoneware and porcelain, and is probably the only dollmaker who uses RAKV, which is a Japanese method of firing clay. It gives beautiful smoke patterns, glaze crackling, and metallic lustres. The results of the fast firing, however, are unpredictable, and the breakage rate is high. Each piece that is successful however, is unique and so impressive, that the risk is worthwhile.

Sheila often makes her figures to illustrate a theme, be it characters from Charles Dickens, such as David Copperfield, or a fantasy theme of woodland fairies. Snow and ice became another theme with the Snow Queen, as the central point, surrounded by moving spirit figures in white and silver, shimmering in the light. The dolls of Sheila Rose are touching, beautiful, and full of fantasy.

XH12
Sheila Rose. JUGGLING MARIONETTE CLOWN. 20 in. (51 cm). Porcelain and fabric marionette. Photograph courtesy of Sheila Rose, Toronto, Ont. See colour Fig. XH12.

XH8
Sheila Rose. ELF AND INSECT. 7in. (17 cm). Porcelain and silk. Photograph courtesy of Sheila Rose, Toronto, Ont. See colour Fig. XH8.

XH5

XH6

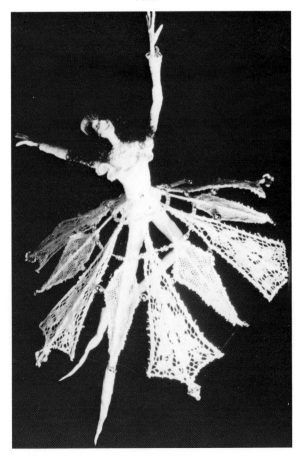

XH9

XH5
Sheila Rose. GREAT AUNT BETSY. 17 in. (43 cm). A character from David Copperfield. Photograph courtesy of Sheila Rose, Toronto, Ont.

XH6
Sheila Rose. WILLIAM LYON MACKENZIE. 36 in. (91.5 cm). Stoneware and fabric figure giving an impassioned speech from a vegetable cart. Photograph courtesy of Sheila Rose, Toronto, Ont.

XH9
Sheila Rose. SNOWFLAKE DANCER. 11 in. (28 cm). Papier-mâché and fabric. Photograph courtesy of Sheila Rose, Toronto, Ont.

Madeleine Saucier

Madeline Saucier was a distinguished doll artist and a member of the National Institute of American Doll Artists. She was from Montréal, and many of her dolls represented French Canadian historical figures.

Madeline showed her artistic talents and her interest in the doll world very early, for as a child she made clothes for her dolls sewing different outfits for them for every occasion. She also made rooms full of furniture for her dolls.

Her early training began at a convent school where she studied painting and sculpture. She was the youngest student to win the "École des Beaux Arts" award for a painting in oils. She later studied at the Art School of the Museum of Fine Arts in Montréal where she concentrated on drawing, portraits, and anatomy.

Madeline Saucier utilized her extensive training in the creation of exquisite felt dolls. She sketched and then sculpted the head, after which she moulded and shaped the felt over the form. The features were painted with a non-flaking paint and the head was treated with a special preservative. The bodies were built around a wire armature. Many of her dolls had articulated limbs and a swivel head.

Madame Saucier exhibited her dolls at Expo 67 in Montréal where her remarkable dolls attracted a great deal of attention. She made a series of seventeen dolls dressed in the costumes of different countries. Her Snow Babies were also notable. Madame Saucier died in 1985. Her dolls are exhibited in many museums around the world. She was one of our first and most noted doll artists.

CP18
Madeline Saucier. 1963. RED RIVER DOLL. 15 in. (38 cm). Cloth body over wire armature. Felt head; brown painted eyes; light brown wool braids; closed mouth. Mark: cloth label on the back, Madeline Saucier/Montréal, P.Q. Dressed in Red River winter outfit in felt. From the collection of Ina Ritchie, Aurora, Ont.

CT7
Madeline Saucier. ca.1967. SWEDISH GIRL. 15 in. (38 cm). Cloth one-piece body. Felt swivel head; blue painted eyes, lashes; synthetic blond hair; closed painted mouth. Mark: cloth label inside petticoat, Madeline Saucier (in script)/Montréal, P. Qué. Original dress in felt with a cotton blouse and head scarf. One of an international series. Author's collection.

CP18

CT7

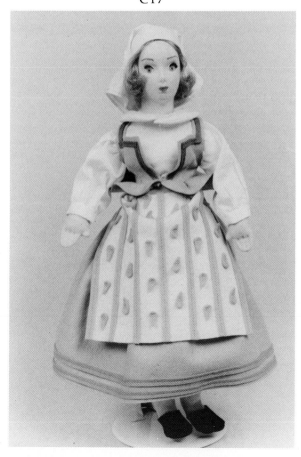

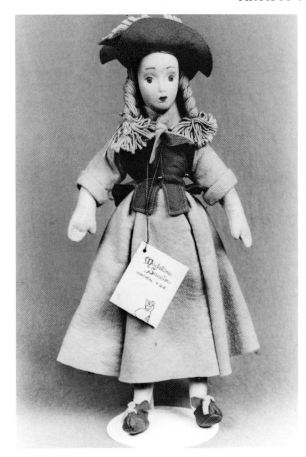

AP17

AP17
Madeline Saucier. 1967. MADELINE DE VERCHERES. 15 in. (38 cm). Felt body over a wire armature. Felt head; brown painted eyes, painted upper lashes; brown wool braids; closed mouth. Mark: label, Madeline/Saucier/Montréal, P. Qué. Dressed all in felt. From the collection of Maureen West, Niagara Falls, Ont.

Irina Schestakowich

Irina Schestakowich was born of Russian parents in West Germany. She moved to Montréal, Qué., in 1953. She studied art under Arthur Lismer at the Montréal Museum School as well as with Director Hugh Le Roy, printmaker Susy Lake, and animator Richard Holiday.

In 1972, she graduated from Montréal Museum of Beaux Arts and then attended Sir George Williams University in fine arts. She received her BFA degree from the University of Victoria, B.C. in art history and painting. She studied printmaking with Pat Martin Bates, and studied with painter John Dobreiner and sculptor Ruth Beer.

Irina works in many mediums and is skilled in various techniques. She is not only a doll maker but a print maker and an expert in soft sculpture and painting on silk. Her paintings and drawings have been in numerous exhibitions. In 1983 she exhibited a series of "Winter Dolls" in the Ontario Craft gallery in Toronto.

Irina received the Ontario Arts Council, Travel-Study Grant in 1983, to attend a weaving workshop in Victoria, B.C. with Lily Bohlin.

She began making dolls in 1978 and utilizes materials such as thin canvas, unbleached cotton and silk, which she watercolours and prints. Some of her dolls are entirely of silk but most are done in a wild mixture of materials which blend to produce the theme the artist is portraying. Usually, the dolls are made in a series, with each doll being different from the others yet following the same theme.

Irina's dolls have a distinctly Russian feeling which led the Toronto Star, 17 June, 1982 to state, 'Full of wit and whimsey ... Irina Schestakowich has married Russian folklore and modern technique.

BT30

BT30
Irina Schestakowich. 1980. THREE WISE WOMEN. 8 in. (20.5 cm). Cloth bodies, stuffed. Printed faces (faces made on tin plates and printed on cotton). Fleece hair. Each doll body is formed by the clothing with ribbons, sequin, and old lace. Courtesy of Irina Schestakowich, Toronto, Ont.

BT33
Irina Schestakowich. 1984. 11 in. (28 cm). Cloth body, stuffed. Cotton head treated with gesso and painted with watercolours; hair is red fleece; flowers in her hair. Clothing is sewn on. Eyelet skirt, lace apron, and velvet trimmed with sequined top. Holding out a rattle. Courtesy of Irina Schestakowich, Toronto, Ont.

BT33

Lois Schklar

Lois Schklar was born in Nashville, Tennessee, but has lived in Ontario for many years. She graduated with a B.F.A. from the Atlanta School of Art, Washington University, School of Fine Arts. She attended the George Peabody School for Teachers where, among other things, she studied ceramics. She has also done multi-media work with the Ontario College of Art.

Lois feels the work she does is a reflection of dreams, fears, and hopes that emerge from the unconscious. Some of the dolls simply evolve as if by magic. Others are carefully thought out and planned in detail before any sewing is done.

The artist uses a wide variety of fabrics including upholstery material, velvets, sequins, buttons, and trim. She does not like to repeat her work, so after a puppet or jumping jack has been worked out and the construction details decided, Lois has two women who sew the bodies, although she does the faces herself.

This artist has entered her work in many exhibitions including the Mariposa Folk Festival in 1977-78; the Brampton Art Gallery Doll Show, 1979; Mask Show, Prime Canadian Crafts 1980; and the Ontario Crafts '81 Juried Show where she won the John Mather Award of Excellence. She has also had her work exhibited at several one man shows.

Lois has taught numerous workshops, she has given courses in such things as soft sculpture, and she has extensive teaching experience in art programs.

Lois Schklar's work has been recognized in newspaper and magazine articles such as the *Toronto Monthly Theatre and Events Guide*, the *Toronto Star*, the *Globe and Mail*, *Craft News*, and *The Liberal*. Lois has a fecund imagination, and her images from the unconscious haunt the mind.

BV24
Lois Schklar. 1983. JUMPING JACK. 20 in. (51 cm). A movable doll form with arms and legs controlled by a string. Body is quilted upholstery material; arms and legs stuffed with polyester fibre fill. Four piece cloth head; stitch sculpted nose, cheeks, and chin; dyed eyes with embroidery and sequins. Photograph courtesy of Lois Schklar, Thornhill, Ont. See colour Fig. BV24.

BV25
Lois Schklar. 1983. THE SECRET GARDEN. 30 in. (76.5 cm). Appliqued standing doll form with beads, buttons. Painted papier-mâché face mask. Painted cardboard hands. From the collection of Leslie North. Photograph courtesy of Lois Schklar, Thornhill, Ont. See colour Fig. BV25.

BV26
Lois Schklar. 1983. THE KEY. 20 in. (51 cm). Cloth and gesso doll form. Face, arms, bottom part of legs connected separately, and treated with gesso and pencil with acrylic spray. Photograph courtesy of Lois Schklar, Thornhill, Ont. See colour Fig. BV26.

Carmen Vair

Carmen Vair was born in Barrie, Ont. As a child she played with Ojibwa children from the Moon River Reserve. Her grandfather had many friends among the Indians and they were frequent visitors to his home. Carmen played with the children there and became familiar with the shy dark-eyed beauty of the Indian children. She also began making dolls during her childhood and, in fact, Carmen can't remember when she didn't make dolls.

By 1974, the artist had become so proficient at dollmaking, that people asked to buy her dolls and Carmen was happy to oblige. She feels that she puts a great deal of personal energy and feeling into her dolls. She designs the body, makes it in cotton double knit, stuffs it with kapok, and achieves a doll with lifelike poses. She paints the facial features with such feeling and expression that the gentle shy personality she is portraying shine through. The hair is very distinctive as it is made with synthetic fibre which gives the doll a natural tousselled look.

Carmen researches her dolls clothing carefully and each doll is extremely well-dressed as it's clothing consists of many layers of handmade items. Each doll is marked on the side of one foot with the artist's name.

A new facet of Carmen's expertise is the small white baby she makes with a needle sculptered face. They are adorable and cuddly with delicate colouring and real eyelashes. They are dressed in sleepers and can assume the realistic poses of a very young baby. Carmen Vair's dolls are totally original and are outstanding.

AZ17
Carmen Vair. 1980. INDIAN BABY. 21 in. (53.5 cm). Cloth body. Cloth head; painted facial features; black synthetic hair. Mark: label, Native dolls/by Carmen. Dressed in a white cotton dress and panties, leather vest and boots, beaded pendent, feather headdress. From the collection of Mrs. D. Steele, Ottawa, Ont. See colour Fig. AZ17.

BO6A
Carmen Vair. 1984. LITTLE SNOW FOX (Koon-Wah-goosh). 23 in. (58.5 cm). Cloth body. Cloth head; expressive painted features; black synthetic hair with back in braids. Mark: label, CARMEN/NATIVE DOLLS. Handmade clothing, Cowichan style sweater, deerskin shoes, carrying a cloth Indian doll dressed in leather. From the collection of Ed Henderson, Winnipeg, Man. See colour Figs. BO6A and BO7A.

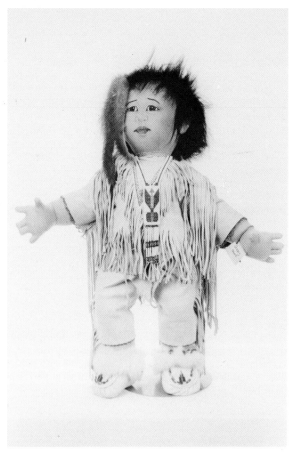

AE11

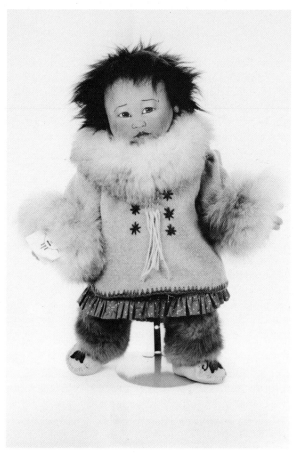

AE12

AE11
Carmen Vair. 1983. GREY OWL. 23 in. (58.5 cm). All cloth body, individual fingers. Cloth head; painted facial features; black synthetic hair. Mark: on foot, CARMEN 83/ A circle with a C inside and the number inside the C. Dressed in hand painted leather suit trimmed with fringed leather; wearing beaded necklace; handmade moccasins beaded and trimmed with rabbit fur and bells; headdress trimmed with mink. From the collection of Judy Smith, Ottawa, Ont.

AE12
Carmen Vair. 1983. 23 in. (58.5 cm). Cloth body, detailed fingers and toes. Cloth head; painted facial features; synthetic fur wig. Mark: on side of foot, CARMEN 83. Clothing designed and handmade by Carmen; knitted leggings and underdress, cotton print dress, covered by a wool coat with hood, fox fur collar and cuffs, handmade moccasins, beaded and trimmed with red fox. From the collection of Judy Smith, Ottawa, Ont.

Jeanne Venton

Jeanne Venton of Victoria, B.C., is an artist who paints portraits in oils. A few years ago she began taking lessons in porcelain doll making from Marilyn Kilby and clay sculpture from Peggy Packard. A talented pupil, she learned very quickly. Her first three-dimensional doll " portrait" was of her grandson Jerry. Since then she has created five more heads and has also sculpted arms, legs, and a shoulderplate. The first original heads that she made were mounted on reproduction bodies or composition bodies, although she has now begun to use her own body moulds to create a completely original doll. Jean also enjoys designing and making the clothing of the dolls herself.

The dolls she has made are very different from one another, and they show a great deal of talent. Her dolls have expression on their faces. She is able to portray feeling in porcelain, not an easy thing to do. The colouring is subtle and the painted features are expertly executed.

Jeanne plans to make limited editions of up to twenty of each doll. She prefers making an entirely new doll rather than doing many copies of one. She has begun selling at local doll shows. She should find a ready market for her excellent original dolls.

CA4
Jeanne Venton. 1985. SNOW-WHITE. 22 inches (56 cm). Composition ball-jointed body. Original bisque head; blue glass stationary eyes; painted lashes; dark brown human hair wig; closed mouth. Marks vary from doll to doll. Original yellow satin gown with blue velveteen bodice. SNOW-WHITE is holding a bird on her hand. A sensitive portrayal of a well-known Walt Disney character. Courtesy of Jeanne Venton, Victoria, B.C. See colour Fig. CA4.

CA10

CA10
Jeanne Venton. 1983. LUCY. 18 in. (45.5 cm). All porcelain reproduction body. Bisque head; brown stationary side-glancing eyes, painted upper and lower lashes; black tightly curled wig; open-closed mouth, showing teeth. Red and white polka dot dress with rickrack and ribbon trim. Courtesy of Jeanne Venton, Victoria, B.C.

CA15
Jeanne Venton. 1985. PRINCE WILLIAM. 20 in. (50.5 cm). All porcelain body, jointed hips, shoulders, and neck. Original bisque head; blue glass stationary eyes; painted lashes; blond synthetic wig; open-closed mouth. Marks vary from doll to doll. Original velveteen pants and white ruffled shirt. Courtesy of Jeanne Venton, Victoria, B.C. **See colour Fig. CA15.**

BZ4

Philomena Wallace

Philomena Wallace was born in Nova Scotia but now lives in Victoria, B.C. Phil studied sculpture for three years at Camosum College and began producing dolls in 1983.

This artist loves to work with her hands and enjoys using FIMO® a modelling clay to form the hands and model the heads of her dolls. The bodies are cloth with a wire armature to allow the doll to pose in different positions. The back of the head of each doll is marked P.W.

Phil is aiming for perfection and never makes more than one-of-a-kind. Each doll is unique and is totally original.

BZ4
Philomena Wallace. 1983. MILKMAID. 12 in. (30.5 cm). Cloth over wire armature body; clay hands. Head sculpted from FIMO® modeling clay; painted eyes; mohair wig; open-closed mouth. Mark: on head, P.W. Blouse and dress of old fabric. Carrying a pail. Courtesy of Phil Wallace, Victoria, B.C.

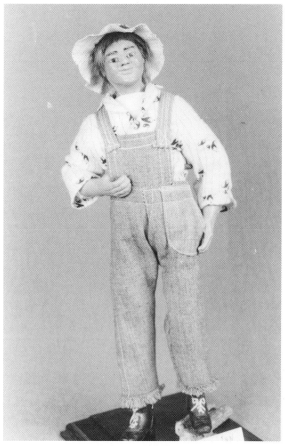

BZ5

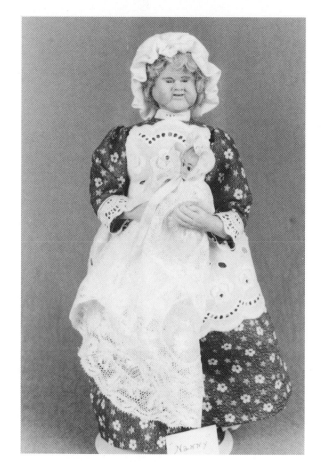

BZ3

BZ5
Philomena Wallace. 1983. FARM BOY. 12 in. (30.5 cm). Cloth over wire armature body; clay hands. Head is sculpted from FIMO(R) modeling clay; painted eyes; dynel hair; closed smiling mouth. Mark: on head, P.W. Handmade clothing of old material. Courtesy of Phil Wallace, Victoria, B.C.

BZ3
Philomena Wallace. 1985. NANNY AND BABY. 12 in. (30.5 cm). Cloth over wire armature body; clay hands. Sculpted clay head; painted eyes; mohair wig; closed mouth. Mark: on head P.W. Handmade cotton print dress with embroidered apron and dust cap. Baby in handmade lace gown. Courtesy of Phil Wallace, Victoria, B.C.

Nell Walsh

Nell Walsh was born in Saint John, N.B., where she still resides. A graduate of art school many years ago, Mrs. Walsh has been collecting dolls all her life. She began to make dolls in 1950. They were so well crafted that she found a ready market for them. She still makes dolls and musical stuffed animals because she loves it. It is a very happy hobby.

Nell makes her own composition and sculpts the heads. Occasionally she dips the composition heads in wax to produce a skin-like finish. She makes the body with a wire armature and carves the hands and feet from wood. Her dolls are identifed by a tag or on the foot as Nellcraft. She does not make more than one-of-a-kind.

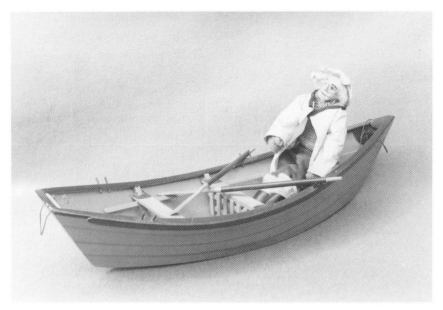

BJ26A

BJ26A
Nell Walsh. Date unknown. FISHERMAN. Approximately 8 x 18.5 in. (20.5 x 47 cm). Wire armature forming body with wooden hands and feet. Sculpted composition head; painted features; mohair wig. Unmarked. Dressed in authentic raincoat and hat, rubber boots, and sitting in his dory. From the collection of Nora Moore, Fairvale, N.B.

Marina Withers

Marina Withers, of Lunenburg County, N.S., began making dolls in 1960. She had no formal training in her craft, but, after much experimentation to perfect her dolls, she began to sell them in 1976.

Marina's dolls are made for personal enjoyment, and she is joined in her hobby by her husband Donald Withers, who makes the accoutrements, like the beautifully finished Granny rockers for her dolls to sit on.

BF10A
Marina Withers. 1979. GRANDMA AND BABY. 10 in. (25.5 cm). Wire armature bound with pantyhose body. Apple-head; peppercorn eyes; polyester yarn hair. Cotton print dress and white cotton apron. Sitting on a granny rocker made by Donald Withers. Courtesy of Marina Withers, Musquodobit Harbour, N. S.

BF10A

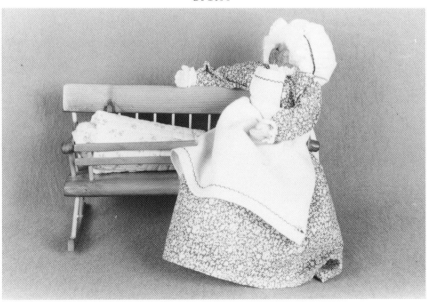

Stephanie Woods

Stephanie Woods, of Calgary, Alberta, was born in Clinton, Ontario. She began making dolls during her teen years as gifts for her friends. She attended the Banff School of Fine Arts, the University of Alberta, and worked at the Stratford Festival Theatre in Ontario in costume design.

The cloth dolls she makes are dressed very fashionably and authentically in elegant fabrics and with fine sewing. Her interest in costume design is exemplified in the dolls dressed exactly as the actresses were in their rolls on stage in the Stratford Festival Theatre. Stephanie's dolls can be identified by the seahorse she embroiders on the body.

CB8
Stephanie Woods. 1983. LADY SUSAN. 21 in. (53.5 cm). Cloth body; jointed hips, shoulders, and detailed fingers. Cloth head in four sections; embroidered features; mohair wool wig; brilliant earrings. Mark: a seahorse. Costumed as a fashionable lady of 1885 from the 1983 Stratford Festival production of Arms and the Man by G.B. Shaw. From the collection of Jean Woods, Chilliwack, B.C.

CB9
Stephanie Woods. 1983. 1885 FASHION LADY. 21 in. (53.5 cm). Cloth body, jointed hips and shoulders with button joint, arms bent at the elbow, hands have finger detail. Cloth head with four sections; embroidered features; mohair wool done in bouffant style; gold earrings. Mark: a seahorse. Costume from George Bernard Shaw's Arms and the Man, Stratford, Ont. Blue satin dress with bustle over cream eyelet underskirt, lawn petticoat and drawers, white stockings and handmade beige shoes. From the collection of Mary E. Van Horne, Chilliwack, B.C.

CB8

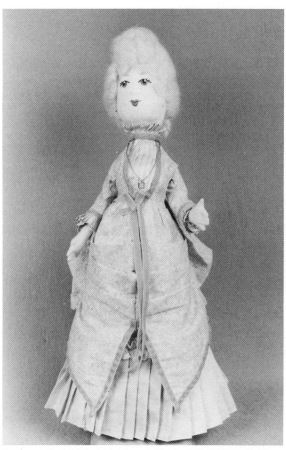

CB9

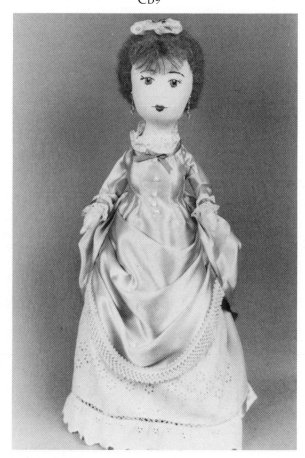

GLOSSARY

armature: dolls inner frame of wire, metal or wood

bed doll: long slim cloth lady doll, sometimes called a Flapper or Boudoir doll

bent-limb: baby with arms and legs moulded in a bent position

bisque: unglazed porcelain

bonnet head: doll with hat moulded on the head

caracul: the skin of a certain kind of very young Asian or Russian sheep with soft curly hair, used for wigs

character doll: used to describe dolls with realistic expressions

chemise: simple dress of thin cotton usually worn as an undergarment, usually the only clothing of an undressed doll

cold process: method of composition production where the moulds are cold and the composition is hand pressed by machine and allowed to dry

composition: various mixtures usually including wood-pulp

crier: cylindrical device with a tiny bellows inside, an early Canadian model invented by Dr. Lloyd of Orillia, Ont.

excelsior: wood-wool

Flexee-vinyl: D an C registered tradename for their version of vinyl skin

flexiwire: wire armature inside a one piece doll to allow the doll to bend it's limbs.

gauntlet hands: composition hand and wrist

glasseine eyes: glass pupil and iris set in metal eyeball, usually covered with a tough transparent paper for safety. Used during the thirties and early forties. Glasseine eyes sometimes crystalized giving the eye a milky look.

glassine eyes: a plastic lense on a mushroom shaped plastic button which fits into a plastic eye socket as a fixed eye. Used from the fifties on.

growing hair: synthetic hair that comes out of a hole in the head when it is released by pressing a button on the doll's body.

hard plastic: poly vinyl choride which has been injection moulded in two sections of each part and glued together

homespun: plain weave cloth usually woven by hand

hot press: the gas-fired machinery which is used in the hot process method to heat and compress the composition in the moulds

incised brows: cut into the plastic or composition

kapok: a mass of silky fibres that clothe the seeds of the Ceiba tree

knock-about doll: inexpensive doll with composition shoulderhead and hands and an excelsior stuffed cloth body and legs

magic skin: latex skin

maribou: synthetic feathers

mask face: thin moulded shell which forms the face of a cloth head doll

mohair: fleece of an Angora goat

mould, mold: the form, usually of brass for composition and steel for plastics used to shape the parts of a doll

moulded hair: head shaped in the mould to look like hair, usually spray painted

open-closed mouth: mouth that is modelled in the open position but has no entry into the head cavity

pantalettes: long drawers usually trimmed with lace, often designed to show below the dress

papier-mâché: mixture usually made of paper pulp and glue and pressed or moulded into shape and then dried

penny wooden: nineteenth century style jointed wooden doll

petticoat: underskirt, often lace trimmed

plastic: poly vinyl chloride blow moulded hard but not rigid or thick like injection moulded hard plastic

plastisol: soft vinyl

polonaise: coat-like overdress with cutaway skirt

Princess slip: one-piece combination underwear

rickrack: zig-zag cotton braid

ridigsol: one-piece stuffed vinyl rigid body used for teen dolls

rooted hair: synthetic thread fastened to a vinyl head by machine into small holes

saran hair: synthetic thread.

Skintex: D an C tradename for latex skin

sleep eyes (or sleeping eyes): eyes that close when the doll is laid down

sock doll: cloth doll constructed from a sock and stuffed

transition doll: doll made during the change from composition to plastics, usually of two or more materials

trapunto: quilting with an embossed design

turned head: head and shoulders modelled with the head turned slightly to one side

vinyl: poly vinyl chloride rotational moulded to form a soft plastic

Vinyl-flex: one-piece stuffed vinyl skin often with a wire inside to allow doll to assume any position

watermelon mouth: smiling closed mouth showing a line but no lips

BIBLIOGRAPHY

Anderton, Johana Gast. *More Twentieth Century Dolls.* North Kansas City: Athena. 1974.

Anderton, Johana Gast. *Twentieth Century Dolls.* Des Moines, Iowa: Wallace-Homestead. 1981.

Boehn, Max von. *Dolls.* New York: Dover Publications. 1973.

Coleman, D.S. *The Collector's Encyclopedia of Dolls.* New York: Crown. 1968.

Collard, Elizabeth. *Nineteenth Century Pottery and Porcelain in Canada.* Montreal: McGill University Press. 1967.

Ferguson, Ted. *Kit Coleman : Queen of Hearts.* Toronto: Doubleday. 1978.

Francis, Jean. *Doll Collecting Canadian Style.* Whitby, Ont.: Canada Yearbook Services, ©1978.

Johl, Janet Pagter. *The Fascinating Story of Dolls.* New York: H.L. Lindquist. 1941.

Hyslop, Marion. *Dolls in Canada.* Toronto: Dundurn Press. 1981.

Jenness, Diamond. *The Indians of Canada.* 7th ed. Toronto: University of Toronto Press. 1977.

Kant, Joanita. *Old Style Plains Indian Dolls from collections in South Dakota.* Vermillion, S.D.: W.H. Over Museum, University of South Dakota. 1975.

King, Constance Eileen. *The Collector's History of Dolls.* New York: Bonanza Books. 1978.

King, Constance Eileen. *Dolls and Doll's Houses.* London: Hamlyn. 1983, ©1977.

McGhee, Robert. *Canadian Arctic Prehistory.* Toronto: Van Nostrand Reinhold. ©1978.

Lavitt, Wendy. Dolls. *(The Knopf Collectors' Guides to American Antiques)* New York: A.A. Knopf. 1983.

MacLean, John. *Canadian Savage Folk.* Toronto: W. Briggs. 1896.

McKendry, Blake. *Folk Art: Primitive and Naive Art in Canada.* Toronto: Methuen. 1983.

Patterson, Nancy-Lou. *Canadian Native Art: Arts and Crafts of Canadian Indians and Eskimos.* Don Mills, Ont.: Collier-Macmillan Canada. 1973.

Tomlinson, Judy. *Those Enchanting Eaton's Beauty Dolls.* Canada: J. Tomlinson. 1981.

Webster, Donald Blake. *The Book of Canadian Antiques.* Toronto: McGraw-Hill Ryerson. 1974.

INDEX TO ALL FIGURE CODES AND THEIR PAGE NUMBERS

GENERAL INDEX